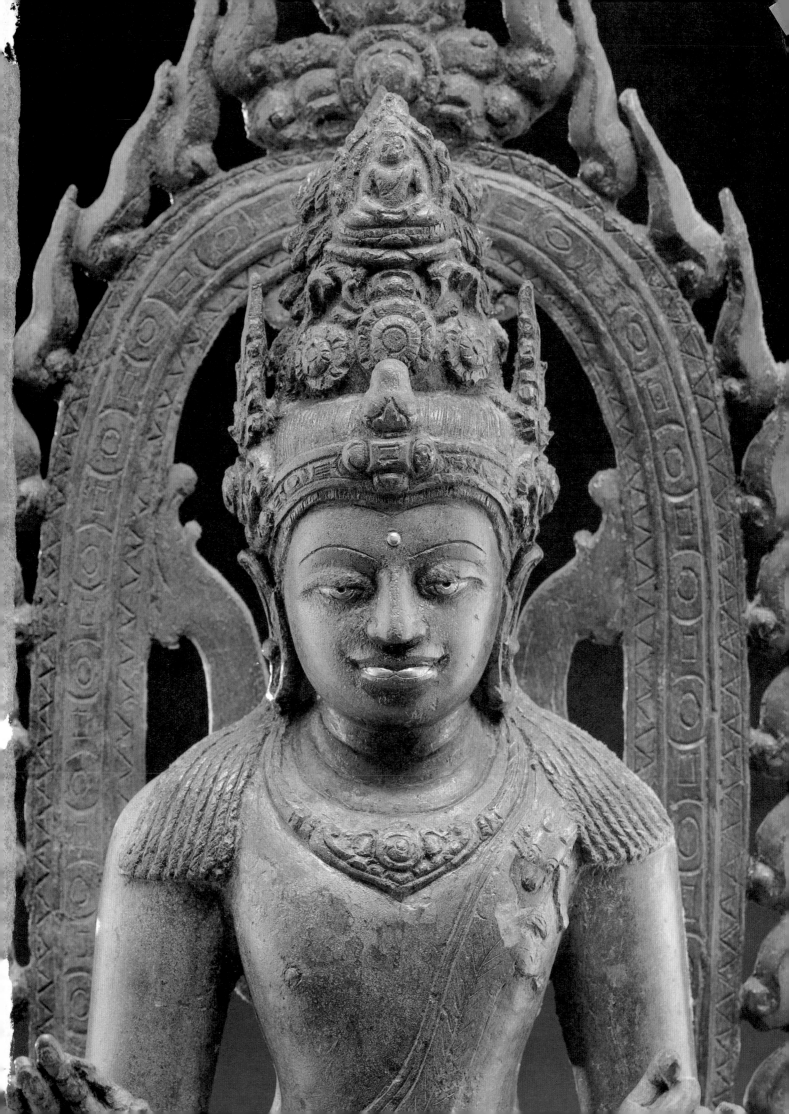

THE SCULPTURE

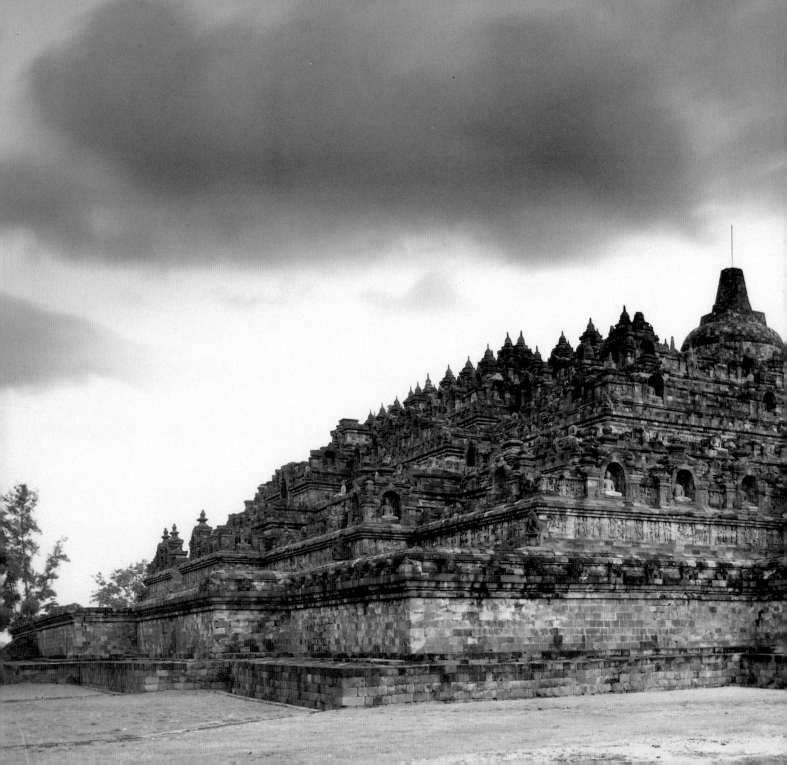

OF INDONESIA

JAN FONTEIN
with essays by
R. SOEKMONO
EDI SEDYAWATI

NATIONAL GALLERY OF ART
WASHINGTON

HARRY N. ABRAMS, INC.
NEW YORK

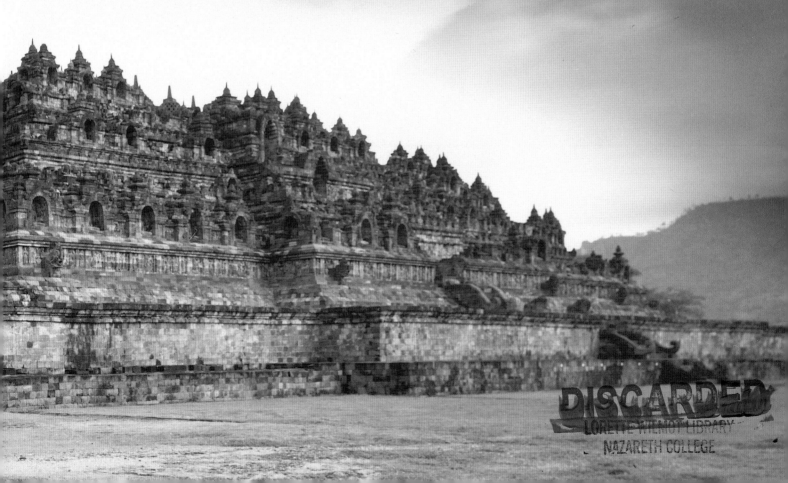

The exhibition was made possible by a grant from Mobil Corporation

The Sculpture of Indonesia was organized by the National Gallery of Art.

Exhibition dates:

National Gallery of Art, Washington
1 July–4 November 1990

Houston Museum of Fine Arts
9 December 1990–17 March 1991

The Metropolitan Museum of Art, New York
21 April–18 August 1991

Asian Art Museum, San Francisco
28 September 1991–5 January 1992

Additional support was provided through an indemnification from the Federal Council on the Arts and the Humanities. Transportation between Indonesia and the United States has been provided by Garuda Indonesian Airways.

Produced by the Editors Office, National Gallery of Art, Washington
Editor-in-Chief Frances P. Smyth
Edited by Jane Sweeney

Photography by Dirk Bakker
Maps drawn by Steven Kraft
Designed by Dana Levy, Perpetua Press, Los Angeles
Typeset in Sabon by BG Composition, Baltimore
Printed on New Age by Dai Nippon Printing Co., Tokyo

The clothbound edition is published in the U.S.A. and Canada by Harry N. Abrams, Inc., New York. A Times Mirror Company

Library of Congress Cataloging-in-Publication Data
Fontein, Jan.
 The sculpture of Indonesia / Jan Fontein ; with essays by R. Soekmono, Edi Sedyawati.
 p. cm.
 Catalog of an exhibition held at the National Gallery of Art, Washington, D.C., 7/1–11/4, 1990 and at other museums.
 Includes bibliographical references (p.)
 ISBN 0-89468-141-9 (paper)
 ISBN 0-8109-3817-0 (cloth)
 1. Sculpture, Indonesian—Exhibitions. I. Soekmono, R. II. Sedyawati, Edi, 1938– III. National Gallery of Art (U.S.) IV. Title.
 NB1026.F6 1990
 730′.9598′07473—dc20 89-13678
 CIP

cover: cat. 24

p. 1, cat. 45

pp. 2–3, Candi Borobudur

pp. 4–5, cat. 33

p. 6, cat. 29

pp. 8–9, Gate of the mosque at Sendang Duwur

back cover: cat. 86

TABLE OF CONTENTS

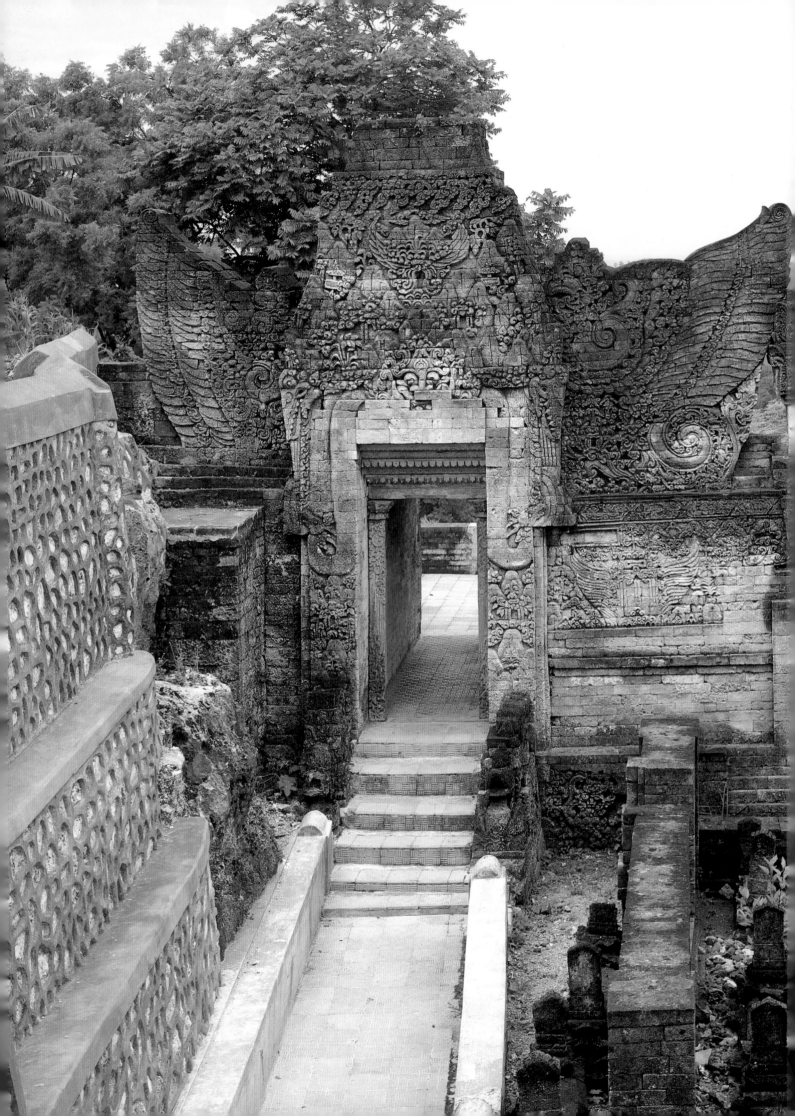

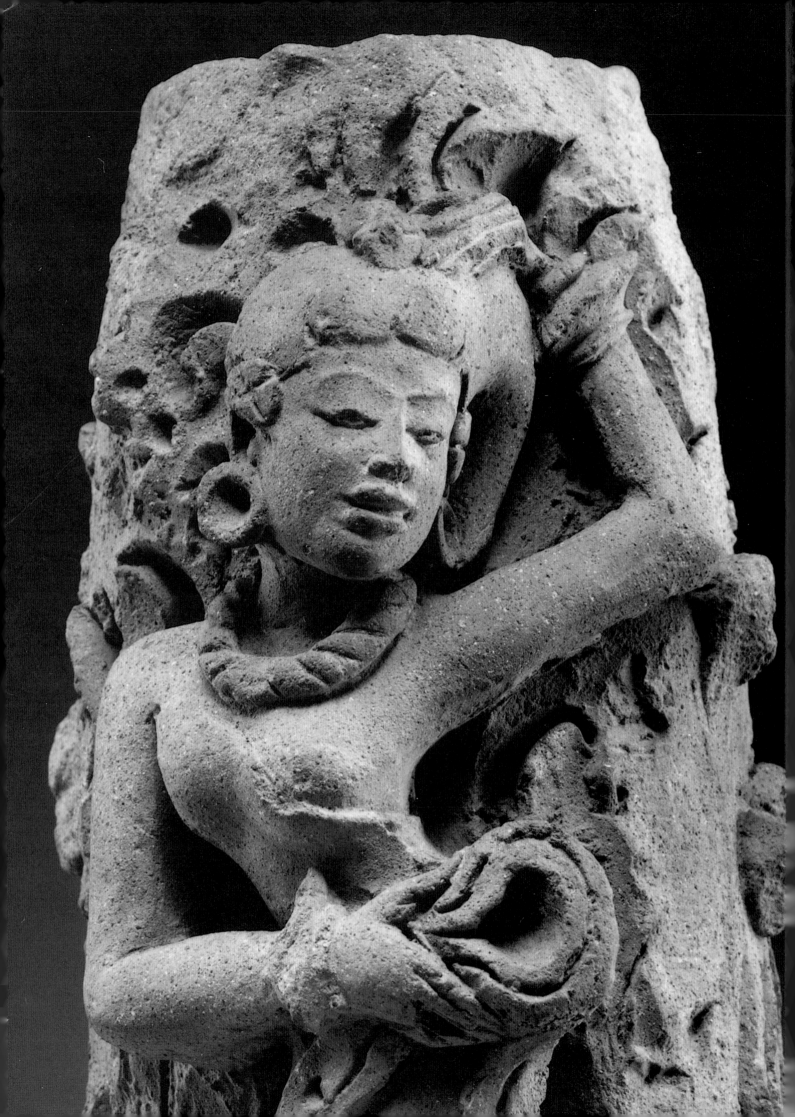

FOREWORD

To many Americans it comes as a surprise that a map of Indonesia, if it were laid over a map of the United States, would extend beyond both American coasts. Others might be similarly surprised to know that Indonesia, in terms of population, is the fifth largest country in the world. Particularly unfamiliar to the American public is Indonesia's rich and diverse cultural heritage. It is our hope that *The Sculpture of Indonesia* will help remedy that, by bringing together for the first time so many of the greatest relics of the artistic heritage of ancient Indonesia.

The Sculpture of Indonesia assembles the finest sculpture in stone, bronze, silver, and gold produced in ancient Indonesia. These works were created between the eighth century, when Buddhist and Hindu monuments were first built, and the fifteenth century, when Islam came to replace the traditional religions in Indonesia. Arriving in islands already equipped with compelling visual traditions and rich iconographies, Buddhism and Hinduism interacted with Indonesia's indigenous religions to generate art characterized by power and beauty.

The exhibition has drawn from those works preserved in their country of origin as well as those that were dispersed to other countries in Asia, Europe, and America during the last two hundred years. We are deeply grateful to lenders on three continents, and especially to the governments of Indonesia and the Netherlands, whose extraordinary generosity has enabled us to include a significant majority of the great masterpieces of freestanding ancient Indonesian sculpture. This assemblage of objects, unprecedented in size, scope, and quality, gives the visitor a unique opportunity to evaluate the artistic genius of the ancient Indonesian sculptors.

The exhibition is one of the principal events of the Festival of Indonesia 1990–1991, an eighteen-month-long celebration of Indonesia's cultural heritage being held in many cities in the United States. The festival has been endorsed by the governments of the Republic of Indonesia and the United States, and includes two other major exhibitions, *Beyond the Java Sea*, an exhibition featuring the arts of Indonesia's outer islands, organized by the Smithsonian Institution, Washington, and *The Court Arts of Indonesia*, organized by the Asia Society, New York, in cooperation with the Arthur M. Sackler Gallery, Smithsonian Institution.

cat. 105

We wish to express our sincere gratitude to Dr. Mochtar Kusumaat-madja, who conceived the idea of the Festival of Indonesia and its diverse cultural manifestations when he was serving his government as minister of foreign affairs, and who continues his direct involvement in the festival as chairman of the Yayasan Nusantara Jaya in Jakarta, a private Indonesian cultural foundation. This foundation, led by R. Adenan, vice chairman of the executive committee of the Festival of Indonesia 1990–1991, coordinated the preparations for the exhibition on the Indonesian side and provided support for the project during the stages of selection, assembling, packing, and shipping of the works of art. On the American side Ted M. G. Tanen, the American festival coordinator, played a role of crucial importance in providing the organizational backup for the project in its initial planning stage.

Integral to this festival is a museum training program under which staff members of Indonesian museums receive specialized training, both in Indonesia and in the United States, in conjunction with the preparation and presentation of the exhibitions that are part of the Festival of Indonesia. The Ford Foundation, the Rockefeller Foundation, and the Asian Cultural Council, New York, provided generous financial support of this innovative program and coordinated its implementation.

We wish to extend our heartfelt gratitude to the representatives of the Republic of Indonesia: the minister of education and culture, Dr. Fuad Hasan; the minister of foreign affairs, Dr. Ali Alatas; and to two successive directors-general of culture, Prof. Dr. Haryati Soebadio and Drs. GBPH Puger, who all enthusiastically supported the concept of the festival in its exhibitions and its other cultural manifestations.

Rarely has an exhibition been so much the product of a single person's talent as *The Sculpture of Indonesia.* Jan Fontein, a lifelong student of Indonesian art, lived in Indonesia for two years preparing the exhibition and its catalogue. His experience as a leading American museum director (at the Museum of Fine Arts, Boston), his knowledge of Indonesian, Dutch, and the major oriental languages, and his persistence, energy, persuasiveness, and scholarly acumen have made this exhibition what it is.

An indemnity from the U.S. Federal Council on the Arts and the Humanities has substantially benefited the international loans to this exhibition. We wish, finally, to express our deepest gratitude to the Mobil Corporation for its sponsorship of this project from its initial planning stage. With a long track record in support of worthy projects, Mobil has been a pleasure to work with at every level. Without their early and generous support this exhibition could not have been realized.

J. Carter Brown
Director
National Gallery of Art

Philippe de Montebello
Director
The Metropolitan Museum of Art

Peter C. Marzio
Director
The Museum of Fine Arts, Houston

Rand Castile
Director
Asian Art Museum of San Francisco

LIST OF LENDERS

Asian Art Museum of San Francisco
The British Museum
Direktorat Perlindungan dan Pembinaan Peninggalan Sejarah dan Purbakala, Jakarta
Kern Institute, Leiden
Linden-Museum, Stuttgart
The Metropolitan Museum of Art, New York
Musée Guimet, Paris
Museum of Fine Arts, Boston
Museum Mpu Tantular, Surabaya
Museum Nasional, Jakarta
Museum Het Princessehof, Leeuwarden
Museum Purbakala, Mojokerto
Museum Radya Pustaka, Solo
Museum Sono Budoyo, Yogyakarta
National Museum, Bangkok
Private collections
Rijksmuseum, Amsterdam
Rijksmuseum voor Volkenkunde, Leiden
Staatliche Museen Preussischer Kulturbesitz, Museum für Indische Kunst, Berlin
Suaka Peninggalan Sejarah dan Purbakala, DIY, Bogĕm, Kalasan
Suaka Peninggalan Sejarah dan Purbakala, Jawa Tengah, Prambanan
Royal Tropical Institute—Tropenmuseum, Amsterdam

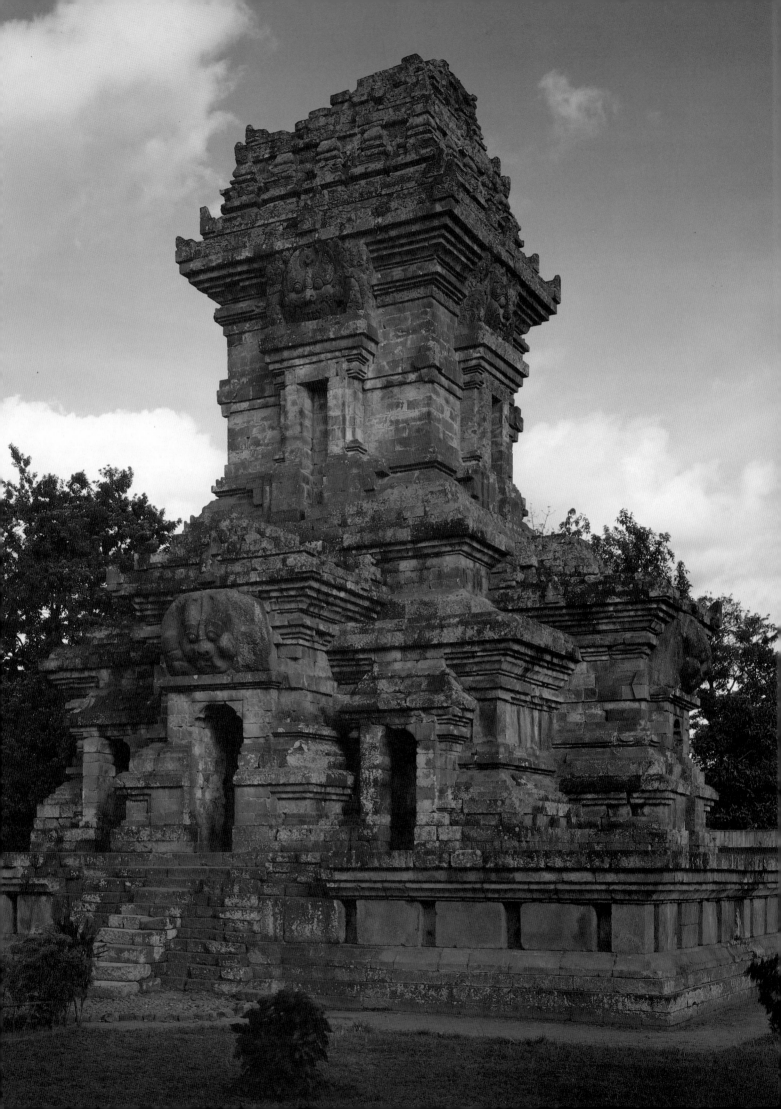

ACKNOWLEDGMENTS

IN AN EXHIBITION of this scope, and which involves a certain amount of original research in a new and unfamiliar environment, a scholar is dependent for guidance and information upon the helpfulness and generosity of his colleagues. My warmest thanks, therefore, go to Prof. Dr. P. J. Zoetmulder, S.J., of Yogyakarta. For a year and a half he generously provided me hospitality in his splendid research library, thereby enabling the writing of this catalogue in the country of origin of the works of art and in close proximity to the great monuments of ancient Indonesia. Unstintingly he shared his vast knowledge of ancient and modern Javanese culture. While many of the catalogue entries have profited from his advice and almost all reveal traces of his inspiring influence, he is not responsible for the many imperfections they undoubtedly still contain.

This project received from the outset the enthusiastic, wholehearted support of the director of the Directorate of Museums, Jakarta, Drs. Bambang Soemadio; the director of the Museum Nasional, Jakarta, Dra. Suwati Kartiwa, M.Sc.; the director of the Directorate for the Protection and Restoration of Historical Remains and Antiquities, Drs. Uka Tjandrasasmita, and the head of the Research Centre of Archaeology of Indonesia, Dr. Hasan Ambary.

I would like to mention especially the following heads and staff members of the museums and branch offices of these directorates, who provided the necessary introductions, who gave me firsthand information on the objects in their care, and who provided access to these objects for the purpose of study and photography: at the Directorate of Museums, Jakarta, Drs. Basrul Akram; at the Museum Nasional, Jakarta, Dra. Nuriah, Dra. Intan Mardiana Napitupulu, and Drs. Wahyono Martowikrido; at the Research Centre of Archaeology of Indonesia, Jakarta, Prof. Dr. R. P. Soejono, Dra. Sri Soejatmi Satari, and Teguh Asmar, M.A.; the head of the Bureau of Palaces, Drs. M. Djoko Purwono; at the Museum Sono Budoyo, Yogyakarta, Director Drs. Roedjito; the head of the Service for Historical Remains and Antiquities for the Province of Central Java, Prambanan, Drs. I Gusti Ngurah Anom; the head of the Service for Historical Remains and Antiquities for the Special Region of Yogyakarta, Drs. Th. Aq. Sunarto and Dra. Rita Margaretha Setianingsih; the head of the Section Museums, Dis-

Candi Singasari

trict Office, Surabaya, Drs. R. Prajoga Kartamihardja and Himawan, M.A.; the head of the Service for Historical Remains and Antiquities for the Province of East Java, Mojokerto, Drs. Mohammad Romli; at the Mpu Tantular Museum, Surabaya, Director Drs. Soetjipto; at the Museum Jawa Tengah, Semarang, Drs. Slamet Marsudi; at the Museum Radya Pustaka, Solo, KRT Hardjonagoro.

I consider it an honor that Prof. Dr. R. Soekmono, who played a key role in the restoration of Candi Borobudur and other Indonesian monuments, was willing to contribute an essay on architecture to this catalogue. On countless occasions during my stay in Indonesia, this colleague and friend gave me his invaluable advice, based upon his vast experience in the field. Dr. Edi Sedyawati's essay provides the American reader for the first time with an Indonesian perspective on the question of "local genius," a topic much debated among western scholars. Her useful comments on the introductory essay and especially her suggestions concerning the bronzes from Surocolo (cat. 66) have been deeply appreciated.

With unfailing courtesy and infinite patience the staff of the Nusantara Jaya Foundation provided generous hospitality and logistical backup for the participants in this project. I am especially grateful to Judi Achjadi, Raya Sumardi, Mr. Soepono, and Erman Soehardjo for their help on many occasions. With skill and cheerful dedication Anggrek Koetin completed the complex task of typing the manuscript of the catalogue.

I wish to express my thanks to H. Acord of Mobil Oil Indonesia for the personal interest he has taken in this project, which is sponsored by the Mobil Corporation. A travel grant provided by Mobil Oil Indonesia enabled me to visit monuments and archaeological sites in East Java, Madura, and Sumatra in preparation for this exhibition.

I owe a special debt of gratitude to Prof. Dr. Koesnadi Hardjasoemantri SH, rector of Gadjah Mada University, Yogyakarta, who extended the hospitality of his university to me during my stay in that city. I also wish to record my indebtedness to Drs. R. Soegondo of the same university, whose instruction in the Indonesian language introduced me for the first time to the world of modern Indonesian scholarship on ancient Indonesian art.

In addition I would like to thank the following persons, who gave me advice, assistance, and who rendered many other services that were of vital importance to this project: T. E. Behrend, Robert H. Ellsworth, Alan H. Feinstein, Anthony Gardner, Anthony F. Granucci, Wilhelmina H. Kal, Maureen Liebl, Francis William Lowrey, Pauline Lunsingh Scheurleer, Dr. Pierre-Yves Manguin, Dr. E. Edwards McKinnon, Dr. John H. Miksic, Ellis Gene Smith, and Ted M. G. Tanen.

At the National Museum, Bangkok, Director Somsak Ratanakul and Chief Curator Kamthornthep Krataithong were extremely helpful in making their Indonesian collection available for inspection and photography. Dr. M. C. Subhadradis Diskul, whose grandfather H.M. King

Chulalongkorn brought back these statues from a journey to Java, provided valuable documentation on the often misunderstood events that resulted in the formation of the Indonesian collection of the National Museum, Bangkok.

At the National Gallery I wish to gratefully record the help of D. Dodge Thompson and Ann Bigley Robertson of the department of exhibitions; of Frances Smyth, Jane Sweeney, and Abigail Walker in the editor's office; of Gaillard Ravenel and Mark Leithauser in the department of installation and design; and of Mervin J. Richard of the department of loans and exhibition conservation.

Dirk Bakker, assisted by Stephen Lundquist, photographed all of the objects from Indonesian collections and most of those coming from Europe. Dana Levy designed the catalogue, and Steven Kraft drew the maps.

A spirit of friendly cooperation between the Indonesian and American participants prevailed at all stages during the preparations for this exhibition and throughout the implementation of this project, giving all who were involved a sense of lasting, positive achievement. To this all whose names have been mentioned have contributed, as well as many others, the recital of whose names has been sacrificed to the exigencies of brevity, but to whom our gratitude is no less sincere.

Jan Fontein

overleaf: Candi Borobudur

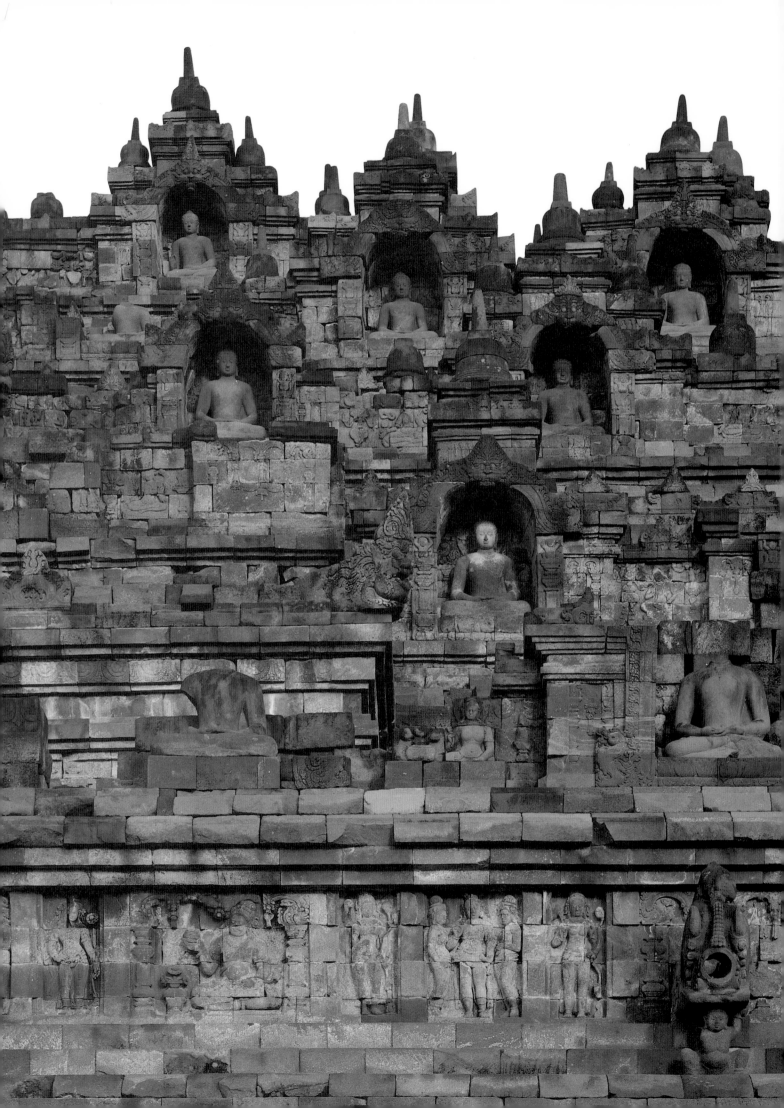

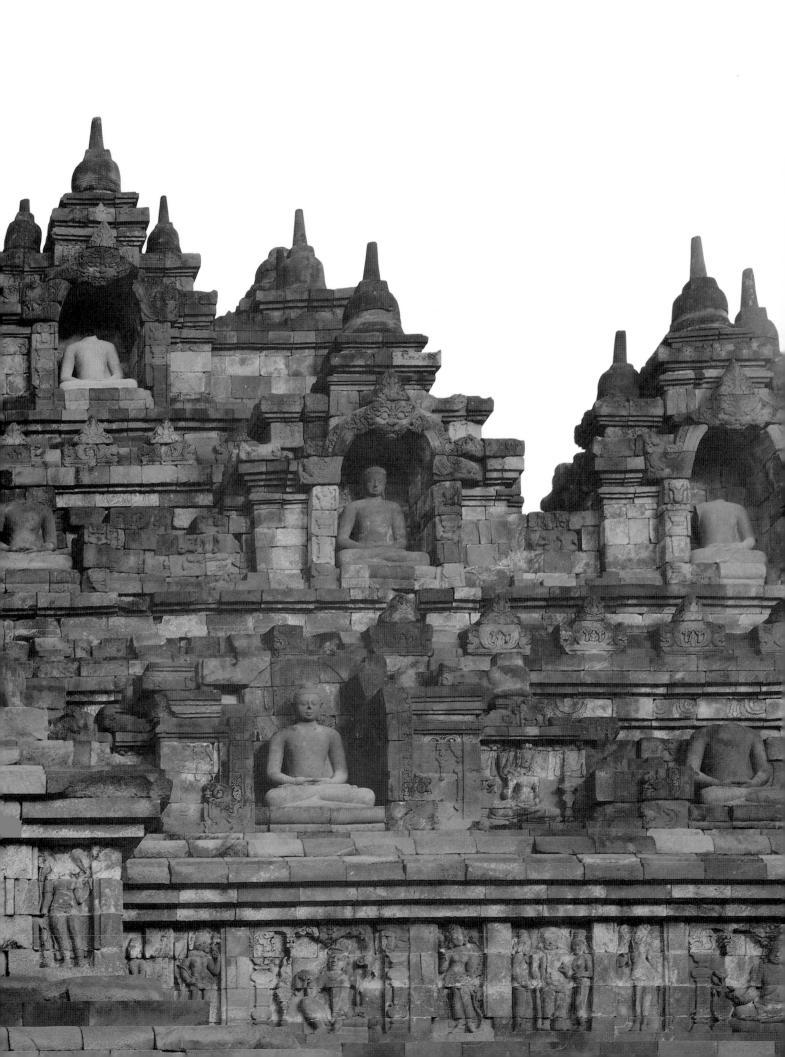

JAVA

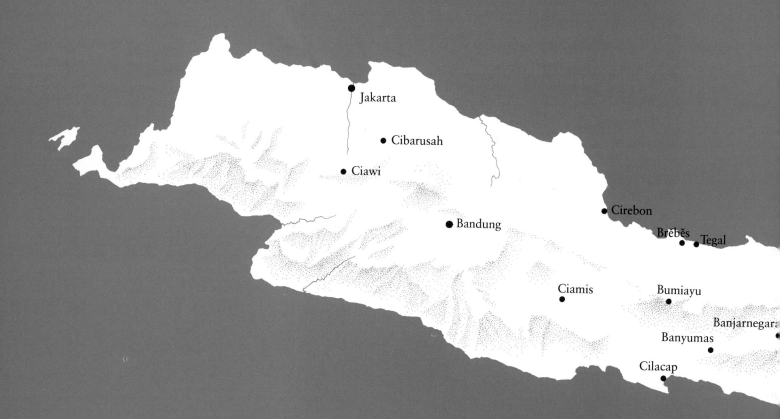

Jakarta

Cibarusah

Ciawi

Cirebon

Bandung

Brĕbĕs Tegal

Ciamis Bumiayu

Banjarnegara

Banyumas

Cilacap

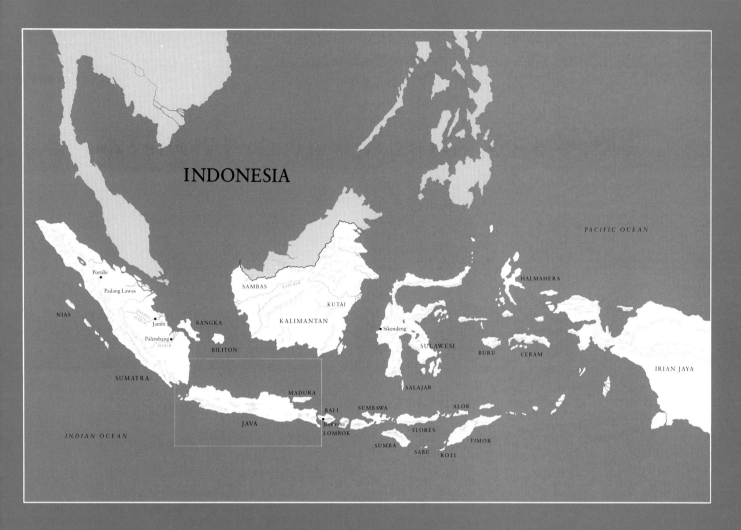

INDONESIA

NIAS

Portibi

Padang Lawas

Jambi

SUMATRA

Palembang

BANGKA

BILITON

INDIAN OCEAN

SAMBAS

KAPUAS R.

KUTAI

KALIMANTAN

Sikendeng

SULAWESI

BURU

CERAM

HALMAHERA

PACIFIC OCEAN

IRIAN JAYA

MADURA

BALI

Jembrana

LOMBOK

SUMBAWA

SUMBA

JAVA

ALOR

FLORES

SABU

SALAJAR

TIMOR

ROTI

Mantingan

Kudus

Rembang

Tuban

Semarang

Blora

Sendang Duwur

Banyuates

Diëng Plateau

Temanggung

Wonosobo

Boyolali

Sragen

Surabaya

robudur

Ngawèn

Mojokerto

rworejo

Sleman

Klaten

Madiun

Nganjuk

Trowulan

Mt. Pěnanggungan

Bantul

Prambanan

Ceto

Jalatunda

Jawi

Pasuruan

Yogyakarta

Sukuh

Wonogiri

Kediri

Mt. Arjuna

Singasari

Gurah

Trenggalek

Malang

Kidal

Tulungagung

Blitar

Jago

Bondowoso

Kotablater

Puger

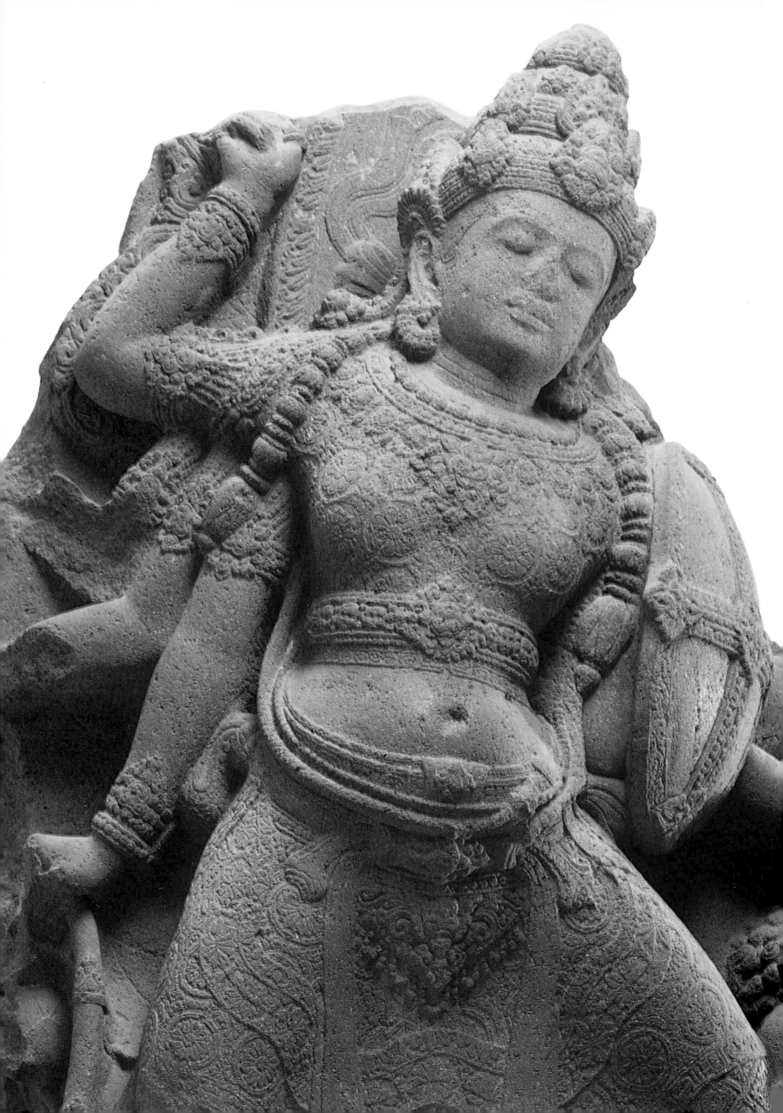

INTRODUCTION
THE SCULPTURE
OF INDONESIA

Jan Fontein

THE STRING OF EMERALDS of the Indonesian archipelago comprises more than three thousand islands. Extending from Aceh on the northern tip of Sumatra to Irian Jaya almost 3,500 miles to the east, it bridges the distance between the continents of Asia and Australia. About 170 million Indonesians populate these equatorial islands, together forming a colorful mosaic of ethnic groups, languages, cultures, religions, traditions, and types of economy. Thus the country encompasses simultaneously the densely populated island of Java, a land of terraced paddy fields and the home of the descendants of the great temple builders, as well as the inaccessible, thinly populated primeval rain forests of Kalimantan (formerly Borneo) and Irian Jaya (formerly New Guinea), where some of the tribes have only recently come out of the Stone Age.

The entire archipelago is in the grip of the tropical monsoon climate with its alternating seasons of torrential rainfall and hot dry spells. Monsoons are trade winds, of which the ancient Austronesians, who were skilled mariners, could avail themselves. Much of the cultural history of Indonesia can only be understood if the role of maritime trade and all its implications are taken into account. For while Indonesia is on the one hand at the end of long continental trails and chains of islands, thereby the final destination of many migrating tribes, it also lies at the crossroads of ancient trade routes between the high civilizations of India and China.

Across the straits and seas or by way of the ancient land bridges that once must have connected the Indonesian archipelago with the Asian

cat. 23 (detail)

23

mainland came the tribes that now populate most of the islands of Indonesia. Among those who seem to have come relatively late, perhaps during the first millennium B.C., are the ancestors of the people who now inhabit the islands of Java and Sumatra. They brought with them some of the tools, technical skills, traditions, and religious concepts that would become the foundation on which later Indonesian civilization would be built.

The early history of these peoples, much of which is still lost in the mist of time, is gradually beginning to emerge. The period of late prehistory, once a millennium almost completely unknown, is now gradually coming alive as a result of new archaeological discoveries.

Late prehistory and the early historical period coincide with the Bronze Age that was followed soon afterward by the introduction of iron technology into the islands. Among the most distinctive artifacts of the Southeast Asian Bronze-Iron Age are the kettle drums, the products of a bronze culture named Dongson after the area in Vietnam where it was first identified. In Indonesia most of these drums were discovered along the sea routes between continental Southeast Asia and the eastern part of the archipelago. The finest and largest specimens all seem to have been found in the eastern islands of Indonesia, where they may have been received in barter for the spices that abound in that area. The typological originality and high artistic quality of the bronze artifacts from such faraway islands as Sabu and Roti (cats. 4, 6) suggest that continued thorough and systematic research in the eastern part of Indonesia may reward us with a more balanced view of the variety of early cultural developments in both eastern and western parts of the archipelago.[1]

In a country of the geographical complexity of Indonesia not all tribes attained the same level of technology simultaneously. Consequently, stone, bronze, and iron tools were used side by side by neighboring tribes in the same island. The designs of the Dongson culture flourished through the years, and their distant echo still reverberates in the arts and crafts of the Torajas of Sulawesi, the Dayaks of Kalimantan, and the Papuas of Irian Jaya, whose art is the topic of *Beyond the Java Sea,* another exhibition that is part of the Festival of Indonesia.

Many tribes of Indonesia, each in its own way, had already formed their characteristic patterns of social and cultural life, relying on trade and on their own resources, when some of them made their initial contacts with the bearers of new concepts and techniques from the more highly developed civilization of India. At that time they already possessed most of the basic elements of their culture. Only when we recognize the capability of the early Indonesians to shape their own destiny and only when we take into account the powerful dynamism of their native way of life can we begin to appreciate and understand their astonishingly creative response to the impact of Indian civilization. The present exhibition includes a few selected artifacts of the Bronze-Iron Age to provide the viewer with an impression of the great variety and artistic quality of the ceremonial objects of the early period before the influx of Indian ideas.

FONTEIN

The first modest but unmistakable signs of Indian influence date from the early or middle of the fourth century A.D. and are found in Kutai (East Kalimantan). They consist of seven sacrificial columns called *Yūpa* stones that were erected at the behest of a local potentate who had taken, in imitation of royal nomenclature then in vogue in India and other parts of Southeast Asia, an Indian name.[2] The discovery at Kota Bangun, in this same area, of a large bronze statue of a Buddha (destroyed in a fire at the Colonial Exhibition, Vincennes, in 1931) and of a cave at Gunung Kumbeng containing Śivaite and Buddhist stone statuary point to a center of Indianized culture that may have flourished for several centuries.[3] Whereas the script on the *Yūpa* stones at Kutai reveals unmistakable influence from the South Indian Pallava kingdom, all *Yūpa* inscriptions in India seem to originate from Rājputāna, Mathurā, and Allahabad.[4] This seems to foreshadow the eclectic Indonesian approach to things Indian, in which styles and traditions from different parts of India were freely combined.

The second group of remains of another Indianized center of only slightly later date is found the home of the Sundanese, in West Java, where a local ruler named Pūrnavarman left a number of inscriptions and carved footprints on huge boulders.[5] The name of his kingdom Tārumā survives in the name of the river Citarum. One inscription was carved in the twenty-second year of the king's reign, a sign of some political stability. It commemorated the construction of waterworks of considerable scope involving the diversion of a river.[6] One of his inscriptions refers to the god Visnu, but no mention is made of Buddhism. Meager as this evidence is, it at least tallies with a remark made by the Chinese Buddhist pilgrim Fa Xian (Fa Hsien), who probably visited Java in 414, and found it inhabited by heretics and followers of Brahmanism, but without any Buddhists to speak of.

Tārumā was never heard of again. It may have fallen victim to the eastward expansion of the first major Indonesian power, which in all probability had its center in the area of present-day Palembang (south Sumatra). Named Śrīwijaya and ruled by the Śailendra dynasty, it entered recorded history during the seventh century and extended its influence into Central Java during the next hundred years. The arrival of the Śailendras upon the Central Javanese scene and the advent of the Buddhism of the greater vehicle (*Mahāyāna*) that they brought with them may have coincided with the beginning of one of the most fascinating epochs in Indonesian history. For a period spanning two centuries, from A.D. 730 to A.D. 930, Central Java became the scene of one of the most impressive building booms in the history of the world. Using boulders of andesite, a volcanic stone found in abundance all over the region, the Javanese constructed, in rapid succession, three very large and hundreds of smaller temples and temple complexes, shrines, and other types of religious structures. These were dedicated to the gods of Buddhism and Hinduism and were filled with stone and bronze statuary of these deities. Almost as abruptly as this feverish building activity started, it seems to have come to a sudden halt around 930, when the rulers moved their palace (*kraton*) to East Java. The fertile plains of Central Java were

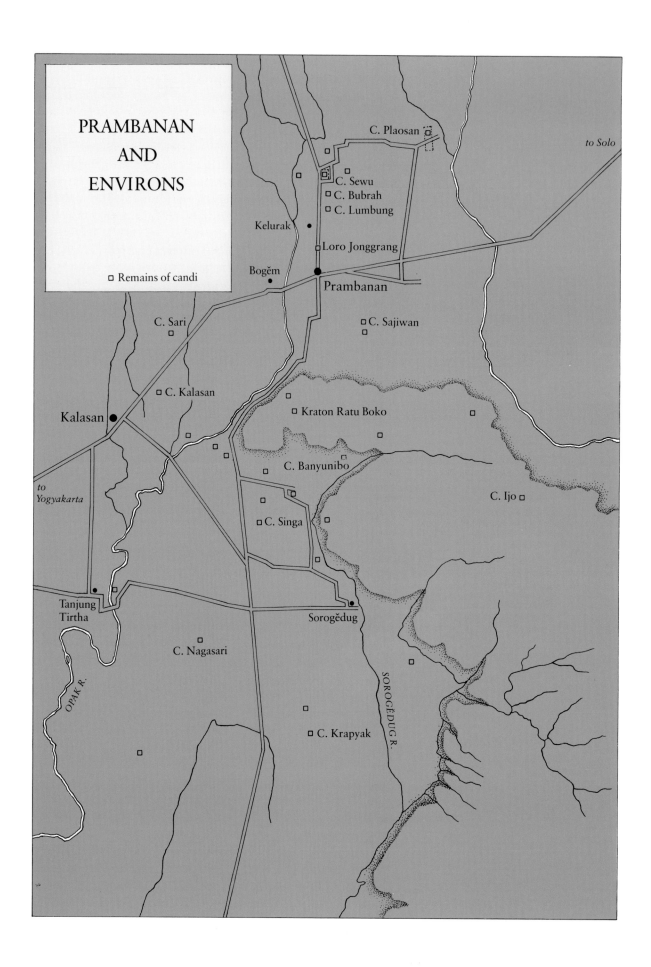

PRAMBANAN
AND
ENVIRONS

□ Remains of candi

C. Plaosan

to Solo

C. Sewu
C. Bubrah
C. Lumbung

Kelurak

Loro Jonggrang

Bogěm

Prambanan

C. Sari

C. Sajiwan

C. Kalasan

Kalasan

Kraton Ratu Boko

C. Banyunibo

C. Ijo

to
Yogyakarta

C. Singa

Tanjung
Tirtha

Sorogědug

C. Nagasari

OPAK R.

SOROGĚDUG R.

C. Krapyak

FONTEIN

deserted by the population and the temples abandoned by their flocks, apparently for a considerable period of time.

Among the primary written sources for the study of ancient Indonesian cultural history are inscriptions engraved in stone or metal. At first glance the amount of material looks impressive. According to figures compiled by Louis-Charles Damais in 1952, to which many more recent discoveries of the Indonesian Archaeological Services could be added, there are 210 datable inscriptions from Java, dating from 732 to 1486; 67 from Bali, dating from 896 to 1430; and 13 from Sumatra, dating from 682 to 1374.[7] Unfortunately, most of these inscriptions were not written for the purpose of recording for posterity the deeds of heroism, wisdom, or generosity of rulers who were convinced that they were making history. By far the greatest number of inscriptions merely record the establishment of *sīma*, tax-exempt lands that were ceded to religious communities attached to temples. *Sīma* grants were made in perpetuity, and one of the purposes of recording them in a durable medium was to guarantee continued enjoyment of these privileges long after those who granted the rights had ceased to exist. Only a few of these charters mention the reasons why they were granted, and it is from them that historical data of great interest can be extracted. The systematic scrutiny of these tax documents may throw light on the social structure and trade of ancient Indonesia, but the inscriptions do not yield a coherent picture of the course of historical events. For example, the lack of clarity in the political, religious, and genealogical relationship between the Sumatran Śailendras and the Javanese house of Sañjaya during the eighth and ninth centuries makes it impossible to establish with certainty to whom we should attribute the construction of the great monuments of Borobudur and Prambanan. It is only from the beginning of the tenth century that the identity of the successive rulers of the principal Javanese kingdoms can be firmly established from epigraphical and later historical sources.

If we add to the uncertainty and complexity of royal nomenclature the universal hazards of epigraphy, such as lacunae and partially effaced or illegible graphs, it is not surprising that theories built upon epigraphic evidence collapse like a house of cards with the discovery of only one new inscription or the reinterpretation of a single line.

The case of Candi Kalasan, one of the most beautiful Buddhist temples in Central Java, may serve here as an example of some of the hazards that accompany the historical interpretation of Javanese inscriptions. In the year 1866 an inscribed stone was found close to the railroad track between the villages of Kalasan and Prambanan (Yogyakarta). The inscription records the founding, at a place named "Kalasa," of a temple dedicated to the goddess Tārā (see cat. 44) by a king of the Śailendra dynasty in the year Śaka 700 (778). Although the area where the stone was found is known for its numerous remains, the occurrence of the name Kalasa seems to have convinced the scholars that the inscription refers to the temple now known as Candi Kalasan. This splendid example of Buddhist architecture thus came to be considered the only dated landmark in

the cultural history of Central Java, a prime example of Śailendra art at its best. Since then, several scholars have reinterpreted the inscription, extracting from it the names of not one but two kings, presumably of two different royal houses. At the same time archaeologists were able to prove that Candi Kalasan as it stands today is the third structure in that place, erected on top of and enveloping the second one, in which the core of the original building is hidden.[8] The inscription of 778 recording a new foundation is therefore likely to refer to the first, now completely enveloped structure. Whether the inscription really refers to Candi Kalasan, a temple in which a Buddha of gigantic proportions was once enshrined as the principal icon, still remains uncertain.

One of the basic problems of philological research in support of Indonesian archaeology is that the existing texts, almost all of which date from after the tenth century, rarely mention specific monuments still in existence. Not a single inscription or other text records the construction of such colossal monuments as Borobudur or Prambanan. In fact, as Haryati Soebadio summed it up: "the world of the texts and the actual evidence in the field are completely different and separate."[9]

For later periods, to which this last remark does not apply to the same extent, we have two important historical sources. The oldest of these is the *Nāgara-Krĕtāgama*, a poem written by Prapañca in praise of King Hayam Wuruk of Majapahit in 1365.[10] What was believed to be the only surviving copy of the text was discovered in 1894 in the library of the *kraton* of Lombok during a punitive expedition against that island by the Dutch; however, in recent years other copies have been found.[11] It includes a list of all sanctuaries of the realm and descriptions of some of these temples. *The Nāgara-Krĕtāgama* contains a report on a royal tour of the eastern part of the king's East Javanese domain and a description of his *kraton*, providing us with a wealth of information on court life, funeral rituals, and sanctuaries that has greatly deepened our understanding of fourteenth-century Javanese culture.

A large part of the prose of the second of these important historical sources, the *Pararaton*, is taken up by a lively but largely legendary account of the circumstances surrounding the founding of the Singasari dynasty (see cat. 24), followed by a chronicle of the Singasari and Majapahit dynasties.[12] It was not committed to writing before the end of the fifteenth century and reflects later traditions, and is therefore far less reliable as a historical source than the *Nāgara-Krĕtāgama*, but it often provides a different perspective on the same events, adding colorful touches not known from other sources.

Chinese historical works shed some light on the earlier history of the Indonesian islands, especially the dynastic annals in which the arrival of so-called tribute-bearing emissaries at the imperial court are recorded. Reflecting China's traditional inward-looking, continental approach, the annals are often imprecise, vague, and contradictory in their description of foreign kingdoms and their locations. In them the names of kings are sometimes mistaken for those of their capitals or kingdoms, and geographical information is often provided with carelessness and the thinly

disguised scorn that Chinese customarily reserved for "barbarians" from faraway places.

One would perhaps expect China's traveling intellectual elite, the Buddhist pilgrims who visited Indonesia en route to or from India, to have left us more detailed and precise information. However, brilliant ecclesiastics such as Yi Jing (I Ching, 635–713), who visited the capital of Śrīwijaya three times during his travels, were so preoccupied with their primary tasks of learning Sanskrit and gathering and translating sacred texts that they usually relegate remarks on the geography and culture of the places they visited to footnotes and marginalia in their Buddhist treatises.[13]

Despite the obvious limitations of the written sources, several scholars have demonstrated that it is possible to produce significant results by judiciously combining bits of information scattered throughout texts and epigraphs. The classic example is that of George Coedès, who was able to resurrect from almost complete obscurity the once-powerful and far-flung Sumatran maritime kingdom of Śrīwijaya, using only a small number of scattered references in stone inscriptions and Chinese annals.[14] Ever since it has been suspected that the capital of Śrīwijaya should be sought in the vicinity of Palembang. Yi Jing described a cosmopolitan center of Buddhist learning, the destination of pilgrims from all over Asia, where famous Indian gurus came to teach large numbers of monks. These included Vajrabodhi, who visited Śrīwijaya in 717 and who may have met the youthful Amoghavajra in Java not long afterward, before he came to play a key role in the spread of Tantric Buddhism in China. Atīśa, the Tantric missionary to Tibet, likewise studied in Śrīwijaya.

There is no reason to doubt the testimony of these learned pilgrims. In the reliefs of Borobudur, the world of learning and devotion they describe, the coming and going of monks, the gurus and their pupils, is depicted in great detail. What gives occasion to speak of the gap between literary evidence and archaeological remains is that in Palembang almost nothing has been found to recall that golden age of Buddhism. However, the archaeologists who concluded from a few exploratory excavations that there was no major cultural center of Śrīwijaya in or around Palembang may have been premature in their conclusions.[15] New discoveries in recent years have raised hopes that we may still be able to gain a clearer picture of the cultural history of this area in the not-too-distant future.[16]

A major obstacle to an understanding of the process of acculturation, through which Indian religious concepts, ceremonial practices, literary genres, dance techniques, art styles, and iconographical types were appropriated by the Indonesians and transformed in their new and typically Indonesian culture, is the obvious fact that so little has been preserved. Perhaps it is not so much the paucity of the remains that creates the obstacle as the lack of balance in the rate of survival of remains in different media. In Europe, the survival of such ancient and rich cultural relics as the *Books of Kells* or the *Bayeux Tapestry* may

well be considered nothing less than a miracle. In Indonesia, on the other hand, the monsoon climate reduces to virtually zero the chance that anything made of organic material could have been preserved from ancient times. The inevitable result is that only some of the relics carved in stone or cast in metal remain relatively unscathed by the inexorable process of destruction to which both nature and man have subjected the cultural heritage of Indonesia.

Yi Jing obviously considered Śrīwijaya a major center of Buddhist learning, and one can hardly look at the reliefs of Borobudur without encountering learned brahmans and monks instructing pupils, books in hand, or all kinds of other people carrying books or charts. However, most written documents were carved into the polished surfaces of the leaves of the lontar palm (Borassus flabelliformus), and under tropical conditions even the most meticulously prepared and carefully preserved lontar leaves have a natural life span of two hundred years at best.[17] While generations of Balinese copyists have preserved the literary heritage of ancient Java, there is only a single page of verse that can be said with certainty to date from the Central Javanese period, and that is a text engraved on a copper plate.[18]

In painting the situation is even worse. A pair of Borobudur reliefs illustrates an as yet unidentified episode in a pious legend in which a prince finds his future spouse through an exchange of framed portraits. These two reliefs constitute just about the only visual proof of the existence of portrait painting in Indonesia, and even that slender evidence is suspect. The fact that the sculptor envisioned the prince and princess as statues placed in frames makes us wonder whether the artist, commissioned to illustrate a typically Indian legend, really knew what a portrait should look like.

Modern study of the transmission of Indian art styles to Indonesia is handicapped by the fact that there are no iconographic drawings similar to those that played such a key role in the transmission of Chinese styles and iconography to Japan. Only one single image of Hārītī and her son Priyankara (cat. 50), engraved in thin lines on a copper plate, lifts even an edge of the veil that hides this process from observation in Indonesia.

A relief at Borobudur gives evidence of yet another aspect of ancient Indonesian art that is now irretrievably lost, the colors. In the relief artisans fashion and apply colors to toys in the shape of mythical bird-men and -women. A stone and pestle (Jav. *pipisan* and *gandik*) for grinding the colors is among their tools. We know that many of the Central Javanese temples were covered with a thin hard layer of *vajra-lepa* (literally "plaster as indestructible as diamond"). By filling the pores of the stone, this coating prevented the growth of mosses and lichens and kept moisture from penetrating it. Were colors applied to this white surface, or do the whitewashed temples on the hills of Mandalay give us the best idea of what ancient Java may have looked like? The instruction carved in the frame of one of the reliefs of Borobudur's hidden base reads "of golden complexion."[19] Should that monosyllabic

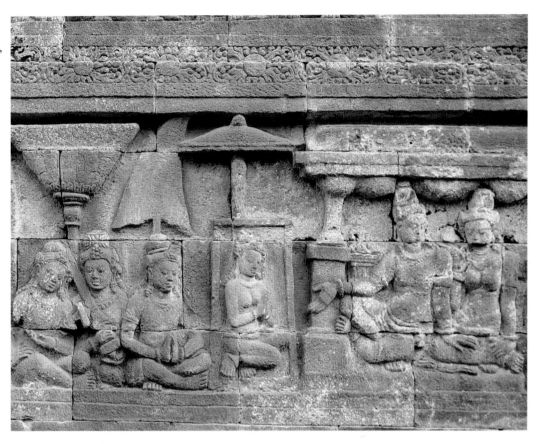

Portrait of a princess presented to a royal couple by emissaries from a distant kingdom. Relief, Candi Borobudur, no. 1 b 35

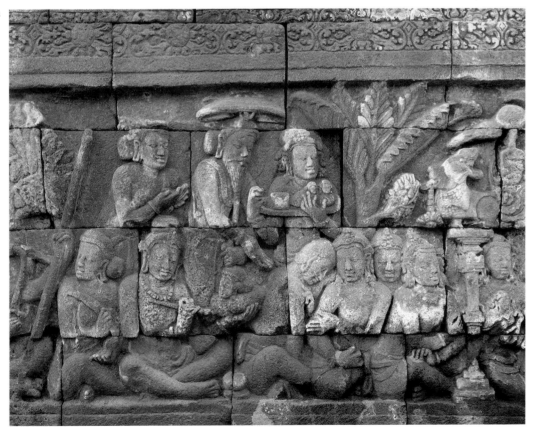

Artisans present painted toys in the shape of *kinnara* to a royal couple as gifts for their young prince. Relief, Candi Borobudur, no. 1 b 51

instruction, a word lifted from the text that the sculptor was asked to illustrate, be taken literally? The weathered gray color that seems so appropriate for these monuments today may be only the result of exposure and centuries-long neglect.

EVEN THOUGH INDONESIA MAY have lost its *Book of Kells*, it still has its equivalent of the cathedrals. Only this word can evoke a proper image of religious edifices towering over the houses, towns, or villages as solitary remnants of the religious devotion of the past. The most important difference between a cathedral and the *candi* is one of function. The cathedrals were built to accommodate large flocks of faithful worshippers, and the space needed for this purpose could only be created by the wide span of the true arch. The *candi* is a house not for people but for the gods, into which they descend during the appropriate rituals performed by a small number of priests and other celebrants.[20] The limited space needed to accommodate the statuary and the priests with their paraphernalia could easily be created by corbeling stones. There was no need, therefore, for the true arch; except for its occasional use in Burma, it does not occur in Southeast Asian architecture.

Several of the largest Central Javanese monuments, both Hindu and Buddhist, though quite different in layout and architectural shape, are symbolic representations of the universe as its shape and structure were imagined by the ancient Indians and described in their literature. For reasons still not fully understood, Indian cosmology had a tremendous impact on Southeast Asian architecture, providing the inspiration for sanctuaries as far apart as Angkor Vat in Cambodia and Candi Borobudur, Candi Sewu, and Candi Loro Jonggrang in Java. In all of these monuments the architects attempted to reproduce on earth a replica of the universe in order to foster and perpetuate the harmony between heaven and earth, between macrocosm and microcosm, without which kingdoms could not flourish and people could not live in peace and prosperity. The grandeur with which this concept was given architectural shape, combined with an extraordinary talent for retelling Indian epics and Buddhist *sūtras* in narrative reliefs, created monuments that surpassed anything created in the Indian subcontinent itself. This is all the more remarkable since it was in India that the basic philosophical and cosmological concepts were first formulated and where the literature that provided inspiration for the reliefs was composed.

According to Indian cosmology the world consists of a round, flat continent called Jambudvīpa. From its center rises Mount Meru, the cosmic mountain that reaches into the heavens, the abode of the gods. This continent was ringed by concentric chains of mountains separated by oceans. Although Buddhist and Hindu cosmology differ in some details, they share the basic idea of the cosmic mountain that connects heaven and earth and that acts as a pivot of the universe.

The basic shape of Candi Borobudur is that of a *stūpa*, a monument built over the ashes of a Buddhist saint. The bell-shaped body of the *stūpa* was erected upon an elaborate, richly sculptured, multiple-stepped base. That it was also thought of as a replica of Mount Meru is

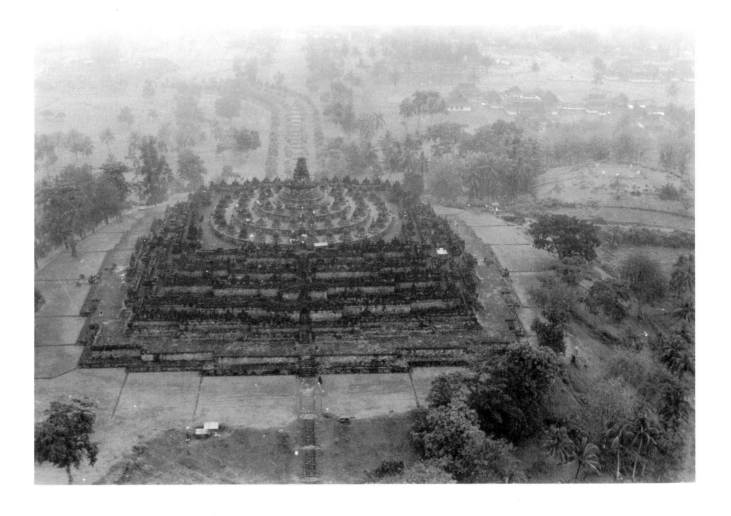

Aerial view of Candi Borobudur

evident from a frieze of reliefs on the exterior facade of the lowest balustrade. These reliefs, faithfully reflecting the descriptions in the sacred books, depict the host of *yaksas* and other demigods who were believed to populate the slopes of the cosmic mountain. From a contemporary description of an imaginary temple we may conclude that the rows of subsidiary buildings that surround the principal shrines at Loro Jonggrang were equated with the chains of mountains that separate the oceans of the world.

In two great Buddhist monuments an elaborate configuration of Buddhas, together forming a huge, three-dimensional mandala, was superimposed on these replicas of the cosmos. At Candi Sewu ("Thousand Temples") this mandala may have consisted of approximately 250 Buddha statues, at Candi Borobudur of more than twice that number.

Many theories have been advanced to account for these monumental architectural and artistic achievements. Early scholars, especially the European ones, were inclined to attribute the penetration of Indian ideas and techniques to conquests or settlements. Although most of them considered the Indian role in this process as largely peaceful, they also saw it as an active, deliberate expansion of Indian culture into what was called "Greater India" or "Indian Asia," a logical extension

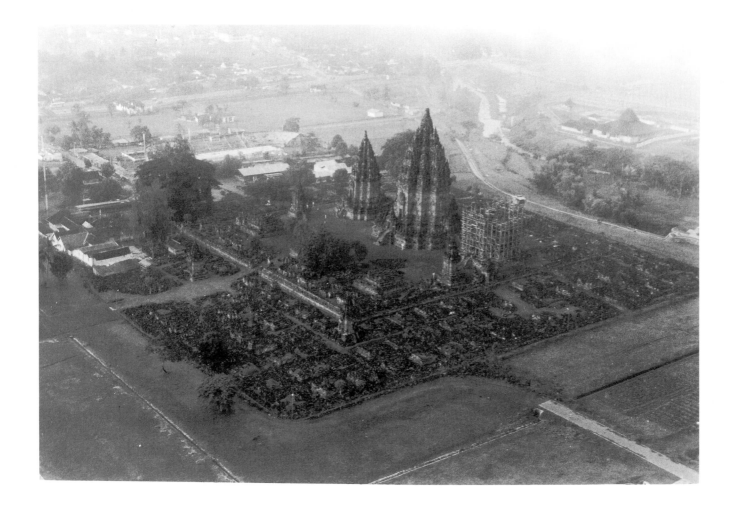

Aerial view of Candi Loro Jonggrang

overseas of the Buddhist and Hindu penetration into the Dravidian lands of south India. We now know that merchants, itinerant brahmans, Buddhist pilgrims, and diplomatic missions played a much more crucial role than the occasional maritime expedition recorded in inscriptions. In his inspirational essay "Local Genius and Ancient Javanese Art," Bosch pointed out that Indian influence in Indonesia was not primarily the result of Indian efforts to expand their sphere of influence and to export their own culture, but the fruit of Indonesian initiatives to assimilate those Indian elements that appealed to them and that seemed to fit best into the pattern of their own culture.[21] The approach of the Indonesians who visited the holy land of Buddhism and Hinduism was an eclectic approach, one of picking and choosing instead of absorbing indiscriminately.

They may well have taken as a role model Sudhana, the hero of the Buddhist story of the *Gandavyūha*, who traveled all over India in his determined search for the ultimate truth. The extraordinary amount of space allotted to the illustrations of this eastern equivalent of *Pilgrim's Progress* at Borobudur, almost one-third of all panels, bears testimony of the high esteem the Buddhist community there must have had for the *Gandavyūha*. Many of the pilgrims who braved the seas to sail to India

must have identified with this pious young man. In other respects, too, the *Gandavyūha* seems to have agreed with Indonesian points of view, for the equality of men and women that some of the inscriptions seem to imply and that is typical of many Austronesian societies is equally manifest in this sacred text of Buddhism. Perhaps, therefore, another element in the story also appealed to the Indonesians. An essential component in the story of the *Gandavyūha* is the fact that none of Sudhana's teachers was able to teach him the whole truth, and that he had to travel all over India to visit fifty-three teachers, kings, queens, monks, nuns, goddesses, and bodhisattvas in ascending order of holiness before he finally obtained the ultimate truth. Traveling to many different centers of worship and learning, reflecting the rich ethnic, religious, and artistic diversity of India, the Indonesian pilgrims selected and blended these divergent traditions into a new Indonesian tradition. An artist who combines and harmonizes a multitude of diverse stylistic elements acts in a manner that is quite similar to that of the ecclesiastics whose efforts concentrated on resolving varying, at times even contradictory, points of view taken by their different gurus. In China, where a wealth of textual material has been handed down to us, we can trace the phases of these religious, philosophical developments almost step by step. There is every reason to assume that similar developments took place in Indonesia, where no documentation of this type has been preserved.

A key role in the transmission of these ideas from India to Southeast Asia was played by the *vihāras*, the Buddhist universities of India.[22] The university of Nālandā (South Bihār) is the best known of these centers of learning. A ninth-century inscription tells how a monks' abode was founded there by King Bālaputra of the Śailendra dynasty, probably for the benefit of pilgrims from his kingdom. King Devapāla of Bengal contributed the income of five villages as a kind of operating endowment. The manner in which this institution was founded may have set a precedent for establishing Buddhist communities for foreigners in India, for the creation of a similar *vihāra* at Negapatam (Nagapattinam) during the eleventh century followed a similar pattern. The success of these study centers is evident from the fact that monks continued to travel back and forth even during the decline and almost until the very extinction of Buddhism in India. The renewed Javanese interest in Indian sculpture of the late Pāla period that so unmistakably manifest itself at Candi Jago (cat. 21) during the thirteenth century occurred at a time when Buddhism had already almost disappeared from eastern India. For the monastery of Vikramaśīla (near Bhagalpur) continued as a center of Tantric studies only until the first years of the thirteenth century, at a time when Nālandā had ceased to exist. Only in southern India, at the Buddhist stronghold of Conjeeveram (Kāñchīpuram), did monks still sing the praise of an East Javanese king in the fourteenth century.

Chinese drawings show homeward bound pilgrims carrying backpacks loaded with holy sculptures. We also know that some of them brought back drawings or small, carved stone models of such famous shrines as

the temple at Bodhgayā, the sacred spot where Gautama Buddha attained supreme enlightenment. However, Indian architectural treatises tend to emphasize the religio-magic aspects of building rather than structural, technical problems, and even drawings—if anything like architectural drawings ever existed—could only convey part of the indelible impression that the great monuments of India must have made on these visiting pilgrims. Even if their desire was to re-create at home what they had seen in the holy land of Hinduism and Buddhism, as is suggested by the frequent use of Indian toponyms, it would have been difficult for them to achieve their aim.

It is probably no coincidence, therefore, that the influence of Indian prototypes is felt most strongly in bronze cult images. Small in size and light to carry, they were an indispensable part of the treasures that the traveling pilgrims brought back. The deeper insight gained in recent years into the regional art styles of Buddhist and Hindu art of India has made it easier to trace some characteristics of Indonesian bronzes to their Indian origins, from Chittagong (the land of shrines), Bengal, and Bihār (named after *vihāra*) in the east to Conjeeveram and Negapatam in the south. Nevertheless, especially the early phases of the process of amalgamation of styles are still far from clear. In Indonesia at least half a dozen large figures and many more smaller statues reflecting various styles originating from India, Bangladesh, and Sri Lanka have been found, and these were often discovered in remote areas where no trace of other remains could be located. Their provenance often remains a matter of conjecture. Given the substantial number of statues in bronze hoards found in India in such places as Nālandā, Kurkihar, and Negapatam, the large number of finds in Indonesia is not surprising. Bronze Buddhas have been found in Sumatra, Kalimantan, Sulawesi, Java, Bali, and the lesser Sunda Isles, the finest and largest from such remote areas as Sikèndèng (Sulawesi, cat. 36) and Kota Bangun (Kalimantan). Of the highest artistic quality are statues of the Buddha with his monk's garb draped in the manner that originated from Amarāvatī in India (cats. 35, 36). Once regarded as the earliest harbingers of Buddhism in the archipelago and elsewhere in Southeast Asia, the estimates of their age have been reduced by half a millennium. Whatever their exact date and provenance, this is perhaps the first example of Indonesian Buddhists rejecting an Indian option, for the Amarāvatī style of drapery did not leave any trace in the later Buddhist art of these islands.

Just as the pilgrims must have followed in each other's footsteps generation after generation, the flow of images from India to Indonesia was a continuing process of which neither the chronology nor the regional distribution can be reconstructed at this moment. It is evident, however, that all major centers of bronze manufacture in India contributed to the process in different places and in varying degrees. The phase of copying and of mere imitation does not seem to have lasted long, for already in the course of the ninth century a distinctly Javanese style developed into full maturity. There are no conveniently dated examples that serve as landmarks in the chronology of the stylistic development. The numerous parallels between sculpture in stone and in bronze sug-

gest that any division into successive phases of development will have to rely not only on information extracted from statuary in stone and bronze, but also will have to take into account architectural and epigraphical data.

Such complex developments, taking place over a long period of time and in an extended area, cannot be reconstructed without using all available information, including that on the provenance of the statues. The sites where objects or statues are found, especially such easily transportable objects as small bronzes or jewelry, need not be their places of manufacture, nor should every hoard be assumed to contain only relics of the same age, especially since the reasons for burying these hoards remain unclear. Many of the finds made during the late nineteenth and early twentieth centuries were split up, creating an obstacle for later comparative studies. Except for the purpose of numismatics, very little use seems to have been made of the wealth of information on provenance and context in the proceedings of the Batavian Society of Sciences and other Dutch sources. There can be little doubt, as John Miksic recently pointed out, that unreported finds, especially of objects made of precious metals, far outnumbered those dutifully reported to the authorities.[23] There may be other factors not yet recognized that could distort the outcome of any statistical approach to these often incomplete pieces of information. A detailed discussion of this topic would go beyond the scope of this introduction. Yet because the provenance of all pieces in this exhibition has been recorded to the full extent to which it could be ascertained, a few remarks of relevance to the exhibited objects would seem to be in order.

A preliminary count of the finds of gold, silver, and bronze statues, various types of bronze utensils, and pieces of gold and silver jewelry, reported in the proceedings and reports of the Batavian Society of Sciences, the inventories of the Museum Nasional, and the annual reports of the successive archaeological services of the colonial administration and the Republic of Indonesia, can be broken down into the following number of finds (not objects):

	METAL STATUES	BRONZE OBJECTS	GOLD, SILVER, JEWELRY
West Java	5	11	25
Central Java	66	177	314
East Java	18	103	135

The striking fact is the small number of finds from West Java. It parallels the almost total lack of architectural remains of the Indo-Javanese period in that area. The present administrative division of Java into three provinces even tends to reduce the imbalance in these statistics, as half of all finds in West Java occurred in the areas immediately adjacent to the Central Javanese province. The *Nāgara-Krĕtāgama* of 1365 maintains that Buddhism never spread to western Java at all, but even that statement does not offer an adequate explanation for the paucity of any traces of Indianized culture, an absence confirmed by a lack of buried

treasure. Systematic archaeological exploration may uncover traces of ancient Tārumā, the kingdom of the famous stone inscriptions, which was located in an area that has not yet yielded any remains that can be confidently attributed to the kingdom.

Before the end of the nineteenth century the area around the Plateau of Diëng (Central Java) seems to have been only thinly populated. At that same time the reporting of archaeological finds became more common. John Miksic suggested that the subsequent population growth and the more intensive land use resulting from it may be one of the causes of the high frequency of finds of objects made from precious metals in this area.[24] The number of reported finds must have been greatly reduced by the local tradition, already noticed by Raffles, of paying taxes in excavated gold. The numbers, imperfect as they may be, also seem to reflect a local tradition of burying precious objects. Two of the five largest hoards of gold and silver statuary ever found in Indonesia came from this area. One of these, the hoard from Gĕmuruh, is represented in this exhibition (cat. 54). Not far from there fifteen silver statues of Hindu gods were found, together with a pair of inscribed gold and silver plates, datable to 914 and recording the cremation of a Guru Siwita.[25] This seems to suggest that the pieces were buried not for safekeeping but for ceremonial purposes. In the village of Kepakisan, near Diëng, a gold statue of Śiva was found in 1924, buried with an inscribed silver urn placed over it as a protective dome. The dedicatory inscription mentions "Bhatāra I Dihyang," the supreme god of Diëng, and leaves no doubt that the figure was buried for a ceremonial purpose.[26] The fact that the two largest hoards of gold from the Diëng area consist of statues of Hindu gods seems to support the theory that the dominant religion of the northern parts of Central Java during the eighth and ninth centuries was Hinduism. Most of the remains of *candis* and the majority of the stone statues found in this area are indeed Śivaite in character. This circumstance has given rise to the hypothesis that a Śivaite dynasty ruled the north, while the Buddhist Śailendra dynasty ruled the southern part of Central Java. Another hypothesis, claiming that Hinduism was the religion of the masses whereas Buddhism was only embraced by the ruling elite in the south, is not supported by the evidence provided by excavated metal statues: Buddhist bronzes far outnumber the images of Hindu gods, and are spread over a much wider area.

The discovery in 1982 of Candi Bogang (Solomerto, Wonosobo), where a Buddhist stone statue more than eight feet in height was excavated, suggests that the surface finds of ruined temples may not always reflect the true historical situation.[27] This new find supports the view that the Central Javanese monuments of Buddhism and Hinduism, instead of reflecting the religious zeal of two different dynasties, may be the products of a carefully maintained balance, a kind of peaceful coexistence in which an element of competition was never absent. Just as in India the Visnupad, the holy footprint of Visnu, is only six miles from Bodhgayā, where the enlightenment of the Buddha was celebrated, in Indonesia Candi Banon with its magnificent stone statues (Museum

Nasional, Jakarta) was the brahmanic counterpart of nearby Borobudur, and just as the great Buddhist shrine of Candi Sewu was built in the immediate vicinity of Loro Jonggrang, the largest complex dedicated to the three gods of Hinduism, so Candi Bogang may have represented the Buddhist presence near the holy city of Dihyang (Dieng), the sanctuary of the Hindu gods.

What Candi Bogang and Candi Banon, although of different religious affiliation, seem to have in common is an impressive array of sculpture and an almost total absence of architectural remains. Recently Soekmono suggested that the old idea, which held that where there is a statue there must have been a *candi*, may not always be valid.[28] The statuary of these two sites may never have been enshrined in a temple, but instead installed in the open or sheltered only by a *pĕndopo*, a pavilion open to all sides.

Another factor that may account for the much smaller number of Buddhist sanctuaries is that the good works of the Buddhist faithful often seem to have been directed toward improving and expanding existing temples rather than toward building new sanctuaries. The high merit that, according to Buddhist tenets, accrued to those who restored and expanded temples may have influenced this trend. Yi Jing made special mention of the religious motivation inspired by a search for karmic merit (*punya*) among the inhabitants of Srīwijaya.

One aspect of classical Javanese art to which this exhibition cannot do justice is the extraordinary talent of the sculptors for illustrating stories. This ability found its earliest and most successful expression in the reliefs of Candi Borobudur and Candi Lara Jonggrang. The recent reconstruction of these two monuments precludes the possibility of exhibiting any of these reliefs.

These reliefs are among the most interesting creations of the Central Javanese period. From instructions to the sculptors left above the unfinished reliefs of Borobudur's base, which was covered up during the construction of the monument, we know that the texts, which perhaps as many as four successive generations of Javanese sculptors illustrated on the walls and balustrades of Borobudur, were written in Sanskrit. This Indian language played a role in the Buddhist world comparable to that of Latin in European cultural history. At Borobudur these texts were primarily treasured for their edifying contents. Selected episodes from the life of the Buddha have been carved in stone ever since the beginning of Buddhist art, but nowhere has this story been illustrated in such rich detail as it is at Borobudur. At Prambanan Vālmīki's ancient Indian epic, the *Rāmāyana*, is illustrated in two series of balustrade reliefs, dwarfing anything comparable in India.

At Borobudur, with its carefully designed sequence of texts chosen for the viewer's gradual progress toward the ultimate truth, any depiction of violence would have distracted the viewer from the elevated thoughts evoked by these reliefs. Consequently, what little violence or other reprehensible activity that was mentioned in these texts was played

down or only hinted at by the use of subtle symbols or gestures. At Prambanan, on the other hand, violent action is a key ingredient of the narrative, and the sculptors seem to have been reluctant to skip even a single demon, whose demise at the hands of Rāma, or, in the reliefs of the Visnu temple, the young Krishna, is recorded in the texts. The conspicuous differences between the reliefs of Borobudur and Prambanan can to some extent be explained by the contrasts in content and spirit of Buddhist *sūtras* and epic literature. Also, the larger slabs of stone used for the Prambanan reliefs afforded a greater freedom of composition than the sculptors of Borobudur had (see cats. 10, 13). Whatever difference there was in approach or in spirit, however, a comparison of the few Borobudur and Prambanan scenes that depict identical situations reveals that the art and architecture inspired by Buddhism and Hinduism are branches of the same Javanese tree.

Toward the end of the Central Javanese period, esoteric Buddhism of the Diamond Path (*Vajrayāna*) began to spread in Indonesia, propagated by the *vihāras* of Bihār and East Bengal. With this new type of Mahāyāna Buddhism came the cult of female counterparts (*Prajñās*) of the Buddhas and bodhisattvas (cat. 49) and of multiarmed gods and goddesses (cat. 63). With the spread of *Vajrayāna* also came the mandala, the geometrically arranged hierarchic grouping of a rapidly expanding pantheon. If any painted examples of the types that Chinese pilgrims brought from India ever reached Indonesia, they have been lost without a trace. In Java the mandalas took the shape of three-dimensional diagrams consisting of a large number of small statuettes. Except for the much later Tibetan mandalas, such as the Lamaist pantheons consisting of hundreds of figurines preserved in temples in Beijing,[29] only solitary statuettes of such groups have been found elsewhere in Southeast Asia. In this exhibition a small selection of statuettes from Nganjuk (cat. 67) has been joined by a group of small bronze figurines from Surocolo, near Yogyakarta (cat. 66), shown here for the first time. The iconography of the first of these groups was based upon a literary source that can only have been written in India shortly before the statuettes were cast. It demonstrates how fast new ideas and their modifications traveled in the Buddhist world, and leaves no doubt that Indonesia was not a distant provincial backwater, but a lively center of international Buddhist exchange and a meeting place for learned ecclesiastics familiar with the latest philosophical and iconographical developments.

As the civilization that produced the *candis* of Borobudur and Prambanan flourished in the plains of Kĕdu, Prambanan, and Sorogĕdug, it also began to spread into the outlying areas of Central Java and eastward into the fertile valley of the Brantas River. The increasing prosperity of East Java, stimulated by extensive maritime trade, made the kings look to the East. In the early years of the tenth century the name of King Balitung appears on two Ganeśa statues in East Java, one at Mojosari (904/905) and one in Blitar (907). His successors followed his example and also left a number of East Javanese inscriptions, the last of which dates from 928.[30]

The next year the *kraton* of King Sindok moved East to Tamelang (Tembelang, Jombang?) and with him, it would seem, most of the population of Central Java. There has been much speculation as to the reasons that prompted such a drastic relocation. Some have attributed it to economic causes, citing signs of East Java's growing prosperity. Others point to the threat of Śrīwijaya, namely an invasion by forces of Malayu, a vassal of that maritime kingdom, as recorded in an inscription dating from about 930. Another theory depicts the population of Central Java, exhausted by the demands made upon them by the religious zeal of their rulers, fleeing their oppressors and relinquishing the glorious monuments they had been obliged to build for them. Boechari rightly rejected this view when the wrote: "The structure of the ancient Javanese kingdom, the relation between king and subject, the attitude towards the building of religious sanctuaries and the nature of the ancient Javanese economy make the picture of a despotic ruler, forcing his subjects to build splendid edifices to his own glory, resulting in economic collapse, rather improbable."[31]

It is much more plausible to identify a natural disaster as the cause of this migration. The Dutch geologist van Bemmelen has found evidence of a catastrophic eruption of Mount Merapi, affecting especially the area southwest of the crater.[32] The reference to an enormous eruption in an inscription of 1016 prompted him to date the eruption of Mount Merapi that engulfed the area of Muntilan, near Candi Borobudur, in that year. But the eruption of 1016 affected the royal *kraton*, which had already moved to East Java in 929, and therefore it seems more likely that the eruption of 1016 took place in another area. The catastrophic eruption of Mount Merapi, of which such clear geological evidence was found, could have occurred in 928 or 929. Although volcanic ashes and other debris must have rendered the land temporarily unfit for cultivation, the exodus of the population may not have been motivated solely by economic or practical considerations. An eruption of this magnitude is likely to have been seen as an unmistakable sign of the wrath of the gods.

One such eruption, if not the same one, may have completely covered with volcanic debris the small Śivaite complex of Sambisari, near Prambanan. Rediscovered by accident in 1966, it was excavated and completely reconstructed by Indonesian archaeologists in 1976 and 1977.[33] At Candi Morangan, much closer to the crater of the Merapi, a subsidiary temple, completely buried, was discovered in the fall of 1987.

The fact that there are, except for a single rock inscription at the Diëng Plateau, no epigraphical records of Central Java from 928 until the fifteenth century is an indication of the scope of the disaster. Even though the *Nāgara Krĕtāgama* mentions "Budur," presumably a reference to Borobudur, among the sanctuaries of the Buddhist Vajradhara sect, there are no signs of any repair, modification, or new construction of religious monuments in Central Java until the terraced sanctuaries of Candi Sukuh and Candi Ceto (cats. 33, 34) were built in the fifteenth century.

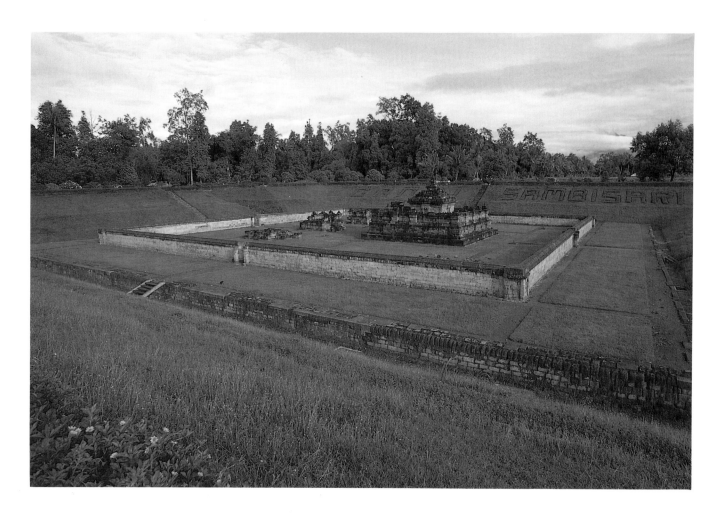

Candi Sambisari, in the village Purwomartani, Kalasan, Sleman, Yogyakarta, after excavation and reconstruction

Ancient Javanese literature contains several poetic descriptions of temple ruins. In the *Arjuna-Wiwāha* it is said of a ruined temple that "its demon's masks looked as if they were weeping in silence" (canto 15:13) and the same metaphor is used in Mpu Tanakun's *Śiwarātrikalpa* (canto 3:1).[34] In the *Arjuna-Wijaya* (the victory of Arjuna), the poet Mpu Tantular, after first describing the ruinous state of a temple, provided a vivid account of the king's efforts to restore the site to its former glory.[35] Another king received the epithet *Jīrnnodhāra* (restorer of ruins).[36] However, all these poetic impressions and royal activities concern sanctuaries in East Java. In spite of the enormous amount of time and energy invested in them, the great monuments of Central Java were abandoned by those who built them and were left exposed to the hazards of earthquakes, volcanic eruptions, and the encroachment of the jungle. They were not restored, modified, and expanded as were ancient monuments in countries with a long religious continuity such as Thailand or Burma. Deserted by the faithful who went East, later ignored by a population that had adopted the Islamic faith, the great monuments of Central Java were forgotten and for centuries suffered complete neglect.

The pinnacles and spires, dislodged by earthquakes, were the first to go. They toppled and their scattered stones were soon covered by thick

layers of volcanic ashes and sand. A Javanese chronicle records[37] that the towers of Loro Jonggrang collapsed as a result of an earthquake in 1584. The actual body of a temple, deprived of its superstructure, often remained the only part visible and accessible. The first western visitor whose impressions have been preserved was the merchant C. A. Lons of the Dutch East India Company. Perhaps in search of antiquities for his boss, Frederick Julius Coyett, the first Dutch collector of Javanese sculpture, he used the opportunity of an official visit to the *kraton* of Kartasura in 1733 to make an excursion to Prambanan. He found the temples so overgrown with shrubbery "that they looked more like hills than like chapels."[38] The travelers who followed in the footsteps of Lons, including Sir Thomas Stamford Raffles during the brief period of British rule of Indonesia in the Napoleonic era, still found numerous remains of temples, scattered in the plains of Kědu, Prambanan, and Sorogědug. Unfortunately rapid economic development of this fertile area during the nineteenth century soon brought great changes. When Ijzerman, the discoverer of Borobudur's hidden base, visited the area in 1885 he found only "pityful ruins, dismantled by bastardized descendants incapable of appreciation for the greatness of their ancestors."[39] This was hardly a fair judgment, for while there can be no doubt that the local populace had carried off its fair share of the many well-cut *candi* stones for the foundations of their modest farmhouses, these farmers, ruthlessly exploited by the colonial regime, certainly were not the chief culprits.

When J. Knebel, a representative of the Archaeological Commission, surveyed the area in 1909, there were at least twelve monuments, known from earlier descriptions by such pioneers as H. W. Hoepermans and the Reverend J. F. G. Brumund, of which he could not even find a trace. This sad discovery prompted him to lament that "There, where the Brahmanic and Buddhist cults were once practiced with Hindu devotion and Hindu artistic sensitivity, now rites are being performed at the altar of God Capital, with the owner of the sugar mill or, previously, of the indigo plantation, officiating as its high priest."[40]

At the time of this complaint the colonial government had already become conscious of the necessity to safeguard the ancient cultural heritage of Java and had begun to take the first measures to protect, repair, and reconstruct the remaining temples. During the twentieth century the successive archaeological services have recouped many of the losses suffered during the previous hundred years. The development and perfection of rebuilding techniques has made possible the resurrection of monuments once dismissed as ruins beyond hope of salvage. At Candi Plaosan, where two once-identical buildings, one reconstructed and one still in ruins, stand side by side, the visitor can judge the spectacular success of one of these reconstructions, which restored Candi Borobudur and several temples of the Loro Jonggrang complex to much of their ancient glory.[41]

This recounting of the fate of the great Central Javanese monuments through the centuries of their neglect and decline to their modern resur-

rection, a departure from the chronological sequence of events, has interrupted the description of the development of Javanese art and culture as it evolved and flourished in the eastern regions of the island. Perhaps that interruption was appropriate, for it serves to emphasize the fact that the move of the seat of government to East Java represented in many ways, and certainly in the field of art and architecture, a real break with the past.

The feeling that this art and architecture changed radically is caused in part by the fact that very few monuments from the next two hundred years survive, so that in addition to a change of scene, the art went through two centuries of development that, for the most part, can no longer be traced. In this exhibition the change seems less abrupt because five major works that date from the intervening period are represented. These include three statues from Gurah (cat. 20), which represent, as their excavator Soekmono has convincingly argued, a link between the arts of Central and East Java.

The king who first moved the *kraton* and who seems to have established his authority over a large part of East Java is Sindok, who ruled from 929 to 947.[42] About one of his successors, Erlangga, we are relatively well informed, for the Calcutta Stone (1041), one of the rare inscriptions that deal with a coherent sequence of historical events, provides extensive biographical data on his eventful life. It tells how the capital Medang was destroyed and how Erlangga, a royal relative who happened to be visiting from Bali at the time of the calamity, escaped by going into hiding. He was subsequently offered the throne and reestablished royal authority over parts of Java, although it is not clear how far his kingdom extended.

The bathing places Jalatunda (cat. 18) and Belahan, both at the foot of Mount Penanggungan, date from his reign, and it is thought that the statue of Visnu on Garuda (Museum Purbakala, Mojokerto) is a portrait of this king. Shortly before his death after 1042, the kingdom was divided between his two sons, a division that was to last almost two hundred years. The kingdom of Janggala, in the area of Surabaya, never seems to have achieved importance, but the more centrally located kingdom of Kadiri flourished and became a center of culture that produced most of the great literature in the Old Javanese language.

The kingdom of Kadiri was brought to an end by Ken Angrok, whose rapid rise to power is depicted in colorful if not always credible detail in the *Pararaton*.[43] He established a new dynasty in Singasari in 1222, and although the dynasty itself did not last more than seventy years, the descendants of his wife, Queen Děděs (cat. 24), were to rule East Java for the next three hundred years until the *kraton* of Majapahit was conquered by Muslim troops.

The Majapahit kingdom reached its apogee during the reign of King Hayam Wuruk (1350–1389) and his minister Gajah Mada (died 1364). This was the age of the poets Prapañca and Mpu Tantular. Prapañca left the *Nāgara-Krětāgama*, a rich source of information on this period. Although the decline set in after Majapahit lost its ascendancy over the

Indonesian states outside Java, it may not have been as rapid, and the internal strife not as fatal, as once was thought.[44] The Javanese tradition that the kingdom had fallen by 1478 is probably mistaken, for in 1513, when the mariner Tome Pires visited Java, King Bhra Wijaya, the last ruler of Majapahit, was still in power. His reign probably lasted until 1527, the time of the conquest by Muslim troops.

As the center of political power in Java shifted eastward, the kings of Kadiri (929–1222), Singasari (1222–1293), and Majapahit (1293–1527) seem to have distanced themselves, both physically and mentally, from the Indian examples that had been a source of inspiration to the dynasties of Central Java. At the same time a more direct impact of Indian culture made itself felt in the various Indianized kingdoms that arose in the island of Sumatra. The East Javanese kingdoms continued to have extensive overseas connections and from time to time mounted maritime expeditions to maintain or reestablish their sway over other parts of the archipelago. However, there is only occasional evidence of a new influx of ideas from the Indian subcontinent, and the religions, traditions, and literature that had been adopted earlier were now subjected to a thorough process of progressive Javanization.

As the centuries from which almost no architectural remains have been preserved coincide with what has been called the Golden Age of Javanese literature, it would seem useful to look at the Javanese poet's response to the literature of India and to compare it with that of the sculptor. The process by which the native spirit of the Javanese asserted itself in its response to the profound impact created by the classic epics of India, the *Rāmāyana* and the *Mahābhārata*, bears many similarities to the process we can observe in the visual arts, and the students of literature face questions parallel to those asked by art historians.

In the inscriptions, Sanskrit, the written language of the Indian intellectual elite and the vehicle for the knowledge of things Indian, was largely superseded by Old Javanese. The imprint Sanskrit left on the Javanese vocabulary is unmistakable and large, but the structure and character of Old Javanese was left intact. There can be little doubt, however, that during the initial phases of Indian influence in Indonesia the impact of Sanskrit was strong. From the fact that the instructions to the sculptors at Borobudur were all carved in rudimentary Sanskrit we can conclude that the texts illustrated there were all written in that language. All these stories are set in an Indian world, their texts replete with references to Indian customs and traditions. One should ask what it was that the sculptors intended to show their viewers. Did they offer a glimpse of the holy land of Buddhism and Hinduism as they imagined it to be, and of which they had at best second-hand knowledge? Or did they place their stories in the native Javanese environment with which both sculptors and viewers were thoroughly familiar? Although efforts have been made to decide these questions on the basis of small technical details such as the difference in shape between excavated mirrors and the Indian-style mirrors shown in the reliefs, such criteria are too narrow to produce reliable results. A comparison with Javanese literature may help to clarify the question.

In the *kakawin*, poems composed between the eleventh and fifteenth centuries in Old Javanese according to the rules of Sanskrit prosody, the names of all the characters are Indian. In their choice of plots the poets reveal a close dependence on prototypes of Indian origin. Nevertheless, the life that they depict is essentially Javanese, the dramatis personae act like Javanese, and the environment in which they live is Javanese too. That does not mean that the texts reflect life as it was lived in Java. Zoetmulder maintained that "any attempt to reconstruct the Old Javanese scene from the literary products of that time must amount to a careful and judicious evaluation of the various elements in the story."[45] Exactly the same could be said of Javanese relief sculpture.

Sivaramamurti, an Indian art historian with a vast knowledge of Sanskrit literature, looked at Borobudur through Indian eyes, explaining Indian customs and identifying Indian paraphernalia as they appear on the reliefs.[46] It is not surprising that his interest focused on the Indian components of Javanese culture instead of on Javanese culture as a whole. Even though Borobudur presents a magnificent and variegated collection of petrified Indian customs, traditions, and realia, the monument does not depict life as it was lived in India in those days. Instead, more than one world is shown here. In the reliefs of the hidden base the down-and-out, the street musicians, the beggars, and the convicts being led to their execution have been portrayed as they really were. The text the Javanese sculptors were commissioned to illustrate deals with universal human values, and there was no need for them to deviate from daily life as they knew it. The *Stories from Previous Births* and the *Life of the Buddha* were all laid in India, the holy land of Buddhism, and while many details were borrowed from daily life in Java, the sculptors probably tried to depict an Indianized fairy-tale world. The same may apply to the first part of Sudhana's pilgrimage when he pays visits to gurus who are common mortals. However, the reliefs of the third and fourth galleries, which depict his visits to the bodhisattvas Maitreya, Mañjuśrī, and Samantabhadra, portray exactly the kind of miraculous dream world described in that part of the text. As a source of information on life and architecture in ancient Java these reliefs are useless.

The story of Rāma as told in the Old Javanese *Rāmāyana* is not the story of Vālmīki's epic, but is based upon a much shorter version known as the *Bhattikāvya* (poem of Bhatti), written in Gujarat in the sixth or seventh century. Its poet used the well-known story of Rāma in order to illustrate in verse various points of Sanskrit grammar, prosody, and rules of literary composition. It is, in other words, a textbook, and one could imagine that an Indian guru brought it with him to teach his Javanese pupils. The Old Javanese *Rāmāyana* largely follows the text of Bhatti's poem, and may, therefore, be considered a work from the early phase of the adaptation of Indian literature. However, the systematic, line-for-line comparison of the two texts undertaken by Hooykaas reveals that already in this early stage the Javanese poet consistently expanded and embroidered upon those passages in which Bhatti described the chief personages in the drama as crying or lamenting.[47]

The same story as told by the sculptors of Loro Jonggrang in two installments on the balustrades of the Śiva and Brahmā temples, the most elaborate illustration of the epic anywhere in the world, differs considerably from how it is told in the Old Javanese *Rāmāyana*, even though both date in all probability from the same period, the late ninth or early tenth century. This raises the question of another element that seems to have played an important role in both literature and sculpture, the oral tradition.

Most of the points in which the illustrations of the *Rāmāyana* deviate from the ancient epic by Vālmīki can be traced to other Indian versions of the story. The large number of those deviations in India can be attributed to the long period during which the story was orally transmitted by bards. In Java the *dalangs* (puppeteers) of the *wayang* shadow plays were the bearers of orally transmitted *lakon* (plots). That some unusual variants, found only in such late versions of the story in Malay as the *Hikayat Seri Rama*, found their way onto the reliefs may well be the result of the sculptor's familiarity with *wayang* versions of the same plot, seen after a hard day's work of carving at Loro Jonggrang.

Perhaps some of the reliefs at Borobudur and Prambanan may indeed be seen as creations of the first phase of Javanese story-telling in stone, when the reliance on Indian prototypes was still strong, but in which deviations from the texts suggest that the native spirit of the sculptors was already beginning to assert itself through emendations, interpolations, and elaborations of those themes that were closest to the Javanese heart.

Just a century later, when the gargoyle reliefs at Jalatunda (cat. 18) were created, any uncertainty as to what is Indian and what is Javanese had been swept aside. The stories depicted on these gargoyles are undeniably Indian. In the story illustrated on the relief exhibited here, the cause of all trouble is a pregnant queen's sudden, irrational craving (Skt. *dohada*), a common element in Hindu fiction. However, exactly as in the literature of the *kakawin*, all the rest is purely Javanese. The requirements of royal protocol that crowded the Borobudur reliefs with a surfeit of retainers seem to have been forgotten: the king runs after the bloodthirsty Garuda all by himself. The dress even of royalty is simple and informal, while the palace architecture shows none of the baroque pomposity of the Borobudur palaces. These buildings are set in a rock-strewn landscape, rendered in a style that would even survive the transition into the Islamic period. The world of the poet and the world of the sculptor became one, and from this moment on Javanese sculptors turned for inspiration to the inexhaustible source of their own literary heritage.

Even though it still borrowed basic themes and plots from the old Indian epics, this new source of inspiration was thoroughly imbued with the typical Javanese sense of beauty (Jav. *kalangwan*), and from now on depicted only purely Javanese settings and situations. The illustrations of the adventures of Arjuna, whose resolve to do penance

withstands the temptation of the most seductive nymphs (cat. 32), of the blameless Śrī Tañjung who, having been killed by her jealous husband, returns to life from a trip to the netherworld (cat. 113), of Sadewa, the youngest of the Pandawas, who releases the Goddess Durgā from a terrible curse placed upon her by her husband, or of Kuñjara-karna who pays a visit to hell like a Javanese Dante—all these legends and countless other stories provided the Javanese sculptors, goldsmiths, and makers of bronze lamps with a cornucopia of written and oral traditions upon which they could draw to decorate their utensils and jewelry.

Almost all the surviving monuments in the mature East Javanese style create the impression that the unsurpassed talent for narration that was typical of the Javanese sculptors of Borobudur and Prambanan re-emerged during the Singasari and Majapahit periods after having lain dormant for approximately two centuries. In all probability this gap is the result of lost monuments rather than of a temporary eclipse of a great artistic tradition. In spite of the many differences between the relief sculpture of Central and East Java, there is an unmistakable continuity in narrative devices and methods of illustration that could hardly have survived if a discontinuity of two centuries had really occurred.

The style of the reliefs that the East Javanese sculptor created is often called the *wayang* style after Java's popular shadow plays. While the "lobster claw" headdress of the heroes of Indian stories (see cat. 108) and the low relief in which most of their adventures have been carved may perhaps justify the comparison with the shadow plays, we should not take the similarity too literally. For just as it is unlikely that the sculptors created low reliefs in stone to enhance their resemblance to shadow puppets, one finds it difficult to imagine that the puppet makers were inspired by the style of the temple reliefs.[48] In all probability both the relief sculpture and the *wayang* theater are different expressions of the same thing: the continuing Javanese fascination with the complexity of the human condition, with its moments of glory and defeat, the conflicts of loyalty to one's ruler and one's family, of spiritual deliverance and human weakness, as it had found its expression in their literature.

IN SPITE OF THE FACT that Central Javanese monuments of the late ninth and early tenth century reveal architectural features foreshadowing developments that were to come to full fruition in East Java, and that there is, therefore, ample evidence of continuity, there are differences between the art and architecture of Central and East Java. The first is one of scale. Never again did the Javanese build monuments of the soaring grandeur of Prambanan or the labyrinthine complexity of Borobudur, and no other texts were ever translated into stone in such detail as the *sūtras* at Borobudur and the *Rāmāyana* at Prambanan. For all their grace and beauty, even the largest of the East Javanese sanctuaries, Candi Singasari (cats. 23, 24, 25) and Candi Panataran, are dwarfed by the ambitious scale of the Central Javanese shrines.

As if the more intimate scale of the East Javanese *candis* invited a more personal, wandering, less structured approach, the rigid clockwise circumambulatory sequence of the reliefs of Borobudur and Prambanan was relinquished and sometimes replaced by a seemingly haphazard sequence. However, at Candi Surawana what seems at first sight to be a confusing arrangement of illustrations of three different stories turns out to have been carefully orchestrated to capture a unified vision of the moral world.[49] The story of Śrī Tañjung and that of Bubuksa and Gagang-Aking (see cat. 113 and below) have been made into subsidiary tales, providing reflection and commentary of thematic interest to the principal series of bas reliefs illustrating the well-known story of Arjuna's Wedding.

Another difference between the temples of Central and East Java is to be found in the manner in which the *candis* are decorated. In Central Javanese architecture the ornament applied to the facades never competes with the architectural elements, merely filling the space between them, providing visual support and subtle accents.[50] In the course of the Central Javanese period this coordination between architecture and ornament was gradually perfected. As monuments that were left unfinished clearly demonstrate, the architects began to select the shape and size of their building blocks in anticipation of the decoration that was going to be applied to them. Perhaps this trend to accommodate the decoration foreshadowed developments of the East Javanese period, in which the ornament sometimes seems to overwhelm the architecture, covering it with elaborate decoration as if it were ivy.

Yet another difference between the *candis* of Central and East Java is that the balance between Śivaite and Buddhist sanctuaries seems to have shifted to a clear ascendancy of the Hindu gods. The number of shrines dedicated to Buddhism is small compared to that of Śivaite sanctuaries, and while the Old Javanese literature abounds with references to Hindu gods, Buddhism is only rarely mentioned. During the Majapahit period the elite seem to have regarded both religions as different forms of the same truth, and the daily practice of the two religions became increasingly amalgamated. Instead of shrines of the two religions built in each other's proximity, as we saw in Central Java, several East Javanese shrines seem to have been built in order to recognize symbolically the coexistence of the two religions. At Candi Jago the choice of stories illustrated in the reliefs constitutes a mixture of Buddhist and Śivaite legends.[51] At Candi Jawi (see cat. 22) a Śivaite shrine with Śivaite sculpture is topped by a Buddhist *stūpa,* an apt memorial for a king immortalized as Śiva-Buddha. It is possible that Prapañca, the poet of the *Nāgara-Krĕtāgama,* gave a somewhat one-sided impression of the strength of Buddhism, for he himself came from a Buddhist family. And the poet Mpu Tantular, a Buddhist according to Balinese sources, claimed that there was no essential difference between Śiva and Buddha, and he equated the five manifestations of Śiva with the Five Jinas.

Several kings chose to be reunited upon death with gods of both religions. Yet there must have been, at times, a certain amount of competi-

tion in what seems to have been a world of remarkable tolerance. This is suggested by the reliefs illustrating the story of Bubuksa and Gagang-Aking. At Candi Panataran, where this legend is illustrated on the *pĕndopo* terrace,[52] the story seems to run as follows: two brothers have opted for a life of asceticism, and together have built a mountain retreat. However, while Bubuksa (glutton) continues to eat and drink to his heart's content, his brother Gagang-Aking (dry stalk) leads an abstemious life. The supreme god Bhatāra Guru decides to test them. In the guise of a tiger he approaches Gagang-Aking for food, adding that he likes only human flesh. Gagang-Aking, however, refers him to his corpulent brother, who immediately offers his own body as food to the hungry tiger. He is judged ripe for heaven and allowed to ascend on the back of the tiger. Responding to Bubuksa's pleading, the tiger permits Gagang-Aking to come along by holding onto his tail. In heaven Bubuksa, the Buddhist, receives full blessing, while the Śivaite Gagang-Aking is only entitled to partial bliss. At Candi Surawana, on the other hand, an abbreviated version of the story shows a complete reversal of roles with Gagang-Aking instead ascending to heaven, a version not supported by the existing literature.[53]

Despite such revealing visual signs of competition between the two religions, greater forces were at work that would shape them into increasing congruence. In the last decades of the Central Javanese period Esoteric Buddhism had gained a strong foothold in Java, and following a trend first manifest in India, both the Śivaite and Buddhist cults became strongly tinged by Tantric concepts and practices that aimed at deliverance by magic means. The Tantric Buddhist *Kalacakra* cult, probably imported from the East Indian monastery of Vikramaśīla, may have gained powerful adherents during the Singasari period, especially during the reign of its last king Krĕtanāgara, who is believed to have been assassinated during a Tantric ritual. Not much is known about this *Ganacakra* ritual as practiced in East Java, or about its possible connections with the Tantric cult of Bhairava, a demonic and destructive form of Śiva that began to spread in East Java at the same time.[54] Such late East Javanese literary sources as the *Tantu Panggelaran* and the *Korawāśrama* make frequent mention of the *Bhairavapaksa*, the followers of Bhairava. This cult provided inspiration for two of the finest stone sculptures in this exhibition (cats. 25, 28). It was practiced in secluded places such as those used for the cremation of corpses, and consisted of demonic rituals and magic spells.

This form of Buddhism was exported to Sumatra, where it found favor among the Batak and Minangkabau tribes, whose conversion to Tantric Buddhism was probably facilitated by their recognition of elements of their native religion in the sorcery and magic spells of the Tantric priests.[55] The gigantic statue of Bhairava from the Upper Batang Hari district (now in the Museum Nasional, Jakarta) and the remote temples of Padang Lawas (cat. 26) are among the most remarkable cultural relics of these Buddhist kingdoms. However, after flourishing briefly, Buddhism here seems to have been overwhelmed by and absorbed into the mainstream of indigenous beliefs and magic practices, and only

these remote monuments now remain as relics of this fascinating episode in Sumatran history.

If there ever were any doubts as to whether the sculptors of East Java were the equals of their Central Javanese predecessors, such misgivings are dispelled by their sculpture in the round. The statuary of Candi Singasari displays a boldness of design, a subtlety of detail, and a profound spirituality that has rarely been surpassed in the history of Southeast Asian sculpture. In the gloriously triumphant Durgā Mahiśāsuramardinī (cat. 23) and the deeply introspective Prajñāpāramitā (cat. 24) of Singasari, Indonesian sculpture reached its all-time apogee. More than a century later the statuary from Jebuk (cats. 29, 30) displays an originality and an apparent freedom from iconographic convention that give the sculpture a uniquely human, non-iconic appearance.

It was perhaps in response to the extraordinary blending of human and divine power that emanated from these statues and to account for their mysterious beauty that the theory of the portrait statue was first proposed. These so-called portrait statues are among the greatest achievements of the sculptors of the Singasari and Majapahit periods, and four of the most important statues of this type are included in the exhibition (cats. 24, 27, 29, 30).

The earliest epigraphic evidence of the Javanese belief in royal apotheosis dates from 919 when "His Majesty the King, who has died in Pastika" was called in the same sentence "The God of Pastika," a clear sign that the king was believed to have joined and become one of the gods upon his death.[56] In Cambodia and Champa (Vietnam) there existed a tradition of naming statues by joining part of the name of a deceased king to part of the name of a deity in order to symbolize the king's absorption into the godhead.[57] It seems that such a name sufficed to establish the connection between deceased royalty and the deity with whom the king had merged upon death. In Java the *Nāgara-Krětāgama* and the *Pararaton* record the deaths of kings and queens of the Singasari and Majapahit dynasties in combination with the name and the location of the temples that were built in their memory. When Stutterheim, Moens, and other scholars developed the theory of "portrait sculpture," the temples in which these statues had been enshrined were thought to be funerary temples, where the ashes of deceased kings and queens were kept and buried. Since that time, however, Soekmono has convincingly demonstrated that the sanctuaries are of a commemorative rather than a funerary character.[58] The words *dharma* and the passive verb *dhinarma*, previously interpreted as "interment" and "interred," may now be explained as meaning "to enshrine, to give a temple to," or "to build a temple for."[59]

Just as "commemoration" was interpreted as "burial," the meaning of yet another key word in the texts may have been taken in a sense more physical than seems to be warranted by the facts. This is the word *pratistha*, usually translated as "image or statue of a god," an explanation that does not seem to be confirmed by the documentary evidence (Zoetmulder 1982, 1410). It is actually a word for a ceremony such as

Live snail emerging from a conch (detail, opposite left)

the ritual of *swātmapratistha* or *prānapratistha*, in which the soul is invited to descend into the effigy of a god.

If historical evidence collected from India, Cambodia, and Champa can tell us anything, it is that physical likeness was not a requirement for memorial statues. Coomaraswamy suggested, therefore, the neutral term of "effigy" rather than "portrait statue."[60] Nevertheless the word *wimba*, which means statue or figure without any suggestion of physical resemblance, was often translated as "likeness." As the translations of these key words were accepted, the belief spread that the noble facial features of these "portrait statues" faithfully reflected those of famous kings and queens, and this belief in turn stimulated the search for connections between statues and historical personages. However, there is ample evidence to the contrary. For example, the Old Javanese *Sumanaśāntaka* tells how, after the death of a king and queen, a joint statue of them as Ardhanarīśwara was enshrined in a sanctuary within the royal compound, where their children came to communicate with them.[61] The fact that the statue represented Ardhanarīśwara (half Śiva, half Pārvatī) precludes the possibility of any resemblance to the deceased.

Often the literary sources in which the commemorative temples are mentioned also give the name of the deity or deities with whom the king and queen were believed to have merged upon death. A deceased king was sometimes thought to have been absorbed by more than one divine being. For example, Krĕtanāgara, who died in 1292, was identified at the same time with Śiva, Ardhanāri, and with the Jina Aksobhya. We need not view these statements of multiple identifications as contradictory, but merely as an indication that the deceased was believed to have become one with the gods.[62]

Sometimes the names of the locations of the commemorative temples are thought to have survived in the modern names of villages or temples. If in a village bearing such a historical name the remains of a temple are found, it is assumed that this is the sanctuary mentioned in the texts. If, in addition, a statue can be attributed to that site or if a statue is actually found in situ and if, finally, that statue shows attributes that identify it as the deity with whom the king or queen associated with the site is thought to have merged after death, this statue is then considered to be a portrait statue of that particular king or queen. A portrait statue was thought to be a sculpture in which the facial features of the deceased king or queen have been preserved and combined with the iconographic characteristics of the deity with whom they are thought to have merged upon death. This, briefly stated, is the theory of Javanese portrait sculpture that has been developed over the years in numerous articles by Moens, Stutterheim, Schnitger, and many others.

The first question that arises is how do we distinguish portrait sculpture from ordinary statues representing the same deities? Moens believed that only portrait statues showed deities with the conical crown *kirīta-mukuta*, whereas all statues with a tall headdress of knotted hair, the *jatāmukuta*, represent gods.[63] He also maintained that Visnu's tradi-

Statue of a four-armed deity, possibly a portrait statue of King
Krĕtarājasa (1293–1309), h. 79 in., from Candi Sumberjati,
Simping, East Java. Museum Nasional, Jakarta, inv. no. 2082

The goddess Pārvatī, possibly a portrait statue of a Majapahit
queen, h. 79 in., from Candi Rimbi, Majaivarna, Jombang,
East Java. Museum Nasional, Jakarta, inv. no. 1794

tional emblem, the conch, is shown empty in statues of gods, whereas portrait sculpture that includes this attribute shows a live mollusk emerging from the shell, an interesting and ingenious hypothesis for which proof is still lacking.[64]

If we review the lists of kings and queens of the Singasari and Majapahit dynasties whose commemorative shrine is known by name as well as that of the deity with whom they are thought to have merged upon death, it turns out that this information is available for nine kings or queens in the *Nāgara Krĕtāgama* and for twelve in the *Pararaton*. Portrait statues of five of these are believed to have been found, one of which is shown in this exhibition (cat. 27). In addition, there are three very important statues of queens, all included in this exhibition (cats. 24, 29, 30), whose provenance cannot be traced with certainty to a commemorative shrine mentioned in the texts, but which have nevertheless become associated with two famous queens in the history of East Java.

At the time of its discovery in the early nineteenth century, the Prajñā-pāramitā from Singasari (cat. 24) was already associated by the local Javanese population with Queen Dĕdĕs, the consort of King Rājasa and ancestor of all Singasari and Majapahit rulers. The two statues from Jebuk are thought to represent Queen Suhita of Majapahit (reigned 1429–1447); in one of them she is accompanied by her husband (cat. 30). While the identification of all portrait statuary is to varying degrees based upon unproven assumptions, that of the last two statues seems to be even more hypothetical. However, there is at least one important fact that favors their association with that famous queen: the style of the sculpture is consistent with that of the period of the queen's reign. The same cannot be said of several of the other portrait statues, and one would feel more comfortable in accepting the hypotheses that resulted in all of these identifications if only the statues, placed in the chronological order suggested by their royal association, would display a convincing pattern of stylistic development.

One certain way to prove that a statue is a portrait statue of a historical figure is if more than one example of the same portrait can be found. One of the strongest arguments of George Coedès in favor of the identification of four Khmer statues as portraits of King Jayavarman VII is that the four heads look alike.[65] Unfortunately Java differs from Cambodia in that most of the faces of these statues are damaged, and several statues have lost their heads altogether. Although four statues of Prajñāpāramitā have been found, two are headless and one head is damaged beyond recognition.

Damage also makes it impossible for us to establish any facial resemblance between the only two Javanese statues that we can confidently call portrait sculpture. One of this pair is the statue, popularly known as Joko Dolok (Brother Fatso), which now stands under a banyan tree in a small park in the heart of Surabaya.[66] At first sight it resembles the Buddha Aksobhya, his right hand in the prescribed Earth-touching gesture. However, the statue lacks all the customary bodily marks (Skt.

laksana) of a Buddha, such as the curly hair, the *ūrnā* in the forehead, and the cranial protuberance. The inscription, dated Śaka 1211 (1289), contains a hymn in praise of King Krětanāgara, who was consecrated as a Jina (Buddha) during his lifetime. While the inscription does not use a word such as "likeness," one could imagine that the statue originally bore a likeness to the famous king. Unfortunately, the face of the statue has been badly damaged and poorly restored. This same misfortune befell a smaller uninscribed version of the same statue, now standing in front of the building of the police association in Malang. Rigg, who was the first to notice its resemblance to Joko Dolok in 1847, mentioned that it had been given a wooden nose. It is of interest to note that this, the only well-documented case of Javanese portrait statuary, concerns statues made during the lifetime of the king. In this respect Joko Dolok and his smaller, second version parallel the famous Cambodian portrait statues of Jayavarman VII (c. 1181–c. 1218), portrayed as an ascetic, likewise made while the great Khmer king was still alive.

As far as the reliability of the oral tradition is concerned, some reservation is certainly in order. Only the Prajñāpāramitā of Singasari, the greatest of all the portrait statues, was linked to a specific historical personage. The statue of Pārvatī from Candi Rimbi (Museum Nasional, Jakarta), most likely to be a portrait statue, was already named Arimbi after the mother of Ghatotkaca, a demoness of the *wayang* shadow plays, when Wardenaar first set eyes upon it in the early nineteenth century.

Fifty years ago, when Stutterheim addressed the question of portrait statues for the last time, he concluded: "the identification of royal portraits continues to be a search for a working hypothesis,"[67] and it would seem that little has changed since that time. While there can be little doubt that the statuary in commemorative shrines represents kings and queens in the form of deities with whom they were united upon death, the identification of individual statues and the division between divine and portrait statues remain matters of speculation. Even when all the chronological and stylistic contradictions have been resolved, we will never know whether the faces that we admire for their nobility of expression are really the faces of the great kings and queens whose legendary exploits are recorded in history.

THERE IS A MARKED DIFFERENCE between the arts of Central and East Java in the radical changes that took place in the art of casting bronze. Even though only a relatively small number of statues escaped the fate of being melted down in later times, there is ample evidence, both in the shape of large statues like the Śiva from Tegal (cat. 52) and in the silent evidence of empty socles and niches in the *candis* of Central Java, that the Javanese had highly developed skills in the casting of large bronze statuary.

The small and delicate statuettes from Surocolo (cat. 66) and Nganjuk (cat. 67) represent the last phase of the art of the bronze image in Java, for soon, perhaps within a century after the move of the *kraton* to East

Java, bronze images ceased to be made. The finds of metal statues in East Java, far fewer than those from Central Java (see table above), consist almost entirely of statues in one of the Central Javanese or international styles. They provide evidence of the Indianization of East Java during the Central Javanese period, but do not represent later local styles.

It has sometimes been suggested that the disappearance of small bronze statuary may be due to the ascendancy of the Śaiva-Siddhanta school of brahmanic worship, which favors ritual practice and incantations over the worship of statues.[68] Although in Buddhism, too, there is a tendency to emphasize *bhakti* and the Hindu ritual of *puja*, no fully satisfactory explanation of the disappearance of bronze statuary can be given, especially as there is plenty of statuary in stone. That it was not a loss of technical skill is apparent from the new creations on which the Javanese bronze casters seem to have concentrated their efforts: bells, ritual paraphernalia, ceremonial finials, and elaborate lamps, which equal and often surpass comparable bronzes of the Central Javanese period.

By far the most common bronze relics of both the Central and East Javanese periods are ceremonial bells, perhaps five hundred of which have been preserved. Of the nearly two hundred bells in the Museum Nasional, Jakarta, a large number have come from about half a dozen finds. For reasons unknown to us bells are frequently found in clusters of five, seven, or up to seventeen in a single hoard.

This preponderance of bells is a phenomenon observed not only in Java, but in other parts of Southeast Asia as well. In a recent German exhibition catalogue of Ban Chiang (Thailand) ceramics and bronzes it is stated: "A typical, friendly predilection for bells of all sorts and shapes runs like a thread through fifteen hundred years of Ban Chiang culture, conveying a vision of a constant ringing of bells that could be heard all over the settlements and the surrounding rice fields. When we contrast the paucity of spearheads with the enormous quantity of bells we are inclined to think of the bearers of this culture as non-martial happy people."[69] That rosy view conjures up a romantic image at variance with reality, at least in Java, where the absence of weapons among finds in the soil may have other causes. In Indonesia the process of forging the sword (*keris*) from clumps of iron ore and meteorite into a sharp blade of patterned steel is often seen as a symbolic parallel to the process of purification to which the soul is subjected after death by the gods. The *keris* is, therefore, a weapon with immense magical potential (see cat. 33), which, in the eyes of the ancient Javanese, may have rendered it unsuitable for burial. Some ritual objects have been found together with such iron tools as chopping knives and axes, all stored in jars.[70] Stutterheim suggested that such hoards may have been buried at the conclusion of a solemn ritual to found a *sīma* or freehold or a religious sanctuary, and that these tools, once used for this ritual purpose, could not be used again.[71]

Of all the other ritual equipment that has been preserved, such as finials

and lamps, the large majority seems to have come from a very small number of hoards. These were found in Kebonsari (East Java, 1882, more than fifty pieces), in Batu Agung (Bali, 1888, forty pieces), and a smaller hoard in Selumbung (East Java, 1928). All three hoards are represented in this exhibition. The exact circumstances under which these pieces were found have not always been recorded, but in those cases where information is available it points to a deliberate burial in a chest or jar. The highly fragile lamps especially would not have survived burial had they not been packed carefully in a *kĕndogo* or some other bronze container or jar (*pengaron*).[72] Sometimes the bronze or iron chain from which a bell or lamp was suspended was buried in a separate container (cat. 70), indicating again the great care with which these objects were committed to the earth, as if they were meant to be rediscovered.

The reports on many of these finds attest to the extraordinary magic power that is still attributed to metal buried in the ground.[73] One cannot help wondering whether the awe and fear these objects continue to instill in Indonesians today is not a distant echo of similar feelings that caused them to be buried. That the largest of these finds occurred in Jĕmbrana on the island of Bali suggests that the conversion to Islam, which never took place there, may have nothing to do with the burial of these pieces. That lamps of the East Javanese period must have had a ritual or ceremonial purpose is suggested by the care with which they were buried and the context of ritual paraphernalia in which some of the lamps of known provenance have been found.

The elaborate lamps of the East Javanese period (cats. 83, 84, 85, 87) show the art of the Majapahit bronze caster at its best. The lamps, which could either hang or stand, are all decorated with elaborate, fragile scrollworks of stylized flowers and flames. The pedestal in the center of these quadruple lamps is decorated with a group of figures, usually illustrating a popular legend. As these lamps were suspended in the air, it was only natural that the artists chose flying creatures to decorate them. Their flickering light cast moving shadows, making the Garuda and heavenly nymphs seem to flap their wings, adding to the magic of these beautiful pieces. Rassers once compared the shape of these lamps with the *kekayon* or *gunungan*, the mountain or tree-shaped carved piece of leather that is placed in front of the *wayang* screen at the beginning and at the end of each performance.[74] Although none of the East Javanese lamps seem to foreshadow the shape of the *belencong* or *wayang* lamp as it was used in modern times, the possibility of some connection with the *wayang* should not be excluded.

The art of the Javanese bronze casters and that of their colleagues, the goldsmiths, is deeply imbued with the same spirit expressed in the literature of East Java. The subtle elegance and artful complexity of their creations is like that of the intricate *kakawins*, the poems in which the legends illustrated on the works of art are told in verse. The common thematic content of jewelry, lamps, regalia, and relief sculpture lends cohesion and harmony to the art of East Java. Śrī Tañjung crosses

the river of the hereafter on her fish-elephant (cat. 113), the monkeys build their causeway to Rāvana's island kingdom (cat. 114), and Garuda redeems his mother from slavery by stealing the nectar of the gods (cat. 85), not only in the reliefs of the small, profusely decorated East Javanese *candis*, but also on lamps, finials, and on personal jewelry of different shapes.

Ever since Brandes in 1889 formulated the ten characteristic and cultural achievements of Indonesia prior to the advent of Indian civilization, scholars have continued to argue about the indigenous origins of the *wayang* shadow play and the *batik* technique of textile decoration.[75] Even if his method of defining indigenous cultural traits—those that use exclusively native terminology—may not always be valid, Brandes certainly was correct in not underestimating the strength and vitality of ancient Indonesian culture.

Many of the elements that provided the continuity in Indonesian culture may escape our observation, submerged as they were for centuries in a flood of Indian imagery and terminology. For example, the aspects of pre-Hindu ancestor worship that we can discern in the commemorative *candis* and their "portrait" statues may have been much stronger in the lower strata of society, about whom the historical sources remain silent and of whom no monuments in stone remain. One element that can be traced through most of the history of Indo-Javanese culture as a constantly recurring theme is that of the worship of the Lord of the Mountains.[76] Once perhaps only a local deity, this survivor of pre-Hindu times gained ascendancy in the state pantheon of the Majapahit period. If it seems surprising that some of these ancient traditions re-emerged with great strength during the twilight of Indo-Javanese civilization, the conclusion to be drawn is that their tenacity and durability during the preceding centuries may have been underestimated.

The Islamization of Indonesia, which began in Sumatra and then came to Java, first along the north coast of the island and from there gradually toward the interior, made the followers of the old religions retreat to inaccessible areas. The last generations of Javanese temple builders, in a final display of their extraordinary talents, chose mountain sites for the last great *candis,* Candi Sukuh and Candi Ceto (cats. 33, 34). It is unlikely that they were motivated solely by a wish for seclusion. On these remote mountain slopes they blended the ancient traditions of the worship of mountains and terraced sanctuaries with their lasting love of the Indian legends of man's search for deliverance from evil and his quest for spiritual liberation. In their reliefs Durgā is no longer the goddess of the puranic literature who slays the buffalo-demon Mahiśa in an epic battle symbolizing the triumph of good over evil. She has been transformed by her husband's vengeful curse into a demoness, and must seek Sadewa's help to regain her divine appearance. It is obvious that such tales of exorcism draw upon native sources outside the sphere of the courtly *kraton.* Placed on top of a stepped pyramid of an almost pre-Columbian appearance was a huge sculpted phallus of Meru shape that may once have been the principal object of worship at this site,

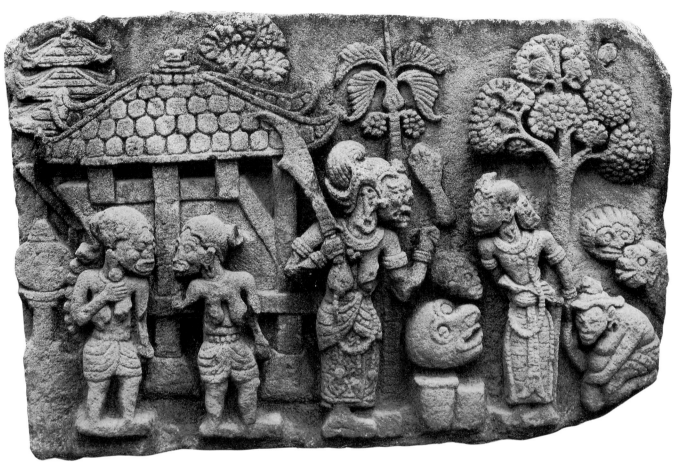

Sadewa, tied to a tree, is threatened by the demonic goddess
Durgā and ghostly apparitions. Stone relief from Candi Sukuh,
first half fifteenth century

where winged creatures, demons, and giant tortoises stand around in disarray (see pp. 114–115).

The slow but continuing retreat of those who clung to the old traditions against the forces of a new non-iconic religion is reflected in the dates the builders of those monuments left behind: at Sukuh, at an elevation of 2,750 feet, the last inscription dates from 1459; at Ceto, at 4,500 feet, from 1475. In East Java, on Mount Penanggungan, the last of the many monuments on that mountain was erected in 1512, thirty years before it was conquered by the sultan of Demak.

The Islamization process was gradual, as is evident from the relics the early Islamic communities left behind. It is regrettable that this exhibition cannot do justice to this development simply because the finest of the relics that can best illustrate this process are monuments and graves that are immovable and still play an important role in the religious life of the local population.

The early Javanese mosques, built on the square floor plan of the Javanese *candis* and provided with the multiple *meru* roof that can still be seen in Bali today, have courtyards, split gates, and *gopuras* in the East Javanese and Balinese styles. They are not foreign structures imported into Indonesia by missionaries from abroad, but examples of native architecture modified and adapted to the requirement of Muslim worship.[77] One of the oldest minarets, the *menara* of Kudus (Central Java), is a brick structure of a type recalling the *kul-kul* towers of Balinese temples. The wooden *mimbar* (pulpits) were decorated with carvings in which the *kāla-makara* motif survives, albeit stylized almost beyond recognition.

Of particular interest because of their great artistic quality are a large number of sculpted stone medallions, originally from a mosque dating from 1559 in Mantingan near Japara on Java's north coast. These medallions were let into the walls of a new mosque rebuilt in the same location in 1927.[78] Next to the mosque is the tomb of the sixteenth-century queen Kali Nyamat and her husband, whom she succeeded as ruler of this area. Besides round medallions with decoration based upon stylized and intertwined Arabic calligraphy, there are round and oblong medallions with interesting floral decoration. One type shows the unmistakable influence of Chinese blue-and-white porcelain designs of the fifteenth century. Chinese plates were often let into the walls of mosques along Java's north coast. This type of stone medallion obviously replaced such fragile decoration with carvings in a more durable material.

Another type shows such animals as elephants, tigers, a monkey, and a crab composed entirely of floral components, creations of a Javanese Arcimboldo who worked perhaps a few decades earlier than his European counterpart. This clever and artistically successful substitution for animal shapes has generally been regarded as a device forced upon the artists by the well-known Islamic injunction against the representation of humans and animals. However, in the *Wangbang Wideya*, a Javanese

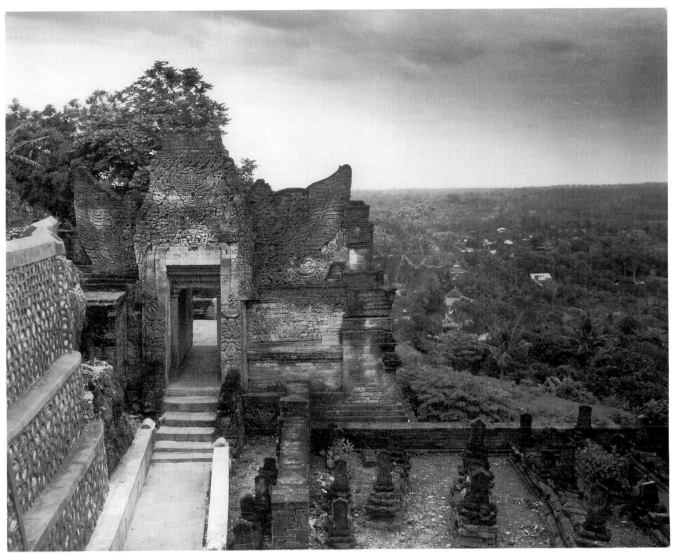

Winged stone gate of the mosque at Sendang Duwur, near Paciran,
Lamongan, Bojonegoro, East Java, mid-sixteenth century

Pañji romance, the story of which is set in pre-Islamic Java, we find the following description (canto 3:65 b): "Meanwhile the painter had laid down his brush; the king looked at his work, as did his wives, as well as the queen, amazed to see how all kinds of flowers had been painted to form a fierce demon, sturdy and hanging like a flying fox in a *pandana* palm."[79] The names are listed of all the plants and flowers that the artist wove into his composition, not all of which can today be identified precisely. What appears to be an unquestionable example of the Mantingan artists adapting to Islamic requirements turns out to be the adoption of an existing Javanese tradition that perfectly suited the purpose of the new religion.

In recent years the suggestion by de Graaf and Pigeaud that Queen Kali Nyamat may have built the mosque and her husband's tomb on a site already sacred in pre-Islamic times has been confirmed in a most surprising way.[80] During recent restoration work carried out by the Archaeological Service, it was discovered that the backs of some of the medallions had carved *Rāmāyana* scenes of a type very similar to those found at Panataran (see cat. 113). It is obvious, therefore, that the stone carvers of Mantingan recycled the stones of a *candi* decorated with illustrations of the *Rāmāyana*.

An early Islamic monument of great beauty is the winged gate of Sendang Duwur, which was built of porous volcanic stone quarried from the rock on which it stands.[81] The doorway is framed by the *kāla* motif, combined not with *makara* but with deer, just as can be seen in such temples as Candi Sukuh. Many of the decorative details recall East Javanese reliefs as well as the wood carvings in a mixed Javanese-Chinese style, which are found at the grave sites of the *walis*, the early teachers of Islam along Java's north coast. Against a magnificent panoramic backdrop, the gate of Sendang Duwur stands close to a precipice, clearly demonstrating that the architects had lost none of their ancestors' talent for placing monuments in the landscape. The gate has two large wings that make it look like a Garuda flapping its wings, about to embark upon his adventurous flight in search of the elixir of immortality.

While Central Java and parts of East Java entered this new phase in their cultural and religious history, the residents of the easternmost part of the island continued to worship the gods of their ancestors for several centuries. The princedom of Blambangan, around Banyuwangi, did not become Islamic until the eighteenth century, and in the Těnggěr Mountains even today many farmers still uphold the ancient rituals.

Many adherents of the old religions migrated to Bali and contributed to an Indo-Balinese civilization in which many elements of Majapahit culture have been absorbed, and which has remained a living religion to this day. While the sultan of Demak proudly recalled that at the time of his conquest of the *kraton* of Majapahit all the "Buddhist books" went up in flames, many of these texts, far from being destroyed, were preserved in Bali as part of the treasured possessions of Javanese refugees fleeing the Muslim conquest. But even though the importance of

the role of the Balinese in the preservation of the early literary heritage of Java can hardly be underestimated, we would do them a great injustice if we saw them merely as conservators of a gradually fossilizing Javanese tradition. Rather, in Bali the art and literature of Majapahit constitute two of the basic components of a new Balinese culture that has preserved its vitality to the present day. In a country as diverse as Indonesia there always remained regional differences in the manner and intensity with which religions were experienced and the influence they exerted upon the daily life of their adherents. In spite of the Islamization of Java, the literary traditions of the past—in which the two great Indian epics, the *Rāmāyana* and the *Mahābhārata,* had played such prominent roles—stayed alive in the repertoire of the *wayang* shadow plays. And so not only in India itself, but also in Java and Bali, the prophesy of Vālmīki, the poet of the *Rāmāyana*, was fulfilled: "As long as the mountains stand and the earth is watered by streams, the *Rāmāyana* will continue to be transmitted among men."

1. MacKnight 1986.
2. Vogel 1918.
3. Bosch 1925.
4. Chhabra 1949, and de Casparis 1961, 121–163, esp. 130–131.
5. Vogel 1925.
6. Noorduyn and Verstappen 1972.
7. Damais 1952.
8. Soekmono 1965.
9. Soebadio 1986.
10. Pigeaud 1960–1963.
11. Hinzler and Schoterman 1979.
12. Brandes 1920.
13. Wolters 1986.
14. Coedès 1918.
15. Manguin 1987.
16. McKinnon 1985.
17. Zoetmulder 1974, 38.
18. de Casparis 1956, no. 11, 280–330.
19. Fontein 1989, 56–57.
20. Sedyawati 1986.
21. Bosch 1952.
22. Dutt 1962, 328–380.
23. Miksic 1989.
24. Miksic 1989.
25. *TBG* 25 (1879), 464.
26. *TBG* 64 (1924), 334.

27. Dwiyanto 1983.

28. Soekmono 1987.

29. Clark 1937.

30. Boechari 1976.

31. Boechari 1976, o.c. 13.

32. van Bemmelen 1949.

33. Soediman 1980.

34. Teeuw 1969, 73.

35. Supomo 1977, 227.

36. *TBG* 59 (1919–1921), 326.

37. van Hinloopen Labberton 1920.

38. *BKI* (1855), 10–12.

39. Ijzerman 1891, 114.

40. van Erp 1943c, no. 9/10, 190.

41. The story of these reconstructions falls outside the scope of this essay, but the essay on architecture by R. Soekmono included in this catalogue touches upon this topic as it is seen from the perspective of one of the chief architects of this great cultural achievement.

42. de Casparis 1988.

43. de Casparis 1979.

44. Noorduyn 1978.

45. Zoetmulder 1974, 188.

46. Sivaramamurti 1961.

47. Hooykaas 1955, and Hooykaas 1958.

48. Tjan 1938, proposition no. 1.

49. Worsley 1986.

50. Stutterheim 1923.

51. Sedyawati 1989b.

52. Suleiman 1978, 9, no. 19.

53. Worsley 1986, 339–340.

54. Zoetmulder 1965, esp. 336.

55. Mulia 1980b, 9.

56. van Naerssen 1976, esp. 301.

57. Mabbett 1986, esp. 303.

58. Soekmono 1977.

59. Zoetmulder 1982, 367–368

60. Coomaraswamy 1931.

61. Zoetmulder 1974, 206.

62. Zoetmulder 1974, 272.

63. Moens 1921, 186.

64. Moens 1919, 493–526, esp. 504.

65. Coedès 1960.

66. Kern 1910; Poerbatjaraka 1922; Bosch 1918.

67. Stutterheim 1939, 86.

68. Stutterheim 1937a, 13.

69. Moeller 1985, 57.

70. For iron implements buried in jars see *JBG* 6 (1939), 103, nos. 6484–6490, and *JBG* 7 (1940), 83–84, nos. 6981–6996.

71. Stutterheim 1940, esp. 23.

72. Galestin 1958.

73. For popular beliefs concerning finds of metal objects see *O. V.* 1928, 97–98; *ROD* 1915, 139, no. 1512; *NBG* 1883, 59, and *NBG* 1885, 133.

74. Bernet Kempers 1933b, 23.

75. Brandes 1889. See also Sedyawati essay in this volume.

76. Supomo 1977, 227.

77. Pijper 1947.

78. *O. V.* 1930, 52–57.

79. Robson 1971, 65–66.

80. de Graaf and Pigeaud 1974.

81. Tjandrasasmita 1984.

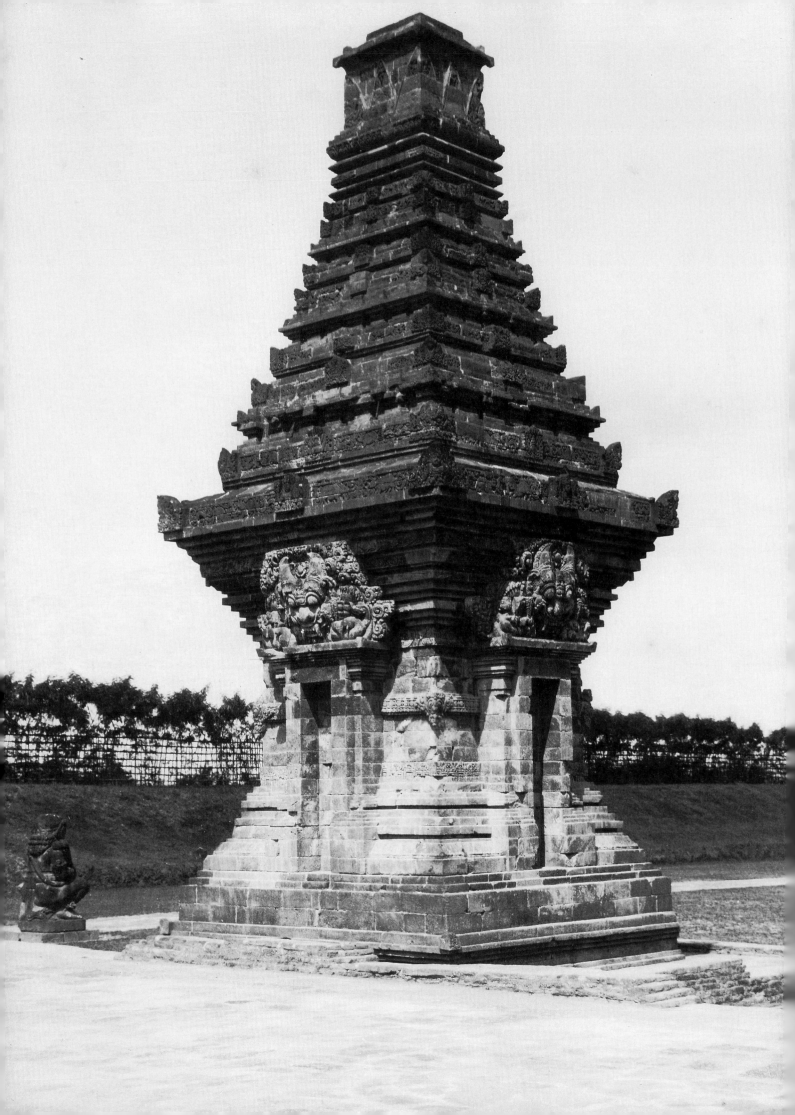

Indonesian Architecture of the Classical Period: A Brief Survey

R. Soekmono

I
T IS NOT KNOWN when the Indonesians first began to construct buildings. We may assume that when they began to settle and till the land during the Neolithic period, the need arose for shelter against sun and rain. In all probability the houses of that time were built from materials that were both readily available and easy to work, such as bamboo, wood, straw, and thatch grass. Of course no trace of these ephemeral habitations is left. The oldest structures that have come down to us are stone buildings called *candis*. These are not human dwellings but religious shrines, and it is from these buildings that many of the sculptural objects in this exhibition came. Statues in these *candis* were representations of deities that depicted deceased royalty and at the same time acted as representatives of ancestors who had crossed into the netherworld. The *candi* was, therefore, a place of worship in which homage was paid to deified royalty as well as to ancestral spirits.

As a meeting place of worshipper and worshipped, of this world and the world beyond, the temple building symbolized the entire universe. The world of the gods and the symbolism that is reflected in the *candi* point to a strong influence of Indian civilization, especially of that of its two great religions, Hinduism and Buddhism. It is assumed that this influence began to exert itself during the early years of the Christian era, though the oldest evidence, Sanskrit inscriptions written in South Indian Pallava script, dates from a few centuries later.

THE OLDEST ARCHITECTURE

The *candis* that grace the high plateau of Diëng (Central Java) have been regarded as the oldest examples of Indonesian architecture. Of the

Dated Temple at Candi Panataran, 1369

eight *candis* that have been preserved, Candi Bima, with its roof shaped like an Indian spire (*śikhara*), represents an architectural type recalling North Indian prototypes.

On the other hand, Candi Arjuna, as well as the other *candis* of Diëng, with their squat shapes and pronounced horizontal moldings, reminds us of temples from South India. However, these points of resemblance merely create a first impression. Closer scrutiny reveals more differences than parallels. Nowhere in India can a single temple be found that could have served as a prototype for those in Indonesia. This is especially true of the decoration of the *candis*. For example, the Indonesian version of the *kāla-makara* motif is vastly different from the Indian *kīrtimukha* and the Indian way of rendering the *makara*. Moreover, the reliefs representing Śiva on the east wall of Candi Srikandi, flanked by Brahmā on the south and Visnu on the north wall of the temple, represent an arrangement that is manifestly Indonesian in concept.

This influence of India manifests itself only in the broad outlines, for the execution of small details was entirely in the hands of native Indonesian artists. It is most remarkable that even when a monument has elements of Indian origin, closer inspection reveals that they are often traceable to more than one part of India, sometimes even to more than one period. The art of building *candis* is, therefore, not an art that was transplanted from India to Indonesia. Rather it was an unquestionably Indonesian art form, based upon the Indian world of thought, nevertheless created and developed by Indonesians themselves in accordance with their own native potential and tradition. This indigenous style is characterized in different types of *candi* structures, each representing a specific architectural style of an equally specific period. There are considerable differences between clusters of *candis* of the same period, and even more between *candis* of different periods and in different localities.

The truth of this statement is evident in the group of *candis* called Gedong Songo, which are usually considered to be coeval with or slightly more recent than the *candis* of the Diëng. Because several of the *candis* of the Gedong Songo group have been almost completely reconstructed, their architectural style can now be determined with certainty. The height of these *candis* only slightly lightens the generally squat impression created by their strong emphasis on horizontal moldings. The building technique and the way in which the different components have been constructed is similar to that of the *candis* of Diëng. Candi Semar, a small *candi* at Diëng standing in front of and facing Candi Arjuna, is built on an oblong rectangular floor plan and has a single, ogee-shaped roof. This temple presents a type that is known only from Diëng and Gedong Songo. The similarly unstructured organization of the clusters of temples at Diëng and at Gedong Songo suggests that these two groups of temples should be dated to the same or almost the same period.

Epigraphical evidence suggests that one temple, Candi Gunung Wukir, may be even older than the temples of Diëng and Gedong Songo. The

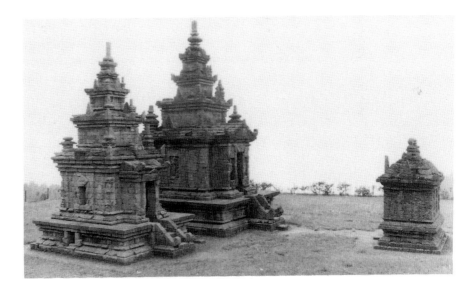

oldest inscription from the Diëng dates from A.D. 802, whereas the inscription of Canggal, which mentions the founding of Candi Gunung Wukir, dates from 732. Yet there is an indication that Candi Gunung Wukir may have been completed after the *candis* of the Diëng; the carving, especially of its *kāla-makara*, represents a development later than that of the Diëng temples.

Candi Gunung Wukir, of which only the base remains, displays in this remaining component a noteworthy architectural feature, the flat plain plinth of its foundation. The moldings that usually commence in the lower part of the structure and are often repeated higher up on the monument are completely absent here. There is no decoration whatsoever.

A plain base is also a feature of Candi Badut in East Java. In all probability this temple is connected with an inscription datable to the year 760. It has been reconstructed up to the lower section of the roof, so that we can observe the principal features of its architectural style. The divisions from bottom to top are the base, the body of the temple, and the roof, all of which are clearly differentiated, as are the divisions between the stepped stories of the roof. In the same way as in the *candis* of Diëng and Gedong Songo, efforts to reduce the emphasis on horizontality are made by dividing the walls of the body of the temple into three parts separated by vertical bands. The central section of the facade has been reserved for the entrance porch, while each central section of the other three walls has been used for a niche housing statuary. The principal image, represented at Candi Badut by the *lingga*, the phallic symbol of Śiva, is enshrined in the center of the cella of the temple. The carved floral decoration on the walls of the body of the temple and the *kāla-makara* framing the niches and the doorway display a stylistic development more advanced than what we see at Diëng and Gedong Songo. Candi Badut should, therefore, be of a slightly later date.

It seems that the flat, undecorated temple foundation is a typical architectural feature of the eighth century. Candi Kalasan, east of Yogy-

akarta, has the same type of foundation. However, the *candi* to which this applies is not the monument that stands today and is admired for the beauty of its stone carvings, but another structure, completely enveloped by it. In all probability there are two *candis* encapsuled within, of which only parts of the bases remain. An inscription dating from 778 that records the founding of a shrine dedicated to the Buddhist goddess Tārā in the village of Kalasa definitely refers only to the first of these structures. About this first Tārā temple not much is known, except that it had a plain, undecorated base.

ARCHITECTURE OF THE EARLY CLASSICAL STYLE

The *candis* of Diëng and Gedong Songo are by tradition considered the oldest architectural remains in Indonesia. As Candi Gunung Wukir was founded in 732, the beginning of architectural history in the island of Java can be placed before the early years of the eighth century. Within the two following centuries feverish building activity resulted in the construction of a large number of *candis* that grace the landscape of Central Java. This activity remained largely restricted to this area, and it is inextricably connected with the colorful political events in Javanese history that occurred before the middle of the tenth century. After this time the center of events shifted to the eastern part of Java. The history of ancient Indonesia is, therefore, divided into Central Javanese and Eastern Javanese periods, which are more of a chronological than a geographical distinction. For example, Candi Badut in East Java represents an architectural style typical of Central Java, while temples in the typical East Javanese style can be found in Central and North Sumatra. In the history of Indonesia the term "classical period" has replaced "Hindu period" to indicate the first fifteen centuries of the Christian era. The same terms could be applied to the styles of *candi* architecture. Thus, "*candi* of the early classical period" replaces the older term "Central Javanese *candi*," and "*candi* of the late classical period" replaces "East Javanese *candi*."

The *candis* already referred to above, Gunung Wukir, Badut, Kalasan I, and the groups of temples of the Diëng and Gedong Songo, are all *candis* of the early classical period. To this style also belong several *candis* that lie scattered over the central part of Central Java and the Plain of Prambanam east of Yogyakarta. The majority of these *candis*, especially the Buddhist temples among them, represent the golden age of the classical period during the reign of the Śailendra dynasty (c. 750–860).

The most conspicuous difference between the oldest *candis* mentioned above and those of the Śailendra period is that the latter were much larger in scale, more complex of construction, and more luxuriously decorated. Efforts were made to emphasize the elevation of these temples by increasing the number of vertical bands, both plain and decorated with spiral motifs, even as horizontal moldings were also maintained. Śailendra architecture in general is characterized by a profile that consists of a plain plinth, a bell-shaped ogee, and a semicircular molding.

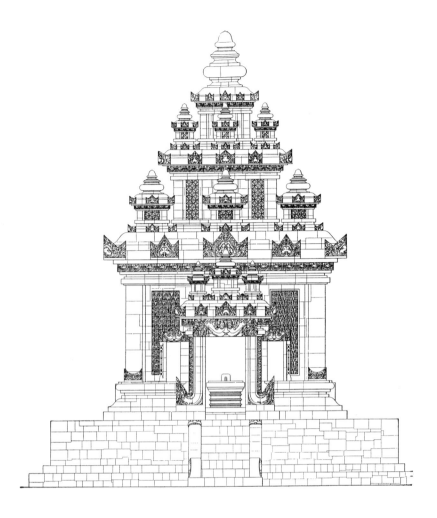

The most prominent structure dating from the reign of the Śailendra kings is Candi Borobudur, which is located not far west of Candi Gunung Wukir. In terms of its shape and structure this sacred monument can hardly be called a *candi*, for it lacks its basic component, a cella to enshrine statuary. Borobudur has the shape of a stepped pyramid crowned by a *stūpa*. Its main function was the worship of ancestors or the founders of the Śailendra dynasty who had merged with the Jinas after death. Even though its shape and structure deviate from the usual, Candi Borobudur does not represent anything special from the architectural point of view. Its special character is manifest in its decoration, its sculpture, and its bas reliefs.

Built on a low (c. 45 feet) hill rising from a wide plain, Candi Borobudur looks like a low dome. It has nine levels. The lowest level functions as the base of the structure, with a square floor plan, each side measuring 370 feet in length, and projections on the four sides. The plain walls of this base rise 12 feet in height. The second level recedes 23 feet from the edge of the base, so that space for a wide processional path is created around the entire building.

The stepped part that makes up the body of the monument consists of five levels that diminish in size as one rises. Surrounding each of the

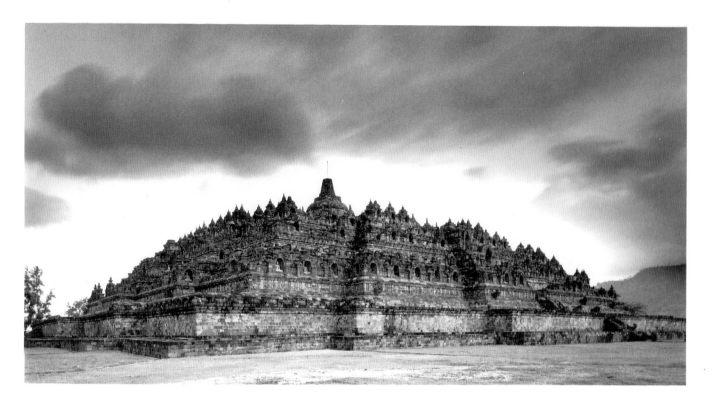

Candi Borobudur

four lower levels are galleries seven feet wide with balustrades. These four galleries are interrupted in the middle by stairs on all four sides of the monument, linking all levels of the *candi* from the lowest to the highest.

Narrative reliefs, consisting of 1,300 panels with a total length of 8,200 feet, cover the walls and balustrades of the galleries. They illustrate, on the first level, the deeds of self-sacrifice practiced by the Buddha in his previous births and the story of his last incarnation as Prince Siddhartha, the life in which he attained Supreme Enlightenment. On the higher galleries the reliefs illustrate the pilgrimage of the young man Sudhana, who sets out in search of the Ultimate Truth.

The original base of the monument, which was later covered by the stones of the wide processional path, is decorated with reliefs illustrating the Law of Cause and Effect. In accordance with this law, human behavior produces its appropriate effect in future rebirths, in which crime is punished and virtue receives its proper reward.

The upper levels of Borobudur are quite different from those of other *candis* because it has no roof. Instead the three upper levels here consist of round terraces made of smooth, plain stones. The element of decoration is provided by hollow *stūpas*, arranged in circles on the three concentric terraces, which surround and support the central *stūpa*, the top of which rises to a height of 113 feet.

Candi Borobudur also has 504 life-size stone images of seated Buddhas. These statues are not placed in cellas, as they are in other Buddhist shrines; 432 of them occupy niches that are part of the balustrades, and

The three divisions of a Javanese temple

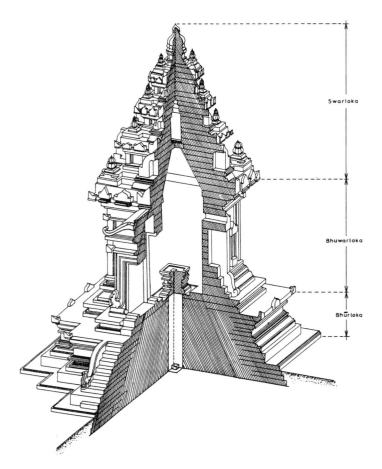

Swarloka

Bhuwarloka

Bhūrloka

72 of them occupy the hollow *stūpas* of the circular terraces below the principal *stūpa*.

The different treatment of the lower, middle, and upper levels of Candi Borobudur reflects a typically Buddhist three-part division of the universe as the Indonesians imagined it to be. The lower level represents the *kāmadhatu*, the Sphere of Desire, in which the human spirit is still chained to greed. Above it lies the *rūpadhatu*, the Sphere of Form, in which the human spirit has succeeded in liberating itself from greed, but in which it is still unable to transcend the phenomenal world. The upper part, consisting of the circular terraces, is the *arūpadhatu*, the Sphere of Formlessness, in which the liberated human spirit has left all earthly considerations behind.

The three basic tectonic subdivisions of other *candi* also embody a three-part symbolic subdivision whose terminology is different, as not all shrines were inspired by Buddhist notions of cosmogony. The three divisions are as follows: the base of the *candi* symbolizes the *Bhūrloka*, the Sphere of the Mortals; the roof symbolizes the *Swarloka*, the Sphere of the Gods, where all the gods were thought to gather; the body of the temple with its cella and statuary that constitute the objects of worship represent the *Bhuwarloka*, the Sphere of the Purified, in which man, after purifying himself, can meet with his ancestors who have merged with the gods.

The resemblance in symbolism and in the representation of the universe between Borobudur and the other *candis* does not necessarily imply that they all performed the same function in the execution of the required religious rituals. Stated in simple terms: man visited *candis* in

Upper terrace of Borobudur with one partially dismantled *stūpa* revealing the Buddha in *dharmacakra-mūdra*

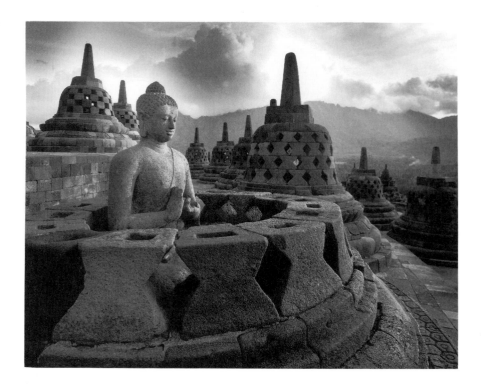

order to pay homage to the gods and to his ancestors. People visiting Borobudur, on the other hand, came as pilgrims to immerse themselves in and to grasp the truth of the Buddha's teachings by studying the contents of the narrative reliefs and to practice meditation in order to obtain the supreme truth.

It is thought that the pilgrims, before visiting Borobudur, first paid homage at Candi Mendut to the three huge stone statues enshrined there. These represent the Buddha and the two bodhisattvas Avalokiteśvara and Vajrapāni. These three statues, the noblest representations of Buddhist figures in Central Java, are seated on lion thrones, facing each other and filling almost the entire space of the cella of Candi Mendut.

The temple is built upon a square foundation barely twelve feet tall, each side measuring seventy-three feet. On the front is a projection twelve feet deep accommodating a flight of steps that projects out even farther. The body of the temple is also square, but it measures only forty-nine feet on each side, standing on a platform more than three feet tall. The edge of the foundation has a balustrade, creating a terrace surrounding the entire temple. The walls of the *candi* are decorated with reliefs representing various bodhisattvas and gods. Of the roof only two levels have been preserved. This gives the monument an incomplete, truncated appearance.

On the whole Candi Mendut does not differ from the *candis* discussed above, in shape or structure, although here and there variations occur as, for example, the double base (also seen at Candi Puntadewa, Diëng) and an entrance taking the shape of a cella, as can also be seen at Candi Bima. The moldings deserve special notice, displaying the typical Śailendra profile with their sequence of plinth, S-shaped ogee, and

Gargoyle in the shape of a lion, Candi Ngawèn II

semicircular molding. Below the semicircular molding there is a row of dentils comparable to those on the original, now-hidden base of Candi Borobudur. The similarity with Candi Borobudur extends to the sculpture and the reliefs, all of which are of the highest artistic quality.

To the same group as Candi Borobudur and Candi Mendut belongs a small *candi* situated between the two large monuments and known as Candi Pawon. It now stands completely restored, even to the top of the roof in the shape of a *stūpa*. The combination of moldings of the typical Śailendra type is found here not only in the foundation, but also at the base of the body of the temple. The sensitive carving and the suppleness of the figures in high relief are typical of the Śailendra style.

Not far southeast of Candi Borobudur, near Candi Gunung Wukir, lies another group of Buddhist *candis* consisting of five structures of different sizes standing in a row from north to south. The largest of these temples, known as Candi Ngawèn II, has a floor plan thirty-six feet square. The temple has been restored to the first level of the roof.

On the whole Candi Ngawèn represents the early classical style, but several features indicate that it is more recent than the *candis* discussed above. For example, a multiplicity of structural elements and types of decoration seems to visually enlarge the temple. The separation of the entrance gate from the body of the temple, creating a freestanding outer gate, also represents a new architectural development. The placement of miniature buildings, each having their own structure and outline, in the corners between the stairs and the temple base reminds us of temples of the later classical style in East Java; for example the statues of lions standing on their hind legs on the four corners of the temple base occur also at Candi Kidal, east of the city of Malang (East Java). These elements of the late classical style in evidence at Candi Ngawèn suggest that this group of Buddhist shrines belongs to the architectural creations of the Śailendra period, but possibly dates from the conclusion of that period.

A temple that was definitely commissioned by a Śailendra king is the aforementioned Candi Kalasan, which was founded in 778 and was twice remodeled by later generations. Candi Kalasan III, though poorly preserved, still displays the style of the early classical period in its squat shapes and pronounced horizontal moldings. Nevertheless it is evident that its architects made every effort to give its appearance a more vertical quality. To the base of the temple nine feet high, additional support is provided by a platform beneath it that is more than three feet high, while the differences between the square ground plan of the temple (fifty-four feet) and that of the entire structure (eighty-nine feet) leaves a wide terrace around the base of the body of the temple, enhancing the vertical appearance of the monument. This impression is further strengthened by the plain double pilasters on the walls of the body of the temple, where they flank pilasters with a carved decoration of floral scrolls. The central part of each wall is occupied by a niche, the columns of which support an arch in the shape of a *kāla* head with a relief in the background depicting the pointed roof of a temple that

Reconstruction drawing of south side of Candi Ngawèn II

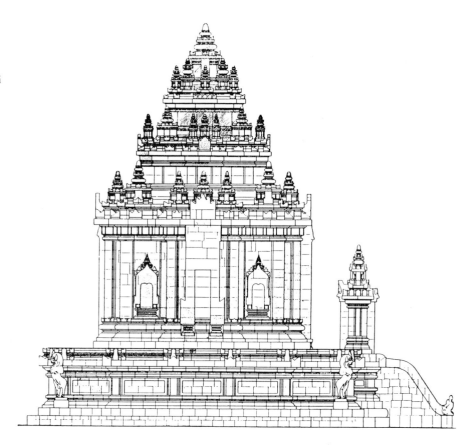

reaches almost to the cornice. The entrance porch leading into the cella projects from the central part of the facade. On the porch the *kāla-makara* motif occurs twice. The first *kāla-makara* crowns the entrance and the second, higher up, constitutes the background, with elaborate carvings that interrupt the moldings defining the cornice of the temple roof.

Candi Kalasan is the earliest of the *candis* of the early classical style with five cellas. One in the center acts as principal cella, surrounded by four subsidiary cellas in the four projections of the building. Each of the four side chapels has its own entrance, the side chapel in the facade acting as an antechamber of the central cella. An empty lion throne, deprived of its icon, is all that remains in the central cella.

All five cellas were once covered by a single stepped roof crowned by a *stūpa*. Only part of the first level of this roof has been preserved, enough to prove that its ground plan did not follow that of the building and its foundation, but took instead an octagonal shape. On each side of the roof is a niche, in front of which a miniature building decorated with a *stūpa* has been placed as if to fill the open space.

Candi Sari is usually mentioned in the same breath as Candi Kalasan. The temples are situated in close proximity, and the style of their carving and sculpture is very similar. The same cannot be said of their architecture. With the exception of its base, Candi Sari has been reconstructed almost completely. The building has a rectangular shape and two stories, each of which contains three rooms lined up in a row and connected by narrow doorways. The second story had wooden floors, and the stairs leading to it were likewise made of wood. There is no

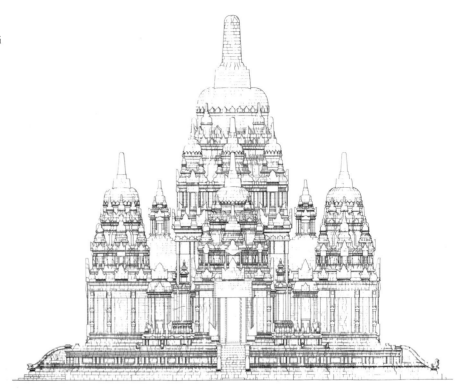

Reconstruction drawing of main temple at Candi Sewu

single roof covering the entire building, but three separate roofs covering each of the three interior spaces. These three roofs, each of which has a row of *stūpas*, appear as if they are connected by the row of niches right below the roofs. The walls of the body of the temple on both upper and lower levels have been divided into sections; the middle of each has a rectangular window flanked by graceful figures of heavenly beings. In this manner an impression of height was successfully created.

Coeval with Candi Kalasan is also Candi Sewu in the Plain of Prambanan. This *candi* is an architectural complex consisting of one principal shrine and 250 subsidiary buildings arranged in concentric squares around it. The shrine is probably the sanctuary referred to in the inscription of Kelurak, which records the founding of a temple in the year corresponding to 782. Another inscription found inside the temple precinct proves that the temple was enlarged or expanded in the year 792. The inscription also names the *candi* Mañjuśrīgriha, a shrine dedicated to the bodhisattva Mañjuśrī. The floor plan of the principal temple of Candi Sewu is the same as that of Candi Kalasan. However, at Candi Sewu the four subsidiary chapels are separated by narrow passageways circling the body of the temple. Each of these chapels has been given its own separate roof crowned by a *stūpa*.

Unfortunately at the present time the main temple of Candi Sewu does not show many of its architectural features, as it has largely fallen into ruins and its reconstruction is still in the initial stage. However, all of the architectural components have already been reassembled, and a reconstruction on paper of the main shrine has been completed. From

the preparatory drawings for the reconstruction it is obvious that this temple belongs to the early classical style. It is also evident that an effort was made to make it look higher, with plain pilasters dividing the walls into vertical zones alternating with tall niches. Another hallmark of the early classical style is the luxurious splendor of every detail of the structure and its decoration.

The subsidiary temples are all of the same type, small, with a single cella and a stepped roof on an octagonal base and terminating in a *stūpa*. The base of the *stūpa* is surrounded by smaller ones, giving the entire superstructure a delicately pointed profile. This effect is balanced by the body of the temple, whose walls are flanked by columns that appear to support the cornice of the roof.

Not far east of Candi Sewu lies yet another Buddhist temple complex, Candi Plaosan Lor. Its twin main shrines stand on a north-south axis and are surrounded by three rows of subsidiary buildings arranged in concentric rectangles. Two of these rows consist of *stūpas*, and one of small shrines. The two principal shrines closely resemble Candi Sari, and likewise have three rooms on each of the two floors. They also have windows flanked by figures of heavenly beings in high relief. The basic difference between Sari and Plaosan is that at Plaosan the tapering roof of each of the twin temples, culminating in a *stūpa*, covers the entire structure. The second difference is that while all the cellas of Candi Sari are empty, those of Candi Plaosan have beautiful statuary, enthroned in situ on lotus seats placed close to the back wall.

Both Candi Sari and Candi Plaosan seem to represent no specific architectural style or period. Just as is the case with Candi Borobudur, the shape and structure that set these twin shrines apart are connected with their religious function, which is different from that of other *candis*. The style of the sculptural decoration of these *candis* definitely makes them part of the Śailendra monuments. The minor differences are those resulting from differences in age and local traditions.

One difference becomes evident at Candi Loro Jonggrang, which is Hindu rather than Buddhist. Usually this complex is dated to the beginning of the tenth century and is regarded the latest of the temples of the early classical period. This view clearly contradicts the information provided in an inscription that is dated in accordance with the year 856. This inscription contains a description of a sanctuary that seems to refer to the complex of Loro Jonggrang. This implies that the complex of Loro Jonggrang already existed in that year, almost a century prior to the end of the early classical period.

Several arguments strengthen the supposition that the complex of Loro Jonggrang really is the last creation of the early classical period. Efforts of the architects to give the *candis* a delicate appearance, a further development from the initial phase in which squat buildings with heavy horizontal moldings prevailed, are immediately evident at Candi Loro Jonggrang from the building itself. The foundation, which is more than nine feet high, serves as a base for the body of the building, which in turn has an additional base decorated with moldings. The body of the

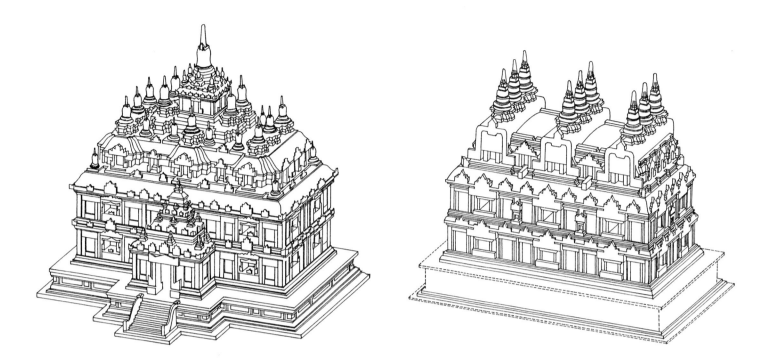

Reconstruction drawings of Candi Plaosan (left) and Candi Sari (right)

building has been divided into two parts, as if it were two-storied, by a belt of moldings. The roof is constructed in such a way that the transitions between the false stories are indistinct. They are even brought closer together visually by filling the transitional space with rows of bell-shaped finials.

The use of a belt of moldings to give the structure a two-storied appearance is a special architectural feature of buildings of the later classical period in East Java. The blurring of the lines of distinction between Buddhist and Hindu elements in the shape of the *stūpa* or bell-shaped decorative pieces as well as in the finial of the spire is another indication that these buildings were built late in the early classical period. One more is that the subsidiary temples of Loro Jonggrang, occupying the corners of the squares, have two entrances, and face, therefore, two directions. The architects of the complex had become preoccupied with external symmetry, forgetting the deeper meaning of the monument. Such are symptoms of an art that has passed its prime and approaches a phase of stagnation and rigidity.

Candi Loro Jonggrang has yet another special characteristic in that it has separate shrines for each of the gods of the Trimurti: the principal shrine in the center dedicated to Śiva, the one to Śiva's right dedicated to Brahmā, and the one on his left to Visnu. This arrangement can be seen also at Candi Srikandi on the Diëng Plateau, where it is executed in relief.

Three temples face those dedicated to the gods of the Trimurti. In the middle, facing the Śiva temple, stands a temple in which a statue of the recumbent bull Nandi, Śiva's mount, has been enshrined. This arrangement is seen frequently in other Hindu temples such as Candi Gunung Wukir, Candi Badut, and elsewhere. Yet another architectural feature,

one that is typical of Candi Loro Jonggrang and not found elsewhere, is the so-called *candi apit* (court temples). These are two temple buildings facing each other on the raised terrace square that separates the six main temples from the rows of subsidiary shrines. What is most noteworthy about these two temples is their elongated elevation. The body of these temples is likewise divided into two sections and they have roofs in the shape of steep pyramids.

Among the many architectural elements of the Candi Loro Jonggrang complex that place it in the transitional period between the early and late classical periods are several features that are typically early classical. The combination of plinth, S-shaped ogee, and semicircular molding as a basic component of the outline of the buildings; the style of their statuary; and the treatment of the *kāla-makara* and other decorative motifs give the complex an undeniable character of the period. The rows of reliefs representing the *Rāmāyana* and *Krĕsnāyana*, carved on the inside of the balustrades of the three main temples, represent the same style. The floor plan of the principal shrine shows a central cella surrounded by four side chapels reminiscent of Candi Kalasan. Stairways into the main cella as well as into the side chapels at Candi Śiva recall the arrangement in the main temple of Candi Sewu. Four rows of subsidiary temples surrounding the central enclosure are another feature that establishes a direct connection with Candi Sewu. It is not impossible that the configuration of complexes like Candi Sewu, Candi Loro Jonggrang, and Candi Plaosan Lor, each of which has been built around a principal shrine in the center, reflects a world of thought that was based upon a system of centralized government as we could imagine the Śailendra dynasty to have been.

ARCHITECTURE OF THE LATE CLASSICAL PERIOD

Around the middle of the tenth century the political activity in Central Java slowed down. In East Java, on the other hand, new events took place that had a decisive impact on the course of ancient Indonesian history. In successive order the kingdoms of Kediri (mid-tenth to early twelfth century), Singasari (1122–1292), and Majapahit (1292–c. 1500) not only ruled large parts of Java, but also played a role in the course of history of several areas outside Java, especially in Bali and Sumatra.

How Indonesian architecture developed from the middle of the tenth to the middle of the thirteenth century, and how the transition between the early and late classical styles took place, we can only surmise. The reason is that no architectural remains have survived from the dynasty of Kediri. The result is that Candi Kidal, which may be considered the prototype of the late classical style, gives the impression that changes had occurred suddenly. This *candi*, which according to the *Nāgara-Krĕtāgama* and the *Pararaton* served as the commemorative shrine for King Anūsapati (died 1247), does not reveal a single characteristic of the early classical style. The tendency to leave the early classical style behind and to introduce elements that would become typical of the late classical style, so clearly in evidence at Candi Loro Jonggrang, did not

continue, and no representative of the early years of the later classical style has survived.

All elements that constituted the typical characteristics of the early classical style disappeared completely from the later style. The solid, heavy, horizontal moldings, such as the plinth-ogee-semicircular molding sequence, were replaced by flat bands of moldings. Of the *kāla-makara* motif only the *kāla* remains, now complete with lower jaw. The vertical bands on the body of the temple, introduced to balance the horizontality of the moldings, were supplanted by miniature structures with niches that look as if they were stuck to the walls of the *candi*. A similar structure also acts as a partition between the entrance and the cella in the interior of the *candi*. It is remarkable that in this case the niches are treated in the same manner as the doorway, with columns and a plain lintel supporting the head of the *banaspati* installed above. The niches have a flight of steps flanked by string walls culminating in a heavy volute. The walls of the body of the temple are decorated with carved round medallions.

The greatest changes took place in the shape of the roof. In the oldest Javanese *candis* the roof was constructed so that each story leaves ample open space on all sides. In later *candis* the transition from one level to the other is disguised by means of rows of *stūpas*, bell-shaped turrets, and antefixes. In the *candis* of the late classical style like Candi Kidal, the roof is an accumulation of layers closely piled one on top of the other without any clear transition. Although these layers diminish in size as they rise, the already minor differentiation is further disguised by antefixes and miniature structures. While in the structure of the roof the courses and layers of stone stand out, emphasizing the horizontal lines, the general impression given by these structures is one of slender verticality. This impression is also enhanced by the structure of the bands that act as supports. These flat bands form a cornice crowning the top of the walls of the *candi*, maintaining a balance with the moldings below that encircle the base of the body of the temple.

The slender profile of the *candi* of the late classical style is further enhanced by the multiple structure of the base, which is of considerable height. The body of the temple itself, housing a single cella, takes the shape of a square block that looks rather squat because it is divided into two horizontal parts by a band of moldings in the middle. Notwithstanding the thickness of the lower and upper moldings, which may be said to be exaggerated, it is evident that they succeed in overcoming the impression of squatness. As a result the *candis* of the late classical style look much taller than those of the early classical style.

The *candis* that closely resemble Candi Kidal, both in elevation and structure, are Candi Jawi, Candi Sawentar, and the Dated Temple that is part of the complex of Candi Panataran. Candi Jawi (see fig. at cat. 22) is located near the town of Pandakan. It rises gracefully to a height of eighty feet from a square base thirty-one feet on a side. The square temple precinct is surrounded by a moat. Another special feature of this temple is the shape of its double finial; the lower part takes the shape of

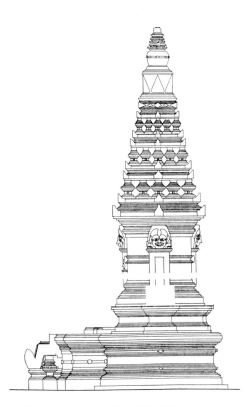

Reconstruction drawing of Candi Jawi

a square block while the upper part is formed by a *stupa*. This clearly indicates that Candi Jawi is a *candi* dedicated to Śiva-Buddha in complete accordance with the account given in the *Nāgara-Krĕtāgama*. The last king of the Singasari dynasty, Krĕtanāgara, adhered closely to the Śiva-Buddha doctrine. It has been established that Candi Jawi is a commemorative shrine for this king who died in 1292.

Candi Sawentar is not far from the town of Blitar (East Java). It looks as if it were standing in a pond. At the time of its discovery it was almost completely covered by volcanic debris. The Dated Temple of Candi Panataran differs from the other structures of its type in that the base is only slightly higher than the surrounding temple grounds. Its modern name derives from the date Śaka 1291 (1369) inscribed in the lintel above the entrance.

In close proximity to Candi Kidal and not far separated from it in time is Candi Jago, which according to the *Nāgara-Krĕtāgama* and the *Pararaton* is the commemorative shrine for King Wisnuwardhana of the Singasari dynasty, who died in 1268 and who was portrayed here in a statue as the Buddhist deity Amoghapāśa. Even though near in time and distance to Candi Kidal, it is evident that Candi Jago is totally different both in shape and in structure. Only the lower part of Candi Jago, its base, has been preserved. It displays some unusual characteristics. The base consists of three levels that retreat as one rises at the entrance on the west side of the monument. The building itself stands in the center of the upper level. As a result the front part of each level has been transformed into a kind of porch that provides ample space for the two flights of steps. These are narrow and flanked by string walls with a heavy volute at the top. The walls of this *candi* are covered with narrative reliefs at all three levels. The lowest contains the story of *Kuñjarakarna*; the second level has the *Parthayajña*; while the third level, which also functions as the base of the body of the *candi*, tells the story of Arjuna's Wedding.

The stepped structure signals the reappearance of prehistoric Indonesian elements, the structures in the shape of stepped sanctuaries that were built on the slopes of hills. It is most unfortunate that the body of the *candi* has fallen completely into ruins and that no trace of its roof has been preserved. It is believed that its roof may have been built with a wooden frame, covered with palm fibers or thatch grass, and that it consisted of a set of roofs with a stepped reduction similar to that of present-day Balinese *meru* towers. The fact that prehistoric elements have echoes in components of Candi Jago suggests that this monument should not be dated in the Singasari period, but in the Majapahit period one century later. This view is supported by the reliefs on the walls, which were executed in a style close to that of the Majapahit period. It finds further support in the appearance in some of these reliefs for the first time of all of the Five Punakawans, who are clownish servants accompanying the heroes of the stories. Still popular in the *wayang* shadow play today, it was only during the Majapahit period that they began to appear together.

The tendency toward a return to pre-Hindu concepts obviously exerted a strong influence on the subsequent development of Indonesian architecture. The temple complex of Panataran in the vicinity of Blitar, which was known under the name of Palah as early as 1197 and which remained an important sanctuary well into the Majapahit period, may be seen as a direct precursor of the Balinese temple of today. The buildings of the temple are no longer laid out around the principal shrine in the center, as we saw at Candi Sewu and Candi Loro Jong-grang, but are arranged toward the back of the temple grounds, with the principal shrine occupying the rear. Not only has the main part of the building been shifted toward the back of its stepped foundation, but the entire building itself has also been moved to the back of the temple precinct. After that all kinds of buildings were scattered over each temple precinct, including open buildings without walls (pĕndopo) of which now only the square or rectangular platforms remain. There is also a building in the shape of a square block that no longer has a roof. Its walls are covered by coiling snakes (nāgas) and it is because of this conspicuous feature that the building is known as the Nāga Temple. There is also a tower temple of a basic shape similar to that of Candi Kidal, the aforementioned Dated Temple.

The principal shrine of Panataran resembles that of Candi Jago in that it has a triple base. Its second level has been shortened on the front side, creating space for a terrace. The smaller third level is erected in the center of the second, while the actual candi stands in the center of the third platform. The body of the candi has completely fallen in ruins and nothing remains of its roof. It is assumed that the roof was constructed in wood covered with palm fiber or thatch grass, and that it had several superimposed roofs like a Balinese meru.

What is most remarkable about the sculptural decoration of the main shrine of Candi Panataran are the sculptures of Garuda and the representations of winged nāgas covering the walls of the third level of the temple base. One can imagine how the whole candi, when it was still standing, may have looked as if it were floating in the air. The walls of two lower levels are decorated with scenes from the Rāmāyana on the first and the Krĕsnāyana on the second.

The candis dating from the Singasari and Majapahit dynasties that have been mentioned above all follow the same pattern in that they are slender, tall, and have a single cella. Candi Singasari (see fig. at cat. 23), to the north of Malang (East Java), deviates from this pattern. The candi, on a square platform, is supported by a base. It has five cellas, including the main one. What is very unusual is that these chapels are in the base of the monument and not in its body, as was common practice. The body of the temple also deviates from the familiar in that it does not have a doorway leading into it. Its walls are decorated with tall, narrow niches crowned by banaspati heads, which look as if they support the roof of the candi. All five cellas are covered by separate roofs, giving Candi Singasari five spires. Of the five roofs only the central could be reconstructed, and even this one only to a small extent. Several of the banaspati heads are unfinished, as are some of the other compo-

nents of the building, indicating that the carving of decorative details was done from the top down.

Two *candis* dating from the second half of the fifteenth century and mentioned in the *Pararaton* are Candi Tigawangi and Candi Surawana, both in the vicinity of Kediri. Only their bases exist, and there is no trace of their superstructure. It is possible that they never had a building on top and that these *candis* merely consisted of a platform, possibly of a stepped shape.

During the Majapahit period temples of yet another shape were also created, with a cylindrical body rising from a square base. An example of such as a temple is Candi Jabung, on the eastern tip of Java, near the town of Kraksaan. On the axes of the building are projections that appear to be later additions because their construction differs from that of the building itself. The projection on the west side functions as a doorway, giving entrance to the square cella; the other three projections contain niches. Both doorway and niches are crowned by horned *banaspati* heads, which seem to support the cornice of the roof. The roof of Candi Jabung is so completely ruined that neither its shape nor its structure can be determined.

The capital of the Majapahit kingdom was situated in the area now known as Trowulan, one of the few capitals of the classical period whose location is known. Only a few buildings there have been preserved, all of which were built in brick. Candi Brahu still displays traces of its former glory, even though it is in such poor condition that its former appearance can no longer be imagined. Candi Tikus, a bathing place with several pools, also contributes little to our knowledge of Majapahit architecture. Candi Wringin Lawang is a gate of a type known as *candi bĕntar* (literally "split gate"). Even though it is not perfectly preserved it can give us an idea of such buildings in their original state. Candi Bajangratu is also a gate, but one of a different type. Whereas the *candi bĕntar* represents some sort of double-sided *candi*, Candi Bajangratu resembles a *candi* structure that has been perforated by the aperture of the doorway in the base and body of the temple. The structure, fifty feet tall, is still largely in its original condition, complete with roof and finial.

A gateway in shape similar to Candi Bajangratu, but less slender and tall, is Candi Jedong, south of Trowulan. It bears an inscribed date of Śaka 1307, corresponding to 1385. Near the town of Wlingi lies yet another gateway coeval with Candi Jedong called Candi Plumbangan. The date inscribed above the doorway is Śaka 1312 (1390). Its shape is totally different from Candi Jedong. It has the usual doorway with a plain frame and a roof resembling a trapezium crowned by an oblong top. At first sight the shape of this gate looks like the niches flanking the entrance to Candi Kidal.

CLASSICAL ARCHITECTURE OUTSIDE JAVA

On the island of Bali a number of *candis* are found that deviate from the usual Javanese type of freestanding structures, instead being carved

from the face of steep, rocky riverbanks. The complex of Candi Gunung Kawi (Tampaksiring) consists of ten structures sheltered by vaulted niches. Five of these *candis* form a row above a base cut from the east bank of the river Pakerisan, four stand in a row above a base cut into the west bank of the same river, and one farther to the south is carved from a rock that is not part of the riverbank. In addition to these *candis* there are caves excavated from the riverbank, which in all probability served as hermit's caves. To the south of the group of five *candis* there is a *vihāra* (monks' abode) that was hewn from the stony bank in such a way that parts were excavated to create space and other parts were left standing to serve as buildings.

These ten *candis* are of the same shape, the bodies closely resembling *candis* of the early classical style, while the roofs are closer to those of the late classical style. Heavy horizontal lines clearly define the different components of each building as well as the stories of each roof. The base is very low, as is the body of the temple. The squat body is made to look taller by the use of vertical panels in the center of the wall where it cuts through the moldings of base and cornice. The roof still has a stepped shape, but the distinctions between the different levels are already hidden behind rows of triple turrets. The style of the script used in the brief inscriptions on some of these *candis* points to a date at the end of the twelfth century for the complex.

Besides Candi Gunung Kawi there are several other rock temples, all of them smaller and of a taller shape, as their roofs are constructed like those of the late classical style. All of these temples have been carved from the rocks of river banks, recessed and sheltered by vaulted niches. At Tegallingga near Gianyar a rock *candi* also has a *vihāra* cut out of the face of the rock.

The art of carving buildings from the face of rocky slopes was apparently already known in Bali prior to the construction of Candi Gunung Kawi. Near the town of Gianyar on the north bank of the river Petanu lies the bathing place known as Goa Gajah (literally "elephant cave"). This complex is thought to date from the eleventh century. It consists of three parts: the bathing places in the center with their gargoyle statues; one cave to the north, its entrance decorated with a huge representation of a demon emerging from a forest; and a relief of a triple *stūpa* on the south side. This *stūpa* has collapsed into the river below, but the place where it stood is still visible, indicating that it was built on a square base. It should be noted that these *stūpas* were provided with finials in the shape of as many as thirteen multiple umbrellas.

If the Balinese art of rock-cut temples represents a local art form independent from direct influence from Java, it is obvious that the political interference in Balinese affairs by the kingdoms of Singasari and Majapahit contributed to the flourishing of the East Javanese architectural style. This is the conclusion that we can draw from the Pura Yeh Gangga, an ancient building in a shape that constitutes a transition between the *candis* of Java and the *meru* of Bali. The Pura Yeh Gangga lies close to the village of Perean, about twenty miles south of Den

Pasar. It gives an idea how Candi Jago and the main temple of Pana-taran looked when they were still crowned by multiple roofs. The base and body of the Pura Yeh Gangga are made of stone, while the seven-story roof is made of wood and palm fiber. A stone discovered in the temple precinct bears a date of Śaka 1256 (1334), which definitely places the Pura Yeh Gangga in the late classical style. Indeed, the structure, the moldings, and the decoration all display characteristics familiar to us from architectural remains of the Majapahit period.

The influence of Singasari and Majapahit also found a response in Sumatra, especially in the area near the provincial capital of Jambi. On the banks of the river Batang Hari are found a number of brick *candis* erected inside spacious precincts. They lie scattered near the village of Muara Jambi, without any apparent method guiding their grouping in clusters. Individually each temple does not display the influence of East Java, but among the several decorative patterns as well as statues and sculptural fragments are many that are reminiscent of the art styles of Singasari. The Buddhist religion inspired the building of these *candis*.

The *candis*, such as Candi Tinggi, Candi Gumpung, Candi Kembar Batu, Candi Gedong, Candi Gudang Garam, and Candi Kedaton, display the same architectural design in the shape of their stepped plat-forms and in the absence of cellas. A deviation from the late classical style is the presence of *makaras*, often large, in which the wings of the stairs terminate.

Architectural remains older than the *candis* of Jambi are found in the interior of Sumatra, close to the equator; they constitute the temples of Muara Takus. At a bend in the river Kampar lies this group of temples, consisting of four brick and stone buildings erected inside a square, walled precinct, the sides of which measure 243 feet in length. Three of these four structures have been reduced to shapeless heaps of brick, but one, known as Candi Mahligai, still stands. Its shape is that of a tower standing on a rectangular platform almost six feet high. The height of the layered base of the temple has been increased by inserting a lotus pedestal. The cylindrical body of the temple is crowned by a *stūpa*, supported by a separate base decorated with stone sculptures of lions. The entire structure reaches a height of about forty feet.

Farther to the north of Muara Takus, in the area of Padang Lawas near the town of Padang Sidempuan, lies a group of temples in the late classical style built on a high base. The *candis*, which have been built in brick and which are called *biaro* (*vihāra*) by the local population, are scattered without any apparent plan in the open space. Some of these *biaros* still stand, and even though they are no longer in a perfect state of conservation, many of their architectural features can still be dis-cerned. The building of these temples was inspired by Esoteric Bud-dhism of the Tantrayāna type.

The most complete of these buildings is Biaro Bahal I, which served as the main shrine of a group of several built within a walled precinct 187 by 160 feet. The *biaro*, which has lost its finial, stands more than thirty feet tall above a square platform six feet in height. The decoration of

the platform consists of vertical bands that divide the wall into a row of square panels decorated with brick reliefs of lions. The projecting part of the platform, built to accommodate a flight of steps, is embellished with brick reliefs representing dancing *rāksasas* in different poses. The base of the body of the temple is very simple, consisting only of an accumulation of flat moldings. Likewise the body of the temple has no decoration whatsoever except for flat moldings and two figures, now headless, in high brick relief flanking the entrance to the cella. The roof of Biaro Bahal I differs from those of the other temples of Padang Lawas in that it is crowned by a cylindrical component. Because it is on top of a lotus cushion it most probably represented a *stūpa*.

Biaro Bahal II, located five hundred yards east of Biaro Bahal I, is in ruins. Its superstructure had an octagonal base and niches in its walls. The niches facing the four points of the compass housed stone statues of lions as guardian figures. Most remarkable is the discovery made in the cella of this temple of a stone statue more than three feet high. Even though it was badly damaged, this statue was pieced together and identified as Heruka, the drinker of blood, a demonic figure from the Tantric pantheon in dancing posture on top of a now-missing corpse.

Biaro Bahal III, located four hundred yards east of Biaro Bahal II, and similar in size, is less well preserved. The walls of the body of the temple, to the extent that they are still standing, are without any decoration whatsoever except the flat moldings at the base and the cornice.

The largest of all the temples in the Plain of Padang Lawas is Biaro Si Pamutung, the principal shrine of a group of temples in a large walled precinct 150 by 200 feet. The remains of a double platform can still be discerned. Most remarkable is that two rows of *stūpas* appear in the ruins of the superstructure; the lower row consists of sixteen, the upper of twelve of these structures. Farther south from Biaro Si Pamutung lies Biaro Si Joreng Belangah, which has no special characteristics. Its shape is like that of the other *biaros*, square and with flat, plain walls rising high because of the tall platform.

In addition to the remains of buildings, several of the walled precincts yielded carved stone pillars or miniature buildings three to five feet tall. The shape of these *stambhas* sometimes recalls those of Candi Biaro Bahal I and of Candi Mahligai at Muara Takus, although there are also considerable differences. The function of these miniature structures is unclear.

On the whole the *biaros* of Padang Lawas show many points of resemblance to the temples of East Java. There are also elements borrowed from Central Java, such as the use of *makaras* on the wings of staircases. Elements derived from the art of South India likewise make an appearance, but more in sculpture than in architecture. However that may be, all likenesses and differences underline the position of the classical architecture of Sumatra as a clear representative of the late classical style. This is also evident from the religious background as well as from the dated inscriptions found in the vicinity of these *biaros*.

THE FINAL PERIOD OF THE CLASSICAL STYLE

The reemergence of pre-Hindu elements in the development of the late classical style continued throughout the period of decline of the Majapahit dynasty during the fifteenth century. The buildings that lie scattered on the slopes of Mount Penanggungan and its vicinity have the shape of stepped sanctuaries built to follow the slope of the mountain. These buildings belong to the late classical style, as can be seen from the decoration and from the reliefs, as well as from the shape of the altar that resembles the body of a late classical temple.

In Central Java, on the slopes of Gunung Lawu east of the city of Solo, lies a temple of yet another architectural style, though its basic shape is that of the stepped sanctuary. This building is Candi Sukuh, which can be dated in the first half of the fifteenth century on the basis of inscriptions. Its shape is that of a truncated pyramid. It has an extremely narrow gateway giving access to the platform on top by means of a flight of steps. Also remarkable at Sukuh is the presence of several obelisks, the bases of which are decorated with reliefs representing the story of Garuda and other as yet unidentified stories, the most famous of which is one depicting the workshop of a smith with Ganeśa as the principal figure (cat. 33).

The architecture of the classical period did not end with the advent of Islam in Java. Even during the heyday of the Majapahit kingdom this new religion already had many adherents in its capital, as is evidenced by several tombstones at Tralaya, south of Trowulan. After the Islamic kingdoms became predominant in the island of Java, several mosques and tombs continued the tradition of the late classical style with some modifications to accommodate the requirements of the new faith. The minaret of the mosque at Kudus is not much different from a *candi* building, and split gates as doorways continued to be a special feature of mosques and Islamic graveyards.

CANDIS AND THEIR RESTORATION

As the power of the ancient kingdoms came to an end and their inhabitants no longer supported the temples and shrines, the *candi* ceased to play a role in the religious life of the Indonesian people. Deprived of their worshippers, the *candis* were abandoned to the forces of nature. Alternating heat and rain made their stones crumble; the wind brought dust and seeds, transforming them into heaps of earth covered by shrubbery. The roots of trees penetrated the cracks of the buildings, dislocating the stones and loosening the bonds between them. Earthquakes helped to speed up the process of decay, which eventually resulted in the collapse of the structures. These ruined *candis* constituted a source of readily available building materials, and thus many of the temples disappeared without leaving behind any trace at all. Centuries passed during which even their existence was forgotten, so that they had to be rediscovered. Often this rediscovery took place before the science of archaeology had an opportunity to bring *candis* into the realm of scholarly investigation.

The *candis* that were already known were all discovered in ruinous condition, frequently consisting merely of heaps of loose stones. Sometimes the remains of a temple structure became known only after they had been brought to light by excavation.

That the *candis* still stand today, albeit in heavily damaged and ruined condition, is almost entirely the result of restorations that have been carried out by the Indonesian government. Restoration does not mean that the temple is rebuilt completely, but merely that an effort was made to prevent further deterioration. Restoration basically means repair. To what extent repairs can result in a complete resurrection of the *candi* depends entirely upon the condition of the remains. If the scattered stones can be collected and placed in their original positions so that all components can be completely reassembled, the *candi* can be reconstructed on paper and subsequently rebuilt completely. If this is not the case restoration can be carried out only to the point where the stones that are still in their original position make this possible. If that is not possible, no rearrangement of any sort should be undertaken.

Usually the *candis* that have been rediscovered while still standing have lost their roofs, while the walls have only been partially preserved. What is often still intact is the base of the temple, even though it has often suffered losses of stones on the exterior. Some of the stones fall into the cella, other stones fall outside and around the building. Usually the stones that originate from the east side of a *candi* pile up on the east side of the building; those from the west side on that side and so on. In the end these piles of stones, together with the remains of the *candi* itself that are still standing, form a low hill. Sometime later the stones of the *candi* are used as building material. Those that are carried off, especially in former times, are first the ones on top, that is those that are part of the walls of the chamber of the temple. That is why in our efforts to reconstruct *candis* it is the body of the temple that presents the most difficulties and that may even frustrate our efforts at reconstruction altogether. When, for example, the base of the structure is still intact, the roof can be pieced together again from scattered stones, but the body of the temple itself cannot be rebuilt as long as there are still details that remain uncertain.

During the first phase of the restoration all scattered stones are gathered and sorted according to type and original location. Stones of the cornice are placed with other stones of the cornice; stones of the ogive with other stones of the ogive; plain stones with other plain stones grouped on the basis of size and shape; one decorated stone with another according to the pattern of the design; stones found on the east side together, as are those from each of the three other sides.

In the second phase of the restoration stones are matched with one another. The method is to carefully examine their shapes and then to try to fit them together. If stones match so that two stones form a complete entity, whether they fit on top or below, on the left or the right, a scale drawing is made.

In the third phase of the restoration these preliminary drawings are

Śiva temple, Prambanan, 1989

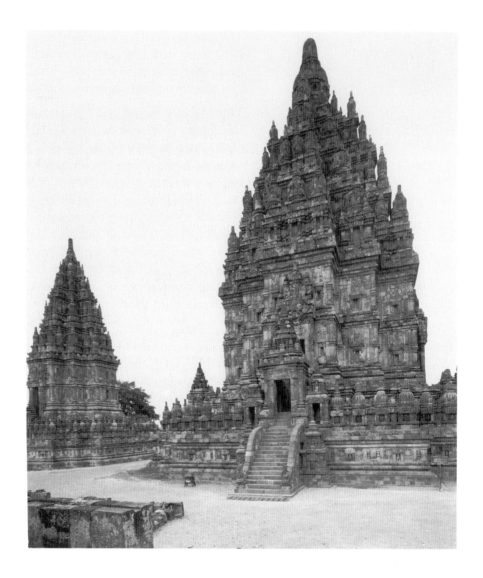

expanded by adding the results of other matchings. In this manner, piece by piece and section after section, the whole structure begins to take shape on paper. Because a *candi* has four sides, the reconstructions on paper should also show the four sides of the building. In order to rebuild the temple the interior of the cella also has to be reconstructed. Usually this reconstruction presents more difficulties, as most of the stones of the cella are usually without any decoration whatsoever. Often it cannot be established with certainty whether two smooth stones that seem to match really belonged together in the original structure.

The *candi* stones that can be fitted together are temporarily piled up on the ground in trial reconstructions, each of which consists of a specific section. When those trial reconstructions are completed to the extent that they reveal the entire *candi*, then one section after the other, layer upon layer of stones, is piled up in reversed order to facilitate the handling of the stones when the monument is actually being rebuilt.

If we receive confirmation from the reconstruction drawings and if the trial reconstructions provide unquestionable evidence of the original

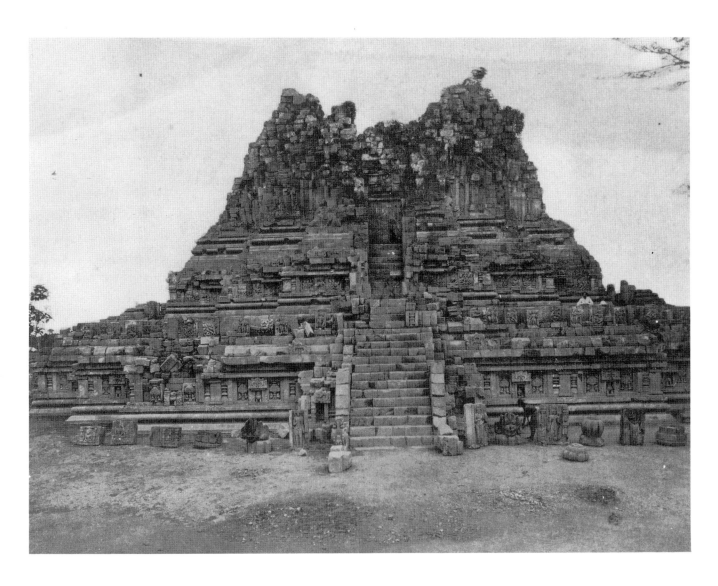

Śiva temple, Prambanan, c. 1895, photograph by Kassian Cephas

shape of the building, only then can we begin to consider the possibility of rebuilding the *candi*. Experience has taught that there is not a single *candi* of which all the stones have been rediscovered. Even when the attempts at reconstruction on paper did not encounter any problems of substance and even if all results are fully accounted for, there are always stones still missing. In the reconstruction on paper the lost stones are replaced by empty spaces, just as in the reconstructed *candi* these empty spaces are replaced by new stones.

The reconstruction of a *candi* using the original stones is called *anastylosis* after the Greek term for erecting or piecing back together memorial stelae or columns. Properly speaking this type of work can only be carried out when all original stones can be recovered and when their original placement in the building can be established with certainty. In reality this situation has never occurred and will never occur in the future, as the collapse of a temple invariably results in stones being smashed or lost forever. Nevertheless *anastylosis* can also be carried out, albeit less than perfectly, when among the recovered stones there

Reconstruction drawing of west side of Candi Gebang

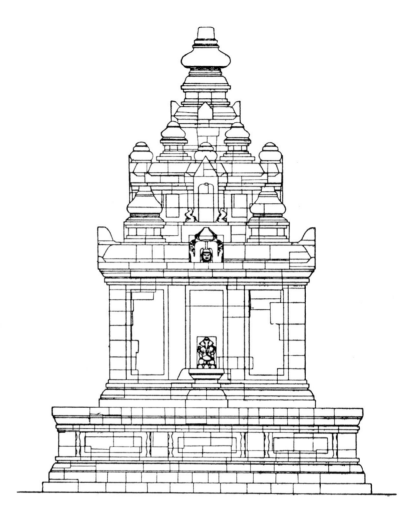

are some that can function as "keystones." In this context the word means a stone that functions as a connection between two layers of stones or between two sections of the structure. Usually such keystones help fit two layers of stone that according to calculations are separated only by a single course of stones. At Candi Merak in Central Java, for example, there is a complete base and roof as well as most of the body of the temple. Nevertheless the monument cannot be rebuilt because no keystone has been found that links one layer of stone of the body of the temple with the next one. On the other hand, Candi Gebang near Yogyakarta and Candi Jawi in East Java were rebuilt thanks to the discovery of such keystones, even though many empty spots remain.

At Candi Gebang the keystone was a corner stone that clearly established a connection between the uppermost layer of stones of the lower section of the body and the lowest layers of stones of the upper section of the body, which had already been reconstructed on paper. A similar situation existed at Candi Jawi, where the stones of the base and the lower half of the body of the temple were complete and the superstructure from the top down to the middle of the body of the temple could

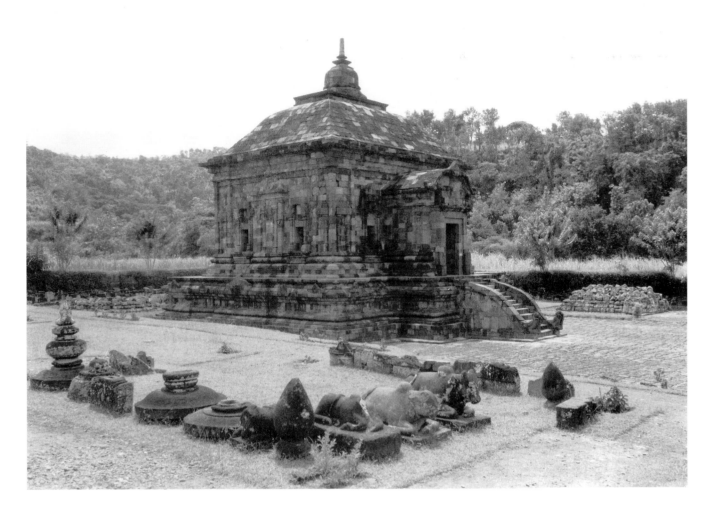

Reconstructed main shrine of Candi Banyunibo

also be reconstructed. Nevertheless the top stones of the lower half and the lowest layer of stones of the upper half could not be matched perfectly even though both consisted of plain, smooth stones. The subsequent discovery of a single stone that acted as keystone provided the solution.

Actually each original stone can function as a keystone when one layer of stones or one section of the structure has lost many of its original stones and when the stones that have been preserved do not seem to support our efforts at reconstruction. When such a stone is flat and smooth, displaying no special characteristics, and when it can therefore fit or be placed just about anywhere, such a stone cannot act as a keystone. A stone can only function as a keystone when it has special identifying marks or characteristics such as chisel marks or elements of carved decoration that fit with those of other stones. The size, shape, and position of a stone in a molding can also provide important clues.

Any decision to rebuild or not to rebuild a *candi* that has already been reconstructed on paper is the province of the science of archaeology.

Speculation should be eliminated, and the desire to have the satisfaction of seeing the resurrection of a once-ruined building should not enter our deliberations at all. Even when ninety-nine percent of the stones have been retrieved, so that the reconstruction on paper is quite convincing, the *candi* should not be rebuilt as long as two parts of the building do not yet connect perfectly. For example, in Candi Gebang and Candi Jawi, the discovery of a keystone, even though it consisted only of a single stone from a layer of stones or from a part of the structure that had suffered considerable losses, enabled the reconstruction of the entire building, as long as the lost stones were replaced by new stones. The use of new stones should be limited to what is strictly necessary to maintain the structural integrity of the building. This is why many *candis* that have been reconstructed reveal holes and empty spots. The new stones used as substitutes should always be left plain. There is really no justification for completing the new stones with any decoration for the purpose of creating a connection with the surrounding stones.

Yet another requirement is that the side of stone that faces the exterior be marked with a small hole filled with lead or a chemical substance in order to clearly indicate that the stone in question is not an original. To mark the stones in this manner is even more necessary when the new stone is part of a plain wall. In the restoration of *candis* it is a rule that decorated stones or parts of a sculpture or decorative pattern that have broken off or that cannot be found again should not be replaced by new stones with any type of carving. If it cannot be replaced by a stone with a smooth surface the damaged or open spot should be left as it is. The nose or hand of a statue, for example, should never be repaired and replaced and the statue should be left incomplete.

The restoration of a *candi* always starts at the bottom and proceeds upward. Sometimes this method means starting from the lowest parts of its foundations. This happens when the *candi* at the time of its discovery has already collapsed or when it no longer has the shape of a building. It often happens that the parts of the structure that are still standing first have to be taken down before reconstruction can proceed. This is the case when the remains of the building lack the structural stability to support the reconstructed building. The same procedure is followed when it is necessary to investigate the foundations of the *candi*. On the other hand, when the remains of the *candi* that are still standing are considered strong enough and when there is no need to investigate what may be deep down below, the restoration of a *candi* is more or less a continuation of the process of placing back the stones in their original position on top of the building as it still stands.

With such exact methods and strict procedures the restoration of brick *candis* is difficult if not totally impossible. The problem is that all bricks are the same, both in size and in shape. Although there are also bricks of individual shape and size, these are small in number and their use is limited to moldings and other structural decorative components. Therefore the restoration of those buildings, even if only on paper,

remains impossible, especially if the restoration includes a reconstruction of the monument.

In order to prevent falsification such as replacing bricks without confirmed proof of their original location, the restoration of brick *candis* cannot be carried out as desired. The restoration should be limited to efforts to strengthen weak sections of the building. Only in case of absolute necessity should we have the courage to dismantle a brick *candi* and to rebuild it, one course of bricks after the other, in strict accordance with the requirements of the methods of *anastylosis*.

Translated from the Indonesian by Jan Fontein

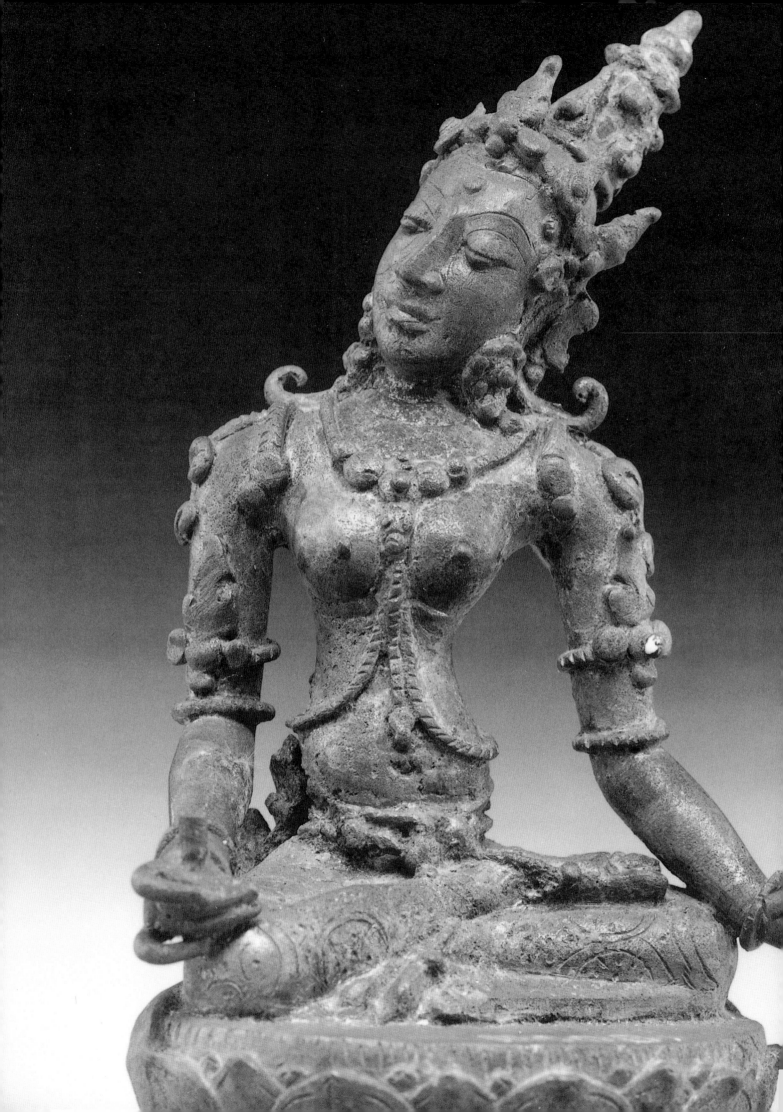

THE MAKING OF INDONESIAN ART

Edi Sedyawati

cat. 67 D.

THE TERM "CLASSICAL" in Indonesian art history designates art forms that show a conspicuously Indian influence. If that group of art forms is understood as appealing to critical taste and therefore superior in aesthetic quality, and thus considered as the inspirational force within the flow of the history of that art, then objections are likely to come forth, because other phases in Indonesian art history may claim such a quality as well. Yet the definition can for the time being be accepted for one reason. It is indeed during the Hindu-Buddhist period that Indonesian art took a seemingly sudden leap in technical and aesthetic achievement. This remarkable accomplishment is evident especially in art in stone: sculpture and architecture. The field of literature, especially poetry, also had noteworthy achievements at that time. Old-Javanese *kakawin* meters were developed following the tradition of the Sanskrit *kāvya;* however, they flourished with such great fervor that among the 232 *kakawin* meters used in Old Javanese literature, 110 were of originally Indonesian creation.[1]

THE PROBLEM OF "LOCAL GENIUS"

The question of Indian influence on Indonesian art is an intriguing theme that has permeated a great number of studies in Indonesian cultural history. The initial notion was one of "Indianization." When scholars first gave their attention to Indonesia's past, some became much attracted by the similarities between certain Indonesian cultural remains with Indian ones. An immediate conclusion was that the Sanskrit language, the Pallava and Pre-Nāgarī alphabets, stone sculpture, stone architecture, and the art of poetry, which were initially practiced

in Indonesia in the fifth to seventh centuries A.D., came from India. This diffusionist approach brought scholars in search of the Indian source or origin of different Indonesian cultural expressions.[2] Conclusions linked certain Indonesian political, commercial, and religious developments with those in India. The development of Indonesian culture was then perceived as a process of borrowing.

The proponents of the "borrowing" or "cultural history" school assumed that certain types of culture spread in circles from a given center, the place where they originated. Thus a given people might have different "cultural layers."[3] By this way of seeing one may find in different parts of Indonesia the existence of different sets of superimposed cultural layers, for instance the Megalithic, the Hindu-Buddhist, the Islamic, and the West European layers one on top of the other.

In keeping with the "borrowing" argument there were hypotheses propounded on "Indianization," or the "making of Greater India," especially regarding the agents of this process. First, there was the idea of colonization: Indians came to Indonesia, and by their agency. Indian culture was spread in Indonesia. There were, though, differing assumptions as to whether those Indians were warriors (*ksatryas*)[4] or merchants (*vaiśyas*).[5] These views cast the Indonesians in the role of the passive receiver. Some scholars, referring to Southeast Asian people, even asserted that "in prehistoric times the autochthonous people of Indochina seem to have been lacking in creative genius and showed little aptitude for making progress without stimulus from outside";[6] and "[Southeast Asia is] the meeting ground of cultural influences from India and China."[7]

A second idea was that Indians did come to Indonesia, but not to deliberately colonize. They were men of religion (*brahmanas*) who came to Indonesia by invitation.[8]

Awareness has been growing among scholars of the active role of the local people themselves in the process of cultural development. As early as about a century ago, H. Kern and J. L. A. Brandes, based on philological studies, stated that what seemed to be highly Indianized cultures in Indonesia also contained cultural elements that were part of an original Indonesian civilization.[9] Brandes proposed ten native cultural elements, consisting of: wet-field rice cultivation, well-developed social organization, the shadow theater, the batik technique of cloth ornamentation, *gamelan* music, indigenous metrical poetry, metal working techniques, and original currency, astronomy, and navigation technology.[10] His argument was based on the use of native, non-Sanskrit terms for details of these cultural elements. There were, however, further discussions on the question of how high the level of originality of those elements actually was.

The adoption of foreign cultural elements, especially the Hindu-Buddhist or Indian, has been further discussed in the light of local potentiality. Through consecutive years of research conducted by many scholars, it has become clear that Indian cultural elements were never

adopted at face value by the Indonesians. They underwent a certain, varied degree of selection, modification, and even remolding during the acculturation process. Quaritch Wales coined the term "local genius," which he defined as "the sum of the cultural characteristics which the vast majority of a people have in common as a result of their experiences in early life." What he meant by "local" is simply pre-Indian.[11] He stated further that local genius can be destroyed by extreme acculturation, but that in a lesser degree of acculturation "some of its features will remain constant, revealing themselves as a preference for what are evidently the more congenial traits of a new cultural pattern, and specific way of handling the newly acquired concepts. These constant features will determine the reaction to the new culture and give direction to subsequent evolution." Borrowing as well as invention is geared by desire, not necessity.[12] He also affirmed that "the Indian influence was the stimulus without which there would have been no response."[13] After reviewing the arts of Java, Champa, and Cambodia, he concluded that "it is variety of foreign influences, rather than complexity of local genius, that most enriches an art."[14]

F. D. K. Bosch, reacting to Quaritch Wales, laid stress on the role of the receiver in the process of acculturation. He put forth the assumption that it was the activity of Indonesian men of learning that was crucial. After initial tutelage at home they went to India to study, thus constituting what he called a "counter current." His conviction is that it was the genius of the Indonesians, meaning their capability to create anew, that provided a foundation for the flourishing of ancient Javanese art.[15]

In 1984, more than thirty years after Quaritch Wales proposed his concept of "local genius," the Indonesian Association of Archaeologists took up the topic again in a seminar, the theme of which was "cultural identity in the framework of national development." The discussions were mostly based on more recent research in archaeology. One point of conclusion was that Indian or Hindu-Buddhist influence did make an important contribution to Indonesian civilization, but on the other hand it did not permeate into all aspects of life in ancient Indonesia. Indigeneous customary law had always been potent in everyday life, especially in the villages; women in many respects had equal rights and comparable roles to men, unlike their fate in the purely Hindu case.[16] Soekmono pointed to recent discoveries in Sumatra, namely the Candi Mahligai (inside the earlier-known Candi Muara Takus), Candi Muara Jambi, Candi Gumpung, and Candi Kedaton. He observed that these religious monuments are unique structures; they have no inner room, but are composed of platforms, with the object of worship on the topmost one. Even the earlier-known monuments of Padang Lawas he considers unique, also having no equivalent in India. These facts bring him to his conviction that Quaritch Wales' assertions: "Certainly the relatively late remains. . .at Muara Takus. . .and Padang Lawas. . .are all decidedly Indian"; and "these temples show so little originality that I think we are not entitled to coin a term 'Indo-Sumatran' for them, if we mean by that any special development of, or variation from, a colonial-Indian style" are no longer tenable.[17]

Viewing the process of acculturation from within the accepting culture, Satyawati Suleiman proposed to discard the notion of Indianization, because Indian cultural elements were actually absorbed into a preexisting Indonesian culture, and remolded to conform with local needs.[18] Independently, at about the same time, other scholars[19] discussed the same issue as one of the themes of a conference. To be applied more generally, in that special occasion to Southeast Asia, the term coined for the above-mentioned process is "localization." This theme "raised the question of whether specific integrated local cultures existed prior to the coming of foreign cultural elements, and to what extent the latter were accepted, fractured and restated, or 'localised,' by pre-existing local cultures."[20]

The process of culture change, moreover, should also be perceived in terms of how local cultures influence each other, rather than only considering how local cultures adopt a "great" culture.[21] Wang Gungwu also raised the possibility that " 'Indian materials,' already transformed and adapted locally, might have been secondarily relayed from the point of entry to other sub-regions in Southeast Asia." He gave an example of this "re-localization": how Javanese and Khmer culture had an influence on Champa. Soekmono gave an Indonesian case, in which the style of the Gunung Kawi temples in Bali tally with the Central Javanese, while the Muara Jambi, Muara Takus, and Padang Lawas temples of Sumatra conform to the Eastern Javanese style. He also gave the notion of a secondary influence through regions or cultures that already had assimilated foreign influence beforehand.[22]

Another point worth noting in the study of acculturation is a remark B. J. O. Schrieke made in 1927, that "a given cultural element does not fulfill the same function in different societies, any more than similar elements produce the same effect." He further stated: "The most important factor will always be the application made of different cultural elements in a given society and the part these elements play in the development of the social life thereof."[23] These remarks actually underlie a challenge to study culture change, or particularly art history, in a functional perspective rather than paying attention only to the diffusion of cultural traits.

THE SOCIAL SETTING

Earlier scholars studying the classical period in Indonesian cultural history had already surmised that the first Indian influences were definitely not received by Indonesian peoples who were barbarians.[24] This assumption has not been demonstrated well enough by research. The following Tārumānāgara data is a case in point.

Tārumānāgara was a kingdom in the second half of the fifth century A.D.[25] It was situated in West Java, in and near the northern coastal area. The existence of this kingdom is known from a number of inscriptions.[26] Data about the kingdom that can be extracted from these inscriptions includes: knowledge of the art and technique of writing, specifically using the Pallava script, which came from South India;

mastery of the Sanskrit language, then the international language of learning; the concept of *nagara* (town, usually with a definite boundary and built-up demarcations in the form of walls and gates), which was known, and were possibly built; a system of time reckoning based on the revolutions of the sun and the moon; the Hindu concept of king, which was applied to Pūrnavarman, the king of Tārumānāgara, who was parallelled to Visnu, and described as strong, brave, courageous, intelligent, wise, having power over the whole earth, conquering all his enemies, and making friends with the *brahmanas*; a system of social organization, at a level enabling a concentration of power by which large public works were executed (in this case making canals to change the course of a river); worship of the likeness of footprints of miraculous, magically powerful personages.

Archaeological sites in and around the area where the Tārumā inscriptions were found have yielded some complementary information.[27] In the Jakarta area there have been sixty-eight "prehistoric" sites identified, twenty-seven of which have been systematically excavated. Eight have been identified as settlement sites, five of which are from the Bronze-Iron Age or the so-called craftsmanship development period. The formation of social groups of this period is characterized by specialization of labor, the development of metalwork technology, and evolving artistic merits.[28] A carbon-14 analysis for one of the sites gives a plus-minus date between 1000 B.C. and A.D. 500,[29] thus providing the possibility that this Bronze-Iron culture converged with the Tārumānāgara Hinduized culture.

Another site revealed gold ornaments, along with other finds such as bronze and iron artifacts, bracelets made of stone and glass, beads, human remains, a quadrangular adze, and a multitude of earthenware objects in a variety of forms and sizes.[30] The existence of gold ornaments, presumably valuable objects not meant for common folk, suggests that there existed an accentuated distinction between the ruler and the people.

These facts suggest that the *nagara* culture that emerged in the center of the state was based on the Bronze-Iron culture, then augmented with new ideas from Indian culture. To a certain extent there must have been a tradition in the division of labor and centralization of power, without which the emergence of kingship is inconceivable. Thus the king of Tārumānāgara actually bore an old status with an old role, but superimposed with a new concept, the Hindu kingship. The Bronze-Iron culture bearers might have been familiar with the concept of leader as not just a man of prowess, but also as a protector in a physical and spiritual sense.

The kingdoms of both Pūrnavarman in West Java and Mūlavarman in Kutai, East Kalimantan, were situated in a coastal area. However, there are other examples where Hinduization did not happen initially in coastal areas, but contrarily in areas deep inland. These examples come from Central and East Java. The sites so-far considered as the oldest Hinduized ones are Canggal and Gunung Wukir in the Kedu area (Cen-

tral Java), Dinoyo in the Malang area (East Java), and the Diëng plateau in northern Central Java. If trade through maritime lines should be considered as the main channel of Hinduization, there is difficulty in explaining why inland areas, not coastal areas, became the first sites of that foreign influence. This difficulty can only be bridged if one considers the possibility that the places of reception are those in which the society was the most prepared to accept new ideas. Logically, it is the old prehistoric centers that were the most susceptible for acculturation, for it was there that comparable concepts were found latent, to be expounded and more explicitly formulated after the introduction of Indian parallels.

From Old Javanese inscriptions it has been inferred that before the Hindu period there existed a coordinating leader above the village level. This kind of leader was called for by the wet-field rice cultivation. He may be considered as like the sovereign with regard to his power to dispose material and labor.[31] He may have lived in a palace compound called the *kaḍatwan;* possibly, together with the emergence of his sovereignty, a consumer class developed.[32] They had the generic titles of either *rakai* or *samgat,* or the variations thereof.[33]

Those sovereigns and their entourages might have communicated with foreign people, possibly initially through trade. Perhaps what became most attractive to these sovereigns might have been the light of new conceptual ideas, in religion as well as politics. Besides that, there was the faculty of writing and the Sanskrit language, the command of which might have made them elated to be able to take part in an internationally disseminated culture. That was possibly how Indian elements of culture came to be adopted and adapted in Indonesia.

Some of the sovereigns in Java acquired the specific title of *mahārāja,* presumably through a religious investiture conforming to Hindu rites. Once the *mahārāja* concept was adopted, a consequence might have been deliberate attempts from time to time to intensify the newly formulated status. Among others, these attempts might take the form of religious and aesthetic expressions. It must be along these lines of development that a new culture emerged, the expressions of which became more and more noticeable in a wider sphere.

There are indications, however, that the few Javanese sovereigns of the early Central Javanese period (eighth century) did not adopt the new culture at the same pace. While one already bore the title of *mahārāja,* the other still assumed the indigenous title of *haji* or *ratu.* Subsequently there were, indeed, struggles for hegemony. Nevertheless, the actual centralization of *kadatwans,* resulting in the emergence of a single superior palace compound, did not happen before the rule of King Balitung in the beginning of the tenth century.[34]

The emergence of a superior center, however, did not mean that bureaucratic administration was at the same time centralized. A study of tenth-century inscriptions has shown that at that time there was no centralization of bureaucratic administration down to the villages. While the central administration in the *kadatwan* sphere tended to form

a hierarchical order, in the villages, on the other hand, there was civil administration with a number of leaders having equal status, each having an equivalent rank in different matters. There was a clear distinction between the central government, which took a Hinduistic image, and the village government, which was based on native Indonesian ideas.[35] Although a certain number of villages were put under the authority of a central government in a *kadatwan* (also called *nagara* or *rājya* after the Hindu terminology), their relation with the center was a rather loose one. Officials from the center, on certain occasions, visited the villages as envoys or functionaries of the king, or invited guests of the village. Ceremonies to declare a freehold, for instance, were held in the villages. Although the declaration was the king's, it was the villagers who organized the ceremony and celebrations, and also provided the ritual gifts for dignitaries from the center as well as for other persons concerned.

The relation between the *rājya* and the villages became tighter in a later period. It was in the era of Kadiri in East Java, in the first half of the twelfth century, that organization of the regions became more systematic. The villages, called *thāni* in ancient East Java, were coordinated into groups of an unfixed number of members. This coordination of villages was called *wisaya*. One of the villages in a *wisaya* had the status of principal village, called the *dalěm thāni*. The kingdom itself, called *bhūmi*, thus consisted of several *wisayas*.[36] Literature as well as inscriptions of this period give some idea of the close relation between the royal family and the people who lived in the villages. A retired royal person could live in a religious community within the village; the royal family could have access to the crops of the village; the king could visit the villages; the villagers could get special rights, granted by the king, to partake in the sophistications of life following the fashion of the *rājya*. Nevertheless, the villages were still allowed to maintain their own customary law.[37]

A greater dimension of coordination was embarked upon in the subsequent era of the ancient kingdom of Singhasāri, in the second half of the thirteenth century. Several kingdoms were united into one imperium. An inscription of this period gives a list of seven kingdoms, Kadiri among others, that were put under the authority of Singasari.[38] It was this imperial set-up that was maintained, and enlarged further, in the succeeding empire of Majapahit, which began in the fourteenth century. In this later state of Majapahit, besides the kingdoms in Java and Madura that were under direct control of the state, there were the *nusāntara* regions beyond those kingdoms, which had some form of relation with Majapahit, probably of a diplomatic nature.

Artists, through whose hands the various works of art came into being, had low status in this society. Old Javanese texts give information on the existence of a class of professionals called the *wulu-wulu*. Members of this class were, among others, potters, smiths for different kinds of metal, woodcarvers, carpenters, different kinds of performers, and last but not least, sculptors. They were classified as *śūdras,* the lowest of the four main castes of the Hindus. Some of these artists lived in the

villages (belonging to the *warga kilalān* group), and some in the palace compound (belonging to the *watĕk i jro* group). Those who lived in the villages were subject to taxation, whereas those who stayed in the palace compound served the state or the royalty.[39]

Apart from the artists who executed such manual work as sculpting, there were also the high-ranking officials who participated in the planning or designing of works of art. Those dignitaries probably included, among others, the *pangajyan śrī mahārāja* (teacher of the king). There is also occasional mention of instances where the king himself took the role of leader in artistic matters.[40]

THE EMERGENCE OF STYLES

There was indeed an emergence of a new style in Indonesian sculpture resulting from cultural contacts with India. Naturalistic figures appeared in stone and in metal, streamlined after the model of classical Indian sculpture. This new style is characterized by a voluminous body molded through a configuration of convex planes and curving lines. Joints and muscles are not exposed, giving the limbs a tubular form. It is as if the smooth surface of the body is brimming with *prāṇa,* the lifegiving streams within the body.[41] F. D. K. Bosch saw a parallel between the delineation of human bodies and that of plants in classical sculpture.[42] The limbs of human beings as well as the trunks and branches of trees were depicted through rounded planes, as if fully filled with life sap.

The principal concept in Hindu literature is that *ātman* (the soul) is the true and only foundation of existence. Physical phenomena are regarded as *māyā* (illusion). The creation of the world, which comprises both aspects, is symbolized in Hindu mythology by the growth of the lotus. The primeval lotus grew from the waters of eternity, bringing forth Brahmā (the god of creation), and subsequently all other sorts of creations.[43] The lotus became therefore a dominant motif in sculpture too. It symbolizes creation and at the same time sanctity. In ancient Indonesian temples, especially of the Central Javanese period, the lotus even became the dominant motif for wall decoration.[44] The first phase of Hindu-Buddhist art in Indonesia, which happened in that Central Javanese period, is characterized by naturalism, but a naturalism without the intention to represent physical beauty as such. At variance with it, the emphasis in this Hindu-Buddhist naturalism is on the representation of ideal beauty, or conceptualized beauty, although realistic forms are indeed used as the starting point. A prerequisite of beauty in art is the quality of *sādṛśya,* the occurrence of a similitude or parallelism of form to the idea represented.[45] Ideal beauty has also been understood as a merging of natural forms and supernatural powers.

Indian ideas affected almost all cultural elements in certain parts of Indonesia. Among the many that were introduced, two can be considered as the most important. The first of these is the religious concepts of the Hindus and Buddhists. The second is the Hindu social concept, especially that concerning kingship. Around these two central themes

other related cultural traits revolved. Ideas and techniques in architecture, sculpture, literature, and performing arts of Indian origin came along with the religious and social concepts.

Most of these Indian ideas underwent a process of adaptation and reinterpretation almost immediately after their touch with Indonesian soil. Indian cultural traits were transformed, either by a process of selection, or modification, or both. These transformations can be observed in sculpture and in dance. Human figures, for instance, especially those of women, are never delineated in as voluptuous a way in Indonesian as in Indian sculpture. Reliefs depicting dances in Central Javanese temples, although showing an explicit corroboration with the classical Indian manual on dance,[46] never display the extremely acrobatic movements known in Indian texts and temple reliefs.[47]

Possibly motivating those changes were the indigenous Indonesian ideas of beauty. There are three steps that can be proposed to aid in their recognition. The first is to identify the prevalent art forms before the emergence of Hindu-Buddhist art in Indonesia; the second is to compare Indian and Indonesian art forms; the third is to compare the early and late developments in art expression of the Hindu-Buddhist period in Indonesia. A clear picture of Indonesian ideas of beauty may appear from the comparisons.

It is supposed that before the emergence of the classical Hindu-Buddhist art style, sculpture in Indonesia was dominated by the "Polynesian" style, so named because of its resemblance to statues found in 1722 on the Easter Islands, Polynesia. This type of statue is characterized by simplicity of design, angularity of lines, and stiffness of poses. Statues of this kind are found in many places in Indonesia: Sumatra (Tapanuli, Palembang, Bengkulu, Lampung), Java (West, Central, East), Kalimantan (Apo Kayan), Sulawesi (Central), Irian (Sepik), and other places. Rumbi Mulia[48] in 1977 proposed another name for this type of statue, "Megalithic," based on the fact that most statues of this type are found in association with Megalithic remains.[49]

The main focus of Megalithic statues is the face. It is the sketch of a face on a block of stone that makes it recognizable as a human figure. The remaining parts of the body are either not depicted or depicted in meager lines on the compact stone block. The impression is that the columnar form of the stone is as important as the image of a figure itself. Nevertheless, the irregularity of composition betrays a technical limitation. This deficiency was later overcome by techniques learned from Indian experts. Meanwhile, the face as the basic component, functioning as identifier of a figure, has stayed on in Indonesian expressions up to the present. Details in the delineation of the face on the *wayang* puppets, and the sets of masks in a variety of dramatic arts in Indonesia, demonstrate the persistence (and at the same time development) of a presumably prehistoric concept of image making.

A second step in revealing the indigenous Indonesian ideas of beauty is comparing Indian and Indonesian Hindu-Buddhist sculpture. The first

phase of Indian influence on Indonesian art is observable in the sculpture of the Central Javanese period (eighth to tenth century A.D.). During the first part of this period the Kedu area was where Hindu rules on iconography were accurately followed; by the later half of the period it was the Prambanan area that took the role of a center of Indianized Javanese culture.[50] Although iconographically the Central Javanese period demonstrates the closest conformity to Indian canons, some stylistic differences can be observed.

An Indian figure statue is almost immediately distinguishable from an Indonesian one. The Indian figure has a robust and voluptuous body with very rounded sculpted planes. Parts of the body are clearly defined, as if set apart from one another. This tendency is most evident in female figures, where the very narrow waist accentuates the separation of the lower from the upper torso. The breasts are almost perfectly rounded, giving the impression of being suspended upon the body. Indonesian figure statues generate a different effect. In these statues the different parts of the body are shaped into a unity. Junctures between the parts are not emphasized, but smoothed; even both legs are consolidated with the torso. This tendency might have originated from an indigenous idea, namely that a figure image should be columnar, thus emanating a quality of uprightness and strength.

This comparison is between Indian sculpture in general and the early Hindu-Buddhist art in Indonesia, specifically represented by the sculpture of the Central Javanese period. This period also shows a conformity to Indian norms in terms of artistic conventions such as the flowing and curving lines of the contour, the stout body, the refined rendering of ornamental details, the delineation of half-closed eyes, and the very thin robe or loincloth.[51] Yet the above-mentioned differences in effect exist as well.

A comparison of the relief sculpture of both cultures again shows differences that might reflect dissimilarity in aesthetic concept. Indian reliefs that depict a story are generally a single panel, whereas such Indonesian reliefs mostly take place in several scenes. As a consequence, the narrative in Indian reliefs tends to be condensed, while in Indonesian reliefs it tends to be extended. It has, further on, a consequence in the composition within individual frames. Indian relief panels are mostly full; every detail has equal importance in regard to the narrative. Indonesian relief panels, on the other hand, show a deliberate distinction between the focus of the narrative and its background. Personages, with all their attributes, are clearly set in the foreground, against a more even background consisting of a multitude of plants, clouds, animals, and other panoramic constituents. Although this background contains a variety of forms, it is to be understood as one unity of information regarding the place and situation of a scene.

A third step, to gain a picture of the underlying Indonesian ideas of beauty directing the evolution of styles, is a comparison between the early and the late Hindu-Buddhist sculpture in Indonesia. In this case, due to the scarcity of data, a comparison will only be made within the

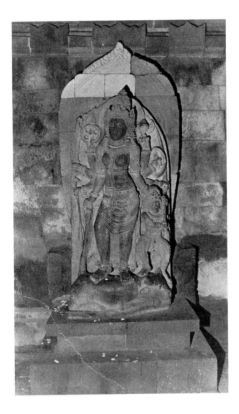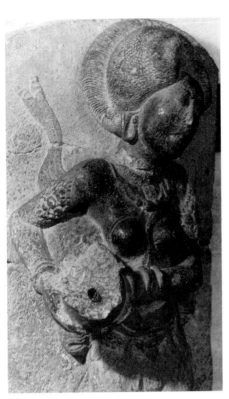

Left: Śalabhañjikā from the mandapa of the
Ghatiśvara temple, Baroli, Rajasthan. The
Denver Art Museum

Center: Statue of the goddess Durgā, Central
Javanese period, ninth century. Candi Loro
Jonggrang, Prambanan

Right: Statue of a woman, East Javanese period,
c. fourteenth century. Museum Nasional, Jakarta

Javanese culture. The earlier phase is to be represented by the Central
Javanese period, and the later phase by the East Javanese one.

The preference for curving lines in Central Javanese sculpture had been
taken over by a tendency toward angular lines in East Javanese sculp-
ture. This tendency is most obvious in narrative reliefs. A striking
horizontality of the shoulder line of personages in East Javanese reliefs
is observable almost without exception. It is so pronounced that both
arms seem to be suspended from that line. The stout figures of the
Central Javanese reliefs are no longer found in East Javanese ones.
They are replaced by slender, lithe, and fragile figures. Even some
figure statues of East Java, especially those not portraying deities, have
the same characteristics. One can infer therefore that slenderness and
suppleness were the criteria for ideal beauty during the East Javanese
period. One can further suspect that these criteria were indeed ever-
present indigenous ones, having the chance to flourish again only after
a long period of experiment with what began as foreign concepts and
technology.

Corroborating this supposition are data from Central Javanese dance
reliefs. These reliefs, especially those of Candi Loro Jonggrang (Pram-
banan) and Candi Borobudur, show definitely that the sculptors knew
precisely the rules of classical Indian dance, not only from written
prescriptions but also from actual performances. This conclusion is
evident from the fact that many intermediary movements are depicted
notwithstanding the texts' silence or rare mention of them.[52] The reliefs

of Borobudur give the context of the dances as part of recognizable narrative scenes. Two spheres for dancing can be distinguished in these reliefs: one is among the high-ranking people, and the other is among the lower-class people. Dances in the higher circles of society show unmistakably the classical Hindu style, while those among the commoners are varied: there are acrobatics, comic dances, and typical local dance styles. This last-mentioned local style is characterized by gentle and possibly restrained movements, sometimes by outward-turning legs, and by dancing with partners and in lines.[53] One inscription of this period describes a ceremonial dance by the male and female village elders. They circumambulate a ceremonial post, possibly in partners and in lines too.[54] Thus, the difference between this local style and the standard classical Hindu one is obvious. The classical Hindu style has wide-ranging movements, while the local indigenous style has more constrained ones. Strong and sudden qualities of movement characterize the classical Hindu style, while light and sustained movements seem to dominate the local dance style.

It is then clear that during the Central Javanese period the two dance styles existed simultaneously: one originated from the high culture of India and in Indonesia became the attribute of the powerful elite, while the other was of native origin and performed by the commoners, including the village elders. There might as well be a parallel situation in the visual arts.

In dance, what later has become the classical Javanese dance is in essence a continuation of the ideas of beauty contained in the old Central Javanese local dance, supplemented by some techniques taken from the classical Hindu dance. Those newly acquired techniques include specifically the full turnout of the legs to form the basic stances. Nevertheless, while the lines of movements of the classical Hindu dance are mostly curving and rotating, those of the Javanese are angular. The emergence of angularity, combined with suppleness and daintiness, in East Javanese sculpture is likewise to be explained as a resurgence of indigenous ideas of beauty, which were once pressed to the periphery of the then "new civilized world." A survey on the distribution of traits of Hindu statues in Java demonstrates the fact that a set of characteristics once developed on the periphery was later taken over by a younger center of the state, which was at the same time the center of the civilized world.[55]

The foregoing review has perhaps revealed in a very schematic way how art styles went through their course of development in Indonesia. Prehistoric art, especially that of stone carving, did not contribute anything to the technology of later art. It did, however, contribute an idea concerning the basic structure of a statue, and the centrality of the face as identifier of an image. Of decisive importance was the technology of stone carving and some aesthetic concepts acquired from Indian culture. It enriched ancient Indonesian art to such an extent that old ideas of beauty became expressed with more elegance.

1. Zoetmulder 1974. See also Edi Sedyawati's review of the translation of this book in *Tempo* 13, no. 35 (October 1983), where the proportion of meters has been counted.

2. A diffusionist perspective was also adopted in the early studies on prehistory, among others pertaining to the problem of Megalithic cultures. It was even asserted that the diffusion happened by migration (Heine-Geldern 1936, 35–36; Heine-Geldern, "Prehistoric Research in the Netherlands Indies," *Science and Scientists in the Netherlands Indies,* ed. Honig and F. Verdoorn (?, 1945), 151; review in Christie 1979. A predominant tendency to see Indonesian cultural history in the light of diffusion has also been pointed out in Rahardjo 1988.

3. This approach was criticized by B. J. O. Schrieke in 1927. His article was originally in Dutch, and later translated into English: "Some Remarks on Borrowing in the Development of Culture," *Indonesian Sociological Studies. Selected Writings of B. Schrieke,* Part 1 (Bandung, 1960), 223–237, 290. Quaritch Wales 1951, 197, still used the concept of "cultural strata" to explain the development of culture: the differences in art are explained as largely due to the complex interactions of the "waves of Indian culture."

4. Vogel 1925; R. C. Majumdar, *Ancient Indian Colonies in the Far East,* vol. 2, "Suvarnadvipa," Part I Political History (Dacca, 1937).

5. Krom 1931.

6. Coedès 1966, 13.

7. Charles A. Fisher, *South-East Asia: A Social, Economic, and Political Geography* (London, 1964), 81. Review by Timbul Haryono in Ayatrohaedi 1986, 207–219.

8. van Leur 1955.

9. Schrieke 1960, 232.

10. Brandes 1889.

11. Quaritch Wales 1951, 17.

12. Quaritch Wales 1951, 9–11.

13. Quaritch Wales 1951, 194.

14. Quaritch Wales 1951, 196.

15. Bosch 1961d. The original article in Dutch is "Het Vraagstuk van het Hindoe-kolonisatie van den Archipel," inaugural address at the Rijksuniversiteit, Leiden, 1946. In this article Bosch discussed the problem of "local genius," using ancient Javanese art as a case for observation.

16. See Ayatrohaedi 1986 for the proceedings of this seminar in February 1984. For the points just mentioned, see among others the essays by Satyawati Suleiman, 157, 172–175; Boechari, 202–206; and Timbul Haryono, 210–218.

17. Soekmono in Ayatrohaedi 1986, 241–245.

18. Satyawati Suleiman in Ayatrohaedi 1986, 152–185.

19. "Southeast Asia in the 9th to 14th Centuries," a conference in March 1984 at the Australian National University. The proceedings of this conference were published under the same title in Singapore in 1986, ed. David G. Marr, A. C. Milner, intro. Wang Gungwu.

20. Wang Gungwu in Marr & Milner 1986, xv.

21. Edi Sedyawati in Ayatrohaedi 1986, 235, 245; Wang Gungwu in Marr & Milner 1986, xvii.

23. Schrieke 1960, 229, 232.

24. See among others H. Kern, *Verspreide Geschriften VII* (?, 1917), 105–120 (originally publishing 1886); and Brandes 1889.

25. de Casparis 1975, 19.

26. See H. Kern, *Verspreide Geschriften VI–VII. Inscripties van de Indische Archipel* ('s-Gravenhage, 1916–1917); Vogel 1925; Edi Sedyawati, "Tārumānāgara: Renafsiran Budaya," paper presented at a panel discussion, Jakarta, University of Tārumānāgara, September 1987.

27. An overview on prehistoric settlements excavated in this area has been given by Hasan Djafar in "Hunian-hunian Pertama di Jakarta," a paper for the seminar *Jakarta dalam Perspektif Sejarah,* Jakarta, Masyarakat Sejarawan Indonesia cabang Jakarta and Dinas Museum dan Sejarah DKI, June 1987.

28. Soejono 1984b, 288–295.

29. The Pejaten site, see Hasan Djafar 1987.

30. The Buni site, see Hasan Djafar 1987. See also I Made Sutayasa, "Sebuah Tinjauan tentang Kompleks Kebudayaan Buni di Pantai Utara Jawa Barat," *Manusia Indonesia* 6 (5–6), 1975, 83–103; I Made Sutayasa, "Prehistory in West Java, Indonesia," *The Artefact* 4 (1979), 61–75.

31. van Naerssen 1979.

32. van Naerssen 1979; also Sedyawati 1985, 297–300 and note 462.

33. de Casparis 1981.

34. van Naerssen 1979, 39, 46.

35. de Casparis 1981.

36. Sedyawati 1985, 301–310.

37. Sedyawati 1985, 324–326, 359.

38. *Mûla-Malurung* inscription; Sedyawati 1985, 311–312.

39. Sedyawati 1985, 341–348.

40. Sedyawati 1985, 321–323, 327–330.

41. Such an interpretation has been given by Stella Kramrisch in *The Indian Sculpture* (Delhi 1981; 1st ed., London, 1933). On *prāna* see Pott 1966. Pott explained about the operation of *prāna* in the practice of *yoga. Prāna* is explained as "vital breath" (better: life-giving streams), which run through thousands of channels within the human body. A *yogin* (a person with qualifications to perform yoga) may direct his *prāna* through three main channels (*susumnā, idā,* and *piṅgalā*) into one force that he can then cause to move from an initial seat in the *mūladhara* (a point between the genitals and the anus) upward, "breaking" six subsequent seats (*cakra / padma*), to meet the supreme god who is on the seat above the fontanel.

42. Bosch 1960.

43. See explanations in Heinrich Zimmer, *Myths and Symbols in Indian Art and Civilization,* ed. Joseph Campbell (New York, 1953).

44. Bosch 1960 discussed this theme using more than three hundred examples, most of which are whole panels filled with lotus branches and foliage.

45. Coomaraswamy 1956, 9–14 and 226, has defined *sādr̥śya* as "concomitance of formal and pictorial elements; conformity."

46. The basic manual, which was and is considered up to the present the source for other manuals on classical Indian dances, in the *Nātyasāstra.* See Ghosh 1951.

47. Studies by Edi Sedyawati on the history of Indonesian (especially Javanese) dance are: "Serangkai Relief Tari pada Candi Lara Jonggrang, Prambanan," *Musika: Brosur Ilmu Musik & Koreografi* (Jakarta, 1973); "Tari dalam Sejarah Kesenian Jawa dan Bali Kuna," Interim Research Report, Faculty of Letters, University of Indonesia (E. Sedyawati & team), 1978; 1981 *Pertumbuhan Seni Pertunjukan* (Jakarta, 1981); "The Question of Indian Influence on Ancient Javanese Dance," *RIMA* (University of Sydney) no. 16.2 (1981), 59–82.

48. Rumbi Mulia has made a survey on the naming of "Polynesian" for a certain style of sculpture in Indonesia and elsewhere. See Mulia 1980a. The term "Polynesian statue" has been used by S. A. L. Muller and W. P. Groeneveldt in their reports on finds of statues in the second half of the nineteenth century. Krom 1923 and Krom 1931 gave a further advocacy for the name "Polynesian," based on the assumption that those statues were made by the native Malay-Polynesian people.

49. Haris Sukendar subsequently used the term "Megalithic statue" in his articles and reports. More specifically he distinguished "Megalithic statue" from a more simple "menhir statue." The last-mentioned comprises a monolithic upright stone, the upper

part of which is chiseled into a schematic depiction of a face. Added sometimes are rudimentary arms or arms and genitals. See Sukendar 1985, 92–108. Surveys on living Megalithic traditions in Indonesia have shown that there are three kinds of functions of menhirs. The first is religious, concerning the rites for the ancestors; the second is social, concerning the ceremonies to maintain the social structure; and the third is secular, for instance as a hitching post or place marker. See also I Dewa Kompiang Gede, "Peranan Compang dalam Hubungan Religi Masyarakat Ruteng, Flores Barat, NTT" (The role of the menhir in the prehistoric society of Indonesia) in *Pertemuan Ilmiah Arkeologi V, Yogyakarta, 4–7 Juli 1989* (Jakarta, 1989), 223–245. Stylistically there is virtually no difference between what Sukendar called "Megalithic statue" and "menhir statue." Therefore, in the present discussion of styles, the two are not to be considered distinct. Rumbi Mulia did not make the distinction either.

50. See Edi Sedyawati, "Kajian Kuantitatif atas Masalah 'Local Genius,' " *Pertemuan Ilmiah Arkeologi IV, Cipanas, 3–9 Maret 1986;* vol. 3, *Konsepsi dan Metodologi* (Jakarta, 1986), 33–49. In this article quantitative analyses are given on sculptural traits and iconometry to determine the character of sculpture in different areas in Java, and how they relate to Indian canons on iconography.

51. Compare Suwadji Sjafei in his article "Hubungan Seni Arca Sailendra Jawa Tengah dengan Seni Asing pada Abadabad 8, 9, 10," in *Pertemuan Ilmiah Arkeologi ke-III, Ciloto, 23–28 Mei 1983* (Jakarta, 1985), 220–239. He demonstrated artistic traits in conformity with Indian conventions observable in Central Javanese, Sumatran, and Thai sculpture. He called the style defined by those traits the Śailendra style. This name was proposed by Satyawati Suleiman to replace "Śriwijaya style." See her article "Studi Ikonografi Masa Śailendra di Jawa dan Sumatra," *Pertemuan Ilmiah Arkeologi, Cibulan, 21–25 Februari 1977* (Jakarta, 1980), 375–391. R. Soekmono made the same proposal in his article "Kesenian Sriwijaya di Seberang Selatan Malaka," *Pertemuan Ilmiah Arkeologi ke-II, Jakarta, 25–29 Pebruari 1980* (Jakarta, 1982), 131–139.

52. These intermediary movements are of the legs as well as the arms. Basic movements found on reliefs, in concordance with the Indian prescriptions, consist of dancing stances, leg movements, foot positions, steps, hand poses, and movements of the sides. See also note 47, especially the last-mentioned article.

53. Sedyawati 1985. These local styles of dancing are depicted on Candi Borobudur, reliefs no. I(B)a.V.42; I(B)b.XIV.89; and I(B)89. Similar dance poses can be seen in one of the Prambanan reliefs, dance relief no. 58 on the Śiva temple.

54. This is mentioned in the inscription of Taji, from Panaraga, A.D. 901. See Sedyawati 1978 and Sedyawati 1982. See also Holt 1967, 281–282, where translation of part of the inscription referring to the dance is given.

55. See Sedyawati 1986. In the Central Javanese period the iconometrical traits of Hindu statues show in the center of the state (in this case Prambanan) a conformance with Indian canons, while the regions outside the center show conversely a contradiction. These contradictory traits, moreover, were later adopted in an East Javanese center of the state (in this case Singasari).

NOTE TO THE READER

Wherever possible names of the locations of *candis,* archaeological sites, and places where finds have been made are rendered in accordance with Marsono, *Daftar Nama dan Nomor Kode Desa/Kelurahan se Indonesia* (List of names and code numbers for the villages of Indonesia), Jakarta, 1983. When not listed in this publication, the possibly outdated geographical names given in older archaeological reports have been maintained. All are listed in the following order: hamlet/village (*desa/kelurahan*), district (*kecamatan*), regency (*kabupaten*).

Dimensions are given height before width before depth.

THE SCULPTURE OF
INDONESIA

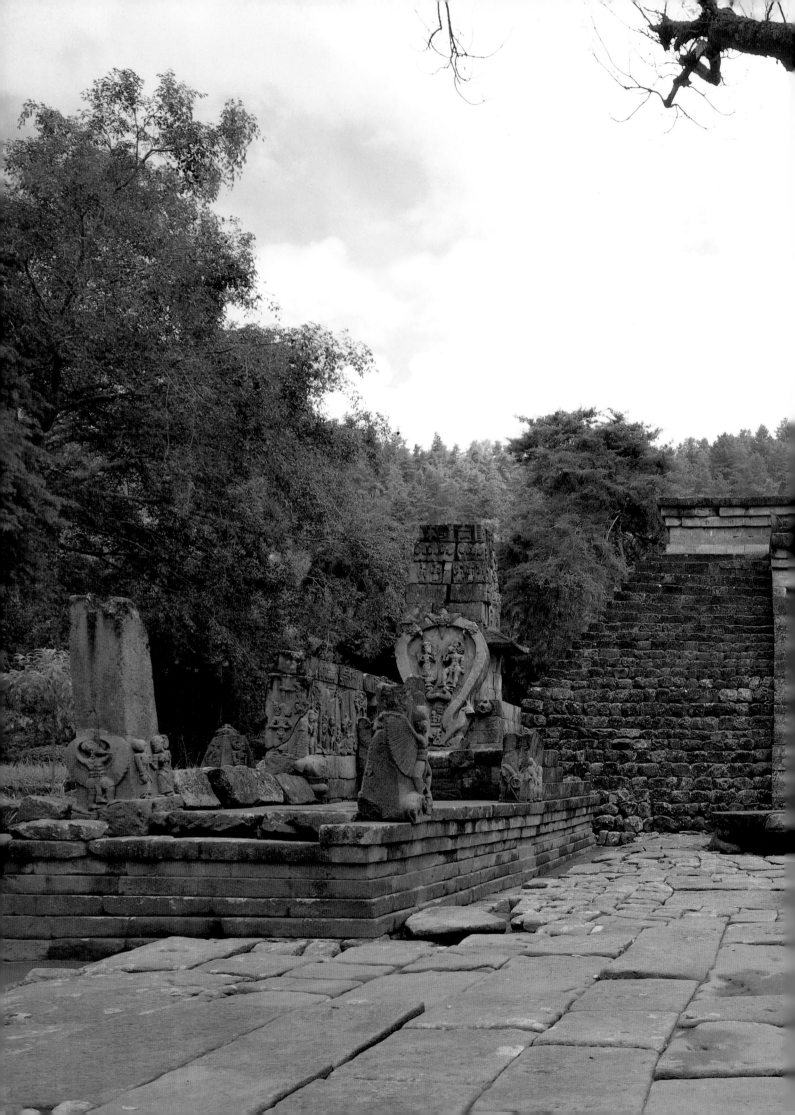

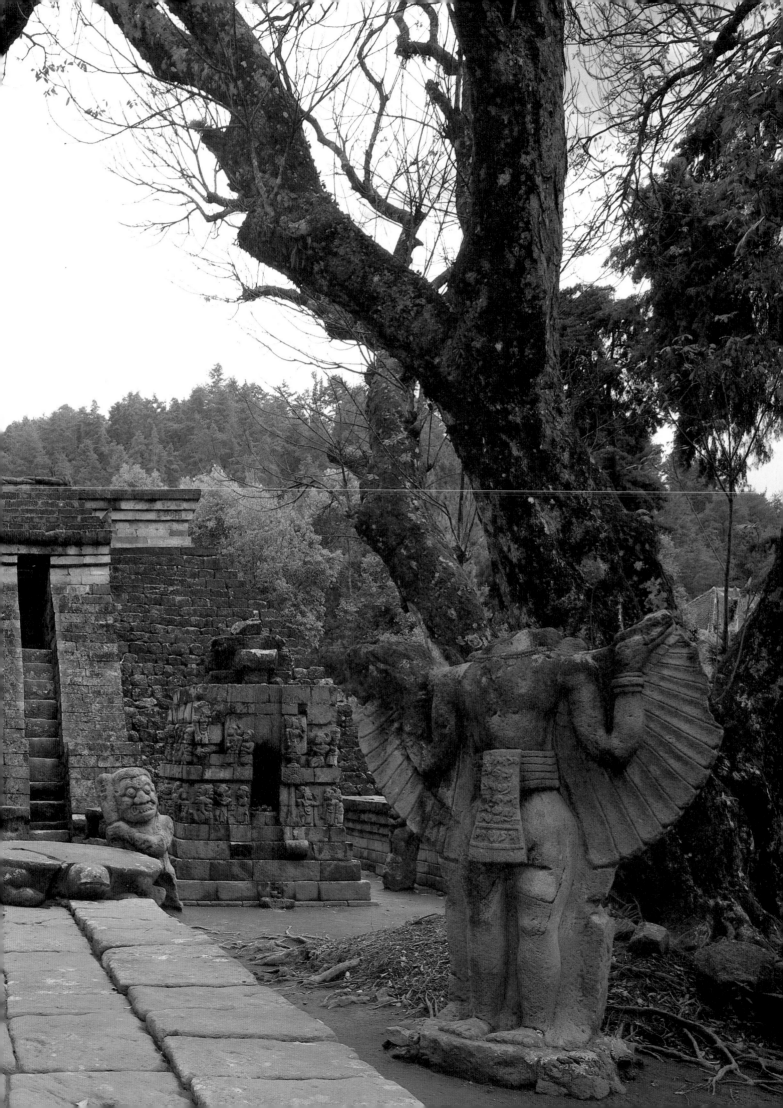

I

Statue of a standing man
first half of first millennium (?)
West Java, from Cibarusah
bronze, h. 9 5/8 in. (24. 5 cm)
Museum Nasional, Jakarta,
Prehistoric Coll. inv. no. 4451

THIS BRONZE STATUETTE of a man was found five feet below ground level in the village of Satus, near Cibarusah in the Regency of Bekasi, not far from Bogor (West Java). Clad only in short pants, the figure stands with his legs apart and arms akimbo, both hands resting on his hips. He wears a simple headdress consisting of a cloth wound around his head. The jewelry he wears is equally simple: a necklace of beads and plain bangles around the wrists.

It is difficult to assign a precise date to this statuette, especially since the archaeological context in which it was found has not been recorded. Van Heekeren characterized its style as nondescript and Bernet Kempers left open the possibility that it might represent a type of rustic folk art of relatively modern date. However, the unusual posture of this man is strongly reminiscent of figures decorating bronze daggers found at Dongson (Vietnam) and in a Warring States tomb in Changsha (Hunan province, China). It would seem possible, therefore, that this statuette portrays one of the early inhabitants of the island of Java.

Literature: van der Hoop 1941, 253, fig. 76; van Heekeren 1958, 38; Bernet Kempers 1959, pl. 5; *Koleksi Pilihan* 1: no. 6; Bellwood 1985, fig. 9.10. The daggers: Goloubew 1929, pl. 19b; Bellwood 1985, fig. 9. 10; and *Kaogu* 1984.

Figure of a man decorating a bronze dagger found at Changsha, Hunan Province, China

overleaf: Candi Sukuh

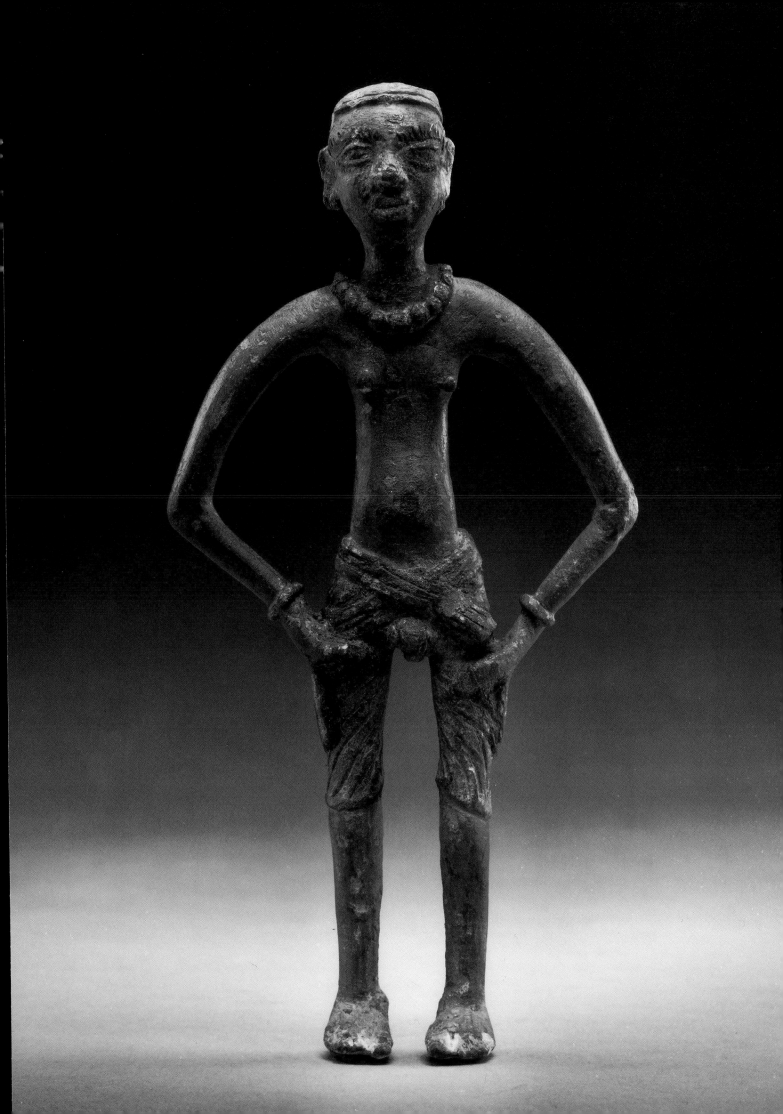

2
Ceremonial vessel

Bronze-Iron Age
Asemjaran, Madura Island
bronze, 33 ¹/₂ x 19 in. (85 x 48 cm)
Museum Nasional, Jakarta, inv. no. 6060

THIS LARGE BRONZE VESSEL is shaped like a flask or perhaps a fisherman's basket (*kepis*). It was found by a farmer in the village of Asemjaran near Banyuates on the north coast of the island of Madura.

The vessel is covered by a bold design in low relief consisting of broad bands of spirals and triangles. These triangles are alternately plain and decorated with a minute, repetitive design of birds. Two small handles are attached on opposite sides of the narrow base of the tapering neck, while a third, slightly larger handle is attached to the bottom of the vessel. The seemingly nonfunctional placement of this third attachment suggests that the vessel may have been carried on a strap that ran through the three of them.

With the exception of the design of birds inside the triangles, the decorative motifs of this vessel do not belong to the standard repertoire of Dongson bronzes, and the overall effect is quite different from that of most bronzes associated with that culture. It is, therefore, of special interest that one of the two vessels similar in shape and design to the exhibited work that have been found to date comes from an area close to the heartland of Dongson culture. It was found at Kandal, Cambodia, and deposited in the Phnompenh Museum. Another example, discovered in 1922 in Lolo, Kerinci (West Sumatra), is cast in two halves kept together by iron rivets. Moreover, clapperless bronze bells displaying a similar spiral ornament have been found in Battambang (Cambodia) and in Selangor and Johore (Malaysia). It would seem possible that all three flask-shaped vessels belong to a post-Dongsonian style of bronze casting that spread over a wide area of Southeast Asia, but that had its origins in Vietnam.

Literature: Bernet Kempers 1953–1954, fig. 8; van Heekeren 1958, fig. 14; Bernet Kempers 1959, pl. 12; Soejono 1984a, 72; Tirtowijoyo and Soepono 1984b, 38–39; Bellwood 1985, 288–289. The vessel from Kerinci: Bosch 1922; Suleiman 1975, pl. 3; *Koleksi Pilihan* 1, no. 10. The Phnompenh vessel: Malleret 1956.

3
Ceremonial tablet

Bronze-Iron Age
reputedly from the island of Roti
bronze, 59 x 11 3/4 in. (150 x 30 cm)
Museum Mpu Tantular, Surabaya,
inv. no. 4088

THIS OBJECT, of which the original function has yet to be determined, is known as the *Sūrya Stambha* (Standard of the Sun God Sūrya). It was obtained by the Mpu Tantular Museum from an art dealer in Surabaya who claimed that it had come from the island of Roti, in the province of Nusa Tenggara Timur. The discovery in 1971 of a very similar object at Kabila on Sabu Island, not far west of Roti, lends credence to the dealer's provenance.

The flat bronze plaque with an oval top tapers toward the lower end. Four pairs of juxtaposed, circular projections line the two edges of the object. The lower part of the plaque is plain, save for a central ridge in low relief. The upper part shows a decoration of concentric circles connected by a scrolling ribbon motif somewhat similar to that on an ceremonial ax found in 1875 at Landu on the same island (see cat. 4).

The oval top has a reticulated design of spokes radiating from the center, which takes the shape of a demon's mask in low relief. The upper part of the plaque with its decoration of concentric circles seems to represent the tattooed body of the demon. His face shows two huge fangs emerging from the lower jaw and reaching eye level.

Although the basic structure of this object is the same as that of the bronze found at Kabila (of which the lower half has been lost), the faces on the two pieces are quite different. The Kabila bronze shows a human face with a wide grin. On both objects the same decoration is applied to both sides.

Among Bronze Age artifacts found in the Indonesian archipelago, the human face is a frequently seen motif. Bronze ceremonial axes (see cat. 4), hourglass drums, kettledrums, and pottery vessels of varying shapes are decorated with human faces or masks, as are stone sarcophagi and cists. In all probability, the motif had a dual function: to ward off evil and to symbolize the spirit of the ancestors.

Although the use of masks as well as of such geometric motifs as concentric circles can be traced to the Dongson culture, which flourished in Vietnam until the third century of our era, the unique shape of these plaques suggests that they are the products of a local bronze culture.

Literature: *Mengenal Koleksi* 1978–1979, 15, no. 5, 49, ill. 5; Bellwood 1985, 287. The Kabila object: Bintarti 1981.

4
Ceremonial ax
Bronze-Iron Age
from Roti, prov. Nusa Tenggara Timur
bronze, 30 3/4 x 16 3/8 in. (78 x 41.5 cm)
Museum Nasional, Jakarta, inv. no. 1442

THREE BRONZE AXES of the same distinctive shape were excavated near Landu on the north side of the island of Roti in 1875. One of these axes was lost in a fire at the Colonial Exhibition, Vincennes, in 1931. Fragments of an ax head of the same type were found at Lake Sentani, Irian Jaya.

The ax has a curved handle terminating in a stylized crocodile's head. The thin circular blade is attached to the flat round top of the handle by a shaft in the shape of a man seated with his knees drawn up. The upper part of the man's body, his arms, and his head with its huge ceremonial headdress are represented in low relief on the blade. The top of the handle is decorated with concentric circles, spirals, and striations similar to those found on artifacts of the Dongson culture. The headdress of the man is of a type still worn by certain tribes in Irian Jaya.

The thin blade suggest that these elegantly shaped and finely decorated axes were not made for everyday use and must have had a ceremonial or funerary function. Like the remarkable bronze plaques from the same or nearby islands (see cat. 3), their unique shape, quite different from the Javanese bronze halberds of the *candrasa* type, points to a flourishing bronze industry capable of producing highly original, distinctive bronze ceremonial utensils.

Literature: van der Hoop 1941, 197–199; Galis 1956; van Heekeren 1958, 10–11, fig. 7; Bernet Kempers 1959, pl. 11; Soejono 1972; Soejono 1984a, 69; Bellwood 1985, 287, fig. 9. 12.

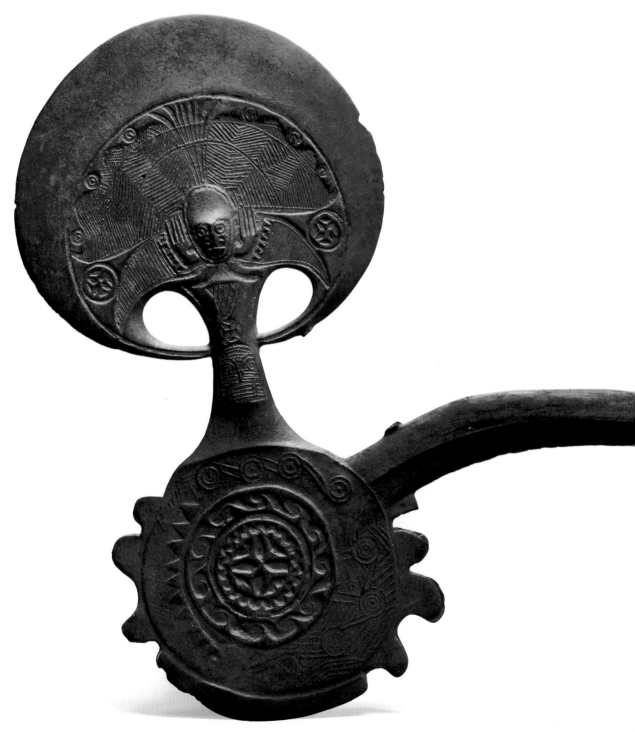

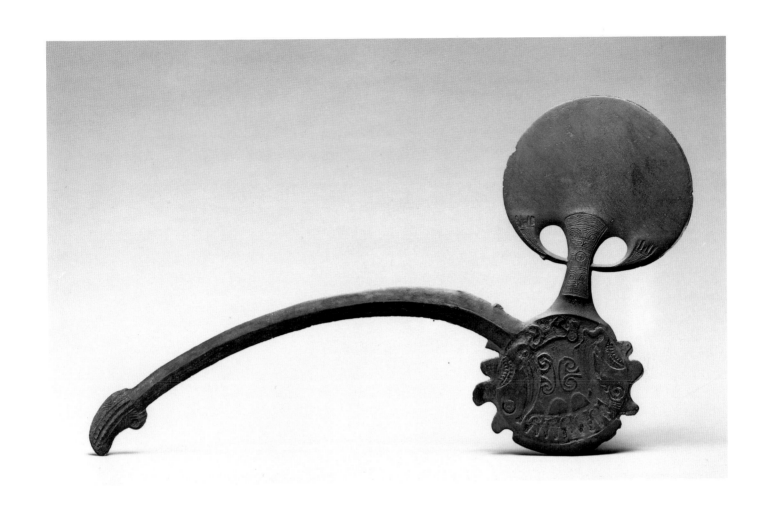

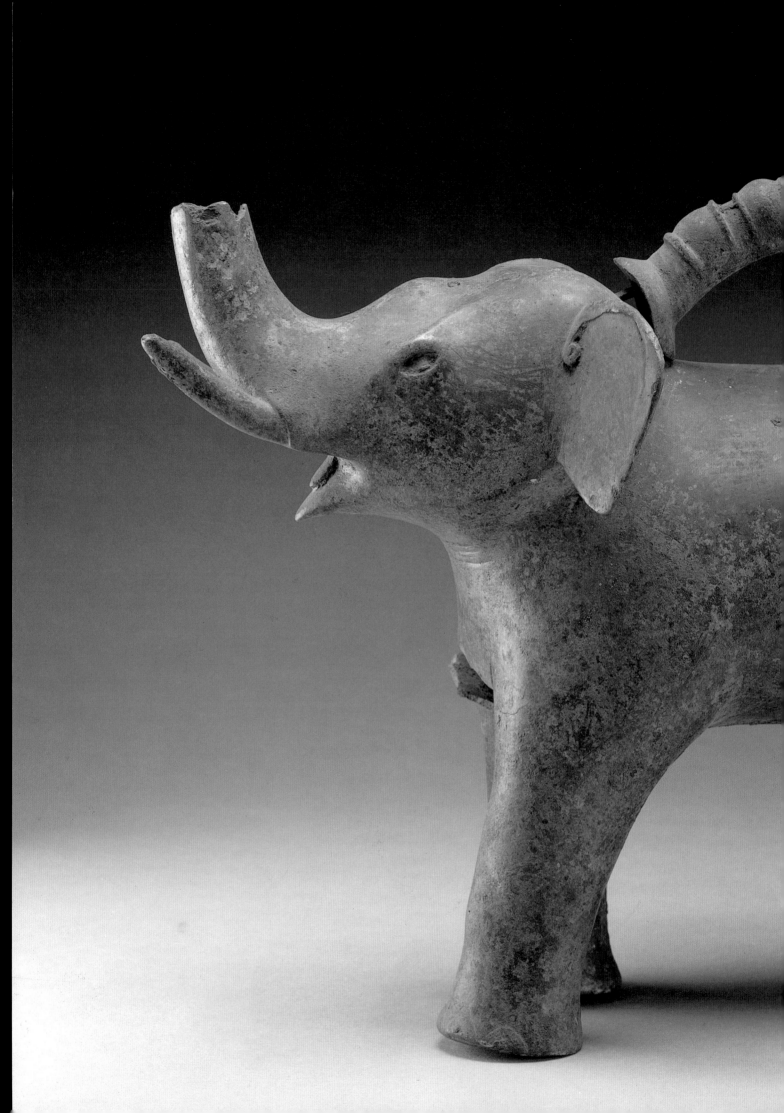

5
Water vessel
Bronze-Iron Age
from Rengel, Tuban, East Java
bronze, 12 1/2 in. (32 cm)
Museum Mpu Tantular, Surabaya

THIS LIFELIKE RENDERING of an elephant
was discovered inside a large kettledrum
(diam. 36 5/8 in., 93 cm) of the Heger 1 type,
found at Rengel near Tuban on the north
coast of East Java. The drum also con-
tained several bronze axes, a spearhead,
and a chisel.

The elephant stands with his partially bro-
ken trunk raised; his right front leg is bro-
ken. The kettledrum also suffered consider-
able damage. The only report on this
recent (post-1975) find classifies the ele-
phant as a statuette. However, its hollow
body and the fact that the elephant's tail
has been transformed into a ringed handle,
the other end of which is attached to the
back of the head, suggests that this piece
may have been used as a water vessel, per-
haps to pour ceremonial water. Except for
the narrow gaps at both ends of the handle,
there is no other orifice than that at the end
of the trunk. Consequently, the hollow
body of the elephant could only have been
filled by submerging it. In Buddhist or
Hindu ritual the use of vessels with only
one large orifice seems to symbolize an in-
exhaustible supply of holy water.

As kettledrums seem to have been fre-
quently used in barter trade, they were of-
ten used long after having been cast; it is
possible, therefore, that the kettledrum
from Tuban and its contents were buried at
a time when Indianized states had already
arisen in Java. However, the fresh natural
modeling of this elephant is quite different
from the more stylized, ornamental ap-
proach of the Indo-Javanese bronze caster
(see cat. 87), and suggests that the object
may predate this time.

Literature: Bintarti 1985, pl. 1.

6

Head of a deity
c. 9th century
Central Java, from Candi Bima
andesite, 9 3/4 x 8 3/4 in. (23.9 x 22.2 cm)
Society of Friends of Asiatic Art, on loan to
the Rijksmuseum, Amsterdam, MAK 231

THE SCULPTURE REPRESENTS the head of a man with a broad forehead, pronounced eyebrows, thick lips, and downcast eyes. In his elongated earlobes he wears heavy, plain ear pendants. Benjamin Rowland characterized this type of sculpture as follows: "The mask-like character of these heads, especially in the flatness of the definition of the planes of the face, is quite un-Indian, and is perhaps to be taken as an early indication of the Indonesian genius in the fashioning of theatrical masks in the modern period."

The head comes from the collection of J. Barrau, a friend and colleague of Th. van Erp, who was responsible for its acquisition by the Society of Friends of Asian Art, Amsterdam, more than forty years ago. The previous owner believed it to have come from Candi Bima, and its shape, style and dimensions are consistent with those of the heads still found in situ as well as with two heads from the same temple that are now in the Museum Nasional, Jakarta (inv. nos. 417, 418). Even though its exact original location on the temple has not been determined and the color of the stone appears to be slightly different from that of other sculpture from the same site, its provenance would seem to be firmly established.

Candi Bima is located on the Plateau of Diëng, Central Java, once the crater of a volcano more than six thousand feet high. The name Diëng or Dihyang is derived from a Sanskrit word meaning "abode of the gods." On this remote plateau, which in ancient times could be reached by an elaborate system of paved roads and stairs, stood a large number of shrines, perhaps as many as thirty or forty, dedicated to the gods of Hinduism. Together these edifices constituted a holy city of temples and buildings housing the priests officiating in these shrines. Today only eight of the shrines remain, but the ruins of several other temples were still visible to the first western visitors who ventured to the Diëng Plateau during the early years of the nineteenth century. The first visitor, H. C. Cornelius in 1814, noted a local custom, also known from India, to name the temples after the heroes of the *Bhārata-Yuddha*, the Javanese version of the Indian epic *Mahābhārata*, but neither the date nor the precise origin of this custom is known.

Perhaps because much of the area was still covered with dense forest at that time, Cornelius did not discover Candi Bima, which stands alone on a hill overlooking the marshy plateau on which the five temples of the so-called Arjuna group are located. As the tallest of the Diëng temples it was named after Bima, the tallest of the heroes in the epic.

Although the body of the temple resembles in structure those of the Arjuna group, the shape and decoration of its roof with false windows framing heads of men, vases, and lotus buds has no parallel in Javanese temple architecture. An early description by the Reverend J. F. G. Brumund mentions other unusually shaped roofs, such as that of the now completely vanished Candi Sĕñ-caki. An early photograph of Candi Parikĕsit, which collapsed in 1873, reveals structural parallels with Candi Bima. At the present time five of probably seven false stories of Candi Bima remain. They were topped by a huge ribbed and pillow-shaped-crowning stone (*āmalaka*), similar in appearance to those crowning the four corner projections at the level of the second false story.

Several authors have noted parallels with Indian temple architecture at Bhuvaneśvara, Sirpur, and Māmallapuram. Recently Dumarçay even suggested that Candi Bima may have been designed after an Orissan prototype by architects who had only drawings at their disposal. This circumstance would presumably account for the considerable deviations from Orissan proportions.

Dumarçay also observed that "the rules which governed the construction of temples were not yet well established," thereby assuming, as many did before him, a date in the beginning of the Central Javanese period for the monument. However there are indications that construction at the Diëng Plateau continued for some time after the temples of the Arjuna group had been built, probably during the middle of the eighth century. The use of round moldings, characteristic of the mature Central Javanese style, and the type of *kāla* head above the entrance, showing a lower jaw *in statu nascendi*, suggest the possibility of a later, perhaps ninth-century date for Candi Bima. The way the heads, framed by the arches, have been carved in situ suggests a degree of coordination between the phases of construction and sculptural decoration that is not usually associated with early Javanese temples.

Many Javanese temples have been left in a more or less unfinished state, and Candi Bima is no exception. Some of the decorative details, especially those below the roof level, are unfinished. While the reasons for it having been left in this state are unclear, we may perhaps assume that the earliest buildings at Diëng are those most likely to have been finished completely.

Among Indonesian temples Candi Bima is indeed unique, or perhaps the sole survivor of a vanished architectural style. In the wider context of Southeast Asian art and architecture, however, heads peering from a window frame are not uncommon, from the earliest, possibly sixth-century type in the ancient kingdom of Fu-nan (Nui-sam, Phuoc-co-tu, Vietnam) to the examples in stone and terracotta from the Môn kingdoms of Dvāravatī (Thailand). Of special interest, for the purpose of comparison with Candi Bima, is the large, sculptured stone block in the National Museum, Bangkok. It seems to represent a multistoried building with heads peering from windows covered by bow-shaped arches at all levels. This sculpture is generally thought to represent a heavenly palace.

In Indonesia the superstructure of a temple was associated with the *svarloka* (sphere of the gods), and the top of temples that are replicas of the cosmic mountain Sumeru is equated with the abode of the gods. The heads in the arched frames of the false windows of Candi Bima, rather than being mere decoration, therefore most likely represent divine residents of a heavenly palace.

Literature: *MBK* 1944, 20; Visser 1948, no. 354, pl. 206; Rijksmuseum 1952, no. 261. Sculpture in Museum Nasional, Jakarta: Rowland 1967, pl. 176a; Bernet Kempers 1959, pl. 32; *AIA* no. 1. Candi Bima: Brumund 1868, 156–161; Brandes 1902b; van Erp 1910; Krom 1919; Muusses 1923, 13–15; Krom 1923, 1:165–205 (esp. 181–187); Bernet Kempers 1955, 6–37 (esp. 20–22); Coomaraswamy 1965, 80, 93–94, and 202, fig. 346; Williams 1981, 22–45 (esp. 35); Laporan 1982, 19–34 (esp. 21–22); Dumarçay 1987, 16.

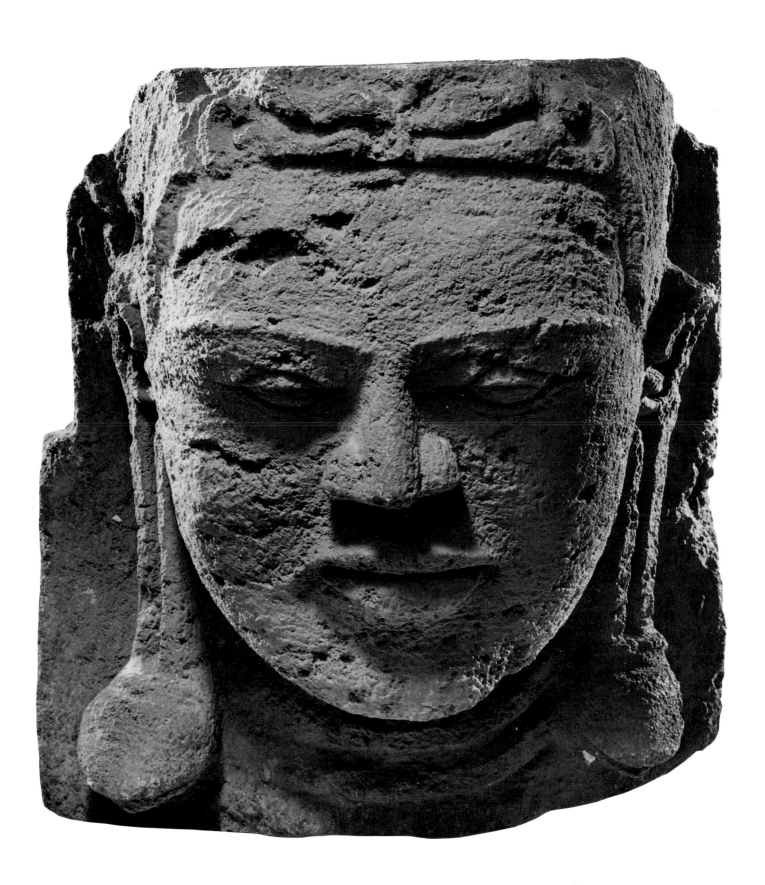

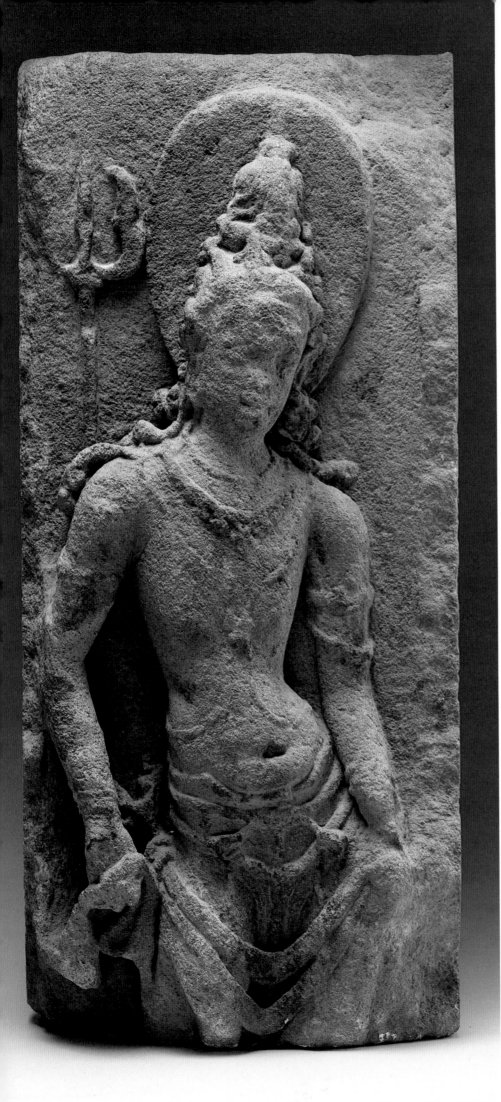

7
Nandīśvara
c. 9th century
Central Java, from Candi Suko, Boyolali
andesite, 23 3/4 in. (61 cm)
Museum Het Princessehof, Leeuwarden

NANDĪŚVARA, a manifestation of the god Śiva and a deity guarding the entrance to a shrine, is shown as a prince in royal attire. His slim, elongated body strikes an elegant, almost languid *tribhanga* ("three bend") pose. His head, framed by an oval halo, is slightly inclined, the face showing a three-quarter profile. Behind his right shoulder stands a trident, his traditional attribute. He wears a crossed sacred thread (Skt. *channavīra*); two girdles and two flat sashes, tied at the hip, have been added over the garment covering the lower part of the body.

Although scholars had long believed the Diëng Plateau to be the place of origin of this piece, the true provenance was established by J. E. van Lohuizen-de Leeuw only in recent years. The key to the puzzle was provided by Krom's discovery, in the archives of the Amsterdam Zoo, of a letter dated 10 October 1841, written by the Reverend C. J. van der Vlis. It describes a temple near Boyolali (Central Java) that he called Candi Bungalan. Of the statues that he described in situ, one matches a piece photographed by the Archaeological Service at Sendang Lerep in the village of Cepago in 1924. It bears a close stylistic resemblance to the Leeuwarden sculpture, which in turn matches exactly the description and measurements of another piece described by van der Vlis at the same site. The name Bungalan is probably the result of a toponymic misunderstanding, for when N. W. Hoepermans surveyed the area in 1866 this name was not known locally. Instead he found the last remnants of a temple named Candi Suko. The stones of that temple, most likely the "Candi Bungalan" of van der Vlis, had all been carried off for the construction of bridges.

The Nandīśvara sculpture was acquired by Anne Tjibbes van der Meulen, who lived in nearby Salatiga in 1895. The collection that he brought back to Bergum in his native Frisia was later acquired by Nanne Ottema, the founder of the Museum Princessehof, Leeuwarden, the capital of that Dutch province.

In his note of 1841 van der Vlis wrote: "The statues at Candi Bungalan are all beautifully and evenly carved. It should be noted that several have been sculpted in relief on oblong slabs of stone. This makes it probable that the statues were part of the walls of the temple, as the stones on which they

have been carved clearly reveal traces of having been part of the outer wall." While nothing can be said with certainty about the architecture of this *candi*, the image of Nandīśvara is likely to have occupied a place to the left of the temple entrance, facing a statue of Mahākāla on the right.

Van der Vlis actually mentioned a statue of a guardian holding a club, obviously the mate to the Leeuwarden statue, but its present whereabouts are unknown. Two other statues in the same style, one in the Radya Pustaka Museum, Solo, and one in the Cleveland Museum of Art, may have come from the same site, but they do not match descriptions given by van der Vlis.

Candi Suko is yet another example of temples such as Candi Banon and Candi Nagasari (cat. 14). Although all traces of these monuments in situ have disappeared, their remaining statuary bears eloquent testimony to their superb artistic quality and their unique sculptural style.

Literature: Hoepermans 1913, 270; Krom 1925; Amsterdam 1938, no. 571, pl. 37; van Lohuizen-de Leeuw 1984.

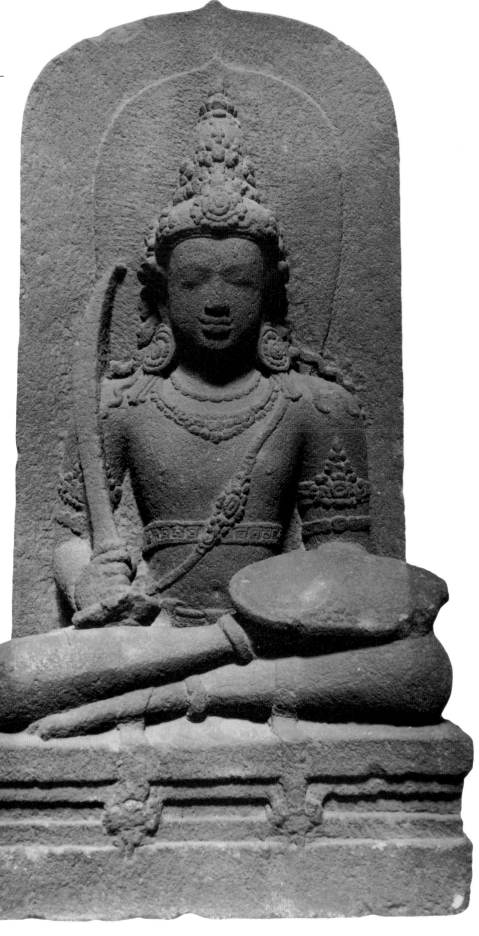

cat. 8

Nairrita, the guardian of the southwest

c. 9th century
Central Java
andesite, 35 ¹/₂ in. (90 cm)
Courtesy of the Trustees of the British
Museum, London,
Gift of C. H. Millett, 1861 10–10.1

THIS STATUE represents a man seated on a rectangular pedestal with the right leg folded on top of the left. The pedestal has a plain throne back. The man is dressed in a simple loincloth, but wears elaborate jewelry and a high headdress. His long hair falls down over his shoulder. In his right hand, resting on the right knee, he carries a sword with a curved blade, while his left hand, placed on the right foot, holds a small oval shield. A pointed, petal-shaped halo indicates his heavenly status.

Bernet Kempers was the first to draw attention to this beautiful sculpture and to propose an identification as Nairrita, one of the guardians of the eight directions. Nairrita, whose attributes are a sword and shield, is the guardian of the southwest. A complete set of eight guardians (Astadikpā-lakas) has been carved on the outer walls of the main temple of the Loro Jonggrang complex at Prambanan, but there it is Sūrya, the sun god, and not Nairrita who occupies the southwest corner. That Nairrita was nevertheless known in ancient Java and associated with that direction is evident from the Old Javanese words for the southwest, "Nairrti," "Nairiti," and "Neriti." In the Old Javanese *Rāmāyana* (XXIV. 8) a weapon called *Nairritāstra* (weapon of Nairrita) is mentioned, together with those of Yama and Varuna, the guardians of the south and west. However, this word seems to denote some sort of magic projectile rather than the sword with a curved blade that we see him holding in this statue. This type of sword was quite common in Central Javanese times; it appears frequently in the reliefs of Borobudur (Ib 47) and Prambanan (Śiva, XXIV).

According to Indian legend, Nairrita was a demon (*rākṣasa*) transformed into a guard-

ian deity. The iconographical texts usually give him a demonic appearance. Even though the serene, elegant appearance of this young warrior is obviously at variance with the Indian iconographical norms, the identification as Nairrita would seem to be quite possible.

No biographical details are known about the donor C. H. Millet. He is said to have received this statue from a local ruler while traveling through Java in 1831. If the identification of the statue as Nairrita is correct, the sculpture is likely to have been part of a set of eight, but no other statues that could have belonged to the same set have been identified.

Another, later representation of Nairrita includes the god's mount, a *bhūta* (demon). This statue, first identified by K. C. Crucq, belongs to a set, now partially dispersed, damaged, or lost, which probably came from Candi Singasari and which dates from c. 1300. It stands in the Chinese temple Wan Kiap Si at Gunung Sari, Jakarta. The temple has been housed, since the middle of the eighteenth century, in the residence built by the Dutchman Frederick Julius Coyett in 1736. When the "captain" of the Chinese, Lim Tjip Ko (captain from 1756–1775), converted this residence into a temple, the collection of statuary was already there, left behind by its original owner. It is a curious coincidence that two statues of Nairrita, of great rarity in Indonesia as well as in India, should have been included in the collections gathered by two of the earliest western collectors of Indonesian art.

Literature: Stutterheim 1924, 297 (identification as "bodhisattva"); Crucq 1930, 229–231; Bernet Kempers 1931; Banerjea 1956, 526–529; van Lohuizen-de Leeuw 1955; Salmon and Lombard 1977, 113; Zoetmulder 1982, 1183, *s.v. Nairrti*.

cat. 9

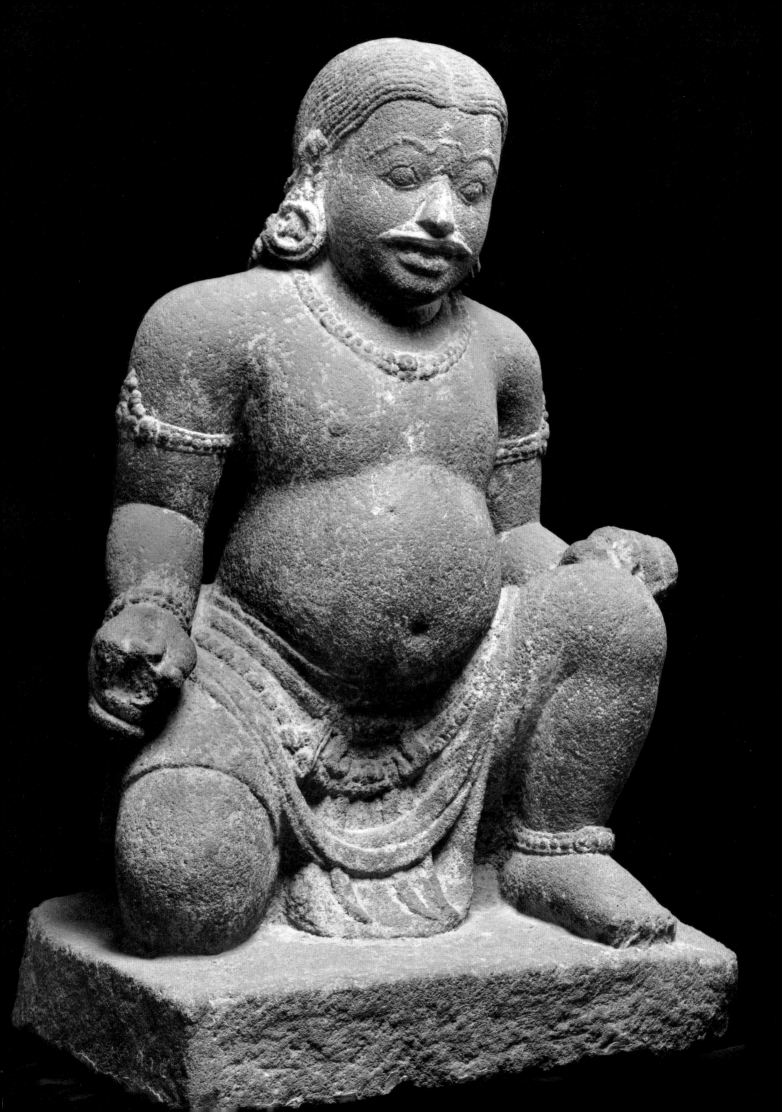

9
Dvarapāla (temple guardian)

c. 8th century
Central Java, from Candi Borobudur
andesite 41 ¹/₂ in. (105.5 cm)
National Museum, Bangkok

THE POT-BELLIED temple guardian is kneeling on his right knee on a plain, rectangular base in a pose traditionally reserved for these figures. His left hand is resting on his raised knee; it may once have held a snake. The *upavīta* (sacred thread) in the shape of a snake, usually worn by dvarapālas, is noticeably absent. In his right hand he holds a dagger pointed downward. He wears simple jewelry, consisting of heavy round ear pendants, a necklace, and arm bands around the upper arms, as well as bracelets around wrists and ankles. His facial expression is only mildly demonic, but this may be the result of damage inflicted upon face and mouth and modern restoration of the mouth and mustache. It is not clear whether the half-opened mouth once revealed a pair of fangs. His hair, parted in the middle, does not show the spreading, curly hairdo typical of *rākṣasas* (demons); it falls in gentle curls across the shoulders, held together on the back of the head by a band decorated with pearls. He is dressed in a loincloth held up by a broad belt into which the scabbard of his dagger is stuck on the right side.

The earliest foreign visitors to Borobudur in modern times saw this statue standing on top of Bukit Dagi, a hill about six hundred yards northwest of the monument. One of the first was Captain Godfrey Phipps Baker (1786–1850) of the 7th Bengal Light Infantry, a soldier in the service of Lieutenant-Governor Thomas Stamford Raffles. In May 1815 Baker drew at least four sketches of the statue and noted that the image was called Tukang Kayu (the carpenter) or Maringi (the scabbard maker) by the local populace. Dr. Thomas Horsefield (1773–1859), an American surgeon who worked in Indonesia from 1801 to 1819, presented what appears to be a tracing of one of Baker's drawings to the India Office Library in London as early as 1820. When the painter H. N. Sieburgh visited Borobudur sometime between 20 November 1837 and 2 April 1839, the statue was still standing in the same place, as is evident from a sketch by his hand now kept in the Rijksmuseum voor Volkenkunde, Leiden.

At Sewu and Plaosan the dvarāpalas flank the entrances to the temple complex, whereas those excavated at Kalasan (now in the Presidential Palace, Jakarta, and in the Museum Sana Budaya, Yogyakarta) are thought to have been associated with the former monastery attached to that temple.

It is quite possible, therefore, that the *dvarapāla* of Borobudur was likewise associated with the monastery attached to the sanctuary rather than with the monument itself.

The fact that the now-solitary lion guarding the west stairway of Borobudur is considerably taller than those guarding the other entrances could be viewed as an additional indication that the location of the monastery attached to Borobudur should be sought on the west side of the monument. This is contrary to the expectation that the tallest lions would have been placed at the east side, where, to judge from the sequence of the narrative reliefs, pilgrims began their solemn *pradakṣinā* (circumambulation) of the sanctuary. Excavations carried out northwest of Borobudur in 1951 brought to light the foundation of a *pĕndopo* (open hall). This is not likely to have been the only wood and brick structure in the area, and further excavation will be necessary before the place where the probably substantial number of monks resided can be definitely identified. It is quite possible and even likely that a monastery was founded sometime before the construction of the huge monument could begin. The *dvarapāla* could, therefore, antedate Candi Borobudur itself by several decades.

An anonymous diarist (later identified as the antiquarian W. R. Baron van Hoëvell) who visited Borobudur in the company of the resident C. L. Hartmann in May 1840 provided the following description: "A hill almost as high as that on which Boroboedoer is situated and which rises almost immediately at its foot had for some time attracted my attention. The Head of the Probolinggo District, who acted as my guide, took me up this hill and told me that he wanted to show me the Tukang (architect) of that beautiful temple. For on the top of this hill stood a solid image of the same appearance and in the same attitude as the guardians at Prambanan, but considerably smaller (i.e. only two and a half feet tall). I was almost surprised to find this figure here, not merely because it was the only one on this hill, but especially because I had not seen any other image of this appearance among the countless sculptures of Boroboedoer."

Shortly afterward (around 1851), F. C. Wilsen moved the statue to the *pasanggra-*

han (government rest house) at the foot of Borobudur. Its presence there is recorded in a photograph made about thirty years later by Woodbury & Page. It was there that in 1896 King Chulalongkorn of Thailand noticed it and asked for its inclusion among the statuary that he took back to Thailand.

The *dvarapāla* of Borobudur is much smaller in size than the huge figures that have been found at other central Javanese Buddhist *candis* such as Kalasan, Plaosan, and Sewu, and is dwarfed by those at Singasari (12 ft.). This may be why Baron van Hoëvell underestimated its size. The pose and appearance of the Borobudur guardian nevertheless leaves no doubt that it is indeed the sole survivor of a pair or a set of four *dvarapālas*. A stylistic comparison of such details as hairdo and jewelry with those of its counterparts at other temples suggests that the Borobudur *dvarapāla* represents an early, simple type of guardian. The later statuary is characterized by elaborate decoration of the base (Candi Kalasan) and a proliferation of snakes as sacred thread or arm bands (Candi Sewu).

Literature: van Erp 1917; van Erp 1923; van Erp 1927; de Bruyn 1937, 65–66; Bernet Kempers 1976, 14–16; van Lohuizen-de Leeuw 1981; van Lohuizen-de Leeuw 1982; Tokyo 1987, no. 64.

Monumental *dvarapāla* near Candi Singasari, village of Candirenggo near Malang, h. 12 ft.

10

A procession of women to a graveyard
9th century
Central Java, from Candi Borobudur
andesite, thirteen stones, each 53 x 32 3/4 in.
(134.5 x 83 cm)
National Museum, Bangkok

THE SERIES OF RELIEFS decorating the first balustrade of Candi Borobudur was created as a result of a drastic change in the building plans, which was put into effect while the construction of the monument was already in progress. Probably to prevent tectonic shifting and sagging, it was decided to encase the base of the monument in a spacious platform of sixteen layers of stone. This platform served as a circumambulatory processional path. It removed from view a series of 160 panels illustrating the *Karmavibhanga*, a text on the Buddhist law of cause and effect. The added height of the platform made it necessary to increase the height of the low balustrade of the first gallery, an effect achieved by installing, on top of the balustrade, 104 niches facing outward, each containing a statue of a Buddha (see cat. 11). Between these niches were placed screen walls, assembled and installed on top of the balustrade without structural connections with either the balustrade or the niches. The additional wall space created by these modifications was used to create a new series of five hundred reliefs, all illustrating *jātakas* (edifying stories from previous incarnations of Gautama Buddha).

The great Chinese pilgrim Yi Jing, who visited the Sumatran kingdom of Śrīwijaya between 671 and 695, mentioned that the inhabitants of the capital, monks and laymen alike, could recite by heart Āryaśūra's *Jātakamālā* (Garland of Birth Stories). It is not surprising, then, that the Javanese chose this text to be illustrated on the first balustrade of Borobudur. Rather than an extensive illustration of the thirty-four stories contained in this celebrated collection, the architects and planners of the monument opted for a relatively concise rendering of the text in 135 panels followed by illustrations of another text or texts of the same literary genre. It is also possible that the monks of Borobudur were in possession of a copy of the text in which the thirty-four stories of the *Jātakamālā* were followed by a large number of other, similar stories, perhaps as many as sixty-six, in order to complete the symbolically significant number of one hundred. No text has been found that treats the later stories illustrated on the first balustrade in the same sequence. As a result only the literary source of those panels that contain conspicuous, easily identifiable clues can be recognized;

the meaning of the majority of these reliefs remains obscure.

Unfortunately, this is also the case with the relief exhibited here, the only one of its kind not in situ. It is part of the collection of Javanese statuary donated by the Dutch colonial government to King Chulalongkorn of Thailand on the occasion of his visit to Indonesia in 1896. It appears that at the time of the royal visit to Borobudur this relief had been reassembled on the processional platform just south of the staircase on the west side of the monument. Th. van Erp has demonstrated that the original location of the Bangkok relief was on the first balustrade, next to the west gate, and that it should be given the sequential number I B a 186. In the location assigned to this relief by van Erp there are at present three stones that do not belong to the Bangkok relief and seem to contradict his reconstruction. However, there seems to be no viable alternative to his suggestion.

In its present incomplete state the relief consists of thirteen stones. The side facing outward shows a seated woman. In her raised right hand she holds a lotus, while her left hand rests in her lap. She is flanked by a vase containing a bouquet of lotus flowers on her left and an incense burner on her right. On the screen walls between the niches figures of men and women, paying homage or performing rituals, alter-

nate, but those flanking the four stairways are always of the same sex, indicating that the staircases constituted the centers of four symmetrical arrangements of these figures. This point, first observed by van Erp, seems to support or, at least, does not contradict his reconstruction of the original location of this relief.

The other side of the relief shows a procession of seven women, all moving to the right, their heads lowered, perhaps in mourning. On the extreme right, where only the base has been preserved, a pair of skulls indicates that the destination of the procession is a cemetery or a charnel ground where corpses were abandoned, two locations that figure frequently in *jātaka* stories.

The identification of this episode, which could be part of the illustration of several different *jātakas*, is made difficult by the fact that the two preceding panels, which could have helped us to identify the story, have both sustained considerable damage. The story illustrated on the reliefs immediately following the original location of this relief, but separated from it by the western staircase, is the *Bhūridatta Jātaka* (Pali collection, no. 543), in which the chief protagonists are a *nāga* and his *nāginī*, each clearly recognizable by the hood of a snake head on top of the headdress. Unfortunately, damage to the Bangkok relief does not allow us to ascertain whether any of

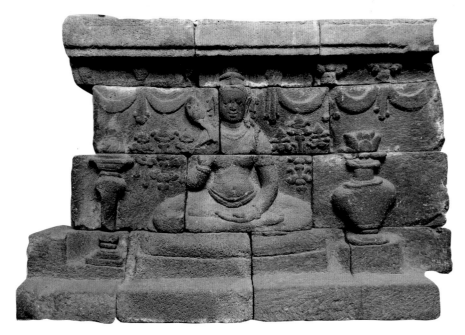

cat. 10, recto

the women in the procession wear such a hood. If this were the case the relief might illustrate part of a version of the *Bhūridatta Jātaka* somewhat at variance with the story as given in the Pali canon. Slight deviations from the legends as they have been transmitted to us in Sanskrit, Tibetan, Pali, Chinese, and other languages frequently prove to be an obstacle to the identification of reliefs at Borobudur.

While the textual source of this episode remains uncertain, the relief does illustrate some of the typical characteristics of the reliefs of Borobudur. By scrupulously avoiding placing the faces at the seams of the stone, the sculptors denied themselves freedom of composition and often ended up creating row upon row of people, seated or standing, all of approximately the same height.

The sculptors also avoided any representation that could interrupt the elevated thoughts and contemplative mood of the viewer. Any mention in the text of violence or other inappropriate behavior was played down or reduced to a symbol. Thus a graveyard scene that provided the reader of the *jātaka* with some rather gruesome details was hinted at only symbolically by a pair of skulls tucked away in the corner of the relief.

Although not as vivid in its characterization of human activities as some of the other *jātaka* scenes, the Bangkok relief nevertheless conveys an accurate impression of the art of Borobudur. The relief fits into the even flow of illustrations of meetings with *gurus*, respectful audiences, or pious pageants and other constantly recurring events, from which unpredictable twists and turns of the stories have been expurgated. This repetition was part of the message instilled in those who came to seek enlightenment at Borobudur, and only the artists' irrepressible penchant for subtle variation prevented it from becoming monotonous. By dint of repetition the desire was awakened in the devout Buddhists to emulate the examples illustrated, preparing their minds for the revelations of faith that they were to experience on the higher galleries of the monument.

Literature: van Erp 1917, esp. 296–298; Krom 1920, 372–373; van Erp 1923, esp. 504–507 pl. 4 (illustrates incorrectly assembled relief); van Erp 1927, esp. 507–508, pl. 6 (illustrates correctly assembled relief); van Erp 1929.

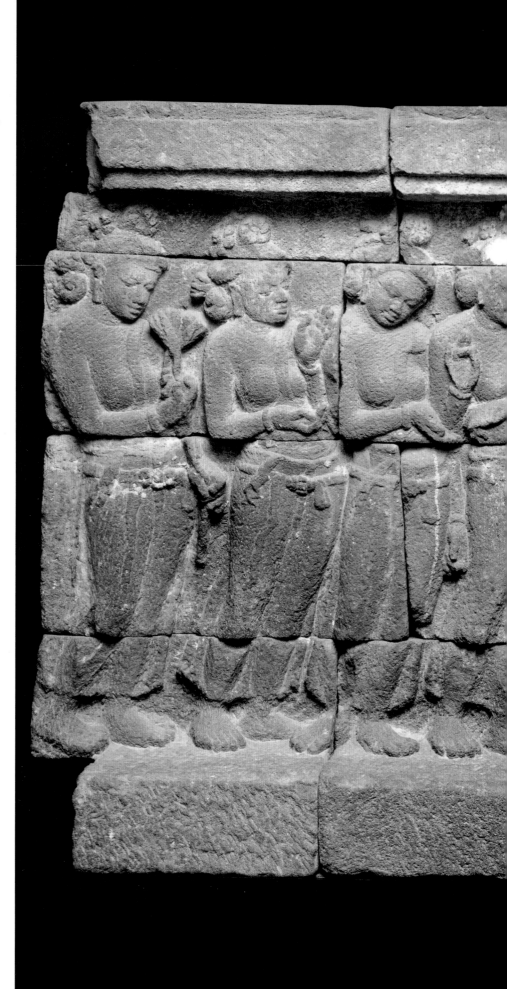

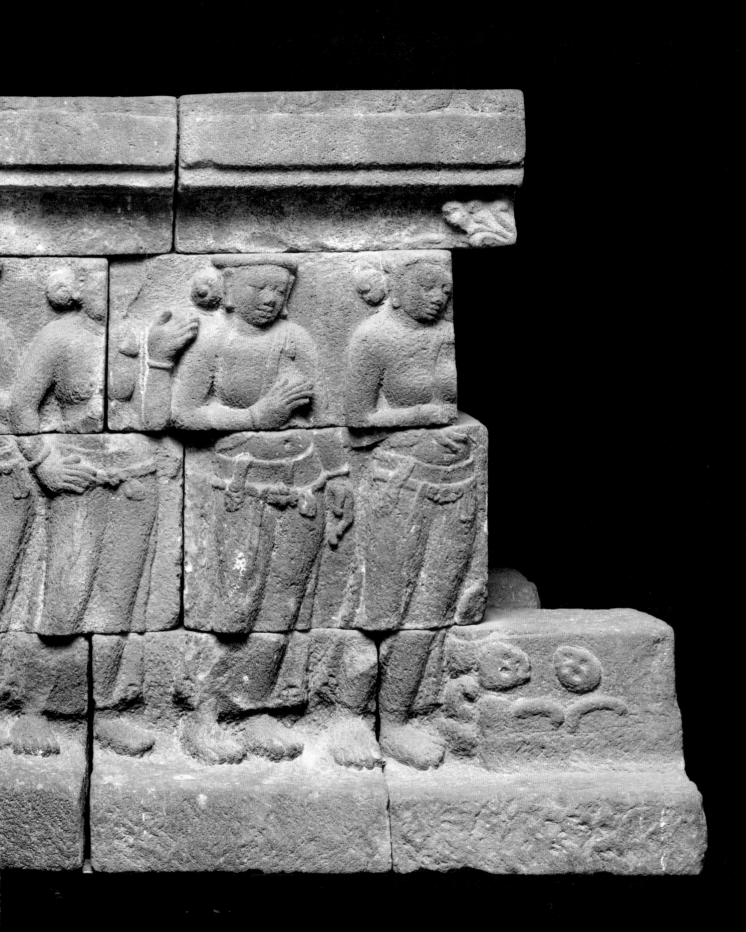

II
Amitābha

c. ninth century
Central Java, from Candi Borobudur
andesite, 41 3/4 in. (106 cm)
Museum Nasional, Jakarta, inv. no. 226

THE BUDDHA is seated in cross-legged position, with closed eyes, deeply immersed in meditation. His hands are held in his lap in a symbolic meditative gesture (Skt. *dhyāna-mudrā*). He is clad in thin, diaphanous monk's garb; as is the case with all seated Buddha images at Borobudur, his right shoulder is bare. In strict accord with the description of the Buddha's appearance given in the canonical texts, the closely spaced curls of hair and the *ūrnā* on his forehead all turn clockwise (Skt. *pra-daksināvartakeśa*). Elongated earlobes suggest the former presence of ear pendants, part of the jewelry discarded by the future Buddha when he resolved to seek the road to Supreme Enlightenment. On top of the head rises the cranial protuberance (Skt. *usnīsa*), another of the bodily marks (Skt. *laksana*) of a Buddha. Although the rather pronounced nose reminds us of its Indian Gupta prototypes, the round face reflects Javanese physiognomy and gives the image a softer quality than many of its Indian counterparts.

This sculpture is one of 504 Buddha statues from the Buddhist sanctuary Candi Borobudur (near Muntilan, Central Java). At Borobudur the architects succeeded in blending three or perhaps even more different concepts into a single harmonious architectural creation. The first of these concepts is that of the *stūpa*, the funerary monument for a Buddhist saint that symbolizes the triumph of *Nirvāna* over the chain of rebirths (Skt. *samsāra*), the root of all suffering. The second concept is that of Mount Sumeru, the cosmic mountain that rises from the center of the world to connect heaven and earth. On a blending of these two concepts the architects of Boro-

budur superimposed an elaborate configuration of Buddhas, together forming a huge, three-dimensional mandala. At Borobudur this system comprises 504 Buddhas.

The 368 Buddha statues that are placed in the niches on top of the first balustrade and the three lower main walls of the galleries of Borobudur display different symbolic gestures (Skt. *mudrā*) on each of the four sides of the monument. These four types of Buddhas are represented in accordance with standard Buddhist iconographical rules. On the north side the statues display the gesture symbolizing absence of fear (Skt. *abhaya-mudrā*); on the east side the gesture of touching the earth (Skt. *bhūmisparśa-mudrā*); on the south side the boon-granting gesture (Skt. *vara-mudrā*); and on the west side the meditation gesture (Skt. *dhyāna-mudrā*). These gestures identify the Buddhas as Amoghasiddhi on the north, Aksobhya on the east, Ratnasambhava on the south, and Amitābha on the west. The statue exhibited here represents the Buddha Amitābha, and comes from one of the ninety-two niches on the west side of the monument.

In the most common Buddha systems, these four directional Buddhas are presided over by the Buddha Vairocana, whose hands form the gesture of the Turning of the Wheel of the Law (Skt. *dharmacakra-mudrā*). All seventy-two Buddhas enshrined in the perforated *stūpas* on the circular terraces on the highest levels of Borobudur display this *mudrā*, and the texts illustrated on the reliefs of the highest galleries of Borobudur, the *Gandavyūha* and the *Bhadracarī*, seem to prepare the viewer for the entrance into the realm of the Supreme Buddha Vairocana. However,

the group of sixty-four Buddhas placed in the niches on top of the fourth main wall all display the gesture of exposition (Skt. *vitarka-mudrā*), and there is no consensus among scholars which Buddha is represented. As the sacred texts that have been illustrated on the walls of Borobudur do not offer any explanation of this obvious deviation from standard iconographical practice, other texts have been adduced to identify these statues. However, efforts to explain these discrepancies with the help of the *Sang Hyang Kāmahāyānikan*, a compilation known in ancient Indonesia but in all probability not older than the tenth century, or the celebrated *Lotus of the True Law* (Skt. *Saddharmapundarīka-Sūtra*), have not yet resulted in a fully satisfactory solution. There are other indications that the *vitarka-mudrā* may have had a different meaning for the Javanese (see cat. 41). The system of Buddhas of Borobudur could therefore well have been an Indonesian variant of the common system, not based upon the texts that have been transmitted to us.

More than two hundred of the Buddha statues of Borobudur have lost their heads. During the recent restoration of Borobudur under the auspices of UNESCO, an effort was made to match fifty detached heads, assembled from all over Indonesia and including some from abroad, with the bodies in situ, but the computer program designed for this purpose yielded only limited results.

Literature: *AIA* no. 3; Brussels 1977, no. 25 c. On the Buddhas of Borobudur: Krom 1927; Mus 1935, 351; Stutterheim 1956b, 33–90; van Lohuizen-de Leeuw 1965; Fontein 1966; de Jong 1974; Bernet Kempers 1976, 159–171; Khandelwal 1977; Boeles 1985.

 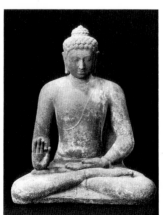

Buddhas displaying symbolic gestures.
Left to right, *abhaya-mudrā*; *bhūmiśparsa-mudrā*; *vara-mudrā*; *vitarka-mudrā*

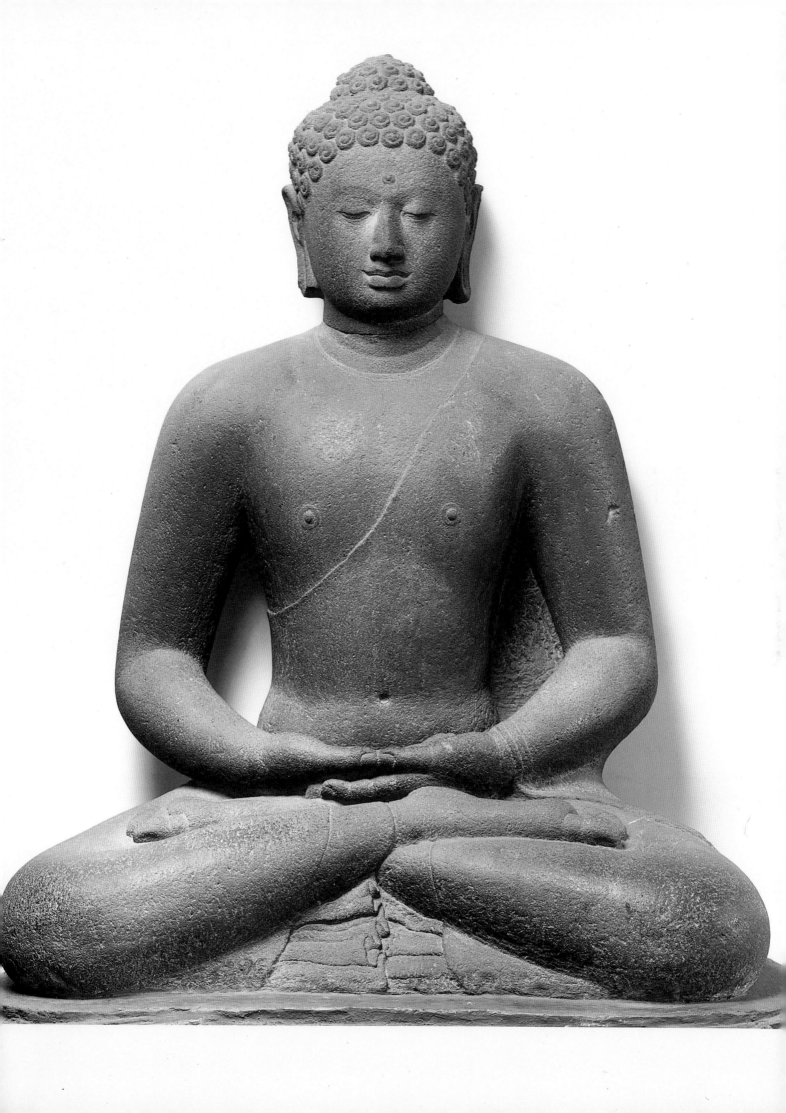

11A
Architectural fragment with *kāla* head
c. 9th century
Central Java, from Candi Borobudur
andesite, 26 x 41 in. (66 x 109 cm)
National Museum, Bangkok

The galleries of Borobudur are surmounted by chapels, each of which contains the statue of a seated Buddha (see cat. 11). All chapels except those on the first balustrade have niches with an arch framed by the *kāla-makara* motif. The arch is crowned by a *kāla* (demon's mask), and the two ends of the arch terminate in *makaras* (fish-elephants) with their heads turned outward. The arches have vegetal motifs, and a stylized treelike triangular element appears above the monster's nose. Not counting the *kāla-makara* framing the gateways of Borobudur, the motif occurs 328 times on the monument. Although many minor variations occur, all *kāla* heads have the same bulging eyes, broad nose, and pronounced cheeks shaped like a handlebar mustache. The *kāla* head symbolizes sun and light, whereas the *makara* stands for water and darkness. The *kāla-makara* thus symbolizes the universe formed by these two primordial elements.

This architectural fragment is one of a considerable number of examples of ancient Javanese art and architecture that were presented by the Dutch colonial government to H.M. King Chulalongkorn of Siam on the occasion of his state visit to Indonesia in 1896. Among the statues the king took to Bangkok were at least five statues of the Buddha from Borobudur, three segments of narrative reliefs from Candi Loro Jonggrang, the only remaining *dvarapāla* from Borobudur (cat. 9), an almost complete relief from the same monument (cat. 10), and a large Ganeśa from Candi Singasari. This was the first time since Engelhard had shipped the statues of Singasari to Holland (cat. 23) that so many statues were removed from ancient Javanese monuments, and the decision of the colonial authorities to grant the king's wishes was later often criticized. There is no doubt, however, that King Chulalongkorn, a devout Buddhist, felt justified in taking these statues from Indonesia, which by that time had embraced the Islamic faith, to Thailand, where several of the statues were enshrined in Buddhist temples. To this day four Buddhas from Borobudur are worshipped at Wat Rachathiwat, Bangkok, while another Buddha image is enshrined at Wat Boworn Nivej in the same city. The king's generous donation to the Archaeological Society of Yogyakarta may well have been connected with his acquisition of sculpture from Prambanan. Three parts of reliefs from Loro Jonggrang were returned to the site in 1926 in exchange for a recently excavated fragment belonging to the Ganeśa from Singasari in Bangkok.

The monster's mask crowning the arches of niches and gateways of Central Javanese *candis* is usually called *kāla* in the archaeological literature. The name is used specifically for the demon's mask of the Central Javanese type, which lacks the lower jaw. The East Javanese version with its full set of fangs is often referred to as *banaspati*, while Indian archaeologists prefer to use the name *kīrtimukha* (face of glory), a term coined in the ancient puranic literature. Although several Old Javanese *kakawins* use the word *cawiri* or *cawintĕn*, this indigenous word has yet to gain acceptance in the archaeological literature. It occurs in the *Arjuna-wiwāha* (Arjuna's Wedding), canto 15:13: "There was a ruined *candi*, the demon's masks looked as if they were crying silently." A similar image is used in the *Śiwarātrikalpa*, canto 3:1: "The monster's head seemed to be weeping as their covered faces were overgrown with a profusion of creepers."

A photograph taken by Isidore van Kinsbergen in 1873 shows this *kāla* head, together with a number of other detached architectural fragments and statues, standing in front of the monument on the north side.

Literature: van Erp 1927, esp. 508, pl. 7; Vogler 1949; Bosch 1960, 45, 177; Teeuw 1969, 73; Zoetmulder 1982, 317.

12

Meditating monk
mid-9th century
Central Java, from Candi Plaosan
andesite, 41 3/4 in. (106 cm)
Suaka Peninggalan Sejarah dan Purbakala
Jawa Tengah, Prambanan

TWO STONE STATUES representing monks immersed in contemplation and two heads that in all probability belonged to similar statuary are thought to have come from the area near the village of Prambanan, where the two great Buddhist sanctuaries Candi Sewu and Candi Plaosan are located. A head in the Museum Nasional, Jakarta, formerly in the Kläring collection, is believed to have come from Candi Sewu, while another head (Museum Nasional, inv. no. 1330) was found at Candi Plaosan. All four show monks with shaven heads and elongated earlobes, suggesting that they portray princes or noblemen who have discarded personal adornments after taking the vows.

The statue exhibited here is the only example of its kind that has come down to us completely intact. It shows a monk seated cross-legged in meditative pose, his head inclined and his hands held in the lap in the symbolic gesture of meditation (*dhyāna-mudrā*). He is clad in a thin monk's robe that bares his right shoulder.

The subtle differences in the shape and expression of the faces suggest that these statues do not merely represent a type or class of people, but that they portray actual persons. In the Buddhist context in which these statues have been found portraits are most likely to be donor portraits.

The Buddhist temple complex of Candi Plaosan consists of a pair of two-storied principal buildings (*vihāras*) in a rectangular courtyard, surrounded by three rows of subsidiary structures. The inner row, as well as the buildings at the four corners, are small temples. All other structures are *stūpas*. To judge from the large number of brief inscriptions that have been carved in stones of the subsidiary buildings, the Plaosan complex was built with the generous assistance of a large number of dignitaries, led by the king himself.

In the walls of the two main sanctuaries figures have been carved in high relief. In all probability they represent the donors of these *vihāras*. To recognize individual donors and to preserve a written record of their meritorious deeds is an ancient Buddhist custom, but nowhere in Java are as many names and titles mentioned as at Candi Plaosan. In this environment, in which such great attention was given to the personal merit of so many individual donors, circumstances may have existed in which portrait sculpture, both in relief and in the round, could come into its own.

Literature: *AIA* no. 5; Brussels 1977, no. 54; Mainz 1980, no. 10. Candi Plaosan: de Casparis 1958; Bernet Kempers 1959, pl. 132; Damais 1968. Candi Sewu heads: Krom 1912; Krom 1926, pl. 6; Bosch and Le Roux, 1931, 666; Bernet Kempers 1959, pl. 134; Rowland 1967, pl. 190.

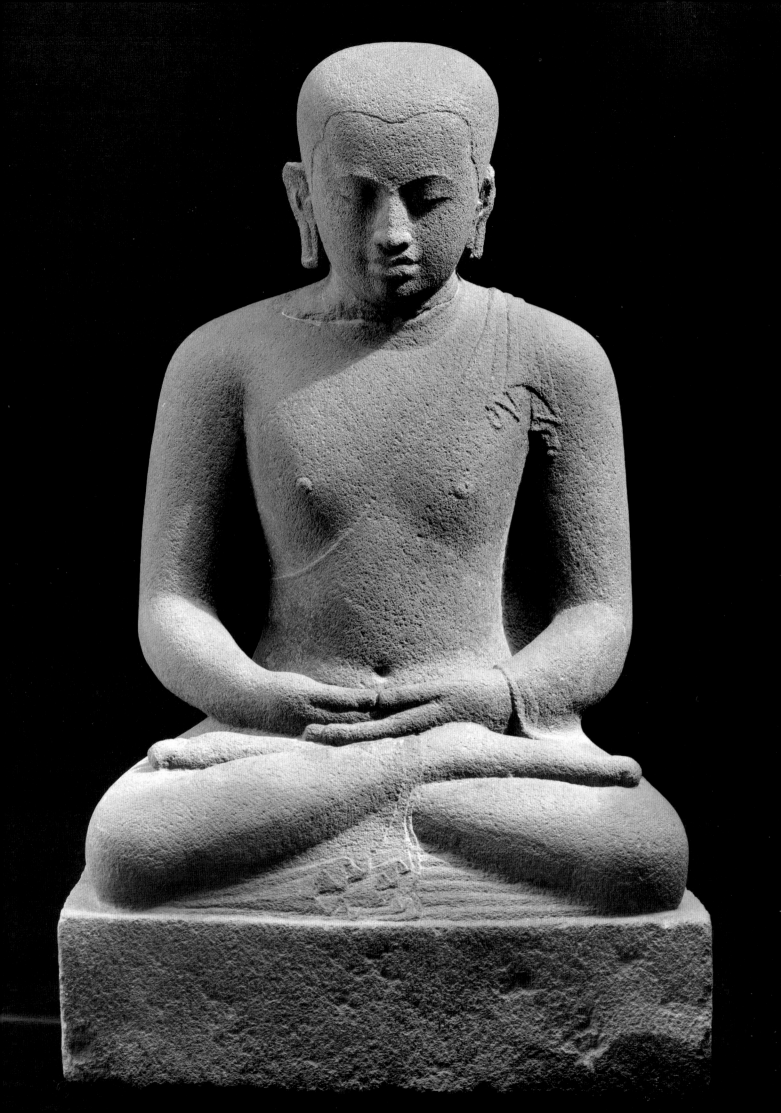

13
Seated queen or goddess with attendant

c. 9th century
Central Java, from Duri, Tirtomartani, Kalasan
andesite, 27 1/2 x 25 3/4 in. (70 x 65.5 cm)
Suaka Peninggalan Sejarah dan Purbakala,
DIY, Bogĕm, Kalasan, inv. no. BG 616

A HALOED QUEEN OR GODDESS is seated on her throne leaning against a round pillow. She is seated in a relaxed pose, her right knee raised, supported by a band (Skt. *gapatta*). Her raised right hand holds a flower; other flowers seem to come falling down from above. To·her left stands an attendant (Skt. *cāmaradhārinī*) in thrice-bent pose (Skt. *tribhanga*) holding a fly whisk in her raised right hand.

Most temple reliefs from Central Java consist of relatively small stones carefully fitted together. This circumstance imposed certain limitations on the sculptors, who took great pains to avoid having the seams between the stones cut through the faces of the figures (see cat. 10). As a consequence the sculptors of the reliefs of Borobudur lacked full compositional flexibility.

The reliefs of the three main temples of Loro Jonggrang, Prambanan, constitute an exception. Relatively large, rectangular slabs were selected for them, giving the sculptors much more freedom of composition. These artists fully availed themselves

of the opportunity to create some of the liveliest and most dynamic narrative scenes in the history of Javanese sculpture.

In the village of Tirtomartani, Kalasan, halfway between Candi Kalasan and Candi Loro Jonggrang, another temple seems to have had reliefs carved on large slabs of stone. The relief exhibited here is one of three carved in a similar style and with the same subject matter, two of which can be traced to the same area. The second is a damaged relief showing a queen or goddess in conversation with a servant kneeling or sitting at her feet, which is kept in the office of the Archaeological Service at Bogĕm. A recent exhibition catalogue mistakenly states its provenance as Kalibeng, Klaten, but it actually hails from Kalibĕning, Kalasan. In the same catalogue the queen is tentatively identified as Sītā, the heroine of the *Rāmāyana*. However, the other reliefs, likewise representing queens or goddesses accompanied by an attendant, do not seem to be narrative in character either, making the identification questionable. The present whereabouts of a third relief, illustrated by

Karl With more than sixty years ago, is unknown.

The dimensions of these pieces, details of the thrones, dress, and jewelry of the queens or goddesses, as well as the flowers falling from heaven in the background, clearly suggest that all three reliefs come from the same set. It is not clear, however, whether they were part of one of the many now completely vanished temples in this area that could still be seen when the first surveys were made during the nineteenth century, or from some completely unrecorded remains.

While the reliefs lack the dynamic movement and freedom of composition that characterize the reliefs of the nearby Prambanan temples, the elegance and quality of the stone carving suggest that the reliefs were once part of a monument of great artistic beauty.

Literature: BG 616 unpublished. The relief in Bogĕm (BG 02): Brussels 1977, no. 74. The third relief: With 1922, pl. 57.

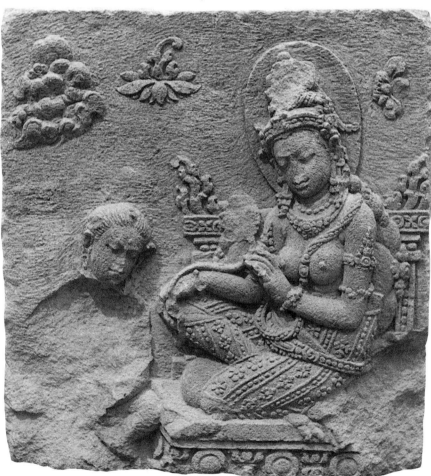

Relief from Kalibĕning, Kalasan. Office of the Archaeological Service, Bogĕm, no. BG 02

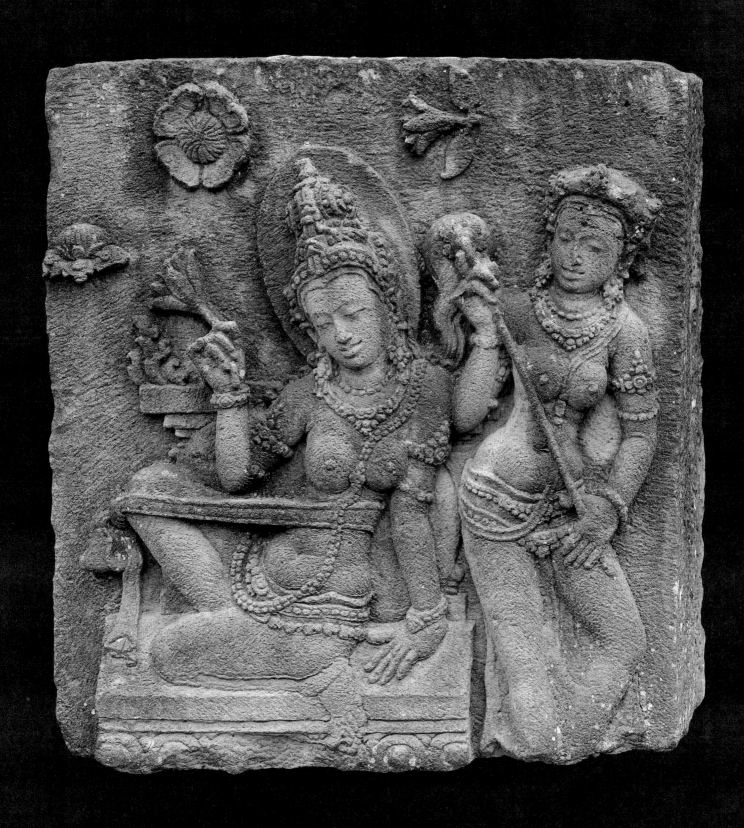

Śrī-Lakṣmī flanked by two elephants

c. 9th century
Central Java
andesite, 18 3/4 x 66 1/2 in. (47.5 x 169 cm)
Museum Sono Budoyo, Yogyakarta,
inv. no. 1304

THE GODDESS OF GOOD FORTUNE, Śrī Lakṣmī, the spouse of Viṣṇu, is seated in cross-legged *virāsana* pose on a lotus throne, her back leaning against a round pillow. Her head is framed by a halo, an indication of her heavenly status. In her raised right hand she holds a red lotus, crowned by a jewel; in the palm of her left hand, resting in her lap, lies a flower. The goddess is flanked by two elephants who sprinkle holy water over her from spouted vessels (*kĕndi*), as if performing a rite of royal consecration. Both elephants carry large bells suspended from collars around their necks. To the back of each is strapped a lotus pedestal surmounted by a large jewel. This auspicious triad stands in high relief, whereas the elegant arabesques on the flat, vertical posts flanking it have been carved in low relief.

This stone sculpture once served as the lintel of the gate leading into the cella of a temple. It was surmounted by a *kāla* (de-

mon's mask); the arabesques are part of the decoration of the door frame connecting the *kāla* above with the pair of *makara* (fantastic fish elephants) below.

In India, gateways of temples have been decorated with representations of Śrī-Lakṣmī since early times. The treatise on architecture *Mānasāra* (c. 6th century) actually contains instructions to temple builders to place a figure of Śrī above the entrance. This instruction may have been known in Central Java, where the entrances to several temples, including those of Loro Jonggrang, are surmounted by figures of the goddess. Yet there is only one other Javanese example of a lintel sculpture showing her flanked by elephants, a representation quite common in India. The upper half of the second lintel of this type lies in the temple grounds of the remains of Candi Sajiwan, not far from Prambanan.

There the elephants carry on their backs dwarflike *kornaks* who raise a sword (or goad) in their right hand. Unfortunately, this sculpture has suffered additional damage since it was first photographed by Th. van Erp, probably around 1905. The lower half of the lintel with the bodies of Śrī, the two elephants, and two flanking deities has not yet been found. However a slab with a *kāla* that fits on top of the lintel has been reunited with it in the course of the reconstruction of Candi Sajiwan, which is presently in progress.

According to van Erp, the lintel included in this exhibition was excavated in 1902 from the remains of Candi Nagasari, one of about a dozen temples in the Plain of Sorogĕdug, to the south of Ratu Boko, that have completely disappeared (see introduction). The Reverend J. F. G. Brumund, who visited the area around 1850, saw no more than a pile of rubble covered by

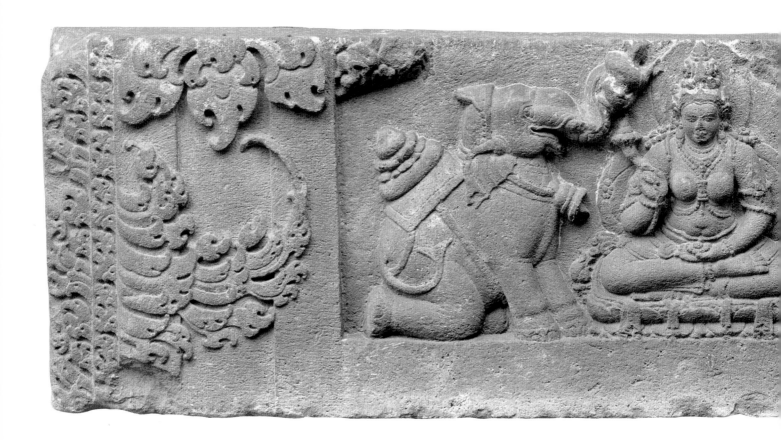

shrubbery. In spite of its ruined condition, however, he was impressed by the high artistic quality of the carving seen at this temple, calling it "a work of art of great value, such as I have never seen before." During the second half of the nineteenth century almost all of the stones of Candi Nagasari, together with all those of other nearby temples, were carried off to provide readymade building material for such projects as sugar mills and dams.

In his report on Candi Nagasari, Brumund singled out a magnificent *yoni* pedestal. This piece was later transported to Tanjungtirta (near Kalasan), and seems to have been taken from there to the Museum Nasional in Jakarta (inv. no. 1302). Van Erp, who visited the site in 1902, appeared convinced that this *yoni* pedestal hails from Candi Nagasari. Bernet Kempers mentioned Candi Krapyak, another of the vanished temples, as a possible provenance.

Early reports and inventories indicate that *yoni* pedestals from both temples were transferred to Tanjungtirta. However, the striking resemblance between the decoration of the neck of the *nāga* of the *yoni* pedestal and the arabesques on the lintel argues in favor of a provenance from Candi Nagasari.

The recorded presence of a *yoni* pedestal at Candi Nagasari indicates that it was a sanctuary dedicated to Śiva, while Candi Sajiwan, where the other Śrī-Laksmī lintel with elephants was found, is definitely Buddhist. It would seem, therefore, that the ancient Javanese followed the Indian tradition of having the doorways of both Hindu shrines and Buddhist temples decorated with representations of the goddess Śrī. In a Buddhist context the representation of a goddess flanked by two elephants was thought to represent Queen Māyā bathed by elephants before she gave birth to the future Buddha.

A bronze vessel (*gěndi*) of exactly the same type as those held by the elephants was found in Padang Lawas (Sumatra). An East Javanese sculpture representing Śrī-Laksmī flanked by elephants, standing in the village of Mojowarno, Jombang, measuring 30 inches (76 cm) in height was reported by A. G. Vorderman in 1839 and inventoried by Knebel in 1907. Its present whereabouts is unknown.

Literature: Brumund 1854, 43; *ROC* 1902, pl. 22, 158; *ROD* 1915, 44, no. 1304 (Verbeek, no. 327); Bosch 1919, pl. 7; Krom 1926, pl. 11 (*yoni* pedestal) and pl. 14a (lintel); Stutterheim 1926a, fig. 16; Yogyakarta c. 1934, 8, no. 7; van Erp 1943c; Bernet Kempers 1959, pl. 161 (lintel), and pl. 166 (*yoni* pedestal); Brussels 1977, no. 10. *Gěndi*: van Erp 1939, 16, fig. 4. East Javanese Śrī-Laksmī: Vorderman 1893, 495; Knebel 1907, 122, 142.

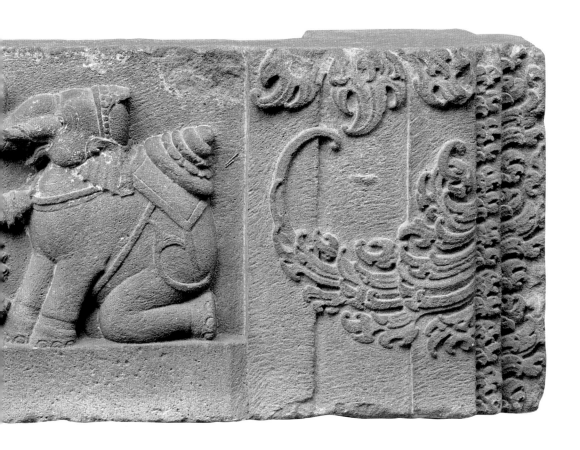

15
Head of a deity

c. 9th century
Central Java, provenance unknown
andesite, 14 ¹/₂ x 15 ³/₄ in. (37 x 40 cm)
Museum Sono Budoyo, Yogyakarta,
inv. no. 5

THIS FRAGMENTARY SCULPTURE, carved in high relief and once part of a wall of a *candi*, represents either a god or a bodhisattva. Part of the halo and the tall headdress have been preserved, but the earrings have broken off and the attribute to the left, perhaps the top of a fly whisk, is almost completely effaced.

The provenance of this charming fragment has not been recorded, but the sculpture is likely to have come from one of the temples near Prambanan or in the Plain of Sorogĕdug.

Literature: Frédéric 1964, pl. 173; *AIA* no. 11; Brussels 1977, no. 41.

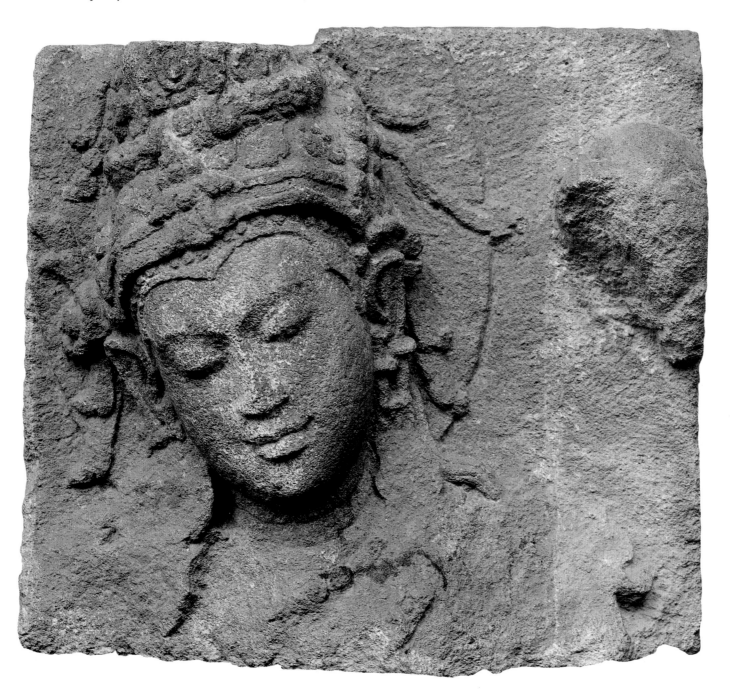

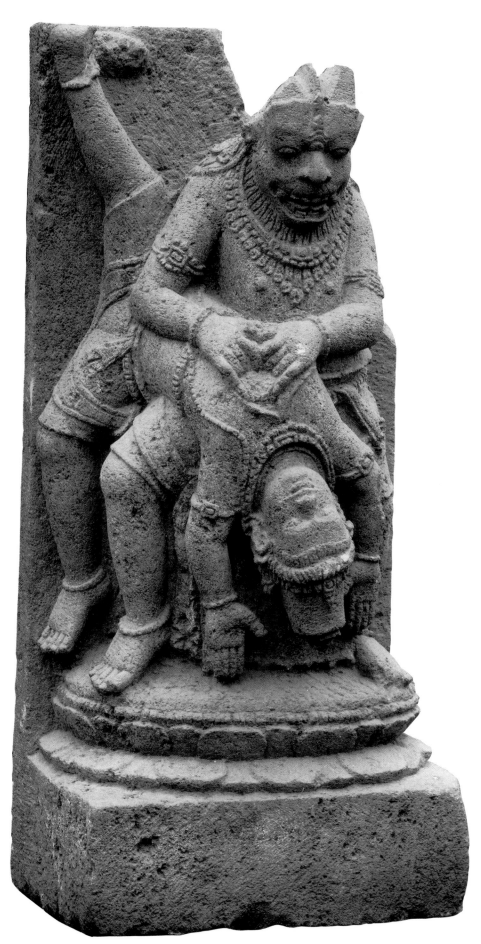

16
Visnu as Narasimha
c. 9th century
Central Java, from Candi Ijo
andesite, 33 7/8 x 15 1/8 in. (86 x 39 cm)
Suaka Peninggalan Sejarah dan Purbakala,
DIY, Bogĕm, Kalasan, inv. no. 547

Narasimha, the *avatar* of Visnu as a man-lion, is shown here as a man with a lion's head, attacking the demon-king Hiranyakaśipu, who was about to kill his own son Prahlāda because he worshipped Visnu. The demon-king has collapsed, lying across Narasimha's right thigh, his head hanging down, his arms dangling helplessly and his right leg in the air in aimless struggle. Narasimha rips open the demon-king's chest with both hands. Although the scene agrees with the story as told in ancient Indian literature, it deviates from standard Indian iconography in that here Hiranyakaśipu is stretched across Narasimha's right thigh, whereas in Indian sculpture he is usually shown on the left thigh. The result is a totally different type of composition.

Representations of the fourth of Visnu's *avatars* are scarce in Javanese sculpture. An inventory of 1902 published in the reports of the Archaeological Commission describes a broken statue from Prambanan of the same iconographic type, but considerably larger in size (50 3/8 in., 128 cm). A later sculpture, perhaps dating from the thirteenth or fourteenth century, is in the Museum Nasional, Jakarta (inv. no. 21). Much smaller in size and in weathered condition, it shows Narasimha grabbing a struggling Hiranyakaśipu with both hands. The demon-king has his back turned toward his assailant. This statue is said to have come from Temanggung, East Java.

The statue exhibited was discovered face down in the grounds of Candi Ijo, a temple complex dedicated to Śiva on the slope of the Gunung Ijo, which is part of the hills overlooking the plain of Sorogĕdug near Prambanan. The stone has the brownish color typical of statues from this site. In the fall of 1989, yet another statue was discovered at Candi Ijo. It represents Visnu in his *avatar* of Trivikrama, the dwarf who made three giant strides. No other representation of this *avatar* has been discovered in Indonesia. The temple complex is in the process of being reconstructed by the Archaeological Service.

Literature: Ijzerman 1891, 54, pl. 21, fig. 84; *NBG* 1893, 6; *ROC* 1902, 44, no. 21; Mainz 1980, no. 102; *Koleksi Pilihan* 1985–1986, pl. 42.

17
Lintel with heavenly beings

early 10th c.
Central Java, from Candi Ngawèn IV
andesite, 18 1/4 x 53 1/2 in. (46.5 x 136 cm)
Suaka Peninggalan Sejarah dan Purbakala
Jawa Tengah, Prambanan

FOUR FIGURES ON THIS LINTEL stand close together, emerging from clouds that reach up to their waists. The figures on the extreme right and left hold what appears to be a staff, but what actually is the bar of a musical instrument known as a bar zither. This instrument frequently appears in the reliefs of Borobudur and is still being used by tribes in central Sulawesi. A similar instrument can still be found in certain parts of south India, where it is known by the name of *kinnara*. Although the etymological origins of this word should in all proba-

bility be sought in the Near East, its resemblance to the name of the mythical heavenly creature *kinnara,* half man, half bird, seems to have resulted in an association of this musical instrument with these legendary creatures and their habitat. At Borobudur *kinnaras* are often depicted playing the *kinnara*; its appearance on a relief usually suggests that the scene is laid in heaven. The presence of the *kinnara* bar zither confirms the heavenly status of the figures in the clouds.

The lintel was found in the remains of

Candi Ngawèn, a group of five temples located in the village of that name near Muntilan. The five temples, numbered I through V from north to south, were laid out in a row, facing east, with equal distance between them. Ngawèn II and IV were considerably larger than the other three. The complex seems to have presented a more or less symmetrical arrangement of temples alternating in size. They were probably dedicated to the five Jinas, but only a statue of Ratnasambhava and one of Amitābha have been found in situ, the first in Ngawèn II, the second in Ngawèn IV.

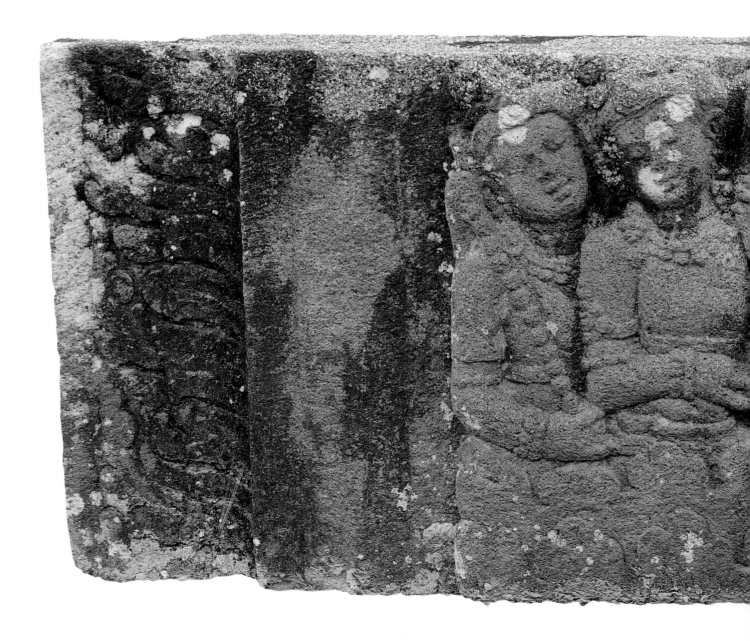

In spite of the fact that the buildings had been razed practically to the ground, and notwithstanding their inaccessibility due to their location in a swampy area, the high artistic value of these ruins was observed as early as 1899 when the Dutch colonial officer J. van Aalst first investigated the site. Th. van Erp followed up with a more complete survey in 1909. In 1927 P. J. Perquin succeeded in partially reconstructing Ngawèn II. Its most striking feature turned out to be the rampant lions, sculpted in the round, at the four corners of the base of the temple and functioning as gargoyles (see photo, p. 75). The second large structure, Ngawèn IV, probably had similar gargoyles, while the three smaller buildings featured corner lions in relief. The gate, a structure separated from the main temple building by a corridor, has its own distinct type of base moldings, quite different from those of the main building. This feature is common to structures dating from the final decades of the Central Javanese period and foreshadows developments in East Javanese architecture.

Ngawèn II has a lintel representing heavenly beings above the entrance of the main building and three lintels of a smaller size with similar figures above the niches in the outer walls of the temple. The lintel exhibited here was found among the remains of Ngawèn IV. Its size suggests that it served as a lintel above the entrance of the temple.

Literature: *ROC* 1911, 17, 73; With 1922, 56; Krom 1923, 1:324; *OV* 1927, 50–83, esp. 60; Kunst 1956, 18–20; Williams 1981, 25–45.

The abduction of Queen Mrigāvatī by a Garuda

c. 977
Eastern Java, from Jalatunda
andesite, 21 5/8 x 38 1/2 in. (55 x 98 cm)
Museum Nasional, Jakarta, inv. no. 5840

THIS RELIEF from the bathing place Jalatunda depicts the Indian legend of the abduction of Queen Mrigāvatī, the wife of King Sahasrānīka of Vatsa. Pregnant with her first child, Mrigāvatī felt a strong desire to bathe in blood. Her husband promised to fulfill her wish, but filled the pool with a red dye instead. As the queen was bathing, she was spotted by a Garuda, who mistook the dye-covered queen for a chunk of raw meat, swooped down, and carried her off. When the Garuda discovered his mistake he dropped her on top of Mount Udaya, where she was found by a hermit's son and hospitably received in the Jamadagni hermitage. There she soon gave birth to Udayana, the last of the illustrious Pandavas.

The scenes on the relief illustrate the main points of the legend. On the left we see Sahasrānīka's palace, a building with a double roof, the upper of which has a tilted gable end. King Sahasrānīka rushes forward from the shadow of a huge tree in an unsuccessful effort to rescue his beloved wife. Scantily clad, her hair hanging loose, she is carried off on the back of the Garuda. Two horizontal H shapes symbolize the clouds into which they are about to disappear. On the right side of the relief we see Mrigāvatī's final destination, a simple hermitage with a hermit's cave, surrounded by stylized rocks.

The carving, originally mounted above a waterspout, is one of sixteen reliefs that were once placed on the central terrace in the main basin of Jalatunda. The monument is located on the west slope of Mount Penanggungan in East Java. The mountain's central peak is surrounded by foothills, the four highest of which rise almost symmetrically on each of its four sides. Mount Penanggungan thus became identified with the cosmic mountain Sumeru, which was thought to be similar in shape. As Mount Sumeru was believed in Indian cosmology to produce the elixir of life, the water that flows from the slopes of Mount Penanggungan was also considered holy. Whereas the monuments higher on the slopes all seem to date from the fourteenth and fifteenth centuries, two bathing places on the slopes, Jalatunda and Belahan, both date from the tenth century.

Jalatunda has a large basin excavated from the slope of the mountain. Through a system of ducts the water of a spring was fed into a sculpted stylized replica of Mount Sumeru (now in the garden of the Trowulan Museum) on a central terrace and flowed from there through sixteen spouts into the basin.

The sixteen reliefs mounted above these spouts illustrate stories from the life of the legendary Indian king Udayana's ancestors and their spouses, all in chronological, generational order, concluding with Udayana himself. Right below the relief depicting Udayana is an inscription giving his name, while another inscription reading "Mragayavatī" was originally placed below the relief exhibited here.

The bathing place, discovered by Ensign J. W. B. Wardenaar in 1817, remained in ruinous condition until B. de Haan restored the monument between 1921 and 1923. Many of the faces of the principal charac-ters in the reliefs had been willfully damaged, but in the course of the restoration some fragments were recovered from the mud-clogged main basin. Most of these could be reattached, but the head of Mrigāvatī, found in the mud right beneath the original location of the relief, seems to have been lost again later.

An inscription on the back wall has the date 899 of the Śaka era (977). This makes the monument the earliest of the datable East Javanese monuments, erected during the lifetime of the father of the great Javanese king Erlangga. It certainly is no coincidence that Erlangga's father's name was Udayana, and we may assume that the Javanese perceived a close analogy between the pedigree of the legendary Udayana and the ancestors of their royal house.

The fact that Ensign Wardenaar found a stone urn under the stones of the terrace was long taken as proof of the funerary character of Jalatunda. Calculations, based in part on solid epigraphical evidence, make it likely that Udayana was born between 963 and 977. Now that Soekmono has convincingly demonstrated the non-funereal character of the Javanese *candi*, the fact that Jalatunda was built early during Udayana's lifetime instead of after his death no longer constitutes a problem.

Jalatunda is the earliest of several bathing places in the East Javanese style. The use of a central terrace and two additional small basins predates by several centuries a similar arrangement at the recently restored Candi Tikus (Trowulan). As remarkable as its connections with later East Javanese monuments are its departures from the Central Javanese style of only fifty years earlier: the eclipse of the *Kāla-makara* motif and the discarding of the *makara* as gargoyles.

The reliefs, too, reveal a radical departure from the Central Javanese style. The requirement to illustrate an often complex story in a relatively small space called for the creation of remarkably detailed scenes for which the coarse grain of the porous volcanic stone was not well suited. There is as yet no trace of the tendency to reduce carving from the three- to the two-dimensional plane, so typical of later East Javanese relief sculpture. On the contrary, the carving, especially of the dramatis personae, is deep and suggests a style borrowed from techniques perfected in more malleable media such as clay or wood. Gone is the large retinue that accompanies each important person in the reliefs of Borobudur; for the slender figures, dressed soberly and mostly without elaborate jewelry, are all by themselves in the setting crowded with typical stylized rock ornament. Jalatunda thus marks the beginning of a new Javanese vision in which the Indian legends, most of which are illustrated here for the first as well as the last time, have been transposed into a purely Javanese setting.

Literature: Krom 1926, pl. 23; Stutterheim 1932; Galestin 1936, 211–214; Stutterheim 1937c; Bernet Kempers 1959, pl 187; Bosch 1961c; Frédéric 1964, pl. 202; Bosch 1965; *AIA* no. 15; Galestin 1967; Satari 1975, fig. 13; Soekmono 1977, 28–29.

19
The abduction of Sītā by Rāvana

c. 11th century
East Java, provenance unknown
sandstone, 15 1/2 x 30 1/2 in. (39.5 x 77.5 cm)
Museum of Fine Arts, Boston,
acc. no. 67.1005

THIS RELIEF depicts one of the key dramatic episodes in the Indian epic *Rāmāyana*, the abduction of Sītā by Rāvana. After Sītā's husband Rāma and his faithful brother Laksmana have been lured away from the hermitage in the forest of Dandaka, in which the three of them are living together in exile, Rāvana gains admission to the hermitage disguised as an itinerant priest. When Sītā turns down his advances, Rāvana reveals his true identity, overpowers the resisting Sītā, and carries her off to his island kingdom Lankā on his mount, Puspaka.

The relief is divided into two halves by a tree and a row of *candis* seen in a type of bird's-eye perspective not unlike that used by the sculptors of Borobudur. The row of temples, resembling the rock-cut *candis* of Tampak Siring (1079, Bali), are part of the enclosure of the hermitage, the walls of which are crowned by decorations in the shape of *kĕbĕn* fruit. In the foreground of the center stands the heroine Sītā, her head demurely turned away from the bogus priest Rāvana, who carries a gourd on a strap and a jingling staff (Skt. *khakkhara*) as the attributes of his disguise.

The identification of the two figures in the buildings of the hermitage is less certain. The seated woman on the left may be Rāvana's sister Śūrpanakhā, whose nose was cut off by Laksmana, the cruel act for which Sītā's abduction was the revenge. As many of the protruding parts of the relief have been damaged, it is unclear whether the damage to the woman's nose was accidental or intended by the sculptor. The figure in the back, who seems to be spying on the scene in the foreground, is probably a second representation of Śūrpanakhā, the result of the artist's synoptic method and based upon the passage that is rendered in the old Javanese *kakawin* as: "There was a certain demoness, Śūrpanakhā, who was a spy for Rāvana. She wandered through the forest and arrived at the hermitage in the Dandaka Forest" (Old Javanese *Rāmāyana*, 4:27).

The right half of the relief depicts the actual abduction. Rāvana has slung his right arm around the waist of his victim, whose posture expresses both her utter despair and the speed with which she is being carried off. She raises her arms in a helpless gesture, her hair trailing behind her in waves. Rāvana is riding Puspaka, a demon

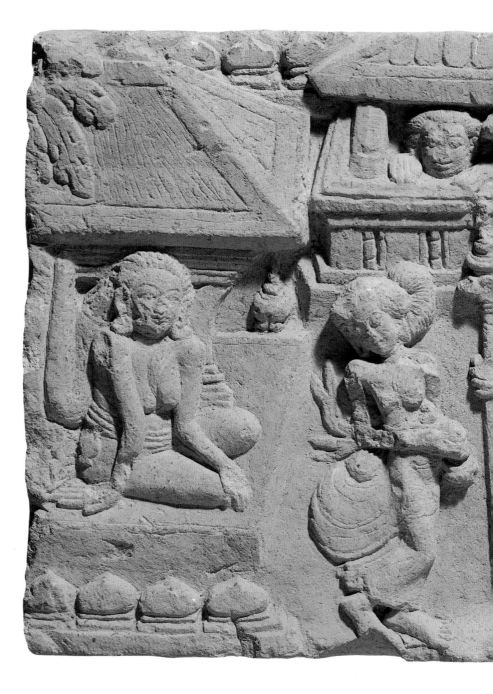

who raises his right hand and index finger in the threatening *tarjani* gesture and who holds a twin-bladed weapon in his left hand. Stylized clouds indicate that Puspaka is already airborne.

Toward the end of the Central Javanese period the epic story of the *Rāmāyana* became known in Java in several different recensions. An inscription dating from 907 records a recital of the *Rāmāyana* at a festive ceremonial occasion. This recited version seems to have been different from the *kakawin*, a poem in Old Javanese, composed according to the rules of Sanskrit prosody. The Old Javanese *Rāmāyana* was

not a translation or adaptation of Vālmīki's Indian classic, but was based upon a shorter and later version known after its poet as *Bhattikāvya* (Bhatti's poem). At approximately the same time the story was carved in stone on the balustrades of Candi Śiva and Candi Brahmā at Prambanan. This sculpted version, the most elaborate rendition of the *Rāmāyana* in stone anywhere, follows more closely the narrative of Vālmīki's epic than does the Old Javanese *Rāmāyana*. However, there are also some important deviations from the story, and some of the reliefs can only be explained with the help of a much later Malay version of the epic tale.

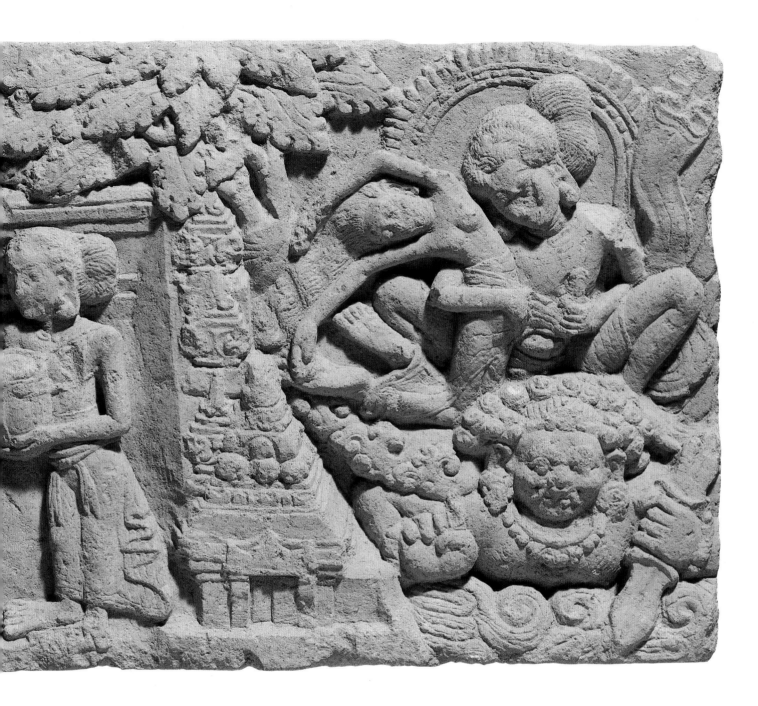

The Boston relief differs in several respects from both the narrative of Vālmīki's epic and the Old Javanese *Rāmāyana*. In the *kakawin* it is told that Sītā left the hermitage to wander off into the surrounding forest before meeting Rāvana. The relief follows Vālmīki's version in that the fateful encounter takes place inside the hermitage. The second deviation from both written sources is that the relief shows Rāvana mounting a demon, whose name Puspaka is mentioned elsewhere in the story, whereas the texts make specific mention of his donkey-drawn chariot. The corresponding relief at Prambanan does justice to the passage in the story in which Rāvana, about to abduct Sītā, assumes again his normal ten-headed appearance. The Boston relief shows Rāvana as a human being.

Sītā's dress and hairdo, the architectural style of the *candi,* and the *kĕbĕn* on the wall of the hermitage, as well as the tree separating the encounter from the abduction, are reminiscent of the Jalatunda reliefs. A relief in the Museum Nasional, Jakarta (inv. no. 396a), of a size identical with that of the Boston relief, once even was attributed to Jalatunda, even though its provenance is unknown, its carving is less deep, and its theme does not seem to fit into the iconographic program of that bathing place. The relief probably represents Hanuman's return to Rāma's camp after a first reconnaissance of Langkā.

It is possible that both reliefs came from a now vanished temple decorated with *Rāmāyana* reliefs, dating perhaps from the eleventh century, the only monument illustrating this epic theme between Prambanan (c. 900) and Panataran (fourteenth century).

Literature: Fontein 1973, no. 363, 21–35.

Bhattāra Guru (?), Sūrya, and Candra

11th–12th century
East Java, Candi Gurah
volcanic stone, 30 3/8 in. (77 cm); 30 1/8 in.
(76.5 cm); and 31 in. (78.5 cm) respectively
Museum Nasional, Jakarta inv. nos.
8454–8456

IN 1957 the Archaeological Service of Indonesia received information that farmers in the village of Tiru (Gurah near Kediri, East Java) had come across an unusually fine stone sculpture while digging a well. This report prompted an in situ investigation, and excavations in the course of the following two years brought to light the remains of a Śivaite temple complex built from brick and stone, covered by about fifteen feet of sand and rocks.

Candi Gurah consists of a main building measuring thirty-seven feet square (enlarged from an original thirty-one feet) facing west, and three smaller subsidiary buildings in a row opposite the main temple facing east, an arrangement known from several Central Javanese sites, but not from East Java. Another feature only known from Central Java are the stone *makaras,* with parrots in their wide-open jaws, flanking the stairs. While the cult image of the main shrine turned out to have been smashed beyond recognition, the middle subsidiary temple contained three complete statues. A reclining Nandin was flanked by statues of Sūrya and Candra, the gods of the sun and the moon, an iconographic arrangement reminiscent of that of Candi Loro Jonggrang, Prambanan (Central Java), where a similar group of statues is housed in the temple opposite Candi Śiva. The third statue, representing a four-headed deity tentatively identified as Brahmā, was found by the farmers in what turned out to be the remnants of the northern subsidiary temple.

Although the layout of the complex, such details as the moldings of the base, and the iconographic program reveal unmistakable connections with Central Java, the statuary bears all the characteristics of East Javanese sculpture. The shapes of the ornate jewelry and the two large sashes tied into bows at the hips, one end falling down across the lotus pedestal, and, above all, the style and extraordinary quality of the carving offer numerous parallels with the statuary of Singasari (see cats. 23, 24, 25).

Sūrya and Candra are very similar, although the quality of the carving of the latter is superior. The main difference between the two statues lies in the gestures of the hands, all of which are held with the palms turned upward and with a flower inside. Candra's right hand rests in his lap, the left rests on his knee, while both hands

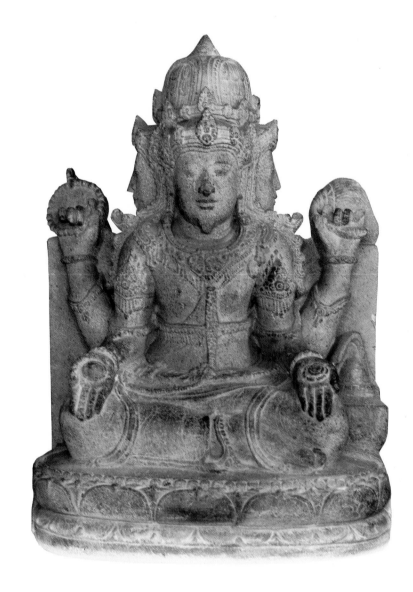

of Sūrya rest upon his folded knees, with the left leg placed upon the right.

While the statues of Sūrya and Candra have plain, arched backs, that of the four-headed, four-armed deity has a square back, low enough to allow the fourth head at the back to remain visible, peering over the upper edge. In his upper hands the deity holds a rosary and a fly whisk; the other two, containing flowers, rest with their palms upward on the knees in a gesture identical with that of the Sūrya. To his left

stands a water pot (*kamandalu*) of unusual shape, provided with a handle and a cover shaped like the cosmic mountain Sumeru.

Although it is usually the god Brahmā who is represented with four heads, the fact that this statue was found in one of the subsidiary temples and is of practically the same size as Sūrya and Candra argues against its identifications as one of the gods of the *Trimūrti*—hence equal to Śiva. It may, therefore, represent another form of Śiva, perhaps Bhattāra Guru, the divine teacher, or

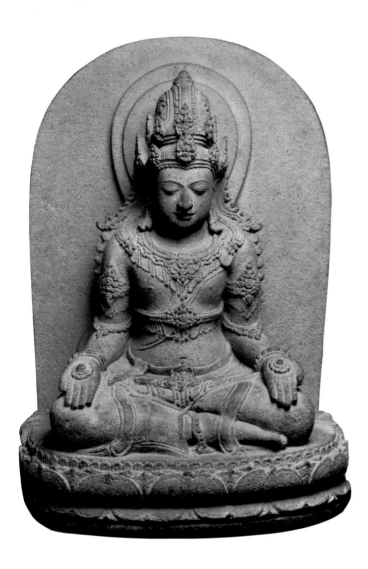 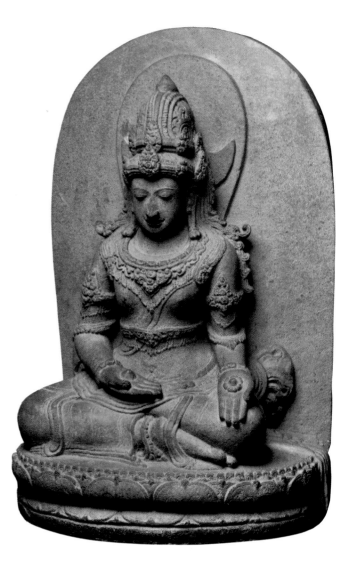

the deified sage Agastya. In the Central Javanese temple complex of Candi Merak, the subsidiary temple to the right of the main structure contained an image of an enthroned Agastya, flanked by two adorers.

Whereas the architectural remains were all found in a ruinous state with little remaining intact above the base level, the excavated statues are all in perfect condition. Buried deep in the earth for centuries, they were spared the wear and tear of the tropical climate. All the minute details of the elaborate jewelry stand out as crisply as if they had been carved yesterday, and no damage has been inflicted upon their faces.

Even the expanded sections of the main building of Candi Gurah with their typical Central Javanese type of moldings and the stone *makaras* are unlikely to antedate the statuary by many years. A brief inscription, consisting of a single word, is written in the style of the eleventh or twelfth century. This epigraphical evidence supports the opinion of the excavators that Candi Gurah should be seen as a link between Central and East Javanese art and architecture, a complex from a dark period from which hardly any other monument survives.

Literature: Soekmono 1969; *AIA* no. 16; Gonda 1970. Nandin temple, Prambanan: Krom 1923, 1:485–486. Statue, Candi Merak: OV 1927, 156 and pl. 26c.

21

The goddess Māmakhī

13th century
East Java, from Candi Jago
andesite, 11 3/8 in. (29 cm)
Courtesy of the Trustees of the British
Museum, London, Gift of the Rev. Flint,
executor of the will of Lady Raffles 1859,
12–28. 171

THE GODDESS MĀMAKHĪ is seated cross-legged on a double lotus throne with a plain, rectangular throne back. She is dressed in royal attire and wears elaborate jewelry such as ear pendants, necklace, arm bands, a cross band on her chest, and bracelets and rings on the thumb of the right hand and the big toe of the right foot. The right hand rests with the palm turned upward on the right knee in the boon-granting gesture (*vara-mudrā*). The raised left hand holds the stem of the blue lotus with pointed petals (*utpala*), which rises above the left shoulder. The sashes of her dress are draped upright against the throne back, and two ribbons float upward against the halo, surrounding the head with its elaborate *jatāmukuta* headdress. The halo is flanked by two parts of an inscription in Indian *Nāgarī* script, cut into the throne back and together reading "Bharālī-Māmakhī."

Four other statues of the same type represent the Jinas Aksobhya and Ratnasambhava and the goddesses Locanā and Pānduravasinī. All four are now in the National Museum, Jakarta (inv. nos. 224a, 225a, 248a, and 248b). All seem to have been part of the same set, which originally may have represented the Five Jinas and their *prajñās* (female counterparts).

These statues all came from Candi Jago, a temple in the village of Tumpang, east of Malang (East Java). Its present name Jago in all probability derives from Jajaghu, a name mentioned in Prapañca's *Nāgara-Krĕtāgama* (canto 41:4) as that of a sanctuary built in memory of King Wisnuwardhana of the Singasari dynasty, who died in 1268. The temple may have been built in that year or in 1280, the year in which a *śraddhā* memorial service was held for him. The terraced structure is decorated with series of reliefs illustrating Buddhist as well as Śivaite legends, while the statuary enshrined in it represents Buddhist deities. This amalgam of Buddhist and Śivaite associations would seem to be a fitting memorial for a king immortalized both as a Buddha and as Śiva.

The principal image (still in situ but now headless) represents Amoghapāśa Avalokiteśvara. The bodhisattva was flanked by statues of Bhrikutī, Hayagrīva, Sudhana, and Śyāmatārā, all now in the Museum Nasional, Jakarta. In both iconography and style they seem to be influenced by stone sculpture from the Pāla kingdom. Like the Māmakhī exhibited here all are inscribed in the Pāla manner in Nāgarī script. The words *bharāla* and *bharālī,* used in the inscriptions for these figures, are terms of Indic origins, used in Nepalese iconographic texts on the pantheon of Esoteric Buddhism.

In 1286 the successor and son of the king commemorated at Candi Jago, King Krĕtanāgara (reigned 1268–1292), commissioned a large stone stele incorporating all of the above-mentioned images. A number of small replicas of the stele, executed in bronze, may have been made at the same time. These replicas show all of the *Prajñās,* including Māmakhī, with their hands folded in respectful *añjali-mudrā.* This change of gestures would seem to indicate that deviations from standard Indian iconography were acceptable.

The statue of Māmakhī is the best preserved of all the sculpture from Candi Jago. The floating sashes that seem to defy gravity are typical of East Javanese sculpture. The iconography and the style of both statue and inscription suggest a last resurgence of influence from the Pāla kingdom, coming to fruition at a time when Buddhist art was already in full decline in India.

Among the earliest foreign visitors to this temple was Lieutenant-Governor Thomas Stamford Raffles, who visited Candi Jago in 1815 and who was the first to publish a description of the site in his *History of Java* two years later. In his account of his visit, Raffles did not mention the statue of Māmakhī. However, it contains an embellished rendering of the sculpture with a caption reading: "From a subject in stone found near Singa Sari and brought to England."

Literature: Raffles 1817, vol. 2, 2d. pl. following p. 54, fig. 1; Brandes 1904a, 103, 107, pl. 18; Krom 1923, 1:114–115; Bernet Kempers 1933c; Ghosh 1980, 91–146; Scheurleer 1989; Sedyawati 1989b.

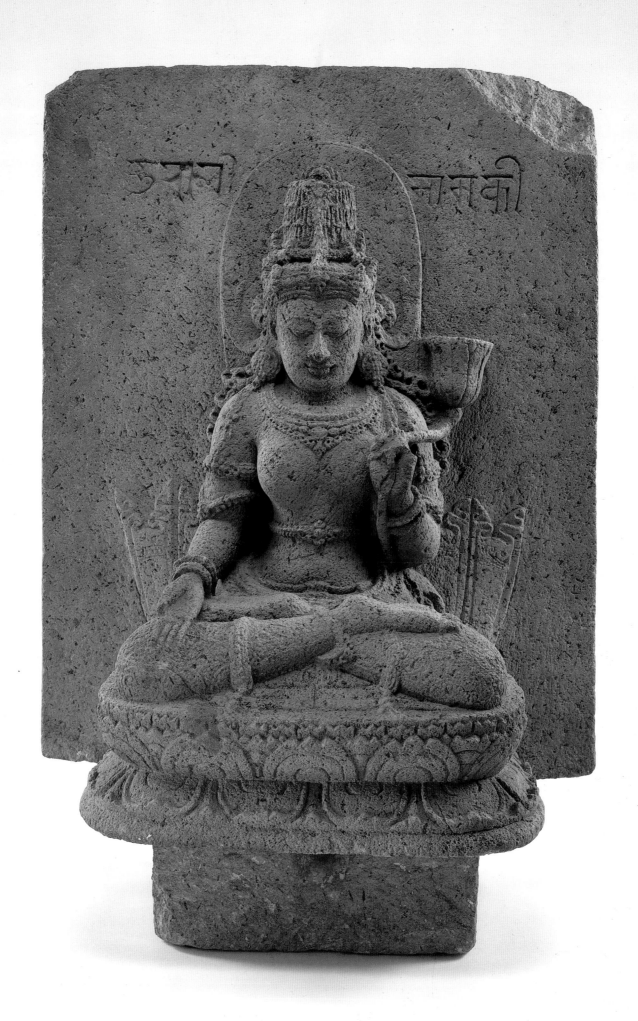

22

Durgā slaying the demon Mahiśa
14th century
East Java, from Candi Jawi
volcanic stone, 37 in. (94 cm)
Museum Mpu Tantular, Surabaya, inv.
no. 1955

THE ANCIENT INDIAN *Mārkandeya Purāna* and *Matsya Purāna* tell the epic story of the battle between the Asura demons, led by their king Mahiśa, and the gods led by Indra. After the army of the gods was defeated and Mahiśa laid claim to power in heaven, Brahmā led the defeated gods to seek the help of Visnu and Śiva. From the miraculous power of the combined wrath of these two gods, the goddess Durgā was born. All the gods hastened to provide her with the most powerful weapons in the hope that she would succeed in defeating Mahiśa. After she had routed the army of the Asuras, Durgā attacked Mahiśa himself, who had assumed the shape of a buffalo. Standing on top of the buffalo, she killed it, after which the defeated demon emerged from the corpse.

The frequency with which Durgā, the slayer of the Asura demon Mahiśa (Skt. Durgā Mahiśāsuramardinī), is represented in Javanese stone sculpture in both the Central and East Javanese periods attests to the lasting and widespread popularity of this goddess in Indonesia. In Javanese temples dedicated to Śiva her icon usually occupies the northern cella or niche. When J. Knebel first conducted a detailed and systematic survey of Javanese Durgā images in 1903–1905, he drew his conclusions from the study of 97 statues. The recent studies by Hariani Santiko (1983 and 1987) are based upon 135 statues, and even her lists are not complete.

The statues of Durgā Mahiśāsuramardinī show the goddess with a number of arms varying from two to ten. The most common iconographic type is the eight-armed Durgā, of which Hariani Santiko listed forty-eight examples from Central and fifty-six examples from East Java. In the Puranic literature the number of weapons given to Durgā by the other gods far exceeds this number of arms. Consequently, there is a choice of weapons that can be shown as attributes of the goddess. A Balinese statue of Durgā even shows a typical Balinese *kĕris* as one of her weapons, but it is evident that the artists on the whole did not have much freedom, and most statues reveal only limited iconographic variations.

From the earliest beginnings Javanese icons of Durgā Mahiśāsuramardinī show marked differences with Indian examples. As a rule, Indian statues depict a violent struggle between the goddess and the buffalo. In the

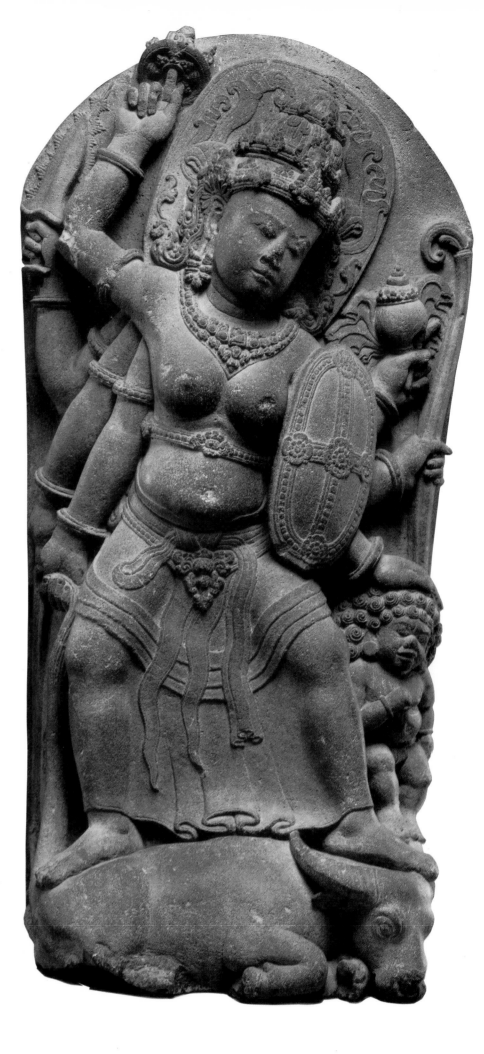

Javanese examples, the battle is already won: the buffalo lies in a static, recumbent position, as if it were the mount rather than the foe of the goddess. In Indian icons the buffalo is the demon, and representations that include both the buffalo and the Asura are the exception. In Java the dwarflike figure of the Asura is invariably seen emerging from the buffalo. This apparent Javanese preference for duplication by showing Mahiśa both as buffalo and as an Asura many have a parallel in the reliefs of Candi Śiva at Prambanan. There the colorful variety of demons that meet their death at the hands of Rāma are often depicted in duplicate, like twins, separating at the moment of death.

The Durgā of Candi Jawi displays many characteristics typical of the dynamic East Javanese interpretation of the classical theme. The goddess stands with her legs wide apart, her feet firmly planted on the back and head of the reclining buffalo. In three left hands she holds a conch (Skt. śankha), a richly decorated shield (Skt. khetaka), and a bow (Skt. dhanu); the fourth hand rests upon the curly hair of the Asura. In three right hands Durgā holds a disc (Skt. cakra), balancing on top of the raised index finger, a sword (Skt. khadga), and an arrow (Skt. śara); the fourth hand pulls at the tail of the buffalo. The sword with its short, broad blade is surrounded by an aura of radiance typical of Majapahit statuary. The halo behind the head, covered by an elaborate headdress, shows ribbons floating upward, a common feature in East Javanese sculpture.

A dramatically raised right hand, balancing the disc and echoing the bent posture of the left leg, dominates the composition, delegating the additional arms to secondary place and thereby enhancing the natural spontaneity of this vibrant scene. The meticulous execution and refined elegance of such details as the jewelry and the decoration of the shield, combined with the quality of the carving of the figure and the face, make this statue of Durgā one of the finest examples from East Java.

The pristine condition of the statue is undoubtedly due to its centuries-long burial in the grounds of Candi Jawi, near Prigen, Pasuruan, at the foot of Mount Welirang (East Java). This temple was built to commemorate King Kr̥tanāgara, who died in 1292. The poet Prapañca, who visited

Candi Jawi in the retinue of King Hayam Wuruk of Majapahit in 1361, made several interesting comments on this temple in his *Nāgara-Kr̥tāgama*. He described it as a combination of a Śiva shrine below and a Buddhist sanctuary above. The fact that the monument is crowned by a *stūpa*, but that all statuary excavated from the site is Śivaite, would seem to confirm Prapañca's words. The poet also mentions that the temple was struck by lightning in 1331, but that the damage had been repaired before King Hayam Wuruk's visit. An inscribed stone carrying the date Śaka 1254 (1332), found in the immediate vicinity, suggests that this restoration may have been carried out not long after the damage occurred.

Between 1938 and 1941 the Archaeological Service excavated the site and succeeded in separate reconstructions of the base, most of the body of the temple, and its superstructure. However, as the exact height of the temple body could not be determined at the time, a complete reconstruction of the monument was postponed. After renewed investigations the entire monument was reassembled between 1975 and 1980.

The temple is a tall, towerlike structure, with a flight of steps on the east side and built upon a high terrace, surrounded by a moat. Other structures in the temple compound included a so-called split gate (*candi bĕntar*), a familiar sight in Balinese temples to this day. One of the reliefs decorating the base of the monument actually shows a bird's-eye view of a temple complex that is in many ways similar to the layout of Candi Jawi itself.

During the excavations of 1938 only remnants of a large Śiva statue were found, confirming Prapañca's words "and inside a likeness of Śiva, splendid, its majesty immeasurable." The other excavated statues, much better preserved, include a Nandīśvara and the Durgā Mahiśāsuramardinī exhibited here. Their superb quality proves that in this case the words of Prapañca were no empty boast.

Literature: Knebel 1903; Knebel 1905; Knebel 1905b; Boeles 1942; Santiko 1983; Renik 1985; Santiko 1987, 586, fig. 7. Candi Jawi: OV 1938, 16, fig. 46; Stutterheim 1941; Bernet Kempers 1959, pls. 243–246; Bernet Kempers 1978, 204–207; Hadimuljono 1982–1983; *Mengenal Koleksi* 1979–1980, 5–7, no. 2.

Candi Jawi

23
Durgā slaying the demon Mahiśa

c. 1300
East Java, from Candi Singasari
volcanic stone, 61 3/4 in. (157 cm)
Rijksmuseum voor Volkenkunde, Leiden,
inv. no. 1403-1622

STANDING TRIUMPHANTLY on top of the slain buffalo, the goddess Durgā strikes a dramatic pose. In six of her eight hands she raises the weapons that the gods presented to her and with which she has just killed the buffalo demon. The hands of the statue have sustained considerable damage, but a comparison with the Durgā from Candi Jawi (cat. 22) and a smaller ($24^{1}/_{2}$ in., $61^{1}/_{2}$ cm), headless Durgā of unknown provenance in the Museum Nasional, Jakarta (inv. no. 146) suggests that all three statues once carried the attributes listed in cat. 22.

A closer comparison of the Durgā statues from Singasari and Jawi reveals a number of marked differences between these two sculptures of the same iconographical type and of approximately the same date. The most striking difference between the two is that of Durgā's posture, sweepingly dramatic and defiant in the Singasari statue, carefully constructed for aesthetic compositional effect in that from Jawi. While the treatment of the drapery folds of Durgā's dress is very similar in both statues, the overall effect of sumptuousness created by the rich, *batik*-like repetitive design of the Singasari costume contrasts with the simplicity of that from Jawi. This contrast extends to the buffaloes, for whereas the Singasari bull has been fitted out with rich trappings of decorated cross bands, the Jawi buffalo looks as if it had just walked in from the paddy fields. As if to emphasize that in the supreme moment of victory there is no longer any need to minimize the Asura Mahiśa, the Singasari statue shows a plump, boyish figure of sizable proportions, whereas the Jawi sculpture makes him into a mean little dwarf.

The introspective, serene facial expression and the extraordinarily rich effect of dress, headdress, and jewelry characterize the Singasari statue as a superb example of the style associated with that monument and, in many ways, the perfect counterpart of the Prajñāpāramitā (cat. 24). The Durgā is the only one of the three Singasari statues in this exhibitions of which the exact original location in the only remaining shrine at Singasari can be established with certainty. In 1804 the discoverer of Singasari, the Dutch colonial official Nicolaus Engelhard, removed six statues from the newly discovered site. Among these were the Nandīśvara and Mahākāla from the niches flanking the doorway to the main chamber, the Ganeśa from the east cella, and the Durgā from the north cella. The lotus pedestal still in situ in the north cella corresponds in dimensions with the Durgā statue. The image of Bhattāra Guru in the south cella, left behind because of the damage it had sustained, confirms that the standard iconographical program of the Javanese Śiva temple had been adopted at Candi Singasari. While the other statues were shipped to Holland in 1819, the Durgā was temporarily installed in the Botanical Gardens in Bogor, and was sent to Holland in 1827. It has been part of the Leiden collection ever since that time.

Candi Singasari, located in the village Candirenggo, Singasari, Malang (East Java), is an unfinished temple structure, consisting of a heavy, square base with four projections rising from a square, elevated terrace. At each of the four sides of the base is a cella; the one on the west side, flanked by two smaller niches, serves as a portico for the central chamber. The other three cellas, which once accommodated the large statues, are accessible from the elevated terrace only. The actual body of the temple is inaccessible from the outside, although its hollow interior is connected with the inside of the superstructure and the main chamber. The narrow, tall niches in the temple body were once partially hidden from view by the roofs above the entrances to the cellas. It is unlikely that they ever contained statuary.

Kāla heads on top of these niches support the cornice of the pyramidal roof, which could only be partially reconstructed. Although the statues in the cellas were all finished, the decoration of the exterior of the temple never reached completion. The carving of decorative details, which started from the top of the monument, was completed only down to the lower end of the cornice of the roof. While the *kāla*-heads supporting the cornice were finished in all their exuberant decorative detail, the shapes of those above the entrances to the cellas have only been roughed out.

According to the *Pararaton*, a temple was built at Singasari to commemorate King Krĕtanāgara, who died in 1292 and whose assassination marked the end of the Singasari dynasty. The historical data concerning the death of the king and the fall of his *kraton* and dynasty leave room for various interpretations, and there is no consensus among scholars about the exact date of Candi Singasari, which may or may not be the edifice Pūrwapatapan mentioned in the chronicle *Pararaton* (see also cat. 24). It would seem reasonable to assume, however, that the cause of the unfinished state of the building should be sought in the overthrow of the dynasty. For that reason the statuary could be attributed to the late thirteenth or early fourteenth century.

An inscription dated in accordance with 1351 records the founding of a shrine to commemorate the priests who lost their lives, together with their king, in the coup of 1292. It is possible that Candi Singasari and its statuary date from this solemn occasion.

Literature: Brandes 1909, pls. 28–29 and 43–45; Krom 1923, 2:68–94; Bosch 1923a; Krom 1926, pl. 26; Blom 1939, 48, 82, 107; Boeles 1942; Bernet Kempers 1959, pl. 237; Rawson 1967, fig. 226; Santiko 1987, 603, fig. 34a.

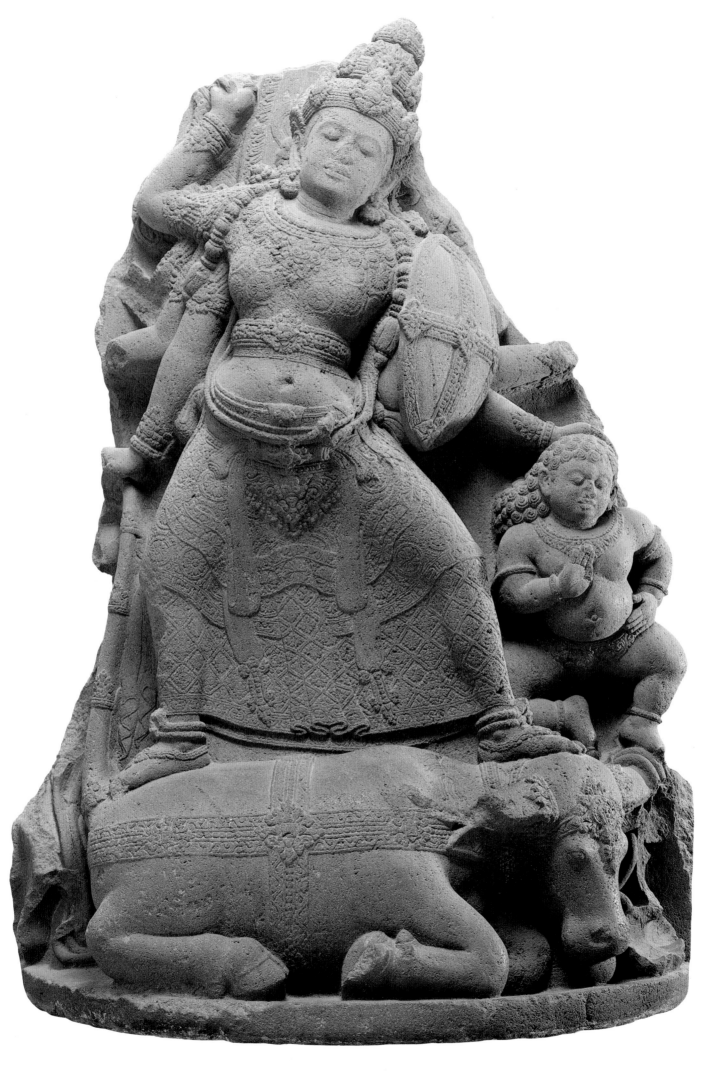

Prajñāpāramitā, the goddess of transcendental wisdom

c. 1300
East Java, from Candi Singasari
andesite, 49 1/2 in. (126 cm)
Museum Nasional, Jakarta, inv. no.
1403/XI 1587

THE GODDESS of transcendental wisdom is seated in lotus position (Skt. *padmāsana*) on a round lotus cushion on a rectangular base. Her hands are raised in front of her chest in the gesture symbolizing the Turning of the Wheel of the Law (Skt. *dharmacakra-mudrā*). A lotus stalk, rising from the pedestal, winds itself around the left arm of the goddess. On top of the lotus flower rests a book, the *Sūtra of Transcendental Wisdom (Prajñāpāramitā-sūtra)*.

The goddess wears sumptuous jewelry, including a sacred thread consisting of triple strings of beads, elaborate bracelets and necklaces, and an ornamental, conical headdress (Skt. *kirītamukuta*). A patterned *kain* covers the lower part of the body and the crossed legs. This display of decorative detail provides a marked contrast with the simplicity of the back slab, which lacks the heraldic animals so often seen on throne backs. The cross bar of the throne back is surmounted by a halo in the shape of a pointed arch, plain except for a border of flames.

The profusion of jewelry also contrasts with the introspective, serene facial expression of the goddess, which is of an awesome spiritual power. In this statue of Prajñāpāramitā, superbly carved and perfectly preserved, the artist has succeeded in creating a perfect fusion of the divine with the human, the supramundane (Skt. *lokottara*) with the mundane (Skt. *lankika*), and transcendental knowledge with the glitter of the phenomenal world from which it has freed itself. There is no other Javanese statue that argues in such a visually convincing manner in favor of the thesis of portrait sculpture, in which gods have human faces and royalty wear divine attributes. In fact this is the only statue that was considered to be a royal portrait before the concept of portrait sculpture was introduced in the scholarly literature. The precise provenance of this statue can only be surmised.

When the Prajñāpāramitā was first seen in 1818 or 1819 by the Dutch colonial official D. Monnereau, the Javanese referred to it as Putri Dĕdĕs (Princess Dĕdĕs), the first queen of Singasari, from whom all kings of Singasari and Majapahit descended. According to J. B. Jukes, who visited Singasari in 1844, one of the ruined temples to the south of Candi Singasari was called "Cungkup (Candi) Putri" or "Temple of the Princess" or "Cungkup Wayang." Jessy Blom has suggested that the Prajñāpāramitā may once have been enshrined in this now completely vanished temple. In 1820 Monnereau gave the statue to C. G. C. Reinwardt, who took it to Holland where it eventually came to be deposited in the Rijksmuseum voor Volkenkunde, Leiden. In January 1978 it was returned to Indonesia, where it was placed in the Museum Nasional, Jakarta.

Our knowledge of Putri Dĕdĕs is largely based upon legendary tradition that may not have been committed to writing before the end of the fifteenth century, when a colorful account of her eventful life and the rapid rise to power of her second husband Ken Angrok, the first king of Singasari, was given in the chronicle *Pararaton*. Putri Dĕdĕs was the daughter of Mpu Purwa, a Buddhist priest of a Mahāyāna sect. She was forcibly abducted by Tunggul Ametung, the governor of Tumapel, who made her his wife. Shortly afterward he was assassinated by Ken Angrok, reputedly the son of a god and a farmer's wife. Ken Angrok took the pregnant Dĕdĕs as his wife. In 1222 Ken Angrok succeeded in overthrowing the regime of the king of Dada (Kadiri) and became the first king of Singasari. King Rājasa or Amūrwabhūmi, as he was henceforth called, died in 1227 and was succeeded by Anūsapati, the son of Dĕdĕs by her slain first husband.

Except perhaps for the fact that Dĕdĕs was the daughter of a Buddhist priest of a Mahāyāna sect, and an identification with the goddess Prajñāpāramitā would, therefore, seem highly appropriate, we have no confirmation of the early nineteenth-century Javanese oral tradition that identifies the statue of Prajñāpāramitā as a portrait of Putri Dĕdĕs. On the contrary, in the *Pararaton*, Ken Angrok's advisor, the brahman Lohgawe, called Ken Dĕdĕs *ardhanareśwarī*, a reference to the goddess Pārvatī. On the other hand, the posthumous identification of another queen with the goddess Prajñāpāramitā is clearly documented in Prapañca's *Nāgara-Krĕtāgama*. This is Queen Rājapatnī, a daughter of King Krĕtanāgara and the queen of King Krĕtarājasa (reigned 1293–1309).

There are three other large stone statues representing a goddess with her hands in *dharmacakra-mudrā* and, consequently, identified as Prajñāpāramitā. The first is a headless statue (54 in., 137 cm) found near Candi Singasari in 1901, but already seen and sketched by J. Th. Bik in 1822. Carved from a type of stone that differs from all other Singasari statues, it has a back slab showing a throne back flanked by heraldic *vyālakas* not seen on any other Singasari piece. Jessy Blom suggested that a head, excavated near Singasari in 1927 (Blom 1939, no. 19, pl. 3 D), may have belonged to this statue, an idea that was recently confirmed. Unfortunately the features of the head have been almost completely destroyed and all that can be said with certainty is that the goddess wore a headdress of the *jatāmukuta* type.

Another headless statue of Prajñāpāramitā (41 3/4 in., 105 cm) was found at Candi Bayalangu, Tulungagung, Kediri (East Java). This site has been identified by P. V. van Stein Callenfels as Bhayalangö, mentioned in *Nāgara-Krĕtāgama* (canto 74:1) as the shrine commemorating Queen Rājapatnī. She died in 1350 and the memorial (*śraddhā*) ceremony for her was held in 1362.

The third headless statue of Prajñāpāramitā (31 1/2 in., 80 cm), the sculpture most closely resembling the statue exhibited here, was discovered in 1978 in the grounds of Candi Gumpung (Muara Jambi, Sumatra). Although both lower arms are missing, the two hands forming the *dharmacakra-mudrā* have been preserved.

As two of these statues have lost their heads and the other head has lost most of its distinctive features, we have no possibility of establishing if any of these three statues portrayed the same princess.

Literature: Brandes 1909, 27, 97 and pls. 76–78; Krom 1923, 2:88–89; Krom 1926, pl. 28; Blom 1939, 77, 84–86, 150–154; Stutterheim 1939, 85–104, esp. 94; Bernet Kempers 1959, pl. 222; Tirtowijoyo and Soepono 1984a, 48–49. Ken Dĕdĕs: Brandes 1920; Zimmer 1955, pls. 499–501; Bosch 1956, esp. footnote p. 11; de Casparis 1979, 11; Berg 1981; Muljana 1983, 52–56. Other Prajñāpāramitā statues: van Stein Callenfels 1916b; Blom 1939, 77, no. 11 and no. 19, pl. 3 D; Suleiman 1981, 16 and 74, fig. 7a; Supriyatun 1986.

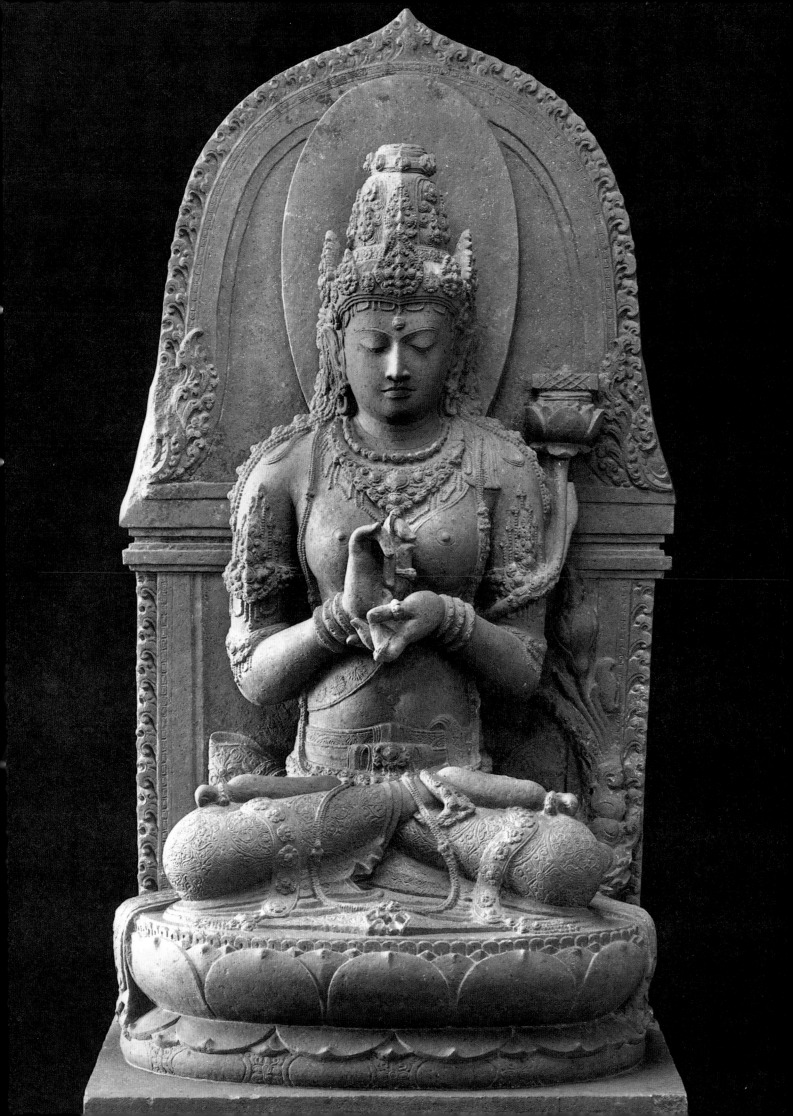

25
Bhairava

c. 1300
East Java, from Candi Singasari
andesite, 65 3/4 x 30 3/4 in. (167 x 78 cm)
Rijksmuseum voor Volkenkunde, Leiden,
inv. no. 1403–1680

THE TERRIFYING four-armed deity Bhairava is seated on his mount, the jackal. Together the two have been placed on a pedestal, the base of which is lined with skulls. Bhairava is entirely naked, wearing only jewelry consisting of a chain of severed heads and a belt of bells. His headdress and ear pendants are decorated with skulls, as are the bracelets on two of his four arms. In the left forehand he holds a skull cup (Skt. *kapāla*) in front of his chest; the right forehand holds a dagger pointed downward. The two raised arms hold a trident (Skt. *triśūla*) in the right and a drum (Skt. *damaru*) in the left. In the half-open, demonically grinning mouth the two rows of teeth are flanked by fangs. The flowing tresses of curly hair stand out against the plain back slab, in which the words *cakra-cakra* have been carved in *Nāgarī* script. On the right side part of the back slab has broken off; it is possible that it contained the last part of the inscription.

Although Indian iconographic texts do not seem to contain a description that exactly matches this statue, and even though the meaning of the inscription remains somewhat enigmatic, the identification of the statue as Bhairava, a demonic form of Śiva, or its Buddhist counterpart Mahākāla, would seem to be beyond doubt.

According to a letter dated 28 February 1827 written by Nicolaus Engelhard, a Dutch colonial civil servant, to the scholar C. J. C. Reuvens, Engelhard discovered Candi Singasari in the year 1803. The letter lists six statues as coming from this site, including the Durgā (cat. 23) and this Bhairava. In 1804 Engelhard removed all six from Singasari, leaving behind only a damaged statue of Bhattāra Guru in the southern cella of the main temple. During the next twenty years the six statues eventually ended up being transported to Holland. Probably as a result of the dense vegetation, Engelhard does not seem to have visited or even known of the existence of the ruins of at least four other buildings to the south of Candi Singasari. These were discovered in 1820 by D. Monnereau.

The statues of Durgā, Ganeśa, Mahākāla, and Nandīśvara, as well as the bull Nandin, all seem to be part of the standard iconographic program of a temple dedicated to Śiva. The dimensions of the empty pedestals and the presence of the damaged statue of Bhattāra Guru in the location where we expect it to be confirm the customary disposition of the statuary. On the other hand, the Bhairava, even though it is mentioned in Engelhard's letter as one of the statues coming from this temple, does not seem to fit into the iconographic program of Candi Singasari. None of the arguments that have been advanced in favor of its original location in the main cella of Candi Singasari is entirely convincing.

Two much smaller representations of Bhairava as an acolyte of other deities, both found in the vicinity of Candi Singasari, closely resemble the style and iconography of this monumental and imposing statue. The first is a tall (84 5/8 in., 215 cm) sculpture of a four-armed Pārvatī with two acolytes flanking the principal icon. On the nimbus above the two acolytes are representation of Ganeśa and Śiva (right) and Bhairava and Kārttikeya (left). The small image of Bhairava is an almost exact replica of the large statue.

The second statue that incorporates a small image of Bhairava is a representation of Camundī, a demonic form of Devī. It was found in 1927 in the village of Ardimulyo, a little more than a mile north of Singasari. It had been deliberately smashed into pieces by the owner of the land on which it was found, as it was thought to have an evil influence on his family. Fortunately the Archaeological Service succeeded in reassembling many of the fragments and in reconstructing a large part of the statue. It represents the eight-armed Camundī, flanked by Bhairava on her left and Ganeśa on her right. The Bhairava is a small-size replica of the exhibited statue. The Camundī carries an inscription datable to 1292.

Studies by Jessy Blom and P. H. Pott have suggested that the large statue of Bhairava may once have been enshrined in the now-vanished Candi B of Singasari. According to the ancient chronicle *Pararaton* there was a Pūrwapatapan sanctuary at Singasari, where King Kĕrtanagara conducted Tantric ceremonies. Jessy Blom has pointed out that Candi B rather than the main temple may have been this *Pūrwapatapan,* and it is possible that the abode of Śivabuddha (Śivabuddhālaya) mentioned in the inscription of Gunung Butak (1294) likewise refers to this structure. As an early description by the Reverend J. G. F. Brummund mentions that the building was divided into three compartments, it is quite possible that the Pārvatī statue occupied the southern, the large Bhairava the central, and the Camundī of Ardimulyo the northern chamber of the temple. In this way Bhairava would have been flanked by a demonic and a peaceful aspect of Devī.

Assuming the Bhairava to be a portrait statue, several authors have advanced hypotheses regarding the identity of the royal persons with whom this statue and the deities on the Camundī statue should be associated. The correction, by Louis-Charles Damais, of the date inscribed on the Camundī from 1332 to 1292 invalidated much of this speculation. There are two historical personages whose association with the cult of Bhairava has been recorded and who have, consequently, been mentioned as possible subjects for this Bhairava statue: Adityawarman, who ruled a West Sumatran kingdom from 1347 to 1377, and Krĕtawarddhana, who married the regent Tribuwana and whose other name was Cakradhana or Cakreśvara. Krĕtawarddhana is known to have died in 1386. The dates of both persons make their association with this statue highly unlikely, if not impossible.

Literature: Brandes 1909, pl. 52; Moens 1924; Stutterheim 1934a; Blom 1939, 11, 106–107, 143–145; Berg 1951–1952, esp. 401–402; Bernet Kempers 1959, pl. 236; Pott 1966, 130–132. The Camundī image: Damais 1962; Santiko 1982.

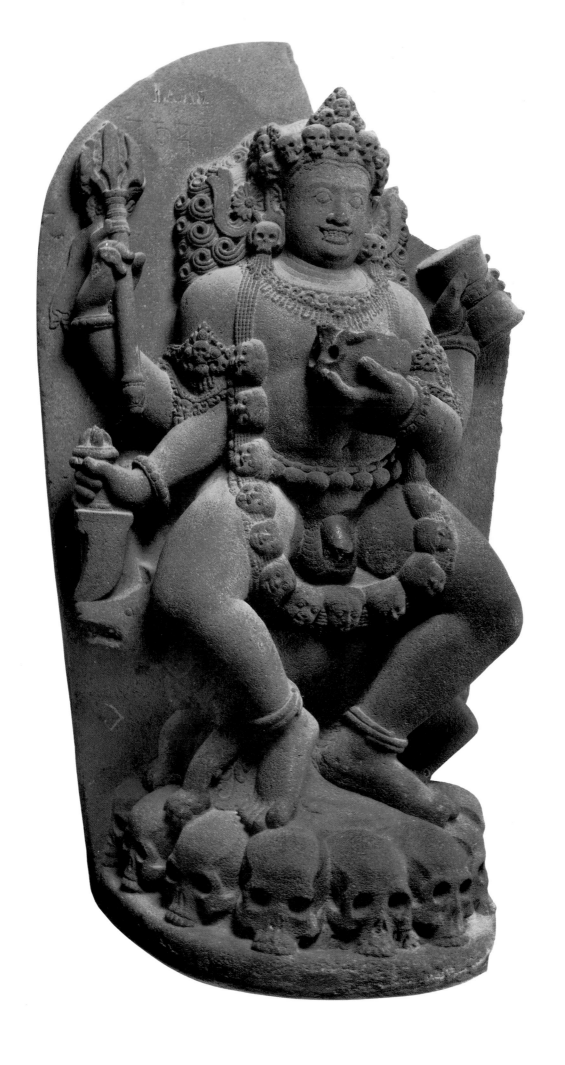

Head of a *dvarapāla* (temple guardian)

c. 1300
Central Sumatra, probably from Biaro
Bahal I, Padang Lawas
stone, 16 1/8 in. (41 cm)
Museum Nasional, Jakarta, inv. no. 102

THE HEAD OF THE *dvarapāla* has bulging
eyes and heavy, raised eyebrows, between
which the bridge of the nose shows a thick
ridge. Above it in the forehead is a bulging
third eye. Two rows of teeth are flanked by
large fangs. The guardian figure wears a
crown and a tall headdress in which the
hair is held together by snakes tied in a
knot; he wears coiled snakes as earrings.

This head is one of a pair of matching
though not identical pieces that entered the
collection of the museum as early as 1864
(inv. nos. 102, 103). They are thought to be
the heads that belonged to a pair of stand-
ing guardian figures (*dvarapālas*) that
flanked the stairs of the temple known as
Biaro Bahal I, Padang Lawas. The two fig-
ures were still standing in situ in 1930.
They were reported as missing by Rumbi
Mulia (1980), but recently parts of both
statues, apparently vandalized instead of
taken, were recovered from the rubble in
the temple grounds. They represent guard-
ians who raised the left hand to the chest,
the index finger pointing in the minatory
gesture known in Indian iconography as
tarjanī (the finger that threatens). To
threaten with the left hand seems to be an
Indonesian, not an Indian custom. In the
Old Javanese *Rāmāyana* (canto 6:30) it is
said that Rāvana threatened Sītā with the
left hand; threatening gestures, made with
the left hand, are frequently seen in the re-
liefs of East Javanese candis. Both figures
were provided with *upavītas* and arm
bands in the shape of snakes, matching
those in the headdress and earrings.

In 1864 the heads were presented to the Ba-
tavian Society of Arts and Sciences by W.
A. Hennij, who received them from the
first western visitor to the inaccessible tem-
ples of Padang Lawas, H. von Rosenberg.
A brief account of von Rosenberg's trip
into the interior of Sumatra was published
in 1855. From the description of his itiner-
ary and the lithographs accompanying his
report, we may conclude that he first vis-
ited the temple Manonjati, also known as
Si Joreng Balangah. The second illustration
accompanying his article gives a view of
this temple with a fallen *stūpa*-shaped finial
(*stambha*) lying in front of it. This finial
seems to be the one seen and reproduced by
F. M. Schnitger in 1935 in situ at Si Joreng
Balangah. The second temple visited by
von Rosenberg was Si Pamutung, a view of
which is given on pl. 1 accompanying his
report. One of the Biaro Bahal temples (it is
not clear which of the three) he saw only

from a distance, without having an oppor-
tunity to investigate the site.

Although the report does not mention the
pieces that von Rosenberg took with him
from this visit and that entered the collec-
tion of the Jakarta museum a few years
later, their provenance is recorded in the
proceedings of the Batavian Society (*NBG*
1864, 178). The heads of the two figures
flanking the stairs of Biaro Bahal I have
never been found in situ. One guardian fig-
ure from Biaro Bahal II is at present in the
site museum, broken in three parts, while a
dvarapāla at Biaro Bahal III, broken in two
pieces, is still in situ. The two heads in Ja-
karta, obviously a pair, are most likely to
have come from Biaro Bahal I, but no effort
has been made as yet to match the heads

from the National Museum with the bro-
ken bodies in the site museum.

In the course of excavations at Biaro Bahal I
two smaller (31 1/2 in.) *dvarapālas* were dis-
covered intact. Similar in iconography to
the larger statues flanking the stairs, one
stands with the left leg bent and the right
leg stretched (Skt: *ālidhā*), while the other
assumed an opposite pose (Skt: *pra-*
tyālidhā), a feature quite common in the
iconography of Tantric Buddhism. Unfor-
tunately both of these statues have now dis-
appeared; only the socle with the feet of
one figure was recovered in 1979 (no. 39/1).

The *biaros* (from the Sanskrit *vihāra*, mon-
astery or temple), as they are called by the
local population, are the ruins of at least
sixteen brick temples. They lie deep in Su-

27
Four-armed Śiva
late 13th century
East Java, perhaps from Candi Kidal
andesite, 48 1/2 in. (123 cm)
Royal Tropical Institute—Tropenmuseum,
Amsterdam, inv. no. A 5950

matra's interior, in Padang Lawas ("The Great Plain"), on the upper course of the Barumun River close to its confluence with its tributary the Panai. Denuded of its once luscious forests, perhaps at the time when these temples were built, Padang Lawas is now covered with sedge grass in which, at the time of von Rosenberg's visit, herds of elephants still roamed. For many years the area was completely deserted, but in recent years farmers have returned to the area, attracted by the rich soil under the grass.

Like a small-scale Pagan (Burma), these temples constitute the sole remains of the Buddhist kingdom of the Bataks, in all probability the kingdom mentioned in an ancient inscription and in historical sources as the kingdom of Panai. An inscription at Tanjore (India), dating from 1030–1031, records a successful attack on the kingdoms of Śrīvijaya and Panai by King Rājendra I of the Cola dynasty (south India). Inscriptions found at various Padang Lawas sites range, according to L.-C. Damais, from 1039 to 1242. The fact that Panai is mentioned in Prapañca's *Nāgara-Krĕtāgama* (1365) suggests that the kingdom continued to exist long after the date of the last inscription.

Inside walled rectangular courtyards, most of the *biaros* consist of *stūpas, pĕndopo* terraces, and a tall main structure often surmounted by *stūpas* crowned by parasols. Apart from repeated efforts to clear the buildings of grass and shrubs, systematic investigation of most sites has not yet begun, although the Dutch archaeologist F. M. Schnitger conducted a few trial excavations (see cat. 60).

Biaro Bahal I, in the village of Bahal near Portibi, is one of the most interesting of the surviving buildings. It has recently been extensively restored. In a courtyard measuring 160 by 187 feet, the remains were found of a *stūpa*, three terraces, and a main temple; of these the base, the square body, and the *stūpa*-shaped roof, decorated with garlands, have been partially preserved. The dancing *yaksa* figures in brick relief on the wings of the main staircase are especially remarkable.

Literature: von Rosenberg 1855; *NBG* 1864, 178; Groeneveldt 1887, 39, no. 102; van Stein Callenfels 1920, esp. 66–67; *OV* 1925, 12–13; *OV* 1926, 27–28; *OV* 1930, pl. 39, 139 (pl. 39 a and d, inv. no. 102; pl. 39 b and c, inv. no. 103); Schnitger 1937, pl. 37, 30 (inv. no. 103); Mulia 1980; Suleiman 1985, 23–37.

THE FOUR-ARMED ŚIVA stands on a double lotus pedestal against an arched back slab that tapers toward the base. Part of the lotus pedestal and the left foot of the god are missing.

The god raises both upper arms, the right hand holding a rosary (Skt. *aksamālā*) and the left a fly whisk (Skt. *cāmara*); rays of light emanate from both attributes. The two human hands are raised to the chest; the right hand, clenched into a fist with the thumb turned upward, lies in the palm of his left hand. This symbolic gesture is not one of the classical Indian *mudrās* or *hasta*. In the sculpture that is believed to portray King Kĕrtarājasa (Museum Nasional, Jakarta, inv. no. 2082), one of the acolytes makes the same gesture. Three statues of the four-armed Śiva, two standing, one seated, in the Museum Purbakala, Mojokerto (East Java), all display the same attributes and *mudrā* (inv. nos. 708/488, 693/527, and 520).

The legs of the god are flanked by lotus stalks growing from spherical roots on the lotus base, a characteristic typical only of sculpture dating from the Singasari period. The god is shown in royal attire and bedecked with all sorts of jewelry, some of which resembles that worn on the statues from Candi Singasari (see cats. 23, 24).

The intensely human expression on the face of the god suggested early on that this could be a statue in which a deceased king is represented as Śiva. F. M. Schnitger was the first to point out the similarity between the double lotus base with its central band of pearls and the pedestals of the corner lions and Garudas sculpted around the base of Candi Kidal, a tall, towerlike temple structure in the village of Rejokidal, near Malang, East Java. According to Prapañca's *Nāgara-Krĕtāgama* (canto 41:1), King Anūsanātha, who died in 1248, was commemorated at Kidal with a Śiva statue. Schnitger consequently identified the statue of Śiva exhibited here with the one mentioned in this famous historical text. While the dimensions of the cella of Candi Kidal do not refute this attribution, the mere similarity of the band of pearls on the pedestal scarcely provides sufficient evidence for the statue's provenance from Candi Kidal, especially since a headless statue of a seated four-armed figure, recovered from the site (De Haan and Bosch 1925, pl. 12), shows a double lotus pedestal without a band of pearls.

There is no record of the original provenance of the statue. It was shipped to Holland, perhaps in 1823, by Nicolaus Engelhard (see cat. 23), the discoverer of Candi Singasari, given to his sister, and sold upon her death in 1860. Sometime after 1861, when the ethnographic collections of the Amsterdam Zoological Society Artis Natura Magistra were first opened to the public, the statue entered this collection, where its presence can be documented from the year 1885.

Literature: Krom 1926, pl. 34; Schnitger 1932; Schnitger 1936a; Stutterheim 1939, 97–98; Amsterdam 1954, no. 633, pl. 54; Bernet Kempers 1959, pls. 216–217; Rawson 1967, fig. 222. For Candi Kidal: de Haan and Bosch 1925.

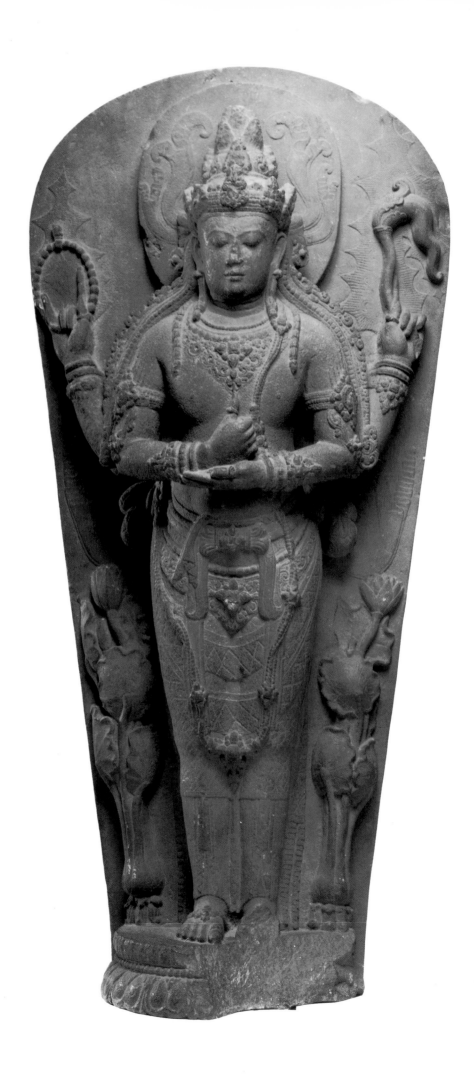

cat. 27

28

Bhairava or Mahākāla

c. 14th century
Eastern Java
andesite, 78 in. (198 cm)
Museum of Fine Arts, Boston,
Frederick L. Jack Fund, acc. no. 1972. 951

THE SLIGHTLY BENT KNEES and the legs and feet spread in an aggressive, defiant posture give the deity a pose reminiscent of that of Durgā slaying the Asura demon Mahiśa (cat. 23). He raises his right arm, but the lower right arm with the hand holding a weapon, once tenoned into the raised arm, has been lost. The left hand that once held a skull cup (Skt. *kapāla*) in front of the chest has also broken off. The god wears a garland of skulls (Skt. *śiromālā*); skulls decorate the headdress and the earrings. The repetition of the skull motif is typical for the demonic (Skt. *krodha*) forms of deities. The thick, curly hair that cascades over his shoulders is like that of *rākṣasas* or other demons. In spite of the considerable damage inflicted upon the nose and mouth, the fangs that flanked the rows of teeth can still be discerned.

Like the statue of Camundī, dated in accordance with 1292 (see cat. 25), which was found at Ardimulyo near Singasari (East Java) in 1927, this statue was smashed into several pieces. It remained in this condition for many years and was considered beyond repair when it was acquired by the Museum of Fine Arts, Boston, from a Dutch collection. The research laboratory of the museum succeeded in reassembling the pieces into a largely complete statue; only small sections of the back, the base, and the drapery flanking the statue have been filled in with new material.

Two-armed demonic figures holding a skull cap in the left hand and a weapon—a trident, club, sword, or chopper—in the right hand usually represent Mahākāla, the Buddhist god of death, or Bhairava, a demonic form of Śiva. These two deities have so many iconographic characteristics in common that it is often difficult to draw clear distinctions between them. Not only in India but also in Indonesia, the identity of statues of these deities can often not be determined with certainty. This is especially true of statues created during the Majapahit period when Buddhism and Hinduism became closely intertwined. References in contemporary literature to the cult of Bhairava make an identification as that deity most likely (see introduction).

In the garden of the former Trowulan Museum (East Java) stand two huge (94 in., 239 cm) guardian figures carved in the same style as the Bhairava exhibited here, and provided with practically identical jewelry.

First described by J. Knebel in 1907, when they were still standing in the yard of a sugar mill owned by the Chinese merchant Tan Bun Liang in the village of Sumengko sometime prior to 1907, they were extensively restored, making the comparison of some details impossible.

In the same museum garden stands yet another smaller, unfinished statue of a Bhairava/Mahākāla (68 in., 174 cm). This statue, of unknown provenance (inv. no. 110 BTA ONB 24 BPP), differs from the Boston statue in that the position of hands and attributes has been reversed. Such variations have their precedents in Indian iconographic texts. Although not all details are clearly discernible due to its unfinished state, the statue is sufficiently similar to the other three statues to warrant the conclusion that all are creations of a local sculptor's workshop that supplied statuary for the temples of the capital of the Majapahit kingdom, located in the area of Trowulan.

Literature: *ROC* 1907, 71–72; *ROD* 1915, 192–193; Mitra 1958; Mitra 1959; Adiceam 1965; Boston Museum 1982, no. 193.

Guardian figure in the garden of the former Trowulan Museum

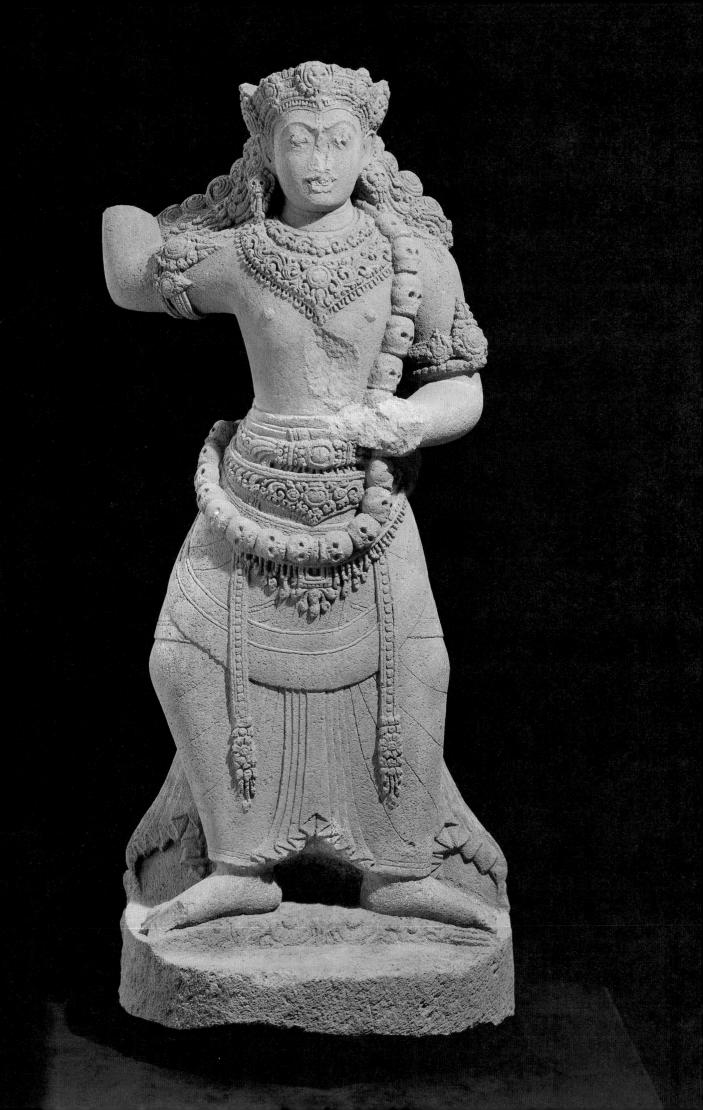

29
Standing goddess or queen

late 14th–early 15th century
East Java, from Jebuk, Tulungagung
andesite, 61 ¹/₂ (156 cm)
Museum Nasional, Jakarta, inv. no. 6058

THE GODDESS OR QUEEN, laden with jewelry, stands on a double lotus cushion, her feet together. In addition to a diadem, heavy ear pendants, necklaces, a sacred thread consisting of five strands of pearls, bracelets, and anklets, she wears several girdles from which hang pendants that reach almost to her ankles. She wears rings on fingers and toes. The upper part of the elaborate headdress as well as the left hand are missing.

In her right hand she holds a lotus bud. The back of the lotus pedestal shows the stylized waves of a pond, from which lotuses in different stages of growth rise to cover the entire back of the statue. Although the combination of a beautiful female figure with exuberant lotus vegetation on the back immediately recalls the celebrated pillar figure from Mathurā (Lucknow Museum), it is unlikely that the Javanese artist ever saw this masterpiece of ancient Indian sculpture. In the statues from Candi Jago (Tumpang, East Java), lotus stalks, sprouting from the lotus pedestal, wind their way upward, flanking the standing figures. In the statuary of the Majapahit period, the lotuses grow from jars placed at the feet of the figures. Only in this masterpiece of Majapahit sculpture has the sculptor moved the lotuses to the back of the statue, creating a surprising yet harmonious and highly aesthetic effect. Whereas in other statuary incorporating lotus stalks they seem to allude to the renewal of life after death, in this sculpture it is as if the whole figure arises from the lotus pond, together with the lotuses.

N. W. Hoepermans, who visited Java from 1864 to 1867, discovered the statue in a clearing in the teakwood forest of Pakuncen near the hamlet Jebuk (Punjul, Kalangbret, Tulungagung, Kediri). Nearby the double statue of a divine or royal couple was found. For the relationship between the two statues and the possible identification of this statue as a portrait of Queen Suhitā, see cat. 30.

Literature: Knebel 1908, 200; *ROD* 1913, 320; *ROD* 1915, 309–310, no. 2003; van Stein Callenfels 1916a; *JBG* 2 (1934), 107–108; *ABIA* 1935, pl. 9; Bernet Kempers 1959, pls. 265–266; *AIA* no. 17.

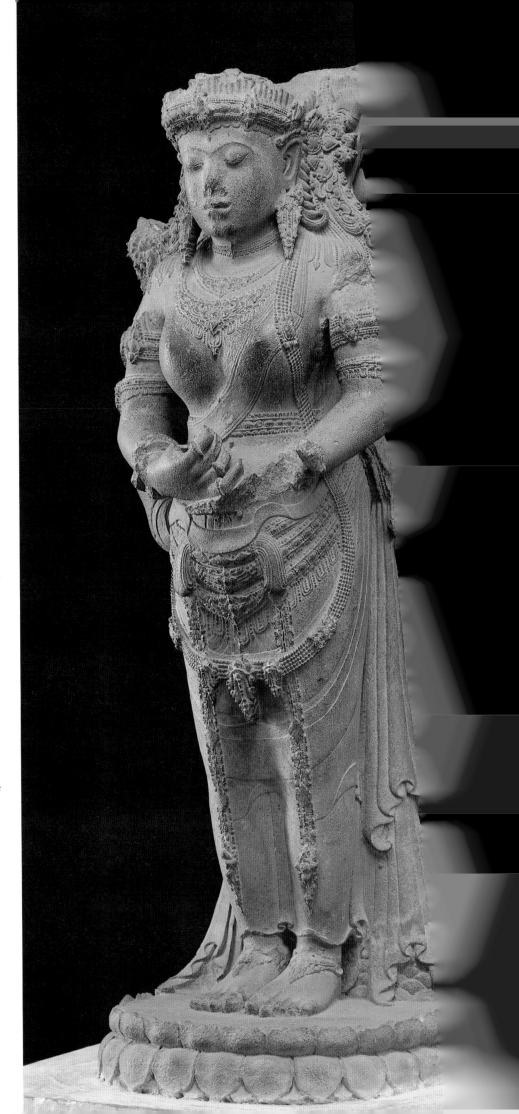

Divine or royal couple

late 14th–early 15th century
East Java, from Jebuk, Tulungagung
andesite, 65 3/4 x 31 1/2 in. (80 x 167 cm)
Museum Nasional, Jakarta, inv. no. 5442

THE MALE FIGURE is seated with the knee of his right leg pulled up and the folded left leg turned sideways to provide a seat for the female figure. Her right hand reaches over the man's shoulder to grasp his raised right hand. His left hand rests upon her left hip. Her missing left arm must have once held the mirror that now seems to float in the air. Her head is turned sideways as if she is looking into the mirror, a pose undoubtedly once coordinated with the movement of her left hand raising the mirror.

Both figures have been placed on a double lotus pedestal with a plain, partially broken back slab. In spite of the extensive damage inflicted upon this superb example of Majapahit sculpture, it seems to have lost little of its extraordinary intimacy.

The ultimate iconographical source of this remarkable double statue would seem to be an Indian representation of the so-called Ālingana-murti of Śiva. In this type of sculpture the god Śiva is represented seated in "royal ease" (Skt. lalitāsana) with his consort Umā in his lap. Although stone statues of the Ālingana-murti of Śiva are quite common in India, bronze images probably provided the inspiration for Indonesian sculptors. A bronze like the Ālingana-murti of Śiva from Paharpur (Indian Museum, Calcutta) could well have served as an example. In this bronze, dating from the twelfth century, Śiva is seated with Umā is his lap. Her right hand is placed on his shoulder, while her left hand holds up a mirror. The four arms of Śiva, three with their customary attributes and one embracing Umā, and the presence of Śiva's and Umā's mounts, the bull and the lion, as well as the fact that Ganeśa and Kārtikeyya flank the divine couple, are all features in strict accordance with Indian iconographical precepts. In the Javanese version the intimacy and sensuousness that pervade the bronze icon have been fully preserved, but the Javanese artist has created a non-iconic, almost secular version of the theme. The mere change in the position of the male's right leg has completely altered the composition. He displays none of the emblems that could have identified him as Śiva, while Umā's attribute, the mirror, here would seem to be merely a typically feminine utensil rather than a divine attribute. One would perhaps be inclined to see these deviations from standard iconography as products of the artistic imagination and skill of the Jebuk sculptor. However, a

Central Javanese statue of Śiva and Pārvatī (Museum Nasional, Jakarta, inv. no. 249) that could almost have been copied by the Jebuk sculptor clearly suggests that the artist was following an earlier Javanese iconographic precedent.

The explorer N. W. Hoepermans, who surveyed ancient Javanese monuments from 1864 to 1867, discovered this statue in a clearing in the teakwood forest of Pakuncen, near the hamlet of Jebuk, Punjul, in the district of Kalangbret, Tulungagung (East Java). Nearby in another clearing he found a statue of a standing goddess (cat. 29). Hoepermans immediately realized that the two statues were by the same hand. A stone fragment of a headdress (makuta) was also found, and in 1914 P. J. Perquin saw this fragment in the village of Lurup in the same area. It is possible that this fragment belonged to the male figure of this double statue.

The informal, human quality of the statue must have prompted the idea that it is an example of portrait sculpture, representing a royal couple united with the gods upon death. Krom, who suggested this possibility, saw a precedent for a double portrait statue in a passage in Prapañca's Nāgara-Krĕtāgama that seems to indicate that King Krĕtanāgara (who died in 1297) and his chief consort Queen Bajradewi were commemorated together in a statue at a shrine in Sagala, in which she was represented as Ardhanarī (Śiva's spouse).

The queen figure in the exhibited double statue closely resembles the standing goddess from Jebuk, whom the late Satyawati Suleiman once suggested might represent the Majapahit queen Suhitā. Queen Suhitā, who ruled the Majapahit kingdom from 1429 to 1447, married Bhra Hyang Parameśwara Ratnapangkaja, who died in 1446. The marriage remained childless and she was succeeded by her brother Kretawijaya, who reigned from 1447 to 1451.

There is no local oral tradition connecting this double statue with a specific king and queen, as was the case with the Prajñā-pāramitā (cat. 24). When Hoepermans first saw the statue he heard the local populace refer to it as reca penganten (bridal couple). While the presence of two statues of such extraordinary quality suggests that a shrine of major importance must have been located in the area, no trace of any structure has been found. None of the local

place names has been associated with that of any of the commemorative shrines mentioned in the Nāgara-Krĕtāgama and the Pararaton. There is, therefore, no literary evidence to support the identification of this "bridal couple" with specific historic personages. Nevertheless the statues from Jebuk occupy a special place among those that have been assumed to be portrait sculpture. The reason is that the two Jebuk statues represent the only known examples of two portraits that may portray the same person, and the facial resemblance of the two female figures certainly constitutes an argument in favor of their being portraits.

Just as the royal or divine couple is different from its possible Indian prototypes, it differs also from the rather rigid portrait statues of Candi Sumberjati and Candi Rimbi (Museum Nasional, Jakarta, inv. nos. 256 and 257). In spite of their deviations from standard Indian iconography, these last two statues clearly represent gods, possibly gods with the facial features of deceased royalty. It is clear that the divine prevails over their human aspect, whereas in the statues from Jebuk exactly the opposite seems to be the case.

Krom suggested a late fourteenth-century date for the double statue. He seems to have been influenced by the idea that the fifteenth century was one of progressive decline, political as well as artistic, and of much internal strife. He attributed only the more rigid, stereotyped Majapahit statuary to that age of decadence. However, although Majapahit had lost its ascendancy in the Indonesian archipelago outside Java, the decline may not have been as rapid, and the internal strife not as fatal, as Krom thought. Moreover, the more spontaneous and natural style of sculpture, of which the statuary from Jebuk is a prime example, may have represented a separate style that was not necessarily the precursor of the conventionalized style of the fifteenth century, but a contemporaneous development of a special, local character. Consequently, neither a fifteenth-century date nor an association with Queen Suhitā should be ruled out completely.

Literature: Knebel 1908, 200; NBG 1913, 111; ROD 1913, 320–321; OV 1914, 194; ROD 1915, 309–310, no. 2003; Moens 1921; Krom 1923, 2:322–323, 3: pl. 94 (left); Bernet Kempers 1959, pls. 262–264; Noorduyn 1978.

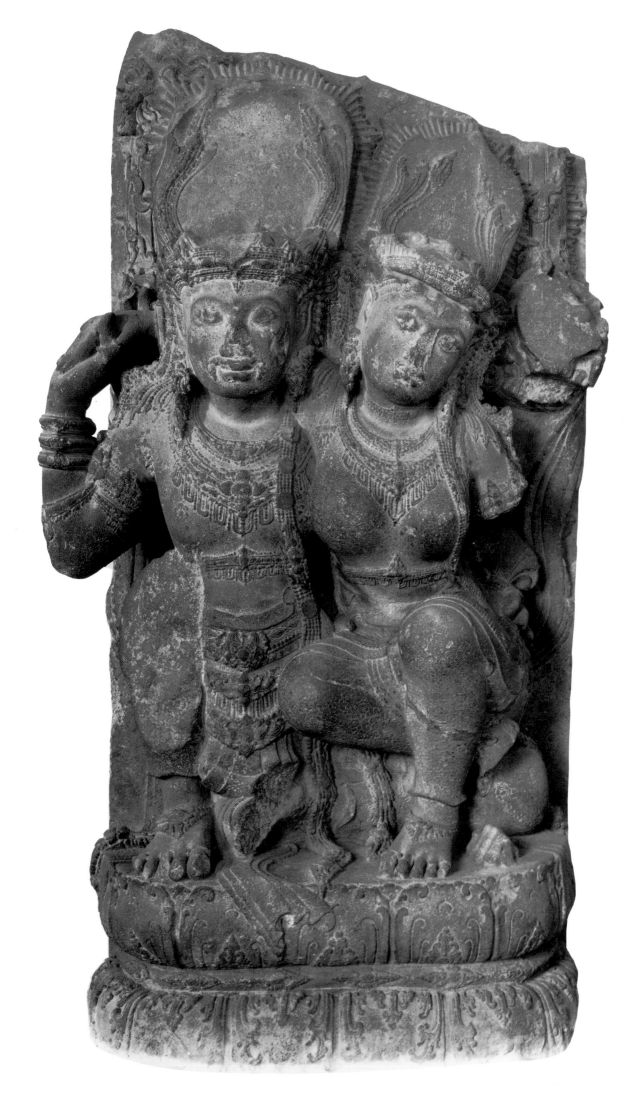

31
Mother with two children (the goddess Hārītī)
c. 13th century
East Java, from Sikuning, Mount Arjuna
brownish sandstone, 24 1/2 in. (62 cm)
Museum Purbakala, Mojokerto, inv. no. 643

THE STANDING FIGURE wears an elaborate headdress and a profusion of jewelry consisting of heavy ear pendants, a pearl necklace, two jeweled belts, bracelets, and double anklets. Her rich attire suggests royal or divine status, an indication confirmed by her halo. At the same time she represents an ordinary mother, for to her right stands a young child that she leads by the hand while she carries a baby in a sling (*selendang*) on her left hip.

This statue, remarkable for its rare combination of the human and the divine, was found in 1915 in the forest Sikuning on the north slope of Mount Arjuna (East Java) in the immediate vicinity of the remains of a small (10 1/2 x 5 1/2 ft.) temple. In the course of an excavation carried out that same year by Leydie Melville, another slightly smaller (22 1/2 in.) statue was found. Carved in a similar style from the same type of stone and of similar size, it represents twin gods holding hands. Occasionally Śiva and his consort Pārvatī are shown holding hands, as for example in a stone statue in the Museum Nasional, Jakarta (inv. no. 251) and in the gold statues recently discovered in the Seplawan Cave in Purworejo, Central Java (cat. 55). No other statues of two figures of the same sex holding hands are known, even though people of the same sex holding hands are a common sight in Java even today. Both statues from this site, therefore, represent unique iconography.

The only deity frequently associated with children is the Buddhist ogress-turned-goddess Hārītī. An early relic of her cult as a protectress of children has been discovered in Central Java (see cat. 50). Two Balinese statues provide evidence that the cult of Hārītī spread to Bali at an early time. One statue was found at the Elephant Cave or Goa Gajah, near Bedulu, Bali. It shows the goddess with seven of her children, and may date from the late tenth century. The second Balinese statue, from the Pura Panataran Panglang at Pejeng, shows her with five children. It bears an inscription datable to 1091. While the number of five children suggests the sculptor's familiarity with the Indian tradition that she gave birth to (or, according to another version, devoured) five hundred children, Men Brayut, as she is called in Bali, is now usually thought to have had eighteen children.

In two Old Javanese poems composed during the Kediri period (before 1222), the *Smaradhana* and the *Bhomāntaka*, mention is made of this mother of many children. However, the editors-translators of both texts have declared these passages to be later interpolations. Especially in the passage in the *Bhomāntaka*, where the number of children adds up to exactly eighteen, the possibility of a later Balinese interpolation in the text would seem likely. Even though there is, therefore, no solid literary evidence of a Hārītī cult during the East Javanese period, it would seem highly likely that the Balinese cult of Men Brayut had its roots in an older Javanese tradition. Recently Edi Triharyantoro has identified two terracottas in the Trowulan Museum as representations of Hārītī. Both were excavated in the hamlet Kepiting of the village Temon near Trowulan. They date from the fourteenth or fifteenth century.

Krom, the first to comment on the unique characteristics of this statue, considered the sculptor's attempt at a natural representation less than successful. Perhaps he was influenced by a tendency, prevalent at that time, to regard deviations from the Indian iconographic standard as degenerate

symptoms. He believed that what he saw as an inability to create a more spontaneous treatment contributed to the emergence, during the Majapahit period, of a rigidly frontal style of sculpture. One should bear in mind, however, that at the time that Krom made these observations he probably had not yet had an opportunity to see the statues from Jebuk, Tulungagung (see cats. 29, 30) that were brought to the Jakarta Museum in 1922 and 1934. Rather than considering this statue of Hārītī an early indication of decline or an isolated experiment without any lasting consequences in the development of Eastern Javanese art, it is possible to see it as one of the earliest examples of a search for greater artistic freedom that would eventually result in such masterpieces as the statues from Jebuk.

Literature: *OV* 1915, 2, 142; *ROD* 1915, 220, no. 1744; Krom 1923, 2:352, 3: pl. 94 (center); Krom 1926, 67, pl. 44. Balinese sculpture: Stutterheim 1929a, fig. 25, 130–131, 76, 85, 142, and fig. 38; Goris n.d., 191–192, fig. 3.08; Grader 1939. Terracottas: Triharyantoro 1988. Old Javanese texts: Poerbatjaraka 1931, canto 31:5; Teeuw 1946, 12:6.

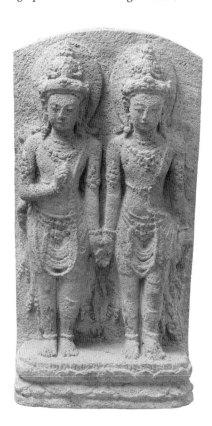

Twin gods holding hands, excavated at Sikuning.
Museum Purbakala, Mojokerto

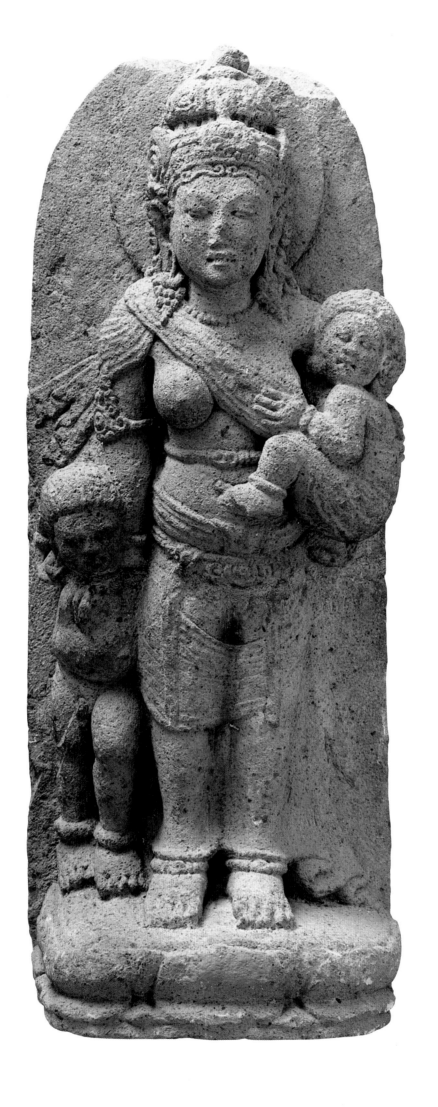

32

Fountain sculpture with Arjuna and the nymphs

c. 14th century
East Java, from Tugurejo, Kediri
volcanic stone, 26 x 28 3/4 in. (66 x 73 cm)
Museum Nasional, Jakarta, inv. no. 6840

THIS RELIEF illustrates an episode from the *Arjuna-Wiwāha* (Arjuna's Wedding) by the poet Mpu Kanwa (c. 1030). Indra, the ruler of heaven, is threatened with an attack by the demon Niwātakawaca, who cannot be killed by either god or demon. Indra decides to seek help from a human being and chooses Arjuna, who is deeply immersed in meditation on Mount Indrakīla. In order to test the strength of Arjuna's resolve to do penance, Indra dispatches several beautiful nymphs, among them Suprabhā and Tilottamā, to interrupt his meditation and to seduce him, but their efforts are of no avail.

In the relief we see Arjuna flanked by the two beauties, one of whom tickles him under the chin and pulls his left arm over her shoulder. The scene is surrounded by stylized clouds. In the center, right below the figure of Arjuna, is a round opening. Through it the water flowed into the basin above which this sculpture must once have been placed, in an arrangement perhaps similar to that of the Jalatunda relief (cat. 18). To install a sculpture representing the temptation of Arjuna at a bathing place was appropriate since the story relates how the nymphs bathed and adorned themselves before they attempted to seduce the hero.

The episode of Arjuna and the nymphs enjoyed great popularity throughout East Java, which is evident from the frequency with which it has been depicted on temples and other monuments. Reliefs illustrating the story can be found in the cave of Selamangleng, Tulungagung (end of tenth century), at Candi Jago (thirteenth century), at the cave of Guwa Pasir, Tulungagung (fourteenth century), at Candi Kedaton (1370), Candi Surawana (fourteenth century), and at site LXV on Mount Penanggungan (fifteenth century). The *Report of the Archaeological Commission* of 1902 illustrates two other stone sculptures of Arjuna's temptation as well as a heart-shaped gold repoussé modesty plaque, now in the Museum Nasional, Jakarta. In the Mpu Tantular Museum, Surabaya, is a slightly smaller (23 in.) fountain sculpture similar to the piece exhibited here. In Bali the story remained popular through the ages, as is proven by a set of Balinese *Arjuna-Wiwāha* paintings dating from the nineteenth century.

The original report (*JBG* 6, 125) gave its provenance as the district Gampengrejo, just to the north of Kediri, but in the museum's inventory the name of the district was later crossed out and changed to Tugurejo, the name of a village in Kediri.

Literature: *JBG* 6 (1939), 125, fig. 12; Bernet Kempers 1959, pl. 191–192 (Selamangleng), pl. 193 (Guwa Pasir), pl. 251 (Candi Jago), pls. 302–303 (Surawana), pl. 305 (Kedaton), and pls. 327–328 (Penanggungan); Worsley 1986. Synopsis of the *Arjuna-Wiwāha*: Zoetmulder 1974, 234–249. Other sculptures: *ROC* 1902, pl. 4; *ROD* 1914, 208, no. 678.

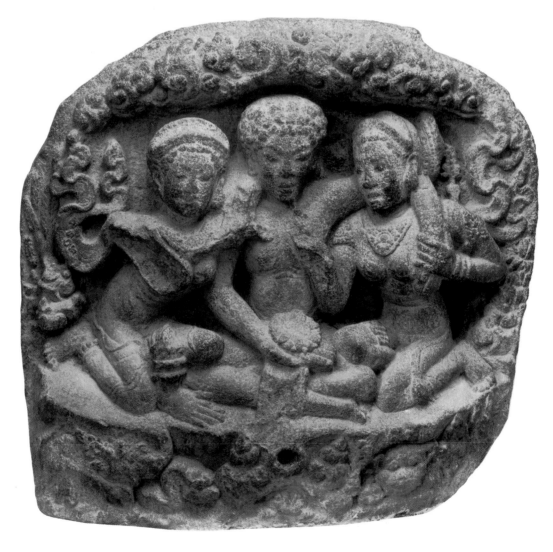

33
Scene in a blacksmith's shop
15th century
Central Java, from Candi Sukuh
volcanic stone, 64 x 86 in. (162.5 x 218.5 cm)
Direktorat Perlindungan dan Pembinaan
Peninggalan Sejarah dan Purbakala, Jakarta

ON THE SLOPES OF MOUNT LAWU (Central Java), at a height of 3,000 feet, lies the terraced sanctuary of Candi Sukuh, one of the last monuments of Indo-Javanese culture, built shortly before the population of this area was converted to Islam. Dates inscribed on one of the gates and on pedestals and statues range from 1416 to 1459. At Candi Ceto, another sanctuary located on the same mountain at a higher elevation (4,800 ft.), inscribed dates as late as 1475 have been found.

Although tigers roaming the forests of Mount Lawu made overnight stays impossible as late as the 1860s, when Hoepermans visited these *candi*s, the temples of Mount Lawu had attracted visitors from the time of the first awakening of interest in Javanese antiquities. Raffles visited here in 1815; and the visits especially of the Reverend C. J. van der Vlis in 1842 resulted in an excellent description of the site, all the more valuable as much that was recorded by this observant antiquarian has since disappeared. Even at that early time it was not possible to get a clear understanding of the original layout of this sanctuary, where large headless figures, huge stone tortoises, and reliefs are distributed in seemingly random fashion over three terraces (see pp. 114–115). All stand close to the principal monument, a truncated pyramid. A huge stone phallus (now in the Museum Nasional, Jakarta) with four balls, suggesting a symbolic quinary representation of the cosmic Mount Sumeru, originally came from this temple and may once have been placed on top of the pyramid. Everywhere are remains of gargoyles and ductwork. It is evident that holy water from mountain springs played an important role in the rituals performed at this temple, an impression confirmed by one of the inscriptions.

This terminal phase of Indo-Javanese art and culture reveals a fascinating mixture and harmonious blending of such ancient pre-Hindu features as terraced mountain sanctuaries and the worship of megaliths, the Śivaite *linggam* cult, and the rich lore of later Javanese legends. In all of these stories deliverance is the basic theme. The reliefs illustrate how the mother of Garuda is redeemed from slavery, how Durgā is delivered from a curse that had transformed her into a demoness, and how the hermit Tambrapetra had his eyesight miraculously restored. Most of these reliefs have been identified, but the relief exhibited here, the largest and most attractive of the reliefs of Candi Sukuh, has defied a fully satisfactory explanation.

This relief, consisting of three large stone slabs fitted together, depicts in fascinating detail the interior of a smithy. On the right side stands the smith's assistant, who is working a bellows under a tiled roof supported by four columns. The bellows feeds the air to the fire through pipes running under the floor. On the left, in the crouching position that is the master's prerogative, sits the smith. Both he and his assistant wear an elaborate headdress frequently seen at Sukuh (see cat. 34). Adopting a bird's-eye perspective, as if viewed from above, the artist filled the space in front of the deeply carved crouching figure of the smith with a bas-relief showing a variety of tools, weapons, and ceremonial objects, all of which are displayed on the floor and on two shelves. At the smith's feet are the tools of his trade: a file, a hammer and, perhaps, a small anvil. The lower shelf displays a variety of weapons: a pair of large scissors and a chopping knife, obviously a sampling of the products of the smithy. Two of the weapons on this shelf bear a close resemblance to ceremonial bronze weapons found in the cache from Selumbung, Gandusari (East Java, thirteenth century). Among the objects on the top shelf we recognize a finial in the shape of a *nāga* dragon and a cloud-and-lightning finial closely resembling examples in this exhibition (see cats. 95, 97).

As a reminder that these objects are on shelves, the sculptor made the lower end of the bottom shelf project several inches. On the console thus created lies a *kĕris* (sword) that the smith holds by the tang in his bare left hand, a procedure that can be observed in Java to this day. It has been suggested that this is no ordinary swordsmith, but one who uses his knee as an anvil and his right hand, compressed into a fist, as a hammer. However, a closer inspection of the actual relief reveals that the *kĕris* rests upon the projection of the shelf, not upon the swordsmith's knee, and we may suppose that the other hand is raised by the smith to maintain his balance in the squatting posture, as he is about to either thrust the tip of the blade forward into the flames or to pull it from the fire to quench the blade. However, there is no trace of a water container that would be indispensable in this essential step in the forging process.

The relief seems to give a remarkably detailed and accurate rendering of a blacksmith's workshop and all of its paraphernalia, were it not for the sudden intrusion, in the central slab of this relief, of the supernatural in the shape of a nude male figure with an elephant's head, wearing a headdress of a priest and holding in his right hand a small dog. He seems to stumble into the smithy, stopping in front of the flaming forge.

In recent years the relief, which has already puzzled several generations of scholars, has twice been the subject of detailed analysis, first by the Indonesian archaeologist Ph. Subroto in 1977 and later by the American scholar Stanley J. O'Connor in 1985. The first focused primarily on the evidence of material culture as provided by this relief, the second on its magical-religious connotations.

In ancient times the *pamor* process of forging the Javanese *kĕris* out of shapeless iron ore, reduced to blackened sponge, its subsequent welding with meteorite, and its ultimate purification and transformation into the powerful blade of a *kĕris* was seen as a metaphor for the spiritual transmutation of the human soul after death. As a result the smith occupied a special position in society, just as his creation, the *kĕris*, has a spiritual power that far exceeds its material effectiveness.

O'Connor identified the elephant-headed figure as Ganeśa, the remover of obstacles, and suggested a connection between the relief and a Tantric ritual called *Ganacakra*, mentioned in Prapañca's *Nāgara-Krĕtāgama*. He even found a faint echo of such rites in stories about court ceremonies once held in the *kĕraton* of Solo, not far from Candi Sukuh. As the leitmotif of all other legends illustrated in the reliefs of Sukuh is deliverance from a curse or bondage, an interpretation in terms of Tantric ceremonies designed to liberate the soul seems plausible. It should be pointed out, however, that nothing is known about the *Ganacakra* ceremony as it was performed at the East Javanese court, and the role played in it by the elephant (Skt. *gana*) is equally obscure.

The contrast between the smith and his helper engaged in their menial task, albeit one exceptionally rich in powerful symbolism, and the strange apparition of the elephant holding his little dog may perhaps be explained in a different way. Both would

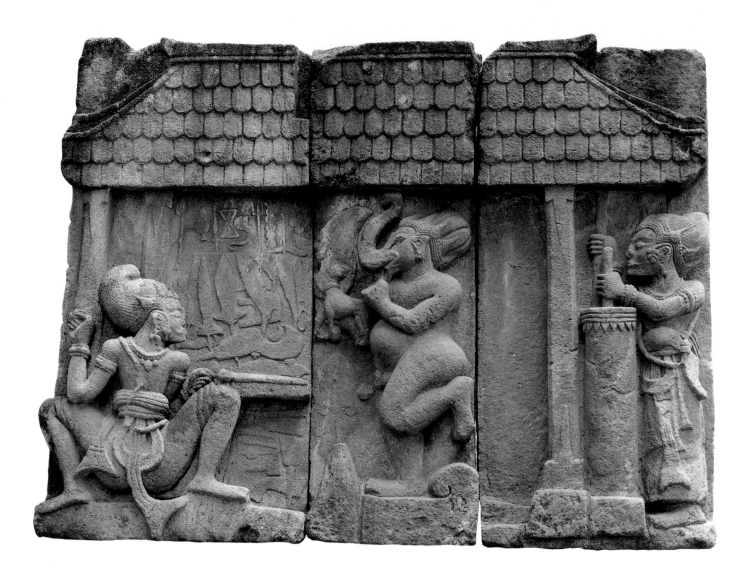

make sense if we assume that the two men portrayed at work were surprised by the sudden appearance, from or in front of the flames of the forge, of a god or a messenger of the gods in the shape of an elephant. Instead of interpreting his movements as O'Connor did as "awkward hopping," the elephant could be seen as descending from heaven. The stylized cloud of dust that trails behind his right foot resembles the reverse of the clouds on which heavenly messengers, appearing in people's dreams, can be seen riding in the reliefs of Borobudur.

Although Ganeśa is undoubtedly the best known of the elephant-headed figures, he is not the only one. Airāwata, the mount of the god Indra, the king of heaven, makes an appearance in the reliefs of Borobudur whenever his divine master acts as the *deus ex machina* in one of the Buddhist birth stories (Skt. *jātaka*).

The key to the full understanding of this relief probably lies in a legend from the rich lore of later East Javanese literature. The source from which the sculptor drew his inspiration may not be one that can be found in the palm leaf manuscripts in which so many stories have been transmitted. For the reliefs of Sukuh represent *wayang*, the Javanese shadow play, carved in stone. Once carved they remained the same, whereas the *lakon* (plots) of the *dalang* (puppeteers) continued to grow and change during another four hundred years of oral transmission.

Literature: Krom 1923, 2:371–381 and 386–389; Muusses 1924; van Stein Callenfels 1925; Stutterheim 1930b; Bernet Kempers 1959, pl. 334; Subroto 1980; O'Connor 1985.

cat. 34

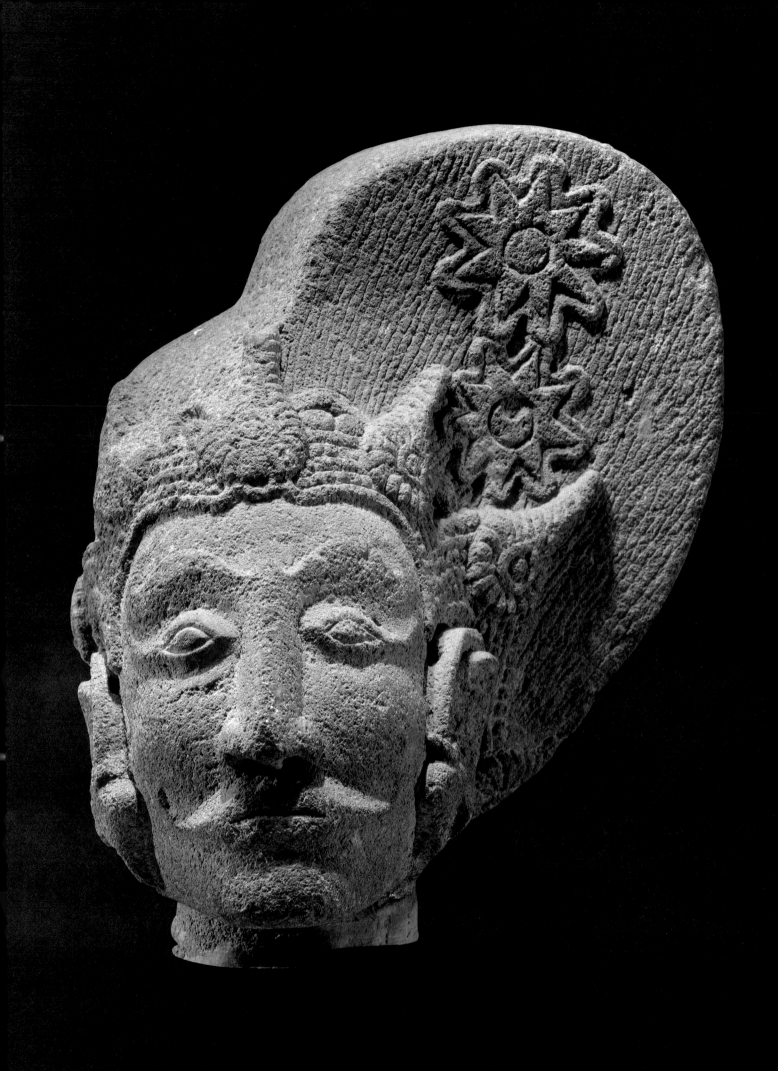

34
Head of a man (Jatāyu?)
mid 15th century
Central Java, perhaps from Candi Sukuh
volcanic stone, 15 3/4 in. (40 cm)
Society of the Friends of Asiatic Art, on
loan to the Rijksmuseum,
Amsterdam, MAK 1295

THE MAN sporting a martial-looking mustache wears his hair in a tall, asymmetrical hairdo held in place by a richly decorated diadem. The hairstyle is similar to the headdress of the blacksmith and his assistant in the relief from Candi Sukuh (cat. 33). In the hair two nine-pointed stars, representing the sun and moon, may depict the sun- and moon-shaped ornaments (*sūrya-kānta* and *candrakānta*) often mentioned in East Javanese literature. His ear ornaments in the shape of curved stalks have holes into which flowers could be inserted on festive occasions, a feature often seen in Balinese sculpture to this day.

The head came to Holland more than a century ago, and may have been in a public collection in Zwolle (Overijssel) as early as 1852. The right eye has been repaired with a cementlike substance. It is evident that this was not done by one of its anonymous early owners from the fact that the left eye of the elephant in the relief of the blacksmith's shop from Candi Sukuh shows exactly the same type of repair.

The original records of this head did not mention a provenance from Candi Sukuh; it was first attributed to this temple in an exhibition catalogue in 1922. In 1951 Th. P. Galestin identified it as a head of Jatāyu, the heroic bird-man of the *Rāmāyana*, whose unsuccessful intervention in Sītā's abduction by Rāvana resulted in his untimely death. Galestin suggested that the head belonged to one of the two headless statues representing winged bird-men still standing at Candi Sukuh (see photo, pp. 114–115). The identification as Jatāyu, who was reborn in heaven as a reward for his selfless heroism, still seems plausible and appropriate for a statue from Candi Sukuh. However, an investigation in situ, not feasible at the time Galestin's theory was first proposed, has proven that the measurements of head and body do not match. Also, the color of the stone of the head is slightly different from that of the reddish tinted sculpture at Candi Sukuh. However, the possibility that the head belonged to a statue from nearby Candi Ceto cannot be excluded.

Literature: The Hague 1922, no. 73; Krom 1923, 3: pl. 99; Krom 1926, pl. 45; Galestin 1951; Rijksmuseum 1985, no. 183.

35
Standing Buddha
c. 7th century
South India, Sri Lanka, or Java, found at
Kotablater, Jember (East Java)
bronze with gold usnīsa, 16 1/2 in. (42 cm)
Society of Friends of Asiatic Art, on loan to
the Rijksmuseum, Amsterdam, MAK 193

THIS BRONZE BUDDHA is clad in a monastic garment draped to leave the right shoulder bare. Both hands are raised to the level of the chest, the right hand in the symbolic gesture of exposition (Skt. *vitarka-mudrā*), the left hand as if grasping an edge of the garment. The robe is draped around the slender body in regularly flowing folds, which take the shape of soft ripples. The Buddha has a long, thin face with a sharp aquiline nose. The *usnīsa*, cast separately, has been lost and replaced by one in gold. The right foot of the statue is a modern (1950) restoration, cast from a mold made of the left foot.

Bronze images of the Buddha in the tradition of statuary from Amarāvati (Āndhra Pradesh, India) have been found in many places in Southeast Asia, from Dong Duong (Vietnam), Pong Tük (Thailand), to Sulawesi and Java. A distinctive characteristic of the Amarāvati styles is the linear treatment of the drapery folds, but in the Southeast Asian examples the technique of rendering the lines of these folds differs widely. These differences, as well as the considerable variation in the shape of the head and the modeling of the body, suggest that in spite of a general resemblance to the Amarāvati style the group of statues may be of rather heterogeneous origin and varying dates.

In the extensive literature devoted to these Buddha images, the earlier publications tend to date them closer to the original Amarāvati style of the early centuries of our era, while in recent years scholars have been inclined to consider these statues offshoots and later adaptations of the Amarāvati school. Thus, varying viewpoints on the stylistic sequence have resulted in widely different dates being given to these statues. The Buddha with the golden *usnīsa* is no exception. It has been variously given an ultimate provenance from India, Śri Lanka, or Java, where it was actually found, while the dates assigned to it range from the third to the ninth century. Only new finds, excavated under circumstances that would allow us to reconstruct their archaeological context, may eventually help us to solve the many questions these statues continue to pose to scholars.

One interesting aspect of this statue that does not seem to have been sufficiently considered is its unusual provenance. It was acquired by the Museum of Asiatic Art, Amsterdam, from F. L. Broekveldt, a former colonial official who served in Indonesia during the early years of this century. In 1904 he submitted a report on the antiquities of Mojokerto (East Java) to the Batavian Society that demonstrates his talent as an observer of cultural remains. The thoughtfulness of his report lends credibility to his statement that the Buddha from his collection came from Kotablater in South Jember (East Java). This area, although remote from the center of Central Javanese culture, is of special interest, because it was part of the kingdom of Blambangan (Banyuwangi), the last of the Javanese Indianized states. It was only during the eighteenth century that this area converted to Islam, and during the nineteenth century such antiquarians as Hageman and Verbeek still saw many ruins of brick structures in this area. That Buddhism may have come early to this area is suggested by the discovery, in 1874, of a large hoard of gold and silver Buddhist statues, at Puger, about ten miles west of Kotablater. The statues were divided between the Jakarta and Leiden museums.

The long continuity of Indo-Javanese culture in this area may offer an explanation for the golden *usnīsa*, which is neither original nor modern. If the Buddha from Kotablater was kept and worshiped in one of the now-ruined temples in the area, the golden *usnīsa* could well be a repair dating from the fifteenth or sixteenth century. Pauline Scheurleer has suggested that it may have replaced a separately cast *usnīsa* crowned by a flame. This type of *usnīsa* is common in statuary from Negapatam (Nagapattinam, South India) and its Sri Lankan and Southeast Asian adaptations. A seated Buddha from Sathing Phra (Thailand) and a seated Buddha in the Amarāvati style from Java (Rijksmuseum voor Volkenkunde, Leiden) have *usnīsas* crowned by a flame.

Literature: Roorda 1923, pls. 10 and 11; Bosch 1940; Lévi d'Ancona 1952; Dupont 1958–1959; Amsterdam 1988, no. 1. The hoard found at Puger: *NBG* 1874, 3a, 57c, 83, VI and *NBG* 1875, 31; Juynboll 1909, 87, nos. 2687–2691; *ROD* 1923, inv. no. 2522.

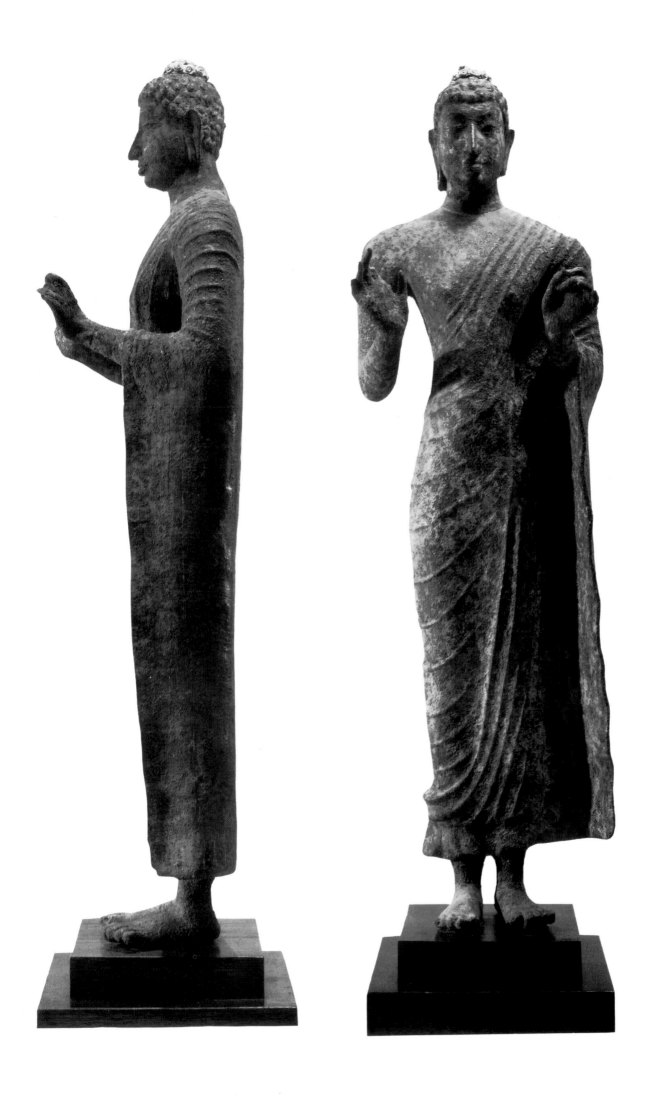

36
Standing Buddha

c. 7th century
West Sulawesi, Sikendeng
bronze, 29 1/2 in. (75 cm)
Museum Nasional, Jakarta, inv. no. 6057

THE SECOND LARGEST BUDDHIST bronze ever discovered in Indonesia has lost little of its majestic presence despite its loss of both hands and feet. The folds of the thin garment, wrapped tightly around the body, have been treated as thin, parallel grooves. Although this treatment of the drapery characterizes the statue as one of the group of images in the Amarāvatī tradition (see cat. 35), the closest stylistic parallels to this statue are not found in India proper, but in the school of Anurādhapura in Sri Lanka. Until the move of the seat of government to Polonnaruwa in 1070, Anurādhapura was the capital of the Singhalese Buddhist kingdom. Especially during its formative years Singhalese Buddhist sculpture was strongly influenced by styles current on the Indian subcontinent. The style associated with Amarāvatī contributed particularly to the emergence of the Anurādhapuran style. The curved hairline and the lack of an ūrnā (the round curl between the eyebrows) suggest that the statue is not an adaptation of an Indian prototype, but most likely derived from statues of the Anurādhapura school of sculpture.

The statue was found about 1921 in Sikendeng, a village at the foot of a hill overlooking the Karama River, north of Mamuju on the west coast of Sulawesi. Shortly after the Buddha's discovery, the government linguist A. A. Cense conducted an extensive investigation of the site, but was unable to locate any remains of a settlement, except one dating from prehistoric times. In nearby Wulu a bronze bell with a *vajra* top in the south Indian manner was found. The lack of traces of a temple or a settlement has strengthened the belief of some scholars that the bronze was imported, perhaps from Sri Lanka. It should be recalled, however, that along the east coast of Kalimantan, on the other side of the Makassar Strait, a considerable number of remains, both Buddhist and Sivaite, have been located. These included the large bronze Buddha from Kota Bangun, lost in the fire at the Colonial Exhibition in Vincennes in 1931.

The separately cast hands were inserted into the sockets of the arms of the statue, each held in place by means of a pin. In all probability the right hand was raised in the gesture symbolizing absence of fear (Skt. *abhaya-mudrā*), while the left hand held the tip of the monastic garment. F. D. K. Bosch saw in this method of casting an indication that the statue was made locally by bronze casters of limited technical skills. However, the superb rendering of the drapery folds and the nobility of the facial expression are hardly the work of apprentices, and the technique of separately cast arms was also used in Java during the eighth and ninth centuries (see cat. 57).

Literature: Bosch 1933; van Erp 1933a; *JBG* 2 (1934), 107; Blom 1953, 62–64; Dupont 1958–1959; *AIA* no. 22; *Koleksi Pilihan* 1, no. 17.

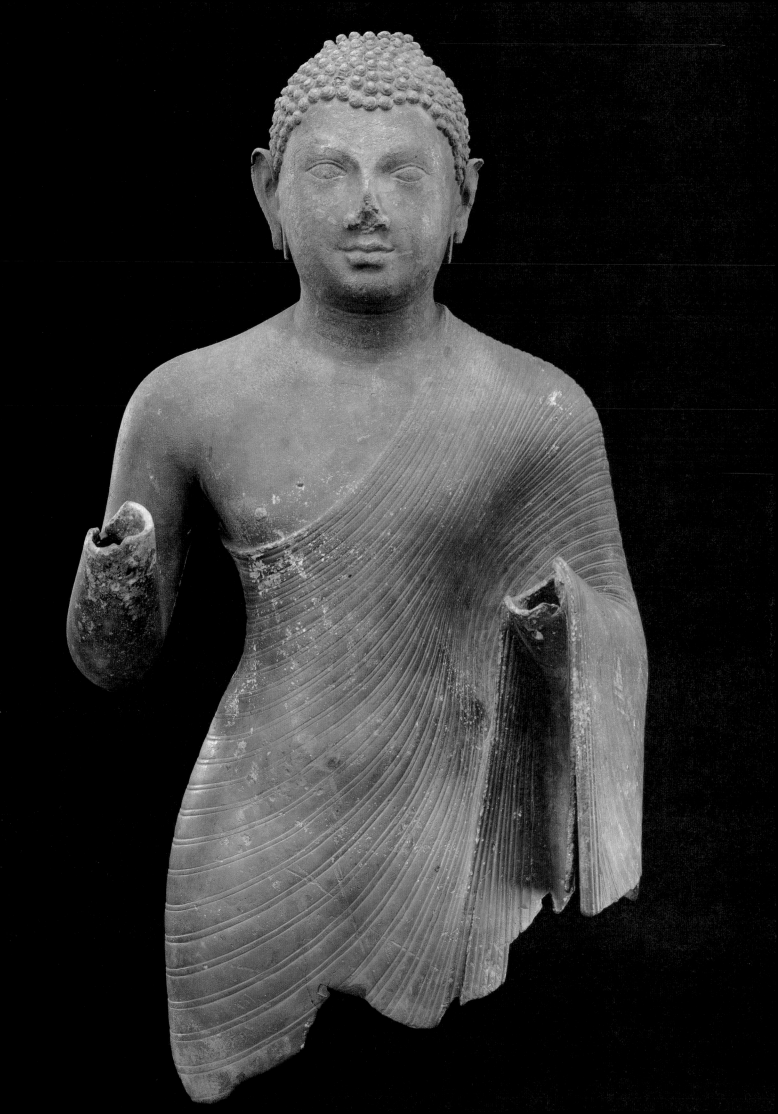

37
Standing Buddha

8th–9th century
from East Lombok
bronze, 8 ¾ in. (22 cm)
Museum Nasional, Jakarta, inv. no. 8524

THE SLENDER BUDDHA is clad in a monk's robe that clings to the skin and leaves the right shoulder bare. The pronounced hem of the robe crossing the chest and the heavy fold running up from the right ankle to the left hand is seen in many bronze images found in Southeast Asia that derive, directly or indirectly, from Indian prototypes cast in Buddhapad or Negapatam. In most Buddha images of this type the right hand is raised to the level of the waist in a gesture symbolizing absence of fear, the bestowing of gifts, or exposition. Here, however, the arm is extended with the palm of the hand turned down. This unusual gesture, combined with the outward thrust of the right hip and the flexion of the left knee, creates the impression of movement. This prompted the Belgian author of an exhibition catalogue to draw a comparison with the walking Buddhas of the Sukhothai style in Thailand. This lively, non-iconic pose brings to mind the Buddhas portrayed in the reliefs of Borobudur, where they are involved in human activities and not reduced to a static iconographic formula. The square face and the broad neck are quite unlike the physiognomy of other Southeast Asian Buddhist bronzes and may be a local characteristic, but the gesture of the right hand occurs also in a Javanese statue (Bosch 1923b, 140).

This bronze statue was discovered in December 1960 in the eastern part of the island of Lombok, together with several other bronzes, including images of Tārā (Museum Nasional, Jakarta, inv. no. 8522) and Avalokiteśvara (inv. no. 8523). In addition to the native Sasaks, Lombok has a sizable population of Balinese extraction, who introduced their traditional culture to the island. While Sumbawa, the next island in the chain, was long known to have remains of an Indianized culture, this find was the first of its kind in Lombok. R. Soekmono, who first reported it, pointed to the resemblance to the Buddhas of Borobudur and concluded: "In the light of this resemblance the only conclusion which can be drawn is that in the eighth and ninth centuries there were already followers of Mahāyāna Buddhism in the eastern part of Lombok."

Literature: van Naerssen 1938; Soekmono 1965, esp. 44; Brussels 1977, no. 35. The Javanese statue: Bosch 1923b, 140, fig. 1.

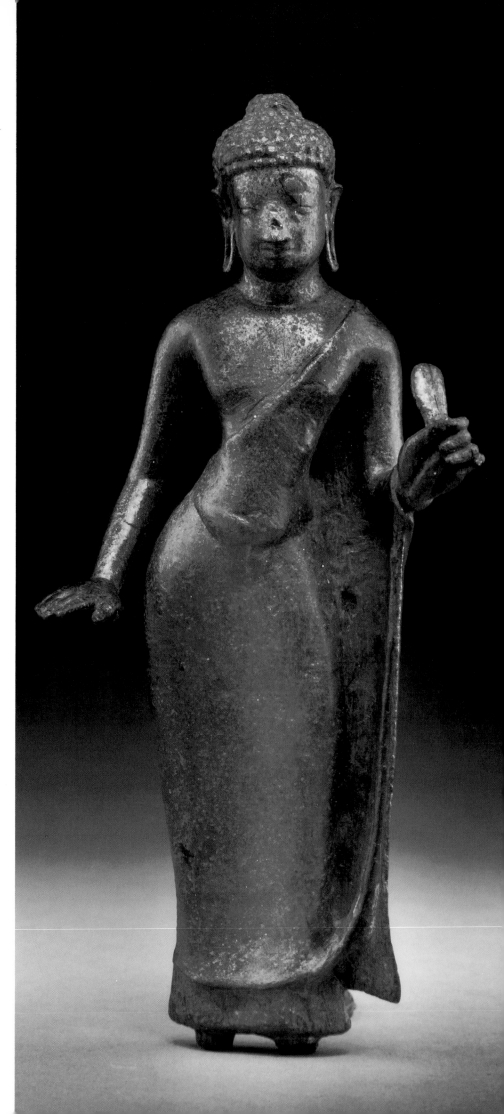

38
Seated Buddha

c. 8th–9th century
said to have been found in Java
gilt bronze, 12 in. (30.5 cm)

Museum of Fine Arts, Boston, Gift of the Honorable Lady Hood, Dona L. Coomaraswamy, William F. Whittemore, The MFA Expedition, The MFA Expedition and the University Museum of Philadelphia, Reginald Jenney, N. M. Heeramaneck, W. O. Comstock, Abdul Farag Shaer, Dr. Eliza A. Melkon, John Ware Willard Fund, Marshall H. Gould Fund, Marie Antoinette Evans Fund, and Samuel Putnam Avery Fund, by exchange, and Mary S. and Edward J. Holmes Fund, acc. no. 1988.151

THE BUDDHA is seated in the western manner (Skt. *pralambapāda*); the left wrist rests on the left thigh with the palm, in which the remnants of a mark are discernible, turned upward. The lower right arm and hand, probably raised in the symbolic gesture of exposition (Skt. *vitarka-mudrā*), have been lost. The Buddha is clad in a monk's robe that leaves the right shoulder bare. The double hem of the robe crosses the chest as if it were a sacred thread (Skt. *upavīta*). Across the lower legs and ankles the hem of the robe and the undergarment are clearly indicated.

Although the claim of a Javanese provenance for this statue of hieratic beauty cannot be substantiated, the close similarity to a gilt bronze Buddha of slightly larger size (14 in., 35.5 cm) from Sidarejo in the regency Cilacap strongly argues in favor of the attribution. Both statues are cast of solid bronze to which a coating of gold has been applied. In both cases the way in which part of the gold has flaked off at first sight suggested that it had been applied by hammering. However, a closer examination of the Boston statue indicates that the gold was applied by the mercury-amalgam technique, commonly used for gilt statues of this period. Although the hands of the Sidarejo and Boston statues formed different *mudrās*, the pose of the figures and the shape of the limbs and head are very similar, as is the treatment of the drapery.

Of the numerous images of the Buddha in a variety of Indian-derived styles that have been found in Java, Sumatra, Kalimantan, Sulawesi, and Lombok, the Boston and Sidarejo statues belong to a small group that seem to have been primarily inspired by prototypes from south India. The technique of gilding, the drapery of the monk's garb with the pronounced hem across the chest, the tapering shape of the arms, and the mark in the palm of the Buddha's left hand all recall south Indian statuary. Even though the hallmark of Negapatam Buddha statues—a cranial protuberance (Skt. *usnīsa*) surmounted by a flame—is absent on both statues, their close affinity to the gilt bronze Buddha from Melayur near Negapatam (Museum of Fine Arts, Boston) is evident.

Their ultimate provenance and exact date remain uncertain, but it is clear that statuary of this south Indian type exerted a strong influence in Java. An example is the Buddha from Ampel (cat. 39) in which this southern style has been harmoniously blended with ideas and techniques originating from other centers of bronze casting in India.

Literature: Wineman 1987, no. 2 (image reversed). The Sidarejo Buddha: *AIA*, no. 27. The Buddha from Melayur: Fontein 1980.

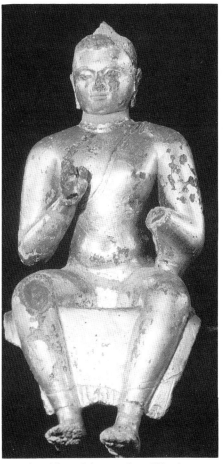

Seated Buddha, gilt bronze, from Sidarejo. Museum Nasional, Jakarta, inv. no. 8242

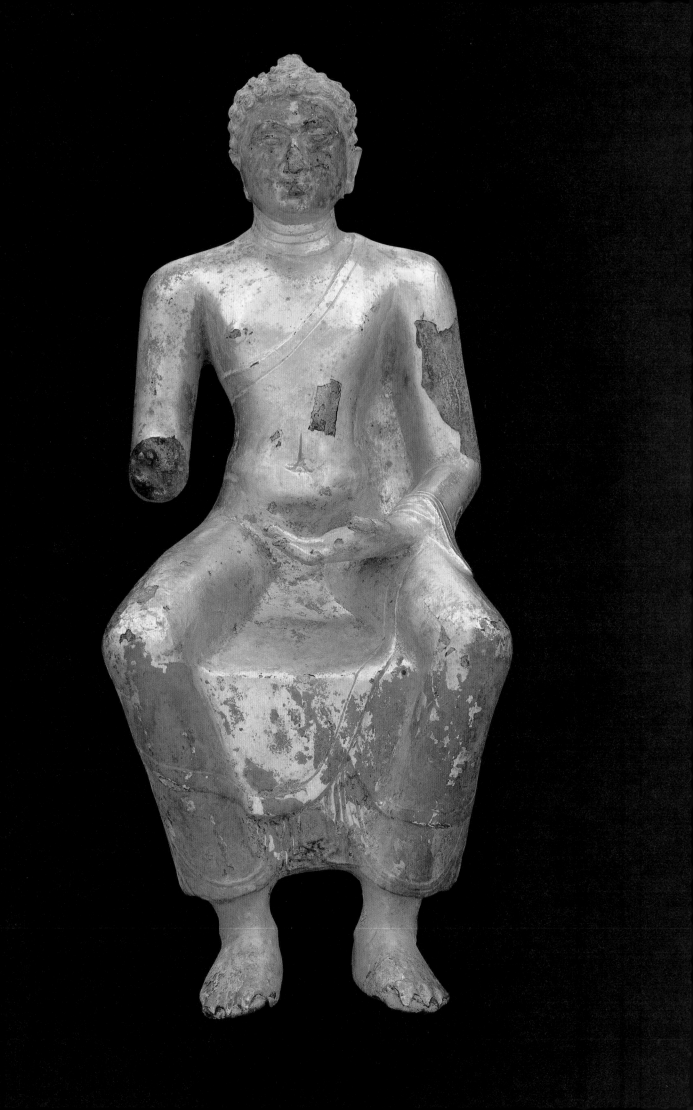

39
Seated Buddha
9th century
Central Java, from Ampel, Solo
bronze with gold and silver inlay,
6 3/4 in. (17 cm)
Museum Nasional, Jakarta, inv. no. 588

THE BUDDHA, who has lost his throne and pedestal, is seated in the so-called western manner (Skt. *pralambapāda*), the right hand raised in the gesture of exposition (Skt. *vitarka-mudrā*); the left hand, held in the lap, holds the edge of his monk's garment. The *ūrnā* and the lower lip have been inlaid in gold, the eyes in silver.

The position of the Buddha's hand is usually seen in standing figures of a Buddha type found in different parts of the Indonesian archipelago and in other Southeast Asian countries, reflecting diverse Indian influences. In this statue the inlaid eyes and lip point to Bengal and Bihār, while the pointed cranial protuberance (Skt. *usnīsa*) suggests influence from Negapatam in South India. The pose and shape of the body are very similar to those of a gilt bronze image of a seated Buddha found at Sidorejo near Cilacap (Central Java), now in the Museum Nasional, Jakarta (inv. no. 8242) and, to a lesser degree, to the gilt bronze Buddha in the Museum of Fine Arts, Boston (cat. 38). However, in these two gilt bronzes foreign influences still clearly manifest themselves, and the possibility that these statues were imported from outside Java should not be discounted. In the seated Buddha in this exhibition these diverse influences seem to have been fully blended and appropriated. The statue probably dates from the first half of the ninth century, when this process of appropriation had reached its completion.

Literature: Groeneveldt 1887, 172; *ROC* 1912, 13; Brussels 1977, no. 32.

⟨ cat. 38

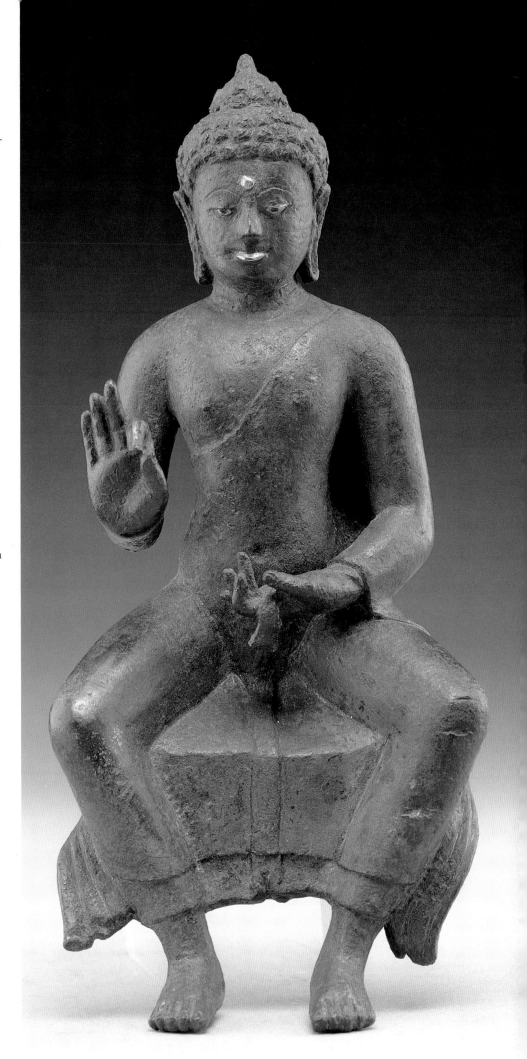

Throne back

c. 9th century
Central Java, provenance unknown
bronze, 17 3/4 x 13 in. (45 x 33 cm)
Suaka Peninggalan Sejarah dan Purbakala
Jawa Tengah, Prambanan, inv. no. 315

THE THRONE BACK consists of a rectangular panel, framed by two pilasters and a horizontal crossbar. It is flanked by a symmetrical heraldic arrangement of crouching elephants surmounted by prancing lions (*vyālakas*). They support the crossbar of the throne, the ends of which take the shape of fish elephants (*makaras*) with their heads turned outward. On top of the crossbar an oval halo, surrounded by flames, has been attached.

The horizontal bar and the vertical posts of the throne back are decorated with an engraved pattern, a variant of the typically Central Javanese "flower-and-seed-vessel" design. The halo has an engraved design of a wheel with four spokes, a reference to its origin as the wheel of the sun. The nave of the wheel gives us an indication of the height of the original cult image, which must have been ten inches (25.5 cm). The superb quality of the cast makes the lack of the image for which it once served as the background more acute.

The style and structure of this throne are similar to that of east Indian prototypes dating from the seventh or eighth century, when the use of crouching elephants as supports for the *vyālakas* came into fashion in India.

Magnificent throne backs of a similar type and likewise lacking the statuary for which they were designed can also be seen in stone in the cellas of several Central Javanese *candi*s. At Candi Kalasan (near Prambanan) a huge throne of the same type, flanked by the same heraldic animals, is found in the main chamber of the temple. The presence of a footrest suggests that the original icon was a Buddha seated in the so-called western manner (Skt. *pralambapāda*). This Buddha may have been similar to the principal stone image of Candi Mendut, whose throne is of the same type as that in Kalasan. The detailed study of these thrones by J. L. Brandes (1903) concluded from the measurements of the throne in Candi Kalasan that the cult image must have been about twice the size of that of Mendut, therefore about eighteen feet tall.

In Cambodia the first discovery of a gigantic statue in bronze occurred only in 1936 (the Sleeping Visnu of the Mebon Occiden-

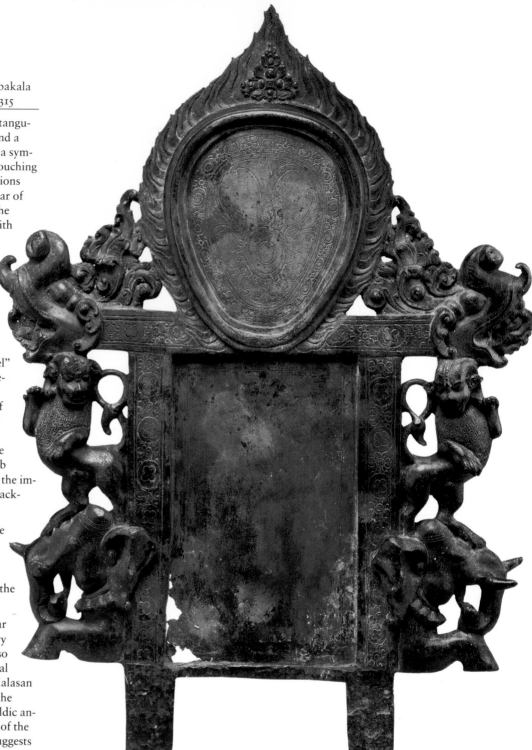

tal), but in Indonesia proof of the casting of huge bronze images, in addition to the silent evidence provided by countless empty pedestals, was discovered as early as 1900 when J. F. L. Gessner found a life-size bronze finger in the main cella of Candi Sewu (Prambanan). Since Brandes had reconstructed the height of the principal image of that cella as being about twelve feet, the finger obviously did not belong to that image. However, in 1927 bronze fragments of a Buddha's curls were found in a village near Candi Sewu (now in the Museum Radya Pustaka, Solo, and the Museum Nasional, Jakarta). From a comparison with the curls of the Buddha in Candi Mendut we may conclude that the curls belonged to a statue about twelve feet tall, quite possibly the missing image from the main chamber of Candi Sewu.

Literature: The throne back has not been previously published. *NBG* 1900, 68, 92, and CLIX; Brandes 1904b; *OV* 1927, 27–28; Stutterheim 1929b; Auboyer 1949, 36.

41
Seated Buddha
9th century
Central Java, provenance unknown
bronze, 14 3/4 in. (37. 2 cm)
Rijksmuseum voor Volkenkunde, Leiden,
inv. no. 1403–2844–1883

THE BUDDHA is seated in the "western manner" (Skt. *pralambapāda*) on an elaborate throne. His hands, raised in front of the chest, form the gesture of Turning the Wheel of the Law (Skt. *dharmacakra-mudrā*). As has been often observed, the statue bears a striking resemblance to the Buddha in the cella of Candi Mendut. There, too, the wheel, flanked by a pair of recumbent deer, alludes to the historical moment when the Buddha set it in motion, delivering his first sermon at the Deer Park in Benares. His seat is supported by two *gaja-simha* (lions attacking elephants, see cat. 42). The back of the luxurious throne, much more elaborate than that in Candi Mendut (see below), shows crouching elephants surmounted by dwarfs and prancing *vyālakas*. The greater part of the vertical posts supporting the crossbar of the throne has disappeared, as has the canopy that once was attached to the top of the nimbus. As if all these components of the assemblage were not sufficient, the artist added a pair of lions flanking the throne and flowers attached to the throne back.

In Javanese bronze sculpture only seldom has the *gaja-simha* motif been incorporated in the throne. In stone there is only a single example; it hails from Candi Bubrah, Prambanan (*ROC* 1910, pl. 153), but its original context is unclear. The two additional lions flanking the throne are also most unusual. Often a pair of lions is attached to the pedestal or throne to symbolize the Buddha's lion throne, but only in one other bronze group are they represented in the round, like the lion statues in the niches in the base of Candi Loro Jonggrang. This other example is a Śiva and Pārvatī from Kretek, Wonosobo, in which figures of the bull Nandin and a lion are placed in front of the pedestal (Museum Nasional, Jakarta, inv. no. 5802). This bronze was lost in the fire at Vincennes in 1931 (*TBG* 71, 1931, fig. 6 after p. 670). No other example of the addition of a flower to the figures flanking the throne back is known.

This surfeit of decorative elements may have been inspired by the artist's desire to contrast the splendor of the phenomenal world with the serenity of supreme enlightenment. He may also have delighted in including as many components appropriate for thrones as he could fit in, even adding one of his own invention, the flowers. It is evident, however, that the process of harmonizing these many different elements into a new style had not yet fully crystallized at the time when this bronze was created. Therefore it probably dates from the early ninth century.

At Borobudur the historic moment commemorated in this bronze is represented on the relief that concludes 120 panels of the life of the Buddha on the first gallery (I a 120). In that scene, however, the Buddha is not shown, as we would have expected, with his hands forming the *dharmacakra-mudrā*. Instead the right hand, now broken off, appears to have been raised in the gesture of exposition (*vitarka-mudrā*). It may, therefore, be questioned whether the principal statue of Candi Mendut and the bronze exhibited here really represent Śā-kyamuni in the Deer Park at Benares. The gesture of the Turning of the Wheel of the Law is also associated with the supreme Buddha Vairocana. In recent years it has been suggested that the statuary in Candi Mendut and the figures carved in relief on the outside of that temple constitute a Matrix Mandala or *Garbadhātu-mandala*. Of this mandala Vairocana is the central figure. While comparisons with Japanese mandalas of this type offer many interesting parallels, there is no complete correspondence between their iconographic programs, and this interesting theory remains, therefore, unproven.

Literature: Juynboll 1909, 89–90 and pl. 12; Bernet Kempers 1933a, 28, 65–67; Bernet Kempers 1959, pl. 62; Chandra 1980; Singhal 1985; Amsterdam 1988, no. 24.

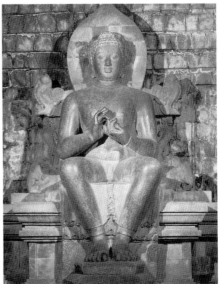

Seated Buddha in cella of Candi Mendut

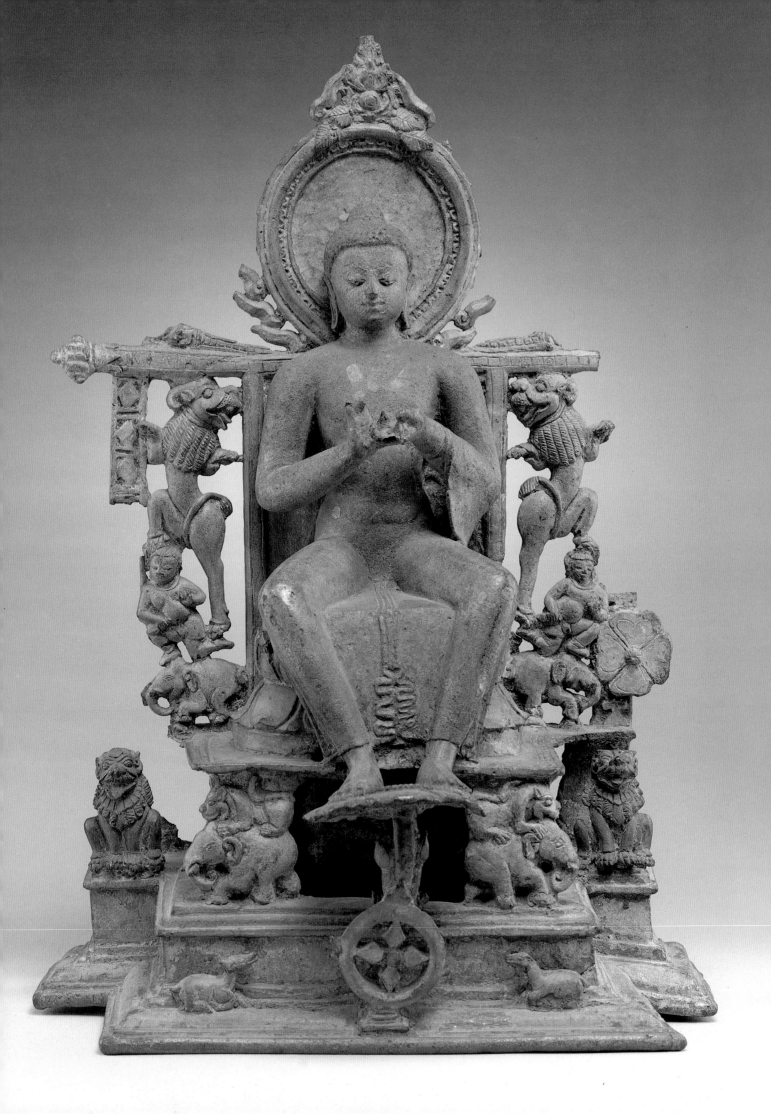

42
Jambhala
second half 9th century
Central Java
bronze, 11 in. (28 cm)
Musée Guimet, Paris, gift of J. J. Meijer,
inv. no. MG. 3814

THE LARGE NUMBER of bronze images of Jambhala, the god of wealth, attests to the widespread popularity of this deity in Central Java. Images of this god, worshipped by Buddhists and Sivaites alike and whom the Buddhists call Jambhala but the Sivaites Kuvera, are virtually indistinguishable; only the context in which a statue was found can sometimes indicate which name it should be given. In the case of this image, the Buddhist character is evident from the inscription engraved on the back of the pedestal. It is the so-called Buddhist Creed, written in Sanskrit in *siddham* script: "of all phenomena springing from a cause the Tathāgata (the Buddha) has told the cause and their cessation; Thus spoke the Great Mendicant." This inscription is often found on Buddhist statues (see cat. 44).

Jambhala, as always represented as a corpulent young man (an inscription from Candi Ijo even calls him "repulsive"), is seated in the posture of "royal ease" (Skt. *lalitāsana*) on a cushion embroidered with floral motifs and placed on top of a pedestal with supports imitating turned wooden columns. In his right hand, resting upon his knee, he holds the lemon (Skt. *jambhara*) from which his Buddhist name derives. In the left hand he grasps the neck of a mongoose (Skt. *nakula*) from whose open jaws a necklace of jewels spills forth.

The god is in royal attire, wearing an elaborate headdress (Skt. *kirīti-mukuta*), two necklaces, a belt, arm bands, and anklets, all richly decorated. His right foot is supported by an upturned vase (Skt. *pūrnaghata*), from which a profusion of jewelry spills over the cloth on which the cushion has been placed. In front of the pedestal are seven other containers of jewels; the total number of eight may be a reference to the Eight Treasures (Skt. *astanidhi*), one of the traditional attributes of the god.

The statue is flanked by lions devouring elephants (Skt. *gaja-simha*) between the columns in front of the pedestal. The lion is a royal animal, associated with the sun, while the equally royal elephant symbolizes the earth. Together they are appropriate emblems for a throne serving a king or a god. These elaborate details of the throne emphasize the absence of the throne back and halo that usually complement statues in such a setting. An approximate idea of what this Jambhala may have originally looked like is conveyed by an image of the

same god found at Ngepok, near Temanggung, Central Java. There we see a similar although much less delicately cast Jambhala, seated on an elaborate throne flanked by prancing heraldic lions (*vyāla-kas*), standing on top of crouching elephants. The flaming halo with a reticulated border is surmounted by a canopy. Both statues show a slip of cloth of rounded shape, emerging from beneath the cushion and hanging across the front of the pedestal. This feature is typical of bronzes from Sirpur in India and from the Comilla and Chittagong districts in Bangladesh.

While most of the details of this sculpture can be traced to different local styles of eastern India and Bangladesh, these elements have been blended harmoniously; the round modeling of the figure and the delicate rendering of minute details of dress and jewelry are unmistakably Javanese. Richer in detail than the Jambhala from Ngepok, it should perhaps be dated in the second half of the ninth century.

Literature: Krom 1917, esp. 391; Musée Guimet 1924, pl. 37; Cologne 1926, pl. 10, no. 2; Bernet Kempers 1959, pl. 167; Musée Guimet 1971, no. 3814; New York 1975b, no. 30. The Jambhala from Ngepok: *AIA* no. 37.

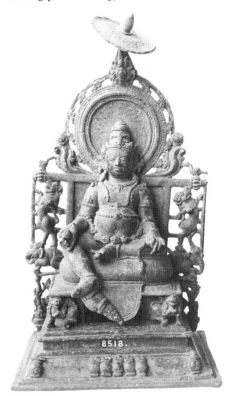

Jambhala or Kuvera, bronze, found at Ngepok. Museum Nasional, Jakarta, inv. no. 8518

‹ cat. 41

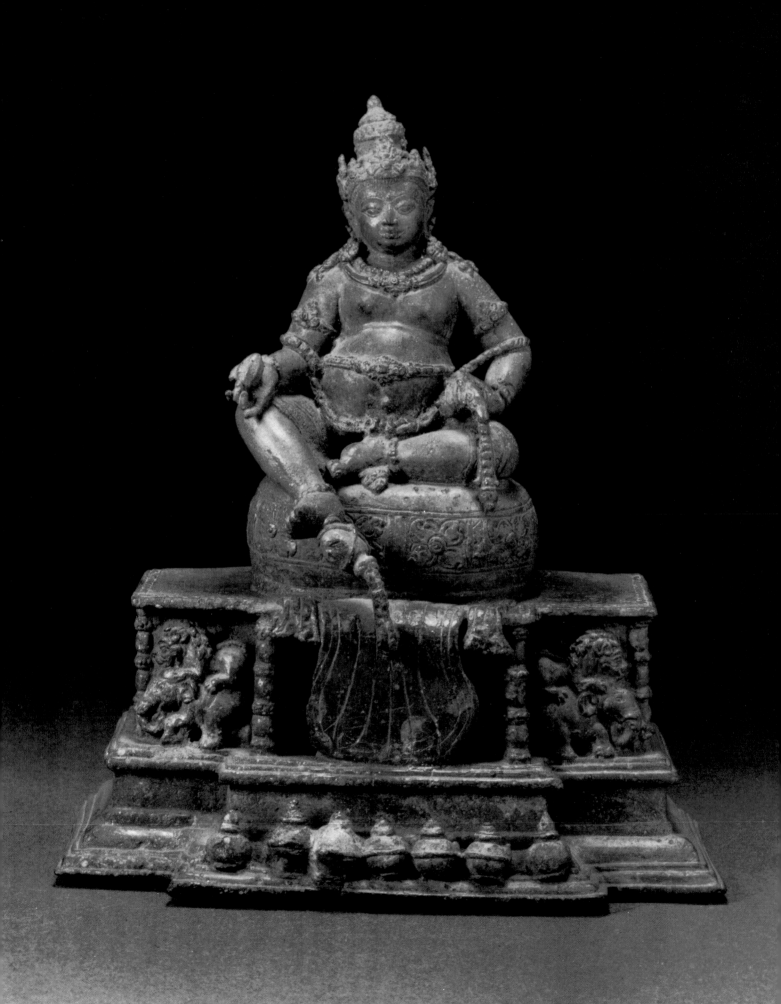

43
Jambhala

second half 9th century
Central Java, from Candi Sajiwan
bronze, 6 ¼ in. (15.8 cm)
Suaka Peninggalan Sejarah dan Purbakla
Jawa Tengah, Prambanan, inv. no. 106

THE POT-BELLIED god of wealth is seated in
sattvaparyanka, the right foot resting upon
the left thigh, on a double lotus throne
placed upon a square unadorned base. In
the palm of his right hand, which rests
upon his knee, he holds a lemon (Skt. *jam-
bhara*); the left holds a money bag in the
shape of a mongoose, spilling its precious
contents of strings of pearl over his left leg.
The crossbar of the low throne back ends
in stylized *makaras*. The solid halo with its
flaming border, to which the canopy is at-
tached, was cast separately and has been
attached to the base with two rivets.

Although it is much more simple than the
bronze from the Musée Guimet (cat. 42),
this statue of the god of wealth is of special
archaeological interest as it is associated
with a specific monument. It was found
buried in the grounds of Candi Sajiwan,
Prambanan, a Buddhist sanctuary situated
about a mile south of Candi Loro Jong-
grang. Candi Sajiwan, which is known for
its bas-relief vignettes of animal fables and
for the beauty of its statuary, is presently
being reconstructed by the Indonesian Ar-
chaeological Service. During the cleaning
of the ruins by the Archaeological Society
of Yogyakarta in 1902 a small, headless sil-
ver statuette of a bodhisattva was found. It
is now in the Museum Nasional, Jakarta
(inv. no. 659 b/A 71). It is often assumed
that the many Buddhist bronze statuettes
that have come down to us from Central
Javanese times were originally placed on
house altars. Yet archaeological evidence of
their use is totally lacking. This statuette of
Jambhala and the silver image mentioned
above are among the few small Buddhist
icons that have been found in the grounds
of a Buddhist monument.

Literature: not previously published. Candi Saji-
wan: van Blom 1935. The silver statuette: *NBG*
1902, 57 and CCXVII; *ROC* 1912, 47.

⟨ cat. 42

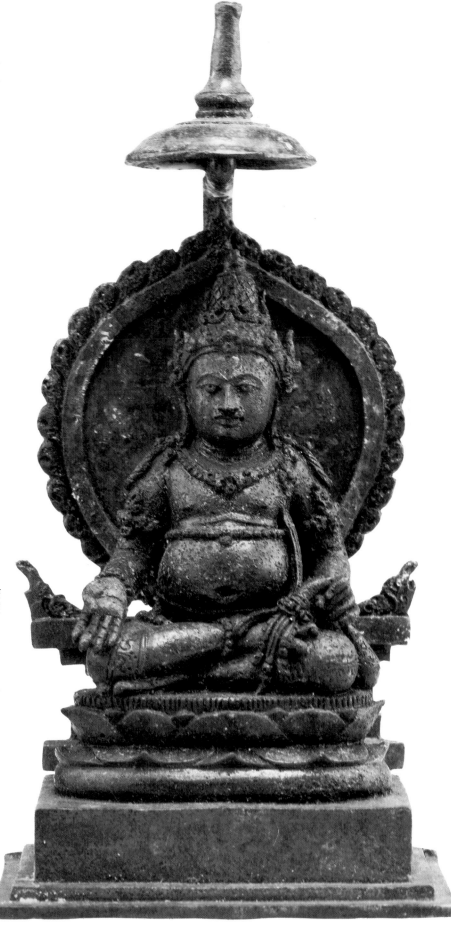

44
Seated Tārā
c. 9th century
Central Java, Bumiayu, Brebes
bronze with gold and silver inlay, 6 ¹/₄ in. (16 cm)
Museum Nasional, Jakarta, inv. no. 6590

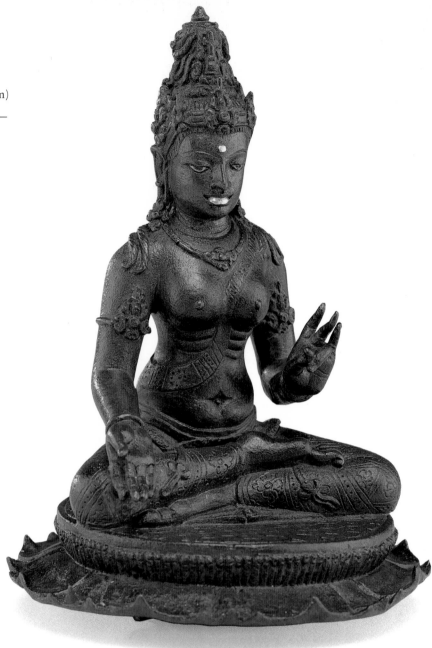

THE GODDESS TĀRĀ is seated on a lotus pod bordered by a single row of petals, in the posture *paryankāsana* (with her right leg placed on top of the left). She wears a small *stūpa* in her elaborate headdress. Her right hand rests upon the right knee, the palm turned upward in the gift-bestowing gesture (*vara-mudrā*). The left hand is raised, the tip of the thumb touching that of the third finger, forming the *kartarī-mudrā*, a gesture often used for holding attributes. In all likelihood this hand once held the stem of a blue lotus (*utpala*). Her sacred thread (Skt. *upavīta*) takes the shape of a ribbon, partially covering the three folds of flesh (an Indian mark of beauty) below her breasts. Her eyes are inlaid in silver, the *ūrṇā* and her lower lip in gold, a technique often applied in Javanese bronze statuary inspired by Indian prototypes from Bengal and Bihār (cats. 39, 45, 52).

A Sanskrit inscription around the lotus base consists of a standard formula, often referred to as the Buddhist Creed (see cat. 42). Buddhists believe that it was with those words that the historical Buddha Gautama converted his first disciples Śāriputra and Maudgalyāyana. The Creed, with numerous minor variations, often occurs on votive clay tablets excavated at Nālandā, and is frequently engraved on stone statues of the East Indian Pāla dynasty, especially on statues from Bihār. It is also quite common on clay tablets found all over Southeast Asia in areas as far apart as Burma and Bali. The statuary included in this exhibition demonstrates that the Buddhist Creed was not associated with any figure of the Buddhist pantheon in particular (see cats. 42, 63). A bronze image of Avalokiteśvara and Tārā side by side, found at Kurkihar (East India), is also inscribed with the same formula.

A cavity with a tubular attachment surrounded by four petals in relief in the center of the bottom of the lotus-pod base suggests that this elegant, superbly cast statuette once stood on a lotus stalk and that it may have been part of larger altarpiece. On the back of the statuette is a loop to which a halo was once attached.

The cult of the goddess Tārā is of uncertain origins. Tārā is the name of the star that guided Indian navigators; her help was invoked to obtain safe passage across the seas. Tārā made her first appearance in the Buddhist pantheon at a relatively late date as the female counterpart of Avalokiteśvara in his role as the Savior from the Eight Perils. As the remover of all obstacles, the destroyer of fears, and the bestower of boons, Tārā became the female personification of the compassion of Avalokiteśvara. Gradually her role expanded into that of the tutelary deity of "all who cross the ocean of worldly existence," dispelling ignorance and providing guidance to enlightenment. Acquiring the characteristics and attributes of other deities, Buddhist as well as Hindu, she assumed many different forms and ultimately became the supreme goddess of Buddhism and the female counterpart (*prajñā*) of the Tathāgata Amoghasiddhi in the system of the Five Prajñās (see cat. 21).

Perhaps because of its maritime associations, the cult of Tārā spread to Java at an early date. An inscription found near Candi Kalasan records the founding of a sanctu-ary of Tārā in the year Śaka 700 (778) by a king of the Śailendra dynasty. The name of the village in which this sanctuary was founded is given as Kalasa. The fame of this temple, in all probability identical with Candi Kalasan, seems to have spread to the holy land of Buddhism itself, for the Indian text *Ārya-mañjuśrīmūlakalpa* (LIII: 833) mentions Kalasa as one of the places where Tārā was worshipped.

A stone statue representing Tārā found at Bogĕm (near Prambanan) represents her as a goddess with a lotus surmounted by an image of Amitābha. Like the statuette exhibited here, the stone sculpture from Bogĕm showed a stūpa in Tārā's headdress.

Literature: *JBG* 6 (1939), III, pl. 3; *AIA*, no. 30; *Koleksi Pilihan* 1, no. 21. Tārā: de Blondy 1895; Ghosh 1980. The Tārā from Bogĕm: *ROC* 1912, 73.

45
Standing Avalokiteśvara
second half 9th century
Central Java, reputedly from Sragen
bronze, with gold and silver inlay,
16 1/2 in. (42 cm)
Museum Nasional, Jakarta, inv. no. 7515a

WITHOUT THE SLIGHTEST flexion of body
or legs Avalokiteśvara stands straight on a
double lotus base on top of a square pedes-
tal. He raises his right hand in the fear-
dispelling gesture (*abhaya-mudrā*), the left
hand in the expounding gesture (*vitarka-
mudrā*). The open halo has the stylized
head of a *kāla* (monster) on top and two
stylized fish elephants (*makaras*) below; it
consists of a flat band with repetitive orna-
ment, bordered on the outside by leaping
flames. The band of ornament, consisting
of alternating rounded and rectangular
shapes, although occasionally seen in Nā-
landā stone sculpture, was in all probabil-
ity derived from earlier patterned bands of
flowers alternating with seed vessels. In
Java these bands can be dated exactly, as an
example occurs on the stele from Talaga
Tañjung (Museum Nasional, Jakarta, inv.
no. D 20), dated Śaka 783 (861). The sim-
plified later pattern, in which these two
types of flowers have been reduced to geo-
metrical shapes, as they are in this bronze
statue of Avalokiteśvara, can also be seen
in the halos of the stone statuary at Candi
Plaosan.

Between the feet of Avalokiteśvara a lotus
bud emerges from the lotus stand. The
same ornament is repeated in the elaborate
headdress, which is crowned by a small im-
age of the Buddha Amitābha. A detachable
canopy, broken at the time the bronze en-
tered the collection of the Jakarta Museum,
has since been restored.

The lower lip and *ūrnā* are inlaid with
gold, the eyes with silver. The use of inlaid
precious metals or lips, eyes, and *ūrnā* is
typical of the bronze workshops of Bihār.
The frequency with which this technique
was applied in Java for Buddhist as well as
Śivaite statuary attests to the strong and
widespread influence of bronze icons from
northern India (see cats. 39, 44, 52). The
open halo is another hallmark of bronzes
from Nālandā and Kurkihar, but the styl-
ized *kāla-makara* motif is typically Java-
nese and leaves no doubt as to its original
provenance from Central Java.

Literature: *AIA* no. 28; *JBG* 9 (1941–1947), 98,
pl. 3; Brussels 1977, no. 46.

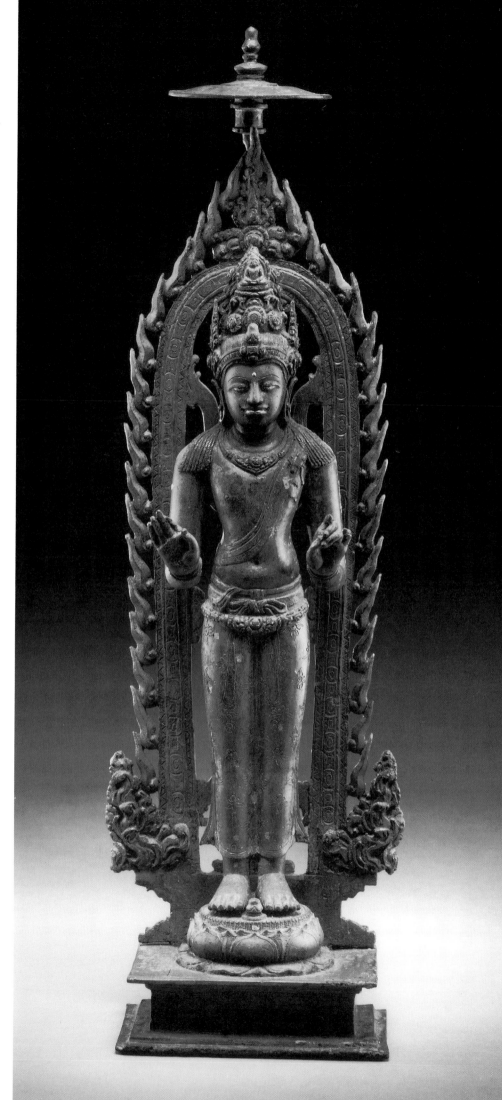

The youthful Bodhisattva Mañjuśrī

early 10th century
Central Java, from Ngemplak Semongan
silver, 11 3/8 in. (29 cm)
Museum Nasional, Jakarta, inv. no. 5899

THIS SUPERB STATUE was found in October 1927 by a farmer in the village of Ngemplak Semongan, a little more than a mile southwest of Semarang (Central Java). The statue is cast in solid silver of ninety-two percent purity, weighing more than eighteen pounds.

The Bodhisattva is seated in relaxed pose (Skt. *lalitāsana*), with the right hand resting in boon-granting gesture (Skt. *vara-mudrā*) on the right knee. The raised left hand holds the stem of the blue lotus (Skt. *utpala*) with its pointed petals, on top of which rests a book. The Bodhisattva wears a conspicuous necklace consisting of a rectangular amulet incorporating two tiger's teeth, curved outward, and pendants, some of which take the shape of tiger's claws (Skt. *vyāghra-nakha*). The figure is clad in a loincloth with floral designs, held at the waist by a belt with a decorated clasp. The head is shaven, except for three long tufts of hair (Skt. *tricīra*). The middle tuft is held on top of the head by a clip, the front of which is decorated with a triangular piece of jewelry. The other two tufts, twisted like ram's horns, fall behind the ears and across the shoulders. The headdress and necklace, as well as the attribute and *mudrā*, characterize this unique piece of sculpture as a representation of the Bodhisattva Mañjuśrī, who was often depicted in youthful appearance (Skt. *kumāra-bhūta*). The necklace with tiger's teeth and claws was thought to provide magic protection for boys (see cat. 111). This tradition of Indian origin seems to have continued in Indonesia until modern times. At the beginning of this century children in Aceh (North Sumatra) were still given necklaces with amulets incorporating tiger claws, called *gukeë rimoëng*.

The statue was made in strict accordance with the iconographical rules current in the East Indian Pāla kingdom, and is reminiscent of bronze statuary from Nālandā and Kurkihar. Only a few examples of Indian statuary cast from precious metals have survived, notably the Visnu as Trivikrama in silver, found at Vikramapura (Indian Museum, Calcutta), which may date from the years of decline of the Pāla-Sena kingdom (c. twelfth century). In that sculpture, too, it is evident that statues in precious metals were only commissioned from the best artists. Except for this later example, however, nothing comparable has been preserved in India, and no prototypes in

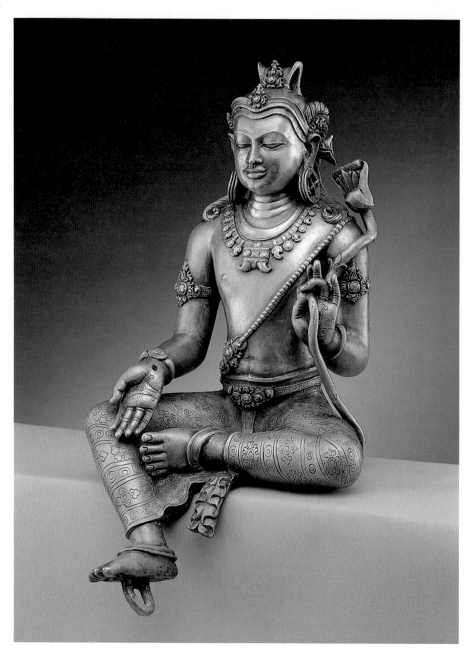

bronze of Pāla origin have been found that could have served as a model for this masterpiece of silver casting. We have no certainty, therefore, that the sculpture was imported from India, as has sometimes been suggested.

Inside the loop by which the statue was originally attached to its now-lost throne or pedestal (a similar loop is attached to the right foot), a fragmentary sheet of silver was found containing the Buddhist Creed (see cat. 42) written in early *Nāgarī* (sometimes also called *Siddham*) script. It dates, in all probability, from the early tenth century. Unfortunately, this document has been lost in recent years.

Literature: Bosch 1929b; Rawson 1967, fig. 197; Brussels 1977, no. 42; *Koleksi Pilihan* 1, no. 29. The Visnu from Vikramapura: Huntington 1985, 413 and figs. 18–33. Aceh necklaces: Veltman 1904, 341–380, pl. VII, no. 17; Djajadiningrat 1934, 510.

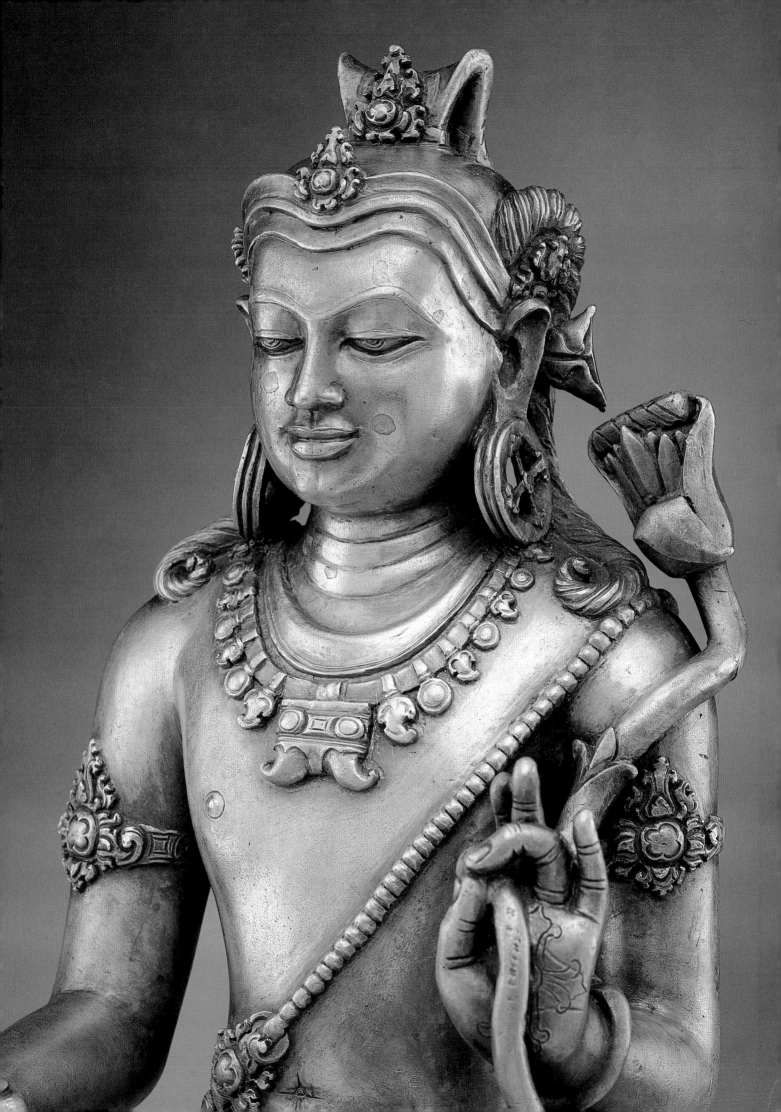

47
The bodhisattva Mañjuśrī

c. 9th century
Central Java
silver, 2 5/16 in. (5.8 cm)
Linden-Museum, Stuttgart, inv. no. SA 35
244L

THE BODHISATTVA MAÑJUŚRĪ IS REPRE-
SENTED AS A YOUTHFUL PERSON (SKT.
kumāra). He is seated in *sattvaparyanka*,
his right leg placed on top of the left thigh.
His right hand, resting on his right knee,
makes the boon-granting gesture (Skt.
vara-mudrā), while his raised left hand
holds a blue lotus on top of which lies a
book.

The bodhisattva's youth is indicated by the
fact that he wears a boy's double sacred
thread, the crossed *channavīra*, with a
four-petaled clasp on his chest. While this
is in accordance with standard Indian ico-
nography, the pair of crescent-shaped orna-
ments behind the head are an Indonesian
addition for which no Indian precedent
seems to exist. We see it often in statuary of
bodhisattvas and deities who are thought
to be youthful, such as Mañjuśrī, Jam-
bhala, or Kuvera. In the relief of the en-
trance porch of Candi Mendut, the chil-
dren of Hārītī are likewise shown with
these crescents behind their heads (see ill.
in cat. 50).

The provenance of this statue is unknown.
Besides the large silver statue from Ngem-
plak (cat. 46), a small silver image of a
standing Mañjuśrī was found at Karang-
Jambe, Banjarnegara (Central Java),
in 1891.

Literature: Linden-Museum 1984, no. 20. The
statue from Banjarnegara: *NBG* 1891, 41, bijlage
12, no. 632a; *ROC* 1912, 39; *ROC* 1914, no. 369.

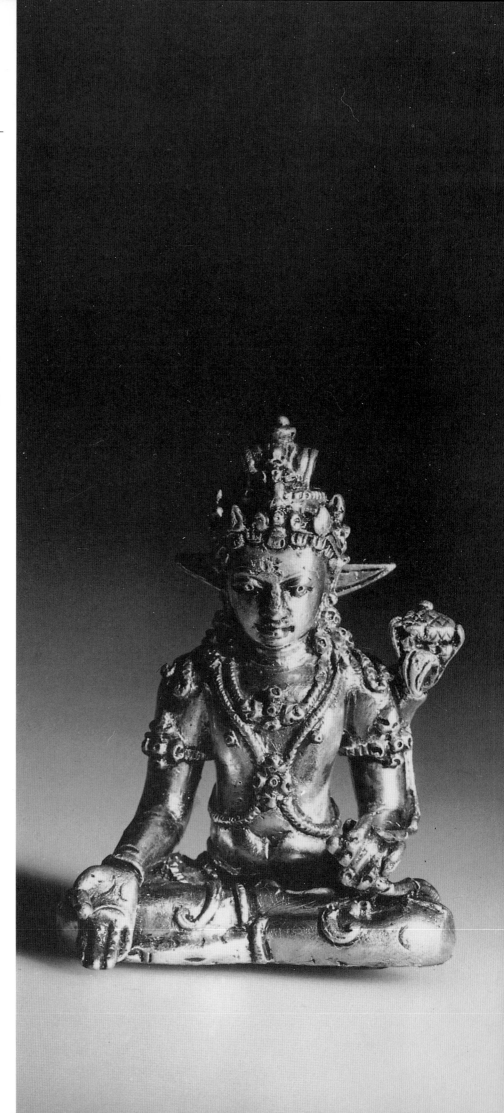

48
Śrī Devī

9th–10th century
Central Java, provenance uncertain
bronze, 8 1/4 in. (21 cm)
Museum Sono Budoyo, Yogyakarta

THE GODDESS is seated in *sattvaparyanka*, the right foot placed on the left thigh, on a double-petaled lotus throne on top of a plain, molded rectangular base. In her left hand she holds the stalk of an ear of rice growing out of the left side of the pedestal. Her right hand makes the boon-granting gesture (Skt. *vara-mudrā*). She wears royal attire, a richly decorated, tall headdress and a sacred thread (*upavīta*) in addition to the crossed thread (*channavīra*) usually worn by women and boys. Her garment is decorated with a four-petaled flower motif. Behind her head is an oval nimbus bordered by stylized flames. The statuette is covered with a rust-colored patina seldom seen on Javanese bronzes.

The identification of this beautiful bronze has in the past been a topic of considerable discussion. Krom first identified it as the goddess Mārīcī, who holds a stalk of the Aśoka-flower in her left hand. The fact that this statuette clearly shows an ear of rice invalidates that identification.

In Indian iconographic texts the goddess Vasudhārā, the consort of Jambhala, is said to exhibit the *vara-mudrā* with the right hand and to carry an ear of *dhānya* in the right. Albert Le Bonheur has suggested that the word *dhānya* used in the texts left the artists ample room for interpretation, as the word signifies different sorts of grain, including rice. (The translation "corn" used by Indian and Dutch scholars has added to the lexicographical confusion.) It was only natural, therefore, that the Javanese chose to represent the goddess with an ear of the cereal plant that constitutes the staple of their diet.

In Hindu mythology, the deity Śrī-Lakṣmī, the consort of Viṣṇu, is often associated with Kuvera, the brahmanic counterpart of Jambhala (see cat. 42), whose consort is Vasudhārā. In India images displaying the iconographical characteristics of Vasudhārā have sometimes been found inscribed with the name Śrī Devī.

While there is good reason, therefore, to identify the statue as Śrī, its connection with the popular cult of the goddess of rice is not entirely clear. Representations of the goddess holding a head of rice are surprisingly small in number. Hariani Santiko mentions only three examples in stone. One of these represents the goddess as the consort of Viṣṇu (Museum Sono Budoyo, Yogyakarta). Of the bronzes of the Va-

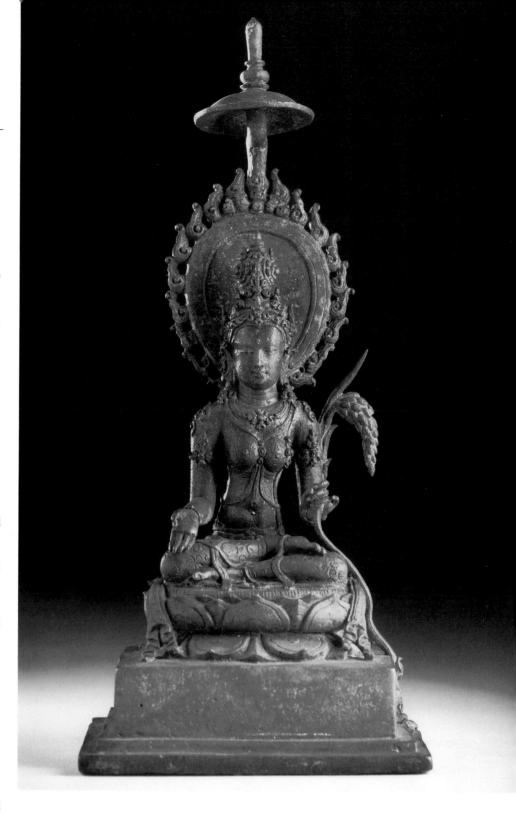

sudhārā type, the statuette exhibited here is the only one in which an ear of rice is clearly visible. The style of the halo and the slender limbs of the goddess suggest a date toward the end of the Central Javanese or the early years of the East Javanese period. It is possible that the cult of Śrī Dewī as the Javanese goddess of rice developed after the era in which this bronze was cast.

Stutterheim, who was acquainted with the collector, Mrs. A. J. Resink-Wilkens, re-

corded as its provenance the village of Wanajaya. There was a village of that name in the Kecamatan Pare (Kediri, East Java), but whether this village or another with the same name was meant is unclear.

Literature: Krom 1923, 3: pl. 108; Krom 1926, introd. 9, pl. 20; Bernet Kempers 1933a, 45–46; Stutterheim 1934b, 167–189; Bernet Kempers 1959, pl. 112; Musée Guimet 1971, 198–203; Brussels 1977, no. 76; Santiko 1980; Amsterdam 1988, 22–23.

49
Avalokiteśvara and consort

late 9th century
Central Java, provenance unknown
silver (statues) and bronze (pedestal), 4 3/4 x 5 1/8 in.
(12.1 x 13.1 cm)
Asian Art Museum of San Francisco, gift
of the Walter and Phyllis Shorenstein Fund, inv. no. B86 B1

AVALOKITEŚVARA, identified by the figure of Amitābha in the headdress, is seated on a double petaled lotus throne on a rectangular, molded pedestal. His right hand makes the boon-granting gesture (*varamudrā*), while his raised left hand holds the stalk of a lotus, now broken. Next to the bodhisattva, assuming exactly the same posture and *mudrā*, sits a goddess. In her left hand she holds the stalk of a cereal plant, the ear of which is like the spike of grain that is the attribute of the goddess Vasudhārā (see cat. 48). The top of the nimbus behind the goddess is broken; in all probability both statuettes were originally provided with a parasol.

Although the goddess displays the characteristics usually associated with Vasudhārā, her identity is uncertain. Vasudhārā is, first and foremost, the consort of Jambhala, while it is the goddess Tārā (see cat. 44) who always acts as the consort of Avalokiteśvara. In the Patna Museum (India) is a statuette of Avalokiteśvara and a goddess identified as Mattarī Tārā. Exactly as in the sculpture exhibited here, Avalokiteś-

vara and this form of Tārā are seated side by side and are of equal height. A statuette of the Buddha Akṣobhya is placed above them. The Buddhist Creed engraved on the pedestal (see cat. 42) is written in the style of the ninth or tenth century. The statue is said to have come from Kurkihar, south of Nālandā (Bihār).

Double statues of Jinas and bodhisattvas accompanied by their consorts (Skt. *prajñā*) came into fashion in Central Java towards the end of the ninth century. Seated on separate lotus thrones on the same pedestal, the two figures usually echo each other's posture, *mudrā*, and attributes. Among the small number of statuettes of this type that have survived, only one other has silver statuettes and a bronze pedestal. It was found in Ledok, Bagelen (Central Java), and is now in the Museum Nasional, Jakarta (inv. no. 364). Another pair in bronze is in the British Museum, London (inv. no. 19063. 7–10.1). In that group the goddess is smaller than the bodhisattva.

Literature: unpublished. The Patna bronze: Ghosh 1980, 50–51, fig. 16. The statuette from Bagelen: *ROC* 1911, 321–322. Other examples: Moeller 1985, 30–33; Amsterdam 1988, no. 47.

Avalokiteśvara and consort, bronze. Courtesy of the Trustees of the British Museum, inv. no. 19603. 7–10.1

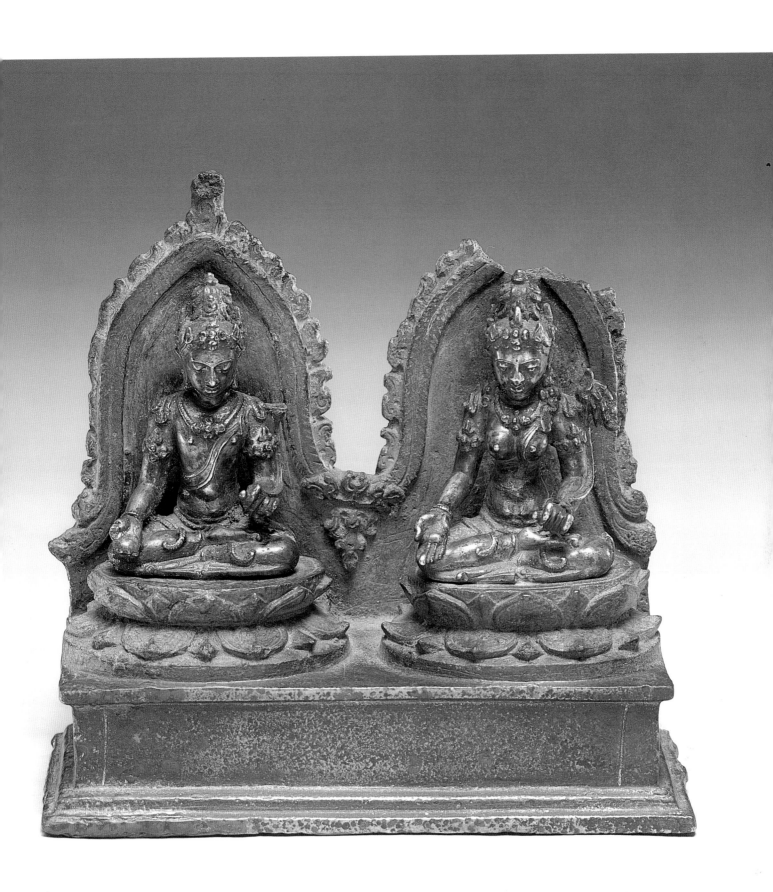

50
Hārītī holding her son Priyankara

8th–9th century
Central Java, probably from Cebongan
drawing and Sanskrit inscription engraved
on copper, 14 3/4 x 6 3/4 in. (37.5 x 17 cm)
Kern Institute, on deposit at the
Rijksmuseum voor Volkenkunde, Leiden, inv. no. B-79–1

A PICTURE of a mother and child, drawn in spare, crisp lines, has been engraved upon a copper plate, together with a Buddhist formula (*dhāraṇī*) in Sanskrit. Although the unkempt hairdo of the mother characterizes her as a demon, this ferocious female bends over lovingly to look at her child, whom she caresses with her right hand in a tender gesture.

An inscription on the plate, first read by Stutterheim but later correctly interpreted by Lokesh Chandra, identifies the mother as Hārītī (one who steals), a child-devouring ogress who was converted to Buddhism by the Buddha Śākyamuni himself and who henceforth became the protectress of all children. The Indian iconographical treatise *Nispannayogāvalī* (early twelfth century) dictates that Hārītī should be represented together with her son. In all likelihood she is shown with her favorite son Priyankara, the youngest of her five hundred children, in the engraving.

In the inscription, the goddess is invoked as "She, whose womb holds a thunderbolt child," meaning a child that could survive the odds of the high infant mortality of those early days. One legend tells how Hārītī as an ogress devoured the five hundred infants in a city. Another tradition, the one obviously followed in Central Java, held that Hārītī had five hundred sons, all of whom were healthy and strong.

At Candi Mendut, near Borobudur, Hārītī and the Yaksa Atāvaka, another anthropophagous monster converted to strictly vegetarian Buddhism, guard the entrance to the cella of the temple, surrounded by their children. Similar reliefs, now almost entirely lost, once decorated the entrance to the restored Candi Banyunibo, near Ratu Boko (Prambanan, Central Java).

The drawing of Hārītī and her son Priyankara is the only surviving example of an illustrated *dhāraṇī* of Buddhist magic formula from Central Java. As Coomaraswamy pointed out, "this beautiful figure gives at least a suggestion of the style of the mural paintings that must have once existed."

Although the exact provenance of this well-preserved copper plate is not known, the piece was recorded as early as 1915 to have come from the collection of G. Dom, who lived in and collected ancient Javanese sculpture from the area around Cebongan, near Sleman, Yogyakarta. Not far away is Batang, where a cache of twenty-five Buddhist bronzes was discovered in 1914.

For an East Javanese representation of Hārītī see cat. 31.

Literature: *ROC* 1914, 60–61; Stutterheim 1926c, fig. 58; Stutterheim 1956a; Coomaraswamy 1965, 209; Chandra 1977, 466–471; Amsterdam 1988, no. 64. Mendut reliefs: Bernet Kempers 1959, pls. 56–57. Banyunibo reliefs: *OV* 1941–1947, 42–44, figs. 8, 10–20.

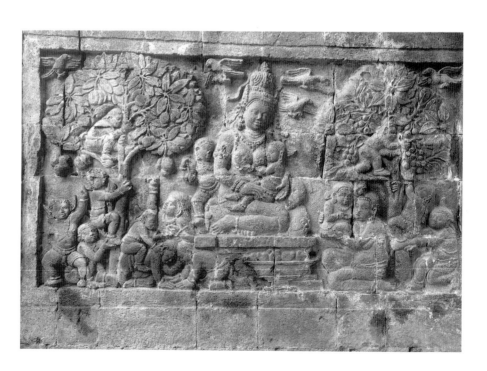

Hārītī surrounded by her children, relief, entrance porch of Candi Mendut

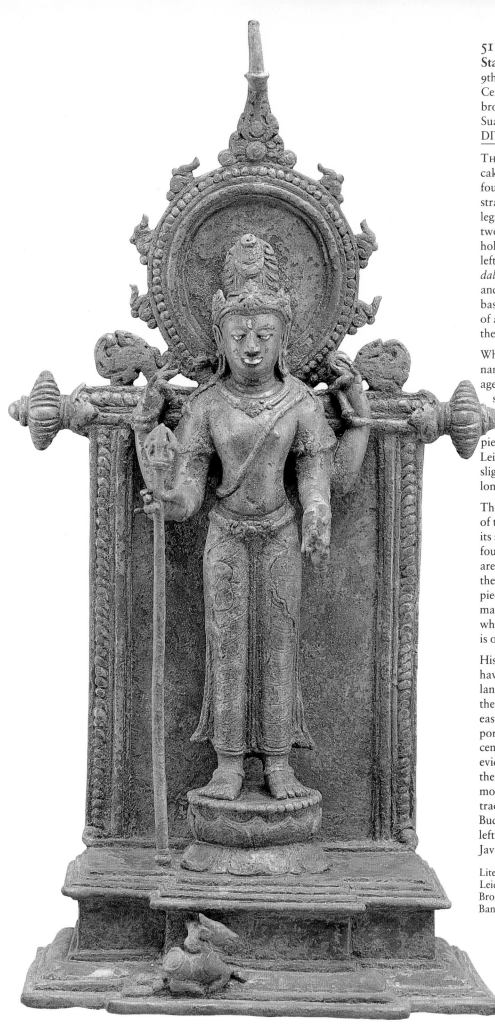

51
Standing four-armed Śiva
9th century
Central Java, from Kricak Lor, Yogyakarta
bronze, 18 in. (46 cm)
Suaka Peninggalan Sejarah dan Purbakala,
DIY, Bogĕm, Kalasan

THIS BRONZE, found in the village of Kricak Lor, Tegalrejo, in 1984, represents a four-armed Śiva. The god is standing straight, without any flexion of body or legs, on a double lotus pedestal placed on a two-tiered base. In the lower right hand he holds a trident (*triśūla*), while in the lower left hand he carries a water bottle (*kamandalu*). The two raised hands hold a rosary and a fly whisk. On the lower tier of the base, to Śiva's right, is placed a small image of a reclining bull, Nandin, the mount of the god.

While of unquestionable Javanese provenance, the statue is part of a group of images that were obviously inspired by metal statuettes of a style current in Chittagong in southeast Bangladesh during the eighth and ninth centuries. A very similar piece in the Rijksmuseum voor Volkenkunde, Leiden (inv. no. 1403–2839), while of slightly different iconography, seems to belong to the same category.

The iconography, shape of the halo, details of the throne back, as well as the base with its single projection, all recall examples found in Chittagong, Bangladesh. There are also some noticeable deviations from the Indian prototypes. In most Indian pieces the throne back is left open while the main icon is held in place by struts, whereas in the Javanese examples the back is often solid.

Historical sources and ancient inscriptions have revealed the important role that Nālandā and its Buddhist university played in the spread of Buddhism throughout Southeast Asia. In recent years, however, the importance of stylistic influences from other centers of bronze casting has become more evident. Just as Bihār derives its name from the Sanskrit *vihāra* (Buddhist temple or monastery), the name Chittagong can be traced to Caityagrama (land of Caityas). Its Buddhist as well as its Śivaite statuary has left a clear imprint on images from Central Java.

Literature: published here for the first time.
Leiden statuette: Amsterdam 1988, no. 22.
Bronzes from Chittagong: Mitra 1982, pl. 32–33;
Bandyopadhyay 1981, 39.

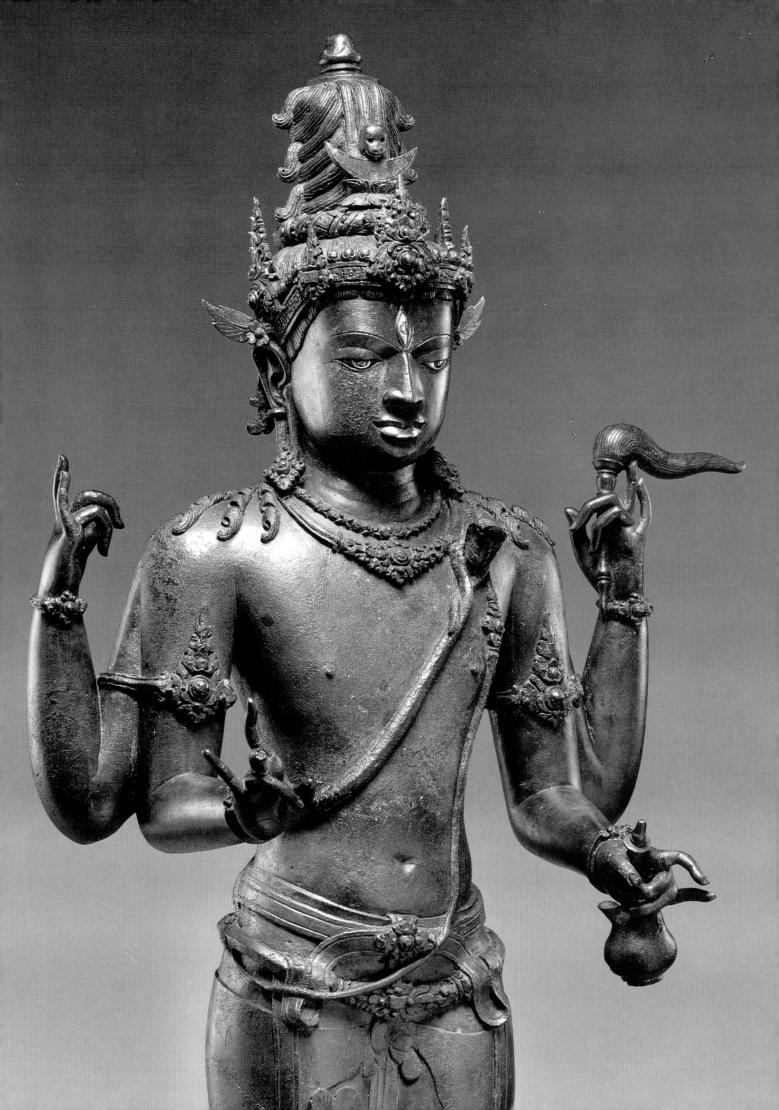

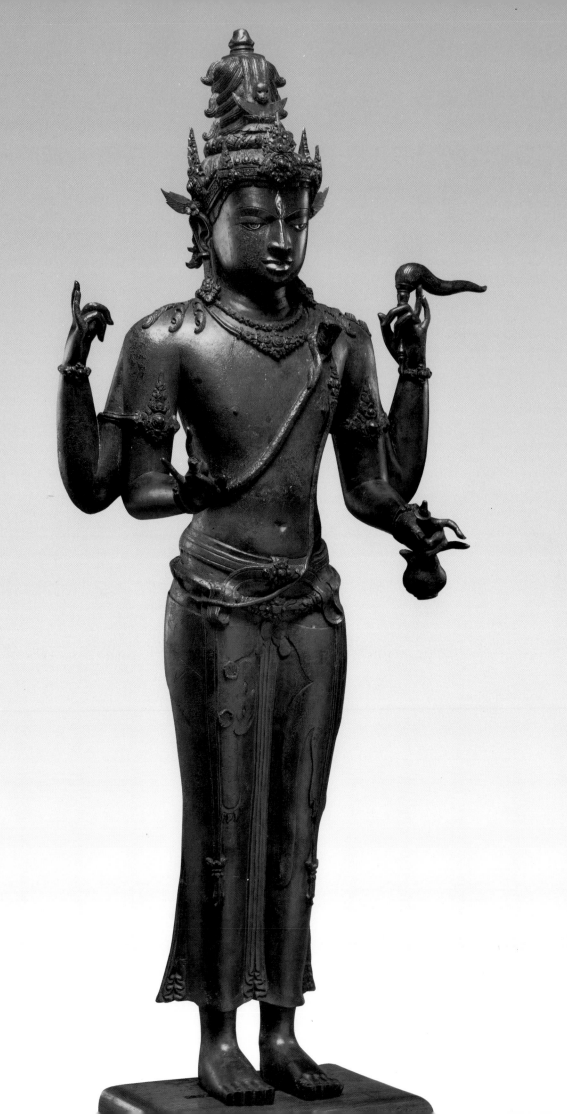

52
Śiva Mahādeva
c. 9th century
Central Java, from Tegal
bronze with gold and silver inlay
42 1/2 in. (107.5 cm)
Museum Nasional, Jakarta, inv. no. 6050

THE FOUR-ARMED DEITY, dressed in royal attire, has lost the attributes he once held in his right hands. The gesture of the upper right hand suggests it once held a rosary. In the upper left hand is a fly whisk, in the lower left hand a vessel of the *kĕndi* type with a curved spout, possibly bent out of shape. The sacred thread (*upavīta*) takes the shape of a snake, part of whose head is broken off. A plain cord with a decorated clasp runs over the left shoulder to the right hip. Over the garment that covers the body below the waist he wears a tiger skin, its head clearly visible in low relief on the right leg. Large loops on the soles of the statue's feet served to attach it to the now-missing lotus base. On the back, between the shoulder blades, is a second loop for the attachment of a nimbus or canopy.

The eyes, including the third eye in the forehead, have been inlaid in silver, whereas the lower lip is inlaid in gold, a technique quite common in statues inspired by the bronze sculpture of eastern India. Here the contrast of the gleaming eyes and lower lip with the brownish patina of the bronze emphasizes the intensity of the facial expression. Claire Holt wrote: "A concentration of contained and yet outward directed energy emanates from this figure, so unlike the inward absorption of the Buddhist images."

The extraordinarily fine workmanship in the sensitive modeling of the hands, the detailed execution of the rich jewelry, and the tall headdress (Skt. *jatāmukuta*) makes this one of the finest ancient Javanese bronzes. It is the only bronze of this size to have escaped the crucible—by being thrown into the river Kali Wadas, in which it was rediscovered in 1933 by farmers taking a bath. Although it has lost its halo, its pedestal, and two of its attributes, the statue itself has suffered only slight damage—one lost finger of the lower right hand and the head of the snake of the *upavīta*. Neither in Indonesia nor in India has any other statue of this size, quality, and style survived.

While the north coast of Central Java between Kendal and Pekalongan has been surveyed by the Archaeological Institute in 1975–1976, no systematic search for archaeological remains has been carried out in the westernmost areas of Central Java, in Tegal and Brebes. Some stone statuary, often in the style associated with the Diëng Plateau, has been found there, but no remains of *candis* have been discovered so far. That the Śiva from Tegal and the Tārā from Bumiayu (cat. 44), two of the finest bronzes, came from this area indicates that it may have been less of a cultural backwater than the surface finds suggest.

Literature: *JBG* 1 (1933), 222–223; *JGB* 2 (1934), 112 and pl. 4, fig. 4; Holt 1967, 51, pl. 36; *AIA* no. 52; Satari 1978; Tokyo 1980, no. 26; *Koleksi Pilihan* 1, no. 19.

53
Four-armed Visnu
c. 8th–9th century
Central Java, from Pahingan, Temanggung
gold figure and silver base, 7 3/8 in. (18.8 cm)
Museum Nasional, Jakarta, inv. no. A2/486

THE STANDING VISNU raises the disc (Skt. *cakra*) and the conch (Skt. *śankha*) in his right and left upper hands, while the left lower hand holds a club (Skt. *gadā*). The lower right hand, usually in boon-granting gesture (Skt. *vara-mudrā*), here either bears a square mark in the palm or holds a small, square box. This last iconographic feature, at variance with standard Indian iconography, can also be seen in cat. 54. Visnu wears a disc in his right ear, but in his left an oblong pendant. Asymmetrical jewelry is often seen in Central Javanese stone sculpture. Visnu is wearing a sacred thread with a decorative clasp and a loincloth with a floral pattern; it has been pulled up on one side, leaving part of his right thigh uncovered.

This statue was unearthed in the village of Pahingan near Parakan, Temanggung, on the slope of Mount Sundoro, in 1863. The location is close to the Diëng Plateau, and the statue presents a style associated with that area.

Only one other gold image of Visnu, less well modeled but of similar iconography, has been discovered in Indonesia. It was found in the ground in Muara Kaman in the sultanate of Kutai (East Kalimantan) in 1840, and became part of the sultan's regalia, worn by the crown prince on festive occasions.

Literature: *NBG* 1863, 305; *NBG* 1864, 7, 60 and 135; Groeneveldt 1887, no. 486; *ROC* 1911, 279–280; *AIA* no. 92; Tokyo 1980, no. 53. The Visnu from Kutai: *OV* 1925, 141–142.

Four-armed Visnu

8th–9th century
Central Java, from Gĕmuruh
gold repoussé plaque, 14 5/8 x 7 in.
(34.5 x 17.5 cm)
Museum Nasional, Jakarta, inv. no.
A31/486a

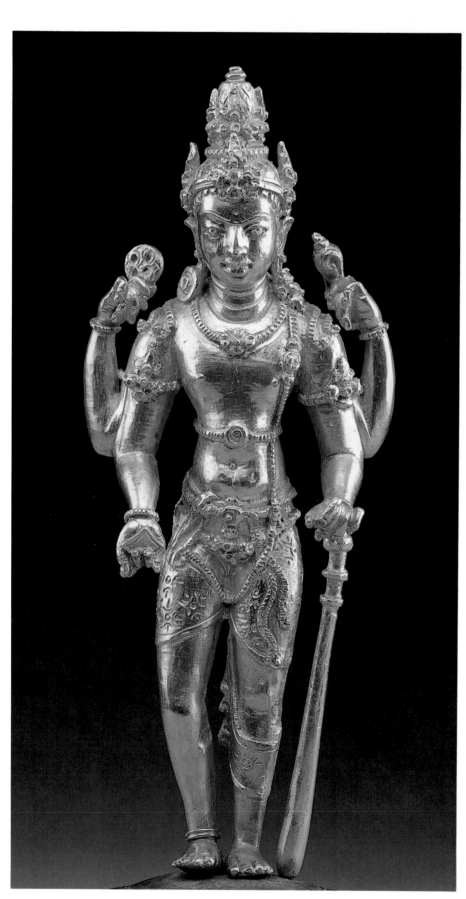

cat. 53

IN THIS GOLD REPOUSSÉ PLAQUE, one of four from the same hoard, the god Visnu is shown in splendid royal attire, much more lavishly bedecked with jewelry than the Śiva on another plaque from the same find. In three hands the four-armed god holds the traditional attributes, the conch and disk in his upper hands and the club in his lower left hand. The lower right hand, usually held in the boon-granting gesture (Skt. *vara-mudrā*), here is turned outward, showing a square in the palm. It either represents a mark in the palm, or, as Brandes suggested, a small box. This apparent deviation from standard iconography can also be seen in the gold statue of Visnu from Pahingan, Temanggung, in the same area (see cat. 53).

Visnu wears a tall, conical headdress (Skt. *kirītamukuta*) of a type reminiscent of south Indian statuary and a triple sacred thread of pearls. Standing on top of a lotus flower, he seems to be showered with flowers falling from heaven. At his right side stands a small figure of his mount Garuda, here shown as a winged human holding a snake in his hands. The representation of Garuda as a winged human being rather than a bird suggest a date for this piece in the early part of the Central Javanese period.

The gold hoard of which this plaque was part came to light in 1903 in the hamlet of Gĕmuruh in the village of Banyukembar, Leksono, near Wosonobo, on the slope of the Diëng. It contained five gold images and four gold repoussé plaques, and is one of the largest groups of gold objects ever discovered in Central Java.

Literature: *NBG* 1903, 118, XCI–XCII; Brandes 1904c, pl. 4; *AIA*, no. 91; *Koleksi Pilihan* 1: no. 27.

55
Śiva and Pārvatī

c. 9th century
Central Java, from Seplawan Cave
gold statues, silver base, overall 7 7/8 in.
(20 cm)
Direktorat Perlindungan dan Pembinaan
Peninggalan Sejarah dan Purbakala, Jakarta

IN AUGUST 1979 a team of archaeologists,
making an inventory of local antiquities
and assisting the authorities in a survey of
potential tourist sites, entered a deep lime-
stone cave in Mount Seplawan in the vil-
lage of Donorejo, district Kaligesing, re-
gency Purworejo (Central Java). Five
hundred meters inside the cave filled with
stalagmites and stalactites, on top of a tall
rock shaped like an altar, they discovered a
large bronze vessel containing several ob-
jects, including this gold and silver statuette
of a couple holding hands.

The statue consists of a hollow, square sil-
ver base to which a double lotus pedestal,
cast in gold, has been attached by means of
four gold rivets. The lotus pedestal and
base were filled with yellow and brownish
earth, semiprecious stones of various col-
ors, beads as well as gold leaf, and silver
fragments cut into different shapes. The
contents resemble those of caskets or other
containers found in or near the foundations
of temples and believed to be sacral
deposits.

The twin statues represent a divine or royal
couple, the man slightly taller (4³/₄ in.,
12 cm) than the woman (4⁵/₁₆ in, 11 cm).
The male figure extends his right lower
arm and hand, the palm turned upward.
His left hand grasps the right hand of his
consort, who carries a round object, per-
haps a jewel, in her left hand in front of the
chest. Both wear elaborate headdresses of
the *jatāmukuta* type, and behind their
heads are oval halos with a design of
flames. Above their heads is a pair of para-
sols. Each figure is clad in a robe that
leaves the upper half of the body bare. The
robes are decorated with bands of floral de-
signs, held at the waist by scarves tied into
elaborate, flower-shaped bows on the
back. The only statue that reproduces a
similar bow on the back of the figure is the
headless Prajñāpāramitā from Muara
Jambi (see cat. 24).

Next to the cave entrance were found the
remains of the foundations of two struc-
tures, one of which housed a *yoni* and *ling-
gam* altar; the *yoni* was made of a tufa-like
stone and the *linggam* of andesite. This dis-
covery suggests that the cave served as a Śi-
vaite sanctuary. Several other objects were
found together with the statue. Among
these were a spoon and a diadem in silver,
and a gold spout of a ewer. In another con-
tainer, found near the altar-shaped rock,

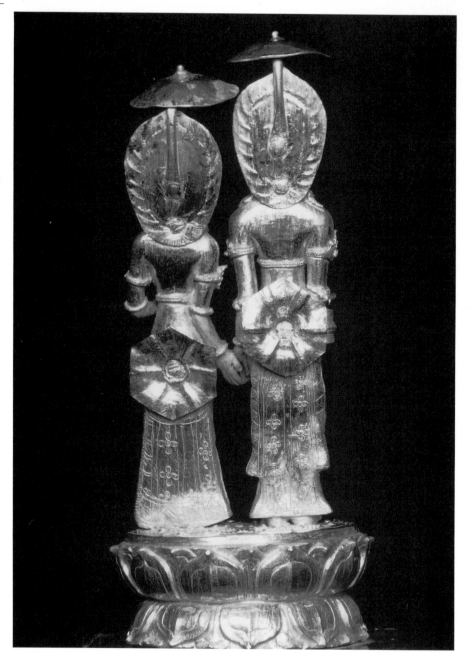

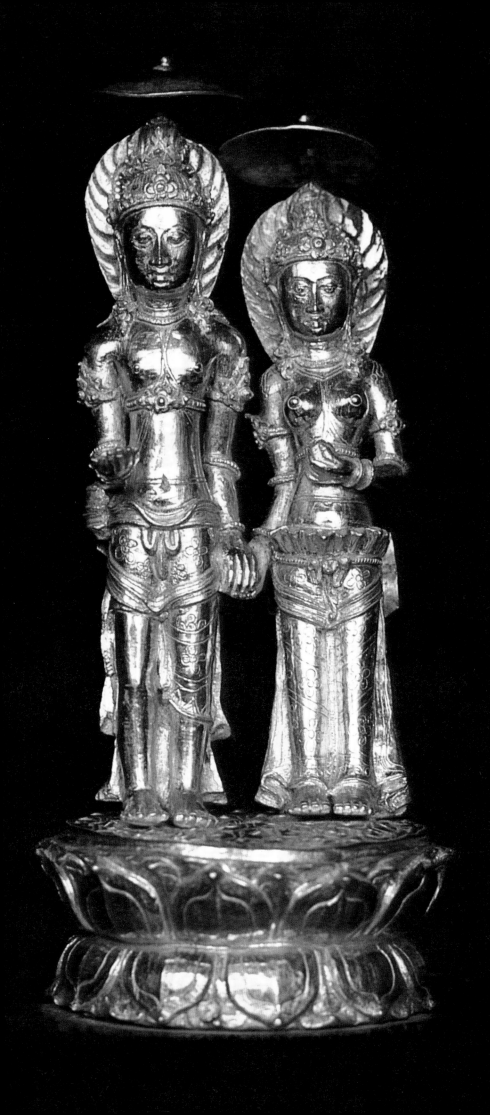

was a silver vase for flowers of a type frequently seen in the reliefs of Borobudur. All these objects could well date from about the ninth century.

In view of the Śivaite context it would seem reasonable to assume that the double statue represents Śiva and his consort Pārvatī. A double stone statue from Klaten (Museum Nasional, Jakarta, inv. no. 6091) shows the two deities almost equally tall, as does a bronze statue of Śiva and Pārvatī from Kretek (Central Java). Other statues that are likely to have been made as pairs show Śiva slightly taller. This is in keeping with Indian iconographic traditions, likewise followed in such Southeast Asian countries as the Môn kingdom of Dvāravatī. The cast gold statues of Śiva and Pārvatī in the gold hoard from Gĕmuruh, Banyukembar, Leksono, Wonosobo (Central Java), now in the Museum Nasional, Jakarta (inv. no. 519a) show Śiva taller than Pārvatī. The same is true of the pair of silver statuettes in the Rijksmuseum, Amsterdam (inv. no. MAK 524a and b). The unusual iconographic feature of Śiva and Pārvatī holding hands has a parallel in a stone sculpture of unknown provenance in the Museum Nasional, Jakarta (inv. no. 251).

While there seems to be no close stylistic parallel for this statue, and its unusual characteristics even made the discoverers hesitant to attribute to it an early date, there is no reason to doubt its antiquity. The hoard from Gĕmuruh reveals many unusual stylistic features that have no parallel among statuary cast in less precious metals. It is quite possible that our knowledge of the stylistic diversity of gold statuary has many lacunae as a result of the large number of pieces that were melted down. During the nineteenth century, districts in the area near the Diëng Plateau are said to have paid their taxes in gold by melting down treasure.

Other discoveries of gold statues in Java have been chance finds. This is the only known example of one recovered above ground, obviously due to the inaccessibility of the cave.

Literature: Soekatno 1982; Jakarta 1986, 12. On Gĕmuruh: Brandes 1904c. Dvāravatī: Dupont 1959, 11; Rijksmuseum 1985, no. 194; *AIA* no. 12. Back of the Prajñāpāramitā from Muara Jambi: McKinnon 1985.

56
Four-armed Avalokiteśvara
late 8th–early 9th century
Central Java, from Tekaran, Wonogiri
bronze, silver coated and parcel-gilt,
38 1/2 in. (98 cm)
Museum Nasional, Jakarta, inv. no. 509
Two arms
bronze, silver coated and parcel-gilt
Museum Radya Pustaka, Solo, inv. nos.
A238 and 238a

THE FOUR-ARMED BODHISATTVA wears a
richly decorated headdress of the *jatāmu-
kuta* type in which a small figure of the Jina
Amitābha appears. The statue has lost two
lower arms, all four hands, and both legs
beneath the knee. Except for the hair, in
which traces of green remain, the entire
statue is covered with a silver coating, to
which gilding was added for the jewelry.
The bodhisattva wears two *upavītas*, one
in the shape of a broad ribbon, the other in
that of a braided cord. Three necklaces
cover the chest, and there are bracelets on
all four upper arms. His loincloth, deco-
rated with alternating bands of circles and
cross-hatching, is held by two belts with
decorative clasps, from which three heart-
shaped pendants are suspended, one be-
tween the legs and one on each side.

The clay core of this statue was modeled
around a cast-iron armature, the ends of
which are visible through the holes of the
broken arms, wrists, and legs. In recent
years the blackened silver coating was
cleaned and the gilt jewelry restored to its
original splendor.

The statue was discovered in October 1855
by a farmer digging a ditch in the village of
Tekaran, Wonogiri (Central Java). The
farmer obviously reported this remarkable
find to the proper authorities, for shortly
afterward the statue was offered as a gift to
the Batavian Society of Arts and Sciences,
the precursor of the National Museum, by
the governor-general of the Dutch East In-
dies, A. J. Duymaer van Twist. The statue
has been in the museum's collection ever
since that time.

The first report of the discovery appeared
in 1859 and was written by R. H. Th. Frie-
derich. As knowledge of Buddhist and
Hindu iconography was still in its infancy
at the time, it is hardly surprising that
Friederich, on the advice of the well-known
antiquarian the Reverend J. F. G. Brumund
and misled by the third eye that appears in
the bodhisattva's forehead, misidentified
the statue as Śiva, even though it is identifi-
able as a representation of Avalokiteśvara
by the figure of Amitābha in the headdress.
That the importance of this find was fully
understood is apparent from the fact that
an English translation of Friederich's article
was published in the *Journal of the Royal
Asiatic Society* in 1873.

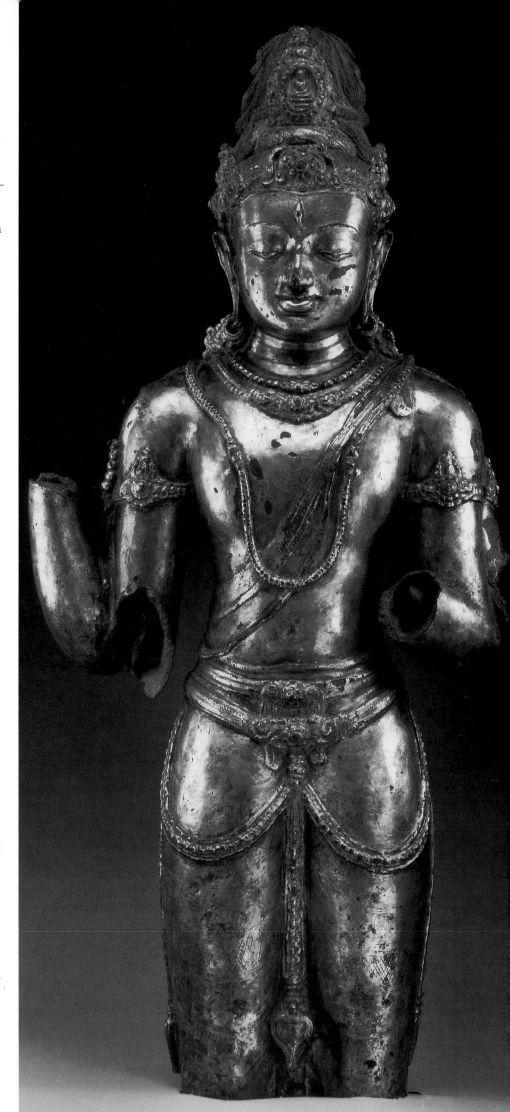

A comparison of the Tekaran Avalokiteśvara with several other statues of the four-armed bodhisattva, including a bronze statue likewise dug up by a farmer in Lampung (Sumatra) in 1980, permits us to reconstruct the position of its four hands, the attributes that they carried, and the gestures in which they were held. From this comparison we can surmise that the upper left arm was raised to the shoulder, holding a rosary (Skt. *aksamālā*). The lower left had was held in the boon-granting gesture (Skt. *vara-mudrā*). The upper right arm was raised to the shoulder, holding a book (Skt. *pustaka*), while the lower right hand held a lotus. The two missing arms would hold the book and the hand in *vara-mudrā*.

Bronze statuary of this size, probably quite common in Central Java during the eighth and ninth centuries, has vanished almost completely, and among the few pieces that have been preserved, those cast in bronze and covered with a silver coating are extremely rare. In the collection of the Museum Radya Pustaka, Solo, are two lower arms, cast in bronze, silver coated, and with gilt bracelets. The silver has oxidized to a deep black and only the gilding of the bracelets is clearly visible; consequently the pieces had been mistaken for gilt bronze, which is much more common among Javanese statuary (Brussels 1977, no. 27). As one of the hands holds a book and the

other displays the *vara-mudrā*, it seemed logical to associate these two fragmentary pieces with the Tekaran statue. A subsequent investigation established that the arms from Solo had breaks that matched the size and shape of those of the Jakarta statue, and that the arms had the correct proportions for those of the statue. The statue, as it is shown here, does not yet reflect the results of this discovery.

It is not possible to reconstruct the exact course of events that resulted in the separation of arms and body. Tekaran is located in an area that was, at the time of the discovery in 1855, part of the territory of the susuhunan of Solo. The statue was first brought to Solo, and was presented by the susuhunan to the governor-general on the occasion of his retirement. Somehow the arms, which must have broken off during the discovery, were left behind in Solo. The fact that they were later numbered consecutively indicates that their common origin was known, but the inventory to which the numbers refer no longer exists.

The closest stylistic parallels to the Avalokiteśvara of Tekaran are not found in Indonesia, but in peninsular Thailand. One is a statue of an eight-armed Avalokiteśvara from the temple Wat Phra Barommathat in the Chaiyā district (now in the National Museum, Bangkok). A much more damaged life-size bust of a Padmapāni in the

same museum came from Wat Wiang, also in the Chaiyā district. It may be identical with a Padmapāni mentioned in an inscription from 775, which records the dedication of such a statue by King Dharmasetu of Śrīwijaya. The date and the royal connection argue strongly in favor of a common origin of these three statues in the kingdom of Śrīwijaya at the time of its ascendancy in Central Java under the Śailendra dynasty. Only three years later a king of the Śailendra dynasty dedicated a temple to the Goddess Tārā at Kalasan (see cat. 44 and introduction).

These three statues, all embellished with the same type of sculpted jewelry, and among the finest of all early Southeast Asian bronzes, present visual evidence of the close relations between Śrīwijaya and Central Java during the late eighth and early ninth centuries.

Literature: Friederich 1859; Groeneveldt 1887, 147–148; *ROC* 1910, 58–59; *ROC* 1912, 31; *ROC* 1915, 87, no. 1347 (Verbeek no. 386); *JBG* 8 (1941), 73; Bernet Kempers 1959, pl. 43 (before cleaning); *Ars Buddhica* 58 (Sept. 1965), pl. 2; Rawson 1967, fig. 202; *AIA* no. 26. One arm: Brussels 1977, no. 27. Reassembling the arms and body: Kompas 1989a; Kompas 1989b. The statues in the National Museum, Bangkok: Krairiksh 1980, pls. 30, 32; Subhadradis Diskul 1980, pl. 26.

57
Hand and lower arm of a statue
8th–9th century
Central Java, from Solo
bronze, 10 1/2 in. (26 cm)
Museum Nasional, Jakarta, inv. no. 5746

IN THIS ELEGANT FRAGMENT of a statue, consisting only of a hand and lower arm, all fingers of the hand are bent to varying degrees. The tips of the third finger and thumb touch, while the little finger and index finger are raised and spread. This symbolic gesture of the hand resembles the *kartarī-mukha* (arrow shaft face) of Indian iconographic texts. It is the name given to a gesture often used when the hand holds attributes. In this case this attribute probably was a lotus, for part of a stalk still winds itself around the lower arm.

Whereas the two lower arms from the Radya Pustaka Museum (see cat. 56) were fragments broken off the Avalokiteśvara from Tekaran at the time of its excavation, the smooth flat end of this piece shows that it was cast separately, to be attached to a statue by means of a socket. Although only three examples of such separately cast arms have been preserved, the fact that two have been found in Central Java indicates that

the technique of multiple casts was not one merely used by provincial bronze casters of limited technical skills. F. D. K. Bosch once suggested that the fact that the Buddha from Sikèndèng had a separately cast cranial protuberance and arms was a possible indication of its local production (see cat. 36).

Two other hands of the same type have been preserved. One right hand, formerly in the Dieduksman collection, would seem to constitute a pair with a left hand holding a book, formerly in the A. J. W. Harloff collection; this last piece was found in the vicinity of Prambanan. These two could well be the two upper hands of a four-armed Avalokiteśvara of the same iconographical type as the statue found at Tekaran.

Literature: *OV* 1918, 142; *OV* 1930, pl. 9; Bernet Kempers 1959, pls. 44–45; *AIA* no. 42; Tokyo 1980, no. 29.

58
Standing Buddha

9th–10th century
Sumatra, from Palembang
bronze, 14 5/8 in. (37 cm), excluding loops
Museum Nasional, Jakarta, inv. no. 6023

THE BUDDHA raises his right hand in the gesture symbolizing absence from fear (Skt. *abhaya-mudrā*), and the left hand holds an edge of the monk's robe that covers both shoulders. He has a large cranial protuberance (Skt. *uṣnīṣa*), but lacks the curl on the forehead (Skt. *ūrnā*). Two loops under the feet indicate that the statue was once mounted on a pedestal.

The statue conforms to the Central Javanese tradition as it is seen at Borobudur, in that it shows a standing figure with the garment draped over both shoulders, and it generally seems to be close to bronze statuary from Central Java. However, the two bodhisattva statues with which it was dredged up reveal characteristics suggesting their local manufacture (see cat. 59).

In recent years renewed interest in Śrīwijaya has resulted in archaeological exploration of the area in and around Palembang, where the capital of this maritime kingdom is thought to have been located (see introduction). While these investigations have produced considerable quantities of shards of Chinese ceramics, they have not yet resulted in the discovery of major Buddhist bronze statuary like the statues dredged from the Komering River.

Only two large Buddhist stone statues have been found in the vicinity. One is the huge stone statue, more than eleven feet tall, of a Buddha from Bukit Seguntang, which may date, according to the latest study by Nik Hassan Shuhaimi, from the seventh to the eighth century. The folds of the drapery and the shape of the head indicate that it is the product of a school quite different from the one that produced the bronze Buddha and bodhisattvas from the Komering River. The other stone statue of a bodhisattva (68 in. tall) is thought to reveal Sinhalese influences.

Given the paucity of the remains, it is perhaps not surprising to find such a wide range of stylistic differences; these need not indicate that the statues have been imported from other areas of Indonesia or Southeast Asia. For example, the Buddha from Bukit Seguntang, long thought to have been carved from stone not found in the Palembang area, turned out to be sculpted from locally quarried stone.

Literature: *OV* 1930, 156, pl. 45c; *ABIA* 1931, pl. 10; Schnitger 1937, pl. 8; Bernet Kempers 1959, pl. 174–176; *AIA* no. 24; Tokyo 1980, no. 27; Suleiman 1981, 4.

59
Eight-armed Avalokiteśvara
9th–10th century
Sumatra, from Palembang
bronze, 20 7/8 in. (53 cm)
Museum Nasional, Jakarta, inv. no. 6024

THIS STATUE OF AVALOKITEŚVARA is the tallest of three bronzes dredged up from the Komering River at Palembang. It was brought to the surface from the bottom of the river by a commercial dredger in November 1930, together with a bronze statue of a standing Buddha (cat. 58) and a seated figure of Maitreya (for a map showing the exact location see *OV* 1930, 157).

The Avalokiteśvara has lost seven of its eight arms. While the Buddha from the same group represents a style very close to that of Central Javanese statuary, the Avalokiteśvara belongs to a regional style that may have had one of its centers in Palembang. Its unusually high and elaborate headdress, which recalls the style of Kurkihār, is not found among statuary from Central Java. The closest parallel, as pointed out by Satyawati Suleiman, is an eight-armed bronze Avalokiteśvara found in Bidor, Perak, Malaysia. Much better preserved, the Malaysian bronze shows the same treatment of the hair, falling in tresses across the shoulders and the *dhotī* (garment) held by a single belt. The Perak statue wears a tiger skin over the *dhoti* in the same fashion as the Śiva Mahādeva from Tegal (see cat. 52).

In view of the well-documented provenance of this Avalokiteśvara from an area closely associated with the maritime kingdom of Śrīwijaya, it would seem reasonable to assume that it represents not an imported style, but one that originated in this kingdom. As the power of the kingdom made itself felt over the Malaysian peninsula, this style may have spread to Malaysia and peninsular Thailand. The kingdom of Śrīwijaya was defeated by a maritime expedition from the Indian Cola Kingdom early in the eleventh century. The Avalokiteśvaras from the Komering River and from Perak represent the mature style of the Śrīwijaya kingdom. An earlier phase is represented by the Avalokiteśvara from Tekaran (cat. 56).

Literature: *OV* 1930, 156–157, pl. 45; *ABIA* 1931, pl. 10; Schnitger 1937, pl. 8; Bernet Kempers 1959, pls. 174–176; Quaritch Wales 1976, 117–120, pl. 11; Suleiman 1981, pls. 4a and 4b; Bandyopadhyay 1981, pl. 13; Amsterdam 1988, no. 59.

60

Throne back
11th–12th century
Sumatra, from Biaro Bara, Padang Lawas
bronze, 22 x 18 ½ in. (56 x 47 cm)
Museum Nasional, Jakarta, inv. no. 6115

THE BRONZE HALO, covered with a dark green patina, is crowned by a monster's head (Skt. *kīrtimukha*; Javanese: *kāla*) with a headdress of pointed shape. The lower jaw of the *kāla* is flanked by two elephant heads turned outward. Their jaws emit a string of pearls and flames, which undulate downward to end up in the open jaws of a pair of fish elephants (*makaras*), their heads turned inward. This halo of flames encloses a round nimbus standing on a lotus stalk. This nimbus has a hole in the center and a border of lotus petals. At the back double loops attached behind the *makaras* attached the halo to its pedestal or throne. Two loops at the top, behind the *kāla* head, once held the stem of a canopy.

This superb example of the art of bronze casting, impressive in spite of the fact that it lacks its missing cult image, must have stood behind a seated bronze figure approximately twelve inches (30 cm) in height. It was excavated by F. M. Schnitger in 1936 from the *biaro* (from Sanskrit *vihāra*, sanctuary) of Bara, Padang Lawas (see cat. 26). A most colorful account of the excavation of this piece, its temporary appropriation by a local *rāja*, and its subsequent recovery for the Jakarta Museum by means of a ruse, was published by its discoverer in Dutch and later in 1939 in English.

The style of the halo and the means by which it was attached to its base are reminiscent of south Indian bronzes, although it is difficult to point to close parallels. Perhaps because the trade routes from the east to the west coast of Sumatra passed through the region during the classical period, the temple ruins as well as the objects found here often display south Indian traits. A few pieces, as, for example, a bronze female figure found at Biaro Bahal I, are definitely of South Indian origin. Another bronze group, the Lokanātha from Gunungtua, Tapanuli, could have been taken for an Indian statue if it were not for the inscription, dated in accordance with 1039, which clearly points to a local origin.

Biaro Bara is situated on the south bank of the Panei River, not far from the three *biaros* of Bahal on the north bank. Its courtyard is the largest of all temples in Padang Lawas (255 x 284 ft.). Inside the main shrine Schnitger found a *nāga* stone pedestal with a decoration in Central Javanese style. As such pedestals are usually found in temples dedicated to Śiva; this find suggests that Biaro Bara was a Śivaite sanctuary amid temples of the Tantric Buddhist sect. In that case the missing cult image might have represented a Hindu god rather than a figure from the Buddhist Tantric Pantheon. In 1982 a stone statue of Ganeśa was discovered at Tandihat, providing additional evidence of Hinduism in Padang Lawas.

Literature: Schnitger 1936b; *JBG* 3 (1936), 200, no. 6115; Schnitger 1937, pl. 34; Schnitger 1939, 102–105, pl. 8; Mulia 1980b.

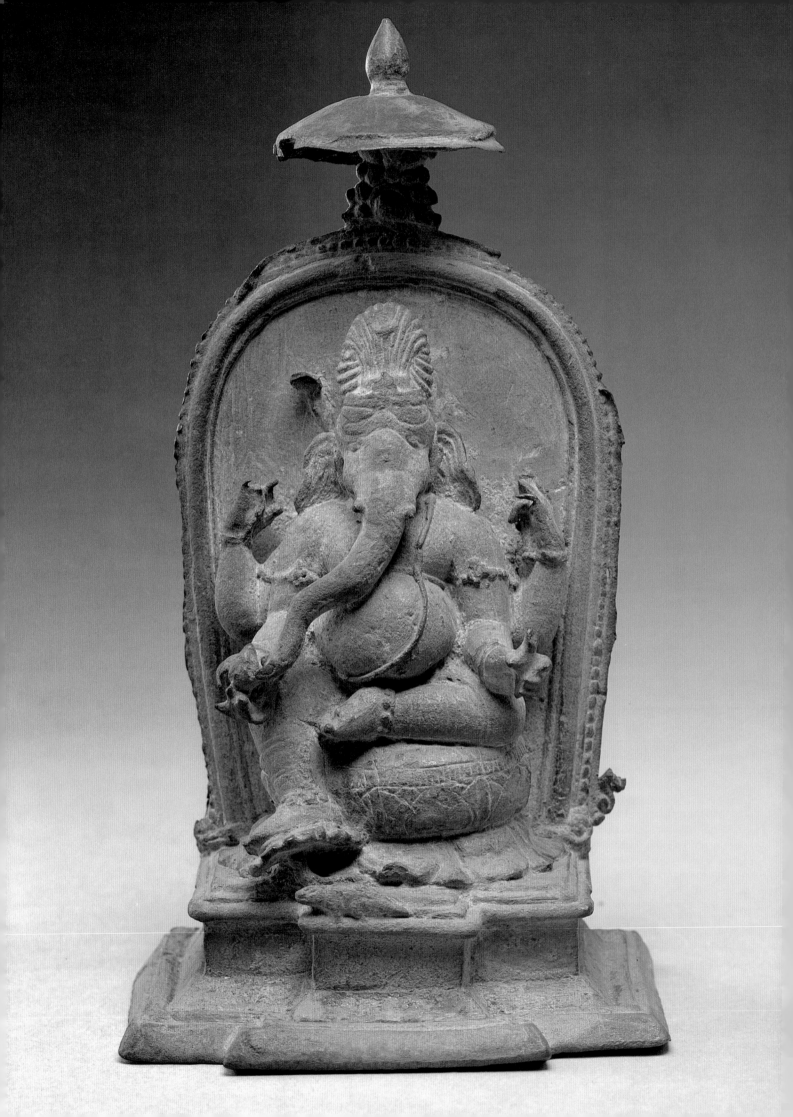

61

Ganeśa

c. 9th–10th century
Sumatra, probably from Padang Lawas
bronze, 8 in. (20 cm)
Museum Nasional, Jakarta, inv. no. 534a

THE POT-BELLIED GANEŚA is seated at ease (Skt. *lalitāsana*) on a round cushion placed on top of a lotus pedestal with a single row of petals pointing downward. The plain throne back has a flaming border and is surmounted by a canopy. The figure's right leg, hanging down, is supported by a lotus on a short stalk growing out of a pedestal that is trapezoidal in shape with a single projection in the center in front. Ganeśa's mount, the rat, sits at his feet. The four-armed deity carries his traditional attributes: in his lower right hand a bowl of sweets from which he is nibbling with his trunk; in his upper right hand a rosary. In the upper left hand he holds an ax (damaged) and in his lower left hand a broken tusk. The sacred thread (Skt. *upavīta*) falls from his left shoulder, passes under his right arms, and emerges above the right ear in the shape of a *nāga*.

The iconography of this bronze follows closely that of East Indian prototypes, although the fact that he holds the bowl of sweets in his right hand instead of in his left, his trunk therefore swinging to his right side, is rather uncommon. The shape of the pedestal and nimbus are in the Indian style, and there is little to distinguish this work from an Indian or Bangladeshi prototype.

The bronze was found in Sumatra, where imported pieces are perhaps somewhat more common than in Java, but unfortunately there is some uncertainty as to its exact provenance. The proceedings of the Batavian Society for 1904 report "the receipt of the advice of shipment of a small bronze statue of Ganeśa, excavated some time ago in Padang Lawas (Tapanuli)." The sender was the Dutch colonial official R. C. van den Bor at Sarulangun, Jambi. Possibly misled by the fact that the sender resided in Jambi, the same report elsewhere lists the statue as having come from Jambi. According to the membership lists included in the annual proceedings of the Batavian Society, Mr. van den Bor lived in several different places in Jambi during the years 1904 to 1908. As the first reference seems to quote a now-lost written document, the statue is more likely to have come from Padang La-was, as mentioned in the advice of shipment, than from Jambi. A bronze Ganeśa of exactly the same type was in the New York art market in 1980. Its present whereabouts is not known. For another bronze from Padang Lawas reflecting a South Indian style, see cat. 60.

Literature: *NBG* 1904, 45 and 125–126.

62

Standing Avalokiteśvara-Padmapāni

c. 9th century
Sumatra
bronze, 7 1/8 in. (18 cm)
The Metropolitan Museum of Art, New York, anonymous gift 1985. 401

THE STANDING AVALOKITEŚVARA lowers the right hand in the gift-bestowing *vara-mudrā*, while the raised left hand holds the remnants of a lotus. Although the statuette is of unknown origin, its striking similarity with an image of Avalokiteśvara, reputedly found in Kerinci (West Sumatra), establishes its Sumatran provenance. The statuette from Kerinci, now in the Museum Nasional, Jakarta (inv. no. 6042), still has the lotus in the left hand, suggesting that it represents the form of Avalokiteśvara known as Padmapāni (lotus-bearer).

The circumstances under which the statue from Kerinci was discovered are far from

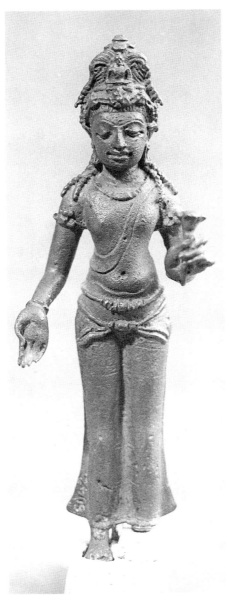

Avalokiteśvara (Padmapāni) found in Kerinci, Sumatra. Museum Nasional, Jakarta, inv. no. 6042

clear. From the cryptically brief entry in the Annual Report of the Batavian Society (*JBG* 1, 221) it would seem that a colonial official from Palembang supplied the provenance. Perhaps that explains why it was included in Schnitger's *Oudheidkundige vondsten in Palembang*, even though Kerinci is far away from this center of Śrīwijayan culture.

E. Edwards McKinnon has pointed out the importance of the location of Kerinci on the inner-Sumatran trade routes and its proximity to Mārga Tanah Rendah, an important source of gold. It is possible, therefore, that the statuette and its damaged companion piece (Museum Nasional, Jakarta, inv. no. 6043) were imported into the area from the territory of Śrīwijaya. The style of the tall headdress with the small image of Amitābha and the locks of hair falling across the shoulders are similar to those of the Amoghapāśa from Palembang (cat. 59). Satyawati Suleiman and Nik Hassan Shuhaimi have pointed out similarities with statuary from Malaysia and peninsular Thailand. Most likely, therefore, both statues were cast in Śrīwijaya during the period of its ascendancy in Southeast Asia.

Literature: unpublished. The statue from Kerinci: *JBG* 1 (1933), 221, no. 221; Schnitger 1936c, frontispiece; Schnitger 1937, 13; Suleiman 1981, 73 fig. 6a; Shuhaimi 1982; McKinnon 1985, esp. 31.

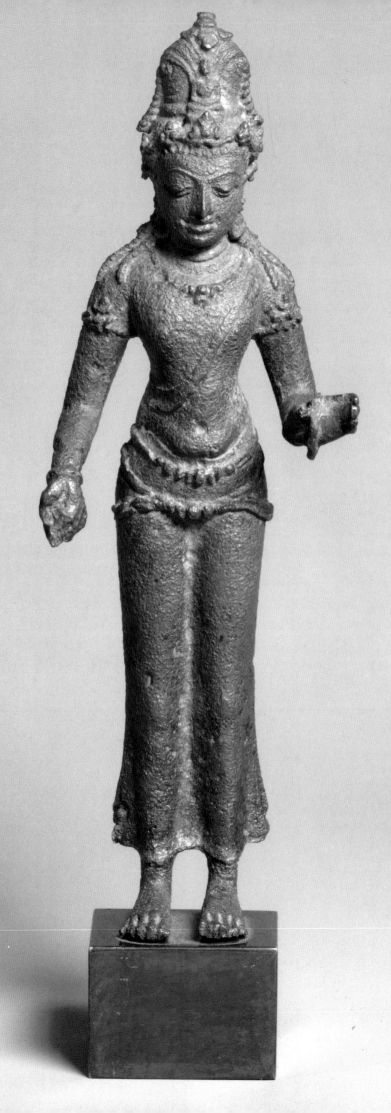

cat. 62

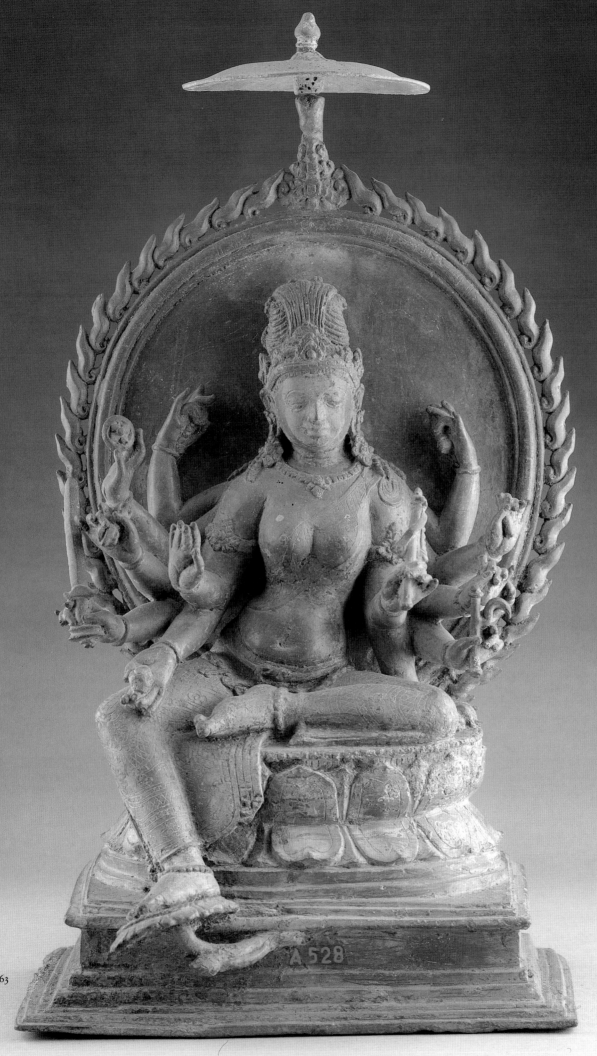

cat. 63

63
Twelve-armed goddess (Cundā?)
c. 9th–10th century
Central Java, provenance unknown
bronze, 14¹/₂ in. (37 cm)
Radya Pustaka Museum, Solo, inv. no. A. 528

THE TWELVE-ARMED GODDESS is seated in relaxed posture (Skt. *lalitāsana*) on a double-petaled lotus throne, her right leg pendant. Her right foot is supported by a lotus growing out of the molded, rectangular pedestal on which the throne has been placed. She wears a tall headdress (Skt. *jatāmukuta*), jewelry, bracelets, and anklets. Her loincloth has meticulously engraved striated and floral patterns.

The gestures made by her six right hands or the attributes held by them are, from top to bottom: a rosary (*aksamālā*), a wheel (*cakra*), a double thunderbolt (*vajra*), a sword (*khadga*), the gesture symbolizing absence of fear (*abhaya-mudrā*), and a flower, fruit, or jewel; in the left hands, in the same order: a book (the *Prajñāpāramitā-sūtra [Sūtra of Transcendental Wisdom]*), broken (only part of the stem or stalk visible), broken, an elephant goad (*ankuśa*), a garland (*mālā*) or lasso (*pāśa*), and a scepter.

The large nimbus with border of stylized flames and surmounted by a parasol encompasses the multitude of arms and their various attributes and *mudrās*. It is inscribed on the back with the Buddhist Creed found on several Buddhist statues in this exhibition (cats. 42, 44). The prominent *abhaya-mudrā*, the relaxed posture, and the serene expression of the face give the goddess a peaceful, benevolent appearance.

In Indonesia twelve-armed goddesses are rarely seen. In spite of the fact that all except two of her attributes have been preserved and can be recognized, the identity of this elegantly modeled figure is uncertain. She bears the closest similarity in attributes to Cundā, but differs from the description of this goddess offered in Indian iconographic texts. Apart from several other bronzes, all of which show slightly different attributes, there is the monumental standing figure of an eight-armed Cundā carved in relief in the northeast facade of Candi Mendut, near Borobudur. With the notable exception of a conch, the attributes of the goddess as she is represented there largely agree with the bronze exhibited here. Recently Sudarshana Devi Singhal described forms of Cundā with two, four, eight, twelve, sixteen, eighteen, or twenty-six arms. The only known example of a twelve-armed Cundā is a bronze from Nālandā (National Museum, New Delhi), but the *mudrās* and attributes displayed by this figure differ somewhat from those of the statue from Solo.

Under the influence of the doctrines taught at the *vihāras* of Nālandā and Vikramaśīla in Bihār, frequented by pilgrims from Indonesia, Esoteric Buddhism began to spread in Java during the second half of the ninth century. The proliferation of multiarmed goddesses is one of the results of this development.

Literature: unpublished. Cundā: Musée Guimet 1971, 204–211; Singhal 1985, esp. 712; Singhal 1989.

64
Vajrasattva
late 9th or early 10th century
Central Java, provenance unknown
bronze, 5¹/₂ in. (13.9 cm)
Museum Nasional, Jakarta, inv. no. 602a

VAJRASATTVA IS SEATED on a double lotus throne, the right leg placed on the left thigh in the posture known as *sattvaparyanka*. In the right hand, raised in front of the chest, he holds the *vajra* (thunderbolt), while the left hand, resting on the thigh, displays the priest's bell (Skt. *ghantā*). The rectangular pedestal is supported by an elephant in the center and flanked by two lions at the corners. Behind the deity is a jewel-shaped nimbus with a border of the stylized "flower and seed vessel" motif and surrounded by flames. It is surmounted by a canopy. This type of nimbus is rarely met with in ancient Indonesian art. There is one example in the Berlin State Museums (MIK II 318), one in the Vatican Museums (inv. no. 5193), and one in the National Museum of Ethnography, Leiden (inv. no. 1403-2389).

Although the identification of this figure as Vajrasattva is beyond question, a possible departure from the usual iconography should be noted. Of the two deities bearing the name Vajrasattva, one is the Supreme Ādi-Buddha. He is often shown with his mount the elephant and he assumes the lotus position, as, for example, in a statue in the Linden-Museum, Stuttgart. The second Vajrasattva is one of a group of sixteen Vajrabodhisattvas, who are invariably shown with their legs in *sattvaparyanka*. As this statuette combines the mount of the Ādi-Buddha with the posture of the Vajrabodhisattva, the exact identity of this figure remains unclear. It is possible, however, that the elephant supporting the pedestal does not represent a mount. Lotus pedestals supported by an elephant flanked by lions also occur in the reliefs of Candi Mendut, where they serve as seats for minor deities.

The baroque shape of the nimbus and the slender shape of the figure suggest a date toward the end of the ninth or the beginning of the tenth century. For another representation of Vajrasattva see cat. 65.

Literature: Groeneveldt 1887, 176; *ROC* 1912, 43 pl. 17 (left); *AIA* no. 43; Linden-Museum 1984, no. 2; Moeller 1985, 40–41, fig. 16; Amsterdam 1988, 23–38.

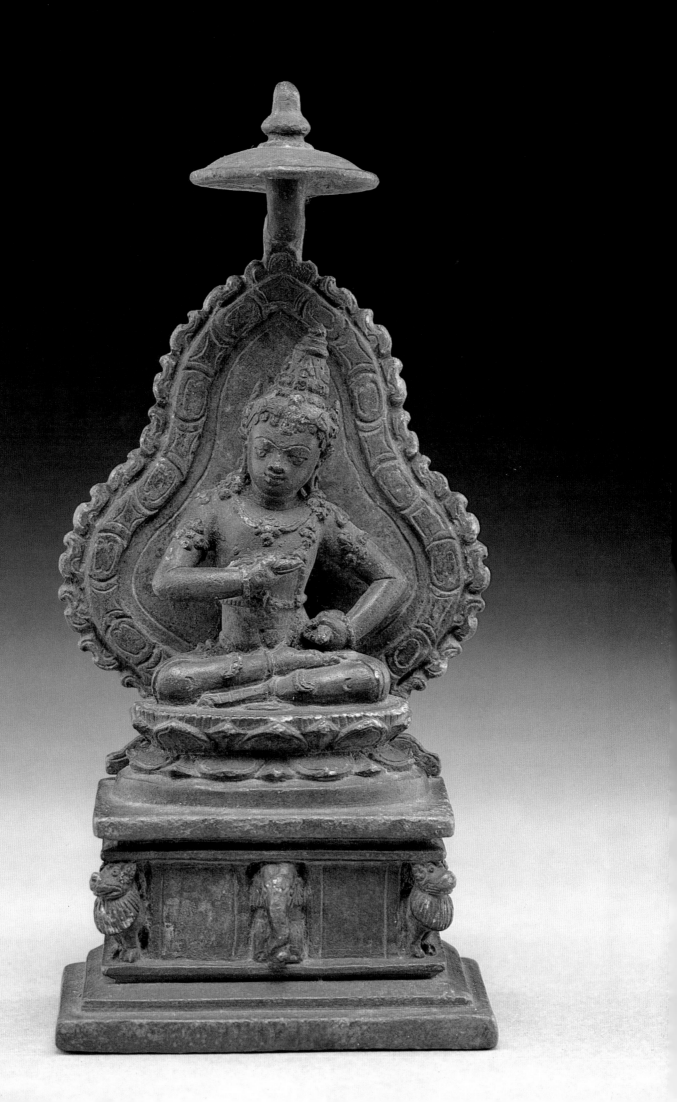

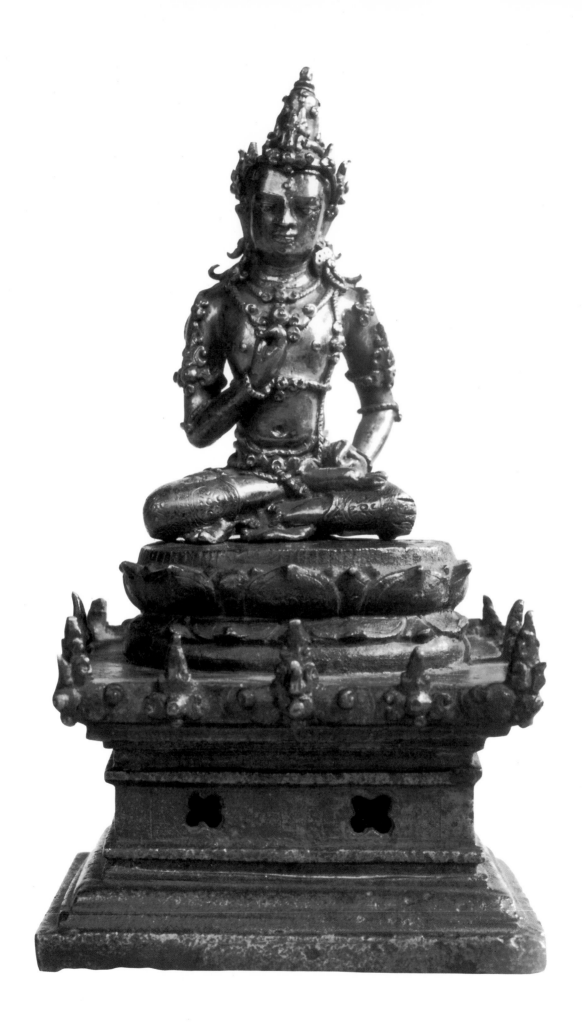

65
Vajrasattva
late 10th or early 11th century
East Java, provenance unknown
silver figure on bronze pedestal, 5 3/8 in.
(13.5 cm)
Rijksmuseum, Amsterdam, gift of the
Rijksmuseum Stichting, inv. no. 1970-2

THE SILVER FIGURE, dressed in royal attire, is enthroned on a bronze double lotus on an elaborately decorated pedestal. His right leg is placed on the left thigh in the position known as *sattvaparyanka*. His right hand is raised to the chest and must once have clasped a double *vajra* (thunderbolt). The left hand, resting on the thigh, once held a *ghantā* (priest's bell).

A. J. Bernet Kempers, who considers the absence of hand-held attributes intentional rather than the result of losses, sees the lack of attributes, combined with the appropriate pose for holding them, as a Javanese deviation from Indian iconographic rules. However, the fact that some of the bronzes of Surocolo (cat. 66) and Nganjuk (cat. 67) have separately cast attributes (some of which are lost) argues for the more matter-of-fact explanation.

A figure in royal attire with these two attributes held in hands that have assumed the appropriate poses can be identified as Vajrasattva. However, two different beings in the pantheon of Esoteric Buddhism bear this name. One is the Ādi-Buddha Vajrasattva, who occupies the supreme position in the pantheon of certain Buddhist sects. This Ādi-Buddha is shown in royal attire and therefore difficult to distinguish from bodhisattvas, who are always shown in this manner. The second is the Vajra-bodhisattva Vajrasattva, one of a group of sixteen bodhisattvas whose names are preceded by the word vajra and who surround, in groups of four, the Jinas Aksobhya, Ratnasambhava, Amitābha, and Amoghasiddhi in the peripheral circles of the Inner Circle of the Mandala of the Adamantine Sphere (see cat. 66). One would be inclined to identify an image cast in precious metal of this size and placed on a richly decorated throne with the Supreme Buddha. However, in Indian iconography the sole distinguishing mark between the two Vajrasattvas is the position of the legs.

The Ādi-Buddha Vajrasattva is always shown with legs crossed in the diamond pose or *vajraparyanka*, whereas all vajra-bodhisattvas are shown with the legs in *sattvaparyanka*. That this distinction was made in Indonesia as well as in India is apparent from a Javanese image of the Ādi-Buddha Vajrasattva in diamond pose complete with his mount, the elephant (Linden-Museum, Stuttgart, inv. no. SA 35. 228 L) and from a group of Vajrabodhisattvas from the Surocolo find who are all shown with their legs in *sattvaparyanka* (see cat. 66). Another Vajrasattva (cat. 64), shown with the elephant, constitutes an exception.

If the Amsterdam statuette should indeed represent the Vajrabodhisattva Vajrasattva—a secondary figure in the pantheon—it is difficult to image what the principal icon of that pantheon or mandala may have looked like: an image in gilt bronze like the Mahāvairocana Sarvavid in the National Museum in New Delhi, or perhaps even an image in gold?

The elaborate pedestal with its row of antefixes, as well as the slender shape and the profusion of jewelry of the figure, characterize this statue as a work roughly coeval with the Nganjuk bronzes from the late tenth or early eleventh century.

Like nos. 68 and 71 in this catalogue, the Vajrasattva comes from the distinguished collection of the pioneer Dutch collector Alexander Loudon (1822–1868). The large collection of his uncle and mentor F. G. Valck (1799–1842), acquired for the Jakarta Museum in 1843, constituted the core of what is now the national collection of Indonesia.

Literature: Krom 1918–1919, fig. 8; The Hague 1922, no. 60; Amsterdam 1936, no. 171, pl. 10; Amsterdam 1954, no. 645; Rijksmuseum 1985, no. 188; Bernet Kempers 1985; Amsterdam 1988, no. 53.

66
Eighteen statuettes from a Buddhist mandala
early 10th century
Central Java, from Surocolo
bronze, 2 1/8 in. (5.4 cm) to 4 in. (10.2 cm)
Suaka Peninggalan Sejarah dan Purbakala,
DIY, Bogĕm, Kalasan

IN SEPTEMBER 1976, when the farmer Su-darnowijono was digging behind his house in the hamlet of Surocolo, Panjangrejo, Pundong, Bantul, his hoe struck an earthenware jar buried about two feet below the surface. The jar, smashed when struck by the hoe, turned out to contain twenty-two small bronze statuettes. At first the importance of his discovery was not recognized, and the children of the village were allowed to play with the statuettes as if these were tin soldiers. However, as the news of the discovery spread, the Yogyakarta branch of the Archaeological Service arrived on the scene and succeeded in reassembling the hoard.

Although the twenty-two statuettes were found together, they are probably not all part of the same set. The three largest statuettes have lotus pedestals of a type that is quite different from that of the smaller bronzes, and are of markedly inferior workmanship. One of these three represents Śiva. It could not have been part of the original Buddhist ensemble, which constitutes the remnants of a three-dimensional mandala in which a large number of Buddhist divinities were arranged in circles and squares according to strict rules contained in iconographic texts. The other nineteen statuettes, of which seventeen are exhibited here, all share the same stylistic characteristics. They are cast in an extraordinarily fine and detailed technique displaying a wealth of iconographical detail, much of which becomes evident only upon viewing them under magnification.

The first report of the discovery, submitted by Th. Aq. Soenarto, provided useful descriptions of all but one of the statuettes, but identified only a few of them. Most recently Edi Sedyawati presented a paper entitled "Arca-arca 'Kecil' dalam Pantheon Bauddha" ("Small" statuettes in the Buddhist Pantheon) at the Fifth Archaeological Conference (Pertemuan Ilmiah Arkeologi)

in Yogyakarta in July 1989. In her paper she grouped some of the statuettes according to the Indian iconographic text *Nispanna-yogāvalī* by Abhayākaragupta, which may date from the late eleventh or early twelfth century. While these comparisons with the *Nispannayogāvalī* resulted in a number of new identifications, they also reveal that the Surocolo statuettes in all probability represent an earlier stage of iconographical development of Esoteric mandalas than that described in the Indian text. Comparisons with Japanese iconographic drawings of mandalas, based on Chinese T'ang prototypes that in turn were probably based on texts and drawings imported from Nālandā and other Indian centers of the Diamond Path (*Vajrayāna*) of Buddhism, prove equally useful. Even the much later Tibetan pantheons can sometimes throw light on the possible identification and placement of the figurines in certain types of mandalas. Whereas the exact identity and literary source of the mandala to which many if not all of the Nganjuk bronzes (cat. 67) belonged has been established with certainty, the iconography of the remaining Surocolo statuettes does not permit us to draw similar conclusions. Consequently, many of the identifications of the exhibited statuettes still remain tentative or speculative and will stand corrected once it is discovered to which type of mandala these pieces belonged.

According to the shape and size of their lotus pedestals, the statuettes can be divided into three groups. Although it is obvious that shape and size vary with the pose of the figures, they may also be an indication of the sections of the *mandala* in which each of these figures was to be placed.

The largest group exhibited here consists of ten figures, all seated in *sattvaparyanka* and all provided with a double-petaled lotus throne of oval shape. These statuettes can be identified tentatively as follows:

66A
Vajrarāga
inv. no. BG 132 (formerly 1402)
bronze, 2 5/16 in. (5.9 cm)

Vajrarāga, the bodhisattva of love, is one of the sixteen vajrabodhisattvas surrounding the four Tathāgatas (Jinas) in the four chapels surrounding the central chapel of Vairocana. Vajrarāga, armed with bow and arrow, belongs to the Vajra family and occupies the place south of the Jina Aksobhya in the east chapel of the Mandala of the Adamantine Sphere.

A damaged statuette representing the same bodhisattva is among the pieces from the Nganjuk hoard (Museum Nasional, Jakarta, inv. no. 5415).

Literature: Soenarto 1980, fig. 4.11. The Nganjuk bronze: *ROD* 1913, fig. 15; Chandra and Singhal 1989, 4, no. 9.

66B
Vajraraksa
inv. no. BG 124 (formerly 1405)
bronze, 2 5/16 in. (5.9 cm)

This divinity seems to be applauding and could, therefore, represent the Vajrabodhisattva Vajrasādhu, who is customarily showing his approval (*sādhu*) by clapping his hands. However, a more likely explanation of the position of the hands is that they once held a now-missing attribute.

Exactly the same position of the hands can be seen in one of the statuettes of the Nganjuk hoard (Museum Nasional, inv. no. 5421), where the bodhisattva holds a cuirass, identifying him as Vajraraksa. Vajraraksa is one of the sixteen vajrabodhisattvas and one of the four of the family of Karma, surrounding the Jina Amoghasiddhi in the northern chapel of the Mandala of the Adamantine Sphere.

Literature: Soenarto 1980, fig. 4.9. The Nganjuk statuette: Krom 1913, fig. 35; Chandra and Singhal 1989, 6, no. 42 (misidentification as Vajragarbha).

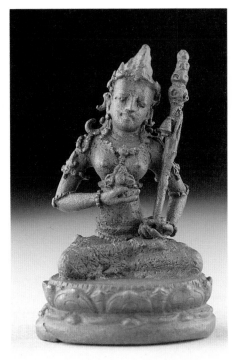

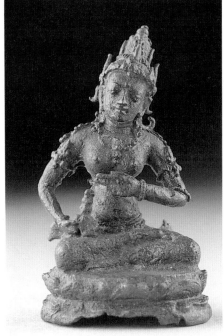

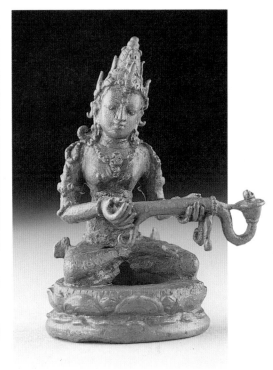

66C
Vajrakarma (?)
inv. no. BG 136 (formerly 1394)
bronze, 2 3/16 in. (5.5 cm)

The bodhisattva holds a quadruple *vajra*
(Skt. *viśvavajra*) in the right hand, raised
before the chest, while a *khatvānga*, to
which a bell has been attached, rests up-
right in the left palm, leaning against the
shoulder. The *viśvavajra* and bell are the
attributes of Vajrakarma, one of the sixteen
vajrabodhisattvas and one of the four fig-
ures of the family of Karma, surrounding
the Jina Amoghasiddhi (see cat. 66B).

In the mandala of Vairocana known as
Durgatipariśodhana are two female divini-
ties, Vajradūtī and Vajrakālī, who are both
shown with a *vajra* in the right hand and a
khatvānga in the left. It is possible that one
of these divinities is represented here.

Literature: Soenarto 1980, fig. 4.12; Mallmann
1975, 405, 409.

66D
Vajrabhāsa (?)
inv. no. BG 140 (formerly 1410)
bronze, 2 1/4 in. (5.8 cm)

The bodhisattva holds a *stūpa* in the right
hand resting on the right thigh. In some
Japanese mandalas a vajrabodhisattva
holding a *stūpa*-shaped attribute in the
right hand is identified as Vajrabhāsa. One
of the sixteen vajrabodhisattvas, Va-
jrabhāsa is one of the four figures of the
Lotus family, surrounding the Jina Ami-
tābha in the western chapel of the Mandala
of the Adamantine Sphere.

66E
Vajradhūpā, goddess of incense
inv. no. BG 139 (formerly 1409)
bronze, 2 3/8 in. (6 cm)

Like her counterpart in the Nganjuk man-
dala (cat. 67D), Dhūpā holds an incense
burner with a long handle in her left hand.
As one of the eight goddesses of the offer-
ings (Skt. *pūjā*), she is one of the four god-
desses of the outer circle, positioned in the
southeast corner of the square enclosing the
five chapels of the Mandala of the Ada-
mantine Sphere.

Literature: Soenarto 1980, fig. 4.1.

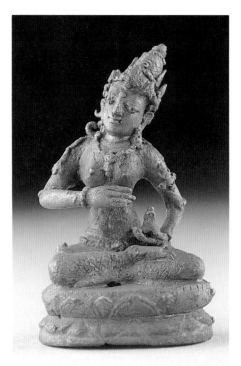

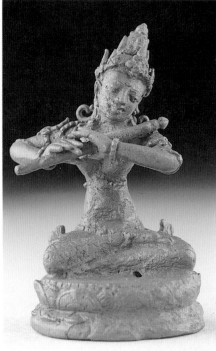

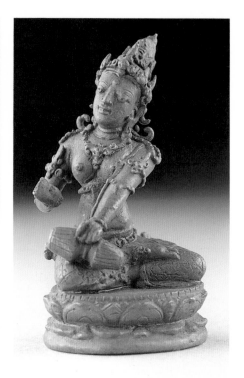

66F
Vajrālokā or Vajradīpā, goddess of the lamp
inv. no. BG 126 (formerly 1396)
bronze, 2¹/₄ in. (5.6 cm)

In the left hand, resting in her lap, the goddess holds what would seem to be a small lamp, the light of which she shades with her right hand.

Vajrālokā or Vajradīpā, the goddess of the lamp, is one of the four goddesses of the offerings of the outer circle, positioned in the northwest corner of the square enclosing the five chapels of the Mandala of the Adamantine Sphere.

A statuette of the same goddess was among the Nganjuk bronzes destroyed by fire in the Colonial Exhibition in Vincennes, 1931.

Literature: Soenarto 1980, fig. 4.6; Krom 1913, fig. 23; Bosch 1961, pl. IIIC; Chandra and Singhal 1989, 7, no. 48.

66G
Vaṃśā, goddess of the flute
inv. no. BG 137 (formerly 1407)
bronze, 2¹/₄ in. (5.8 cm)

The goddess of the flute (Skt. *Vaṃśā*) is one of the four heavenly musicians. She is shown playing the traverse flute.

The four musicians make their appearance in several mandalas. However in the Mandala of the Adamantine Sphere the first three of these do not seem to appear, although all four are represented among the Surocolo bronzes.

Literature: Soenarto 1980, fig. 4.4.

66H
Mukundā, a goddess of the drum
inv. no. BG 133 (formerly 1403)
bronze, 2¹/₄ in. (5.8 cm)

Mukunda and *muraja* are the names of two different types of drums, and the goddesses playing these instruments bear their names. Both belong to the four heavenly musicians. Mukundā holds an hourglass-shaped drum in her left hand and raises her right hand to beat it.

Literature: Soenarto 1980, fig. 4.3.

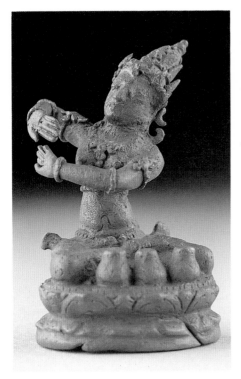

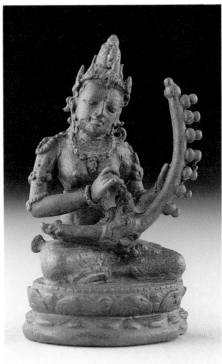

66J
Murajā, a goddess of the drum
inv. no. BG 135 (not in Soenarto)
bronze, 2¹/8 in. (5.4 cm)

Muraja is a smaller type of drum, resembling the Indian *tabla*. Three of these drums are placed in front of the seáted goddess. The meaning of the gesture of her hands is unclear; it may represent a dance gesture (see below cat. 66R). Murajā is one of the group of four heavenly musicians represented in the Surocolo mandala.

66K
Vajragītī, goddess of song
inv. no. BG 138 (formerly 1408)
bronze, 2¹/4 in. (5.8 cm)

The goddess of song accompanies herself on the harp (Skt. *vīnā*). Exactly like in the statuette from Nganjuk (Museum Nasional, inv. no. 5423), the harp is shown with seven pegs. Harps shown in the reliefs of Borobudur and Jalatunda have ten and four pegs respectively. Gitā or Vajragītī is one of the eight goddesses of the offerings and one of four placed inside the circle of the five chapels of the Mandala of the Adamantine Sphere. She occupies the northwest segment of this circle.

Vajragītī is usually accompanied by Vajralāśī, Vajramālā, and Vajranrtyā. In some types of mandala these goddesses have been replaced by the four heavenly musicians, Vamśā, Mukundā, Murajā, and Vīnā. As the first three of this group are represented in Surocolo, it is possible that the goddess of song, who accompanies herself on the *vīnā*, is in reality the goddess Vīnā, the fourth goddess of this group. This same uncertainty applies to the statuette from Nganjuk, for one of the Nganjuk pieces photographed by the Archaeological Service in the Termijtelen collection represents Mukundā or Murajā, indicating that the Nganjuk mandala may also have contained a set of the four heavenly musicians.

Among the published types of mandalas there is only one in which both groups of goddesses appear together. This is the Mandala of Vajrasattva according to the *Samputa-tantra* (Raghu Vira and Lokesh Chandra, *A New Tibeto-Mongol Pantheon* [New Delhi, 1967], vol. 12, no. 3). However, this mandala contains many multi-armed figures and obviously follows another iconographical tradition.

Literature: Soenarto 1980, fig. 4.5. The Nganjuk statuette of Vajragītī: *AIA*, no. 45; Krom 1913, fig. 37; Bosch 1961c, pl. 11b.

There are five statuettes in the Surocolo group that are placed on lotus pedestals of an oblong shape. There are three figures with the right leg bent and the left leg stretched (Skt. *pratyālidhā*), one figure with the left leg bent and the right leg stretched (Skt. *ālidhā*), and one in a posture with both legs bent and spread (Skt. *mandala*). The pedestal of this last figure is slightly larger in size. Three of the five figures have human heads, while two have animal heads. This last iconographic feature suggests that these figures may represent some of the divinities that have been incorporated into the Buddhist pantheon as guardian figures. Twenty in number, they occupy the outer square of the Mandala of the Adamantine Sphere. In the Japanese iconographic drawings of mandalas some deities are shown with a boar's or an elephant's head. The Chinese translations of their names, reconstructed back into Sanskrit, often do not occur in such iconographic treatises as the *Nispannayogāvalī*.

Another possibility is that they represent guardians placed at the four "gates" of the mandala. Edi Sedyawati has identified the two animal-headed deities as guardians of the gates.

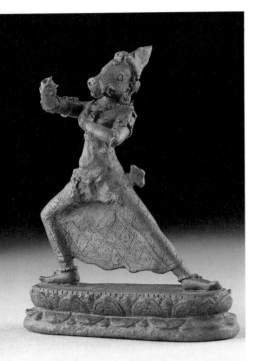

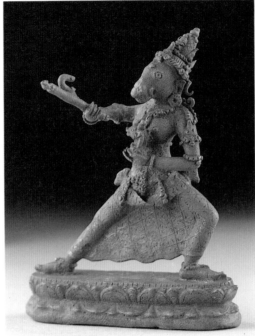

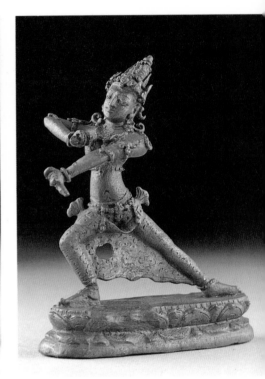

66L
Śūkarāsyā, the divine sow (?)
inv. no. BG 130 (formerly 1400)
bronze, 3¹/8 in. (7.9 cm)

The head of this female deity, standing in
pratyālidhā pose, is definitely that of a
sow. She holds her left hand on her chest
grasping a *vajra*; the raised right hand has
lost its attribute. Śūkarāsyā is one of a
group of four female guardians who guard
the four gates of the mandala. The other
three have the head of a mare (Hayāsyā,
see cat. 66M), a lioness (Simhāsyā), and a
dog (Śvānāsyā). In other mandalas Vaj-
rānkuśa and three other male deities or Vaj-
rānkuśī and three other female deities per-
form the same duty. In the Mandala of the
Adamantine Sphere, as in Nganjuk, it is
this last group of male deities who guard
the gates (see cat. 67A).

Although the identification as Śūkarāsyā is
plausible, it is also possible that the statu-
ette represents Vajravārāhī or Vajramukhī,
one of the twenty divinities of the outer
square.

Literature: Soenarto 1980, 5.2.

66M
Hayāsyā, the divine mare (?)
inv. no. BG 128 (formerly 1398)
bronze, 3 ³/16 in. (8.2 cm)

Assuming the *ālidhā* posture, the goddess
holds an elephant hook (Skt. *ankuśa*) in the
right hand and a boar's head in the left. Edi
Sedyawati has identified this statuette as
the horse-headed Hayāsyā. However, the
head with its large fangs looks rather por-
cine, and as Śūkarāsyā, the divine sow (see
cat. 66L) is supposed to hold a skull cup,
the severed head of a boar would seem to
be an appropriate substitute for such an at-
tribute held by a boar-headed deity.

Literature: Soenarto 1980, fig. 5.1.

66N
Unidentified guardian figure
inv. no. BG 127 (formerly 1397)
bronze, 3¹/8 in. (7.9 cm)

This female deity stands in *pratyālidhā* pos-
ture, the outstretched left hand holding a
now-broken and unidentifiable attribute,
perhaps a dagger, while the right hand
holds a *vajra*.

Literature: Soenarto 1980, fig. 5.3.

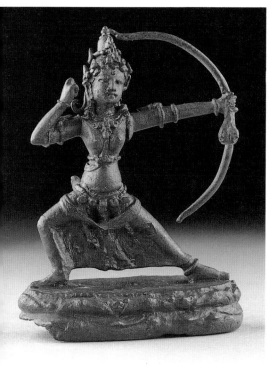

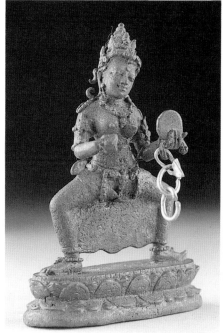

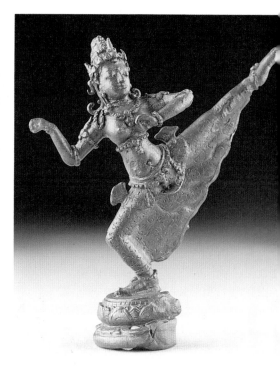

66P
Vinayaka with bow and arrow (?)
inv. no. BG 144 (formerly 1417)
bronze, 3 3/16 in. (8.2 cm)

The deity stands in *pratyālidhā* posture aiming his bow and arrow. From his left hand, holding the bow, four severed heads dangle by their hair. Among the twenty divinities guarding the outer square of the Mandala of the Adamantine Sphere in Japan is a deity holding a bow and arrow. He is called the "Vināyakā with bow and arrow." Sometimes he is represented with a boar's head.

Literature: Soenarto 1980, fig. 5.5.

66Q
Vajrasphotā (?)
inv. no. BG 129 (formerly 1399)
bronze with silver chain, 3 in. (7.6 cm)

The deity stands with both legs spread and bent in the posture called *mandala*. In her left hand she holds a mirror or the disk of the sun, while a few links of a chain, cast separately and probably made of silver, are attached to it. Edi Sedyawati has identified this figure as Vajrasphotā, the goddess of the chain, who is one of the four guardians of the gates of the Mandala of the Adamantine Sphere.

There is no published mandala in which the four female guardians appear together with the four animal-headed guardians. As the chain would seem to be an addition to the statue, the identification is uncertain. For a Vajrasphotā from the Nganjuk mandala see cat. 67B.

In Japanese mandalas there are several figures holding a disk of sun or moon, including Candraprabha and Nārāyana. The identity of this figure remains, therefore, uncertain.

Literature: Soenarto 1980, fig. 5.4.

66R
Vajranrtyā, goddess of the exuberant dance
inv. BG 131 (formerly 1401)
bronze, 3 1/8 in. (7.9 cm)

The goddess balances on her right, bent leg on a small round lotus pedestal, while her left leg is raised high, her foot pointing into the air. It is tempting to identify this elegant and lively statuette as a representation of the Goddess (Vajra-) Nrtyā, whose dance, according to Marie-Thérèse de Mallmann, is of an exuberant style. The goddess Vajranrtyā is one of the four goddesses of the inner circle, placed in the northeastern segment of the circle.

The Nganjuk hoard contained a seated figure of Vajranrtyā (inv. no. 5407), which is one of those lost in the fire at Vincennes in 1931. Japanese mandalas, too, portray the goddess in seated position, her arms making dance gestures. Although this stationary dance reminded Stutterheim of the Balinese dance called *kĕbyar*, this dance is a modern creation, not connected with the dance shown in the mandalas.

Literature: Soenarto 1980, fig. 5.6. The Nganjuk figure: Krom 1913, fig. 21.

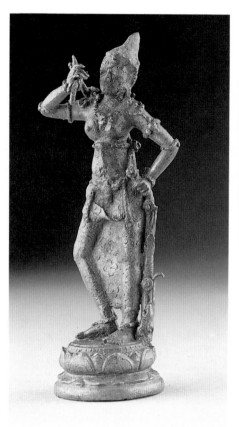

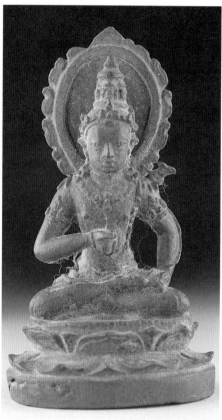

These tentative identifications point to certain iconographic characteristics of the Surocolo mandala. Even if, as is likely, some of these identifications will have to be revised later, each of these characteristics has a parallel in one or another of the several pictorial mandalas that have been preserved or recorded in literary sources in different parts of the Buddhist world. In the present state of our knowledge it would seem that there is not one specific type of mandala in which all of these iconographic characteristics have been combined.

Several small statuettes in Thai and American collections suggest that the Surocolo hoard may not have been the only one of its kind. A bronze Varāhī in the Cleveland Museum of Art (acc. no. 80.14) is quite similar to the boar-headed statuette from Surocolo. A *yaksinī* or *rāksasī* in the Los Angeles County Museum of Art, standing with her legs apart in *mandala* pose, is slightly larger (4 ½ in., 11.4 cm) than the figure in the same pose from Surocolo, but very similar in style. A vajrabodisattva assuming the same posture was discovered in Sathing Phra District, Songkla Province, in Thailand.

Literature: Soenarto 1980; Sedyawati 1989a; Chandra and Singhal 1989; Mallmann 1975, 405, 409; Vira and Chandra 1967; Krom 1913; Bosch 1961c.

66s
Vajralāśī (?)
inv. no. BG 134 (formerly 1404)
3½ in. (8.9 cm)

The goddess stands with the right leg flexed and the left hand resting on the hip. A lotus rises along the straight left leg, passes through the left hand, crosses the back, and emerges on the right shoulder, where she grasps it with her raised right hand. The only other figure to be placed on a small round lotus, she seems to be the counterpart of Vajranrtyā (cat. 66R) and may represent Vajralāśī, the goddess of the slow dance. The goddess occupies the southeastern segment of the circle surrounding the five chapels of the Mandala of the Adamantine Sphere.

Literature: Soenarto 1980, fig. 5.7.

66T
Vajrasattva (?)
inv. no. BG 122 (formerly 1392)
4 in. (10.2 cm)

The bodhisattva is seated in *sattvaparyanka* on a double-petaled lotus throne. The left hand resting on the thigh and the right hand raised before the chest, he assumes the posture of Vajrasattva, but the customary attributes, the *vajra* and the bell (*ghantā*), can no longer be recognized (see cats. 64, 65).

Although the Surocolo mandala probably once contained statues of a larger size than almost all pieces found in this hoard, technical as well as stylistic differences make it unlikely that this larger figure was part of the set. As Vajrasattva in *sattvaparyanka* is one of the sixteen vajrabodisattvas, one would expect a figurine of this divinity to be smaller, closer to the size of the other vajrabodisattvas exhibited here.

Literature: Soenarto 1980, fig. 2.1.

67
Six statuettes from a Mandala of the Adamantine Sphere
10th–11th century
East Java, from Nganjuk
bronze, 3¹/₂–4³/₄ in. (9–11 cm)
Museum Nasional, Jakarta, inv. nos. 5406,
5408, 5502, 5913
Tropenmuseum, Amsterdam

IN 1913 TWO FARMERS in the village of Candirejo, Nganjuk (East Java), discovered on their land a huge hoard of bronze statuettes. When archaeologists first became aware of their discovery, the farmers had already sold a number of pieces to private collectors, and only some could be retrieved. In that same year the Batavian Society first acquired thirty-six statuettes, including thirteen from the collection of J. Termijtelen and five from the van der Blij collection. Six additional statuettes were acquired later during the same year, while another nineteen pieces were added in 1914. According to a survey made by M. E. Lulius van Goor in 1920, the Termijtelen collection at that time still contained twenty-six Nganjuk statuettes, while the size of the van der Blij and Dencher collections could not be established. The statuettes found in several European and American museums probably include many dispersed from those private collections. The hoard of Nganjuk may, therefore, have contained as many as ninety statuettes, nine of which were lost in the fire at the Colonial Exhibition in Vincennes in 1931.

The village in which the images were discovered is near Candi Lor, a temple of which only the foundations survive. In the immediate vicinity an inscribed stone was found, recording the founding by King Sindok of a Buddhist sanctuary named Jayamerta in the year Śaka 857 (A.D. 935). In the inscription the name of the locality is given as Anjuk, apparently an old name for Nganjuk.

Using comparative material from secondary Japanese sources, F. D. K. Bosch was able to demonstrate that the bronzes of Nganjuk constitute the remnants of a three-dimensional Mandala of the Adamantine Sphere (Skt. *Vajradhātu-mandala*). Later K. W. Lim identified the mandala more precisely as one based upon the commentary of the *Tattvasamgraha*, called *Tattvalokakarī*, written by Ānandagarbha, an Indian ecclesiastic who lived during the reign of King Mahīpāla of the Pāla dynasty (last quarter tenth to first half eleventh century). The representation of the Mandala of the Adamantine Sphere with a four-headed Mahāvairocana as Sarvavid (the Omniscient Lord) at its center probably originated from the University of Nālandā in Bihār. From there it spread to Tibet, the Far East, and to Southeast Asia. A fine example of a gilt bronze Sarvavid from Nālandā, probably dating from the eleventh

century, is in the National Museum, New Delhi. In the monastery of Alchi (Ladakh, India) the walls are covered with paintings representing mandalas of Sarvavid.

With the help of Indian iconographic treatises such as the *Nispannayogāvalī* and Japanese iconographical drawings, many of the statuettes can be identified and their position in the mandala established. However, as a result of the circumstances under which the pieces at Nganjuk were recovered, the character of this hoard cannot be established with certainty. The first to express an opinion on this subject was M. Lulius van Goor in 1920. Although she was not aware of the possibility that the statuettes could represent a three-dimensional mandala, her views are important as she had an opportunity to inspect a much larger number of pieces than anyone else ever had. Her tentative conclusion was: "We have probably discovered the remains of a bronze foundry, of an atelier of Javanese artists. The unfinished state of some of the pieces; the mixture of rough and fine examples; the varying quality of the bronze; the fact that for some groups the same mold was used and that these statuettes were completed by the addition of various separately cast attributes; that there are large and small statuettes of the same deity; that some occur in duplicate and triplicate and that there seem to have been five sets of Dhyāni Buddhas—all this points to a large scale foundry."

Bosch, after introducing the idea of the three-dimensional mandala, stated as his opinion: "It is important to notice that among the bronzes several specimens of the same deities are to be found differing only in their dimensions and in details of minor importance. As this reminds us of the fact noted in the foregoing that the nine squares composing the mandala again and again exhibit the same deities or their various qualities, attributes and aspects, we are on sure ground when supposing that the bronzes not belonging to the central square represent the deities of the eight outer squares of the mandala." Not all of Lulius van Goor's arguments are equally convincing now that the identity of the Mandala of the Adamantine Sphere has been established, and Bosch's statement that all statuettes were part of one and the same mandala still requires much more detailed study before it can be accepted.

The statuettes exhibited here can be identified as follows:

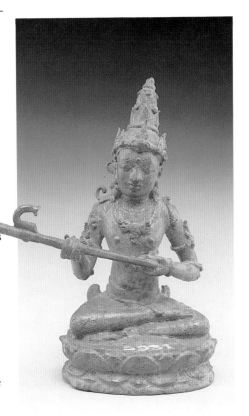

67A
Vajrānkuśa, guardian of the east
bronze, 3 ³/₄ in. (9.5 cm)
Museum Nasional, Jakarta, inv. no. 5913

The seated figure holds an elephant hook (Skt. *ankuśa*) in both hands. Vajrānkuśa is placed in the center of the east side of the square surrounding the five chapels of the Mandala of the Adamantine Sphere.

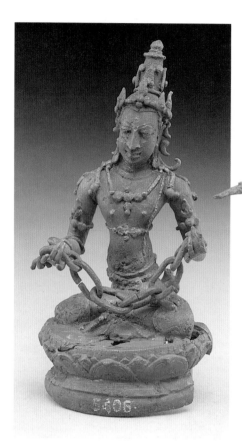
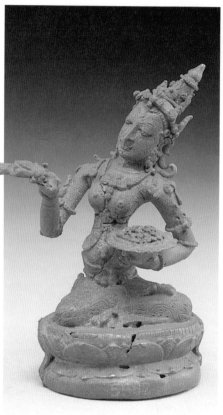
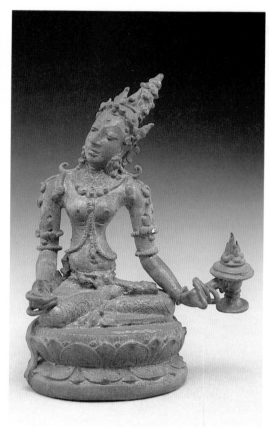

67B
Vajrasphotā, guardian of the west
bronze, 4¹/₂ in. (11.5 cm)
Museum Nasional, Jakarta, inv. no. 5406

The seated figure holds a chain (Skt. *sphotā*) suspended between both hands. Vajrasphotā occupies the center of the west side of the square surrounding the five chapels of the Mandala of the Adamantine Sphere.

Literature: *AIA* no. 46.

67C
Vajragandhā, goddess of fragrance
bronze, 4¹/₈ in. (10.3 cm)
Museum Nasional, Jakarta, inv. no. 5502

One of the eight goddesses of the offerings, Vajragandhā holds a tray of powdered incense in her left hand, while she sprinkles it with her right. As one of the four exterior goddesses of the offerings she is positioned in the northeast corner of the square enclosing the five chapels of the Mandala of the Adamantine Sphere. This statue was previously identified as Vajrapuspā, the flower goddess. Here the new identification by Lokesh Chandra has been adopted.

Literature: Bernet Kempers 1959, pl. 171; *AIA* no. 48; Chandra and Singhal 1989, 7, no. 49.

67D
Vajradhūpā, goddess of incense
bronze, 4 in. (10.2 cm)
Museum Nasional, Jakarta, inv. no. 5408

One of the eight goddesses of the offerings, Vajradhūpā holds an incense burner with a long stem in her left hand. As one of the four exterior goddesses of the offerings she is positioned in the southeast corner of the square enclosing the five chapels of the Mandala of the Adamantine Sphere.

Literature; Krom 1913, pl. XIX, fig. 22; Bosch 1961, pl. IIIb; *AIA*, no. 47.

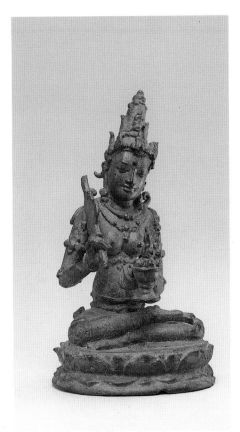

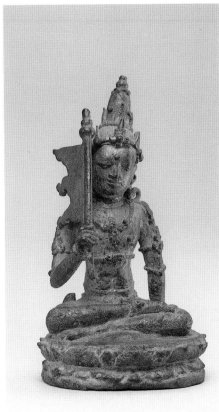

67F
Vajraketu

bronze, 3¹/₂ in. (8.3 cm) Royal Tropical Institute—
Tropenmuseum, Amsterdam, inv. no.
2960–54 , on loan from Univ. of Amsterdam

The bodhisattva Vajraketu holds a banner
of victory in the right hand. He is one of
the sixteen bodhisattvas surrounding the
Four Jinas and occupies a position north of
the Jina Ratnasambhava, whose chapel
is to the south of the central chapel of
Vairocana.

Literature: Amsterdam 1988, no. 52; Chandra
and Singhal 1989, 4, no. 14.

All the statuettes from Nganjuk show gods,
goddesses, and bodhisattvas seated with
the right leg folded on top of the left (Skt.
sattvaparyanka). Each wears a tall, pointed
headdress with triangular ornaments, while
the hair falls across the shoulders in curls.
Their rich jewelry seems to represent a
transitional phase between the more re-
strained fashion of the Central Javanese
period and the exuberant profusion of
jewelry common for statues of the four-
teenth century.

While most of the Nganjuk statuettes are of
excellent quality and have been cast by art-
ists with an eye for minute details, a com-
parison with the more recently discovered
statuettes from Surocolo (see cat. 66), espe-
cially those representing the same deities,
reveals the superior skill of the earlier
bronze casters of Central Java.

Even though the iconographic prescription
for the central Sarvavid Mahāvairocana
and his Jinas in royal attire can only have
been written shortly before the Nganjuk
bronzes were cast, the other figures of the
pantheon were known to the artists from
other sources. Instead of being representa-
tives of an innovative style, most of the
Nganjuk figures would seem to be the last
creations of an earlier tradition that had
already reached its artistic apogee at
Surocolo.

Literature: *NBG* 1913, 86, 95, 113, and XLVII–LIV;
Krom 1913; van Goor 1920; Tucci 1935, 3: part 1,
30–68; Bosch 1961c; Lim 1964; Snellgrove and
Skorupski 1977, 34–43; Huntington 1985, 402,
fig. 18.18; Amsterdam 1988, 32–35; Chandra and
Singhal 1989, 10; Sedyawati 1989a, 25.

67E
Vajragandhā, goddess of fragrance
bronze, 3¹/₂ in. (8.3 cm)
Royal Tropical Institute—Tropenmuseum,
Amsterdam, inv. no. 1770–284

One of the eight goddesses of the offerings,
Vajragandhā holds a container with fra-
grant substances (Skt. *gandha*) in her left
hand, wafting the fragrance with a fan held
in her right hand. As one of the four exte-
rior goddesses of the offerings she occupies
the northeast corner of the square enclosing
the five chapels of the Mandala of the Ada-
mantine Sphere.

Lokesh Chandra, who identified cat. 67c as
Vajragandhā, also identified a statuette that
was previously called Vajragandhā (Ja-
karta, Museum Nasional, inv. no. 5928;
AIA no. 49) as Vajrapuspā, the flower god-

dess (Lokesh Chandra 1980, 7, no. 47).
While both of his identifications would
seem to be correct, they also result in a du-
plication with the statuette exhibited here.
Given the attributes of the goddess, it is dif-
ficult to assign any name other than Vajra-
gandhā to her. If this identification is in-
deed correct it would demonstrate that the
Nganjuk hoard does not only contain the
duplicates already pointed out by Lulius
van Goor and Bosch, but that it also con-
tains statuettes of the same deity, but of dif-
ferent iconographic types.

Literature: Chicago 1949, no. 18, ill. p. 27.

68

The supreme Buddha Mahāvairocana

late 9th–early 10th century
Central Java, provenance unknown
gold image, bronze throne, 3 3/8 in. (8.5 cm)
Society of Friends of Asian Art, on loan to
the Rijksmuseum, Amsterdam, MAK 313

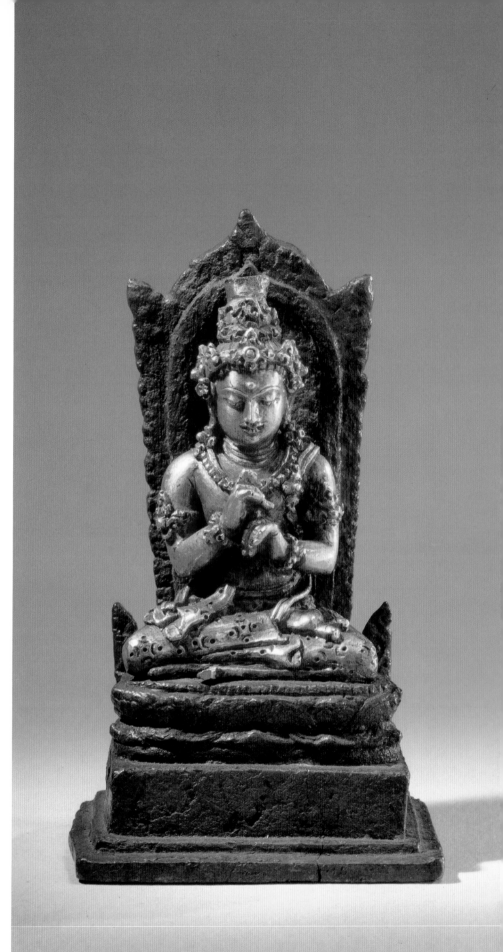

THIS RARE GOLD STATUE shows a Buddha in royal attire seated on a bronze lotus throne, placed in front of a throne back on which a halo is indicated in low relief. The gesture displayed by the Buddha's hands was long interpreted as that of two hands clasping a missing attribute, such as a *vajra*. The statue itself, on the strength of its royal attire, was thought to be that of a bodhisattva. K. W. Lim was the first to correctly identify the *mudrā* as the wisdom first gesture (Skt. *bodhyagrī-mudrā*) and the statue as the representation of Mahā-vairocana as a Buddha "paré," that is a Buddha in royal attire revealing his glorious body of bliss (Skt. *Sambhoga-kāya*). In the Mandalas of the Adamantine Sphere (Skt. *Vajradhātu-mandala*) transmitted in Japan, Mahāvairocana occupies the center and displays the *bodhyagrī-mudrā*. On top of the elaborate headdress is an empty socket which may once have contained a precious stone, a symbol of the brilliance of the Supreme Buddha's wisdom that pervades the universe.

The statuette is of unusual proportions in that the head is rather large, whereas the legs, dressed in a loincloth, seem relatively thin and short. There is a marked contrast, undoubtedly intentional, between the rich details of the golden figure and the stark simplicity of the throne back. Although the details of the statuette are not as well executed as the *mandala* figurines from Surocolo (see cat. 66), the gold Buddha resembles them in its detailed rendering of dress and jewelry and may be dated to approximately the same period.

This statuette, of unknown provenance in Java, came from the collection of Alexander Loudon and was acquired by the Museum of Asiatic Art, Amsterdam, at the auction of that collection in 1953, together with cat. 71.

Literature: Krom 1918–1919, no. 12, fig. 10; The Hague 1922, no. 65; Amsterdam 1954, no. 640; Bosch 1955; Rijksmuseum 1962, no. 353, pl. 63; Rijksmuseum 1985, no. 187; Bernet Kempers 1985; Amsterdam 1988, no. 41.

69

Gargoyle in the shape of a *makara*

c. 9th–10th century
Central Java, provenance unknown
bronze, 5¹¹/₁₆ x 5¹/₂ in. (14.5 x 14 cm)
The Metropolitan Museum of Art,
New York, Gift of the Kronos Collection,
1984, inv. no. 1984.486.2

THE *MAKARA* or fish elephant is a composite mythical creature that evolved from an animal resembling a crocodile in early Indian art. In Central Java it can be seen in many different guises. It usually consists of a monster's head with gaping jaws and large teeth, with the upper jaw ending in a curling elephant's trunk. Sometimes this trunk is transformed into yet another fantastic animal with one more set of gaping jaws, while from the original *makara's* jaws figures of deities, lions, or birds emerge. A pair of *makaras* constitutes the lower components of the *kāla-makara* motif, framing the doorways and niches of the Central Javanese *candis*. The *kāla* or demon's mask on top symbolizes the sun and light; the *makaras* below are associated with darkness and water. In addition to their role in framing doorways, the *makaras* decorate the ends of crossbars of thrones and flank the flights of steps leading up to temples.

Yet another function, and one in keeping with its symbolical connotation, is that of gargoyle. Of the one hundred gargoyles that evacuate the rainwater from Candi Borobudur, the twenty located at the base of the monument take the shape of *makaras*, while those higher up are all in the shape of *kāla* heads. Installed in the balustrade of the first gallery and supported by brackets in the shape of squatting dwarfs, the water accumulating on the first gallery flows through their round spouts to the processional path surrounding the monument.

The bronze miniature replica of such a gargoyle exhibited here is quite close to those of Candi Borobudur. It is a unique piece of which neither the original context nor the exact function is known. Except for its prominent eyes, which are known from only a few examples from Jambi and Padang Lawas (Sumatra), the bronze would seem to fit stylistically among the larger examples in stone from Central Javanese monuments.

In Java the *makaras* flanking the stairs disappeared shortly after the Central Javanese period came to an end. The last known examples were those excavated at Gurah (see cat. 20). One of the four monumental *makaras* from Solok, Jambi (Sumatra), now in the Museum Nasional, Jakarta, bears an

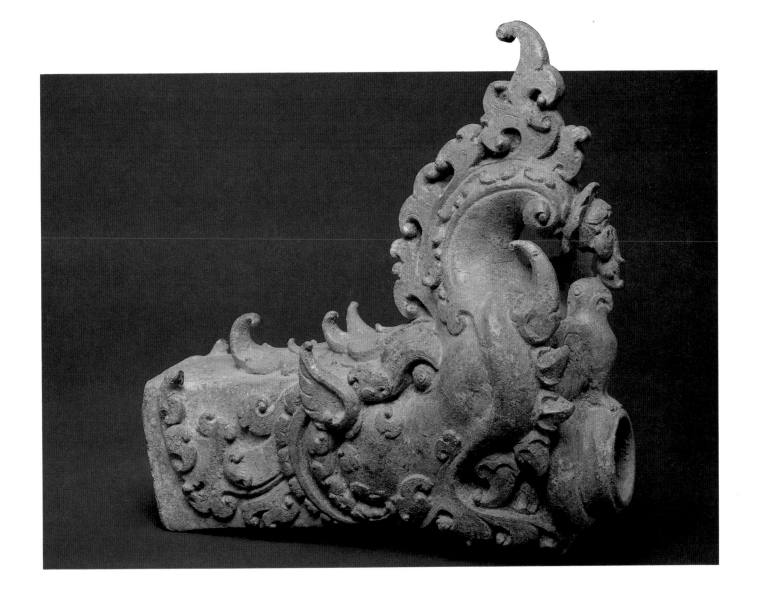

70

Temple bell

c. 9th century
Central Java, from Candi Kalasan
silver-plated (?) bronze, 23 in. (58.5 cm)
Museum Sono Budoyo, Yogyakarta

inscription dating from Śaka 986 (1064). In its function of gargoyle the *makara* enjoyed greater longevity. The fourteenth-century bathing place known as Candi Tikus near Trowulan (East Java) still has spouts in the shape of *makara*.

The only comparable piece that may have served a similar function is a bronze spout in the shape of an elephants' head recently sold at auction (Christie's, Amsterdam, 7 June 1989, no. 343). In the *kakawin Arjuna-wijaya* (Arjuna's Victory), gargoyles in the shape of elephants' heads are mentioned, confirming the attribution to the East Javanese period given in the auction catalogue.

Literature: New York 1984, no. 47. On *makara*: Brandes 1901; Brandes 1902a; Neeb 1902; van Erp 1931, 82, 178; Bosch 1960, 20–34.

THIS LARGE TEMPLE BELL, the largest ever found in Indonesia, was discovered near Tañjung Tirta, west of Candi Kalasan (Central Java) in November 1927, when the introduction of a new variety of sugar cane necessitated deeper plowing. Near the bell was found a Chinese jar containing an iron chain from which the bell must once have hung.

The *stūpa*-shaped bell rests upon a double lotus cushion, which is supported by a torus of robust proportions. A richly decorated central band with antefixes enhances the bell's resemblance to the central *stūpa* of Borobudur. Strings of pearls hang from this band and are suspended in loops, inside which parrots appear. This festoon and bird motif is a common repetitive element of Central Javanese architectural decoration. Here, however, the bronze caster has skillfully avoided monotony by showing the parrots in different lifelike poses.

A second double lotus cushion at the top of the bell serves as a pedestal for a crouching lion. Its belly bent to the ground, the roaring lion, its jaws wide open, raises its front paws. The bell was hung from a heavy ring on the lion's back. Most lions atop bells are shown in a kind of rampant or prancing posture. Here the animal's crouching position may have been dictated by the considerable weight of the bell, which required support. The bell was cast without a clapper and, like most Buddhist temple bells in south and east Asia, was struck with a mallet or wooden hammer to produce a sound.

The lion-shaped top embodies several Buddhist symbols. The historical Buddha was known as the lion of the Śākya clan, and the lion's roar is a metaphor for the first sermon, the Buddha's message to the world. Also, the lion's yawn (Skt. *simhavi-*

jrmbhita) is sometimes used as a metaphor for the enlightened conduct of bodhisattvas and saints. Each time a bell was struck these symbolic messages were made known to the world.

While many bells have been found in Central and East Java, no other example of this size and quality of casting is known to exist. One of the reliefs of Borobudur's hidden base (0–131) shows the presentation of an even larger bell to a temple. The accompanying instruction to the sculptors, carved above the panel, reads "*ghantā*," the Sanskrit word for bells, apparently of any size.

The bronze bell has a silvery patina, but to this date no tests have been conducted to establish whether this silvery shine is the result of a high silver content of the alloy, a silver coating applied to the bronze, or some other technical procedure.

Candi Kalasan is one of the few Central Javanese temples of which the founding is exactly known. An inscription found near the temple records the founding in the year 700 of the Śaka era (778) of a temple dedicated to Tārā at a place named Kalasa (see introduction). The present building is of a later date, the result of several drastic modifications of the original structure. While it would stand to reason to connect this magnificent bell with the monastery that was once attached to Candi Kalasan, excavations in the immediate vicinity of the spot where it was discovered failed to yield supporting evidence. The monastery is thought to have been located south of the temple.

Literature: *OV* 1927, 105–106; *OV* 1928, 87–88; Bosch 1929a; Bosch 1929b; Sono Budoyo 1934, no. 41; Bernet Kempers 1959, pl. 109; Sono Budoyo 1982–1983, 21, no. 2.

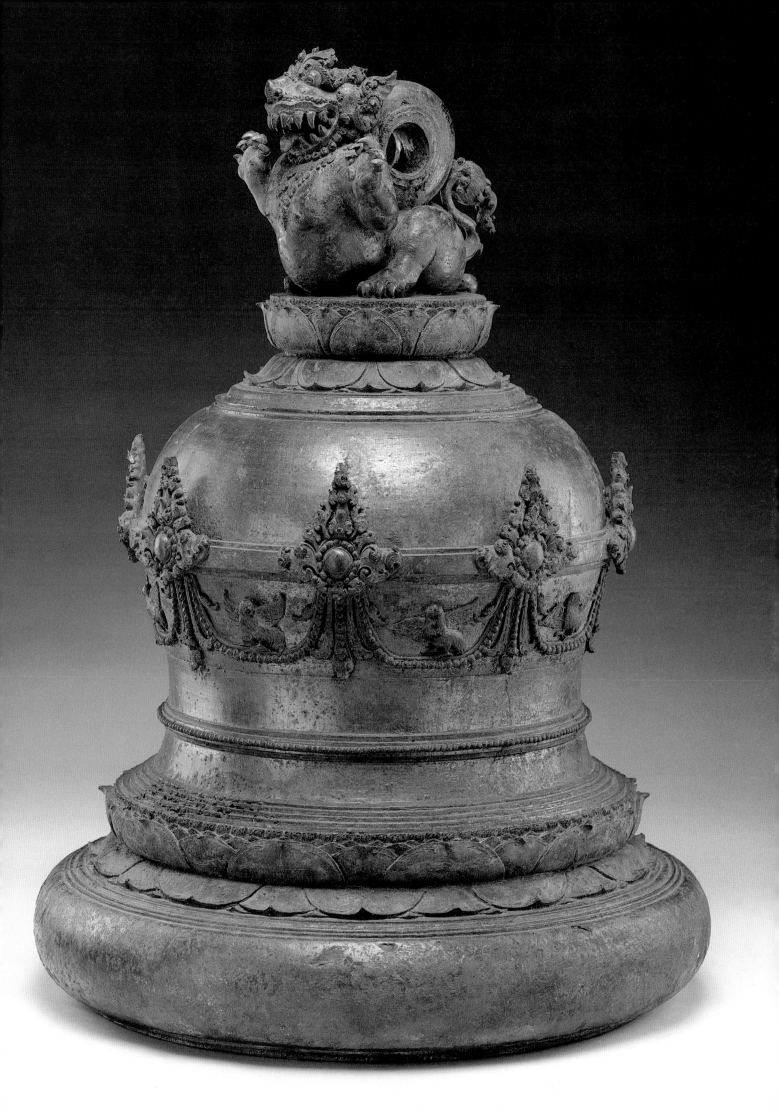

71
Priest's bell

c. 9th–10th century
Central Java, provenance unknown
bronze, 7 1/4 in. (18.5 cm)
Society of Friends of Asiatic Art, on loan to
the Rijksmuseum, Amsterdam, MAK 314

THE PRIEST'S BELL (*ghantā*) consists of three parts: the domed bell itself, the handle with four faces, and the *vajra*-shaped top, each of which is supported by a double lotus. The top consists of a five-pronged *vajra* or thunderbolt, the shape of which may have matched that of one half of the other priestly ritual implement, a double *vajra*, with which it once may have formed a pair.

The four heads of the handle represent the four-headed, crowned Mahāvairocana (The Omniscient One) Sarvavid, whose cult spread to Java during the later part of the Central Javanese period. That he is indeed the central Jina of Esoteric Buddhism is suggested by the presence of the symbols of the four directional Jinas on the antefixes decorating the central band on the body of the bell: a *vajra* (Aksobhya), a jewel (Ratnasambhava), a lotus (Amitābha), and a quadruple *viśvavajra* (Amoghasiddhi).

The use of *vajra*-topped bells in conjunction with a double *vajra* in priestly ritual is recorded in reliefs as well as in statues representing Vajrasattva (see cat. 64). The two implements symbolized the female (bell) and male (*vajra*) aspects of the universe. By mounting a *vajra* on the handle of a bell the two elements were united.

Priests' bells are among the bronze objects most frequently found in Java. The Museum Nasional in Jakarta has more than 180 examples, and the total number in Indonesian, European, and American collections may well exceed 500. The use of such bells in priestly ritual can be observed to this day in the Těngger region of East Java as well as in Bali and Lombok. However, in Bali and Lombok only *vajra*-topped bells are used, whereas the village priests of the Těnggěr area use bells with tops of various shapes (see cat. 76). Why such large numbers of bells have been preserved and almost no double *vajras* is not clear. For reasons not yet understood priest's bells often seem to have been buried in large numbers together. Among the chance finds from both Central and East Java are groups of seventeen, sixteen, and eleven bells. Several other finds contained four, five, or seven bells.

While a number of these bells have a handle with four faces, no other piece can match the perfection of the casting and the artistic distinction of this ritual object. Of

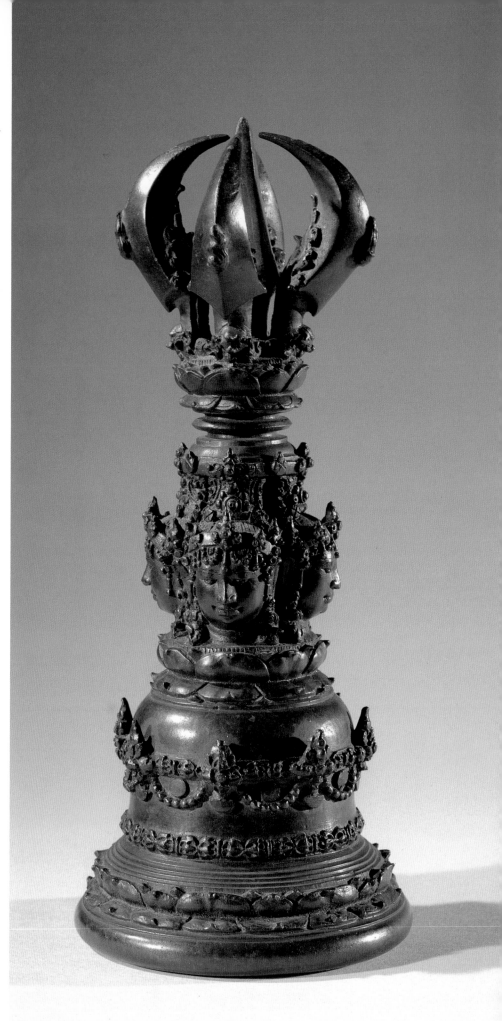

72

Five-pronged double *vajra*

9th–10th century
Central Java, from Tegal-Toprayan, Klaten
bronze, 10 1/4 in. (26 cm)
Museum Nasional, Jakarta, inv. no. 8390

unknown provenance, it was acquired by one of the earliest and most discerning collectors of ancient Indonesian bronzes, Alexander Loudon, and bought by the Museum of Asiatic Art, Amsterdam, at the auction of this famous collection in 1953.

Literature: Krom 1919, 383–395; The Hague 1922, no. 46, fig. 2; Krom 1923, 2:453; Krom 1926, pl. 22a; Amsterdam 1936, no. 188; Visser 1948, pl. 211, no. 363; Amsterdam 1953, no. 1066; Amsterdam 1954, no. 673; Bosch 1954; Bernet Kempers 1959, pl. 111; Rijksmuseum 1962, no. 354; Bernet Kempers in Rijksmuseum 1985, no. 200; Amsterdam 1988, no. 67.

FROM BOTH ENDS of the round grip in the center of the utensil grow lotus flowers; on each rests a five-pronged *vajra*.

In Esoteric Buddhism the *vajra* (thunderbolt), originally the attribute of the god Indra, is a diamond and symbolizes supreme enlightenment. Together with a *vajra*-topped hand bell (Skt. *ghantā*), they constitute the two principal ceremonial utensils of priests of the "diamond path" (Skt. *Vajrayāna*) of Esoteric Buddhism, which spread to Java during the final decades of the Central Javanese period and flourished during the East Javanese period. The shape of the *vajras*, with their four outer prongs almost touching the slightly larger central point, represents the classic Central Javanese type. Its provenance from the village

of Tegal-Toprayan near Klaten (Central Java) also points to a date in the late ninth or early tenth century.

Whereas *ghantās* have been found in large numbers, both in Central and in East Java (see cat. 71), very few *vajras* seem to have survived. Not a single case of a matching *ghantā* and *vajra*, of which many examples exist in the countries of the Far East, has been reported from Indonesia.

A possible explanation could be that in Java the *vajra*-topped *ghantā* soon replaced the matching pairs, and became the sole ceremonial utensil held by the priest.

Literature: *NBG* 1893, 148; Bernet Kempers 1959, pl. 116; *AIA* no. 85; Brussels 1977, no. 56.

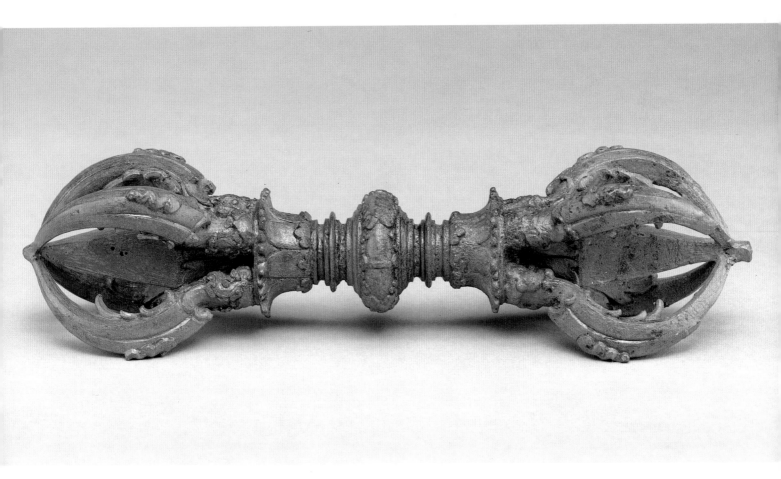

73
Temple bell

datable to 1289
East Java, from Ngrejo, Kalangbret,
Kauman, Tulungagung
bronze, 12 1/4 in. (31 cm)
Museum Nasional, Jakarta, inv. no. 9581

THE BELL RISES from a double lotus cushion, supported by a semicircular torus. Above the plain body another double lotus with the upper row of petals pointed upward serves as a pedestal for two intertwined dragon snakes (*nāgas*). These animals have horns on their noses, and curling tongues hang from their open jaws. The chain, complete with a hook at the end, is attached to a ring on top of the *nāga* heads.

On the scaly body of one of the *nāgas* appears a cast inscription reading "1211," the year of the Śaka era that corresponds to 1289. This makes the bell the last of a group of four bells of similar shape that are datable by their inscriptions to the late thirteenth century. The earliest of these is a bell in the Linden-Museum, Stuttgart, bearing a date corresponding to 1276. In a private collection in Washington is a similar bell, dating from 1284. What appears to have been a particularly fine example was a bell dating from 1287, once in the Jakarta Museum. It was destroyed by fire in the pavilion of the Dutch East Indies at the Colonial Exhibition, Vincennes, France, in 1931. Except for the lost bell, which was crowned by a *nāga*, each of the other datable pieces has a top in the shape of a rampant lion. No other example with a top of intertwined *nāgas* is known.

Literature: *NBG* (February 1910), 16–17, XXXIII; *AIA* no. 59; *Koleksi Pilihan* I, no. 16. Bell of 1276: Linden-Museum 1984, no. 52. Bell of 1284: Amsterdam 1988, no. 73; Amsterdam 1989, no. 357. Bell of 1286 (ex Jakarta museum, inv. no. 958 f): *NBG* 1896, 25, and CIV; *ROD* 1923, 59; Krom 1926, pl. 42; Bosch and Le Roux 1931.

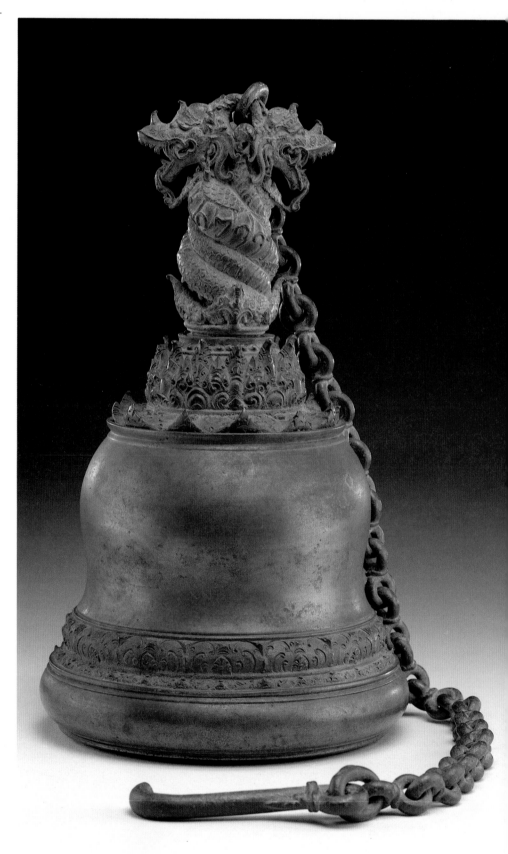

74
Demon-shaped bell finial

second half 13th century
East Java, from Selumbung, Trenggalek
bronze, 8 5/8 in. (22 cm)
chain 27 1/8 in. (69 cm)
Museum Nasional, Jakarta, inv. no. 5942

THE DEMON ASSUMES an aggressive posture, his right hand placed on his right hip. He is dressed like a warrior and wears a double sacred thread (Skt. *upavīta*) and reticulated, winged shoulder patches of a type reminiscent of those worn by actors in the Thai theater. On the palm of his raised left hand he carries a spouted container of *amrĕta* (nectar of the gods). The hair on top of his head has been shaped into a loop to accommodate the chain from which the bell, of which this statuette once was the top, was suspended.

Although Garuda carrying off the nectar of the gods is a common motif in Indonesian art, representations of a demon carrying the vase of *amrĕta* are relatively rare. It has been suggested that such *rāksasas* (demons) represent Ratmaja, the demon king who, according to the Javanese poem *Hariwijaya* (Visnu's Victory), stole the nectar of the gods. Visnu, assuming the shape of a beautiful woman, tricks Ratmaja into surrendering the *amrĕta*, after which he kills him. The story, as told in the *Hariwijaya*, is an extensive poetical elaboration of a brief episode in the *Ādiparwa*, the first section of the Indian epic *Mahābhārata*. In the passage that provided the inspiration for the Javanese poem, the name of the demon is not even mentioned.

This finial was part of a cache of bronze objects discovered by chance about sixty years ago in the village of Selumbung, Gandusari (East Java). Among the pieces was an octagonal bronze tube, carrying a cast inscription containing the date Śaka 1185 (1263). A bronze *kĕntongan* or slit drum, hexagonal in shape, carried the date Śaka 1209 (1287). While nothing is known about how or when these objects were committed to the earth, perhaps for safekeeping in a time of unrest, it is quite possible that the other objects from this hoard may likewise date from the second half of the thirteenth century.

There are two other bell finials in the shape of a demon carrying an *amrĕta* vase in the Museum Nasional, Jakarta (inv. nos. 944 and 944a), one of which has been preserved complete with its bell and chain.

Literature: *OV* 1928, 97–98; Crucq 1929a; Bernet Kempers 1959, pl. 221. Ratmaja: van der Tuuk 1897, 1:739, *s.v.* Ratmaja; van Buitenen 1973, 74–75; Zoetmulder 1974, 386–387. Museum Nasional objects: *AIA* no. 60 (inv. no. 944) and *NBG* 1904, CLXXXVII (inv. no. 944a).

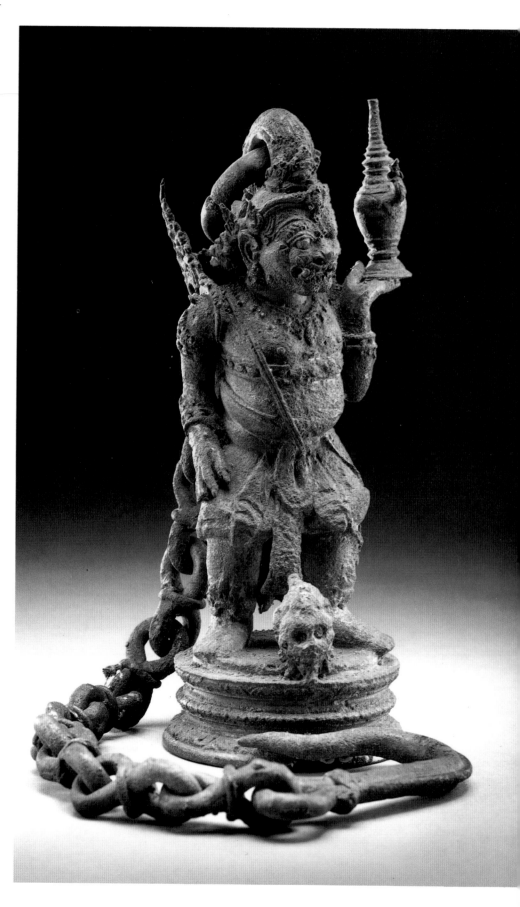

75
Elephant bell

c. 12th century
Central Java, from Panunggalan, Cahyana,
Banyumas
bronze, 9 in. (23 cm)
Museum Nasional, Jakarta, inv. 986a

BRONZE BELLS shaped like European helmets of the sixteenth century have been found in Java in large numbers and vary greatly in size. The bell exhibited here is one of the largest of its kind. These largest bells are commonly called elephant bells, and even though they resemble today's wooden and brass cow bells (Javanese: *klontang*), there is sufficient evidence to maintain the designation of the antiquarians. The bells hanging on both flanks of an elephant on a lamp (cat. 87) and a bell attached to the collar of an elephant in a relief at Candi Sukuh (fifteenth century) are of the same type as the bell exhibited here. There is no proof, however, that such bells were worn exclusively by elephants.

An inscription stands out on the smooth surface of the bell in relief and constitutes the sole decoration of the piece. It reads, in so-called Kadiri Quadratic script: "*Sahati.*" The word means "he is victorious" in Sanskrit, or "one of heart" in Javanese. For a bell that was made to be worn by an elephant, a royal symbol, the Sanskrit interpretation seems to be the most appropriate.

Contrary to what the name suggests, the Kadiri Quadratic script was not used exclusively during the Kadiri period (929–1222), and its use for the inscription on this bell does not give us a precise date for the piece. Bells of this type were already in use during the late Central Javanese period. In the village of Dompon, Purworejo, Semarang, a helmet-shaped bell (Museum Nasional, Jakarta, inv. no. 6352) was found with a charter, inscribed on a bronze plate, dated in accordance with 901. By the charter a maharaja grants trade privileges to the villagers of Ayamtĕas. As such privileges were granted in perpetuity, it is likely that the written proof protecting the village from the ubiquitous tax collectors was handed down by the village elders for generations. A charter may, therefore, date from a much earlier period than the objects buried with it. In this case the date of the charter, so close to the end of the Central Javanese period, could indicate that the villagers did not enjoy these rights for long and that the bell was buried with the charter soon after it was issued. As this is the only bell of this type found in association with a dated document, perhaps the only assumption we can make is that the more ornate examples date from the Majapahit period, while relatively simple bells like the inscribed bell exhibited here may date from the eleventh to thirteenth century.

Literature: *NBG* 1884, 96; Groeneveldt 1887, 250; *ROC* 1912, 133. The find at Dompon: *OV* 1937, 26; *JBG* 5 (1938), 137 (nos. 6351–6355). Kadiri Quadratic script: de Casparis 1975, 42.

cat. 76

cat. 77

76
Priest's bell with lion
c. 14th century
East Java, provenance unknown
bronze, 7 11/16 in. (19.5 cm)
Museum Nasional, Jakarta, inv. no. 7979

THE *STŪPA*-SHAPED BELL has a handle with a node in the middle to fit the shape of the hand. It is crowned by a statuette of a roaring lion. In comparison with the lion crowning the large Central Javanese bell from Candi Kalasan (cat. 70), it is obvious that the lion has now become even farther removed from the actual appearance of the species, which no Indonesian artist had ever seen. As if to emphasize its complete domestication, the doglike creature has been provided with an ornamental collar.

Among ritual bells from East Java there is a great variety in the shape of the tops of the handles. Bosch once listed the emblems crowning these bells in the order of their frequency: *nandin* (bull), *simha* (lion), *nāga* (dragon or snake), *triśūla* (trident), *cakra* (wheel), and many other emblems only infrequently met with. Bulls or tridents suggest a connection with Śivaite cults, whereas lions are likely to have been associated with Buddhist rituals. Perhaps it would be wise not to assume a direct connection with rituals of specific religious groups, for a group of bells discovered together in 1938 at Jalen, Campurdarat, Tulungagung (East Java) displayed a *vajra*, a bull, a lion, and a wheel, emblems of more than one such group. In Bali only priest's bells topped with the *vajra* are used, whereas in the Tĕnggĕr region of East Java the variety of emblems typical of the Majapahit period has been maintained until modern times.

The lion bell exhibited here was acquired for the Museum Nasional by the Archaeological Service in May 1952.

Literature: *AIA* no. 61; Bosch 1961b; Scholte 1919, esp. 68.

77
Priest's bell with squatting figure
13th–14th century (?)
East Java, provenance unknown
bronze, 5 3/4 in. (14.5 cm)
Museum Nasional, Jakarta, inv. no. 8114

THE TOP OF THE HANDLE of this simply designed hand bell consists of a man seated on a lotus pedestal, clasping his arms around his drawn-up knees. His bulging eyes and heavy, curly eyebrows are like those of a demon, but the gentle expression on his face makes it more likely that he represents an enlightened ascetic.

Bells topped with a seated or squatting figure occur in several collections. The Museum Nasional, Jakarta, has several examples, of which the bell exhibited here is the finest in design and quality of casting. East Javanese literature contains numerous stories about men who withdraw from the world to practice asceticism in caves in remote mountain areas. Whether bells with emblems in the shape of such ascetics had a special ritual function is not known.

This bell was purchased by the Archaeological Service in October 1953 and transferred to the Museum Nasional in Jakarta. Its provenance is unknown and its date is uncertain.

Literature: unpublished. Other bells: Linden-Museum 1984, nos. 76–78; Amsterdam 1988, no. 70.

78
Hanging lamp
c. 8th century
Central Java, from Purwojati, Kertek, Wonosobo
bronze, 18 3/4 x 17 in. (47.5 x 43 cm)
Museum Nasional, Jakarta, inv. no. 8319-8320

TWO SYMMETRICALLY CURVED RODS, together forming the shape of a *ratna* (jewel), connect the *Kāla*-head on top with the base for the oil lamp below. The parts have been cast separately and are held together by rivets. At the time of its acquisition by the Archaeological Service of Indonesia in 1955, the lamp was in two separate pieces.

The actual receptacle for the oil and the wick, once placed on top of the base in the shape of a *kumbha* (vessel) surrounded by flames, was already missing at the time the lamp was acquired. The top, to which a long chain has been attached, takes the shape of a flying Garuda holding a snake in his left hand. Garuda has a short beak and human legs, characteristics typical of representations of this mythical bird dating from the first half of the Central Javanese period (see also cats. 80 and 54).

The bronze oil receptacle of a lamp with heart-shaped arches has been preserved in the collection of the National Research Centre for Archaeology, Jakarta. In 1935 a lamp similar in shape and structure to the piece exhibited here was found in the village of Gĕmutuk, on the southern slope of Mount Gunung Slamet (North Central Java). A small ceramic cup of Chinese manufacture was found in shards next to it. It raises the possibility that the lamp exhibited here was likewise provided with an oil container made of a material other than bronze. The arches of the lamp from Gĕmutuk (now in the Museum Nasional, Jakarta, inv. no. 6622) are embellished with two figures of birds, flanking the *kāla*-head on top, and the addition of leaf-shaped extensions at the end of the curves. This would seem to represent the early beginnings of a stylistic development that would ultimately transform the plain, sober arches of the type of lamp exhibited here into the convoluted, ribbonlike arches of the Majapahit period (see cat. 116).

Although the possibility of a ritual use of this lamp cannot be ruled out, only its secular, utilitarian function can be documented with certainty. Two arched lamps of similar shape and design can be seen in a relief of Borobudur, where they provide light in a palace room in which a queen is giving birth to a prince.

Literature: *AIA* no. 65. Gĕmutuk lamp: van Dapperen 1935, fig. 9. Jakarta lamp: Soekatno 1981, no. 84.

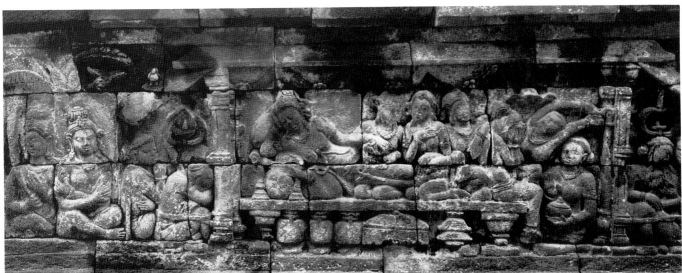

Two arched lamps in Borobudur relief II B 283

cat. 80

cat. 79

79
Candelabra with three lamps
8th–9th century
Central Java, from Kretek, Wonosobo
bronze, 15 in. (38 cm)
Museum Sono Budoyo, Yogyakarta

THE CANDELABRA has three arms, each ending in an oil receptacle in the shape of a lotus flower. The hollow, profiled shaft terminates in a lotus cushion, surmounted by an open, three-lobed ring in the shape of a jewel (Skt. *ratna*), to which the three arms of the lamps have been attached. The central vertical arm is straight and has the profile of a turned column, whereas the two side arms have the undulating shape of a lotus stalk or rhizome complete with scale leaves.

In most Javanese bronze lamps the rim of the oil reservoir has been bent outward, forming a spout to accommodate the wick. In this lamp the center of each oil receptacle consists of a small, hollow and upright cylinder with a slit on one side. It apparently served to hold a wick in vertical position, while allowing the oil to be drawn into the wick through the slit.

This lamp of rare elegance and fine workmanship first came to the attention of scholars after it had entered the collection of the noted connoisseur Mrs. A. J. Resink-Wilkens about seventy-five years ago. It would seem that there was some doubt as to its authenticity at that time, for the photograph made by the Archaeological Service is listed in its annual report (*Oudheidkundig Verslag*, 1915, 74) with the remark: "modern lamp with old motives."

That the candelabra itself, with its jewel-shaped center and its three arms, is of ancient Javanese origin is beyond question. A similar triple structure can be seen carved in high relief in the walls of the cellas of the subsidiary temples of Candi Sewu, Prambanan. There, however, the lotuses support niches that once housed bronze statuary instead of lamps. *Ratna*-shaped finials occur on several reliefs of Borobudur.

The different patina of the three lotus-shaped receptacles suggests the possibility that these are modern restorations. However, a restorer could hardly have created the holders for the wicks, of which no other example is known in ancient Javanese art. That such devices actually existed in ancient Java can de deduced from two lamps with arms shown in the *Karmavibhanga* reliefs on the hidden base of Borobudur (0–24 and 0–155). Both clearly show the flames originating from the center of the oil reservoirs, not from the side, as we would see if the more widely known way of accommodating the wicks had been

Two standing lamps from Borobudur reliefs 0–24 and 0–155

adopted. These two illustrations of ancient lamps suggest that the central shaft of the lamp, instead of being fitted on a wooden staff and carried around in procession, as some scholars have hypothesized, may have stood on a base. The two illustrated examples appear to have been quite tall, perhaps almost the size of a man and certainly larger than the lamp exhibited here. Such large lamps with many wicks may have been used, for example, in the main cella of Candi Śiva at Prambanan. There, the walls of the main cella are covered with repetitive, batiklike designs in low relief that are barely visible in the unlit space, into which daylight enters only through the door. Many other temples, including the Nandin temple opposite Candi Śiva, have plain stone brackets protruding from the walls to serve as a base for lamps, but at Candi Śiva apparently the architects and artists did not wish to have their elegant wall decoration interrupted by consoles.

During the Majapahit period (14th–15th century) the decoration of bronze lamps often showed scenes laid in heaven. In Central Javanese times lamps were objects of great religious significance, to which deep respect was due. This is evident from two passages in the Buddhist text *Karmavibhanga*, both of which are illustrated at Borobudur. In the fifth paragraph those who destroy the lamps of *stūpas* and temples are condemned to rebirth as repulsive-looking persons, while the seventy-fifth paragraph mentions the positive karmic results of the donation of a lamp to a temple. Among the rewards in a donor's future life are "unfailing eyesight, brilliant insight, and great happiness."

Literature: *OV* 1915, 74; Stutterheim 1934b, esp. 184; van Erp 1943b, esp. 152 and fig. 5; Bosch 1960, pl. 38a; Bernet Kempers 1959, pl. 177; Fontein 1989, 21–23 and 66–67.

80
Hanging lamp with flying Garuda
late 8th or c. 9th century
Central Java
bronze, 12 3/8 x 5 1/8 in. (31.5 x 13 cm)
Museum Nasional, Jakarta, inv. no. 1101a

GARUDA, VIŚNU'S MOUNT, is represented here as a winged human being with a bird's head. His wings are spread and his legs are bent as if running, and he holds a lotus stalk in both hands. The lotus leaves are oil containers, the rims of which have three indentations to accommodate an equal number of wicks. A conch, Visnu's constant attribute, has been attached to Garuda's chest and functions as a third oil reservoir accommodating a single wick. In Garuda's back is a rectangular opening, the cover of which is lacking.

J. L. Brandes was the first to draw attention to the gradual transformation of the mythical bird Garuda in Indo-Javanese art. The earliest Javanese representations invariably show Garuda with human legs and feet and a relatively small beak. Toward the end of the Central Javanese period the human feet are transformed into the claws of a bird of prey, his beak becomes larger, while his hair grows longer and becomes increasingly curly like that of a *rākṣasa* (demon).

The human feet, the short beak, and the hair with its short curls suggest that this Garuda lamp may date from the late eighth or ninth century. It entered the collection of the Jakarta Museum in 1890 as gift of J. Kläring, a longtime resident of an estate in the area of Candi Sewu and Candi Loro Jonggrang (Prambanan, Central Java). The recorded provenance from the Yogyakarta area is consistent with that of other works of art from the same collection. On top of Garuda's head is a ring to which a chain could be attached to suspend the lamp.

Flying creatures and heavenly beings must have been considered suitable subjects to be represented on oil lamps. The flickering lights enhanced the illusion of movement in such pieces and created lively shadows on the walls of the space in which they were hung. Garuda, the mount of Visnu, the god of light, was particularly appropriate to serve as a vehicle for a lamp, spreading light after the sun god Sūrya had completed his daily course.

Literature: *NBG* 1890, 19; *AIA* no. 66; *Koleksi Pilihan* 1, no. 22; Tokyo 1980, no. 38.

81
Flying Garuda
c. 8th century
Central Java, from Blora
bronze, 4 in. (10 cm)
Museum Nasional, Jakarta, inv. no. 714

THE WINGED GARUDA is shown in a flying posture, both legs bent, the left leg pressed against the body and the right leg in the air. He wears a necklace, large earrings, and short pants held up by a belt. In his hands fragments of a *nāga*, the staple of his diet, can still be discerned.

The top of Garuda's head has been flattened and provided with a tenon, and the bottom of the figure has a tenon of similar shape. This suggests that the Garuda once was a component of a larger bronze, perhaps of a lamp. For the representation of Garuda as a human being with a bird's head see cats. 54, 80.

The short beak and the human body suggest an early date during the Central Javanese period. Blora, the town where this Garuda was excavated, is in the easternmost part of Central Java, an area from which no other bronze finds have been reported.

Literature: *NBG* 1864, 251; Groeneveldt 1887, 205; *ROD* 1915, no. 1586.

82
Finial in the shape of a snake woman
9th–10th century
Central Java, from Solo
bronze, 9 7/8 in. (25 cm)
Museum Nasional, Jakarta, inv. no. 8009

ABOVE A HOLLOW SHAFT that fits the top of a staff, a lotus of unusual stylized shape, decorated with strings of pearls, serves as a platform for a woman who holds a large snake with both hands. She is dressed in the rich attire of a goddess or queen, and stands with the tail of the snake between her feet, lifting it up, apparently without much effort, by the sides of the hood. The snake (*nāga*) spills a string of pearls or jewels from its jaws, and balances a small, footed dish on its head.

India and Indonesia are both countries rich in serpent lore, and *nāga* and *nāginī* appear frequently on the reliefs of Borobudur. There, however, the *nāga*s are invariably shown as human beings with a three- or five-fold hood of snakes. The tradition of representing *nāga*s in human guise was so strong that the sculptors even adhered to it when it made little sense, as, for example, in the episode from the life of the Buddha, when the *nāga* Mucilinda protects the bodhisattva from the rain, a story to which only a *nāga* with a body of a snake can do justice. At Borobudur Mucilinda is shown as a human *nāga*, paying homage to the bodhisattva.

The possibility exists that the *nāga* went through a process of transformation similar to that of its eternal adversary, the Garuda, who was gradually transformed from a bird man into a bird of prey. The *nāga*, shown as snake man on the Borobudur reliefs, later assumed its true serpentine appearance. The snake woman of this finial may represent a *nāginī* in an intermediate stage of development, in which man or woman and snake came to be separated. It is also possible, however, that she represents a real snake charmer and that the lotus pedestal on which she stands is in reality a jeweled basket, one of the tools of her trade. Such a basket is mentioned in the *Bhūridatta Jātaka* (Pali no. 543). A story like this *jātaka*, in which *nāga*s and *nāginī*s play a leading role, may well have inspired the artist of this charming piece of sculpture. That it is not exactly this *nāga* tale is evident from the fact that two pairs of bird's feet flank the feet of the snake woman. They may have belonged to a now-lost pair of *garudas*.

It is obvious that this enigmatic sculpture represents a fragment of a larger piece, perhaps a lamp, the receptacle of which could have been mounted on top of the snake's head. Reputedly found near Solo, the piece was acquired by the Archaeological Service for the National Museum in April 1953. The modeling of the figure of the snake woman, her costume, and her jewelry all point to a date in the later part of the Central Javanese period.

Literature: Bernet Kempers 1959, pl. 181, The *Bhūridatta Jātaka*: Cowell 1978, 80–113.

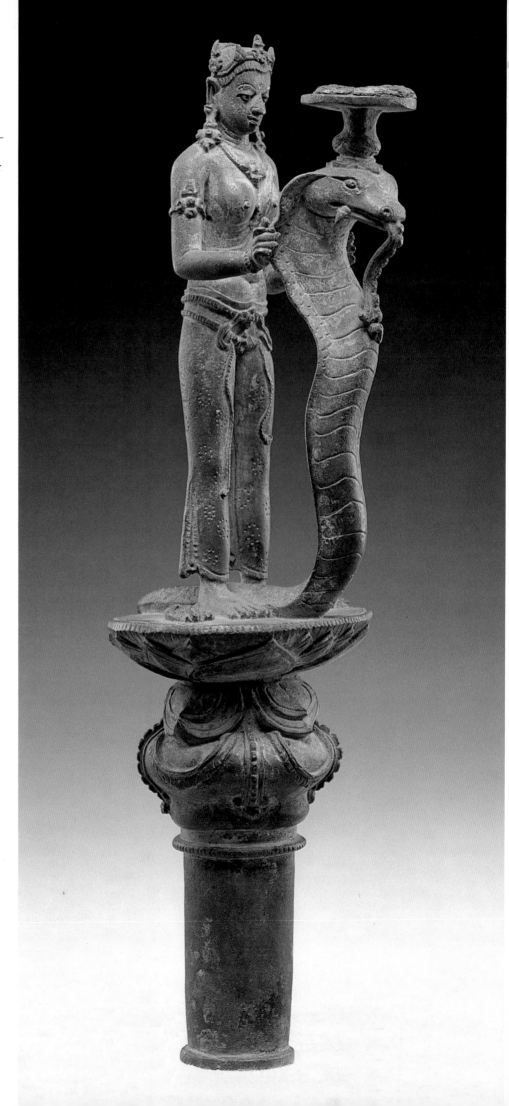

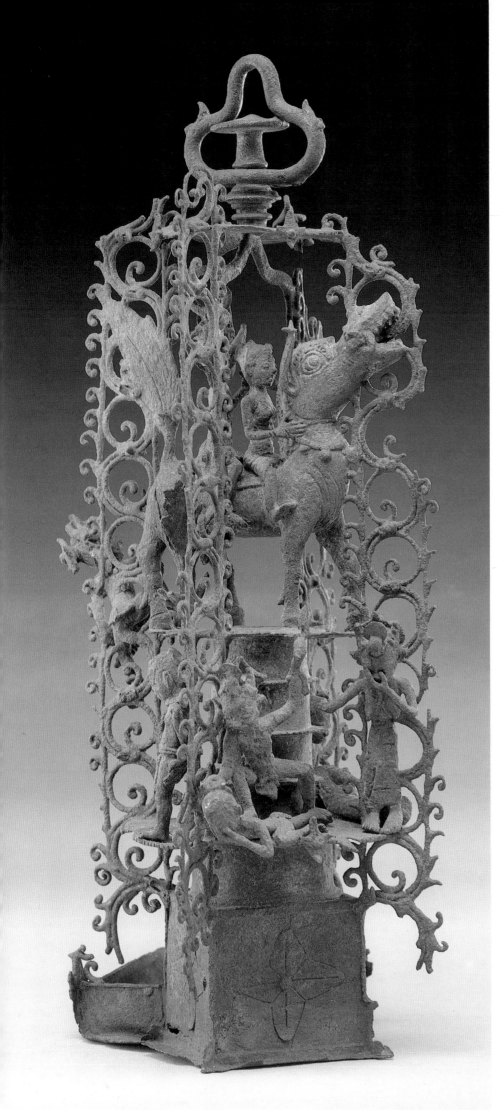

Hanging lamp with scenes from a legend
c. 14th century
Central Java, from Rembang
bronze, 14 in. (35.5 cm)
Museum Nasional, Jakarta, inv. no. 1073a

THE SQUARE, shallow oil reservoir, the corners of which have been shaped into spouts to accommodate the wicks, is divided into four compartments, three of which have broken off. A two-storied pedestal, which changes in shape from a square at the base level to a ringed cylinder above, rises in its center. On each of the two levels is a square platform on which figurines rest. An arch, to which the chain of the lamp has been attached by means of a swiveling ring of *ratna* (jewel) shape, surmounts the upper platform. On all four sides the pedestal is flanked by thinly cast, reticulated floral scrolls that connect the partitions between the oil reservoirs with the top. Parts of these most fragile components of the lamp have been lost.

A figurine of a long-eared quadruped (cf. cat. 86) carrying a man and a woman stands on the upper platform. The man, who has an elaborate headdress, brandishes a *kĕris* to protect the woman seated in front of him from the assault by an armed attacker. The assailant, a demon to judge from his fierce appearance, uses the reticulated floral scrolls to climb up from the lower platform to reach the couple above.

On the lower platform other figurines form three separate scenes: a man tied to a tree; a man being killed by an assailant wielding an ax while a female witness weeps; a mourner holding the head of a corpse, wrapped in cloth, as is still done in Bali today. In all probability all four scenes represent different episodes of the same story.

Epic confrontations such as those between Muka, Arjuna, and Śiva, described in the Lingobhava episode in the *kakawin Arjuna-wiwāha* (Arjuna's wedding), occasionally provided the inspiration for the scenes that decorate the center pieces of lamps of the East Javanese period. Rarely, however, do we see the kind of dramatic action concentrated in this single piece. The literary source of these scenes has not yet been identified.

The theme of a man tied to a tree features in several ancient Javanese legends. In the *Sudamala*, a story illustrated on the reliefs of Candi Sukuh and Candi Tegawangi, Sadewa is caught, tied to a tree, and threatened by the goddess Durgā, who has been put under a spell. In the story *Sri Sedana*, performed as a *wayang* (shadow play), the

farmer Buyut Wangkeng is tied to a tree by the demon Kaladan after he refuses to divulge the whereabouts of the princess Dewi Śri. The Old Javanese *Tantri Kāmandaka*, a collection of ancient tales, contains the story of a treacherous goldsmith who causes an innocent brahmin to be accused of murder and tied to a tree. As none of the other episodes in these tales offer an explanation for other scenes on this lamp, it is unlikely that any of these three stories is represented here. A fragment of a lamp in the Rijksmuseum, Amsterdam, likewise shows a man tied to a tree, suggesting that a story in which this theme occurred was a popular topic to be illustrated on a lamp.

This lamp was donated to the museum in 1892 by the representative (captain) of the Chinese community of Rembang (Central Java), where the lamp is reported to have come from. Another lamp of the same type, decorated with the same figurative scenes, was excavated at Bagelen before 1855 and donated to the museum in that year (Museum Nasional, inv. no. 1072).

Literature: *NBG* 1892, 112 and CLXIX-CLXX; van Erp 1941, esp. 108, n. 1; Bernet Kempers 1959, pl. 312. Lamps illustrating the Lingobhava episode: Siswadhi 1977; Stutterheim 1926a, fig. 130. Stories about men tied to a tree: Hooykaas 1931, 141, 145 and pl. 16; Rassers 1925; van Stein Callenfels 1925, 91, 121 and fig. 7. The lamp from Bagelen: *AIA* no. 67; *TBG* 3 (1855), *berigten* VII (description by E. Netscher).

84
Hanging lamp
c. 14th century
East Java, provenance unknown
bronze, 12 1/4 in. (31 cm)
Museum Radya Pustaka, Solo inv.
no. A 128

THE SQUARE BASE of the lamp, partitioned into four sections, functions as the oil reservoir. At the four corners the straight rim has been bent outward and shaped into spouts to accommodate the four wicks. In the center rises a square platform, divided into horizontal sections by thin moldings and flanked on all four sides by stylized flame motifs, placed upon the partitions of the reservoir. On top of the platform, under an arch bordered by stylized flames, stands an owl flapping its wings who carries the figure of a man on its back. The chain from which the lamp hangs is attached to the top of the arch. The lamp consists of two separately cast components, which are held together by a pin (a modern replacement) running horizontally through the center of the platform. A lamp from Madiun in the Museum Nasional, Jakarta (inv. no. 6292), is of similar construction.

There is no other bronze lamp with the figure of a Javanese owl (Strix Javanica), which was first named by the American naturalist Thomas Horsfield, a contemporary of Raffles and the discoverer of Candi Panataran. Yet the owl would seem to be a particularly appropriate subject to portray on a lamp, for at "the time when the lamps are lit" (Old Javanese: *pasang damar*) this bird embarks upon his nocturnal excursions.

What is shown here, however, does not seem to be a real bird of the species Horsfield named, for it carries a man on its back. Perhaps it is not a real man either, for in the *Sudamala* (canto 3:2) a description of a graveyard is followed by the verse: "storks were there, and the female black cuckoos and owls, skilled in executing orders to fetch the human souls—for that is their task." While this quotation from a coeval literary source may hint at the meaning of the enigmatic centerpiece of this lamp, we can only guess at its possible ceremonial function.

Literature: *AIA* no. 69; van Stein Callenfels 1925, 95; *OV* 1930, 235; Zoetmulder 1982, s.v. *dares*. The lamp from Madiun: *JBG* 5 (1938), 133 and fig. 8.

85
Hanging lamp
c. 15th century
East Java, provenance unknown
bronze, 13 1/4 in. (33.5 cm)
Society of Friends of Asiatic Art, on loan to the Rijksmuseum, Amsterdam, MAK 269

THE BASIC STRUCTURE of this lamp is very similar to that of the lamp from the Museum Radya Pustaka, Solo (cat. 84). Here, too, the oil reservoir is partitioned into four sections, and a square pedestal of similar shape occupies the center. Stylized flame motifs likewise mark the partitions of the reservoir.

The principal differences between the two lamps are to be found in the center piece on top of the pedestal and in the shape of the arches. Whereas the lamp from Solo has a semicircular arch on two vertical columns, here four arches, their lower ends attached to the top of the pedestal, carry the weight of the suspended lamp. Many Javanese lamps made for two or four wicks have lobed arches, which give their silhouettes the shape of a *ratna* jewel, but here these lobed arches have been elaborated and broken up into quadrilobate shapes with stylized flames attached to each curve of the composite arches. The complex, symmetrical structure of elegant curves creates an effect resembling that of reticulated tracery. It is evident that this treatment of the arches represents a late, perhaps fifteenth-century stage of a development whose first beginnings can be seen in the lamp from Purwojati (cat. 78).

In accordance with the predilection for the theme of flying very much in evidence among the East Javanese artists who made these lamps, the centerpiece consists of a statue representing the mythical bird Garuda. In his right hand Garuda raises a sword or club, and with his left arm he holds a woman who is seated on his left thigh. In all probability this is Garuda's mother Vinatā, whom Garuda has just redeemed from the bondage of slavery by stealing the elixir of the gods. Vinatā, if indeed she is portrayed here, holds a conical object in each of her hands. This object resembles, it would seem, those in the right hand of the human or divine being riding a heavenly horse (cat. 86) and a demon standing on top of an elephant (cat. 89). The meaning of these objects is unclear.

Literature: Bernet Kempers 1933b; Visser 1936; Visser 1948, no. 367, pl. 213; Rijksmuseum 1952, no. 309; Bernet Kempers in Rijksmuseum 1985, no. 199; Amsterdam 1988, no. 81.

cat. 84

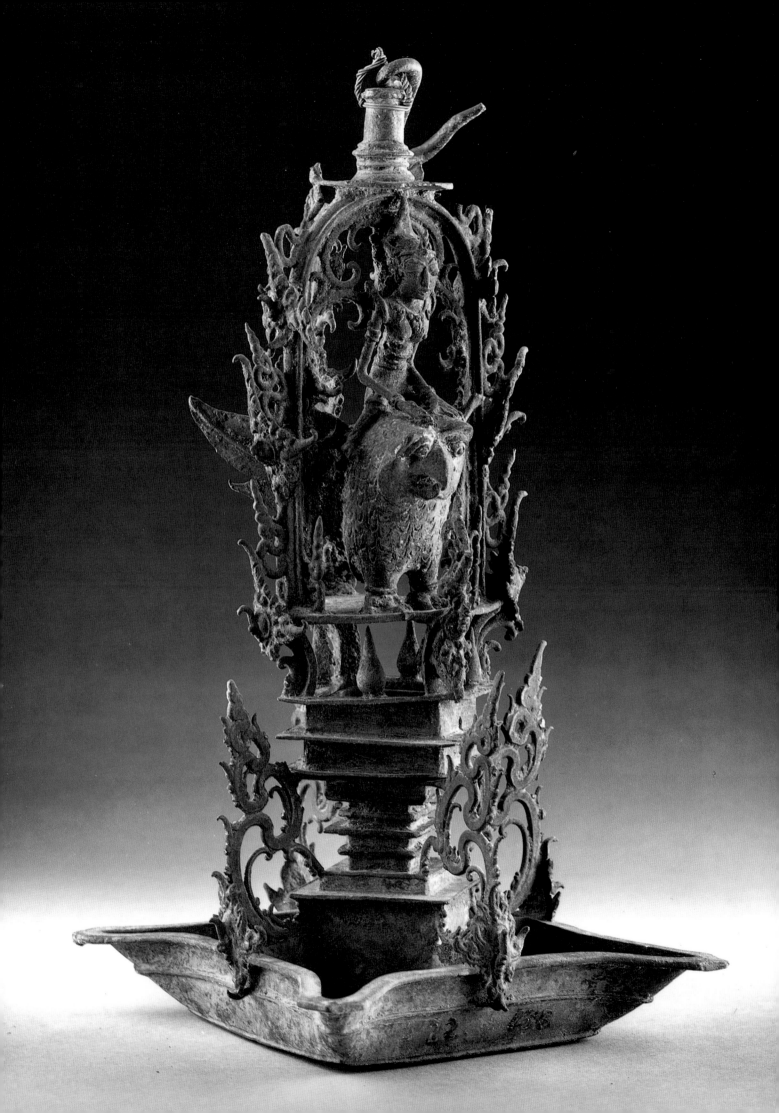

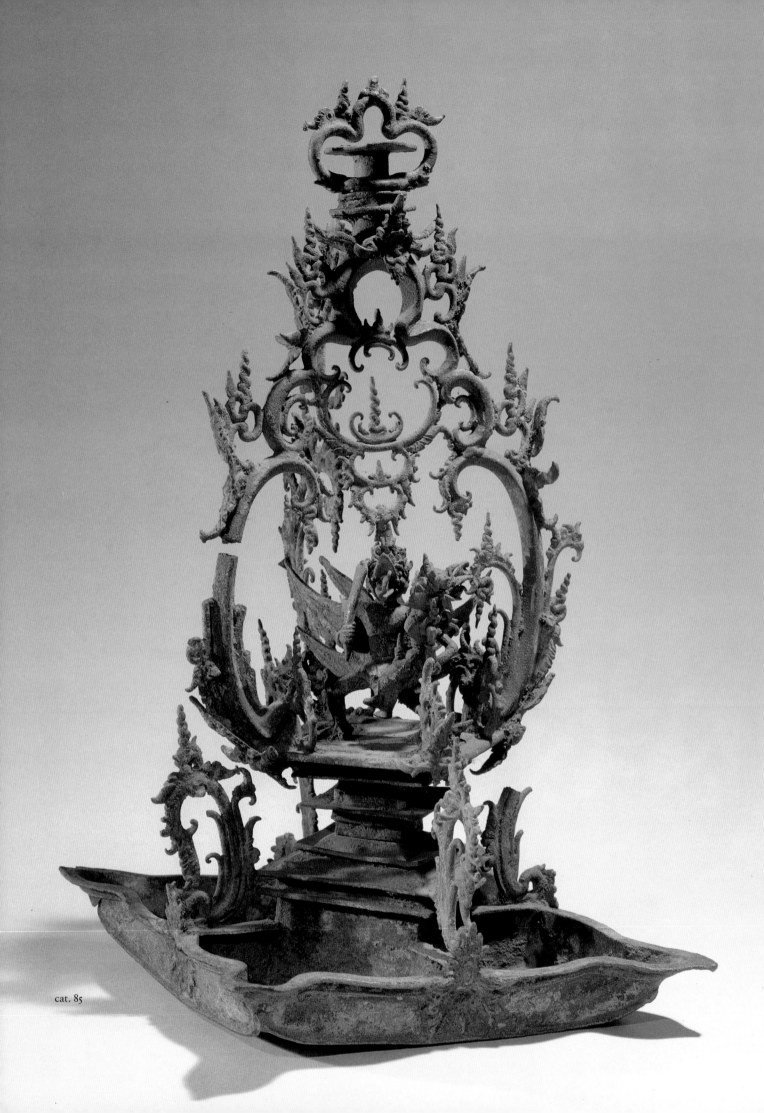

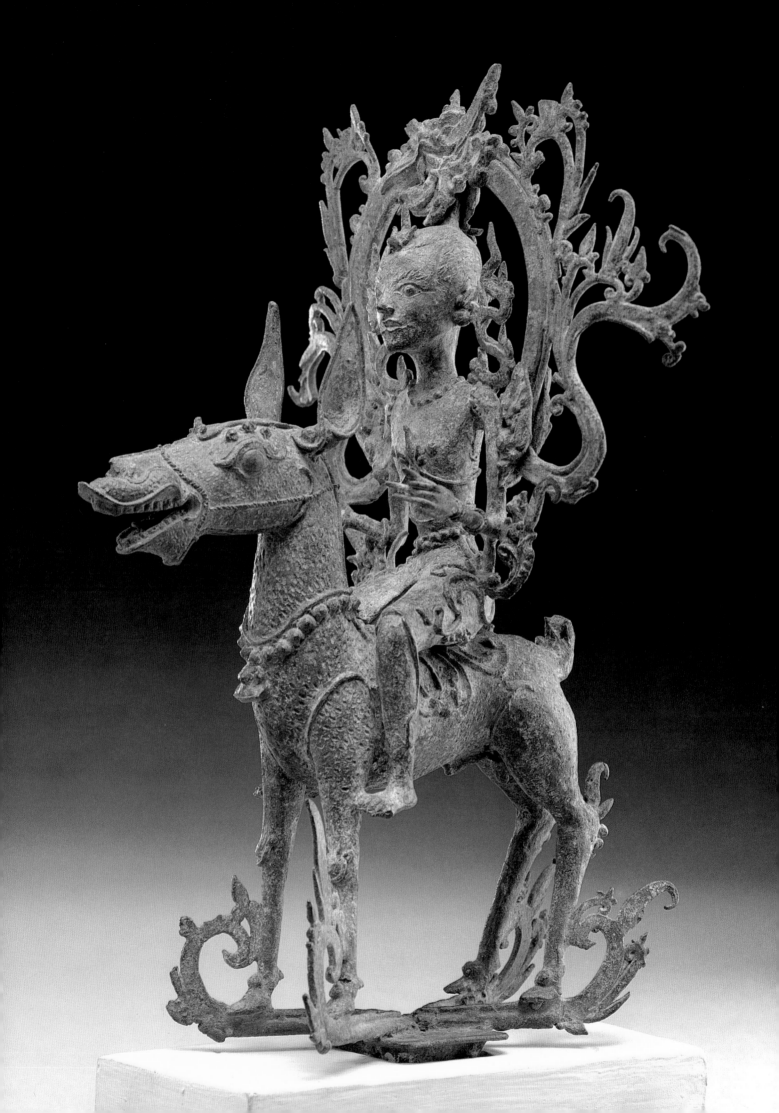

86

Deity riding a long-eared beast

c. 14th century
East Java, from Tenggung, Tulungagung
bronze, 11 1/4 in. (28.5 cm)
Museum Nasional, Jakarta, inv. no. 1073c

THIS FRAGMENT of the central part of a hanging lamp was found, together with twenty other bronze ceremonial utensils, in the village of Tenggung near Tulungagung (East Java) in 1903. It shows a man in rich attire, riding a long-eared mount. In his right hand he holds a short staff; the left hand, in the same position, is empty, and may have lost an attribute it once held. The four feet of the quadruped are supported by brackets in the shape of stylized flames, and the upper part of the rider's body is framed by a flaming halo flanked by sashes floating in the air.

Various types of long-eared four-footed animals make their appearance in ancient Javanese art. At Prambanan they guard the trees of heaven decorating the base of the temples. Their origin can be traced to the *aśvins*, horse-headed, long-eared twin animals that accompany the sun god Sūrya or that draw the sun chariot. As a result of their association with Sūrya, his horse, named Uccaiśravasa, was likewise depicted with long ears. While it seems plausible to identify the animal as a horse associated with Sūrya, a suitable theme for the center piece of a lamp, the identity of the rider remains uncertain. Perhaps it is Sūrya's son Karna, who plays an important role in the Old Javanese literature, inspired by the Indian epic *Mahābhārata*. In the *Korawāśrama* he actually mounts Sūrya's horse Uccaiśravasa. For a representation of Sūrya riding his long-eared mount see cat. 115.

Literature: *NBG* 1903, 68, 105, and CI; Stutterheim 1926b; Swellengrebel 1935, 175; Bosch 1960, 182–184.

87

Ceremonial lamp

14th–15th century
Eastern Java, provenance unknown
bronze, 8 1/4 x 9 1/2 in. (21 x 24 cm)
Society of Friends of Asiatic Art, on loan to the Rijksmuseum, Amsterdam, MAK 268

MANY JAVANESE BRONZE LAMPS have been designed to be used in two different ways, either standing or suspended from a chain. Lamps in the shape of quadrupeds belong to this category. Several of these take the shape of a wild boar or pig, but this lamp is the only known Indonesian example in the shape of an elephant.

The hollow body of the animal serves as the oil reservoir that can be replenished through an opening on the back with a hinged cover. The wick was inserted into the raised hollow trunk through a small orifice. Van Erp suggested that the lamp served a ritual or ceremonial rather than a practical purpose, as the small wick could have provided very little light.

The strongly modeled elephant stands firmly on its four legs, its trunk raised as if about to trumpet. The large ears, tail, and underside of the trunk are embellished with elegant designs. A decorated strap encircles the belly and on both flanks large bells are suspended from chains. On its back, right behind the head, rides a man with a pointed beard and Śiva's third eye on his forehead. Van Erp suggested that he may represent a king who has just renounced the world and who is on his way to his hermitage on his royal mount.

Ceremonial bronze lamps with an elephant as a center piece have been found in India and Sri Lanka. An incomplete elephant lamp was found at the Jogheswari Caves on the island of Salsette near Bombay. C. Sivaramamurti dated it to the period when the cave temples were founded during the West Chalukyan period (c. eighth century), but the excavation of two very similar pieces in Sri Lanka suggests a later date. These two lamps were discovered in a *stūpa* chamber of the Kotavehera at Dedigama (Sri Lanka), together with Buddhist statuary, other lamps, and coins, including one from the reign of King Parākramabāhu the Great (twelfth century).

In the best-preserved piece from Dedigama the figure of the elephant was placed in the center of the oil receptacle. The hollow body served as a reservoir for the oil, which was poured into the body through a funnel in one of the animal's forelegs. A hydrostatic device regulated the flow of oil from the elephant's genitals whenever the level of oil in the receptacle fell below its feet.

While the Javanese lamp is obviously of a simpler, less ingenious design, it is possible that lamps of the Indian type were known in Indonesia and provided the inspiration for the Javanese example. The elephant lamps from India and Sri Lanka were all suspended from chains incorporating figures of dancers and drummers. Two chains of exactly the same type have been found in Padang Lawas, Sumatra (Museum Nasional, Jakarta, inv. no. 7950) and in Lumajang, East Java (inv. no. 6972), but the lamp to which one of them was still attached is of a different type.

Literature: van Erp 1941, 110–114; Rijksmuseum 1952, no. 308; Amsterdam 1988, no. 83. Indian and Sri Lankan lamps: van Erp 1939, pls. 1d and 11b–d; Sivaramamurti 1963, pl. 5 a; Godakumbura 1969, 29–30 and pl. 67. Terracotta: Mainz 1980, no. 128.

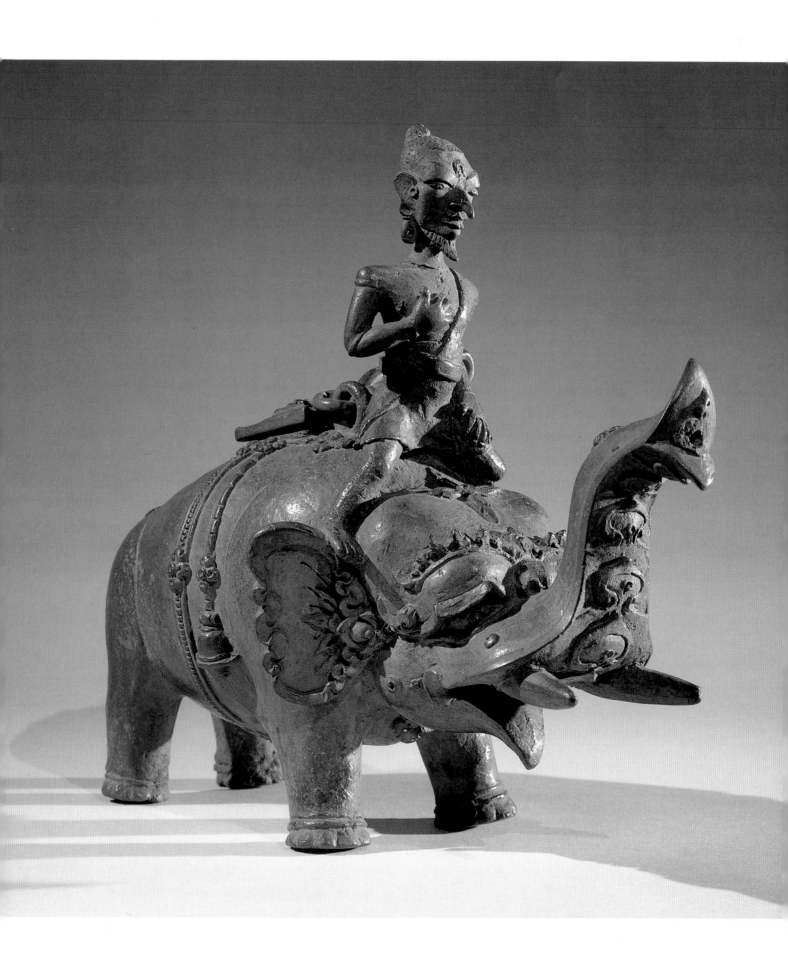

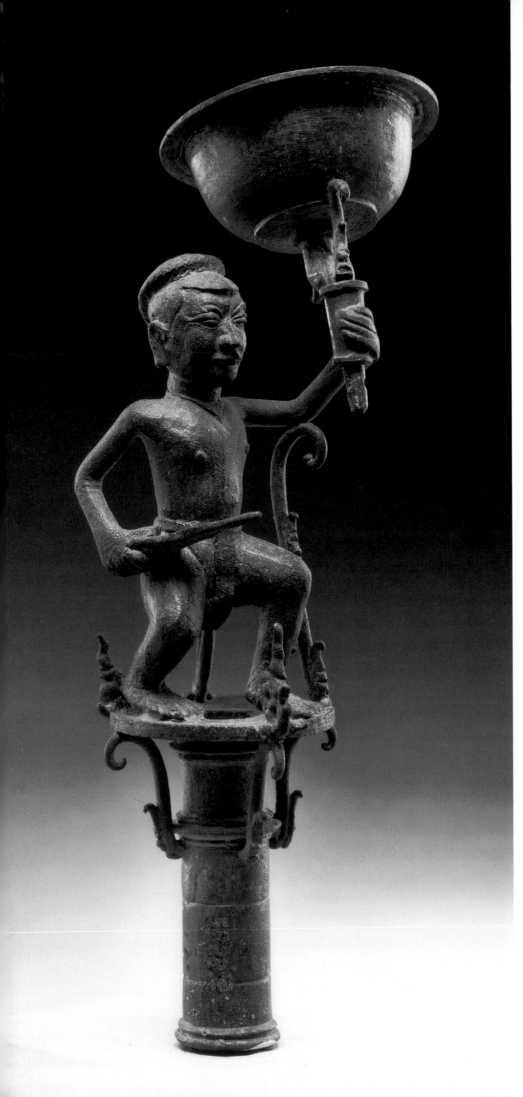

Finial with a man holding a lamp
c. 14th century
Eastern Java, from Tretes Panggung,
Dampit, Malang
bronze, 9 3/4 in. (25 cm)
Museum Nasional, Jakarta, inv. no. 5828 a

THIS FINIAL takes the shape of a man wear-
ing the simple, flat headdress (Javanese:
tĕkĕs) that is usually worn by the hero
Prince Pañji or one of his associates. He is
dressed in a loincloth (Javanese: *cawet*) and
marches ahead, the sword in his right hand
pointing forward. In his left hand he raises
the curved handle of a cup-shaped lamp,
which is like some occasionally seen in
stone reliefs (Panataran, East Java), where
it is used as a standing lamp. Like the finial
exhibited here, another cup-shaped bronze
lamp with a longer, curved stem (collection
J. Polak, Amsterdam) has a hollow end
that could be fitted to the top of a staff.

N. J. Krom published a very similar finial
from the Museum Purbakala, Mojokerto
(inv. no. 204). It shows a warrior in the
same pose, but wearing a round hat and
raising the stem of the lamp in the shape of
stylized flower with his left hand. He holds
a dagger with a broad blade in his right.
The similarity of these two pieces makes it
likely that the warrior represents a specific
character, not from one of the many stories
derived from the *Mahābhārata* or *Rāmā-
yana,* but from the legends of the *kidung*
type, describing the adventures of Pañji,
prince of Koripan, in his search for his be-
loved princess of Daha, Raden Galuh.

Literature: Krom 1926, pl. 49B; Bernet Kempers
1959, pl. 295. Lamp in the Polak collection: Am-
sterdam 1988, no. 85.

89
Demon standing on an elephant
13th–14th century
East Java, from Malang
bronze, 11 in. (28 cm)
Museum Nasional, Jakarta, inv. no. 8323

THE DEMON (*RĀKSASA*) stands on a small, square platform behind the head of an elephant. In his right hand he holds an unidentified object, similar in shape to those seen in cats. 85 and 86. The elephant's raised trunk seems to gradually change, as it turns and drops, into floral ornament. From the presence of a bracket that is attached to the supporting column of this elegant piece we may conclude that it was a component of a larger piece, perhaps a lamp. The tenon on top of the curve of the elephant's trunk suggests that yet another component was attached there.

The playful transformation of animal shapes into vegetation and vice-versa is not uncommon in the arts of ancient Indonesia, but in this case it may have a special meaning. Indra's mount, the elephant Airāwata, is well known from Indian legend for his power to uproot trees. The combination of an elephant with a demon leads one to suspect that this is a representation of the demon king Nīlarudraka who rode an elephant as he marched to do battle with the gods, as told in the *kakawin Smaradhana* (canto 30:1). Another possibility is that it represents the demon Gajahmukha (elephant face), subdued by Sutasoma in the *kakawin Porusādaśānta* (the man-eater appeased) (cantos 32 and 33).

This bronze was acquired in 1955 for the Museum Nasional, Jakarta, by the Archaeological Service from a Dutch collector long active in the Malang area. The provenance from Malang is based on the collector's information.

Literature: previously unpublished. Poerbatjaraka 1931, 30:1; Zoetmulder 1974, 332–334.

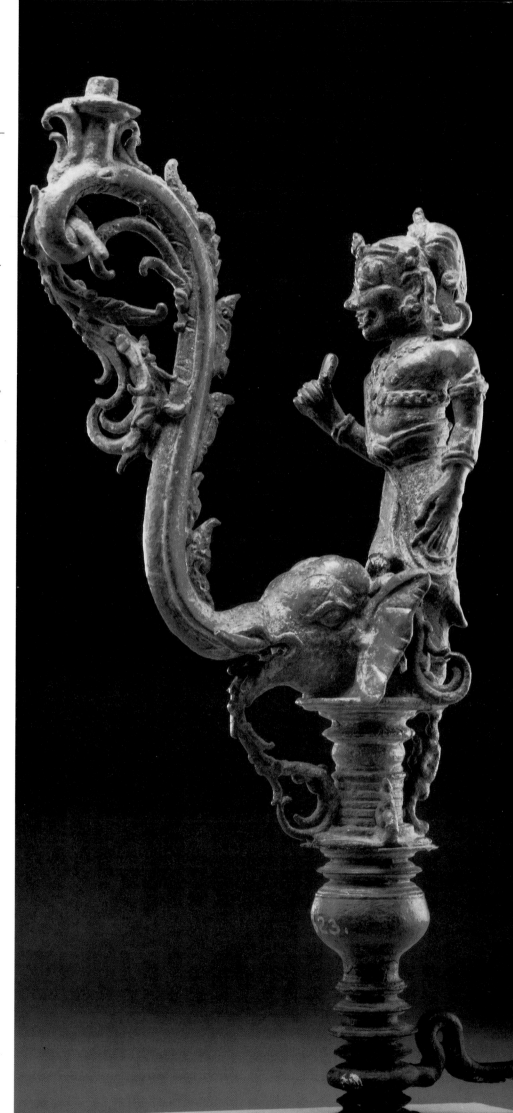

90
Wheel-shaped finial

second half 13th century
East Java, from Selumbung, Blitar
bronze, 11 1/2 in. (29.3 cm)
Museum Nasional, Jakarta, inv. no. 5916

THE WHEEL-SHAPED FINIAL consists of a flat ring decorated with concentric grooves. It has four thin spokes radiating from a hub decorated with four stylized flames pointing to the intermediate directions. On the sides and the top of the wheel the one-eyed *kāla* motif in relief constitutes the base for a decoration of horizontal spear heads and a vertical sword blade.

In ancient Indian symbolism the wheel and the disc (Skt. *cakra*) played important roles as symbols of the sun and the Buddhist law. Banerjea wrote: "The same device was equally available to the various sects of those days to illustrate their own religious faith, and a *cakra*, which in one place might definitely represent a Buddhist *dharmacakra* could in another setting stand for the *Sudarsana* emblem of Visnu, which is a symbol of the Sun God. Coomaraswamy rightly remarks: 'The vocabulary of these symbols was equally available to all sects, Brahmans, Buddhists and Jains, each employing them in senses of their own.'"

The ancient Indonesians inherited this multiple symbolism of the wheel from India, as a consequence of which the *cakra* makes its appearance in different religious contexts. F. D. K. Bosch pointed out the suitability of the wheel and the trident to be used symbolically as emblems for finials and as a decorative pattern that covers the walls of the cellas of some Central Javanese *candi*s.

At Borobudur wheel-shaped finials have different although obviously related functions. Warriors going into battle raise a standard, topped by a wheel-shaped finial (I B a 47a). Often these finials can be seen among the royal emblems, carried by courtiers or planted in the ground in the audience scenes that are common on the Borobudur reliefs (for example, I B b 11). Another *cakra* finial appears in the reliefs of Panataran (East Java). That the *cakra* finial remained in use as a royal emblem for a least a thousand years is evident from a photograph taken by the first Indonesian photographer Kassian Cephas around 1895 in the *kraton* of Yogyakarta. Among the

finials that were carried by the sultan's retainers in parades on festive and ceremonial occasions is a *cakra* of *pamor* iron of the same type as the finials exhibited here.

There are not only differences in the way these emblems were used, but the emblems themselves also display a remarkable variety of decorative detail. The three examples exhibited here give an impression of the range of variation within the obvious limits imposed by the basic shape.

The cache of bronzes found in Selumbung, Gandusari, near Blitar (East Java), in 1928 included an octagonal container dated Śaka 1185 (1263) and a slit drum (*kĕntongan*) dated Śaka 1209 (1287). It would seem that the other pieces from this find, including this wheel-shaped finial, all date from approximately the same period.

Literature: Groneman 1895, pl. x, no. 9; OV 1928, 98; OV 1929, 286–288; AIA no. 79; Banerjea 1956, 152; Bosch 1960, 158–160; Brussels 1977, no. 88; Linden-Museum 1984, no. 56.

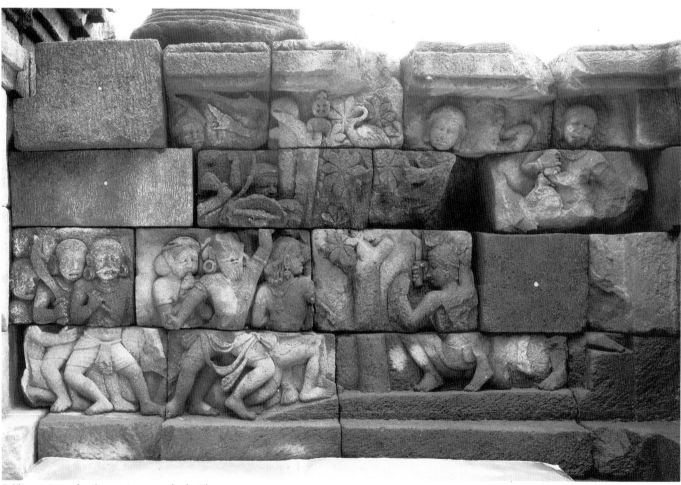

Soldiers going to battle carrying a standard with a *cakra* finial. Borobudur relief IB a 47a

91
Wheel-shaped finial
1176
East Java
bronze, 9 5/16 in. (24.5 cm)
Staatliche Museum Preussischer Kultur-
besitz, Museum für Indische Kunst, Berlin

THE PLAIN FLAT WHEEL with four spokes is supported and flanked by a pair of symmetrically arranged *nāgas*, their heads turned outward and their undulating, scaly bodies encircling the lower half of the wheel. The two dragon-snakes emerge from a one-eyed, stylized *kāla*-head at the bottom of the wheel. This, it would seem, is an inversion of the customary arrangement in which the *kāla*-head, a symbol of the sun, takes its place at the top, while the dragons, symbolizing water and darkness, appear below.

In all probability the *nāgas* guarding the wheel represent an allusion to the epic story of Garuda's quest for the elixir of the gods, as told in the first part of the Indian epic *Mahābhārata* and its Old Javanese version, the *Ādiparwa* (see cat. 96). Upon reaching the place where the elixir is kept, Garuda finds that it is guarded by an iron wheel with a honed edge and sharp blades, revolving incessantly. "No sooner had the Bird seen a way through it than he started revolving in time with the wheel and, contracting his body, flew instantly between the spokes. And behind the wheel he saw two big snakes, shimmering like blazing fires, tongues darting like lightning, mouths blazing, eyes burning, looks venomous, no less powerful than gruesome, in a perpetual rage and fierce, that stood guard over the Elixir, shattered the torture wheel, and flew sweepingly upward" (translation by J. A. B. van Buitenen).

At the top between the two dragon heads, the flat rim of the wheel carries a cast inscription: "[Śaka] 1098," corresponding to 1176, making it the earliest dated bronze object of the East Javanese period. If we assume that the fierce appearance of the *nāgas* is a reflection of the passage quoted above, there is no reason to assume, as Volker Moeller has done, that these legendary animals are a product of Chinese influence. While Chinese influence is evident later during the East Javanese period, it does not seem to have occurred at such an early date.

Literature: Moeller 1985, 51–53, fig. 25; Bosch 1960, 148–150; van Buitenen 1973, 89.

92
Wheel-shaped finial
c. 14th century
East Java, from Kĕbonsari, Pasuruan
bronze, h. 12 1/4 in. (31 cm), diam. 8 in. (20 cm)
Museum Nasional, Jakarta, inv. no. 839b

THE FLAT RING rests upon a lotus base topped by a one-eyed *kāla*, a motif that is repeated at the top of the ring. The wheel has four flat spokes radiating from a large hub. Although only a late example (in the Linden-Museum, Stuttgart) has eight spokes, this finial, like all other *cakra*-finials, has flames pointing from the center into the intermediate directions. The wheel is divided into two concentric bands, separated by a ridge. The inner band shows a reticulated, ribbonlike scroll, interrupted at the end of each spoke by a rectangular cartouche. The solid outer band has a border of jewels with S-shaped snakes at regular intervals.

This wheel-shaped finial is part of a large cache of bronzes found in 1882 in the village of Kĕbonsari, Bangil, Pasuruan (East Java). This hoard, consisting of a large number of bells, lamps, tripods, finials, and other ritual or ceremonial utensils, would seem to be of somewhat heterogeneous content. The objects seem to vary considerably in date. To judge from its style and workmanship, this finial should probably be dated in the later part of the East Javanese period, perhaps the fourteenth century. It is undoubtedly much later than the *cakra*-finial datable to 1176 in the Berlin Museum (cat. 91).

Literature: *NBG* 1882, 62; *AIA* no. 80; Linden-Museum 1984, no. 56.

93
Finial with two *nāgas*
c. 14th century
East Java, from Kĕbonsari, Pasuruan
bronze, 7 1/8 in. (18 cm)
Museum Nasional, Jakarta, inv. no. 843

A HOLLOW CENTRAL SHAFT of tapering shape ringed and decorated with stylized flames attached this finial to the top of a staff. From the base of the shaft two dragons emerge back to back, their heads turned outward. Their scaly bodies are decorated with pointed flames and diamond-shaped flowers. Stylized flames shoot from their open jaws.

This finial, part of the large find at Kebonsari, closely resembles another dragon finial from the hoard found at Batu Agung, Jĕmbrana (Bali). In the simpler Jĕmbrana version the central shaft is made up of the twisted bodies of the two dragons. The similarity between these two pieces suggests that the Jĕmbrana finial, even though it was found in Bali, may well be of Javanese origin.

The flat-topped ringed cylinders on the heads of the dragons resemble those on the finial found at Selumbung (see cat. 90). A slightly later date, perhaps in the early fourteenth century, seems most likely.

Literature: *NBG* 1882, 61; Groeneveldt 1887, 235; *AIA* no. 76.

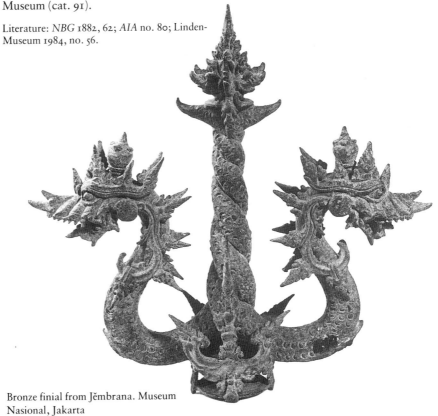

Bronze finial from Jĕmbrana. Museum Nasional, Jakarta

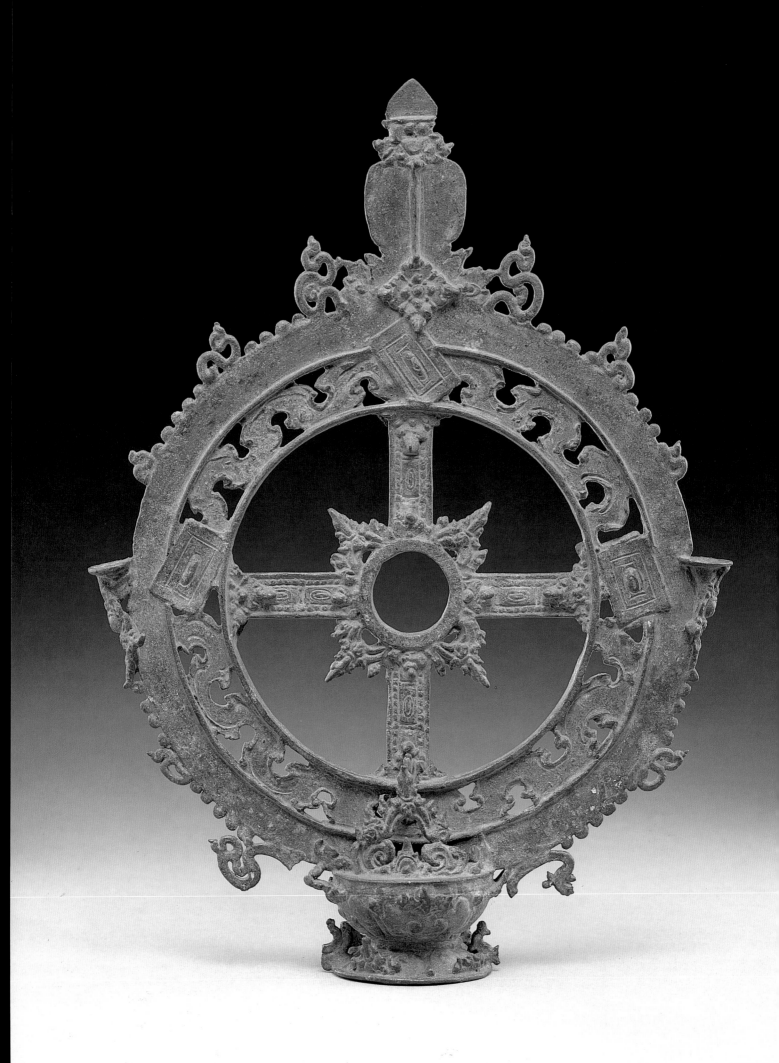

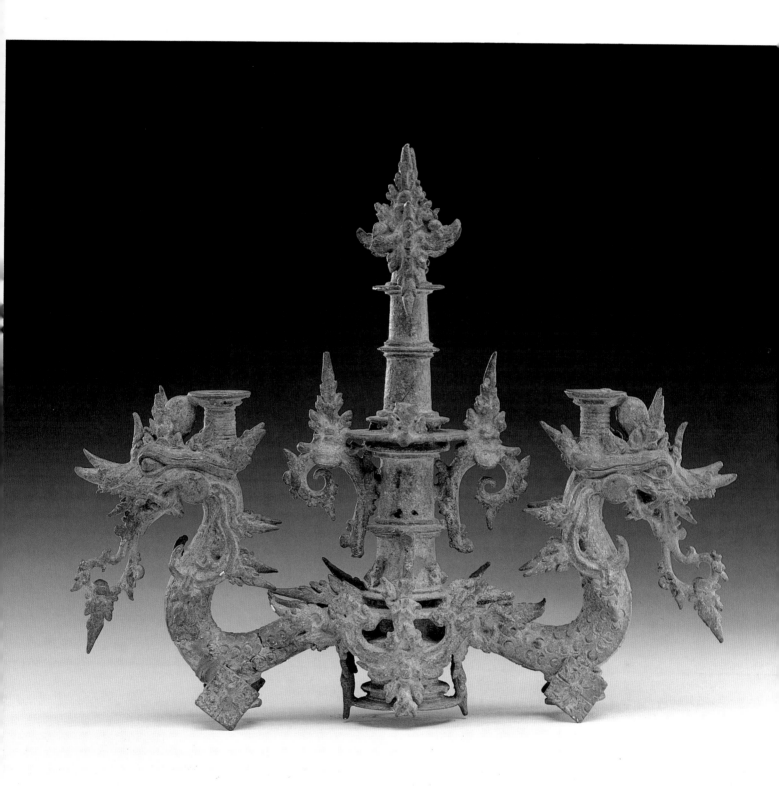

cat. 93

cat. 92

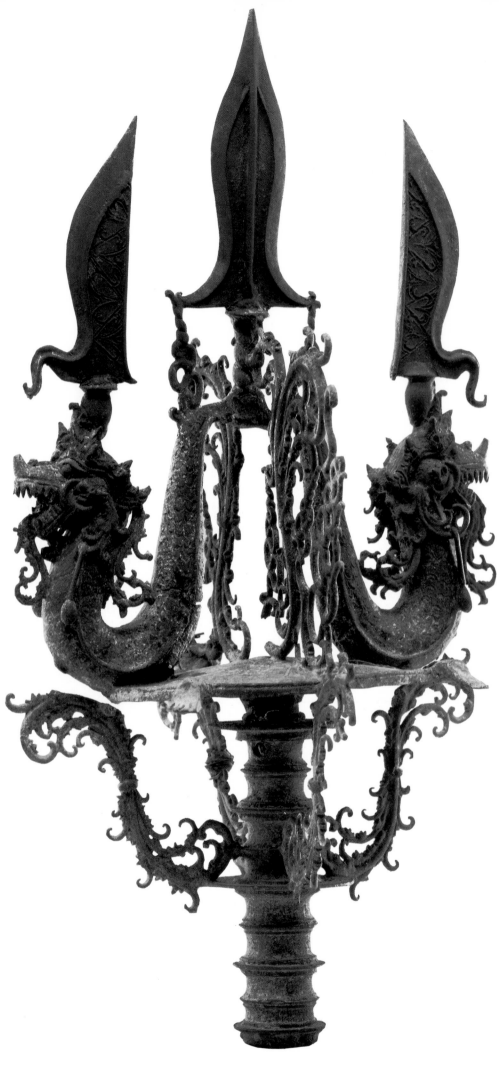

94
Finial with *nāgas* and blades
13th–14th century
East Java, from Kebonsari, Pasuruan
bronze, 6⁷/8 in. (17.5 cm)
Museum Nasional, Jakarta, inv. no. 844

IN THIS FINIAL two motifs frequently used for ceremonial objects, the *nāga* dragon and the trident, have been blended into one single emblem. A platform supported by four decorative brackets in the shape of elaborate floral scrolls stands on a ringed, hollow shaft. On top of the platform two dragons back to back raise their heads and tails. On their heads and at the point where the tails meet stand three blades, the two on the outside single-edged, the one in the center with a double edge. Two elaborate floral scrolls stand on the platform at right angles with the bodies of the dragons.

The dragons with their upturned noses and open jaws are typically East Javanese. The blades closely resemble those found among the ceremonial objects in the hoard from Selumbung, Gandusari, Blitar (East Java). A slit drum (*kĕntongan*) dated Śaka 1209 (1287) and an octagonal bronze container dated Śaka 1185 (1263) were among the pieces found there, and a thirteenth-century date for all objects in that find seems likely (see cat. 90). Among the finials in the Selumbung hoard is a *nāga* finial of a type similar to the piece exhibited here, but with blades attached to the tails of the dragons and pointing downward. A finial in a more simple style, combining blades pointing down with a trident of blades carried by the *nāgas*, was excavated at Prigen, Bangil (East Java), in 1939. Yet another finial with the two single-edged swords missing was formerly in the collection of Spinks & Son, London.

Of all these pieces, the one from Kĕbonsari is the finest in quality. In spite of its fragility, the delicate scrollwork has been preserved. It is probably slightly later than the finial from Selumbung and may date from the late thirteenth or early fourteenth century. As several of the finials come from hoards of large numbers of ceremonial objects obviously buried on purpose, one can only speculate about why they were committed to Earth. The fact that one of the largest hoards comes from the island of Bali suggests that Islamization may not have played a role in this process. Although each of these hoards contains ceremonial utensils used in religious ceremonies, the finials seem to be emblems of royalty or no-

95
Finial in the shape of a *nāga*
c. 15th century
East Java, provenance unknown
bronze, 6 1/4 x 15 3/4 in. (16 x 40 cm)
Rijksmuseum voor Volkenkunde, Leiden,
1403-3329-1903

bility, carried in parades of loyal retainers rather than religious objects carried around in processions. The use of similar finials continued in the Javanese *kĕratons* until modern times. A photograph made by the Javanese photographer K. Cephas at the court in Yogyakarta before 1888 shows a finial wrought in *pamor* iron in the shape of a double Garuda with blades on the heads.

Literature: *NBG* 1882, 61; Groeneveldt 1887, 235; *AIA* no. 78. The Selumbung find: *OV* 1928, 97–98; Crucq 1929a; Bernet Kempers 1959, pl. 267 (center). The trident from Prigen, Bangil: *OV* 1939, 24 and fig. 39. The photograph by K. Cephas: Groneman 1895, pl. IX, 2.

THE *NĀGA* DISPLAYS all the characteristics of the heraldic dragon of the late Majapahit period. His wide-open jaws with long, sharp teeth, his upturned nose, and his long, stylized curly tongue are all marks of the *nāga* in his Eastern Javanese guise. Scaly and plain bands alternate on the dragon's body; his neck and throat are ribbed like the inside of an elephant's trunk. Reticulated scrolls, suggesting long, floating strands of hair, have been soldered to the piece between the raised head and the curve of the dragon's back. Underneath the body a hollow, cylindrical shaft served to attach the emblem to the top of a staff.

The animal's appearance suggests a date late in the Majapahit period, and this is

confirmed by the relief depicting a swordsmith's workshop from Candi Sukuh (cat. 33), where two finials of exactly the same type are shown among the ceremonial objects on the top shelf in the smithy. Their presence in an ironsmith's workshop in that relief may indicate that finials of similar *nāga* shape were made of wrought iron, as is the case with the cloud-and-thunderbolt (cat. 97) finial on display on the same shelf. Old Javanese inscriptions indicate that clear distinctions were drawn between the professions of blacksmiths (*pande wesi* or *besi*), bronze casters (*pande gending*), and copper smiths (*pande tamra*).

Literature: Juynboll 1909, 144; Subroto 1980, esp. 345; Amsterdam 1988, no. 104.

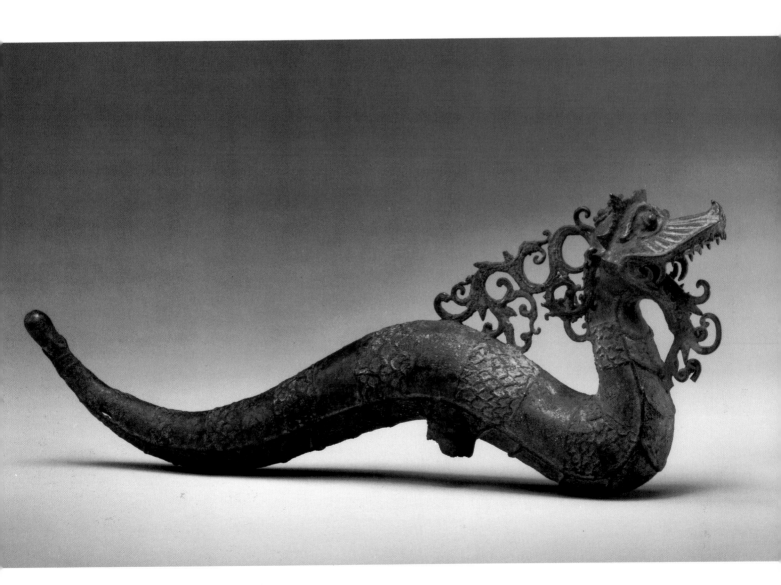

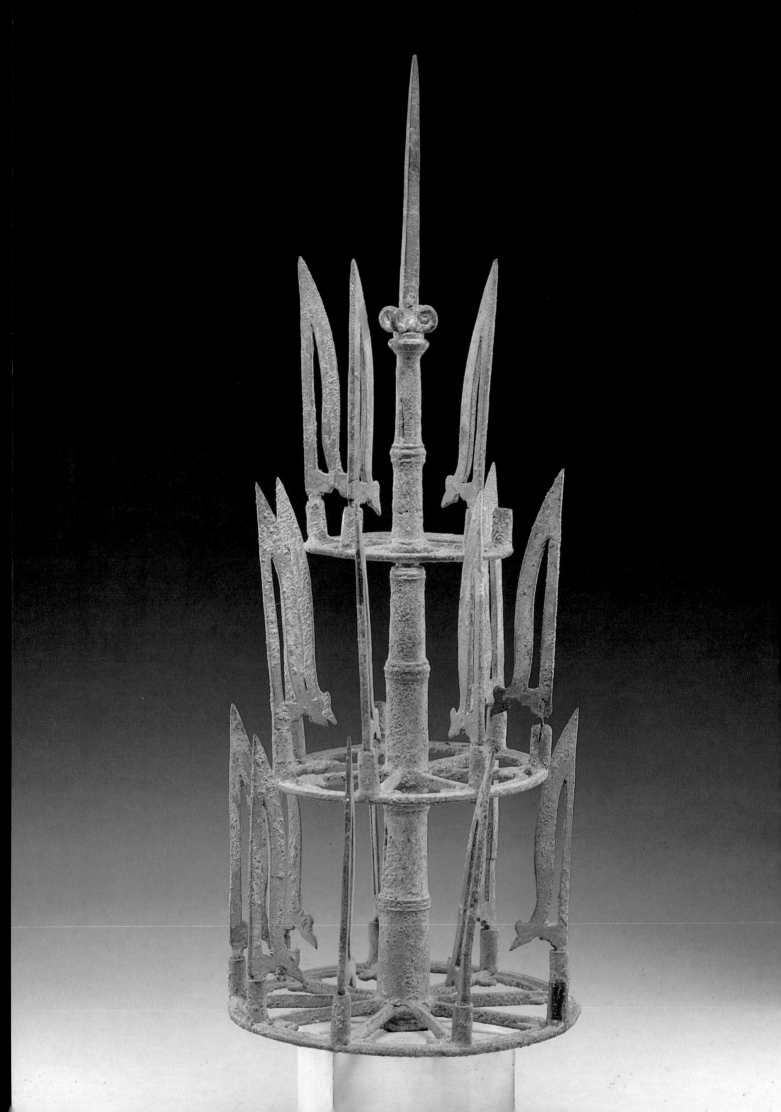

96
Finial of wheels and blades

14th–15th century
East Java, found at Jĕmbrana (Bali)
bronze, 16 1/2 in. (42 cm)
Museum Nasional, Jakarta, inv. no. 839h

THE FINIAL consists of three superimposed
horizontal wheels of diminishing size as
they rise, with nine, seven, and five spokes.
On each wheel stand upright a correspond-
ing number of miniature blades. The open
wheels with their spokes and the reticulated
blades that stand out in silhouette lend this
finial an extraordinary lightness and an ef-
fect of utter simplicity, at variance with the
baroque profusion of decorative details of
many other finials.

The artist of this ceremonial object of rare
abstract beauty may have been inspired by
a passage from the popular legend of Garu-
da's search for the elixir of the gods in or-
der to redeem his mother Vinatā from slav-
ery. The first part of the Indian epic
Mahābhārata and its rendering in Old
Javanese, the *Ādiparwa*, tells that Garuda,
approaching the palace where the elixir
was kept, "saw, in front of the Elixir, an
iron wheel with a honed edge and sharp
blades, which ran incessantly, brightly like
fire and sun, the murderous cutting edge
for the robbers of the Elixir, a surpassingly
dreadful device that had been skillfully
forged by the Gods" (translation J. A. B.
van Buitenen). A representation of this
heavenly antitheft device, fitted on top of a
staff by means of its hollow central shaft,
must have been an appropriate symbol to
be carried in parades as a magic protection
of the king's treasures.

The finial is part of a cache of more than
forty bronze objects found in the village of
Batu Agung, Jĕmbrana (Bali), more than a
hundred years ago. Jĕmbrana, Bali's
westernmost district, was in earlier times
somewhat isolated from the central parts of
the island. It had closer contacts with East
Java by sea than with the other parts of Bali
to the east overland. An indication of its
degree of isolation is that Jĕmbrana did not
even share in the cost of maintaining the
principal temple of Bali, the Pura Besakih
(*Bali, Studies in Life, Thought and Ritual*
[1960], 3–4).

The hoard of ritual objects from Batu
Agung is the only major find of this type
ever made in Bali. It is not clear whether
the objects are of Javanese origin, of Bali-
nese, or perhaps a mixture of both. The re-
semblance of some of the objects to pieces
found in Java argues in favor of the first
possibility (see cat. 93).

Literature: *NBG* 1882, 62; Groeneveldt 1887,
234; *NBG* 1888, 106 and 148; *AIA* no. 82; Juyn-
boll 1906, 43; Stutterheim 1930a; Swellengrebel
1960, 3–4; van Buitenen 1973, 89.

cat. 97

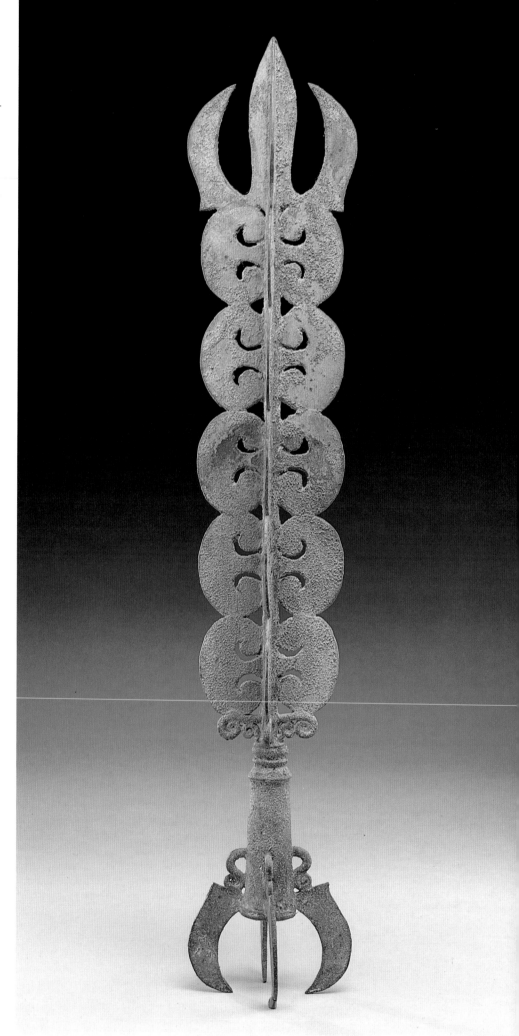

97
Cloud and thunderbolt finial
14th–15th c.
Bali, from Batu Agung, Jĕmbrana
bronze, 19 in. (48 cm)
Museum Nasional, Jakarta, inv. no. 839d

THE MIDDLE SECTION of this finial consists of four oblong bronze plates, cut and perforated into a repetitive design of stylized clouds. These plates are joined and set at right angles forming a cross, the design of clouds tapering slightly toward the base of the finial, which is crowned by a four-pronged *vajra*. The base takes the shape of a tubular shaft of slightly tapering shape, decorated with a smaller, four-pronged *vajra*. This shaft served to attach the finial to the top of a wooden staff or handle. The combination of stylized clouds and *vajra*s, the symbols of lightning, suggests that the finial was intended to symbolize the dark clouds of a thunderstorm from which lightning shoots forth, a powerful weapon of the gods. The simple, two-dimensional treatment of the cloud design reminds us of the finial with reticulated blades (cat. 96) from the hoard found at Batu Agung, Jĕmbrana (Bali) in 1888, of which this finial, too, was part.

Although it is unclear whether the pieces from this cache were made in Java or Bali, the shape of this clouds-and-thunderbolt finial is of unquestionable Javanese origin. An object of very similar shape appears among the ceremonial utensils on the top shelf on the relief of a swordsmith in his smithy from Candi Sukuh (cat. 33). On the back of a large (77 in., 196 cm) statue of Bima from Candi Sukuh, now in the collection of KRT Hardjonagoro in Solo, a similar piece is shown. This statue bears an inscription dated in accordance with 1443. The size of the cloud-and-thunderbolt piece on the back slab of the statue (32³/4 in., 83 cm) suggests that it is a weapon, possibly a club (*gadā*). A very similar bronze object in the National Museum of Ethnology, Leiden, inv. no. 3335, has been catalogued by Juynboll as the upper section of a club.

It is evident that objects of this type remained in vogue after the Islamization of Java from the wooden clubs of this shape that were recorded to be still in use in *wayang wong* performances toward the end of the nineteenth century. Another example in *pamor* wrought iron, in the Radya Pustaka Museum, Solo, is said to be a nineteenth-century copy of one of the regalia in the palace (*kraton*) of Solo.

Literature: *NBG* 1888, 106; Juynboll 1909, no. 3335, 144–145; Serrurier 1896, 183, fig. 27; Stutterheim 1956a.

98
Finial of a mendicant monk's staff
c. 14th century
East Java, reputedly from Mojokerto
bronze, 15¹/4 in. (38.5 cm)
Museum Nasional, Jakarta, inv. no. 6067

KHAKKHARA IS AN ONOMATOPOEIC Sanskrit name for a staff with a ringed finial, which produces a jingling sound. It was as common an attribute of mendicant Buddhist monks in India and Southeast Asia as a crozier was of the bishops of early Christianity. The *khakkhara* served a double purpose. The gently jingling sound alerted all to the bearer's approach. By using his staff to sound a warning, the monk avoided sinning against the rule of *ahimsā* (nonkilling) by warning the insects and other lower forms of life that happened to cross his path. Moreover, as mendicant monks were not permitted to beg for food, the monk could rattle his staff as a reminder to the faithful that they should provide him with food of their own accord.

Even though we owe the earliest detailed description of an Indian *khakkhara* to the Chinese Buddhist pilgrim Yi Jing, who traveled back and forth between China, Indonesia, and India from 671 to 695, not a single example of a *khakkhara* seems to have survived in the country of its origin. The *khakkhara* was common in the Far East, where it even became the attribute of the popular bodhisattva Ksitigarbha. A single example of simple construction has been found in Thailand at a Môn site. In Indonesia *khakkhara* have been found in considerable numbers, and can be divided into three distinct types. By far the most common type of *khakkhara* has two arms, together forming a silhouette in the shape of a *ratna* (jewel), mounted on top of a hollow shaft. On each side, separated by the pointed extension of the shaft in the middle, three flat rings have been attached. Several examples of this type are in the collection of the Radya Pustaka Museum, Solo (*OV* 1923, 145–146), and two have been found at Candi Sajiwan (Suaka Peninggalan Sejarah dan Purbakala Jawa Tengah, Prambangan, inv. no. 159–160). A similar piece appears in a Borobudur relief (IV-28). This type of *khakkhara* definitely dates from the Central Javanese period.

A second type of *khakkhara* uses bells instead of rings to produce a sound. For an example see cat. 99. The third type is an elaboration of the first type in that it has three or four arms instead of two, each in the shape of half the silhouette of the *ratna* jewel. The *khakkhara* exhibited here is of that type. To the ringed, hollow shaft, which fit the top of a wooden staff, four arms are attached, each of which originally held three rings. These four sets of rings were suspended in the lower, semicircular part of the arms, where they were separated by an extension of the shaft, provided with moldings giving it the shape of an elongated *stūpa*. The outside pairs of rings have a grooved surface, while the ring in the middle is beaded.

From the jaws of four stylized *makaras*, from which bead necklaces dangle, the four arms of the *khakkhara* emerge. After the first straight vertical part, the arms end below in a semicircle. Dragons raise their heads at the point where the arms bend from a straight into a round shape. On a lotus pedestal on top of the four *makaras* stand four figures, back to back, surmounted by a six-layer canopy and a finial. This is unusual, as the number of canopies traditionally is uneven: five, seven, or thirteen. In all probability the four figures represent the four Jinas, but their attributes and *mudrās* do not match with those of standard iconography or with those of the four figures on a similar piece in the Berlin State Museums.

It would seem likely that the most elaborate and baroque *khakkharas* date from the East Javanese period. The provenance of this piece, which is said to have been found near Mojokerto, in the heart of the Majaphit kingdom, would seem to support a date in the thirteenth or fourteenth century.

Literature: Krom 1926, pl. 22c; *JBG* 3 (1936), 189; van Erp 1943a; *AIA* no. 83; *Koleksi Pilihan* 2, no. 42. Other *khakkhara*: Musée Guimet 1971, 3470–3473; Moeller 1985, 47–51; Amsterdam 1988, no. 103.

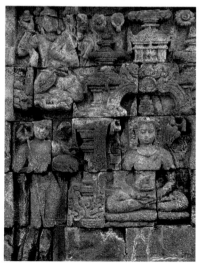

Monk holding *khakkhara*. Borobudur relief IV-28

99
Finial with bells
c. 11th century
Eastern Java, provenance unknown
bronze, 7 1/2 in. (19 cm)
Linden-Museum, Stuttgart, inv. no. SA 35
278L

THE HOLLOW, RINGED STAFF of this
khakkhara is surmounted by a blue lotus
with pointed petals. Eight bells in the shape
of stylized dragon or rhinoceros (?) heads
emerge from this lotus. They support a bell
of flat shape, decorated with antefixes.
This bell in turn acts as the base of a four-
petaled lotus bud. On each of its petals a
meditating ascetic is shown in low relief.
Like the other components of this finial,
the lotus bud is a hollow cast and serves as
a bell. All ten hollow parts have small
pieces of metal inside and produce a jin-
gling sound when the finial is shaken.

While the function of this piece is evident,
the context in which it was used is unclear.
The only illustration of this type of bell-
khakkhara can be seen in the Boston relief
of the abduction of Sītā (cat. 19). There
Rāvana, who has disguised himself as an
itinerant priest, holds a staff with a finial
closely resembling the piece exhibited here.
The Old Javanese *Rāmāyana* mentions a
rosary instead of a staff in its description of
this dramatic episode, but Vālmīki's Indian
classic makes Rāvana disguise himself as a
member of the brahmanic sect of the
Traidandikas, recognizable by the three
sticks they carry. While it is obvious that
the Boston relief illustrates a slightly differ-
ent version of the story, the possibility
should be considered that the type of
khakkhara in which bells instead of rings
are used may have been the emblem of ad-
herents of a brahmanic rather than a Bud-
dhist sect. In this connection it is of interest
to note that in the Museum Sono Budoyo,
Yogyakarta, a fragmentary bronze trident
has been preserved that is fitted out with a
pair of bells. Apparently tridents with bells
were used by Śivaite sects during the Cen-
tral Javanese period.

In view of the close similarity with the staff
finial in the Boston relief, J. E. van Lo-
huizen de Leeuw's tentative dating of this
khakkhara to the early East Javanese pe-
riod is likely to be correct. Another finial of
the same type, but with six dragon heads,
is in the same collection.

Literature: Fontein 1973; Mainz 1980, no. 51;
Linden-Museum 1984, no. 59.

100
Slit drum
13th–14th century
East Java
bronze, 17 in. (43 cm); chain 12 in. (30 cm)
Royal Tropical Institute—Tropenmuseum,
Amsterdam, inv. no. 4037–1

THE BODY OF THE BRONZE SLIT DRUM is
covered with graceful decoration of stylized
kāla (demon masks) and lotus rosettes,
connected by ribbonlike bands and framed
by a border of stylized spiral ornament that
is reduced to cartouches with small central
spirals. The slit has demon masks at both
top and bottom. Above a double lotus
cushion on top of the drum rises the
curved, scaly neck of a *nāga* dragon. Be-
hind his head a ring has been attached for
the chain from which the drum was sus-
pended.

There are several *kĕntongan* with *nāga*
heads in collections in Indonesia and the
United States, such as in the Museum Na-
sional (inv. no. 8268), the Adam Malik
Collection, Jakarta, the Metropolitan Mu-
seum of Art, New York (Samuel Eilenberg
Collection), and the Archaeological Insti-
tute of Indonesia (Pusat Penelitian
Arkeologi Nasional), but the example ex-
hibited here is the finest in design and exe-
cution. The simplified spiral design along
the borders is later in date than that on the
kĕntongan dated in accordance with 1229
(cat. 101), and the shape of the dragon's
head suggests a date not earlier than the
Majapahit period.

These bronze drums are small-size replicas
of large wooden slit drums (popularly
known as *tong-tong*). Their Javanese name
kĕntongan means, literally, "things that
make a sound like *tong-tong*." In Bali the
large wooden drums are called *kul-kul*, an-
other onomatopoeic designation. Wooden
slit drums are an important means of com-
munication in Indonesian village life to this
very day. They are found all over the archi-
pelago except in the Lesser Sunda Isles, the
Moluccas, and parts of Irian Jaya. In Bali
the *kul-kul* are suspended in towers erected
for this purpose in the outer courtyards of
temples. The Balinese carve new slit drums
only on auspicious days from species of
trees carefully selected for their sonorous as
well as magic properties, such as the *in-
taran* (Azadirachta Indica) or the *siligui*
(Woodfordia floribunda). In Java village
heads use the *tong-tong* to call meetings of
the village elders or to sound a warning in
case of sudden flood, fire, theft, or a per-
son running amok. The *tong-tong*, sus-
pended vertically, is often topped by a carv-
ing in the shape of a human head, and the

names for parts of the drum are borrowed
from those of the human body; for exam-
ple, the slit is called "mouth," its rims
"lips."

The bronze replicas are usually relatively
small in size (10–15 in.). The fact that sev-
eral of them have been found in association
with other ritual paraphernalia, as, for ex-
ample, in the hoard from Selumbung, Gan-
dusari (East Java), suggests that they also
were used for some ritual purpose. In the
temple called Pura Manik Beni in the vil-
lage of Pujungan (Pupuan, Tabanan, Bali) a
bronze slit drum named *Kul-kul Pe-
jenengan* is enshrined as an object of wor-
ship. The *kul-kul* was found many years
ago in the immediate vicinity of the temple
and had been deposited in the Den Pasar
Museum. After Indonesia became indepen-
dent from the Netherlands in 1949, the vil-
lagers requested its return to the temple,
and its worship dates from that time. The
Kul-kul Pejenengan carries an inscription,
cast in decorative Kadiri Quadratic script,
reading: "This object has been donated by
a Sasak to commemorate his victory." This
suggests that the *kul-kul* may have been
given to a warrior or a group of warriors as
a reward for services rendered in battle. Al-
though the donor's name Sasak points to a
connection with Lombok, the homeland of
the tribe of that name, the origin of most
kĕntongan of which the provenance can be
established is East Java or Bali (see, how-
ever, cat. 101 for an example from West
Java).

Literature: Amsterdam 1988, no. 77. *Kĕntongan*
in general: Meyer 1939; Goris n.d., 192 and fig.
3–09; Swadling 1986; Surasmi 1986. The *kĕn-
tongan* in the Institute of Archaeology: Soekatno
1981, 198, 65, no. 106.

101
Slit drum
datable to 1229
West Java, from Galuh, Cirebon
bronze, 16 ½ in. (41.5 cm)
Museum Nasional, Jakarta, inv. no. 970

THE OCTAGONAL SLIT DRUM with a broken top has a slit that reaches almost from top to bottom and a flat, plain rim. Both ends of the slit show stylized parts of *kāla* heads with jaws and fangs, suggesting that the slit is like the *kāla*'s wide-open jaws and the sound of the *kĕntongan* like the monster's roar. A spiral ornament, framed in rectangles, is repeated around the upper and lower rim of the body of the drum. On the plain body itself two inscriptions, cast in relief in Kediri Quadratic script, constitute the sole decoration. One inscription reads: "*janma bhuta sarat*," a rebus-like rendering (Javanese: *candrasĕngkala*) of the year 1151 of the Śaka era (1229, not 1189, as older publications maintain). The other inscription reads *majayan* (Hail!).

This *kĕntongan* is one of only two datable examples. The other is a piece inscribed with a date corresponding to 1287 that is part of the cache of ceremonial objects found at Selumbung, Gandusari (East Java, see cat. 74).

The provenance of the *kĕntongan* from 1229 is of considerable interest in that it is one of the few bronzes found in West Java and the only datable bronze from that area. The *kĕntongan* was originally in the collection of the opera singer and gifted photographer Isidore van Kinsbergen, who presented it to the Batavian Society of Arts and Sciences at the meeting of 10 February 1865. It was in this meeting that van Kinsbergen was appointed photographer of the Batavian Society, an appointment that was to result in the first extensive photographic record—of the highest artistic quality—of Javanese antiquities.

Literature: *NBG* 1865, 25; Holle 1877; Groeneveldt 1887, no. 970, 247–248; Krom 1923, 2:454; Stutterheim 1926a, fig. 128; Crucq 1929b, 272; Kunst 1968, 56–57, fig. 73.

102
Mirror handle
late 10th century (?)
East Java, provenance unknown
bronze, 4 7/8 in. (12.5 cm)
Museum Nasional, Jakarta, inv. no. 5745

THIS HOLLOW-CAST and reticulated mirror handle is decorated with a representation of two episodes of the story of Garuda, as it is told in the first book of the Indian epic *Mahābhārata* and in the Old Javanese *Ādiparwa*, which closely follows the Indian narrative. On one side Garuda is shown with his hands folded in *sĕmbah*, respectfully taking leave of a person, who has been variously identified as his mother Vinatā or his father Kāśyapa. At his mother's request Garuda goes to the abode of the gods to steal the elixir of the gods (*amrĕta*) in order to redeem her from the slavery into which she had been forced to sell herself as a result of a foolish wager with her sister and co-wife Kadrū, the mother of the snakes.

The reverse shows Garuda escaping from the abode of the gods, clasping the *amrĕta* container to his chest, while warding off an attack by a deity. On both sides the figures are surrounded by stylized rocks and clouds. The angular, cubelike shapes of the rocks and the representation of Garuda as a human being with a bird's head with long, flowing human hair and a large beak suggest a relatively early date for this handle. As the stylized clouds resemble those of the Jalatunda reliefs (see cat. 18), a date

toward the end of the tenth century is likely.

The vast majority of Javanese mirror handles are solid bronze, flat pieces, decorated with brief inlaid inscriptions in Kediri Quadratic script. Much rarer are the hollow-cast, richly decorated handles of the type exhibited here. A slightly larger (5 3/8 in.) mirror handle in the collection of Samuel Eilenberg (The Metropolitan Museum of Art, New York) illustrates scenes from the *Rāmāyana*, and a broken example, formerly in the collection of Felix Kopstein, Malang (now Museum Nasional, Jakarta, inv. no. 6296a), depicts the legend of the churning of the elixir of the gods (*Amĕrtamanthana*), as told in the *Mahābhārata* and several other Old Javanese texts modeled upon parts of the Indian epic. It would seem, therefore, that no particular symbolism was attached to these representations, and that the bronze artist merely chose well-known, popular stories to decorate his pieces.

Literature: OV 1918, 101; Stutterheim 1926a, figs. 121–122; van Erp 1933b, esp. 262; *AIA* no. 75; Mainz 1980, no. 80. Other mirror handles: Stutterheim 1937b; Crucq 1939, 243; New York 1975a, no. 19. The story of Garuda: Juynboll 1926; van Buitenen 1973, 78–91.

103
Vessel for holy water
14th–15th century
East Java, from Bataan, Bondowoso
bronze, 15 3/4 in. (40 cm)
Museum Nasional, Jakarta, inv. no. 6436

THE OVAL BODY of the vessel stands on a tall foot divided into two sections by a disc. Along the rim of the base stylized rock ornaments have been applied. The hollow body is topped by a lotus flower transformed into stylized rocks, from which a tall shaft rises. It resembles a set of thirteen superimposed parasols (Skt. *chattra*), and is crowned by a round jar. The parasols, instead of tapering, vary in size; three have a border of appliquéd rock motifs. The curved neck of a *nāga* with open jaws and pointed teeth is attached at the side of the oval body.

This type of water vessel, of which many examples have been preserved, was used throughout the Indo-Javanese period as a vase for holy water in various rituals. Even today the religion of Bali is referred to as *agama tirtha* (holy water religion), because of the vital role of holy water in rituals. According to legend the first holy water, the elixir of the gods, was created by the churning of the ocean of the universe by the gods. The pivotal mountain Sumeru functioned as the churning stick and the snake Basuki as the rope used to turn it.

In this vessel the basic components of the ancient Indian myth are symbolically represented. The tall, narrow set of parasols with their stylized rock motifs represent Mount Sumeru, and the ovoid vessel the ocean of the universe. The *nāga* represents Basuki, the giant snake.

Following a lead provided by an article by Ananda Coomaraswamy, F. D. K. Bosch pointed out that, contrary to what is commonly assumed, it is the long, vertical top and not the curved neck of the *nāga* that functions as the spout of the vessel. That vessels of the *kĕndi* type were used in India in this same manner is evident from a description given by the Chinese pilgrim Yi Jing (see introduction). For Java visual proof is provided by a lamp in the Museum Nasional, Jakarta (inv. no. 6027), on which two small figures are shown pouring water from vessels through their pointed tops. That these vessels had to be submerged in order to fill them may perhaps be rather impractical from our point of view, but may have helped to enhance their reputation as *bhadragata* (inexhaustible pouring vessel). In popular legend the snake merely functioned as a churning rope, and in the Javanese world, where function and symbol are inseparable, it

would have been incongruous to have the holy water pour from Basuki's jaws. Moreover, the parasols are crowned by a vessel of plenty, *pūrnakalasa*, a much more appropriate orifice from which the holy water could pour.

The vessel was found in 1938, together with a few other bronzes and some iron tools, in the village of Bataan, Tenggarang, Bondowoso (East Java). The East Javanese provenance of other vessels of the same type, as, for example, a vessel in the Rijksmuseum voor Volkenkunde, Leiden, inv. no. 1403/2346, which was found at Trenggalek, Kediri, confirms the date in the East Javanese period assumed for most pieces of this type.

Literature: Coomaraswamy 1928–1929; Bosch 1934; *OV* 1938, 24; *JBG* 6 (1939), 100, no. 6436; *AIA* no. 73; *Koleksi Pilihan* 1, no. 20.

cat. 104

104
Architectural decoration
c. 14th–15th century
Eastern Java
terracotta, 13 3/4 in. (35 cm)
Rijksmuseum, Amsterdam, RAK 1966–2

MANY HOUSES were richly decorated with ornamental roof tiles in the capital of the East Javanese kingdom of Majapahit (fourteenth–fifteenth century) near the present village of Trowulan. The columns of the open, pavilionlike buildings were covered and protected by sculpture modeled in clay, dried in the sun, and baked at low temperatures. Very few structures remain of the ancient capital and its royal palace (*kraton*), and Prapañca's *Nāgara-krětāgama* (1365) gives a detailed, if perhaps somewhat flattering impression of it. Excavations currently being carried out by the National Research Center of Archaeology of Indonesia may throw new light on the history of this capital, but at the present time only a few temples, a bathing place, and a gateway, all constructed in brick, are well-enough preserved to give us an impression of its onetime splendor.

Pottery serving as roof decoration is mentioned in Prapañca's *Nāgara-Krětāgama*; perhaps the ridge acroteria and other decorative roof tiles that can still be seen along Java's northern shores in the Japara area (Central Java) are the last vestiges of this once-flourishing ancient decorative tradition. A relief of Candi Jawi (East Java, early fourteenth century) clearly illustrates the use of decorative columns in pavilionlike structures. That these columns were made of terracotta and not from carved wood is confirmed by numerous fragmentary terracottas that are reported to have been found in the Trowulan area. Among several pieces that have a cylindrical, hollow interior, identifying them as pillar decorations, are the two pieces included in this exhibition.

A beautiful nymph, posed against outcroppings symbolizing the fantastic shapes of clouds, strikes a seductive, languid pose. Clad in a dress that leaves both shoulders and the right breast bare, she seems to lean on the rocklike clouds with her left hand. The joint of her left elbow is bent outward in the gesture known by the Javanese as *dengklang*. This mark of beauty seems to have carried in East Javanese times an amorous connotation, often symbolizing the pining for an absent lover. Her tall, lopsided hairdo, adorned with flowers, resembles that of the heavenly nymphs of Indra, about to descend upon earth to interrupt the meditation of Arjuna and to seduce him, as they are portrayed in the stone reliefs of Candi Surawana, Kedaton, and Jago (see cat. 32, where a different hairstyle is shown). The use of such popular stories from the *Arjuna-Wiwāha* or later legends (a piece in the Museum of Fine Arts, Boston, shows the equally popular legend of Śrī Tañjung) provided the houses with a decoration that was practical, effective, and auspicious.

Literature: Harmsen-Ydema 1975; Muller 1978, 89; Rijksmuseum 1985, no. 205. Related works: Galestin 1936, 201 and pl. 10; Stutterheim 1948, 94 n. 221.

105
Architectural decoration
14th–15th century
eastern Java
terracotta, 11 5/8 in. (29.5 cm)
Museum Nasional, Jakarta, inv. no. 6076

IN THIS PIECE, similar in technique, style, and function to the preceding one, the woman strikes a more lively, perhaps somewhat less suggestive, but equally charming pose. She raises her left hand, touching her hair. In her right hand she holds a small clay lamp with a single spout to accommodate a wick, a basic type of lamp already common in Central Javanese times. She has wrapped this lamp in her shawl (*selendang*). Unlike the nymph in cat. 104 she wears a heavy necklace, but her dress, although similar, leaves the left breast uncovered.

Although both terracottas are of unknown provenance, their similarity to fragmentary pieces found in Trowulan makes a provenance from that area most likely.

Literature: *JBG* 3 (1936), 190–191, pl. 2; Bernet Kempers 1959, pl. 322.

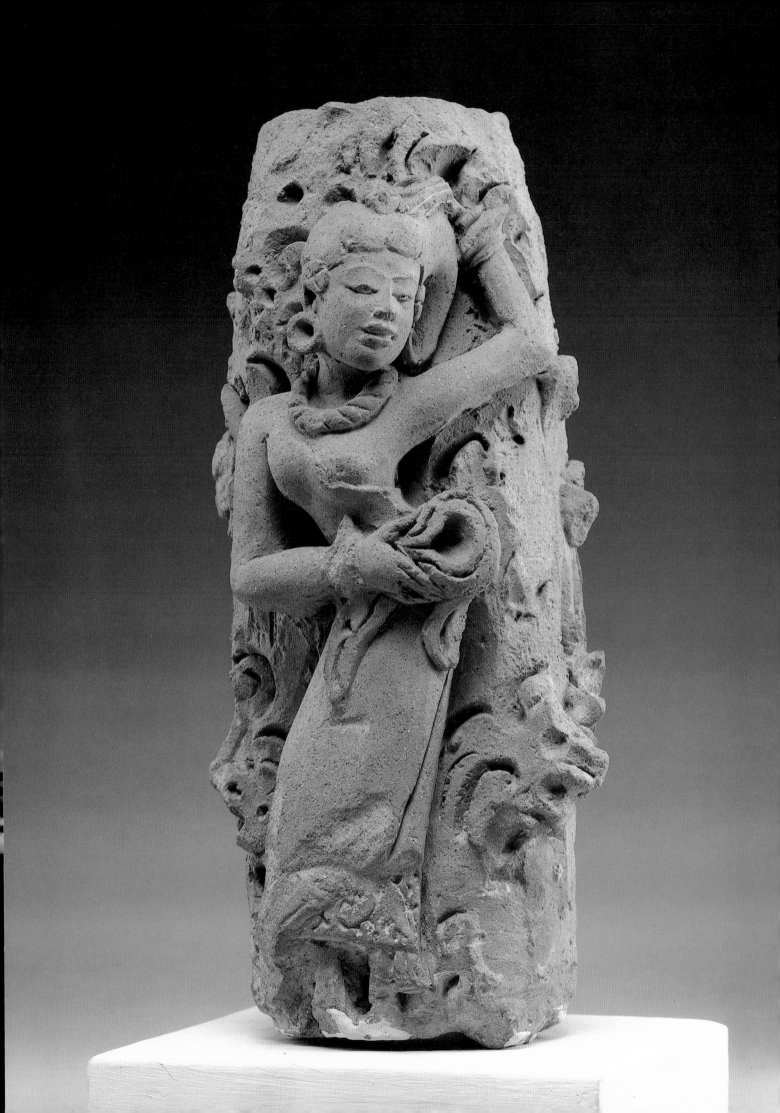

106

**Mask, human silhouette, and
crescent-shaped ornament**
8th–9th century
Central Java, from Nayan, Yogyakarta
gold, mask 5 7/8 in. (15 cm), silhouette
12 1/8 in. (31 cm), ornament 5 7/8 in. (15 cm)
Museum Sono Budoyo, Yogyakarta

IN THE SPRING OF 1960 three farmers discovered an earthenware jar in a mud wall next to a rice field on the edge of the village of Nayan, Maguwoharjo, Depok, just north of the main road from Yogyakarta to Solo. The jar contained four pieces of gold sheet, together forming the silhouette of a headless man, a small mask of a man, and a crescent-shaped ornament, perhaps a pectoral, showing a repoussé decoration of a lotus pod surrounded by foliage. The strikingly individual features of the mask suggest that it is a portrait, preserving the actual facial features of its mustachioed Javanese subject.

Two earlier finds, both within a few miles from Nayan, seem to be of a similar type. During the excavation and reconstruction of nearby Candi Gebang in 1936, a broken bronze vessel was found buried near the temple. Among the pieces excavated with the vessel were a gold, crescent-shaped ornament, similar to that found in Nayan, but inlaid in the center with a single semiprecious stone. In addition to some gold buttons there were strips of gold and silver sheet similar to the Nayan silhouette, but no mask.

Another find at Plembon, Taji, Prambanan, was made in 1959. The objects found here are similar to those found at Nayan, but this time the mask, instead of representing human features, is that of a Buddha, complete with elongated earlobes and cranial protuberance.

The discovery of three similar finds within a radius of six miles suggests a local tradition, but the original, probably ritual, function of these objects remains a matter of conjecture. Sukarto has interpreted them as precursors of the floral effigy, mentioned in Prapañca's *Nāgara-Krĕtāgama* as having been used in the posthumous *śraddhā* (commemorative ceremony) for Queen Rājapatnī in 1362. The floral effigy (Skt. *puspa*), perhaps a puppet made of plaited bamboo, was placed on a lion throne after the soul of the departed queen had accepted the entreaties of the officiating priests to descend into the *puspa*. The use of such temporary abodes of the soul survives in Java among the inhabitants of the Tĕnggĕr mountains (East Java), where many pre-Islamic traditions have been preserved. The use of puppets at funeral ceremonies is also common among the Kalangs of Central Java. Soekmono has pointed out the similarity with Balinese effigies called *adegan*, made of wood or palm leaves, or effigies made of gold or silver chips or of Chinese coins.

Three holes on the edge of the mask to the right and left of the cheeks perhaps served to attach the mask to a piece of cloth. In two of these holes a gold staple remains.

Literature: *OV* 1937, 24 and fig. 11; Sukarto 1960; Pigeaud 1960–1963, 3:74, 4:176–181; Soekmono 1965, esp. 44; *AIA* no. 99abc; Tokyo 1980, no. 56; Seltmann 1987.

107
Finial of a parasol
c. 9th century
West Java, Cirebon
gold repoussé and chiseled, 9 in. (23 cm)
Museum Nasional, Jakarta, inv. no.
A85/1555

IN THIS REPOUSSÉ GOLD PIECE with clay core, floral and martial symbols have been skillfully blended into a finial of refined elegance. The base and the striated bands around the shaft resemble the pommel and grip of a dagger; the top, crowned by a double lotus, is covered with floral ornament. The resemblance of this piece to finials of umbrellas, seen in the reliefs of Borobudur, establish its original function with certainty.

In ancient Indonesia parasols did not merely serve to shield the human body against the sun and rain. They were equally important as status symbols or insignia of rank. A study of the types of parasols, their uses, and the context in which they appear on the reliefs of Borobudur indicates that there were at least four different types of parasols at that time, each used by a distinct class of society. It is quite possible that an even greater variety, comparable to that used in later Javanese court culture, existed already at that time, for two key variables, the color and the material from which they were made, escape our observation in these carvings. At Borobudur the royal umbrella frequently makes its appearance in the company of two other royal insignia, a large fan made of peacock feathers mounted on a staff, and a fan made of a leaf of the *sente* (Cryptosperma or Aracea). In addition to the obvious association of power and gold, the fact that the shape of this finial resembles that of the royal umbrellas of Borobudur strongly suggests a royal provenance. Additional confirmation for this supposition is provided by a copper plate charter, dating from 880, recording "a silver parasol with a lower end (*wangku*), a stick (*danda*), and a finial (*puncak*) made of gold with a weight of nine *kati*—a gift of His Majesty the Mahārāja Raku Kayu Wangi to Bhatāra of Salingsingan."

The actual presentation of a precious parasol accompanied by the inscription *chatradana* (gift of a parasol) is shown on one of the reliefs of the hidden base of Borobudur. The relief illustrates a passage from the *Mahākarmavibhanga*, holding out blessings in future rebirths for anyone donating a precious parasol: "one will be reborn as a canopy of the world—one will become a person of great prestige and status."

From the proportionate size of the parasol in the Borobudur relief it is clear that the sculptor illustrated the gift of an actual parasol. It is evident that replicas of reduced size, made in precious metals, were also offered as gifts from the find of three miniature parasols (ranging in diameter from $12^{1}/_4$ in. to $5^{5}/_8$ in., 31–14.5 cm) in the hamlet of Mandeng, in the village of Sucen, Salaman (Central Java), in 1888. They are now part of the collection of the Museum Nasional, Jakarta (inv. nos. A204/685a– A206/685c). One of the parasols is inscribed "parasol for the god Ganeśa," indicating that such umbrellas were offered as gifts to statues of deities. According to the inscription on the second parasol, it was provided with a finial of gold, but this component was not found. The third of these parasols is the most interesting in that it has an inscription dated in accordance with 19 March 843. That day was a very special occasion, for not only was it a Soma-day (Monday) that coincided with a full moon, but also a day when an eclipse of the moon occurred. A day of a gem eclipse, as such a day was called in ancient India, was an auspicious day; rites performed or donations made on such a day were considered particularly meritorious. That the day selected for the donation of such a precious parasol was the day on which a gem eclipse occurred makes it likely that the Javanese were familiar with and had adopted this Indian tradition.

In this last inscription the finial is referred to as *agra* (summit). Made of quartz and mounted in gold, it has been preserved together with the parasol. Several other small gold finials have been found, all in Central Java.

The parasol continued to play an important role in the life of the Javanese until modern times. On 19 May 1820 the Dutch governor-general van de Capellen issued new regulations concerning the size, color, and material of parasols, and these regulation were revised as late as 1904.

Literature: Cohen Stuart 1875, no. 10; Stutterheim 1925a, esp. 228–230, note 31; *NBG* 1880, 154; *NBG* 1885, 75; *NBG* 1892, 56 and CLXX– CLXXI; Jasper 1904; *ROC* 1911, 251–259; *Koleksi Pilihan* 3, no. 39; Ghautama 1986; Fontein 1989, 57–58.

108
Finial or sword handle
13th–14th century (?)
East Java, provenance unknown
gold, repoussé and chased, around a clay
core, 7 ¹/₂ in. (19 cm)
Private collection, U.S.A.

THIS EXQUISITE OBJECT of unknown use resembles in shape the hilt of a ceremonial sword with an elaborately decorated pommel and guard. That the purpose for which it was made must have been ceremonial rather than functional is suggested by the material from which it was made and from the fragility that is the result of this process of manufacture.

From a square with an edge of sharp points rises the "pommel," terminating in a curved point. It is curved with a floral design of pointed leaves in which a parrot or owl and a human face have been incorporated. The four-lobed guard or base has a stylized floral design on a dotted ground, while the grip has a ribbed surface.

In the inventory of the Museum Nasional, Jakarta, a less well-preserved piece of virtually identical shape is described as a finial of a parasol (*puncak payung*), a supposition for which a good case can be made. The Jakarta piece (inv. no. A86) entered the collection together with the parasol finial in this exhibition (cat. 107), and both are said to have come from Cirebon. In comparing the two objects, both pieces, in spite of their different appearance and shape, consist of the same sequence of components: a guard or base, a ribbed hilt or handle, and an elaborate "pommel" on a square base with an edge of points. This similarity suggests that both served as some sort of finial.

There seems to be no illustration of such an object, either functioning as the component of a sword or as that of a parasol, on any of the Central Javanese reliefs. However, the common provenance of the two Jakarta pieces does not preclude the possibility of a considerable difference in date, and the piece exhibited here has actually been attributed to the thirteenth century. A fragment of the square section with points of what must once have been a third piece of the same type is among the gold objects excavated by a farmer in Cogembung, Kadipaten, Babadan, Ponorogo (East Java) in 1982 and is now in the Mpu Tantular Museum in Surabaya (inv. no. 6463, B4a. 241.0500). The location of this find suggests a date in the East Javanese period.

Literature: *Octagon* 19 (June 1982), 12.

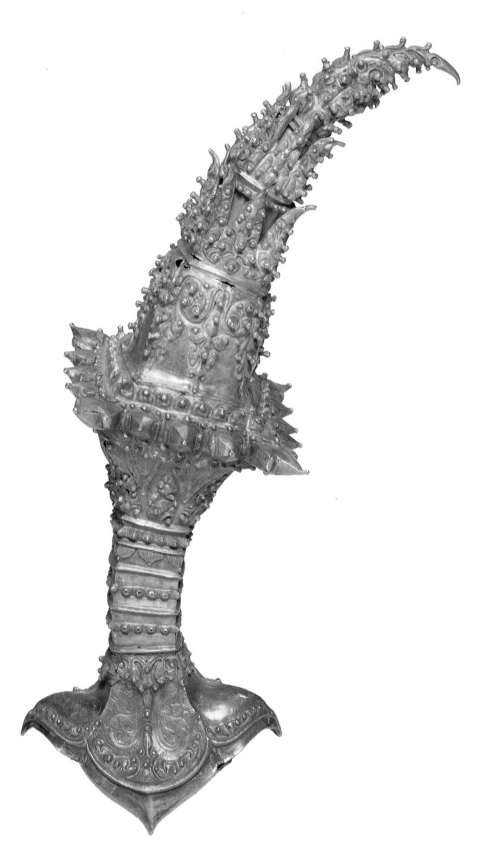

109
Clasp for a sacred thread
9th–10th century
Central Java, from Gemblung
gold, cast and chased, 5 3/8 in. (13.5 cm)
Museum Nasional, Jakarta, inv. no. A147

THIS CLASP, INTENDED to hold the sacred thread (*upavīta*) of a royal or wealthy adherent of one of the Javanese brahmanic sects, is decorated with floral scrolls cast in reticulated low relief.

Although the word *upavīta* occurs only once in Old Javanese literature (where it may actually be a mistake for *upadhīta*), there is abundant visual evidence throughout the Indo-Javanese period for the use of such precious clasps as this. Images of both the Central and East Javanese periods depict clasps of various shapes, sometimes embellished with inlaid precious stones. Actual examples, inlaid with precious

stones, confirm this practice. Clasps shown on statuary dating from the fourteenth century, when triple and quintuple strands of pearls replaced the simpler braided cord of earlier periods, were especially lavishly decorated.

The simplicity of the design of the scrollwork combined with the provenance of this piece from the village of Gemblung, Binangun, Rembang (Central Java), suggests the possibility of a date in the Central Javanese period.

Literature: *AIA* no. 103; *Koleksi Pilihan* 1, no. 28; Zoetmulder 1982, 2138, s.v. *upavīta*.

110
Finial
13th–14th century
East Java, provenance unknown
gold, repoussé and chased, 3 in. (7.5 cm)
Private collection

A CRESCENT-SHAPED, curved band of gold with repoussé and chased floral designs is surmounted by a finial, the top of which takes the shape of a flame. The curved band probably fit the top of the head and was part of the headdress, perhaps of a princess or a dancer.

A very similar object almost the same size (3¹/8 in., 8 cm) is in the Museum Nasional Jakarta (inv. no. A161/6535). Of unknown provenance, it entered the collection as part of the bequest of J. W. van Dapperen, a collector and antiquarian (see bibliography), in 1939.

Literature: *Octagon* 20, no. 1 (1983), 19. The Jakarta piece: *JBG* 6 (1939), 108, no. 6535.

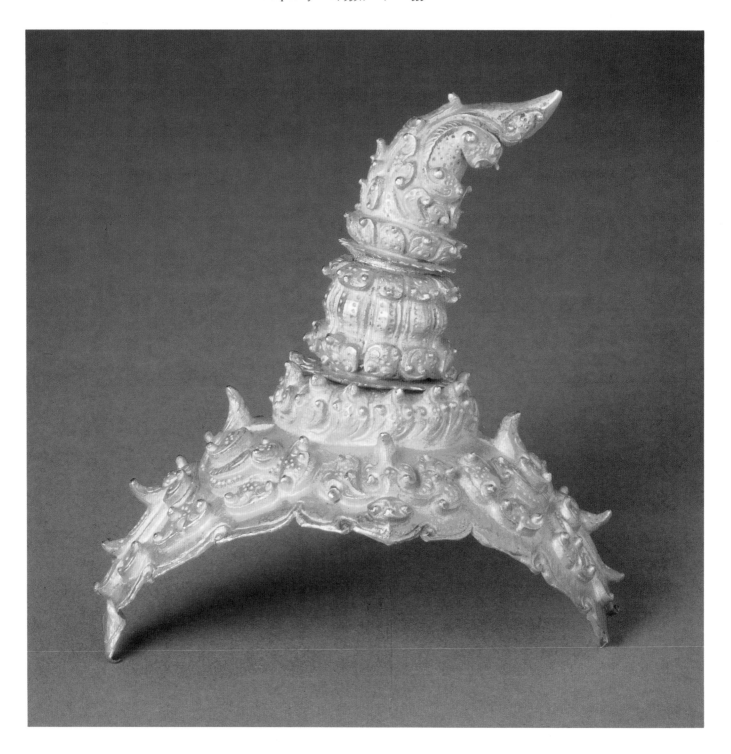

III

Necklace

c. 12th century(?)
East Java
Gold repoussé, 12 ¼ in. (31 cm)
Museum of Fine Arts, Boston,
Frederick L. Jack Fund, acc. no. 1981. 44

THE NECKLACE consists of twelve leaf- or petal-shaped pendants and a centerpiece in the shape of a stylized tortoise. The pendants are attached to thin tubes through which the necklace is strung. The leaf-shaped pendants gradually diminish in size, the largest pieces having been strung closest to the center. When the necklace was acquired by the Museum of Fine Arts, Boston, in the London art market, the original string had been lost and the pieces had been restrung, the rounded tips of the petals pointing inward, probably after the example of a necklace in the Mangkunagoro Collection, Solo.

In 1982 the Mpu Tantular Museum in Surabaya acquired a number of gold objects dug up by a farmer in the hamlet of Cogembung near the village of Kadipaten in the district of Babadan, just to the north of Ponorogo (East Java). Among the pieces excavated was a thirteen-piece gold necklace. A hollow bell-shaped pendant, which may once have held a crystal or semiprecious stone, is the center around which six pendants in the shape of petals and six in the shape of tortoises have been strung in alternating fashion. The necklace is held together by a string of braided gold wire, complete with its hook and eyelet in what is undoubtedly the original arrangement, leaf-shaped pendants strung turning outward. The discovery of this incontrovertible piece of evidence prompted the Museum of Fine Arts to restring its necklace accordingly.

Apart from the improved appearance of the necklace, the new arrangement finds further confirmation in a stone statue from Kediri (Museum Nasional, Jakarta, inv. no. 15a). It represents a four-headed, four-armed deity wearing a necklace of leaf-shaped pendants pointing outward. While these petals are close to floral shapes found in nature, fragmentary necklaces from other areas suggest a connection with the necklaces made of tiger teeth or tiger claws (Skt. *vyāghra-nakha*) that were worn as a magic charm by boys, by the young Krishna, and by such gods and bodhisattvas of youthful appearance (Skt. *Kumāra-bhūta*) as, for instance, Mañjuśrī (see cats. 46 and 47). In these necklaces the teeth and claws invariably turn out.

Pendants of slightly varying shapes have been found in both Central and Eastern Java, as well as in the easternmost areas of West Java, in which the influence of Indo-Javanese culture from Central Java was felt. Perhaps the earliest type of pendant is the single piece found in 1958 in Jambidan, Gondowulung, to the southeast of Yogyakarta (Museum Sono Budoyo, Yogyakarta). In this piece the petal is not directly attached to the tube, as are those of the necklace exhibited here, but to a double lotus cushion that is attached to the tube.

Pieces found in the Eastern Priangan (West Java) lack this reminder of the floral origins of the motif and show a deeper curve of the pointed end, more closely resembling a tiger's claw. This shape can be observed in the pieces discovered in an earthenware jar in the village of Guranting, Ciawi, near Tasikmalaya (West Java) in 1882. Eight pendants are now in the Rijksmuseum voor Volkenkunde, Leiden. A necklace from the village Surakerta, Panumbangan, Panjalalu, Ciamis (Museum Nasional, Jakarta, inv. no. 8082) has pendants of a similar shape. The tortoise-shaped pendants accompanying some of these finds, or found separately, display different degrees of stylization of the animal shape, but there are no indications that these represent different phases of a chronological sequence. As animal- and flower-related versions of the pendants occur simultaneously, it would seem that two ancient symbols were mixed in a process of mutual interpenetration that enhanced the multiplicity of the symbolic associations of these necklaces.

Literature: The Boston, Cogembung and Surakerta necklaces have not been previously published. The Gondowulung find: Katamsi 1960. The Guranting find: *NBG* 1882, 146; Juynboll 1909, 191, no. 2829; *ROD*.1914, 75, no. 224. Indian necklaces incorporating tiger teeth and claws: Asher 1980, pls. 71, 153–154, 224; Mallmann 1956.

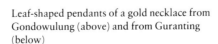

Leaf-shaped pendants of a gold necklace from Gondowulung (above) and from Guranting (below)

Four-headed, four-armed deity, stone, from Kediri. Museum Nasional, Jakarta, inv. no. 15a

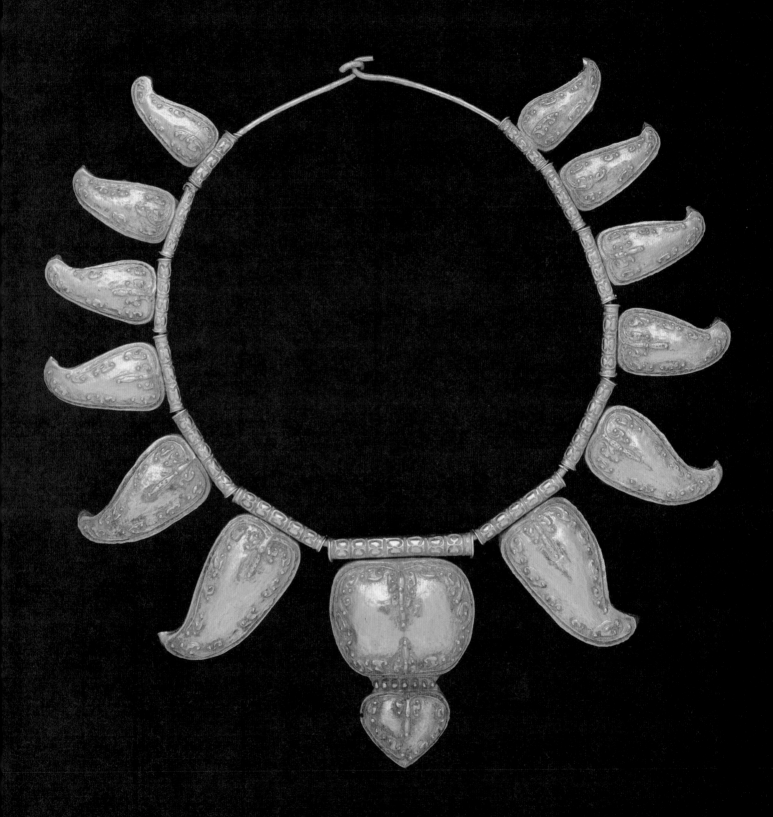

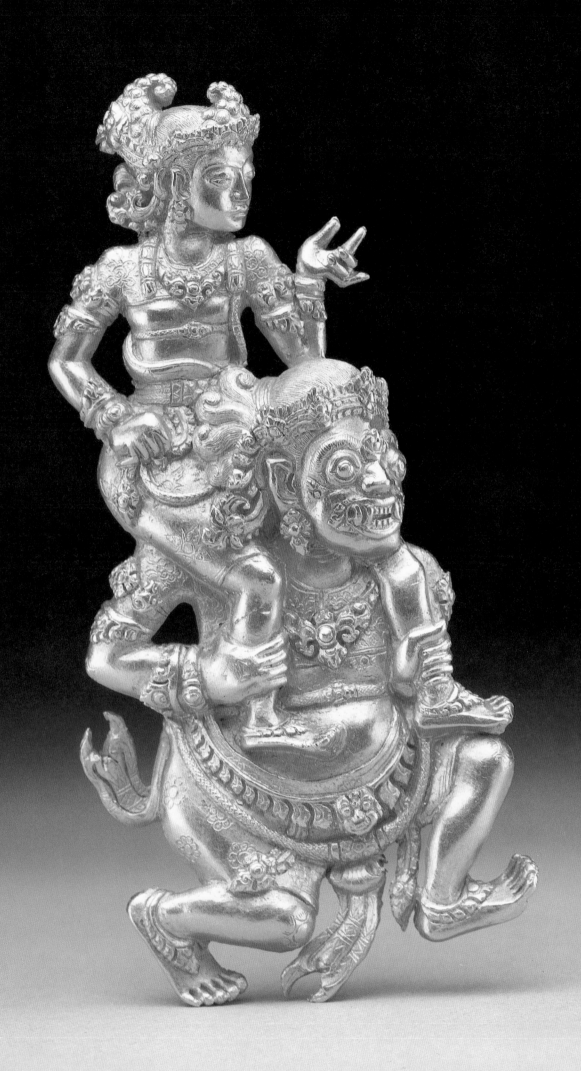

112
Sutasoma carried off by Kalmāsapāda

14th century
East Java
gold repoussé plaque, engraved, 2 3/8 x 1 9/16 in. (6 x 4 cm)
University of Amsterdam, on loan to the
Royal Tropical Institute—Tropenmuseum,
Amsterdam, inv. no. 2960–319

THIS GEM of the art of the Majapahit gold-smith illustrates an episode from the ancient Indian tale of King Kalmāsapāda and Prince Sutasoma. The handsome prince, whose name means lovely as the moon, allowed himself to be carried off to certain death on the back of the king-demon Kalmāsapāda. As the offspring of a king and a lioness, Kalmāsapāda had inherited his mother's insatiable craving for human flesh. After Kalmāsapāda granted him a temporary reprieve to settle his affairs, the virtuous prince voluntarily returned to the demon's lair, where he succeeded in converting the man-eating demon to non-violent behavior.

The goldsmith admirably captured the handsome features of the prince, who is shown wearing elaborate jewelry as a sign of his royal status, and a headdress whose style has survived to this day as the so-called *Gelung Supit Urang* of the Wayang plays. The king-demon, likewise in royal attire, carries the prince on his shoulders, straining under the weight but running; two sashes floating in the air enhance the suggestion of movement. The contrast between the placid appearance of the slender prince and the bent posture and ferocious expression of the pot-bellied man-eater are in perfect accordance with the story.

The Indian tale has been handed down in many different versions, Brahmanic and Jaina as well as Buddhist. In the Buddhist version, found, for example, in such famous collections as Āryaśūra's *Jātakamālā* (fourth century), Sutasoma is none other than the Buddha in one of his many previous incarnations. Āryaśūra's version may have been the first to reach Java, for it is already illustrated on the reliefs of Borobudur (I B a 116–119). During the reign of King Hayam Wuruk of Majapahit (fourteenth century) the story was recast by the Javanese poet Mpu Tantular in his *Purusādaśāntaka*. The gold plaque is likely to date from this period of revived interest in this dramatic tale. Neither its original function nor its provenance are known.

The story of Sutasoma remained popular in Bali until modern times. A manuscript of the text is known to have been illustrated by the noted artist Modara (c. 1830), a painter from Kamasan, who was patronized by the court at Klungkung, but it was lost during the Dutch conquest of the island. The motif of a man riding on the shoulders of an anthropomorphic lion remained common in the arts of the Bataks until modern times.

Literature: Krom 1927, 384–387; Brussels 1953, cat. 139; Zoetmulder 1974, pl. 14. The text of the story: Speyer 1971, 291–314; Zoetmulder 1974, 338–341; Schlingloff 1987, 93–112. Balinese manuscript: Vickers 1982. Batak art: Los Angeles 1985, fig. 94.

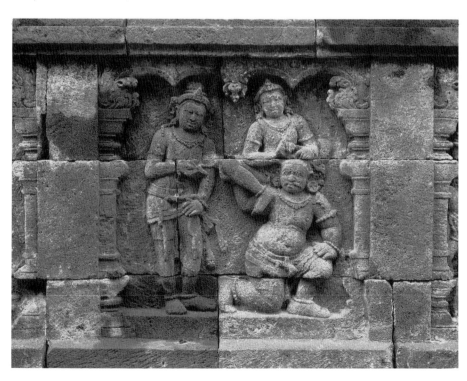

Sutasoma carried off by Kalmāsapāda.
Borobudur relief IB a 117

113
Chastity plaque
c.14th century
Eastern Java, from Madiun
gold repoussé, 3 3/8 x 3 3/4 in. (8.5 x 9.5 cm)
Museum Nasional, Jakarta, inv. no.
1493/A 103

THE HEART-SHAPED PLAQUE shows a repoussé decoration of a woman riding a fish with an elephant's trunk. In all probability this figure represents Śrī Tañjung, the heroine of the Old Javanese sequel to the *Sudamala*, which is illustrated on the reliefs of Candi Sukuh (Central Java, fifteenth century.)

In brief the story runs as follows. The nobleman Sidapaksa was sent by the king, who had fallen in love with the nobleman's wife Śrī Tañjung, on an errand to the palace of Indra, carrying a letter that was designed to infuriate the god and to result in the messenger's certain death. When Sidapaksa, contrary to expectations, returned unharmed, the king told him that Śrī Tañjung had been unfaithful to him during his absence, in spite of the fact that she had virtuously resisted all of the king's amorous advances. Sidapaksa took his wife to a cemetery and killed her there, but when her blood gave off a sweet fragrance, incontestable proof of her innocence, her husband was overcome with remorse. In the meantime the soul of Śrī Tañjung descended into the netherworld, visited hell and, after crossing the river on the back of a fish-elephant, arrived at the gate of heaven. There she was denied admission as her time had not yet come. Śiva's consort Ra Nini, who had once been liberated from a curse by Śrī Tañjung's father Sadewa, brought Śrī Tañjung back to life again.

The story of Śrī Tañjung, as it is presently known, seems to have originated in Banyuwangi, in the extreme eastern part of Java. During the seventeenth century Banyuwangi was part of the kingdom of Blambangan, the last Indo-Javanese state in Java. That the story itself is considerably older is evident from the reliefs of the East Javanese temples Candi Jabung (1354), Candi Surawana (fourteenth century), as well as of the *pĕndopo*-terrace of Candi Panataran (1375), all of which have reliefs illustrating the Śrī Tañjung legend. It is surprising that the episode that provides the key to the identification of the reliefs, her trip across the river on the back of a fish-elephant, does not occur in the modern version of the story as edited by Prijono. Instead this text tells of a "crocodile with a demon's head" who guards the river, and we are left in the dark as to how Śrī Tañjung managed to cross the water.

we are left in the dark as to how Śrī Tañjung managed to cross the water.

Śrī Tañjung and her hybrid mount also make their appearance in other media, in carved brick (in the gateway Bajangratu, Trowulan), in a terracotta pillar decoration (Museum of Fine Arts, Boston, inv. no. 1975. 326), on lamps (see Museum Nasional, Jakarta, inv. no. 1076a), on a *kĕris*, as well as on the bottom of several zodiac beakers. The apparently widespread popularity of the story makes the identification as Śrī Tañjung of all representations of a woman riding on the back of a fish highly likely. However, only when the scene appears as part of a series of illustrations can the identification be considered a certainty.

On the sculpture of Camundī from Ardimulyo (Singosari) dating from 1292 (see cat. 25), a woman riding on a fish is one of the secondary figures. She has been tentatively identified by P. H. Pott as the goddess Trivenī, the guardian of the confluence of the three rivers. It is possible, therefore, that some of the figures identified as Śrī Tañjung represent in reality the goddess Trivenī or Yuktatrivenī.

Although many scholars have assumed that gold plaques of this type were worn by women to cover the pubic area, there seems to be neither written nor visual evidence to document their actual use. An odd exception constitutes the statuary of Candi Sukuh (Central Java, fifteenth century, cats. 33, 34), where two animals, a Garuda and a pig, are fitted out with such plaques. However, especially in the case of the pig, one suspects that the animal has been provided with such a plaque merely as part of a scheme to create a *candrasĕngkala*, a rebuslike chronogram in which four objects, to each of which a specific numerical value has been assigned, are combined to form a four-digit number representing a year of the Śaka era.

Literature: *AIA*, no. 102; *Koleksi Pilihan* 1, no. 26; Tokyo 1980, no. 70. Other representations: Bernet Kempers 1935, 19, fig. 27; Galestin 1939b; Bernet Kempers 1959, pl. 320; Worsley 1986. Sukuh statuary: Stutterheim 1926c; Stutterheim 1937a, 32–33, fig. 23, B28. Story of Śrī Tañjung: Zoetmulder 1974, 435–436; Prijono 1938, canto 5:121–122, 116; Pott 1966, 131–132 (Trivenī).

cat. 114

cat. 113

114
Decorative plaque
14th–15th century
from Kediri, East Java
gold repoussé, 4 3/4 in. (12 cm)
Museum Nasional, Jakarta, inv. no.
A110/6914

A CLIMACTIC EPISODE in the *Rāmāyana* epic is the heroic feat of engineering performed by the army of monkeys who build a causeway across the ocean to the kingdom of the demon-king Rāvana. It seems to have held a special fascination for ancient Javanese artists, who depicted this remarkable exploit in different media.

The Javanese goldsmith who made this handsome decorative plaque transformed the epic drama of the episode into a playful, humorous interlude. Two monkeys throw rocks into the sea, the breaking surf echoing the movements of their arms. They are frightened by the sudden appearance of a crab threatening them with its claws. In the background a reticulated design of squares suggests the solid masonry of the causeway.

It probably was not the great Indian epic of Vālmīki that inspired the Javanese goldsmith but a local Indonesian version, for in the Malaysian *Hikayat Sĕri Rama* it is a crab who distinguishes himself in Rāvana's futile struggle to prevent the completion of the causeway. This detail is mentioned neither in the Indian epic nor in the Old Javanese *Rāmāyana*, but it must have been familiar to the goldsmith who transformed it into an almost comic incident.

The earliest representation of the *Setubandha* (dambuilding) episode is in the last relief of the balustrade of the Śiva temple of the Loro Jonggrang complex at Prambanan. The construction of the dam, the dangers its builders had to face, as well as the subsequent advance of the army across the completed causeway constitute the final scene of the epic as illustrated on that monument. The ensuing battles and the fall of Rāvana's kingdom are depicted on the balustrade of the Brahmā temple. The choice of the completion of the causeway as the point at which the epic was to be divided into two chapters emphasizes the importance of this episode as the crucial turning point in the epic. At the Panataran temple complex (Blitar, East Java, mid-fourteenth century) the episode is given a much less prominent place, and the limited space allotted to the sculptors there did not enable them to fully exploit the dramatic potential of the story.

In recent years another rendering of the *Setubandha* episode was discovered that is closely related in style and spirit to the scene on the gold plaque. During the resto-

ration of the mosque at Mantingan (near Jepara, Central Java, 1559) it was discovered that the reverse of several stones used in the construction of the mosque, including some of the decorative medallions let into the walls of the monument, contained reliefs illustrating scenes from the *Rāmāyana*. The style of these stone reliefs, which had been recycled for the construction of the mosque, is close to that of Panataran, as is apparent, for example, from the representation of clouds in the shape of demons. Among the fragmentarily preserved reliefs is one showing rock-throwing monkeys riding the surf, a scene strikingly similar to the decorative plaque displayed here.

That the *Setubandha* story was a theme also considered appropriate for pictorial representation is evident from a passage in the *Parthayajña*, a metric poem dating from the last century of the Majapahit kingdom. It describes a visit by Arjuna to a hermitage, the walls of which are decorated with a representation of the monkeys building the causeway.

The plaque, the exact use of which has not been established, thus seems to reflect an interest common during the fourteenth and fifteenth centuries. At the time of its acquisition by the museum it was suggested that the small hooks at the top of each of the reticulated squares could have been used to suspend leaf-shaped pendants resembling those on other pieces of Majapahit jewelry, but the authenticity of those appendages is open to some doubt (see cat. 115).

Literature: *JBG* 7 (1940), 90, pl. 4; *AIA* no. 101; *Koleksi Pilihan* 1, no. 32. Prambanan: Stutterheim 1925b, 173, pl. 64–65. Panataran: Stutterheim 1925b, 188, pl. 182–183, 55 (the story of the crab). Mantingan: *Laporan* 1982, 4–13; Tjandrasasmita 1985. *Parthayajña*: Zoetmulder 1974, 368.

115
Pendant (hair ornament ?)
14th–15th century
East Java, provenance unknown
gold repoussé, 5 1/8 x 3 1/8 in. (13 x 7.9 cm)
Museum Nasional, Jakarta, inv. no.
6816/A112

THREE SYMBOLIC REPRESENTATIONS—a pair of *nāgas*, a winged conch, and a heavenly figure on horseback—have been skillfully combined into an elaborate pendant, one of the finest to survive from the Majapahit period.

The sun-god Sūrya and his mount are framed by the sun disc, shown as a ring of flames with a border emitting pointed rays, a traditional way to depict the sun that survived the advent of Islam. Above the disc an empty cavity indicates the spot where a precious stone was once mounted. Below the disc is a winged conch, a symbol often associated with Visnu, the god of light. Two descending *nāgas* flank these symbols, their gaping jaws with sharp teeth turned outward. Just as the sun-god occupies the place that was reserved in earlier styles for the *kāla* or demon's mask, the aquatic *nāgas*, with their elongated, scaly bodies, have replaced the *makara* (fish-elephants) of the classical *kāla-makara* motif. This substitution seems to have infused a new life into the ancient symbolic polarity of light versus darkness and fire against water.

A keystone once covering the top of the vault of the cella of Candi Sawentar (near Blitar, East Java, early thirteenth century) shows the sun-god framed in similar fashion. There, however, he is shown riding a mount with longer ears, perhaps the mythical *aśvin*. The animal is led not by reins, but by a single rope drawn through the nose in the manner still commonly used for water buffaloes.

The association of *nāgas* with gods and royalty became increasingly common during the Majapahit period. It survived the advent of Islam, and *nāgas* can be seen on various paraphernalia associated with traditional rulers throughout later Indonesian history.

The spangles attached to the edges of the ornament by means of gold wire may be an embellishment added in recent times. The

pendant from the Royal Tropical Institute, Amsterdam (cat. 116), has spangles of identical shape. The fact that both ornaments can be traced to a Chinese collector in Tulungagung (Kediri, East Java) some fifty years ago lends further credence to the supposition that these spangles were added at the behest of this collector (see also cat. 114).

Literature: *AIA* no. 100; *Koleksi Pilihan* 1, 242, pl. 30; van Lohuizen-de Leeuw 1979, 126–144; Galestin 1939a. Candi Sawentar: *ROC* 1908, 44–45, pl. 102; Montana 1985, 735.

116
Pendant decorated with three wheels
second half 14th century
East Java
gold, 5 1/2 in. (14 cm)
Royal Tropical Institute—Tropenmuseum, Amsterdam, inv. no. 1278–7

IN THIS GRACEFUL, meticulously crafted piece of jewelry, the classical *kāla-makara* motif of the Central Javanese period reached its final stage of evolution, as it coils like a pair of snakes around the central motif of three wheels. From a pearl-rimmed wheel with eight spokes and a quadrilobate hub, the center of this intricate composition, rises a column crowned by a demon's mask. His full set of long teeth and a well-developed lower jaw characterize him as an East Javanese descendant of the monster-without-lower-jaw, familiar from Central Javanese *candi*s and the direct ancestor of today's Balinese demon masks. The mask occupies the center of a horizontal bar that terminates in both sides in bird's heads. From the beaks of these Garuda-like birds ribbons or striped bands descend. Twisted into loops halfway down, they end in stylized *makara* heads turned outward, almost completely dissolved into floral ornament. These two *makaras* are connected by a plain ribbon twisted into a loop just below the largest of the three wheels.

A comparison with another ornament of almost the same size and probably dating from about the same period demonstrates the simultaneous existence of the same *kāla-makara* motif in two widely different phases of stylization. In the Sūrya ornament (cat. 115) the *kāla*-head has disappeared, its place taken by the sun god himself, or perhaps by the jewel once mounted in the now-empty socket at the center top. The *makaras*, on the other hand, are shown as typical East Javanese dragons with sharp teeth.

The leaf-shaped appendages attached to the edges of both ornaments by means of gold wire were probably added as an embellishment by their previous owner, a Chinese merchant from Tulungagung, Kediri. The back of the ornament shows a pin to attach the piece of jewelry to clothing, also suspected as a modification by its previous owner. Sculpture of the East Javanese period shows jewelry of all sorts in great detail, but no statuary or relief has been found that shows a piece of jewelry of this type.

The wheel (*sudarsanacakra*) is a symbol associated, like the conch, with the god Visnu, but the symbolism of a composition that includes three wheels has defied an adequate interpretation.

Literature: Galestin 1939a; Chicago 1949, no. 4; Wagner 1959, 116; Bosch 1960, pl. 49a.

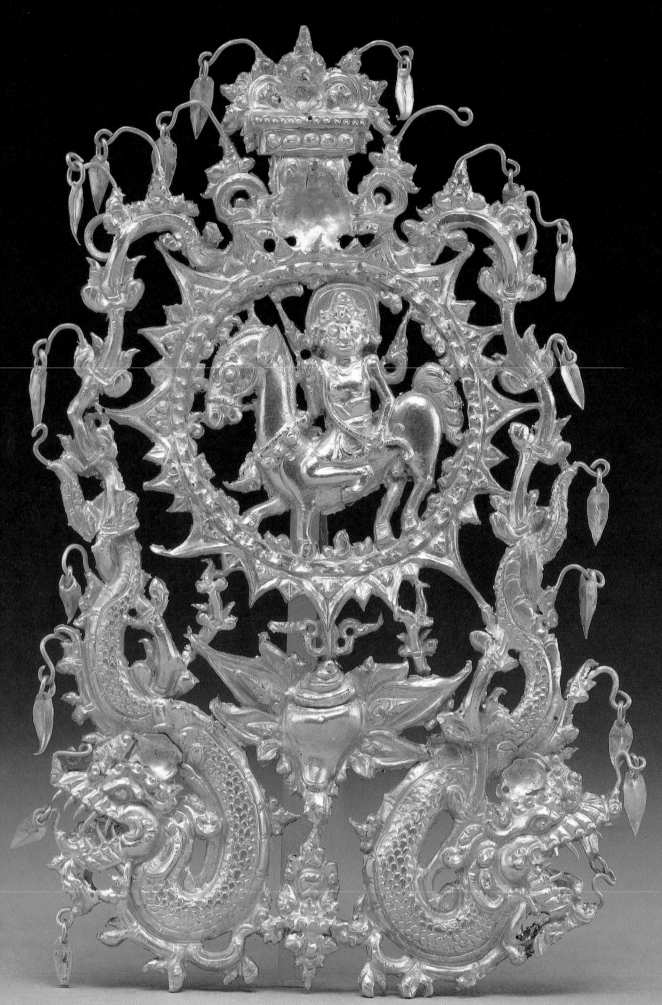

cat. 115

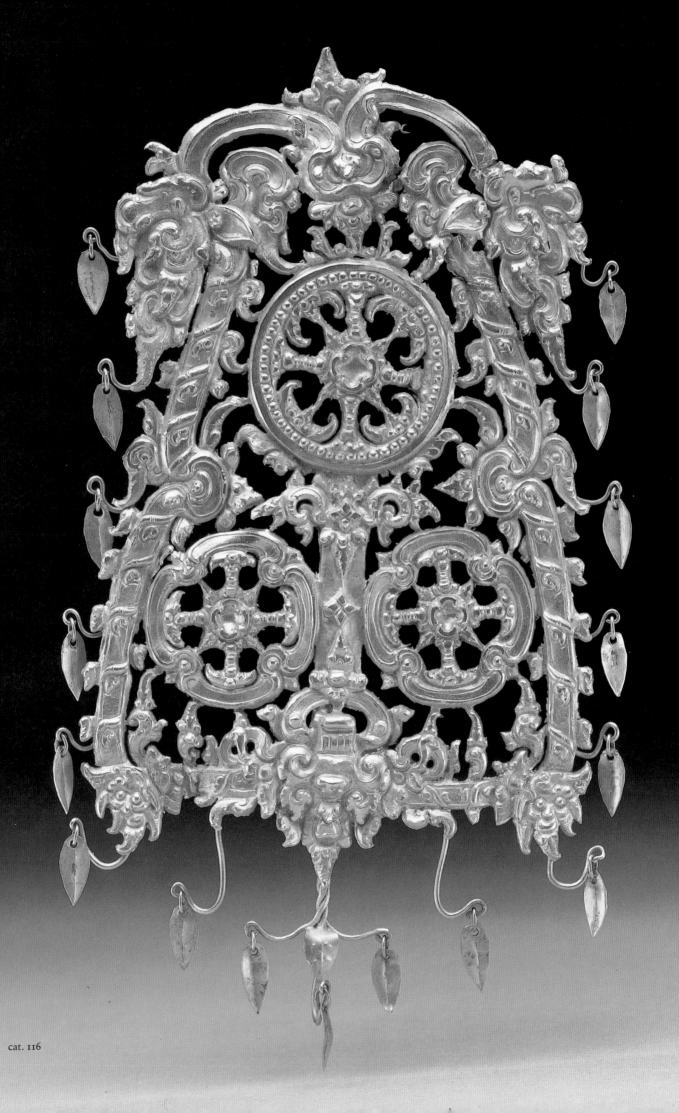

cat. 116

abhaya-mudrā: the fear-dispelling symbolic gesture of a figure of the Buddhist pantheon, made by raising the right hand with the palm facing outward.

agama: religion.

ahimsā: harmlessness; the practice of not injuring or killing any sentient being.

aksamālā: a rosary used by brahmanic and Buddhist sects.

ālidhā: posture similar to that adopted while drawing a bow, with the right leg stretched and the left leg bent (compare *pratyālidhā*).

āmalaka: fluted, melon-shaped component crowning a pillar or spire of a temple.

ankuśa: an elephant prod.

astanidhi: the eight treasure pots of Kuvera or Jambhala.

asura: one of the Eight Classes of Supernatural Beings.

bhūmisparśa-mudrā: the earth-touching gesture in which the middle finger of the right hand touches the base or throne and the left hand rests in the lap, palm upward. This symbolic gesture was adopted by the Buddha Śākyamuni to call on the earth goddess to witness his resistance to the temptations of Māra, the evil one.

bodhyagrī-mudrā: the wisdom-fist gesture in which both hands are raised before the chest, the pointed index finger of the left clenched in the right fist.

cāmara: fly whisk.

candi: commemorative shrine; word also used for other types of ancient Indonesian monuments.

candi bĕntar: literally "split candi," a gateway consisting of two separate, symmetrical parts flanking the entrance to a temple. If placed together, these two parts would form the outline of a *candi*.

candrasa: originally the name of the legendary weapon of Rāvana; also used for a type of socketed bronze ax with a large, thin, crescent-shaped blade.

candrasĕngkala: rebus-like Javanese method of indicating the year. In it four words or images are assigned traditional numerical values; the four digits together form a year, usually of the Śaka era.

channavīra: crossed sacred thread for women and youthful persons.

chattra: parasol.

cungkup: East Javanese term for *candi*.

danda: staff or mace.

dharmacakra-mudrā: the gesture of Turning the Wheel of the Law, a reference to the first sermon delivered by the Buddha at the Deer Park of Benares. The two hands are raised before the chest, making the shape of a wheel with the touching fingertips.

dhotī: loincloth.

dhūpa: incense.

dhyāna-mudrā: the symbolic gesture of meditation, in which the hands lie, palm upward, one on top of the other in the lap.

Dhyāni-Buddha: see *Jina*.

dikpālaka: one of the Eight Regents of the Quarters.

dvarapāla: door guardian.

gada: mace.

gandha: incense.

gapatta: strap used to hold up the raised knee of a person seated in a relaxed pose.

gĕndi: see *kĕndi*.

ghantā: bells of different types, ranging from large temple bells to small hand bells.

hasta: symbolic gesture of the hands.

jatāmukuta: tall headdress of matted hair.

Jina: literally "conqueror" or "Victorious One," epithet of the Buddha and of the Five Cosmic Buddhas (called *Dhyāni-Buddhas* in the older literature).

kakawin: metric poem in Old Javanese.

kāla: literally "time, death, or black"; name given to a demon's mask mounted above doorways and niches.

kamandalu: water vessel, often used by ascetics.

kapala: skull cup.

kĕbĕn: name of a Javanese fruit; a stylized, repetitive ornament based upon this fruit, used on top of walls of palaces and shrines.

kĕndi: spouted water vessel.

kĕntongan: Javanese name for the slit drum called *tong-tong* in Indonesian and *kulkul* in Balinese.

kĕris or *kris*: Indonesian weapon resembling a sword, forged by the *pamor* technique.

khadga: sword.

khakkhara: staff used by mendicants, usually with a finial incorporating jingling rings or bells.

khatvāṅga: scepter decorated with super-imposed skulls; a magic wand that is an attribute of Tantric deities.

kinnara, kinnarī: male and female mythical beings, half human, half bird; they act as heavenly musicians.

kirītamukuta: conical cap or crown with decoration of jewelry.

kīrtimukha: literally "Face of Glory"; the name given to the demon's mask mounted above doorways; also known as *kāla*.

kraton or *kĕraton*: palace of a king or sultan.

krodha: demonic aspect of a deity.

kumāra: youth. Certain gods and bodhisattvas are traditionally shown with a youthful appearance.

kumbha: vase or vessel.

lakon: the plot or story of a *wayang* performance.

laksana: bodily characteristic of the Buddha, such as *ūrṇā, usnīsa,* etc.

lalitāsana: seated posture with one leg folded upon the seat and the other dangling.

makara: mythical aquatic beast, probably derived from the crocodile, sometimes with elephant's trunk. Together with the *kāla,* the *makara* is used to frame doorways and niches of temples.

mandala: Buddhas and deities of the pantheon, arranged in diagrammatic fashion in various geometric configurations, used as an aid in meditation.

mudrā: symbolic gesture of the hands.

nāga: mythical serpent, sometimes resembling a dragon; female, *nāginī*.

pamor: a forging technique in which iron ore and meteorite are combined to produce a steel blade with wavy patterns.

pĕndopo: structure without walls, usually consisting of a pyramidal roof supported by columns placed on a raised platform.

pradaksiṇā: clockwise circumambulation; a ritual performed around *stūpas* and other Buddhist monuments.

pralambapāda: seated posture in the "western" manner, both legs hanging down and the feet resting upon a lotus cushion.

pratyālidhā: opposite of *ālidhā,* in which the left leg is stretched and the right leg is bent.

pura: Balinese temple.

pusaka: heirloom.

puspa: flower.

pustaka: book.

Śaka: an era of Indian chronology, commonly used in Indonesia during the classical period. The Śaka era was assumed to have started in AD 79, five hundred years after the birth of the Buddha.

sĕmbah: Javanese gesture of respectful greeting with the hands folded together; also called *añjali-mudrā*.

stambha: column or standard.

stūpa: Buddhist monument for the ashes of monks and saints, consisting of a dome-shaped body on a square base, crowned by a pinnacle with a parasol.

tarjanī: literally "the finger that threatens"; minatory gesture in which the index finger is pointed at the adversary in a threatening manner.

tĕkĕs: flat Javanese headgear, often worn by Panji and other Javanese heroes.

tribhanga: literally "thrice bent"; a flexed stance of the body in which the line of the body changes direction twice.

triśūla: trident.

upavīta: sacred thread.

ūrṇā: a small curl on the forehead, one of the distinctive bodily marks of a Buddha.

usnīsa: "wisdom bump"; a cranial protuberance, one of the distinctive bodily marks of a Buddha.

vajra: thunderbolt.

vihāra: monks' abode.

virāsana: seated pose with crossed legs, also called *sattvaparyanka*.

viśvavajra: ritual implement consisting of two crossed double *vajras*.

vitarka-mudrā: symbolic gesture of argumentation in which the right hand is raised with thumb and index finger forming a circle.

BIBLIOGRAPHY

In Dutch names, *ij* is alphabetized as *y*.

ABIA
Annual Bibliography of Indian Archaeology

AIA
Fontein, Jan, R. Soekmono, and Satyawati Suleiman. *Ancient Indonesian Art of the Central and East Javanese Periods*. New York, 1971.

Adiceam 1965
Adiceam, Marguerite E. "Les images de Śiva dans l'Inde du Sud, II Bhairava." *Arts Asiatiques* 11 (1965), fasc. 2, 23–45.

Amsterdam 1936
Catalogus Tentoonstelling Aziatische Kunst. Exh. cat. Stedelijk Museum. Amsterdam, 1936.

Amsterdam 1938
Uit de Schatkamers der Oudheid. Exh. cat. Stedelijk Museum. Amsterdam, 1938.

Amsterdam 1953
Auction Catalogue Mak van Waay 113. Amsterdam, June 1953.

Amsterdam 1954
Oosterse Schatten. Exh. cat. Rijksmuseum. Amsterdam, 1954.

Amsterdam 1988
Lunsingh Scheurleer, Pauline, and Marijke J. Klokke. *Divine Bronze.* Exh. cat. Rijksmuseum. Amsterdam, 1988.

Amsterdam 1989
Fine Indonesian Sculpture and Works of Art. Sale cat., Christie's. Amsterdam, 7 June 1989.

Asher 1980
Asher, Frederick M. *The Art of Eastern India, 300–800.* Minneapolis, 1980.

Boston Museum 1982
Asiatic Art in the Museum of Fine Arts, Boston. Boston, 1982.

Auboyer 1949
Auboyer, Jeannine. *Le Trône et son symbolisme dans l'Inde ancienne.* Paris, 1949.

Ayatrohaedi 1986
Kepribadian Budaya Bangsa (Local Genius). Ed. Ayatrohaedi. Jakarta, 1986.

Bandyopadhyay 1981
Bandyopadhyay, Bimal. *Metal Sculpture of Eastern India.* Delhi, 1981.

Banerjea 1956
Banerjea, Jitendra Nath. *The Development of Hindu Iconography.* Calcutta, 1956.

BEFEO
Bulletin de l'Ecole Française d'Extrême-Orient

Bellwood 1985
Bellwood, Peter. *Prehistory of the Indo-Malaysian Archipelago.* Orlando, 1985.

van Bemmelen 1949
van Bemmelen, R. W. *The Geology of Indonesia.* Vol. I, The Hague, 1949.

Berg 1951–1953
Berg, C. C. "De Sadeng-oorlog en de mythe van Groot Majapahit." *Indonesië* 5 (1951–1953), 385–422.

Berg 1981
Berg, C. C. "Naar aanleiding van Prajñā-pāramitā's recente verhuizing." *BKI* 137 (1981), 191–228.

Bernet Kempers 1931
Bernet Kempers, A. J. "Een Hindoe-Javaansch Beeld in het Britsch Museum." *BKI* 88 (1931), 514–518.

Bernet Kempers 1933a
Bernet Kempers, A. J. "The Bronzes of Nālandā and Hindu-Javanese Art." *BKI* 90 (1933), 1–88.

Bernet Kempers 1933b
Bernet Kempers, A. J. "Een Oud-Javaansche lamp." *Mededeelingen van den Dienst voor Kunsten en Wetenschappen der Gemeente 'sGravenhage* 3 (March 1933), 19–23.

Bernet Kempers 1933c
Bernet Kempers, A. J. "De beelden van Tjandi Djago en hun voor-Indisch prototype." *MBK* (June 1933), 173–179.

Bernet Kempers 1935
Bernet Kempers, A. J. "Oud-Javaansche Metaalkunst." *Nederlandsch-Indië, Oud en Nieuw. Jaarboek* (1935), 19, 3–35.

Bernet Kempers 1953–1954
Bernet Kempers, A. J. "Oudheidkundig werk in Indonesia na de oorlog." *Indonesië* 7 (1953–1954), 481–513.

Bernet Kempers 1955
Bernet Kempers, A. J. "Prambanan 1954." *BKI* 111 (1955), 6–37.

Bernet Kempers 1959
Bernet Kempers, A. J. *Ancient Indonesian Art.* Amsterdam, 1959.

Bernet Kempers 1976
Bernet Kempers, A. J. *Ageless Borobudur.* Wassenaar, 1976.

Bernet Kempers 1978
Bernet Kempers, A. J. *Herstel in Eigen Waarde.* Zutphen, 1978.

Bernet Kempers 1985
Bernet Kempers, A. J. "Alexander Loudon en zijn collectie Oudjavaanse metaalkunst." *Vereniging van Vrienden der Aziatische Kunst, Mededelingenblad* 15, no. 5 (Amsterdam, December 1985), 6–15.

Bintarti 1981
Bintarti, D. D. *The Bronze Object from Kabila, West Sabu, Lesser Sunda Island, Aspek-aspek Arkeologi Indonesia* 8. Jakarta, 1981.

Bintarti 1985
Bintarti, D. D. "Prehistoric Bronze Objects in Indonesia." *Bulletin of the Indo-Pacific Prehistory Association* (Canberra, 1985), 64–73.

BKI
Bijdragen Koninklijk Instituut voor de Taal-Land-en Volkenkunde.

Blom 1935
van Blom, Jan Rombout. *Tjandi Sadjiwan.* Ph.D. diss. Leiden, 1935.

Blom 1939
Blom, Jessy. *The Antiquities of Singasari.* Ph.D. diss. Leiden, 1939.

Blom 1953
Oey-Blom, Jessy. "Arca Buddha perunggu dari Sulawesi" (A Buddhist bronze statue from Sulawesi). *Amerta* 1 (1953, repr. 1985), 62–64.

Blondy 1895
Blondy, Godefroy de. *Matériaux pour servir à l'histoire de la déesse Bouddhique Tārā*. Paris, 1895.

Boechari 1976
Boechari. *Some Consideration of the Problem of the Shift of Mataram's Centre of Government from Central to East Java in the Tenth Century AD, Bulletin of the National Research Centre of Archaeology of Indonesia* 10. Jakarta, 1976.

Boeles 1942
Boeles, J. J. "Het Groote Durga Beeld te Leiden." *Cultureel Indië* 4 (Leiden, 1942), 37–50.

Boeles 1985
Boeles, Jan J. *The Secret of Borobudur*. Bangkok, 1985.

Bosch 1918
Bosch, F. D. K. *OV* (1918), 21.

Bosch 1919
Bosch, F. D. K. "Een hypothese omtrent den oorsprong der Hindoe-Javaansche Kunst." *Handelingen van het Eerste Congres voor de Taal-, Land-, en Volkenkunde van Java*. Solo, 25–26 December 1919. Weltevreden, 1921, 93–169, pl. 7.

Bosch 1922
Bosch, F. D. K. "Aanwinsten van de Archaeologische Collectie van het Bataviaasch Genootschap, 5, Een bronzen vat van Kerintji." *OV* (1922), 65–66.

Bosch 1923a
Bosch, F. D. K. "De Banaspati-kop van Tjandi Singosari." *Djawa* 3 (1923), 95.

Bosch 1923b
Bosch, F. D. K. "Oudheden in Particulier Bezit." *OV* (1923), 138–154.

Bosch 1925
Bosch, F. D. K. "Oudheden in Koetei." *OV* (1925), 132–146.

Bosch 1929a
Bosch, F. D. K. "De bronzen klok van Kalasan." *MBK* 1929, 149.

Bosch 1929b
Bosch, F. D. K. "Twee belangrijke aanwinsten van het Batavia'sche Museum." *Feestbundel uitgegeven door het Koninklijk Bataviaasch Genootschap van Kunsten en Wetenschappen bij gelegenheid van zijn 150 jarig bestaan, 1778–1928*. Weltevreden, 1929, 39–48.

Bosch 1933
Bosch, F. D. K. "Het bronzen Buddha-beeld van Celebes' Westkust." *TBG* 73 (1933), 495–513.

Bosch 1934
Bosch, F. D. K. "Bijschriften bij de foto's van eenige belangrijke aanwinsten der Oudheidkundige Verzameling in 1932 en 1933." *JBG* 2 (1934), 110–114.

Bosch 1940
Bosch, F. D. K. "Het bronzen Buddha-beeld met den gouden usnisha." *MBK* (December 1940), 324–328.

Bosch 1952
Bosch, F. D. K. *Local Genius en Oud-Javaanse Kunst, Mededelingen van de Koninklijke Nederlandsche Akademie van Wetenschappen*. Nieuwe Reeks 15:1 (1952).

Bosch 1954
Bosch, F. D. K. "De Hindoe Javaansche bronzen Priesterschel uit de collectie Loudon voor het Museum van Aziatische Kunst aangekocht." *Bulletin Rijksmuseum* 2 (1954), 15–18.

Bosch 1955
Bosch, F. D. K. "Aanwinsten uit de collectie Loudon voor het Museum van Aziatische Kunst." *Bulletin Rijksmuseum* 3 (1955), 22, no. 1, fig. 2.

Bosch 1956
Bosch, F. D. K. "C. C. Berg and Ancient Javanese History." *BKI* 112 (1956), 1–24.

Bosch 1960
Bosch, F. D. K. *The Golden Germ*. The Hague, 1960.

Bosch 1961a
Bosch, F. D. K. "Buddhist Data from Balinese Texts." *Selected Studies in Indonesian Archaeology*. The Hague, 1961, 111–113.

Bosch 1961b
Bosch, F. D. K. "The God with the Horse's Head." *Selected Studies in Indonesian Archaeology*. The Hague, 1961, 137–152.

Bosch 1961c
Bosch, F. D. K. "The Oldjavanese bathing-place Jalatunda." *Selected Studies in Indonesian Archaeology*. The Hague, 1961, 49–107, 111–130.

Bosch 1961d
Bosch, F. D. K. "The Problem of the Hindu Colonisation of Indonesia." *Selected Studies in Indonesian Archaeology*. The Hague, 1961, 1–22.

Bosch 1965
Bosch, F. D. K. "The Oldjavanese Bathing Place Jalatunda." *BKI* 121 (1965), 189–232.

Bosch and Le Roux 1931
Bosch, F. D. K., and C. C. F. M. Le Roux. "Wat te Parijs verloren ging." *TBG* 71 (1931), 663–683.

Brandes 1889
Brandes, J. L. A. "Een Jayapattra of acte van een rechterlijke uitspraak van Çaka 849." *TBG* 32 (1889), 122.

Brandes 1901
Brandes, J. L. A. "Een fraaie variatie van het olifant-visch- of Makara-ornament." *NBG* 39 (1901), CIX–CXVI.

Brandes 1902a
Brandes, J. L. A. "Bijschrift bij de door de Heer Neeb gezonden photo's van oudheden in het Djambische." *TBG* 45 (1902), 128–133.

Brandes 1902b
(Brandes, J. L. A.) "Tjandi Bima beschreven voor zover als reeds doenlijk is." *ROC* (1902), 16–30.

Brandes 1904a
Brandes, J. L. A. *Beschrijving van de ruïne bij de desa Toempang genaamd Tjandi Djago*. The Hague, 1904.

Brandes 1904b
Brandes, J. L. A. "De troon van de hoofdkamer van den hoofdtempel van het Tjandi Sewoe-complex vergeleken met de tronen in de Tjandi Měndoet en de Tjandi Kalibening of Kalasan." *ROC* (1904), 159–170.

Brandes 1904c
Brandes, J. L. A. "De verzameling gouden godenbeelden gevonden in het gehucht Gemoeroeh bij Wanasaba en naar aanleiding daarvan iets over Harihara en de geschiedenis van het uiterlijk van Garuda op Java." *TBG* 47 (1904), 552–576.

Brandes 1909
Brandes, J. L. A. *Beschrijving van Tjandi Singasari en De Wolkentoneelen van Panataran*. The Hague, 1909.

Brandes 1920
Brandes, J. L. A. *Pararaton (Ken Arok), Het Boek der Koningen van Tumapel en van Majapahit, Verhandelingen van het Bataviaasch Genootschap* 49. Ed. N. J. Krom. The Hague, [1896]. 2d ed. The Hague, 1920, 62.

Brumund 1854
Brumund, J. F. G. *Indiana* 2 (1854), 43.

Brumund 1868
Brumund, J. F. G. *Bijdragen tot de kennis van het Hindoeisme op Java, Verhandelingen Bataviaasch Genootschap* 33 (1868).

Brussels 1953
Exposition d'art Indonésienne, ancien et moderne. Exh. cat. Palais de Beaux Arts. Brussels, 1953.

Brussels 1977
Borobudur, Kunst en religie in het oude Java. Exh. cat. Paleis voor Schone Kunsten. Brussels, 1977.

de Bruyn 1937
de Bruyn, J. V. *H. N. Sieburgh en zijn Beteekenis voor de Javaansche Oudheidkunde*. Ph.D. diss. Leiden, 1937.

van Buitenen 1973
The Mahābhārata 1, The Book of the Beginning. Trans. and ed. J. A. B. van Buitenen. Chicago, 1973.

de Casparis 1956
de Casparis, J. G. *Selected Inscriptions from the 7th to the 9th Century AD*. Bandung, 1956.

de Casparis 1958
de Casparis, J. G. *Short Inscriptions from Tjandi Plaosan-Lor, Bulletin of the Archaeological Service of the Republic of Indonesia (Berita Dinas Purbakala)* 4. Jakarta, 1958.

de Casparis 1961
de Casparis, J. G. "Historical Writing on Indonesia (Early Period)." *Historians of Southeast Asia*. Ed. D. G. E. Hall. London, 1961, 121–163.

de Casparis 1975
de Casparis, J. G. *Indonesian Palaeography, A History of Writing in Indonesia from the Beginnings to c. AD 1500, Handbuch der Orientalistik*. Vol. 3. Leiden, 1975.

de Casparis 1979
de Casparis, J. G. *Van Avonturier tot Vorst: een belangrijk aspect van de oudere geschiedenis en geschiedschrijving van Zuid- en Zuidoost-Azië*. Leiden, 1979.

de Casparis 1981
de Casparis, J. G. "Pour une histoire sociale de l'ancienne Java, principalement au x-ième Siècle." *Archipel* 21 (1981), 125–151.

de Casparis 1988
de Casparis, J. G. "Where Was Pu Sindok's Capital Situated?" *Studies in South and Southeast Asian Archaeology.* Ed. H. I. R. Hinzler. Leiden, 1988, 39–52.

Chandra 1977
Chandra, Lokesh. "An Indonesian Copper Plate Sanskrit Inscription cum Drawing of Hārītī." *BKI* 133 (1977), 466–471.

Chandra 1980
Chandra, Lokesh. "Chandi Mendut and Pawon: A New Interpretation." *BKI* 136 (1980), 313–320.

Chandra and Singhal 1989
Chandra, Lokesh, and Sudarshana Devi Singhal. "Identification of the Nanjuk Mandala." Unpublished paper, 1989. At International Academy of Indian Culture, New Delhi.

Chhabra 1949
Chhabra, B. Ch. "Three more Yūpa inscriptions of King Mūlavarman from Kutei (East Borneo)." *TBG* 83 (1949), 370–374.

Chicago 1949
Indonesian Art, a Loan Exhibition from the Royal Indies Institute, Amsterdam. Exh. cat. The Art Institute of Chicago. Chicago, 1949.

Christie 1979
Christie, A. H. "The Megalithic Problem in South East Asia." *Early South East Asia.* Ed. R. B. Smith and W. Watson. New York/Kuala Lumpur, 1979, 242–252.

Clark 1937
Clark, Walter Eugene. *Two Lamaistic Pantheons.* 2 vols. New York, 1937.

Coedès 1918
Coedès, George. "Le Royaume de Çrīwijaya." *BEFEO* 18 (1918), 1–36.

Coedès 1960
Coedès, George. "Le portrait dans l'art Khmer." *Arts Asiatiques* 7 (1960), 179–198.

Coedès 1966
Coedès, George. *The Making of Southeast Asia.* Trans. H. M. Wright. London, 1966.

Cohen Stuart 1875
Cohen Stuart, A. B. *Kawi Oorkonden.* 2 vols. Leiden, 1875.

Cologne 1926
Salmony, Alfred. *Asiatische Kunst, Ausstellung Köln.* Exh. cat. Cologne, 1926.

Coomaraswamy 1928–1929
Coomaraswamy, Ananda K. "A Chinese Buddhist Water Vessel and Its Indian Prototype." *Artibus Asiae* (1928–1929), 122–141.

Coomaraswamy 1931
Coomaraswamy, Ananda K. Preface to T. G. Aravamuthan, *Portrait Sculpture in South India.* London, 1931.

Coomaraswamy 1956
Coomaraswamy, Ananda K. *The Transformation of Nature in Art.* New York, 1956.

Coomaraswamy 1965
Coomaraswamy, Ananda K. *History of Indian and Indonesian Art.* New York, 1965.

Cowell 1978
Cowell, E. B., ed. *Jātakas, Stories of Buddha's Former Births* 6 vols. Repr. New Delhi, 1978.

Crucq 1929a
Crucq, K. C. "Aanwinsten van de archaeologische verzameling van het Koninklijk Bataviaasch Genootschap, De bronsvondst te Seloemboeng." *OV* (1929), 286–289.

Crucq 1929b
Crucq, K. C. "Epigrafische Aantekeningen." *OV* (1929), 258–283.

Crucq 1930
Crucq, K. C. "Oudheidkundige Aantekeningen I." *OV* (1930), 216–239.

Crucq 1939
Crucq, K. C. "Inscripties op Spiegelhandvatsels." *Djawa* 19 (1939), 243.

Damais 1952
Damais, Louis-Charles. "Etudes d'épigrafie Indonésienne III." *BEFEO* 46 (1952), 1–105.

Damais 1962
Damais, Louis-Charles. "Etudes Javanaises II, le nom de la déité tantrique de 1214 Śaka." *BEFEO* 50 (1962), 407–416.

Damais 1968
Damais, Louis-Charles. "Bibliographie Indonésienne." *BEFEO* 54 (1968), 295–521.

van Dapperen 1935
van Dapperen, J. W. "Plaatsen van vereering op de Zuidhelling van den Slamat tusschen de rivieren Peloes en Logawa." *Djawa* 15 (1935), 24–32.

Subhadradis Diskul 1980
Subhadradis Diskul, M. C., ed. *The Art of Śrīvijaya.* Kuala Lumpur, 1980.

Djajadiningrat 1934
Atjèhsch-Nederlandsch Woordenboek. Jakarta, 1934.

Dumarçay 1987
Dumarçay, Jacques. *The Temples of Java.* Sinagapore, 1987.

Dupont 1958–1959
Dupont, Pierre. "Les Buddha dits d'Amarāvatī en Asie du Sud-Est." *BEFEO* 49 (1958–1959), 631–666.

Dupont 1959
Dupont, Pierre. *L'archéologie Mône de Dvāravatī.* Paris, 1959.

Dutt 1962
Dutt, Sukumar. *Buddhist Monks and Monasteries of India.* London, 1962.

Dwiyanto 1983
Dwiyanto, Djoko. "Hasil sementara ekskavasi Selomerto: suatu tinjuan arsitektur dan ikonografi" (Preliminary results of the excavation at Selomerto: an observation on architecture and iconography). *Pertemuan Ilmiah Arkeologi* 3 (1983), 438–454.

van Erp 1910
van Erp, Th. "Naschrift." *TBG* 52 (1910), 120–122.

van Erp 1917
van Erp, Th. "Eenige Mededeelingen betreffende de beelden en fragmenten van Boroboedoer in 1896 geschonken aan Z.M. den Koning van Siam." *BKI* 73 (1917), 285–310.

van Erp 1923
van Erp, Th. "Hindu-Javaansche beelden thans te Bangkok." *BKI* 79 (1923), 491–518.

van Erp 1927
van Erp, Th. "Nog eens de Hindu-Javaansche Beelden te Bangkok." *BKI* 83 (1927), 503–513.

van Erp 1929
van Erp, Th. "De Ommanteling van Barabudur's Oorspronkelijke Voet." *Feestbundel Bataviaasch Genootschap* (1929), 1:120–160.

van Erp 1931
van Erp, Th. *Beschrijving van Barabudur, Bouwkundige Beschrijving* (1931).

van Erp 1933a
van Erp, Th. "Verrassende vondst op Celebes: een bijna levensgroote bronzen Boeddha." *MBK* (October 1933), 317–318.

van Erp 1933b
van Erp, Th. "Een merkwaardige Garoedavoorstelling op een Hindoe Javaansche bronzen hangklok." *BKI* 90 (1933), 259–265.

van Erp 1939
van Erp, Th. "Archaeological Finds in Padang Lawas." *ABIA* 14 (1939).

van Erp 1941
van Erp, Th. "Aanwinst voor het Museum van Aziatische Kunst van eenige hindoe-javaansche ceremonieele lampen." *MBK* 18 (April 1941), 102–114, figs. 5–7.

van Erp 1943a
van Erp, Th. "Een fraaie Hindoe-Javaansche Khakkhara." *MBK* 20, no. 4 (1943), 95–96.

van Erp 1943b
van Erp, Th. "Iets over de verlichting der cella van Hindoe-Javaansche heiligdommen." *MBK* 20, nos. 7–8 (1943), 145–154.

van Erp 1943c
van Erp, Th. "De Indische Geluksgodin met de Olifanten." *MBK* 20 (1943), no. 9/10:190–192; no. 11/12:214.

Fontein 1966
Fontein, Jan. *The Pilgrimage of Sudhana.* The Hague, 1966.

Fontein 1971
Fontein, Jan. "The Abduction of Sītā, Notes on a Stone Relief from Eastern Java." *Boston Museum Bulletin* 71, no. 363 (1973), 21–35.

Fontein 1980
Fontein, Jan. "A Buddhist Altarpiece from South India." *Bulletin of the Museum of Fine Arts, Boston* 78 (1980), 4–21.

Fontein 1989
Fontein, Jan. *The Law of Cause and Effect in Ancient Java, Koninklijke Nederlandsche Akademie van Wetenschappen, Verhandelingen Afdeling Letterkunde Nieuwe Reeks Deel* 139. Amsterdam/Oxford/New York, 1989.

Frédéric 1964
Frédéric, Louis. *Sud-East Asiatique.* Paris, 1964.

Friederich 1859
Friederich, R. H. Th. "Beschrijving van een metalen Çivabeeld." *TBG* 8 (1959), 72–75 (English translation in *JRAS* 1873, 276).

Galestin 1936
Galestin, Th. P. *Houtbouw op Oost-Javaansche Tempelreliefs.* The Hague, 1936.

Galestin 1939a
Galestin, Th. P. "Een Hindoe-Javaansch Gouden Sierraad." *Cultureel Indië* 1 (1939), 73–79.

Galestin 1939b
Galestin, Th. P. "De onverklaarde reliefs van Tjandi Kedaton." *Cultureel Indië* 1 (1939), 154–156.

Galestin 1951
Galestin, Th. P. "De kop van Sukuh." *Bulletin van de Vereeniging van Vrienden der Aziatische Kunst* N.S. 33 (June 1951), 81–88.

Galestin 1958
Galestin, Th. P. "Aantekeningen bij een bronzen lamp van Java." *BKI* (1958), 81–97.

Galestin 1967
Galestin, Th. P. "An Interesting Stone Toppiece of the Oldjavanese Bathing Place Jalatunda." *Pratidānam*. The Hague, 1967, 539–549.

Galis 1956
Galis, K. W. "Oudheidkundig onderzoek in Nederlandsch Nieuw Guinea." *BKI* 112 (1956), 271–278, with *postscriptum* ("Naschrift") by A. N. J. van der Hoop, 279–284.

Ghautama 1986
Ghautama, Gatot. "Bentuk-bentuk payung pada relief Karmawibhangga dan Lalitawistara di Candi Borobudur" (The shapes of parasols in the reliefs of the Karmavibhangga and Lalitawistara at Candi Borobudur). *Pertemuan Ilmiah Arkeologi* 4. Jakarta, 1986, 218–225.

Ghosh 1980
Ghosh, Mallar. *Development of Buddhist Iconography in Eastern India: A Study of Tārā, Prajñās of the Five Tathāgatas and Bhrikuṭī.* New Delhi, 1980.

Ghosh 1951
Ghosh, Manomohan. *The Natyasastra Ascribed to Bharatamuni.* Bibliotheca Indica no. 273. Calcutta, 1951.

Godakumbura 1969
Godakumbura, C. E. *The Kotavehera at Dedigama, Memoirs of the Archaeological Survey of Ceylon.* Vol. 7. Colombo, 1969.

Goloubew 1929
Goloubew, Victor. "L'âge du bronze au Tonkin et dans le Nord-Vietnam." *BEFEO* 29 (1929), 1–46, pl. 19b.

Gonda 1970
Gonda, Jan. "Śiva in Indonesien." *Wiener Zeitschrift für die Kunde Südasiens* 14 (1970), 1–32.

van Goor 1920
van Goor, M. E. Lulius. "Een paar medeelingen betreffende de Bronsvondst van Ngandjoek." *NBG* 58 (1920), 81–87.

Goris n.d.
Goris, R. *Bali, Cults and Customs.* Jakarta, n.d.

de Graaf and Pigeaud 1974
de Graaf, H. J., and Th. G. Th. Pigeaud. *De eerste Moslimse vorstendommen op Java.* The Hague, 1974.

Grader 1939
Grader, C. J. "Brajoet, de Geschiedenis van een Balisch Gezin." *Djawa* 19 (1939), 260–275.

Groeneveldt 1887
Groeneveldt, W. P. *Catalogus der Archaeologische Verzameling van het Bataviaasch Genootschap van Kunsten en Wetenschappen.* Batavia, 1887.

Groneman 1895
Groneman, J. L. *De Garĕbĕg's te Ngajogyakarta.* The Hague, 1895.

de Haan and Bosch 1925
de Haan, B., and F. D. K. Bosch. "Tjandi Kidal A. Bouwkundige Beschrijving B. Historische en iconographische Beschrijving." *Publicaties van den Oudheidkundigen Dienst in Nederlandsch-Indië* 1 (1925), 1–7, 8–14.

Hadimuljono 1982–1983
Hadimuljono, R. *Candi Jawi.* Jakarta, 1982–1983.

The Hague 1922
Catalogus Tentoonstelling Indische Beeldhouwkunst. Exh. cat. The Hague, 1922.

Harmsen-Ydema 1975
Harmsen-Ydema, T. M. M. "Een Oost-Javaansche terracotta." *Bulletin Rijksmuseum* (1975), 87–89, fig. 1.

van Heekeren 1958
van Heekeren, H. R. *The Bronze-Iron Age of Indonesia, Verhandelingen KITLV* 22. The Hague, 1958.

Heine-Geldern 1936
R. von Heine-Geldern. "Prehistoric Research in Indonesia." *Annual Bibliography of Indian Archaeology,* 9 (1936), 35–36.

van Hinloopen Labberton 1920
van Hinloopen Labberton, D. "Oud-Javaansche gegevens omtrent de vulkanologie an Java." *Djawa* 1 (1920), 185–198.

Hinzler and Schoterman 1979
Hinzler, H. I. R., and J. A. Schoterman. "A Preliminary Note on Two Recently Discovered Mss. of the Nāgarakrtāgama." *BKI* 135 (1979), 481–484.

Hoepermans 1913
Hoepermans, N. W. "Hindoe-oudheden van Java." *ROD* (1913), 270.

Holle 1877
Holle, K. F. "De klok of Kohkol van Galoeh." *TBG* 24 (1877), 583–585.

Holt 1967
Holt, Claire. *Art in Indonesia: Continuities and Change.* Ithaca, 1967.

van der Hoop 1941
van der Hoop, A. N. J. Th. à Th. *Catalogus der Praehistorische Verzameling van het Bataviaasch Genootschap.* Bandung, 1941.

Hooykaas 1931
Hooykaas, C. *Tantri-Kāmandaka.* Bandung, 1931.

Hooykaas 1955
Hooykaas, C. *The Old Javanese Rāmāyana Kakawin with Special Reference to Interpolation in Kakawins.* The Hague, 1955.

Hooykaas 1958
Hooykaas, C. *The Old Javanese Rāmāyana, an Exemplary Kakawin as to the Form and Content.* Amsterdam, 1958.

Huntington 1985
Huntington, Susan L. *Ancient India, Buddhist, Hindu, Jain.* New York, 1985.

Jakarta 1986
Pameran Peninggalan Sejarah & Kerpurbakalaan, Mataram dan Denpasar (An exhibition of historical and archaeological remains, Mataram and Denpasar). Jakarta, 1986.

Jasper 1904
Jasper, J. E. "Staatsie, Gevolg en Songsong van Inlandsche Ambtenaren in de Gouvernementslanden op Java en Madoera." *Tijdschrift van het Binnenlandsch Bestuur* 28, 1 (1904).

JBG
Jaarboek van het Bataviaasch Genootschap voor Kunsten en Wetenschappen, 1933–1947.

de Jong 1974
de Jong, J. W. "Notes on the Sources and the Text of the Sang Hyang Kamahāyānan Mantrayana." *BKI* 130 (1974), 465–482.

JRAS
Journal of the Royal Asiatic Society.

Juynboll 1906
Juynboll, H. H. *Adiparwa, Oudjavaansch prozageschrift.* The Hague, 1906.

Juynboll 1909
Juynboll, H. H. *Katalog des Ethnografischen Reichsmuseums, Band 5, Javanische Altertümer.* Leiden, 1909.

Juynboll 1926
Juynboll, H. H. "De Geschiedenis van Garuda." *Gedenkschrift uitgegeven ter gelegenheid van het 75-jarig bestaan van het KITLV van N. I.* The Hague, 1926, 156–170.

Kaogu 1984
The Archaeological Section of the Hunan Provincial Museum. "Excavation of a Warring States Tomb at Shumuling and a Western Han Tomb at Amiling" (text in Chinese). *Kaogu* no. 9, 1894, 790–815.

Katamsi 1960
Katamsi, R. J. "Tunas dan Kura-kura Kentjana" (Buds and tortoises in gold). *Sana Budaya* Tahun ke 1, no. 8 (August 1960), 366–369.

Kern 1910
Kern, H. "De Sanskrit-inscriptie van 't Mahāksobhya-beeld te Simpang." *TBG* 52 (1910), 99–108.

Khandelwal 1977
Khandelwal, Vijay K., a.o. "Cataloguing and Matching of 'Missing' Borobudur Stones Using a Computer." *Pelita Borobudur,* Seri B, 9. Jakarta, 1977.

Knebel 1903
Knebel, J. "De Doerga-voorstelling in de beeldhouwkunst en de litteratuur der Hindoes." *TBG* 46 (1903), 213–240.

Knebel 1905a
Knebel, J. "Prototype en variant in de Doerga-voorstelling van de Hindoesche beeldhouwkunst op Java." *TBG* 48 (1905), 317–338.

Knebel 1905b
Knebel, J. "De Asoera in de Doerga-voorstelling van de Hindoe-beeldhouwkunst op Java." *TBG* 48 (1905), 517–526.

Knebel 1907
Knebel, J. "Beschrijving der Hindoe-oudheden in the afdeeling Djombang." *ROC* (1907), 115–142.

Knebel 1908
Knebel, J. "Beschrijving der Hindoe-oudheden in de afdeeling Toeloeng-agoeng." *ROC* (1908), 181–232.

Koleksi Pilihan 1
Koleksi Pilihan Museum Nasional, Jilid ke 1 (Selected collection of the Museum Nasional, vol. 1). Jakarta, 1980.

Koleksi Pilihan 2
Koleksi Pilihan Museum Nasional, Jilid ke 2 (Selected collection of the Museum Nasional, vol. 2). Jakarta, 1984.

Koleksi Pilihan 3
Koleksi Museum Nasional, Jilid ke 3 (Collection of the Museum Nasional, vol. 3). Jakarta, 1985–1986.

Kompas 1989a
Bail, R. "Badan di Jakarta, tangan di Solo" (The body in Jakarta, the hands in Solo). *Kompas* (17 January 1989).

Kompas 1989b
"Tangan Avalokitesvara di Solo ditemukan karena kebetulan" (The hands of the Avalokiteśvara discovered by accident). *Kompas* (18 January 1989).

Krairiksh 1980
Krairiksh, Piriya. *Art in Peninsular Thailand Prior to the Fourteenth Century A.D.* Bangkok, 1980.

Krom 1912
Krom, N. J. "Bijschrift bij de foto van den kop van Tjandi Sewoe." *TBG* 54 (1912), 129–134.

Krom 1913
Krom, N. J. "De bronsvondst van Ngandjoek." *ROD* (1913), 59–72.

Krom 1917
Krom, N. J. "Een Javaansche brons-collectie." *Nederlandsch Indië Oud en Nieuw* (1917), 385–395, figs. 2–3.

Krom 1918–1919
Krom, N. J. "Hindoe-Javaansche bronzen, de Collectie Loudon." *Nederlandsch-Indië Oud en Nieuw* 3, no. 12 (1918–1919), 383–395.

Krom 1919
Krom, N. J. "De eerste opname van het Diëng-plateau. Handschrift van H.C. Cornelius." *BKI* 75 (1919), 384–437.

Krom 1920
Krom, N. J. *Beschrijving van Barabudur, Archaeologische Beschrijving* 1. The Hague, 1920, 372–373.

Krom 1923
Krom, N. J. *Inleiding tot de Hindoe-Javaansche Kunst*. 3 vols. The Hague, 1923.

Krom 1925
Krom, N. J. "Oudheden bij Bojolali in 1841." *OV* (1925), 174–183.

Krom 1926
Krom, N. J. *L'art Javanais dans les musées de Hollande et de Java*. Ars Asiatica 8. Paris/Brussels, 1926.

Krom 1927
Krom, N. J. *Barabudur, Archaeological Description*. 2 vols. The Hague, 1927.

Krom 1931
Krom, N. J. *Hindoe-Javaansche Geschiedenis*. 2d rev. ed. The Hague, 1931.

Kunst 1958
Kunst, Jaap. *Hindu-Javanese Musical Instruments*. The Hague, 1958.

Laporan 1982
Laporan Pemugaran Peninggalan Sejarah dan Purbakala Jawa Tengah dan Daerah Istimewa Yogyakarta (Report on the restoration of historical and archaeological remains, Central Java and the Special Area of Yogyakarta). Jakarta, 1982.

Van Leur 1955
Van Leur, J. C. *Indonesian Trade and Society*. The Hague/Bandung, 1955.

Lévi D'Ancona 1952
Lévi D'Ancona, Mirella. "Amarāvatī Ceylon and Three Imported Bronzes." *The Art Bulletin* (March 1952), 1–18.

Lim 1964
Lim, K. W. "Studies in Later Buddhist Iconography." *BKI* 120 (1964), 327–341.

Linden-Museum 1984
van Lohuizen-de Leeuw, J. E. *Indo-Javanese Metalwork*. Catalogue, Linden-Museum. Stuttgart, 1984.

van Lohuizen-de Leeuw 1955
van Lohuizen-de Leeuw, J. E. "The Dikpālakas in Ancient Java." *BKI* 111 (1955), 356–384.

van Lohuizen-de Leeuw 1965
van Lohuizen-de Leeuw, J. E. "The Dhyāni-Buddhas of Barabudur." *BKI* 121 (1965), 389–416.

van Lohuizen-de Leeuw 1979
van Lohuizen-de Leeuw, J. E. "An Indo-Javanese Garden of Eden." *The Royal Asiatic Society, Its History and Treasures*. Ed. Stuart Simmonds and Simon Digby. Leiden/London, 1979, 126–144.

van Lohuizen-de Leeuw 1981
van Lohuizen-de Leeuw, J. E. "The Dvarapāla of Borobudur: New Evidence for the Date of the Foundation of the Monument." *Barabudur History and Significance of a Buddhist Monument*. Ed. Luis Gómez and Hiram Woodward, Jr. *Berkeley Buddhist Studies Series* (1981), 15–23.

van Lohuizen-de Leeuw 1982
van Lohuizen-de Leeuw, J. E. "Which European Scholar First Drew Attention to the Unique Dvarapāla of Barabudur?" *BKI* 138 (1982), 285–294.

van Lohuizen-de Leeuw 1984
van Lohuizen-de Leeuw, J. E. "The Images from Candi Suko as Described by van der Vlis in 1841." *BKI* 140 (1984), 263–270.

Los Angeles 1985
The Eloquent Dead, Ancestral Sculpture of Indonesia and Southeast Asia. Ed. Jerome Feldman. Exh. cat. UCLA Museum of Cultural History. Los Angeles, 1985.

Mabbett 1986
Mabbett, Ian. "Buddhism in Champa." *Southeast Asia in the 9th to 14th Centuries*. Ed. David G. Marr and A. C. Milner. Singapore, 1986, 289–313.

MacKnight 1986
MacKnight, C. C. "Changing Perspectives in Island Southeast Asia." *Southeast Asia in the 9th to 14th Centuries*. Ed. David G. Marr and A. C. Milner. Singapore, 1986, 215–228.

Mainz 1980
Java und Bali, Buddhas, Götter, Helden, Dämonen. Exh. cat. Linden-Museum, Stuttgart. Mainz am Rhein, 1980.

Malleret 1956
Malleret, Louis. "Objets de bronze communs au Cambodge, à la Malaysie et à l'Indonésie." *Artibus Asiae* 19 (1956), 308–327.

Mallmann 1956
Mallmann, Marie-Thérèse de. "A propos d'une sculpture du British Museum." *Oriental Art* N.S. 2 (1956), 64–65.

Mallmann 1975
Mallmann, Marie-Thérèse de. *Introduction à l'iconographie du Tantrisme Bouddhique*. Paris, 1975.

Manguin 1987
Manguin, Pierre-Yves. "Etudes Sumatranaises." *BEFEO* 76 (1987), 337–402.

MBK
Maandblad voor Beeldende Kunsten.

McKinnon 1985
McKinnon, E. Edward. "Early Polities in Southern Sumatra: Some Preliminary Observations Based on Archaeological Evidence." *Indonesia* 40 (October 1985), 1–36.

Menengal Koleksi 1978–1979
Mengenal Koleksi Museum Negeri Jawa Timur "Mpu Tantular" (Knowing the collection of the East Java State Museum Mpu Tantular). Proyek Pengembangan Permuseuman Jawa Timur, 1978/1979.

Meyer 1939
Meyer, D. H. "De spleettrom." *TBG* 79 (1939), 415–446.

Miksic 1989
Miksic, John. *Old Javanese Gold*. Singapore, 1989.

Mitra 1958
Mitra, Debala. "A Temple of the Buddhist God Mahākāla." *Indian Historical Quarterly* 34 (March 1958), 1–5.

Mitra 1959
Mitra, Debala. "A Four-armed Image of Mahākāla." *Indian Historical Quarterly* 35 (March 1959), 43–45.

Mitra 1982
Mitra, Debala. *Bronzes from Bangladesh, a Study of Buddhist Images from District Chittagong*. Delhi, 1982.

Moeller 1985
Moeller, Volker. *Javanische Bronzen*. Berlin, 1985.

Moens 1919
Moens, J. L. "Hindoe-Javaansche portretbeelden Çaiwapratista en Boddhapratista." *TBG* 58 (1919), 493–526.

Moens 1921
Moens, J. L. "Aanwinsten van de Archaeologische Collectie van het Bataviaasch Genootschap 4. Een Javaansch-Buddhistisch Guru-Beeld." *OV* (1921), 186–193.

Moens 1924
Moens, J. L. "Het Boeddhisme op Java en Sumatra in zijn laatste bloeiperiode." *TBG* 64 (1924), 521–579.

Montana 1985
Montana, Suwedi. "Mode hiasan matahari pada pemakaman Islam kuno di beberapa tampat di Jawa dan Madura" (The representation of the sun on ancient Islamic tombs in various places in Java and Madura). *Pertemuan Ilmiah Arkeologi* 3 (1985), 722–738.

Mulia 1980a
Mulia, Rumbi. "Beberapa Catatan mengenai Arca-arca Yang Disebut Arca Tipe Polinesia" (Some remarks concerning the so-called Polynesian statues). *Pertemuan Ilmiah Arkeologi.* Jakarta, 1980, 598–646.

Mulia 1980b
Mulia, Rumbi. "The Ancient Kingdom of Panai and the Ruins of Padang Lawas (North Sumatra)." *Bulletin of the Research Centre of Archaeology of Indonesia* 14. Jakarta, 1980.

Muljana 1983
Muljana, Slamet. *Pemugaran Persada Sejarah Leluhur Majapahit* (A reconstruction of the history of the ancestors of Majapahit). Jakarta, 1983.

Muller 1978
Muller, H. R. M. *Javanese Terracotta—Terra Incognita.* Lochem, 1978.

Mus 1935
Mus, Paul. *Borobudur.* Hanoi, 1935.

Musée Guimet 1924
Hackin, J. *La sculpture indienne et tibétaine au Musée Guimet.* Paris, 1924.

Musée Guimet 1971
Le Bonheur, Albert. *La sculpture indonésienne au Musée Guimet.* Paris, 1971.

Muusses 1923
Muusses, Martha A. "De Gelaatsuitdrukking der Hindoe-Javaansche Beelden." *Djawa* 3 (1923), 13–15.

Muusses 1924
Muusses, Martha A. "De Oudheden te Soekoeh." *Djawa* 4 (1924), Extra Nummer, 32–37.

van Naerssen 1938
van Naerssen, F. H. "Hindoe-Javaansche Overblijfselen op Soembawa." *Tijdschrift van het Koninklijk Nederlandsch Aardrijkskundig Genootschap* 55, 2d series. Amsterdam, 1938, 90–100.

van Naerssen 1976
van Naerssen, F. H. "Tribute to the God and Tribute to the King." *Southeast Asian History and Historiography, Essays Presented to D. G. E. Hall.* Ed. C. D. Cowan and O. W. Wolters. Ithaca, 1976, 296–303.

van Naerssen 1979
van Naerssen, F. H. "The Economic and Administrative History of Early Indonesia." *Handbuch der Orientalistik*, Band 7. Leiden/Cologne, 1979, 37–41.

NBG
Notulen van het Bataviaasch Genootschap van Kunsten en Wetenschappen 1–59, 1862–1921.

Neeb 1902
Neeb, C. J. "Het een en ander over Hindoe Oudheden in het Djambische." *TBG* 45 (1902), 120–127.

New York 1975a
Lerner, Martin. *Bronze Sculpture from Asia.* Exh. cat. The Metropolitan Museum of Art. New York, 1975.

New York 1975b
Rarities of the Musée Guimet. Exh. cat. Asia Society. New York, 1975.

New York 1984
Lerner, Martin. *The Flame and the Lotus.* Exh. cat. The Metropolitan Museum of Art. New York, 1984.

Noorduyn 1978
Noorduyn, J. "Majapahit in the Fifteenth Century." *BKI* 134 (1978), 207–274.

Noorduyn and Verstappen 1972
Noorduyn, J., and H. Th. Verstappen. "Pūrnavarman's River Works near Tugu." *BKI* 128 (1972), 298–307.

O'Connor 1985
O'Connor, Stanley J. "Metallurgy and Immortality at Candi Sukuh, Central Java." *Indonesia* 39 (April 1985), 53–70.

Octagon
Octagon. Spinks & Son, Ltd., London.

OV
Oudheidkundig Verslag van de Oudheidkundige Dienst van Nederlandsch-Indië, 1912–1949.

Pigeaud 1960–1963
Pigeaud, Th. G. Th. *Java in the Fourteenth Century.* 5 vols. The Hague, 1960–1963.

Poerbatjaraka 1922
Poerbatjaraka, R. Ng. "De Inscriptie op het Mahāksobhya-beeld te Simpang (Soerabaya)." *BKI* 78 (1922), 426–462.

Poerbatjaraka 1931
Poerbatjaraka, R. Ng. *Smaradhana.* Bandung, 1931.

Pott 1966
Pott, P. H. *Yoga and Yantra.* The Hague, 1966.

Prijono 1938
Prijono. *Sri Tañjung, een Oud Javaansch Verhaal.* The Hague, 1938.

Pijper 1947
Pijper, G. F. "The Minaret in Java." *India Antiqua.* Leiden, 1947.

Quaritch Wales 1951
Quaritch Wales, H. G. *The Making of Greater India. A Study in South East Asian Cultural Change.* London, 1951.

Quaritch Wales 1976
Quaritch Wales, H. G. *The Malay Peninsula in Hindu Times.* London, 1976.

Raffles 1817
Raffles, Sir Thomas Stamford. *History of Java.* London, 1817.

Rahardjo 1988
Rahardjo, Supratikno. "Perkembangan Masyarakat dan Kebudayaan Indonesia: Sebuah Penilaian" (The development of the society and culture of Indonesia: an evaluation). *Diskusi Ilmiah Arkeologi* 6. Jakarta, February 1988.

Rassers 1925
Rassers, W. H. "Over de zin van het Javaansche Drama." *BKI* 81 (1925), 320–324, 332–336.

Rawson 1967
Rawson, Philip. *The Art of Southeast Asia.* New York, 1967.

Renik 1985
Renik, S. A-Kt. "Arca Durgā Mahisāsuramardinī di Pura Penataran Panglang Pejeng" (The statue of Durgā Mahisāsuramardinī in the temple Penataran Panglang at Pejeng). *Pertemuan Ilmiah Arkeologi* 3. Jakarta, 1985, 272–284.

Robson 1971
Robson, S. O. *Wangbang Wideya, a Javanese Pañji Romance.* The Hague, 1971.

ROC
Rapporten van de Oudheidkundige Commissie van Nederlandsch-Indië, 1901–1912, 1923.

ROD
Rapporten van de Oudheidkundige Dienst van Nederlandsch-Indië, 1912–1915.

Roorda 1923
Choix de sculptures des Indes. Ed. T. B. Roorda. The Hague, 1923.

Rowland 1967
Rowland, Benjamin. *The Art and Architecture of India.* 3d rev. ed. Baltimore, 1967.

Rijksmuseum 1952
Museum van Aziatische Kunst in het Rijksmuseum, Amsterdam. Amsterdam, n.d. [1952].

Rijksmuseum 1962
Museum van Aziatische Kunst in het Rijksmuseum, Amsterdam. Amsterdam, 1962.

Rijksmuseum 1985
Asiatic Art in the Rijksmuseum. Ed. Pauline Lunsingh Scheurleer. Amsterdam, 1985.

Salmon and Lombard 1977
Salmon, Claudine, and Denys Lombard. *Les Chinois de Jakarta, temples et vie collective.* Paris, 1977.

Santiko 1980
Santiko, Hariani. "Dewi Sri di Jawa." *Pertemuan Ilmiah Arkeologi.* Jakarta, 1980, 291–304.

Santiko 1982
Santiko, Hariani. "Arca Camundi dari Adimulyo sifat dan fungsi arca" (The statue of Camundī from Adimulyo, character and function). *Pertemuan Ilmiah Arkeologi* 2. Jakarta, 1982, 153–164.

Santiko 1983
Santiko, Hariani. "Durga-Laksmi di Jawa Tengah" (Durgā-Laksmī in Central Java). *Pertemuan Ilmiah Arkeologi* 3 (1983). Jakarta, 1985, 286–305.

Santiko 1987
Santiko, Hariani. *Kedudukan Bhatārī Durgā di Jawa pada abad ke x–xv Masehi* (The position of Bhatārī Durgā in Java during the tenth through fifteenth centuries A.D.). Jakarta, 1987.

Satari 1975
Satari, Sri Soejatmi. "Senirupa dan Arsitektur Zaman Klasik di Indonesia" (Sculpture and architecture during the classical period in Indonesia). *Kalpataru* 1 (1975), 5–38.

Satari 1978
Satari, Sri Soejatmi. *New Finds in Northern Central Java, Bulletin of the Research Center for Archaeology of Indonesia 13.* Jakarta, 1978.

Scheurleer 1988
Lunsingh Scheurleer, Pauline. "A Particular Central Javanese Group of Bronzes." *Studies in South and Southeast Asian Archaeology* 2. Ed. H. I. R. Hinzler. Leiden, 1988, 23–38.

Scheurleer 1989
Lunsingh Scheurleer, Pauline. "The Tridanda of the Main Image of Candi Jago." *Southeast Asian Archaeology Newsletter* 2. Leiden, 1989, 14–19.

Schlingloff 1987
Schlingloff, Dieter. *Studies in the Ajanta Paintings.* Delhi, 1987.

Schnitger 1932
Schnitger, F. M. "Het portretbeeld van Anūsanātha." *BKI* 89 (1932), 123–128.

Schnitger 1936a
Schnitger, F. M. "De herkomst can het Krtanāgara-beeld te Berlijn." *TBG* 76 (1936), 328–330.

Schnitger 1936b
Schnitger, F. M. "Oudheidkundige Vondsten in Padang Lawas, Midden Tapanoeli." *Elsevier's Geillustreerd Maandschrift* (November 1936), 289–304.

Schnitger 1936c
Schnitger, F. M. *Oudheidkundige Vondsten in Palembang.* Leiden, 1936.

Schnitger 1937
Schnitger, F. M. *The Archaeology of Hindoo Sumatra.* Leiden, 1937.

Schnitger 1939
Schnitger, F. M. *Forgotten Kingdoms in Sumatra.* Leiden, 1939.

Scholte 1919
Scholte, J. "De Slametan entas-entas der Tengerrezen en de memukur-ceremonie op Bali." *Handelingen van het Solo'sche Congres voor de Taal-, Land- en Volkenkunde van Java* (1919), 47–71.

Sedyawati 1985
Sedyawati, Edi. "Pengarcaan Ganesa Masa Kadiri dan Singhasari" (Ganeśa statues from the Kadiri and Singhasari periods). Ph.D. diss. Univ. of Indonesia. Jakarta, 1985.

Sedyawati 1986
Sedyawati, Edi. "The Devotional Function of Space Arrangement: An Observation on the Prambanan and Plaosan Temples of Central Java." *International Seminar Cidākāśa—Bhūtākāśa/Inner and Outer Space.* Indira Gandhi National Centre for the Arts, New Delhi, 20–26 November 1986.

Sedyawati 1989a
Sedyawati, Edi. "Arca-arca 'Kecil' dalam Pantheon Bauddha" (Statuettes in the Buddhist pantheon). *Pertemuan Ilmiah Arkeologi* 5. Yogyakarta, July 1989.

Sedyawati 1989b
Sedyawati, Edi. "Candi Jago: Buddhist Architecture in a Javanese Context." *International Seminar on Buddhist Architecture and National Cultures in Asia.* Sarnath, Varanasi, 7–11 March 1989.

Seltmann 1987
Seltmann, Friedrich. *Die Kalang, Eine Volksgruppe auf Java und ihre Stamm-Mythe.* Stuttgart, 1987.

Serrurier 1896
Serrurier, S. *De Wajang Poerwa.* Leiden, 1896.

Shuhaimi 1982
Shuhaimi, Nik Hasan. "Arca Buddha dari Lembah Bujang serta hubungannya dengan style arca Semenanjung Tanan Melaya dan Sumatra antara abad ke 9 dan ke 14" (The Buddha from Lembah Bujang and its connection with the style of Peninsular Malaya and Sumatra between the 9th and 14th centuries). *Pertemuan Ilmiah Arkeologi* 2, 165–181.

Singhal 1985
Singhal, Sudarshana Devi. "Candi Mĕndut and the Mahāvairocana Sūtra." *Bahasa-Sastra-Budaya Ratna Manikam Untaian Persembahan Kepada Prof. Dr. P. J. Zoetmulder* (Language, literature, culture, a string of jewels offered to Prof. Dr. P. J. Zoetmulder). Ed. Sulastin Sutrisno. Yogyakarta, 1985, 702–716.

Singhal 1989
Singhal, Sudarshana Devi. "Iconography of Cundā." To be published by the International Academy of Indian Culture, New Dehli.

Siswadhi 1977
Siswadhi. "The Lingobhava myth on an old Javanese bronze." *Majalah Arkeologi* 1, no. 1 (September 1977), 53–58.

Sivaramamurti 1961
Sivaramamurti, C. *Le Stupa du Barabudur.* Paris, 1961.

Sivaramamurti 1963
Sivaramamurti, C. *South Indian Bronzes.* New Delhi, 1963.

Snellgrove and Skorupski 1977
Snellgrove, David L., and Tadeusz Skorupski. *The Cultural Heritage of Ladakh.* London, 1977.

Soebadio 1986
Soebadio, Haryati. "Philological Research in Support of Archaeology." *Pertemuan Ilmiah Arkeologi* 4 (3 *Konsepsi dan Metodologi*). Jakarta, 1986, 79–85.

Soediman 1980
Soediman. "Candi Sambisari dan Masalah-masalah" (Candi Sambisari and its problems). *Pertemuan Ilmiah Arkeologi* (1980), 155–187.

Soejono 1972
Soejono, R. P. *The Distribution of Types of Bronze Axes in Indonesia, Bulletin of the Archaeological Institute of the Republic of Indonesia* 9. Jakarta, 1972.

Soejono 1984a
Soejono, R. P. "Prehistoric Indonesia." *Prehistoric Indonesia, a Reader.* Ed. Pieter van de Velde. *Verhandelingen KITLV* 104 (1984), 69.

Soejono 1984b
Soejono, ed. *Jaman Prasejarah di Indonesia* (The prehistoric period in Indonesia). Vol. 1 of *Sejarah Nasional Indonesia.* Ed. Marwati D. Poesponegoro and Nugroho Notosusanto. 4th ed. Jakarta, 1984.

Soekatno 1981
Soekatno, Endang Sri Hardiati. *Benda-Benda Perunggu Koleksi Pusat Penelitian Arkeologi Nasional* (Bronze objects in the collection of the National Research Centre for Archaeology). Jakarta, 1981.

Soekatno 1982
Soekatno, T. W. "Penemuan Sepasang Arca Emas dari Purworejo" (The find of a pair of gold statues in Purworedjo). *Pertemuan Ilmiah Arkeologi* 2. Jakarta, 1982, 207–226.

Soekmono 1965
Soekmono, R. "Archaeology and Indonesian History." *An Introduction to Indonesian Historiography.* Ed. Soedjatmoko. Ithaca, 1965, 36–46.

Soekmono 1969
Soekmono, R. "Gurah, the Link between the Central and the East Javanese Arts." *Bulletin of the Archaeological Institute of the Republic of Indonesia* 6. Jakarta, 1969.

Soekmono 1977
Soekmono, R. *Candi, Fungsi dan Pengertiannya* (Candi, its function and meaning). Ph.D. diss. University of Indonesia, 1972. Jakarta, 1977.

Soekmono 1987
Soekmono, R. *Chandi Gumpung of Muara Jambi; A platform instead of a conventional chandi ? Bulletin of the National Research Centre of Archaeology of Indonesia* 17. Jakarta, 1987.

Soenarto 1980
Soenarto, Th. Aq. "Temuan Arca-arca perunggu dari daerah Bantul (sebuah pengumuman)" (The find of bronze images in the Bantul area—an announcement). *Pertemuan Ilmiah Arkeologi* (1980), 392–413.

Sono Budoyo 1934
Stutterheim, W. F. *Catalogus der Hindoeistische Oudheden van Java, tentoongesteld in het museum van het Java-Instituut "Sana Budaja" Djokjakarta.* Yogyakarta, n.d. [c. 1934].

Sono Budoyo 1982–1983
Soekiman, Djoko. *Museum Sono Budoyo dan Riwayatnya* (The Museum Sono Budoyo and its story). Jakarta, 1982–1983.

Speyer 1971
Speyer, J. S. *The Jātakamālā, Garland of Birth-Stories by Āryaśūra.* Repr. Delhi, 1971.

van Stein Callenfels 1916a
van Stein Callenfels, P. V. "De beelden van Tjandi Ngrimbi." *TBG* 57 (1916), 529–534.

van Stein Callenfels 1916b
van Stein Callenfels, P. V. "De Graftempel van Bhayalangö." *OV* (1916), 150–157.

van Stein Callenfels 1920
van Stein Callenfels, P. V. "Rapport over een dienstreis door een deel van Sumatra." *OV* (1920), 62–76.

van Stein Callenfels 1925
van Stein Callenfels, P. V. "De Sudamala in de Hindu-Javaansche Kunst." *Verhandelingen van het Koninklijk Bataviaasch Genootschap van Kunsten en Wetenschappen* 66 (1925), 1–180.

Stutterheim 1923
Stutterheim, W. F. "Oudjavaansche Kunst."
BKI 79 (1923), 323–346.

Stutterheim 1924
Stutterheim, W. F. "Oudjavaansche plastiek in
Europeesche Musea." *BKI* 80 (1924), 287–301.

Stutterheim 1925a
Stutterheim, W. F. "Een oorkonde op koper uit
het Singasarische." *TBG* 65 (1925), 208–281.

Stutterheim 1925b
Stutterheim, W. F. *Rāma-Legenden und
Rāma-Reliefs in Indonesien.* Munich, 1925.

Stutterheim 1926a
Stutterheim, W. F. *Cultuurgeschiedenis van
Java in Beeld (Pictorial History of Civilization
in Java).* Weltevreden, 1926.

Stutterheim 1926b
Stutterheim, W. F. "Oost-Java en de he-
melberg." *Djawa* 6 (1926), 333–349.

Stutterheim 1926c
Stutterheim, W. F. "Schaamplaten in de
Hindoe-javaansche Kunst." *TBG* 66 (1926),
671–674.

Stutterheim 1929a
Stutterheim, W. F. *Oudheden van Bali.* 2 vols.
Singaradja, 1929.

Stutterheim 1929b
Stutterheim, W. F. "Oudheidkundige Aante-
keningen 3, het hoofdbeeld van Tjandi Se-
woe." *BKI* 85 (1929), 487–491.

Stutterheim 1930a
Stutterheim, W. F. "Bronzen beeldjes van Bali."
*Mededeelingen van de Kirtya Liefrinck-van
der Tuuk* 2. Singaradja/Solo, 1930, 43–55.

Stutterheim 1930b
Stutterheim, W. F. *Gids voor de Oudheden van
Soekoeh en Tjeta.* Surakarta, 1930.

Stutterheim 1932
Stutterheim, W. F. "Oudheidkundige Aante-
keningen, 23, Wat Beteekenen de H-vormige
teekens op de Djala-Toenda reliefs?" *BKI* 89
(1932), 269–271.

Stutterheim 1934a
Stutterheim, W. F. "De Leidse Bhairava en
Tjandi B van Singasari." *TBG* 74 (1934), 441–
476.

Stutterheim 1934b
Stutterheim, W. F. "De oudheden-collectie
Resink-Wilkes te Jogjakarta." *Djawa* 14 (1934),
167–197.

Stutterheim 1937a
Stutterheim, W. F. "De Oudheden-collectie van
Z. H. Mangkoenagoro VII te Soerakarta."
Djawa 17 (1937), 13, 32–33, figs. 23, B28.

Stutterheim 1937b
Stutterheim, W. F. "Een Oudjavaansch
Spiegelhandvat." *MBK* (March 1937), 93–95.

Stutterheim 1937c
Stutterheim, W. F. "Het zinrijke waterwerk
Djalatoenda." *TBG* 77 (1937), 214–250.

Stutterheim 1939
Stutterheim, W. F. "Een bijzettingsbeeld van
Koning Rājasa?" *TBG* 79 (1939), 85–104.

Stutterheim 1940
Stutterheim, W. F. "Oorkonde van Balitung uit
905 AD." *Inscripties van Nederlandsch-Indië.*
Batavia, 1940, 3–28.

Stutterheim 1941
Stutterheim, W. F. "Tjandi Djawi op een re-
lief?" *TBG* 81 (1941), 1–25.

Stutterheim 1948
Stutterheim, W. F. *De Kraton van Majapahit,
Verhandelingen van het Koninklijk Instituut
voor de Taal, Land- en Volkenkunde van Ne-
derlandsch Indië.* Vol. 7. The Hague, 1948.

Stutterheim 1956a
Stutterheim, W. F. "An Ancient Javanese
Bhīma Cult." *Studies in Indonesian Archaeol-
ogy.* The Hague, 1956, 107–143. Translated
from *Djawa* 15 [1935], 37–64.

Stutterheim 1956b
Stutterheim, W. F. *Candi Barabudur.* The
Hague, 1956.

Stutterheim 1956c
Stutterheim, W. F. "An Important Hindu-
Javanese Drawing on Copper." *Studies in Indo-
nesian Archaeology.* The Hague, 1956, 147–
158. Translated from *Djawa* 4 (1924), 247–252.

Subroto 1980
Subroto, Ph. "Kelompok Kerja pandi besi
pada relief Candi Sukuh" (The guild of black-
smiths in the relief of Candi Sukuh). *Perte-
muan Ilmiah Arkeologi.* Jakarta, 1980, 342–
355.

Sukarto 1960
Sukarto, M. "Topeng Sang Hyang Puspacarira
(?)" *Sana Budaya* tahun ke 1, no. 9 (December
1960), 399–405.

Sukendar 1985
Sukendar, Haris. "Peranan Menhir dalam Ma-
syarakat Prasejarah di Indonesia" (The role of
the menhir in the prehistoric society of Indone-
sia). *Pertemuan Ilmiah Arkeologi* 3, 92–108.
Jakarta, 1985.

Suleiman 1975
Suleiman, Satyawati. *Pictorial Introduction to
the Ancient Monuments of Indonesia.* Jakarta,
1975.

Suleiman 1978
Suleiman, Satyawati. *The Pendopo Terrace of
Panataran.* 2 vols. Jakarta, 1978.

Suleiman 1981
Suleiman, Satyawati. *Sculpture of Ancient Su-
matra.* Jakarta, 1981.

Suleiman 1985
Suleiman, Satyawati. "Peninggalan-
Peninggalan Purbakala di Padang Lawas" (Ar-
chaeological remains in Padang Lawas).
Amerta 2 (1954). Repr. 1985, 23–37.

Supomo 1977
Supomo, S. *Arjunawijaya, a Kakawin of Mpu
Tantular.* 2 vols. The Hague, 1977.

Supriyatun 1986
Supriyatun, Rini. "Arca Prajnaparamita dari
Muara Jambi" (The statue of Prajñāpāramitā
from Jambi). *Pertemuan Ilmiah Arkeologi* 4,
no. 2b (*Aspek Sosial-Budaya*). Jakarta, 1986,
413–425.

Surasmi 1986
Surasmi, I Gusti Ayu. "Analisis Kentongan
Perunggu di Pura Manik Geni, Pujungan"
(Analysis of a bronze kĕntongan at the temple
Manik Geni, Pujungan). *Pertemuan Ilmiah
Arkeologi* 4, no. 2b (*Aspek Sosial-Budaya*).
Jakarta, 1986, 243–257.

Swadling 1986
Swadling, Pamela. "Some Ethnographic and
Archaeological Continuities and Discontinui-
ties across the Asian-Pacific Interface." *Perte-
muan Ilmiah Arkeologi* 4, no. 3 (*Konsepsi dan
Metodologi*). Jakarta, 1986, 204–234.

Swellengrebel 1935
Swellengrebel, J. L. *Korawāçrama, een Oud-
Javaansch Proza-geschrift.* Santpoort, 1935.

Swellengrebel 1960
*Bali, Studies in Life, Thought and Ritual, Se-
lected Studies on Indonesia by Dutch Scholars,*
vol. 2. Introduction by J. L. Swellengrebel, 1–
76. The Hague/Bandung, 1960.

TBG
*Tijdschrift voor de Indische Taal-, Land- en
Volkenkunde, utgegeven door het (Koninklijk)
Bataviaasch Genootschap van Kunsten en We-
tenschappen.*

Teeuw 1946
Teeuw, A. *Het Bomakāvya.* Groningen, 1946.

Teeuw 1969
Teeuw, A., and others. *Śiwarātrikalpa of Mpu
Tanakun.* The Hague, 1969.

Tirtowijoyo and Soepono 1984a
Tirtowijoyo, Soekatno, and Soepono. *Zaman
Indonesia Hindu* (The Hindu epoch in Indone-
sia). Jakarta, 1984.

Tirtowijoyo and Soepono 1984b
Tirtowijoyo, Soekatno, and Soepono. *Zaman
Prasejarah* (The prehistoric period). Jakarta,
1984.

Tjan 1938
Tjan Tjoe Siem. *Hoe Koeroepati zich zijn
vrouw verwerft.* Ph.D. diss. Leiden, 1938.

Tjandrasasmita 1984
Tjandrasasmita, Uka. *Islamic Antiquities of
Sendang Duwur.* Trans. Satyawati Suleiman.
2d ed. Jakarta, 1984.

Tjandrasasmita 1985
Tjandrasasmita, Uka. "Le rôle de l'architec-
ture et des arts décoratifs dans l'islamisation
de l'Indonésie." *L'Islam en Indonésie, Archipel*
29 (1985), 203–211.

Tokyo 1980
*Borobudur dan Seni Purbakala Indonesia/
Busseki Borobudōru to sono shūhen, Indone-
sia Kodai Bijutsuten.* Exh. cat. National Mu-
seum. Tokyo, 1980.

Tokyo 1987
Tai Bijutsuten (Art treasures of Thailand).
Exh. cat. National Museum. Toyko, 1987, no.
64.

Triharyantoro 1988
Triharyantoro, Edi. "Pemujaan Hariti di Tro-
wulan" (The cult of Hārītī at Trowulan).
Berkala Arkeologi 9, 1 (March 1988), 17–26.

Tucci 1935
Tucci, Giuseppe. *Indo-Tibetica.* Rome, 1935.

van der Tuuk 1897
van der Tuuk, H. *Kawi-Balineesch-Neder-
landsch Woordenboek.* Batavia, 1897.

Veltman 1904
Veltman, T. J. "Nota betreffende de Atjèhse
Goud en Zilversmeedkunst." *TBG* 47 (1904),
341–380.

Vickers 1982
Vickers, Adrian. "A Balinese Illustrated Manuscript of the Siwaratrikalpa." *BKI* 138 (1982), 443–469.

Vira and Chandra 1967
Vira, Raghu, and Lokesh Chandra. *A New Tibeto-Mongol Pantheon*. Vol. 12. New Delhi, 1967.

Visser 1936
V. (H. F. E. Visser). "Een prachtig bruikleen."*MBK* 12, no. 2 (November 1936), 349–351.

Visser 1948
Visser, H. F. E. *Asiatic Art in Private Collections in Holland and Belgium*. Amsterdam, 1948.

Vogel 1918
Vogel, J. Ph. "The Yūpa Inscriptions of King Mūlavarman from Koetei (East Borneo)." *BKI* 74 (1918), 167–332.

Vogel 1925
Vogel, J. Ph. "The Earliest Sanskrit Inscriptions of Java." *Publicaties van den Oudheidkundigen Dienst* 1 (1925), 15–35.

Vogler 1949
Vogler, E. B. *De Monsterkop in de Hindoe-Javaansche Bouwkunst*. Leiden, 1949.

von Rosenberg 1855
von Rosenberg, H. "Hindoe-bouwvallen in het landschap Padang Lawas (Binnenlanden van Sumatra)." *TBG* 3 (1855), 58–62.

Vorderman 1893
Vorderman, A. G. "Bijdrage tot de Kennis der oudheden van Java." *TBG* 36 (1893), 480–499.

Wagner 1959
Wagner, Frits A. *Indonesia*. London, 1959.

Williams 1981
Williams, Joanna. "The Date of Borobudur, in Relation to Other Central Javanese Monuments." *Barabudur, History and Significance of a Buddhist Monument*. Ed. Luis Gómez and Hiram W. Woodward, Jr. Berkeley, 1981.

Wineman 1987
Wineman, Donald J. *Fine Asian Art, A Retrospective*. New York, n.d. [1987].

With 1922
With, Karl. *Java*. 2d ed. Hagen i. w., 1922.

Wolters 1986
Wolters, O. W. "Restudying Some Chinese Writings on Śriwijaya." *Indonesia* 42 (October 1986), 1–41.

Worsley 1986
Worsley, Peter. "Narrative Bas-Reliefs at Candi Surawana." *Southeast Asia in the 9th to 14th centuries*. Ed. David G. Marr and A. C. Milner. Singapore, 1986, 335–367.

Ijzerman 1891
Ijzerman, J. W. *Beschrijving der oudheden nabij de grens van de Residenties Soerakarta en Djogdjakarta*. The Hague, 1891.

Zimmer 1955
Zimmer, Heinrich. *The Art of Indian Asia*. New York, 1955.

Zoetmulder 1965
Zoetmulder, P. J. "The Significance of the Study of Culture and Religion for Indonesian Historiography." *An Introduction to Indonesian Historiography*. Ed. Soedjatmoko. Ithaca, 1965, 326–343.

Zoetmulder 1974
Zoetmulder, P. J. *Kalangwan, A Survey of Old Javanese Literature*. The Hague, 1974.

Zoetmulder 1982
Zoetmulder, P. J. *Old Javanese-English Dictionary*. 2 vols. The Hague, 1982.

Photographs of objects from the Asian Art Museum of San Francisco, the British Museum, the Kern Institute, the Linden-Museum, the Metropolitan Museum of Art, the Musée Guimet, the Museum of Fine Arts, Boston, private collectors, the Rijksmuseum, and the Staatliche Museen were kindly supplied by their owners. Other photo credits: p. 69, Jan Fontein; p. 71, after *OV* 1929; p. 76, after *OV* 1927; p. 77, Suaka Peninggalan Sejarah dan Purbakala Jawa Tengah, Prambanan; p. 79, courtesy R. Soekmono; p. 82, after Amerta I; p. 91, after Groneman 1895; p. 92, after *OV* 1937; p. 107, left, The Denver Art Museum, center and right, Direktorat Perlindungan dan Pembinaan Peninggalan Sejarah dan Purbakala, Jakarta; p. 116, after *Kaogu* 1984, no. 9; p. 134, courtesy Jan Fontein; p. 140, © I. L. Klinger, Heidelberg; p. 189, Museum Nasional, Jakarta; p. 217, Museum Nasional, Jakarta; p. 248, after van Erp 1943b; p. 289, left, after Katamsi 1960 (top) and Juynboll 1909 (bottom). All other photographs by Dirk Bakker.

Map on p. 26 after Krom 1923.